2003

W9-BWL-306

3 0301 00212911 8

2003

Picasso

Picasso

200 Masterworks
from 1898 to 1972

edited by
Bernice B. Rose
Bernard Ruiz Picasso

LIBRARY
UNIVERSITY OF ST. FRANCIS
JOLIET, ILLINOIS

A Bulfinch Press Book
Little, Brown and Company
Boston • New York • London

Front jacket
Woman with Beret and Red Dress
March 6, 1937
(cat. 103)

Back jacket
Woman with Bouquet
April 17, 1936
(cat. 86)

This volume was published
for the exhibition
"Picasso. 200 capolavori dal 1898
al 1972," Palazzo Reale, Milan
September 15, 2001–January 27, 2002

First U.S. Edition, 2002

ISBN 0-8212-2792-0

Library of Congress Control Number
2001096773

Bulfinch Press is an imprint and trade-mark of Little, Brown and Company
(Inc.)

All rights reserved. No part of this book
may be reproduced in any form or by
any electronic or mechanical means,
including information storage and
retrieval systems, without permission in
writing from the publisher, except by a
reviewer who may quote brief passages
in a review.

PRINTED IN ITALY

Original edition in Italian

© Succession Picasso by SIAE 2001

© 2001 by Electa, Milan
Elemond Editori Associati
All Rights Reserved

709.2
p586

$60.00

BN

5-8-03

Contents

*It is a great honor for our region to house, for the second
time and at the same venue, a retrospective dedicated
to Pablo Picasso, unrivaled artist of the twentieth century
whose exhibition at Palazzo Reale confirms the position of Milan
and Lombardy at the heart of the European cultural scene.
For many years the Region has supported and promoted cultural
events of international significance in Milan and Lombardy
and its commitment to this event will help to draw attention
in Italy and Europe to the Lombard "approach," which applies
to cultural aspects as well as to the economy, tourism and social
matters.
In this connection it is important to emphasize that the
importance assigned to culture has found concrete expression
in its recognition as one of the major factors in the development
of Lombardy within the scope of the Regional Program
of Development launched by the 7th Legislature.
So it is with the intention of promoting culture, making it
comprehensible and accessible to all citizens, that the Region
has chosen to support this initiative in the conviction that
it will contribute to the cultural and social development
of our civilization.
Given these premises, I would like to stress that the value and
significance of the works in this exhibition make it a great
opportunity for the people of Lombardy, for Italians in general
and for art lovers from all over the world, presenting as it does
many works never previously shown and offering a glimpse
of the artist's personal and family life.
It is also a unique occasion because it offers a significant
panorama of the multitude of techniques adopted by the artist
and the wide range of subjects he tackled. The works on show,
fruit of a careful selection, represent the different phases
of his artistic career as well as reflecting the cultural movements
and the civil and social changes of the last century.
I must express my deep appreciation of the work carried out
by the curators, who have been able to create a unique
exhibition, an international event of great importance that lends
prestige not just to our region but to the whole country.*

Roberto Formigoni
President of the Regione Lombardia

An exhibition dedicated to Picasso is a great and twofold
challenge. This is because of the reputation that his name carries
with it, as an authentic icon of Western art, one of the shapers
of the modern sensibility: occasions of this kind can end up as
exhibitions of a signature, rather than the artist himself, owing
to the almost insurmountable difficulties in obtaining the loan
of truly significant works and the attendant risk of not being able
to seize the opportunity for an overall critical appraisal that
is the expression of a rigorous scientific project.
The second challenge is that of bringing Picasso back to Milan,
to the Sala delle Cariatidi in Palazzo Reale, the very same venue
as that of the legendary exhibition in 1953 that presented not
just the first major retrospective of the artist in Italy, but also
one of the symbols of the century, Guernica, in a room that
testified, and by deliberate choice will continue to testify, to the
disasters of war and the misery that human beings are capable
of inflicting when they turn against themselves. That exhibition
represented one of the most eloquent signs of Milan's desire for
regeneration and has therefore gone down in the city's history.
To vie with it is an act of courage. Visitors will now be able to
see for themselves whether the double challenge has been met.
Personally, I am convinced that it has: the works by
Pablo Picasso presented here on the basis of Bernice B. Rose's
scientific project and the collaboration of Bernard Ruiz Picasso
and Paloma Picasso are not just genuine masterpieces, in some
cases never shown before, but document the prodigious journey
taken by the great artist in all its phases, revealing the vast range
of techniques that he mastered and opening an unprecedented
window onto the painter's family life.
This result has been achieved thanks to the collaboration the
Commune has received from many quarters—Mondadori
Mostre, Lombardy Region, Wind, Alitalia, Il Corriere
della Sera—which have demonstrated their faith in a project
that does honor to the country and confirms Milan's leading
role on the international cultural scene.
To some extent, this exhibition completes and crowns the plan
that was launched in 1953, that of making Palazzo Reale
one of the major exhibition centers in Europe: a plan revived
with determination in recent years and pursued by ensuring
the quality of the exhibition program and the rapid completion
of work on the restoration of the building which, after
the injuries inflicted on it by the war and the insults of its
subsequent neglect, has entered a new, and great season.

Salvatore Carrubba
Councilor for Culture and Museums
Comune di Milano

Less than thirty years after his death, the artistic, cultural and philosophical legacy of Pablo Ruiz Picasso (1881–1973) appears undiminished in its historic import and aesthetic value. On the contrary, it has grown with the passing of time, rendering it universal and, it could be claimed, cleansing it of a certain cloying as well as uninformed exploitation for ideological and militantly political purposes that was ill-suited from the outset to the complex and powerful personality of an artist whose entire existence was dominated by a passion for research and certainly not by a veneration of political and ideological dogma.

In the first place, this exhibition is intended as a sincere and admiring tribute to one of the greatest artists of the twentieth century, as tormented and difficult a period as the world has ever known. And so it is only right and proper from the cultural and educational viewpoint that Picasso's work should be presented to members of the younger generation who are unfamiliar with it, as well, if possible, as allowing members of the older generation to explore it in an atmosphere free from prejudice and conformity. I also feel that it is important to stress that our primary aim is to pay tribute to the innovative character of his conception of art and his works, a character that has only strengthened over the years.

There is now a full awareness of just how much was anticipated by the artist from Andalusia and just how much he took on board during his long and untrammeled journey through the vast world of the arts. At the same time, we cannot help but admire the audacity with which he broke away from that past, which he had so profoundly assimilated, thanks to an original and highly personal approach not just to painting but also to sculpture, drawing and even ceramics.

This has been and still is Picasso's perennial modernity: his capacity to continue along the lines of tradition and yet remain fully conscious of the need for an evolutionary metamorphosis, not as an end in itself but as the culmination of his complex—and highly successful—research.

Our Region has lent its support to this important anthological exhibition, in which there is an intimate and private component that very opportunely serves to let us see the artist's more human side and get to know him better. It can undoubtedly be regarded as one of the "major events" on the artistic and exhibition calendar not just in Lombardy but in the country as a whole, presented from a deliberately and consciously international perspective and with the precise intention of critically but judiciously reexamining the broad sweep of history in all its components. And among these components, more and more consideration is being given to that of artistic expression.

In fact the revolutionary twentieth-century genius of Picasso, which has proved more groundbreaking than any of the avant-garde movements of the past, makes absolutely necessary a thorough understanding of his art set against the historical background of the time in which it was conceived and realized. An art, however, that was imbued with all the riches of his great predecessors.

Today Picasso returns to Milan for the first time after the remarkable exhibition that was held in the same rooms of Palazzo Reale in 1953. I was very young at the time but paid two visits to that extraordinary show, which—in an Italy still deeply scarred by the tragedy of the war and profoundly and traumatically uncertain in its values, torn between the many conformities inherited from the past and those already taking hold in the present—represented a powerful but salutary shock of vitality and unconventionality. To my adolescent imagination the possibility of seeing a work like Guernica "in flesh and blood" represented a truly unique opportunity to receive a powerful message of liberty and humanity couched in a language as original as it was bold and innovative. At a distance of fifty years the goal set for this exhibition seems to me a truly lofty one, that of paying tribute to a great artist not by diluting his work into myth or reducing it to the level of militant ideology, but recognizing it for what it really was and remains: an exemplary and unsurpassed testimony to the century that has just drawn to a close, with all its ambiguities as well as its bright spots, its vast and bloodstained areas of darkness as well as its stirring (although all too often frustrated) projects to bring about real change with respect to everything that had gone before it. Only a great artist could feel and sense all this and, in particular, bring it to life again today, beyond the barriers of time, through the mercurial power of his work.

Ettore A. Albertoni
Regional Councilor for Cultures, Identities
and Autonomies of Lombardy

The autumn-winter season at Palazzo Reale is unquestionably
a rich one. The exhibition on cartography, "Segni e sogni
della Terra," returns to a theme that has been closely linked
with Palazzo Reale ever since the time of "L'Anima e il Volto":
that of the relationship between art and science.
"Dalla Scapigliatura al Futurismo" resumes the investigation
of the Milanese figurative tradition.
And the major exhibition on Picasso arises out of memories
of the outstanding anthological show mounted in 1953.
Certainly there can no longer be any justification, today,
for transporting some of the masterpieces shown at that time.
But the contribution of the Picasso family renders this exhibition
particularly valuable and stimulating.
A sort of confrontation is taking place, at Palazzo Reale:
between Cubism and Futurism, the wellsprings of contemporary
art. It is the city of Milan that is taking up the question,
a city that, at the time of the original and decisive confrontation,
was evidently second only to Paris.

Flavio Caroli
Chief of Research
for Exhibition Activities at Palazzo Reale

Wind has been in business for just over two years, but has already accumulated considerable experience in the area of cultural promotion: in fact we have selected major events of art and culture as one of our principal channels of communication. We are convinced that a major company has a responsibility to contribute to making the most of our culture, one of Italy and Europe's most precious assets. And we are convinced that a large telecommunications company needs to pay ever greater attention to the content of those communications: entertainment, sport and services, as well as art and culture to be offered to the vast audience of its customers on all the platforms of access, from the computer to mobile and stationary telephones.

For this reason Wind has always seen its participation in major cultural events not as mere sponsorship designed to promote its image, but as an integral part of its business. We are convinced that the contribution of service companies can help to make the organization of major cultural events more efficient, to the benefit of citizens, tourists and visitors. This is why Wind chooses to participate in topflight cultural events that aim to reach a broad section of the public and are open to the use of communication technologies.

The Picasso exhibition at the Palazzo Reale in Milan meets these criteria perfectly: it is an event of the highest cultural significance dedicated to a central figure in the art of the twentieth century and housed in one of the most accessible and functional exhibition venues in Italy, capable of handling thousands of visitors a day: visitors to whom Wind will offer its own telecommunication services. In particular, Wind has constructed a virtual tour of the exhibition, accessible from its own IOL and Inwind portals; it has made special telephone numbers available for information and booking; it has contributed to the production of the audio guide offered to all visitors and was responsible for part of the publicity campaign for the exhibition. After the major exhibitions "Cento capolavori dell'Ermitage" at the Scuderie of the Palazzo Quirinale and "Caravaggio e i Giustiniani" in Rome, this exhibition on Picasso represents the third stage in a fascinating journey to the roots of the European cultural identity, a journey that Wind is honored to have helped make possible.

Tommaso Pompei
Managing Director of Wind

Alitalia is particularly proud of taking part in an event of worldwide resonance, centered on one of the most representative figures of twentieth-century culture, marked for over seventy years by Pablo Picasso's inexhaustible enthusiasm for artistic experimentation and undisputed talent for the interpretation of reality in terms of a new approach to form and color.

The event is seen in continuity with the first major exhibition of Picasso's work in Italy, staged in 1953 in the same suggestive setting of Milan's Palazzo Reale, which, along with the city itself, is proving to be a vital and pulsating center on the international exhibition circuit.

The concept of continuity has for many years underpinned Alitalia's ties with the world of art, in a constant balancing of tradition and innovation.

Alitalia's encounter with art is something that takes place on a daily basis and is rooted in dedication and sensitivity, comprising a variety of aspects. In the first place, the ability to transport masterpieces of great value and large dimensions to any part of the world, through the highly specialized services of its own "Special Cargo" division.

As a consequence Alitalia has over the years become the official carrier for the most important exhibitions in Italy and abroad. Among them, the now historic retrospectives on Mantegna, Guido Reni, Titian, Tiepolo and Modigliani, the recent "one-man shows" of Monet, Chagall, Kandinsky and Caravaggio held in the splendid setting of Rome and the exhibition "Cento capolavori dell'Ermitage" at the Scuderie of the Palazzo Quirinale, which required five Alitalia "all cargo" flights for the transport of over four tons of works of art.

Alitalia's commitment to art also entails the capacity to look within the works themselves, to discover and appreciate the insights of emerging artists and make them known to the general public. This, in essence, is the aim of "Alitalia for Art," an initiative that has been under way for ten years now but whose roots go back to the beginning of the sixties, when Alitalia's DC-8s were "decorated" with pictures by contemporary Italian painters like de Chirico, Campigli, Capogrossi and Cagli: works that transformed the aircraft into genuine flying "galleries."

With the same spirit of profound admiration for the personalities who have illuminated the art of the twentieth century, Alitalia is again present here in Milan with its own contribution to this new and special encounter with Picasso. To his genius, to his extraordinary ability always to be himself whatever means of expression he chose, Alitalia pays tribute, as a company operating in the service sector and fully conscious of the growing value that intercultural communication and encounters are assuming through the universal language of art.

Francesco Mengozzi
Managing Director of Alitalia

With the exhibition "Picasso: 200 Masterworks from 1898 to 1972," Mondadori Mostre takes its place among the foremost international operators in the sector of art events. Thus the Mondadori Group, long active in this field with Electa, confirms its commitment to activities linked with the world of art: from the publication of numerous series of books and catalogues of major exhibitions to the management of museum sites and art bookshops and the creation and organization of important exhibitions.

This commitment to art is consistent with the history and mission of the publishing house. Over almost a century of existence, in an age characterized by profound changes, Mondadori has always pursued the objective of disseminating culture, from a perspective that is not elitist but open to all interests and to all levels of approach to its interpretation and understanding.

With the same spirit it is now engaged in the planning and design of exhibitions, favoring and stimulating interest in art.

The exhibition "Picasso: 200 Masterworks from 1898 to 1972" represents an ideal opportunity to carry forward this policy, with an event that is in many ways exceptional, that is of special value to the younger generation and that underlines the role of art in people's cultural development.

I would like to express my gratitude to all those who have made possible the staging of this extraordinary exhibition, which will present a complete and exhaustive picture of Picasso's works and allow visitors to make the acquaintance of masterpieces never previously shown in public.

Special thanks must go to Bernard Ruiz Picasso who, along with Paloma Picasso, has been involved with the project right from the start and has been personally responsible, together with Bernice B. Rose, for the selection of the works, scattered among some of the world's most important public and private collections; to Arne Glimcher who has made an enthusiastic contribution to the project; to the Commune of Milan, the Palazzo Reale in Milan—which will house the exhibition in the same rooms in which the unforgettable anthological show was held fifty years ago—and the Lombardy Region; to Wind, which once again has given its wholehearted support to our initiative; to Alitalia, which has handled the complex task of organizing the transport of the works; and to Il Corriere della Sera for its collaboration in publicizing the exhibition.

It is thanks to them that it has been possible to stage this memorable event, which for many months will ensure that Milan is at the center of attention of art lovers all over the world.

Leonardo Mondadori
President of the Mondadori Group

**Picasso
200 Masterworks
from 1898 to 1972**
Palazzo Reale, Milan
September 15, 2001
January 27, 2002

Promoters

Comune di Milano
Culture, Museums
and Exhibitions Department

Regione Lombardia

Mondadori Mostre

16

Comune di Milano

Mayor
Gabriele Albertini

*Culture, Museums
and Exhibitions Department
Councilor*
Salvatore Carrubba

*Chief of Research for Exhibition
Activities at Palazzo Reale*
Flavio Caroli

*General Manager
and Department Head*
Alessandra Mottola Molfino

Director
Sandrino Schiffini

Head of Exhibitions Office
Domenico Piraina

Secretarial Staff
Giuliana Allievi
Cristina Andena
Antonella Cantatore
Laura De Luca
Giulia Sonnante

Technical Assistance
Andrea La Boccetta
Luciano Madeo
Angelo Goitom

Custodial Services
Corpo di Guardia di Palazzo Reale
Cooperativa Tesis

President
Roberto Formigoni

*Councilor for Cultures, Identities
and Autonomies of Lombardy*
Ettore A. Albertoni

Director General
Pietro Petraroia

*Director of Structure,
Communication and Promotion*
Giuseppe Costa

*Head of Operations Unit
for Exhibitions, Cultural Events
and Sponsorships*
Maria Antonia Zanferrari

Committee of Experts
Bernice B. Rose
Bernard Ruiz Picasso
Flavio Caroli
Arnold Glimcher

Management of the Exhibition
Domenico Piraina
Sandrino Schiffini

Organization
Mondadori Mostre

Press Office
Electa: Isabella di Nolfo
Sveva Fede
Comune di Milano:
Maria Grazia Vernuccio

*Exhibition Design
and Supervision of Works*
Paolo Capponcelli
and Cesare Mari
with the collaboration of
Cosetta Gigli
and Gianluca Giordano
Panstudio Architetti Associati,
Bologna

Lighting
Roberto Bergamo, Venice

*Supervision and Conservation
of Works*
Paul Schwartzbaum

Preparation
Michele Tosetto, Jesolo

Exhibition Graphics
Studio Camuffo, Venice

Archive Films
Istituto Luce
French Embassy in Rome

Multimedia Services
Natali Multimedia

Insurance
Lloyd's
Progress Insurance Broker

Transport
Propileo, Rome
Transart, Paris

Advance Sales and Ticket Office
Circuito Box Tickets
Le Box Office

*Bookings for Schools, Groups
and Guided Tours*
Ad Artem
Box Tickets
Ellessepromo

Audio Guides
Antenna Audio

Educational Section

Comune di Milano
*Education / Educational Services
Department
Councilor*
Bruno Simini

General Manager
Francesca Della Porta

Department Head
Alberto Ferrari

Organization
Office for Cultural
and Educational Initiatives,
Coordination
Angela Bernasconi

Conception
Fiorenza Mariotti
Teatro Laboratorio di Figure

Installation Design
Loretto Buti

Decorations
Aris Provatàs

Educational Graphic Materials
Soi Sistemi Comunicativi

Installation
New Expo

Contents

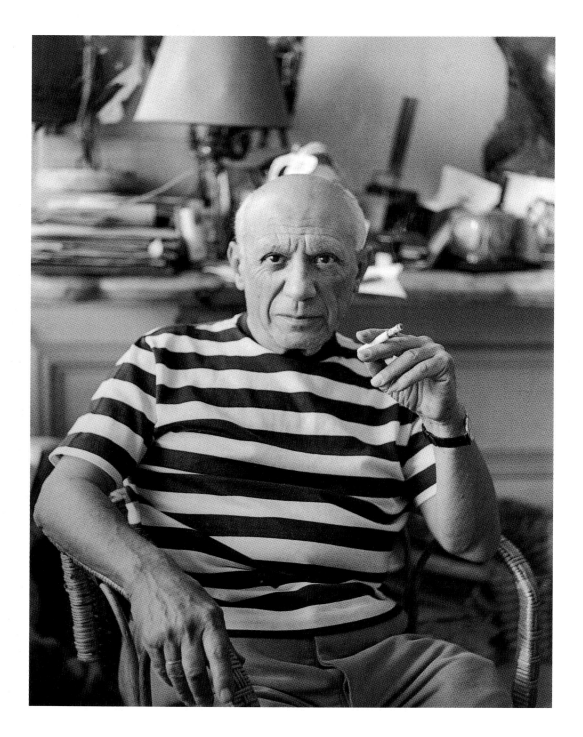

Bernard Ruiz Picasso

**Pablo Picasso:
Man and Artist**

Pablo Picasso
at La Californie,
Cannes, 1960.
Photo André Villers.

Pablo Picasso, in his relations with friends and family, was always frank and straightforward. He lived and worked strongly, even violently, giving his family and friends support and affection.

His loyalty to those close to him reveals the importance he attributed to life, to understanding, and the ties that both bind and separate human beings. Throughout his life he never ceased to discuss his opinions with the thinkers and creators of his time. They expressed their conceptions of life, of modernity and politics, always seeking to defend their ideas and the freedom of expression essential to creativity. This commitment is expressed in certain of his own works. I also wish to add that, as on various occasions he gave moral and financial help to those close to him, the same is also true of the causes that he believed in. Later, by way of a conclusion, I intend to recount an anecdote and two stories which reveal Pablo Picasso's humanity and enable us to understand something of the feelings he shared with his friends.

However, first of all I want to explain why I find this exhibition, mounted at the Palazzo Reale, especially moving. In September 1953 an important exhibition dedicated to Pablo Picasso was held here in this same Palazzo Reale: among the works presented in the Sala delle Cariatidi was *Guernica*, a work that testifies to the atrocities of war. This emblematic work is an act against war: it reminds us that people must always be free to decide their own destiny democratically. In that period *Guernica* was displayed widely in many different countries.[1]

It has taken forty-eight years for Picasso's works to return to Milan. This return gives me great pleasure, because the range of the exhibition means it includes certain exhibits that are essential if we are to interpret and analyze Picasso's work on different levels, so shedding light on its significance and on the various positions which the artist took up in the course of his life. The exhibits in this survey are arranged in chronological fashion to bring out the variety and power of Pablo Picasso's work and the ways in which he revolutionized artistic creation in his own lifetime.

In 1900 Picasso chose to leave Barcelona for Paris, where the artistic climate was propitious: there he developed new concepts and found new modes of artistic and aesthetic expression. The city, as well as his own feelings, combined with many other emotional factors in fostering his creativity. In 1902 he began his intense development.

The breakthrough, *Les Demoiselles d'Avignon*, came in 1907. It formed part of the general upheaval at the start of the century and left its mark on the history of artistic innovations which recur in our civilization at key moments and correspond to the needs and expectations of society. Pablo Picasso was one of those responsible for the rejection of centuries of art founded on the effort to master the codes of perspective and representation.

Freeing modern artistic creativity from the shackles of theory, he gave an impulse to the evolution of artistic thought and created new methods of expression. In doing this he redefined the space of creativity and produced what is today called Cubism. However, in all the various phases of his life, Picasso continued to study and draw upon the works of the great masters of the past, which he revisited as the makers of all the earlier artistic revolutions.

19

The present exhibition reflects this creative renewal and follows the succession of developments and innovations that distinguish Picasso's work. In particular, by painting *Guernica*, the *Massacre in Korea*, and *The Dove of Peace*, Picasso transfused a commitment to peace into his work. Now, in the present stage of my research, I feel I can describe him in this way: "Pablo Picasso: a man and a painter." I am fortunate to belong to his family and to know personally the men and women whom he knew and who were close to him. Their memories matter deeply to me, as I attach the greatest importance to the search for all those hints embodied in the gestures of the artist and the man, which enable me to broaden and enrich my reflections on his art and life. And since the man interests me as much as the artist, here is an anecdote regarding the arrival of *Guernica* in Milan in 1953, as told by John Richardson.[2] Then follows a little story which presents Picasso together with a young Spanish artist Appel.les Fenosa, in 1939, as told by Roberto Otero.[3] And finally the photographer André Villers'[4] memory of his first meeting with Pablo Picasso in 1953.

"Guernica" in Milan,
as told by John Richardson
A few days before the opening of the 1953 Picasso exhibition at the Palazzo Reale in Milan, my friend Douglas Cooper[5] and I sensed that the organizers were unaccountably nervous. Something had gone wrong, but they were keeping quiet about it. A former interrogator, Cooper soon nosed out the truth. On its journey from New York's Museum of Modern Art to Milan, *Guernica*, which was to be the clou of the show, had been slightly damaged as it passed through the Saint Gothard tunnel. The painting was being restored in great secrecy.

Back in France, Cooper and I went to see Picasso, who wanted a full account of the exhibition. "And *Guernica*," he asked slyly, "how did it look?" Before we could stammer out an answer, he roared with laughter, "thrilled," he said, "to hear that the eminent restorer who was repainting Leonardo's *Last Supper* was obliged to turn his attention to *Guernica*. "I hope it gave him some ideas!"

The Year's Most Important Exhibition,
by Roberto Otero
In Spain, the Escuela de París is the name given to the group of young artists who lived in the French capital in the 1920s. Many of them practically produced their whole oeuvre in Paris, and some—like Francis Bores, Hernando Viñes, or Manuel Angeles Ortiz—lived there till the end of their lives. Other famous names of this generation were Antoni Clavé, Joaquín Peinado, Julio González and Oscar Domínguez. One of them, the Catalan sculptor Appel.les Fenosa, was a close friend of Picasso's for fifty years, from 1923 till the painter's death. About a hundred of Fenosa's sculptures were found in Picasso's house at Mougins: he was by far the artist that Picasso collected most.

Fenosa returned to Spain in 1929 and lived there through the years of the Spanish Republic. When the civil war broke out he was in Barcelona. He spent

the war years in Catalonia, where his activities included saving the artistic heritage, especially Romanesque altarpieces, and founding the Artists' Trade Union. At the war's end he succeeded in traversing the French border on foot and took refuge first at Limoges and then Versailles. When he reached Paris in September 1939, he at once went to visit Picasso.

As he was walking toward rue La Boëtie, Fenosa thought of the stories he would soon be able to tell his friend, who would certainly be passionately interested: the dramatic downfall of the Republic—especially the last days in Barcelona, waiting for the arrival of Franco's troops—and the long mass march to the French border, which had to be crossed on foot, and his miraculous escape from interment in a refugee camp. Lastly he would tell the story of how he had escaped and arrived in Limoges, where friends had hidden him in their home.

Picasso greeted him in the living room of his studio-home on rue La Boëtie, but he showed no particular interest in his stories from war-torn Spain. After the usual embraces he exclaimed all at once, in a slightly theatrical tone: "You've arrived just in time come along to an exhibition that's opening today. You'll see, it's sure to be the show of the year…"

Fenosa could not help thinking that his friend had become a monster of selfishness. Was it possible he cared nothing for his feelings or those of the defeated Spanish people? All he was interested in was the success of his latest exhibition!

"But first we'll celebrate! Sabartés, bring a bottle of Jerez [sherry]! Unless you prefer some red wine, like in the old days …"

This proof of his old friend's insensibility made Fenosa even more uneasy. "How could he have painted *Guernica?*" he wondered. "All he cares about is his own immense ego."

"And now, Sabartés, let's have a look at the big exhibition," continued Picasso.

Sabartés opened the doors leading to the next room, where they saw numerous tables laden with sculptures by Fenosa that Picasso had bought in recent years from various Parisian galleries. With them he had now placed some he already owned, for Picasso had been collecting Fenosa's work ever since buying the first four pieces carved by the sculptor in 1923.

Fenosa's indignation was swept away in a great wave of gratitude.

He now understood his friend's playful kindness and knew he could now spend hours or weeks telling him, as he had planned, all about the last days of the Second Republic. He hugged his friend, with the tears running down his cheeks. Picasso, also deeply moved, told him gently, as they embraced: "Remember to call in at the such-and-such a gallery and such-and-such a gallery. They've got money for you …"

This story circulated among the members of the Escuela de París, together with many others testifying to Picasso's generosity to his Spanish friends and colleagues. I heard it from Manolo Angeles Ortiz and Rafael Alberti. Manolo Angeles Ortiz still jealously preserved, fifty years later, the counterfoil of a postal order he had received from Picasso in the refugee camp of Argelés, while Rafael Alberti always recalled that it was Picasso who got him his first job in his exile as a speaker with Radio Mondiale in Paris.

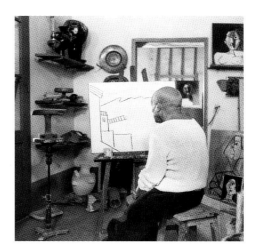

Pablo Picasso in Vallauris, 1954. Photo André Villers.

Passages from "Photobiographie"
by André Villers

After being mad about soccer and then going through the war with its privations, in 1946 I began to feel unwell: the diagnosis was acute osseous decalcification. Early in 1947 I was put in a plaster cast up to the neck and taken to a sanatorium near Vallauris in south-east France. There, thanks to the sun, grafts and careful treatment, by 1951 I learned to walk again. When I was first allowed to take short trips outside the hospital I would go to Vallauris, the nearest town. I spent eight years at that clinic, five of them bed-ridden.

In the sanatorium in 1947, I developed a passion for jazz, kindled by listening to Armstrong, Ellington, and Parker on an old gramophone with an amplifier horn. Discs were rare and it took over twenty years before we were to hear the recordings made by King Oliver! The friend who shared my room, Marcel Portalier, was immensely intelligent: he was very knowledgeable about poetry as well as being a musician and taught me a lot. In those years, thanks to his help, I was able to pick up a lot of ideas about life, both in general and in detail. It was Marcel that introduced me to fine jazz—that's the great debt I owe to him—but when I later met Picasso I realized he had one blind spot, painting. He knew almost nothing about it. Self-taught till then . . . true: but what a lot of time wasted! Thanks, my dear belated teachers.

In 1952, when I had just begun walking again, I took photography courses organized in the sanatorium. My first photos, since I had no landscape available except the walls of the clinic, were aerodynamic shots of the building, portraits of happy faces (it's only in such places that people know how to laugh), images of hilarious decalcified patients, black-and-white photos strangely dominated by green. The photos were an immediate success and so—I would say nowadays—no good at all. Under the guidance of my photography teacher, Pierre Astoux, I prepared the developers, fixatives and other reagents—toners, faders, intensifiers, etc. I was envious of the results attained by a member of the Photoclub from Cannes, one Monsieur Dutrieux, a grocer at Place Vauban and an amateur photographer. His prints, though conceptually uninteresting, had an extraordinary plastic quality which I have never seen since. Certainly an excellent chemist, he printed on a normal emulsion yet managed to get, with the paper of the day, Lumière paper if I'm not mistaken, the whole range from pure white to pure black passing through grey.

Pierre Astoux and I wanted to identify the developer he used. As a reducer he used paraphenylenediamine. My hands were covered with brown blotches, the results were excellent, but they fell far short of Dutrieux's work. I added sugar to give the liquid more body, make it slower, and I made great play with the medium yellow filter . . . I often wonder whether Weston's prints—I've only seen them in reproductions—had the same plastic quality as Dutrieux's. I sometimes get worked up about obtaining good prints. But it's not my principal concern. The smudges of paint on some of Picasso's paintings taught me not to be too fussy, not to waste time with formal perfection but to move on to something else.

In March 1953 I discovered painting and the first painter I ever photographed—what a coup!—was Picasso. Years later he said: "I brought you

into the world!" Later there were meetings—and photos—with Prévert, Léger, Arp, Chagall, Calder, Magnelli, Ernst, Dalí, and all the others, right down to the present, because the list is still growing.

So, that same March, I saw Picasso quite by chance at Vallauris. It was a potter who pointed him out to me. At that time I had no thought of photographing him: The people I mixed with called him the madman of Vallauris, someone to steer clear of. I've told the story of my first encounter with Picasso hundreds of times, but new images, new and more definite memories of that moment, surface in my mind every day. The film of life, it seems, unwinds and shows all over again with greater precision the important events, the ones that were important then.

Before meeting Picasso I had already made some progress in photography and I used to dream about taking part in exhibitions. Pablo certainly didn't distract me from photography (he had a lot of respect for the art practiced by Capa, Milly, Brassaï and others). As for me, I felt the importance of painting, above all his work, which revealed all the faces of its subject, whether a body or object. I always get on well with painters and writers; but the work of photographers, except for a few, always dissatisfied me because they ignored the history of art and never went beyond rehashing earlier work or stammering. A waste of time.

In 1953, while I was still in the Vallauris helio-marine clinic, I didn't have a camera of my own. I used a Rolleiflex belonging to Pierre Astoux or sometimes borrowed one from my roommate. I bought my first camera in a junk shop at Cannes. It was an old camera with plates measuring 9 × 12. You should have seen me when they let me venture out of the clinic, away in the hills taking shots of the scenery with a restrainer. … One day in 1953, at a shop in Cannes where I got my paper and film supplies, I saw an old Rolleiflex for sale. It cost 20,000 francs, a sizeable sum at the time. I managed to pay for it in small monthly installments, and only when they were ended could I hold it in my hands.

After a while it became unserviceable. But this was my camera when I met Picasso. My first photos of him were taken with that old piece of junk. You can imagine the result. I had to focus on a point well beyond the subject, and there were plenty of surprises, because it kept going haywire for no particular reason. I had it repaired without deluding myself (rightly) that it would ever work properly again and in fact the old gadget had rendered up its soul.

One day instinct led me to a café at Vallauris and I found Picasso there. He said: "Where's your old sewing machine today?" I explained that the camera, at its last gasp, was at the repair shop. "It's as if they had removed your eyes. What's the price of a Rolleiflex? I'll buy you one. How much? Come on, tell me."

A few days later I had a brand new Rollei with a Xénar lens that worked like a dream. When Picasso saw me with the shiny new camera he called out: "Now you're a real photographer!"

But at our first encounter I still had that old crate under my arm. Inside it there were all sorts of pictures, especially some portraits of a jovial Marseillais who was also having treatment at the clinic. By tilting the photosensitive paper under the lens of the enlarger during printing I had achieved

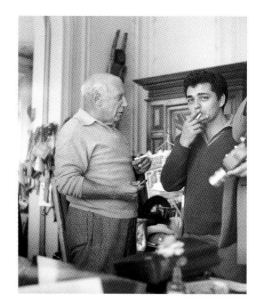

Pablo Picasso and André Villers in Cannes, 1955. Photo André Villers.

23

deformations of his face and then got an effect of half-relief by joining the negative and positive. The image produced a very curious-looking mask. A presentiment of my meeting with Picasso? But he was the last person in the world I had thought of meeting! Anyway, these photos interested him, I realized it straight away, and, and he asked me a lot of questions, I remember, though rather hesitantly. He was very cautious in his questions (perhaps he thought I did not want to give away my secrets).

After looking at the photos, Picasso said: "Would you like to have a look at what I do?" And so, for the first time, I visited his studio on Chemin du Fournas.

That same evening I hunted through the sanatorium library and found no end of books about him. Once I told him if I'd never been ill I would never have met him. He laughed and said: "I brought you into the world."

I then started playing about with his works. I had a great tenderness for the boy with the pigeon. So I cut it up like a jigsaw puzzle and arranged the pieces on a blank sheet of paper. Picasso looked serious: "I see you've understood me." He often had that kind of reaction to my pictures.

"People think I'm mad, and so I tried to tell the truth." I remember these words from my first meeting with Picasso, in March 1953.

In one of our first meetings, at the Ramiés, the ceramists where he worked, he wanted to pay me for some photos I'd brought along. After asking the Ramiés to go out so as not to embarrass me he came up, very pleased, his wallet in his hand. "I want to pay for these photos. What are you asking? How much?" As I refused to hear of payment he said: "So, would you like me to paint your portrait?" Again I refused, to which he said: "Merde alors!"

Text translated by Richard Sadleir

Firstly I would like to thank my wife Almine who assists me tirelessly in reading and correcting my texts.

Heartfelt thanks are due to the friends of Pablo Picasso, now also mine, for telling me the stories, which I have presented just as I heard them: Roberto Otero for the episode of Appel.les Fenosa, John Richardson for the arrival of *Guernica* in Milan and André Villers for letting me quote from his book.

[1] In September 1953 *Guernica* returned to Europe for the first time since 1939 and was exhibited at the Palazzo Reale in Milan; from December 1953 to February 1954 it was at the Second Biennial of São Paulo at the Museu de Arte Moderna: from June to October 1955 at a retrospective mounted at the Musée des Arts Décoratifs in Paris; the same exhibition then went to the Haus der Kunst in Munich, then the Reiniesches Museum of Cologne and the Hamburg Kunsthalle; then it was displayed at the Palais de Beaux-Arts in Brussels, the Stedelijk Museum in Amsterdam, and the Stockholm Nationalmuseum. In late 1956 *Guernica* returned to the United States. From May to September it appeared in an exhibition curated by Alfred H. Barr, "Picasso: 75th Anniversary Exhibition," held at the MoMA in New York then at the Art Institute of Chicago. On returning to New York in 1957 the painting was placed in a specially designed room with *Les Demoiselles d'Avignon* and the *Jeune Fille au Miroir*. Today it is kept at the Museo Nacional Centro de Arte Reína Sofía in Madrid.
[2] John Richardson (London 1924). The author of essays on Manet, Braque and Picasso, as well as numerous articles in various periodicals, notably *The New York Review*. From 1949 to the early 1960s he lived in Provence where he assisted the celebrated collector Douglas Cooper to convert the castle of Castille near Avignon into a private museum of Cubist painting. A close friend of Picasso's, he quotes many unpublished sayings, the fruit of their conversations in those years. He was also the friend of Braque, Léger and Cocteau. In the early 1960s he moved to New York, where he organized various exhibitions, including an important Picasso retrospective in 1962. For many years he headed Christie's New York branch. He has written a number of biographical volumes on Picasso.
[3] Roberto Otero has written numerous books on Pablo Picasso. They include: *Lejos de España, Siempre Picasso, Retrato de Picasso, Recuerdo de Picasso* and *Forever Picasso*. In the 1960s he was one of a group of friends always welcome at Picasso's home. During that period, Otero's photos and notes captured the essence of the artist's daily life and his tireless artistic activity. Large exhibitions of his photos have been held

at the Musée des Beaux-Arts in Montreal, at the Museo Picasso in Barcelona, at the Cercle des Beaux-Arts in Madrid, at Seibu in Tokyo and the Palais de Glace in Buenos Aires, to mention only a few. Museums and other institutions have acquired all or part of the material displayed and important collections of photographs by Otero exist throughout the world. He has also presented his work at numerous collective exhibitions, including those at the international Center of Photography in New York and the Musée Picasso in Paris.
[4] André Villers. Born at Beaucourt in the Belfort region, 1930. A soccer enthusiast, at seventeen he was hospitalized for osseous decalcification. He was then sent for treatment to the Vallauris helio-marine clinic where he was completely bedridden for five years. He began to walk again only in 1951. At the sanatorium he attended his first photography lessons and began to study photographic chemistry. He produced his fist collages under the influence of Arcimboldo.
In 1953 he met Picasso, who gave him his first true camera and was his first guide in art. By cutting out small forms—fauns, birds, heads, etc.—in the images and inserting pieces of dough, grass and cloth, Picasso and Villers created *Diurnes*, a magnificent volume published in 1962 with text by Jacques Prévert.
Villers used photography to capture his encounters with artists (Magnelli, Man Ray, Juan Gris, El Crosier, Hartung) and writers (Aragon and Prévert, who was deeply interested by photography and became a close friend).
Since 1959 his work has been the subject of numerous exhibitions in the United States, Bologna, Barcelona, Toronto, Montreal, Paris etc.
In 1966 Aragon used his "shadows of Aragon sculptures" at the Maeght Foundation to illustrate his *Lautréamont*.
In 1976 his work based on folded cigarette papers fascinated Michel Butor, who called them "Pliages d'ombres," while manuscript texts illustrate his "bouteilles de survie." In 1984 the magazine *Sud* devoted a special issue to his work. For his exhibitions at Dôle and Belfort a splendid *Photobiographie* was published, containing his memories and encounters.
Even more than a remarkably gifted photographer, with the trajectory of his life and his friendships with outstanding figures, Villers looked at the world with eyes that went well beyond photography. "The world that interests me is that of the fullest creativity. Anything that lacks inventiveness leaves me indifferent. The further I go, the more firmly I believe that a work has no need to be narrated. I love works without safety nets or supports, those that support themselves."

[5] Douglas Cooper. London 1911–1984. Art historian, critic and collector, principally of Cubism, Cooper was educated at Oxford and Freiburg. Born to a wealthy family he was able to live independently, mostly in southern France after the war. He spent a significant portion of his fortune early in life to buy modern art. When a depreciation of Cubism occurred in the 1930s, Cooper sold other portions of his collection to buy more, thereby amassing one of the finest private Cubist collections in Europe. During the second world war he worked for British Army Intelligence, perfecting his significant language skills. Throughout his life he made use of his personal acquaintance with artists, including Picasso and Léger, to write monographs on many artists. Cooper possessed an obstreperous personality, cultivating quarrels as much as friends. The French minister of culture became so jealous of Cooper's collection that he refused to allow it to leave the France unless Cooper donated some paintings to the country. His life-long animosity toward his native England caused him many rows with institutions there. In 1950 he was involved in a very public attempt to oust director John Rothenstein of the Tate Gallery. Cooper's criticism of the extremely conservative collecting policies of Rothenstein were valid. However his letters to the newspapers became so nasty that at one point the diminutive Rothenstein threw a punch at Cooper during an art reception. Although the Tate director was never removed, Cooper was made a Trustee of the museum to partly ensure broader collection policies. While he was a friend and champion of both Picasso and Graham Sutherland, in later years he disparaged portions of their work. His partner of fifteen years was the art historian John Richardson.
Methodologically Cooper seldom diverged from the formalism common among insular historians of art before the war. Much of this is because he relied upon his immense personal knowledge of the artists about whom he wrote. His most valuable contribution to the literature of art is his catalogue raisonné of Juan Gris. His monograph on Cubism is his most famous.

Biography: The Dictionary of Art 7, p. 797; John Richardson, *The Sorcerer's Apprentice: A Decade of Picasso, Provence, and Douglas Cooper* (New York, Knopf 1999).
Bibliography: Douglas Cooper, Margaret Potter, *Juan Gris: catalogue raisonné de l'oeuvre peint* (Paris, Berggruen 1977); Douglas Cooper, *The Cubist Epoch* (New York, Phaidon 1971); [war experiences] Douglas Cooper, C. Denis Freeman, *The Road to Bordeaux* (New York, Harper 1941).

25

LIBRARY
UNIVERSITY OF ST. FRANCIS
JOLIET, ILLINOIS

*Pictorial form is the possibility that things are related to one another in the
same way as the elements of the picture
That is how a picture is attached to reality; it reaches right out to it,
It is laid against reality like a measure
Only the end-points of the graduating lines actually touch the object that
 is to be measured
So a picture also includes the pictorial relationship, which makes it into
 a picture
The pictorial relationship consists of the correlations of the picture's elements
with things
These correlations are, as it were, the feelers of the picture's elements with
 which the picture touches reality
If a fact is to be a picture, it must have something in common with what it
depicts
There must be something identical in a picture and what it depicts,
to enable the one to be a picture of the other at all.*

Ludwig Wittgenstein, 1921[1]

EARLY PICASSO

Paris as Poetry

The Frugal Repast (1904, cat. 4)
A man and a woman sit in a wine shop, the man has his arm over the woman's
shoulder and with his other hand he touches her arm. Otherwise there is no con-
tact, no reciprocal involvement, his head is in profile and turned away from hers
while hers leans on her hand. Her gaze seems unfocused, but she looks at us, not
him, and he looks out at nothing. She is a lighter, linear silhouette shifted against
his darker one, both are leaning on the table in front of them where a bottle, two
glasses, a plate, and a crust of bread tell the story of their poverty and hunger.
They are neither dead nor alive. Picasso's eyes look back at us through the
woman; she is his surrogate in the picture. The artist through his other invites
our complicity in the act of his self-creation.

 The acid-bitten shadows of the etching evoke the couple as homeless,
stranded, eaten by base desire. Their wiry outline seems to eat at them, distorting
their silhouettes and pressing them against one another and between the wall and
the picture plane. The line is metamorphic: its movement alone has the power to
create. The tool that traces the line is connected through the artist's hand to his
eye and thence to his mind. Through the power of line, the gaze—the act of look-
ing itself—is transformed into an act of creation, an act of distancing, of doubling.
Picasso is saying, "I am another," and he shows us his double, the watcher. He nev-
er has his eye on "nature," on the expression of a purely observed phenomenon; his
gaze is always conditioned and enriched through dense layers of culture.

 These figures, or others like them, had already been described, not once
but many times, by Baudelaire, who here describes himself in a draft for his pref-
ace to *Les Fleurs du mal:*

Bernice B. Rose

PABLO PICASSO:
The World as Artifact

*Pablo Picasso
in his studio.*

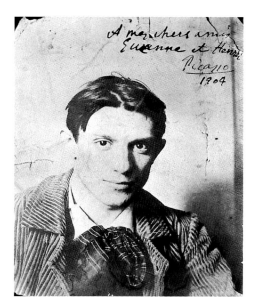

Ricardo Canals,
*Portrait of Pablo
Picasso*, Paris 1904.
Musée Picasso,
Archives Picasso,
Paris.

I have no desire either to demonstrate, to astonish, to amuse, or to persuade. I have my nerves and my vertigo, I aspire to absolute rest and unbroken night. Though I have sung of the mad pleasures of wine and opium, I thirst only for a liquor unknown on earth, which the pharmaceutics of heaven itself could not afford me; a liquor that contains neither excitation nor extinction. To know nothing, to teach nothing, to will nothing, to feel nothing, to sleep and still to sleep—this today is my only wish. A base and loathsome wish, but sincere.[2]

The language that Baudelaire and his cohorts used to write about Paris as it was being destroyed and rebuilt around them transformed each event into an object: a poem—or a painting. Baudelaire, and then Mallarmé, Rimbaud, and Verlaine, were the models for Picasso's friend Apollinaire and his generation, just as Manet, Cézanne, van Gogh, Gauguin, Seurat, and their group were for Picasso and his generation. Their art spoke a new language that manifested the future in the flux of the present. It was the language of vulgar reality. The structure of their language changed the structure of all of the arts—everything "new" had to be measured against their inventions. They invented the idea of the new. They were the first moderns.

The Paris that Picasso paints between 1904 and 1906 is the city of the poor and dispossessed, left stranded as islands in the flow of the future. Just one of the cities of Paris evoked by Baudelaire, it is a city of phantasmagorias, of arcades and smoky cafés, of castaways, of rampant alcoholism among the working class, of absinthe, opium, and tobacco, of syphilitic prostitutes sitting apart in cafés.[3] It is a Paris of street people, a *parade* of performers, wandering actors and acrobats, Pulcinellas costumed and masked with makeup, an endless spectacle of debauchery and license, of mania and melancholia—and already archaic.

The juggernaut of modernization was transforming the city. The new *grand boulevards* of Louis Philippe and Baron Haussmann were intended to open Paris in a series of grand vistas, but paradoxically, as a result of the cuts,

Depending upon where you stood, how you moved, and where you directed your gaze, Paris became instead a series of perspectives: contingent, fragmented, variable, and completely dependent on the subjective mechanism of perception, of sight. The spatial separations built into Haussmann's Paris were ultimately to be bridged by vision. And so, in another paradox inherent in the concept of *dégagement*, these physical distances only served to bring the city closer to the spectator—so close, in fact, that it became an internal phenomenon, an endless series of personal perceptions.[4]

These internal phenomena—and the paradoxical relationship between two structures of the real, the one preindustrial, the other mechanistic, scientific—were embodied as bits of a fragmented social structure, each segment of which held a different point of view. Its unease and its desire for some sort of rest and order, if only for a moment and as an illusion, were embodied in the structure of poetry and of visual art. It was no accident that Edgar Allan Poe's clock became a metaphor of terror. This was Baudelaire's other Paris, and one that was to engage Picasso only later.

Baudelaire, again in the preface to *Les Fleurs du mal*, wrote:

> The poetic phrase can imitate (and in this, poetry is like the art of music and the science of mathematics) a horizontal line, an ascending or descending vertical line; that it can rise straight up to heaven without losing its breath, or fall straight down to hell with the velocity of any weight, that it can follow a spiral, describe a parabola, or can zigzag, making a series of superimposed angles.[5]

Walter Benjamin would later observe that the Jugendstil or Art Nouveau style characteristic of this era, and reflected in Picasso's image, "represents the last sortie of an art besieged in its tower by technology. This attempt mobilizes all the reserves of inwardness. They find their expression in the mediumistic language of the line, in the flower as symbol of a naked vegetal nature confronted by the technologically armed world."[6]

By the beginning of the twentieth century, modernism had been understood as a movement that openly and self-consciously focused on its own means and purposes. Manet had been the center of this focus; his lack of a single signature style had been accepted as a sign of "naturalism" and sincerity because it was true to a singular temperament. Cubism created a crisis within modernism by focusing on its own devices "with a special vengeance."[7] Picasso's vision is the bridge to that point, the bridge from the period of Manet, through Cézanne, when individual perceptual perspectives dominate the history of art, to the formation of a new pictorial order. Those early years after 1900 are the most creative, the densest, the most packed with radical ideas of any time in the century. Between 1907 and 1914, Picasso invented the terms by which modernism, in a powerful act of the imagination, made visual representation a fellow traveler in the philosophical quest of consciousness to take itself as its own object and recast itself as a part of nature.

Rites of Passage
The years 1904 to 1906 are the initial phase in the deconstruction of the conventional representation of art as it was known up to that time. Picasso opened the way through a series of discoveries outside the Western canon, culminating in a picture that scandalized his friends and changed the course of Western art, *Les Demoiselles d'Avignon* (1907).

The exploration of disparate "realities" that Picasso undertook as he sped through the years 1904 to 1906 was the beginning of an era of ambitious investigation in which he hoped to reinvent the language of art itself. When he finally settled in Paris, in 1904, he was already in command of a remarkably diverse range of practices. He had a thorough education in the classical basis of art, especially of drawing. His mastery of technique in delicate contour drawing was already extraordinary. The arabesques of line that carry the mood of *The Frugal Repast* mark the first stage of Picasso's development of a style that is recognizably his own. The multivalent city became his stepping-off point; it was his model and his teacher. But it was not until later that "the human experience of the . . . city [as] a series of shifting points of view, of vistas—not the unchanging one . . . intended, but splinters of vision that together made up the totality of a visual experience," became inscribed in his art.[8]

The only self-portrait in the exhibition, *Meditation* (cat. 5) of 1904, shows Picasso sitting in a blue reverie before his sleeping mistress, Fernande Olivier, who is bathed in light, while he reads in the half-light. This beautiful watercolor, in which Picasso's sheltered young mistress is portrayed as a virgin idol, sets the tone of his Paris at this moment. Each view, morbid or romantic, was a projection of his youthful, inward-turning romantic temperament.

Picasso had chosen at this point to concentrate on drawing—the language of line. He had initially learned drawing from his father, a drawing and painting teacher who had given him lessons, brushes, and the tools necessary to his craft—especially an education at the Royal Academy of San Fernando in Madrid. He had learned from a close study of Ingres, considered the master of contour rendering and the artist whose work exemplified the academic principles that the ideal form was sculptural and the human figure was the measure. The academic drawing was made according to a refined linear system that expressed this ideal. Picasso now looked at Poussin, a master of the sculptural contour line. With Ingres as his touchstone, he also examined the more advanced styles of Toulouse-Lautrec, Manet, and Vuillard, masters who had carefully looked at the decorative contours and flat planes of Japanese prints. The work of these artists, variations on a canon going back to the Renaissance, was part of the visual culture Picasso brought with him. He had always started from an appreciation of three-dimensional forms, which he now began to reexamine in light of new discoveries extrinsic to the tradition. Yet despite his revolutionary dissection of traditional artistic devices—and of the act of looking itself—his art is rooted in exactly those academic conventions of representation whose deconstruction he now took up as the subject of his art.

At the center of the classicizing system—its *raison d'être*—was the self-contained form of the figure. Picasso's intimate knowledge of the figure (especially the female figure and the head, the most detailed self-contained form of all) thus became coextensive with his knowledge of the picture itself. As a result of this passion, all the old distinctions and hierarchies of media, of supports and genres, of the observed and the constructed, were rejected and a whole new order of art invented.

Throughout his life, Picasso felt free to wander in art history and to use elements from any number of sources. His drawings, sketchbooks, and paintings of the years 1904 to 1907, when he completed *Les Demoiselles d'Avignon*, are records of discoveries immediately put to use. Most important was his discovery of Cézanne. At the same time, he found Iberian marble and Osuna bronze sculptures in the Louvre. *Head of a Woman, Fernande*, from 1906 (cat. 14), is a sculpture very much in the monumental Iberian mode. The simplification and monumentality of form, the masklike faces, in drawings of this period are due to a rebalancing of these influences and their translation into two dimensions. An examination of Picasso's work of these years shows that what interested him in a style, whether Western or extrinsic to the Western tradition, was the preexistent artifice of similar linear systems, whether expressed in two dimensions or in three. As Picasso began studies for the *Demoiselles*, in 1906, he took Cézanne as his model, aware that, like his immediate predecessors, he could no longer depend on an objective, system-specific guide comparable to linear perspective, and in a world whose spatial complexity had increased exponentially—not unlike the fab-

ric of the city of Paris, or of modern life itself. With perspective, "the automatic pilot" for pictorial composition, seriously undermined, Picasso fell back on the study of the nude figure according to the system of analogies taught at the academy and the conceptions implicit in the drawing system, determined by Cézanne's example to find a new pictorial strategy of his own.

In 1906 Picasso made a series of studies using oil, gouache, charcoal, ink, or pencil (sometimes several together) and selecting or mixing styles, from Ingresque linear contour to Impressionist dappling to Cézannesque poses and figural compositions. Through early 1907 he gradually transformed the volumetric ovoids of these 1906 figures via a series of drawings in which straight lines alternate with curved outlines as forms are adjusted to a more overtly conceptual and structural description. Interchanging flat and rounded contours, and semidetached planar elements, now create a rhythm of breaks and continuities and of constructed (and deconstructed) rather than observed formal relationships among the elements of the composition.

It was Picasso's knowledge of academic drawing that enabled him to find the shared topic among these superficially disparate aesthetics: the presence of a preexistent system of linear drawing. With only minor changes over the centuries, the principles of academic drawing constituted a highly conceptual system, which even seems to have pretended to something like scientific objectivity. Such drawing took line as the first element of a language for the imitation of reality. It also carried with it a system of formal signs, which were conceived as conventions of draftsmanship. The student learned that the various parts of the body could be reduced to specific ovoid or elliptical forms. These conceptualized forms related shapes to one another through a system of analogy or likeness—that is, of partial similarities that are recognized because the capacity for likeness is preexistent in the mind, being "hard-wired" as a system into the working of the brain. Thus eyes were likened to breasts, breasts to limbs, and so forth. The system of reducing an element of the body to like forms could be used for the description of still life subjects as well: the eye and the rim of a bowl are describable by the same oval. As students advanced, they learned to extend this kind of analogizing from two- to three-dimensional forms, from prints to reliefs, from the life cast to the living model and then to the study of nature itself, through the sphere, the cylinder, and the cone. These geometrically conceived "enclosures" were thought of as interchanging positive and negative space.

The academic system relied on the definition of the visual arts as the arts that imitate nature. But it was recognized that "contour, for example, did not exist in nature, but was a 'sort of convention of art.'"[9] And reality itself seems to have been envisaged as an assemblage of three-dimensional surfaces that were immediately translatable into two dimensions thanks to this preconceived sign system.[10] Three-dimensional form was indicated through shadow, which was manifested by another class of graphic signs, hatching—linear marks—and shading, using the broad edge of the tool to produce "coloristic" effects. The more a drawing imitated the impressions of light and shadow elsewhere expressed through color (chiaroscuro), the closer it came to painting. (Color itself came later, to complete the illusion of reality, and was at times considered a mere sensual "gloss"—not even included in the drawing curriculum.) Finally the student learned to draw the figure in perspective.

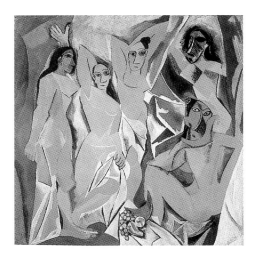

Pablo Picasso,
*Les Demoiselles
d'Avignon*, 1907.
The Museum
of Modern Art,
New York. Acquired
through the Lillie P.
Bliss Bequest.

Most important for Picasso, these signs were not simply the elements of the figure reduced to analogous forms. If the "separable components of the drawing system . . . were evidently thought of at one time as an autonomous aesthetic, so that drawing after the life model was thought of in terms of its constitutive vocabulary,"[11] for Picasso this language of drawing as an "autonomous aesthetic" was the basic language of art itself—and infinitely manipulable. Moreover the vocabulary was collective, and was enforced as such, despite encouragements to bring an individual "style" or "hand" to bear on it. "Beauty" depended on the panache with which one accomplished all this, measured of course against "reality" and the precedent of one's betters and peers. (The work of the masters, of course, was studied as well.) In fact accomplishment—style—was a balancing act among three elements: reality, the apparent artifice with which one portrayed that reality, and the tradition and history of art itself. Aura, that special mystery of creation, depended upon the very special manifestation of the artist's personality in the unique application of the artist's "hand"; the "hand" was assumed to be the expression of a link to God's inspiration.

Figural composition was at the apex of artistic aspiration. If the figure was to be constituted of amalgamations of identifiable signs, figures themselves were to be assembled into compositions through the use of perspectival projection (see fig. on p. 34). Perspective was a mathematically based drawing system for representing objects on a plane as they appeared to the eye in nature, with respect to relative distances and perceptions—but from only one point of view: that of the viewer. Space itself was measurable under this system. In one-point perspective, a grid system was laid on the floor, its lines drawn to a disappearing point on the horizon. The grid was employed as the control, and each item was drawn as seen by the viewer. The system could be augmented in painting, through aerial, or perceptual, perspective renderings and by using coloristic effects to represent natural phenomena. Paint application could be invested with emotion and movement—or not.

Used together, the three systems—one for figuration, another for composition, and a third for color—maintained their hold on a fictional "reality" for several centuries. The Impressionists were the first to question the rules. For the Impressionists, the perceptual field of painting was no longer the illusionistic deep space behind the surface—the Renaissance window onto the infinite. Instead, it occupied the surface. For Manet the pictorial space had become a kind of shallow "stage for representation."[12] Painting became performative: "The artist becomes a shaper, rather than a framer. Rather than the panoptical view, it is the figuring hand that now embodies the human will."[13] Cubism would ask its audience to examine each object within a work not from one viewpoint but from several, offering simultaneous fragmented views. The totality is still seen from one point of view—the viewer's—but is responsive to the conditions of binocular vision. What results is a close-up trip through details, small visual sensations organizing the picture—the objects contained—as a limited fragmented field.

Through the agency of the disparate styles he had been examining—especially beginning in the summer of 1907, when he discovered African art at the Musée de L'Homme (after he stopped work on the first phase of the *Demoiselles*)[14]—Picasso radicalized not just the description of the figure but what he came to understand as the basic structural principle of academic training: "the

organization or manipulation of the elements within the matrix." He took to heart what had always been implicit in that discipline: "A reality in itself, . . . the language of art lent itself to the kind of analysis to which the philosophers subjected natural reality, too, and we can view it as the visual counterpart of mental systems or perspectives used by experts in other fields to order and contain the reality studied."[15]

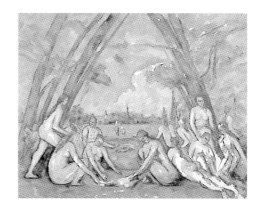

Paul Cézanne, *Large Bathers*, 1906. The Philadelphia Museum of Art, Philadelphia, purchased with W.P. Wistach Fund.

LES DEMOISELLES D'AVIGNON

The *Demoiselles*, quite possibly the most important painting of the first part of the twentieth century, was Picasso's declaration to the world that he was breaking with the current norms to take his place in the grand lineup of modern masters who had invented the Western tradition. Since the subject matter and scale of the painting placed him in the grand tradition of Western art, he must have started out with the idea of attracting attention. It was his turn to invent, and he wanted nothing less than to remake representation. The *Demoiselles* was his salon painting.

 The work is set up as an explicit conflict between heaven and hell. Picasso painted it in two main stages. The idea may well have been sparked by a sequence of paintings by other artists: Ingres's *Bain turc* (1859–63), which he first saw at the Salon d'Automne in October of 1905; the subsequent showing of Matisse's *Bonheur de vivre* at the Salon des Indépendents in the summer of 1906; and the retrospectives of Gauguin and Cézanne beginning in August of 1906. Each time Picasso returned to the *Demoiselles*, the conception changed, making a transition from the world of his Symbolist Blue Period through the pastoral mode of Cézanne's Bathers to this new demonic vision. Each change of thought was obsessively worked through in sketches, drawings, and painted studies of all kinds, from single figures in several styles to compositional studies in which the first scheme, which included a male figure, changed in the second to an all-female cast. According to Pierre Daix, the first stage ended in May 1907. The second stage began in late June of that year and ended in July, when Apollinaire was the first to see the work "completed."[16] As a result of these multiple reconceptions, the *Demoiselles* never fully evolved as a pictorial whole. This is what gives it the edgy feel of a modern picture.

Female Nude (Spring 1907, cat. 7)
This oil on canvas is one of the many studies for the *Demoiselles d'Avignon*, on paper and on canvas, that lead up to the finished picture. Technically an oil sketch, it indicates the variations on—and violations of—the academic system that Picasso was pondering as he worked. Like several other studies of the time, this single figure evidences his response not just to one Cézanne retrospective but to a whole series of Cézanne exhibitions in the years following the artist's death, in 1906. Picasso, clearly, was pitting the *Demoiselles* against the best models.

 In this particular study Picasso is exploring the implications of Cézanne's late series of Bathers. Color is a primary issue here, especially with regard to Cézanne's remark, "As one paints one draws: the more harmony there is in the colors the more precise the drawing becomes. When the color is at its richest, the

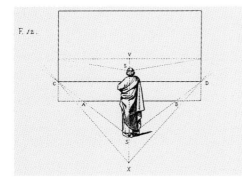

David Sutter,
*New Theory on
Perspective,* 1859.

34

form is at its fullest. Contrasts of harmonies of tones, there is the secret of drawing and modeling."[17] Instead of overlaying color on the graphic system, Picasso is uniting the two, integrating the graphic system with color, which tends to assert its own place in space as one instrumentality.

Imitating Cézanne (and van Gogh), Picasso dispenses with drawing in black. The open contours of the figure—some sides described by concave lines, others by straight ones, to emphasize the flattening of form to the plane—are drawn with the brush in dark blue-green. Sienna, the opposite of this color, appears for expressive emphasis, while the shadows are drawn in blue, suggesting reflections of the sky. (One definition of chiaroscuro is as a contrast of colors.) The use of blue as a sign for reflected light is a direct quotation from Cézanne; so is the emphatic, awkward character of the line.

If the immediate source of the figure lies in Cézanne, its "style" is a combination, a "transcription," of Cézanne and Gauguin and, in the last phase of the painting, the African masks that Picasso was examining at the time: the strong graphic markings of the hollow of the cheek are quotes from African masks. But Cézanne remains the basis of the conception. The figure is inpainted in an ocher that then escapes into the surrounding ground, uniting figure and plane. In the upper left of the picture the ocher is treated graphically, as a pattern of hatched brushstrokes; the shadow/ground surrounding the figure, as patches of atmospheric environment, are drawn in "Cézanne blue." These again signal transcription. Wedges of green and sienna between the legs establish a ground that reemerges to the right, rising under and above the figure's left arm, and is then locked in place by an area of dark brown. The color patches can be interpreted as shadow, local color, and color with its own life.

The free treatment of these areas suggests Cézanne as studied through Matisse's Fauve paintings of 1905—which owe a great deal to Cézanne themselves. Although Matisse draws lines with color in these paintings, he also paints in color patches that are allowed to establish their own limits, a practice based on the understanding that the volume of the color subsumes "outline." (Throughout this period, Matisse and Picasso watched each other closely, move by move. It was a rivalry that was a form of partnership.) The pose of the figure is a studio pose, a variation of the classic contrapposto: much of the weight is placed on one foot, shifting the spine and pelvis slightly out of line. But the use of blue as reflected light tells us that the figure is outdoors, providing yet another connection to Cézanne's late Bathers.

In the final *Demoiselles* painting, Picasso gathers his figures together and goes indoors, although he retains the celestial blue and the light of outdoors. Cézanne's blue is now concentrated in a window behind the figures. This represents Picasso's first examination of the pictorial ground as the actual source of the picture's light, in contrast to light as chiaroscuro effect: light and shadow are cast on figures to create three-dimensional effects, as though the light were coming from a source outside the picture. But the transfer of the source of light to inside the picture, as Picasso imitates it in the *Demoiselles*, is a phenomenon originating in Cézanne's watercolors, which were painted not on the customary tinted papers that had been in use for several centuries but on pure white grounds. Cézanne's aim had been to create art as a "harmony in parallel to nature by making color contrasts the internal life of art and the white ground nature's light. This device,

which transfers the light of drawing—the light that comes from the sheet—into his late paintings as areas of unpainted white ground, precipitated a crisis of finish."[18] With no illusionistic directional light cast from the outside, each color patch, each contour line and its echo, becomes an aspect of what Cézanne called his *petites sensations*: varicolored shadows rendered as the product of light reflecting off the local colors and mixing with the ambient light. The white ground becomes the center of the figure, its *point culminante*—the highest light in the picture, thus making figure and ground interchangeable and rendering form as both flat and volumetric at the same time. The aggregate forms a unified perceptual field of separate elements. Each element is responsive to its own perspective, but also to the overall arrangement across a curved field of vision. This breakdown in scientific perspective is particularly clear in Cézanne's late works. But even in late paintings such as *Still Life with Apples*, 1895–98, which, William Rubin points out, "was nominally finished . . . Cézanne ceased work at a point when much of the surface was still unfinished by any traditional meaning of the term."[19] In this *non-finito* Cézanne had modeled himself on Manet. The lively touch, which renders the feeling of "unfinish," creates the sensation that the eye, distant and analytical, has played an instrumental part in building the forms. The open ground only enhances the sense of tectonic form. Cézanne's analytical habit expresses itself in painting as a constructive faculty.

Embedded in Picasso's investigation of line versus color, then, lies the history of tectonic painting, played back to him via idiosyncratic devices belonging to Cézanne's peculiar late pictorial code but, for Picasso as for Cézanne, seen through Manet's temperament. If Ingres had been Picasso's academic control, representing those for whom line was the master of invention, Manet was his link to the alternative tradition, among whom were counted Degas and their great predecessor Delacroix. These were the artists for whom color, that is to say, paint—as corporeal and tactile—was primary. Cézanne's system, like those of Seurat and van Gogh, was a means of reorganizing the Impressionist breakup of form.

Destroying the Renaissance view of pictorial space as a window, the first Impressionists had broken up the picture into little flecks of colored matter distributed equally across the surface of the canvas, emphasizing the surface as the true site of representation. The second generation, the Post-Impressionists, had wished to preserve this sense of the surface as the direct site of representation, keeping it perceptually intact as a surface, while also restoring some sort of the coherent account of individual forms. Each painter had developed an individual strategy, but each strategy was based on a different graphic model, none of which depended on continuous linear outline drawing, with the exception of that of Gauguin. Seurat, for instance, to make his grand "machine" pictures, had developed a science of painting that involved a procedure for describing figures and a structure for placing them. The two elements were united by a perceptual system of contrasting and separating colors, dividing the canvas into small patches of paint strokes—*taches*—evenly distributed across it, although changing direction. The approach was directly based on Seurat's Conté crayon drawings, in which the crayon marks cluster to compose forms, almost as if the little grains of matter deposited on the grainy surface of the paper were magnetically attracted to one another, then dispersed. In the paintings, color was brushed on in small strokes

that seemed to organize themselves as a clustering of individual dominant tones to depict local forms. It was not Seurat's science of painting that projected itself as a practice into the twentieth century. Instead, what was left was his habit of analysis, an obsession that led to his attempt to synthesize both sequential and immediate perceptions as discontinuities fixed in time.

Picasso, in reworking the academic matrix with outline drawing as his primary tool, used every technical resource of his craft to find a common base for these individual manners. For Cubism Picasso returned to the Impressionist rendering of light; he identified Signac, the great champion of Seurat, as the source for his little *taches*.[20] The technical agent of analogy is transcription, a word I have already used, and one more accurate in this context than "translation," for it is a term of art. Transcription is the linear means by which a representation in one visual system is reinterpreted in terms of another visual system. Transcription is a primary subject of Picasso's art.

Picasso's transcription is more complex than transcription from one drawing system to another, for it is a progressive transcription, a trip through the history of art. It begins with Cézanne, "who formed the bridge between [Picasso's and Braque's] art and the art of the preceding five centuries."[21] Transcription is the artistic basis on which Picasso would continue throughout his life to present one thing in the guise of another, in a constantly inventive stream of multiple disguises and metamorphoses.

The analytic/synthetic thinking about form in which Picasso was engaged is a powerful tool for arresting narrative, for it transfers the viewer's attention to formal properties of the painting, making the subject less important. Picasso and Matisse now began to make this formal force the subject of the picture, transferring narrative to an exchange between the picture's formal elements. Each began with the figure and each moved between the detail and the whole, simplifying and exaggerating to call attention to what they were doing. They were very conscious of the fact that they were the beginning of something new.

The Fall
The story line of the *Demoiselles*—and I hesitate to resort to the discussion of narrative as story in this increasingly formal situation—is now important in terms of transcription, and of understanding how ambitious this picture was and how it succeeded—or failed—to meet Picasso's desires. (He insisted for a time that the canvas was unfinished.) The painting presents a scene in a brothel in the rue d'Avignon in Paris. The *demoiselles* are prostitutes. As a young man on Paris's bohemian scene, Picasso had been struck by the pervasive presence of syphilis in the demimonde of prostitution; he was terrified of the disease, but fascinated at the same time. Picasso's nightmare of a possible personal knowledge of the physical ravages of sin is projected by the imposition of masks of terror on the faces of the *demoiselles*.

On the face of it, the painting is a transcription of the prelapsarian paradise/garden scene in which the figures gambol nude, tied together in a circle of harmony and filled with innocent joy. Picasso uses a great classical model, the linked-figure composition often found on ancient Greek vases, where the figures literally dance around the vessel. Matisse had already painted such a ring of figures in the far distance in his own painting of paradise, *Bonheur de vivre* (1905–06). But

in Picasso's hands the figures no longer romp innocently: their demonic depiction incorporates the Fall, and each of them can be seen as an obsessive variant of the same hellish Venus. This conflict between heaven and hell was finally decided on as a leap into the abyss in the second and final phase of painting.

Formally the painting depends on a sophisticated use of the linked-figure composition, a device with its basis in repetition, in sameness within variation and variation within sameness. The *Demoiselles* begins with an examination of a single figure from several points of view, a practice Picasso learned in life drawing class, where students were required to walk around and study the figure and draw different views—often as many as eight—of the same pose. The painting is a composite of studio views; its variations involve a single figure seen from different vantage points and depicted as a systematic repetition of volume-enclosing contour lines. This is the drawing system that Cézanne had parodied and that Matisse was busily reinventing. Picasso's use of it here depends on seeing it for the moment through the eyes of Cézanne, whose Bathers paintings from the 1870s are the most immediate precedents for the *Demoiselles*, and especially for the repetition of the figures. Cézanne in his turn had borrowed precedents from Manet, Degas, and any number of earlier sources.

In a watercolor study of 1907 (cat. 8) we can see that Picasso has been led back from Cézanne's Bathers to their mutual friend Ingres: the figure in this study is a version of the seated figure at front right in Ingres's *Bain turc*. The squatting figure seen from behind in the lower right of the *Demoiselles*, with her head skewed around so cruelly to the front, echoes Ingres's lute-playing figure with her back turned, but is coupled with the figure in this watercolor, whose head is placed on her shoulders.[22] Indeed the Ingres work is the ultimate source of several other figures, but more important, the whole of the *Demoiselles* reaches back through Cézanne to this painting, a masterful version of the linked-figure composition but now conceived without any regard for human anatomy except as an assemblage of movable, even interchangeable parts. With almost no perspectival space, even the intervals between the forms of the figure come under pressure from the surface and must rearrange themselves.

The central Venus in the *Demoiselles* is shown with her legs drawn close together, the right almost crossed over the left to twist the weight of the body, evoking a come-hither sexuality. The pose is a form of portmanteau, suitable for lying down as well as standing. A beautiful watercolor of 1907, another of the studies for the *Demoiselles*, again shows the figure from this view. She will appear again in several paintings following the *Demoiselles*.

The Metaphysical Figure

Since Picasso will use this contrapposto figure—this pose—again and again, it is worth tracing a history of its earlier rhetorical devices and metaphysics. For this we must turn to Seurat, whose *Parade de cirque* (1888–89) shows the basic pose of a figure in contrapposto (the trombone player) as part of a larger composition.

As Jonathan Crary points out, Seurat's preoccupation with contrapposto certainly began through his study of Ingres.[23] His continuing study of it, however, was founded in a "Renaissance ideal," as can be seen in a drawing of the early 1880s, *Praxitelean Figure*. This study invokes a metaphysical dualism that finds expression in rhetorical devices of contrast and antithesis. The familiar notions

Jean-Auguste-
Dominique Ingres,
Le Bain turc,
1859–63.
Musée du Louvre,
Paris.

37

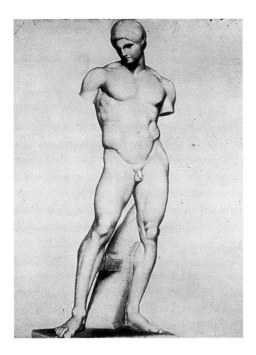

Georges Seurat,
Praxitelean Figure,
early 1880s.

of sculptural contrapposto and chiaroscuro are subsumed within this larger ideal: the "final justification [of contrapposto] lay in its vividness, the clarity with which art by direct contrast could make opposites evident, or bring them into harmony. On this level antithesis touched on basic principles and there was a continuous relation between nature, or our knowledge of nature and art." Seurat's figure of the trombone player "is defined by the frontal and hieratic timelessness of archaic art. As such it proposes a rapt, frozen attentiveness," yet "the lower half," its weight shifted "casually, . . . would seem to be an 'awakening' out of the 'archaic spell,' implanting the figure in the dynamic temporalities of autonomous movement." Nor is this its only antithesis. In classical art, Crary continues, contrapposto "often came to be understood as suggesting 'a living organism controlled by an indwelling will, a person capable of acting spontaneously.'"[24] Seurat's depiction of the pose undoes this expectation: it freezes the bottom half of the figure, which seems to be modeled not on life but on a wooden puppet. "The lower legs," Crary writes, "like wooden pegs, seem almost unanchored, as if the figure were a skillfully managed marionette, only tenuously abutting the ground."[25] In fact the lower legs are cut off at the ankles by the edge of the stage on which this bizarre marionette is poised, confusing the issue of whether he stands on his own or is manipulated by unseen strings.

The bizarre frontal treatment of the figure, frozen and back-lit as a silhouette in a pose that is customarily a sign for "living" movement, brings up the essential aspect of this representation. Our whole attention is turned on what Meyer Schapiro called Seurat's "taste for increasingly schematic movement"[26] in both the individual figure and the whole painting. The figure encapsulates the characteristic of the whole: "Rather than an incongruous composite of the frontality of archaic art and the harmonious oppositions of classical art, the figure suggestively elides the regressive immobility of trance with the machinic uncanniness of automatic behavior."[27]

Automata, articulated dolls, and mannequins were all the rage in late-nineteenth-century Paris. The potential of the first two for suddenly coming to life, in a series of jerky movements, when wound up or pulled was a source of fascination and amusement. Artists and poets considered the doll's disruptive automatic behavior a paradigm of modernity, while the dead stillness of the tailor's dummy coupled "the living body to the inorganic world."[28] Disruptive structure and automatic behavior were inscribed into the new language of poetry and the visual arts; Seurat's *Parade de cirque* has been linked to Rimbaud's poem "Parade." Transcribing from the classical figure, Seurat had turned his own figures into puppets and automata. A parade is a theatrical scene, a bawdy, freaky sideshow to pull the audience in. Rimbaud's savage poem would seem to have little relationship to the painting, yet it describes a cast of characters caught in a mechanistic repetition of all the same old vices, the same old poses. Seurat was perhaps particularly taken with the last two lines, as an invitation to present such a scene as frozen in time:

In costumes improvised with the taste of bad dreams, the figures act out sad songs and tragedies of thieves and demigods, more uplifting than history or religion has ever managed to be! Chinese, Hottentots, gypsies, hyenas, nitwits, Molochs, old lunacies, sinister demons, they mix much-loved old-time ditties meant for mom

with bestial winks and caresses. They're authorities on new pieces for the stage and tunes about "fair lassies." Master stuntsmen, they can transform both the scene and the characters: they use magnetic tricks. Eyes glisten, blood sings, bones grow bigger, tears and little red lines glow. Their horseplay or their panic terror may last a minute, or whole months.
I alone have the key to this screwy sideshow.[29]

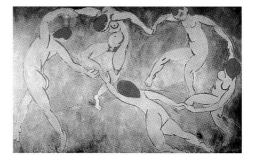

Henri Matisse, *The Dance*, 1910. State Hermitage Museum, St. Petersburg.

The perspective system in *Parade de cirque* has three distinct elements, all schematically intersecting with and overlaying one another. One is a version of aerial perspective, as when Seurat suggests the relative placement of the figure through back and front lighting rather than relative scale. In fact light is a "figure" of its own in this painting: lit by the glow of the individual gaslights, it is also lit from within, by a radiant light that cannot be explained by the local sources of illumination. The second perspective pitting the classical against the archaic is the almost mechanical repeat of the silhouettes of these automata and their variations, as they are manipulated in rows around and back in a shallow circle—a planometric version of the linked-figure composition, containing within it the memory of classic perspective. The last perspective—and the most ambitious, for it is not only the stage on which all the others act but the basis of the whole conceit—is planar perspective. The subdivision of the geometrical plane against which the figures are silhouetted creates the space as a relief whose shifting planes echo the shape of the canvas. Thus each figure works as a counter-pattern that "dances" with the others, reinforcing it as a planar construction of the linked-figure composition. Although Seurat did not draw outlines, the silhouettes of his figures against the light are conceived as though drawn as continuous "boneless" contours.

It has been suggested that Seurat constructed the geometry of his pictures according to metaphysical ideas rooted in Neoplatonism, which attempted to conceive of the world as a union between the conflict of two different impulses, the mystical and the scientific. His use, in at least one painting, of the Golden Section, an ideal proportion implanted in quasi-scientific philosophy, suggests that this may be so.[30] Neoplatonism saw the physical world as emanating from the divine being. It conceived of the artist as a privileged being who participates in God's divine "Idea." According to academic principles, meanwhile, "The artist is charged with the task of providing 'manual' guidance that 'enables the human mind to ascend through all things to the cause of all things.'"[31] The artist participates in God's creation. In this context Seurat's science was passed on to Picasso as an ironization of metaphysics—a parody.

In the *Demoiselles* Picasso pressed an exaggerated parody of the academic system of formal analogies and the decorative and expressive power of line still farther than he had in the many studies leading up to it. He developed each figure separately as an equation of ovoid forms. The repetition of the figures establishes the capacity of line to function as an independent element in a rhythmic pattern that articulates the whole of a surface. (Matisse's two versions of *The Dance* [1910] are another derivation of the linked-figure composition.) The continuous contour drawing of the Blue and Rose periods has been displaced by awkwardly emphatic lines, some flat, some curved, repeated across the composition.

Picasso had been attracted to African art because of what he saw as its

39

Pablo Picasso, Study for *Nude with Drapery*, 1907, woodcut.

Pablo Picasso, *Half-length Young Woman, Three-Quarters View*, 1906, woodcut.

reasonable qualities. He recognized that these were the same qualities he valued in Cézanne's system of individual perspectives: their measured intervals. Tribal art proceeded through codes as rigid as those of the academy. Picasso identified its rule-driven system, which conceived of reality as an assemblage of surfaces in three dimensions, as a common theme among these sources. The intervals between forms were clearly measurable in tribal art—which is to say, their contours were distinct surface divisions. At the same time, though, they felt free to defy the norms of nature for formal and emotional integrity.

Picasso followed the *Demoiselles* with a group of paintings developed out of the individual figures, as such and in new groupings. The figure bursting from the drapery proved so important that her life was extended in an independent painting, *Nude with Drapery*. She appears again in the exhibition in a study for that painting, an extraordinary watercolor study of 1908 in which her figure, no longer frozen as in the study for the *Demoiselles* from which she derives, is expressionistically forced into an eccentric rhyming, her bent leg is the basis for a repeated unifying pattern over the surface.

Another study for *Nude with Drapery*, a woodcut from 1907, shows us how the assertive contours seen in the *Demoiselles* and the paintings immediately following emerged from a digging out of rough outlines originating in the woodcut technique. This primitivizing, expressionist conception of outline was passed on by another of Picasso's mentors, Gauguin, who combined the elegant outline drawing of Ingres with the roughness of contemporary Breton peasant woodblock and Gothic continuous outline drawing. Gauguin has a special place in this history in that he was the defender of contour drawing, passing the tradition on to Picasso and Matisse. Picasso first copied a Gauguin woodcut in 1906, carving out the face and leaving the contours to print in black; he copied this line in the *Demoiselles*. In the later woodcut study after one of the figures in the *Demoiselles*, expressive lines appear not in black but in white, as negative areas—the lines themselves have been carved out.

The carving away of solid areas gathers to the lines left behind the expression of the "lost bodies" between. The lost bodies are boneless, literally cut away, and the regulatory power of their structural underpinning, as well as their expressive detail, has been transferred to outlines. In the *Demoiselles* this line becomes more expressive, coloristic. It both describes form and operates as an independent element of the structure. The planar areas behave in a strange way: as the result of the lines' expressive pressure, they may be perceived as volumetric, and on a par with the lines in terms of structure. Cutting out line creates it as a series of phrased units limited by the length of the cut. The bodies of the women in the woodcuts are defined by a series of opposed convex contour lines that describe their forms as a series of long boneless ovoids. The forms too are conceived as convex. In the *Demoiselles*, though, the repetition of the forms establishes a pattern of linear and flat oval areas across and among the figures, in which figure and ground, positive and negative, are now treated as equal, interchangeable, and as operating on the same plane and under the same pressure from the surface. Radical foreshortening and eccentric elongation tilts up the forms, flattening them; everything has begun to press from the ground outward—the performers are on a shallow stage, pressed between the ground

and the surface. The reversal of positive negative areas in the woodcuts indicates that Picasso was thinking of mirror imaging, but it also enforces the suggestion that these ladies are dark figures from the depths of his psyche. In the *Demoiselles* and in subsequent paintings, individual body parts are obliged to move around, both within the face, where eyes and ears move closer together and grow larger, and within the compressed space of the painting, where figures multiply and exchange limbs, usually losing all sense of individual identity.

Emphasizing the importance of Picasso's effort to free himself from any attachment to naturalistic structural drawing, Leo Steinberg uses the head, one of the artist's most important formal battlegrounds, as his example. At this moment Picasso destabilizes "measure," the normative distance between things; for Steinberg he "moves against these intervals until he has crushed them down. It is not just a matter of distortion simply, which involves liberties taken with a canonic proportion. What Picasso does is more radical . . . features [are] loosed from their structural context." And once he has managed to liberate the features of the face, "they will always be subject to redistribution from this moment on."[32]

These unstable forms gather to themselves all of the psychological and emotional force that Picasso initially felt in the primitive arts being examined at the time, and that he now realized as an insurrectionary energy in Western art. The two modes of expression seem formally unresolved; their relationship is unstable. But it is just this apparent instability—this dualism—that makes the *Demoiselles* a "modern" picture. The will to shock was an important motivating element in this painting; in these now savage figures, the will is expressed in the motif as the essence of the picture—the sign of its fallen-ness.[33]

Nevertheless, this is not yet really a Cubist painting. Among other things, the *Demoiselles* is stylistically inconsistent in the manner in which it simultaneously looks backward to earlier models and struggles to move forward by taking liberties with them. But those very inconsistencies were the backbone of a new adventure, and as one can see by following the numerous studies associated with the painting's development, Picasso worked them out one figure, one feature, at a time. And if, for the moment, the *Demoiselles* did not revolutionize the whole structure of representation, its brutal derangement of representation's norms, and especially of the recognized codes of beauty, were a break to the future. The *Demoiselles* is the harbinger of classic Cubism, and "Cubism is the theme of modernism."[34] It is the first of Picasso's essays into this complex system of two and three dimensions, of variation, similarity, and strangeness— and in the future the complexities and instabilities would only multiply.

In the last transformation of the *Demoiselles*, the frozen classicism of the heads and especially the faces in the two figures to the right was replaced with the colorful makeup of prostitutes, which itself was transcribed into the magic expressiveness of African masks and statues.[35] Probably at the same time, the face of the figure on the left was darkened. African masks demonstrate the primal expressive power of pure linear expression, and African statues are equal to any academic conception in their sophisticated development of a convention of static form, but Picasso, like other artists and poets around him, nevertheless understood them as imbued with a primal life force. However, the measurability—the sense of a reasonable underlying order, akin to that of Western classicism—that Picasso knew lay beneath the emotion he felt in the tribal styles

41

Pablo Picasso, Study for *Standing Nude*, 1907–8, woodcut

Pablo Picasso,
Study for
Standing Nude
at the Bateau-
Lavoir, Paris 1908.
Private Collection.

enabled him to use them to graft a diabolical caricature of Western beauty onto his faces. The *Demoiselles*, in words borrowed from Baudelaire's *Painter of Modern Life*, is "strange and endowed with an impulsive life, like the soul of its creator."[36] It dispenses with conventional "beauty" and the bathos of romantic melancholy, instead describing a scene of primal terror—even as it retains the frozen formal detachment of its classical roots. There is something coldly demonic not only in the faces but in the awkwardly phrased and drawn brushstroke line, and especially in the savage signlike hatching overlaid on the faces of the figures.

Each Picasso work—and each group of works—exists in a state of contradiction, a duality that inheres in its maker and is expressed in terms of "another," an otherness not only of persons but, even more, of styles—multiple answers to a single question. The figures of the *demoiselles* are Picasso's doubles; they enact his own attraction and repulsion, his forbidden sexual desire and his fear of syphilis. Picasso uses the hybrid masks as mirrors that enable him to project his own psychic terror into the picture. The visual shock of these masks grafted onto the bright, pinkish, flesh-colored bodies of the *Demoiselles*—with their forms studied not just from Cézanne but from Iberian statues—ushers in the new order. At the time of his work on the painting, Picasso was living in the now famous Bateau-Lavoir, the name given to a broken-down Montmartre slum building by his sometime roommate, the poet Max Jacob. In response to the 1905–6 exhibition of recently excavated Iberian sculptures from Osuna and Cerro de los Santos in Spain, and to the 1906 Salon d'Automne retrospective of Gauguin, he had already been "primitivizing" his figures and creating mask-like faces. Then, in March of 1907, Iberian statues stolen from the Louvre by Gery-Pieret were brought to Picasso's studio in the Bateau-Lavoir.[37]

Beyond strange, *Les Demoiselles* has also been interpreted as a rebirth announcement. Brigitte Baer describes the painting in Freudian terms as not just a brothel scene but a confrontation with primal terror in which the "mother," at the left, turns a blind eye to the child, refusing to see him. Observing himself through the mirror of his mother's eyes, the artist undergoes a psychic death, only to be reborn as the scene continues to the right. A fight is taking place: "a most terrifying embodiment of a woman bursts on stage like a devil from behind the curtain. She is emerging from a sexual encounter, integrated to the artist's psyche as a fight, or war."[38] Picasso's sketchbook studies show the curtain opening in the shape of a vulva. Baer also interprets the figure squatting in the front as sitting in the birthing position often adopted in traditional, nonindustrial societies.[39] At one point Picasso considered including a child in the group, perhaps in response to Baudelaire's idea that children were closer to knowledge of sin than were adults, and had a deeper insight into it; this idea would have resonated with the rite of baptism, which was to wash sin away.

The "blind-eye" is a reference to one of the earliest novels in Spanish literature, *The Tragicomedy of Calixto and Melibea*, or *La Celestina*, written by Fernando de Rojas and published in 1499. La Celestina is the work's most powerful character, a matchmaker—but characterized as an aging whore and voyeur—who has one blind eye.[40] She is a manipulator, a "jokester" in the most wicked sense of the word, and a grotesque. Picasso would refer to her and her story again and again over the years; she is surely the source of his famous device of a second eye brought around and inserted into a profile view of a face, a fig-

ure that can then be thought of as simultaneously a mirror image and blind to the mirror (that the canvas will later become), as well as a seer and hex figure.

The scene is grotesque, and projection is a key Picasso uses to enter the door of the grotesque, which exists not only in his psyche but in the possibilities of modernism itself. The savage laughter of the grotesque, a parody become a caricature of traditional drawing, is his Promethean challenge to the gods of art. With the laughter of sexual dread, the grotesquely grinning temptresses of the *Demoiselles* invite him to the Fall. Christian grace is undone by pagan bacchanal. Picasso assumes the creative force of nature; now he must create a new answer to a new condition: the modern conceived as "after the Fall." Cézanne and his generation had recognized the imminence of the Fall; van Gogh and Gauguin had lived it out. T. J. Clark concludes his extraordinary essay on Cézanne, "The aesthetic is materialism's uncanny . . . its repressed truth, its ridiculous conclusion . . . who could look at . . . the terrible cramped repetitions of bodies in London, without realizing that ultimately the horror in these pictures reaches beyond any recoverable or irrecoverable human content to the sheer turning of the handle of the representational machine? I stand in front of the Barnes Bathers and hear a hurdy-gurdy playing."[41] So it also went for Matisse, whose two versions of *The Dance* remove the dancers from the Garden of *Bonheur de vivre* to focus on them alone. The removal re-creates them—no longer symbols of innocent joy, they are bacchants.

The first public response to the *Demoiselles* was that it was a form of grotesque joke. Once again, Baudelaire, with his "passion for the difficult,"[42] had been the first to write about the tradition of the "absolute comic . . . the grotesque . . . as fundamental" to the idea of modernity.[43] His conception of an aesthetic of modernism was composed of aspects of irony, parody, the fantastic, the farcical, the violent, and the fleeting—but all with aspirations to the eternal. It was above all dual and contradictory: grotesque. For Baudelaire, laughter came after the Fall; it was created by and belonged to man. Reevaluating the comic in this light, Baudelaire turned it into "a human concern of the highest order."[44] The comic "reflects dread but also culpability; laughter is thus allied with its other, the object of the laughter."[45] The absolute comic, writes Baudelaire,

> The grotesque, is primarily a creation, but with an imitative element, refashioning the preexisting forms of nature, which antedated the Fall. The grotesque derives from one's sense of superiority over nature, presents itself as unified (its moral idea inseparable from the art), is grasped synthetically by intuition and excites a spontaneous, excessive, violent laughter. The impression of unity opens up the possibilities of meaning by refusing to specify a single one.[46]

Humanity challenges the gods by creating a world analogous to nature. This creation both reveals and embodies the harmony of universal analogy, the system of analogizing, which, in creating equivalences between man's creation and nature's, is the human equivalent of the mythical unity of paradise: "It redeems humanity from the Fall." The disfigurement of laughter was for Baudelaire the sign not of depravity but of the rise from the abyss. It was the condition of the modern and, ultimately, of a truly modern art. In this same spirit, the satanic laughter of the *Demoiselles*—their grotesquerie—had invited Picasso to fall.

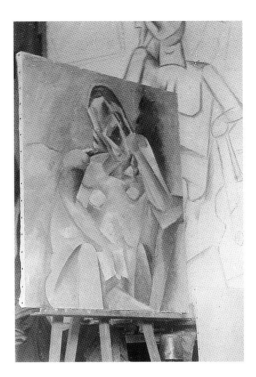

Pablo Picasso, *Woman with Book* in the Bateau-Lavoir studio, Paris, 1909. Private Collection.

43

Having acquired knowledge, he had fallen into the abyss—yet "the phenomena engendered by the Fall will become the means of redemption."[47]

Laughter, taken to the extreme, transcends the comic. This comic absolute brings a sense of inferiority alongside superiority, preserving the ironic dualism on which self-knowledge depends. The loss of control represented by explosive sudden laughter signals the presence of a force beyond our conscious comprehension, the *élément mystèrieux* that cannot be rationalized or explained away. And the nature to which we feel superior is also that in which we must live. The comic absolute confronts us with the fantastic and the surreal, worlds beyond our own and beyond ourselves.

CUBISM

The Transition

The central problems of representational art involve the relationship of figure to ground. Those problems, which are not solely visual, are what Picasso and Braque took on with Cubism: a new definition of the figure in relation to its representation, a new relationship of man to the world. Their art made analogy its operative principle—a principle rooted in the academic system, and therefore impersonal and semiautomatic at its heart. Baudelaire's universal analogy proposes the ultimate irony: if God is dead, man is essentially his own creation. If he was, as Seurat had portrayed him, a puppet dancing on a string; how could he get off the string? How could he inscribe his own freedom in the world?

Before the Fall, everything was in harmony. The word and its referent were one; a name was its object. After the Fall, words and the things they name are no longer identical.[48] On the one hand Picasso wishes to reunite the representation of the figure and its ground as a formal whole, using the traditional pictorial relationships and conventions. On the other, those conventions are empty of meaning; visual and verbal structures no longer match. This contradiction is now considered a condition of the real world. And "if the essence of reality is contradiction, then to be self-divided is to be rooted in the real."[49] Cézanne's anxiety—and van Gogh's—was part of the equation: coincidence of meaning and gesture had been just out of reach, and it was that drama—the drama of their own anxiety in mediating between art and nature—that the work mirrored. But Picasso and Braque broke out to a true-blue comic modernism, "which, like the Symbolist poem, generates itself up entirely out of its own substance, projects its own referent out of its formal devices, escapes in its absolute self-groundedness the slightest taint of external determination, and takes itself as its own origin, cause and end."[50] It also appropriates all things to itself, loosing them from their former contextual meanings, and releasing itself from the fiction of trying or pretending to represent some fictional reality. The only reality is the re-presentation of representation itself.

In seeking to re-present representation, though, Picasso and Braque found themselves face-to-face with the original questions of representation, and had no choice but to reach back through history to remaster it. Picasso's overthrow of the aesthetic was to be achieved from within. Yet something new intervened: "science envy" had been a galling presence in art since the latter

part of the nineteenth century, and it had come to seem that art would have to be scientific in order to be new. Artists going back to the Impressionists and Seurat, as we have seen, had developed scientific theories of painting.[51] Henri Bergson's theories of continuous duration, of simultaneity, were now especially relevant. As science moved into the twentieth century, with ever-new discoveries (Einstein was already at work and in the early stages of his theory of relativity), art's competition with science and technology only increased.

As early as 1904, Picasso had gone to the movies with his friend Jacob. By 1907 movie-going was a weekly ritual. "Each Friday *la bande à Picasso* eagerly trooped over to the cinema at the rue du Douai to see the latest motion picture. Especially at the time of his painting *Les Demoiselles d'Avignon*, the 'cinema was Picasso's other passion.' With his flair for self-dramatization, Picasso developed the menacing look of silent screen actors that can be seen in contemporary self-photographic portraits. Fernande began to look like a screen vamp."[52] The comic and grotesque were the meat and drink of early film. Picasso and his friends loved its lowness. As a medium focused on the figure, film was fascinating, all the more so because it was technically still a little primitive and its mechanical devices were transparent to an astute viewer.

Dissolves, close-ups, multiple exposures, parallel and cross-cuts, inserts to create different viewpoints in which one figure might be seen from the other's point of view as if from inside the frame—all kept the image changing. Here was a whole new illusionist representation of figure to ground, a whole new temporal and spatial simulation of reality. This was not just the stop-action record of movement recorded by Marey and Muybridge, but real movement. Here was a technological invention that converted scientific theory into a concrete visual experience. Did Picasso see an aspect of parody in the conversion? And at what point did moving pictures begin to affect his work? Natasha Staller writes that the great early French filmmaker and inventor Georges Méliès and his colleagues were already doing many things in film that would appear in the next few years in Cubism.[53] It is worth noting that Méliès's films were initially filmed theater; Picasso always saw apparent unities where none had existed before, and exploited them—but only for the sake of creating painting anew. Is it possible that he also saw some of the devices of painting in film? The practices of academic drawing—walking around the figure, for instance, and observing it in different positions, a method that leads to the repetition of the same figure, her pose varying from left to right, in the *Demoiselles*—would have given him the basis on which to "dissolve" film's different points of view into a painting mode.[54] The various close-ups of single figures in film—head shots, three-quarter shots, full-figure shots, etc.—closely conform to the conventions of portraiture. Is it possible that film, with its transparency to painting conventions, comes into the equation in the *Demoiselles*? The integration of Fernande's makeup as the vamp with the makeup of prostitutes and with African masks may be a clue to at least a superficial relationship. And painting, like film, can be transparent, capable of recording different physical layers over time. At this point film may have been all play for Picasso, for there were still important formal problems of painting to occupy him. But by 1910, as discussed below, there is no question that film was playing a seminal part in the invention of Cubism.

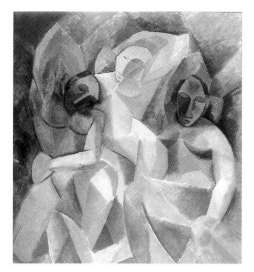

Pablo Picasso, *Three Women*, 1908–9. State Hermitage Museum, St. Petersburg.

46

Painting or Sculpture

In the years after the completion of the *Demoiselles*, Picasso continued to probe the relationship between two- and three-dimensional form as a problem of painting and sculpture. In the extraordinary watercolor (1908, cat. 9), one of a series of studies for the figures in the 1908–9 painting *Three Women*, he returned the figure to the outdoors and continued the investigations of analogous forms begun in the studies for the *Demoiselles*. In its color and line, in fact, the watercolor is not too different from the 1907 oil study for the *Demoiselles*. The background passages actually transcribe the curtain forms in that painting back into something suggestive of trees.

The peculiarity of the figure in this painting is that each of its body parts—the upper and lower arms, the leg, the torso—is treated as a virtually distinct and equal form. Other studies showing all three of the figures in the final painting exaggerate this treatment of form, establishing rhymes of long ovoid forms around and across the canvas. It is apparent that the limbs belong to one figure, mirrored and re-marked. This re-marking is an old technique. Degas, for example, in his repeated pastel studies of dancers and bathers, had traced his figures, turned them recto-verso, and re-marked them, rather than studying each anew from life.

In the version of *Three Women* from the spring and summer of 1908, the central figure faces the mirror frontally. Her lifted arm mirrors that of the figure on the left. The figure on the right also mirrors the figure on the left, but lifts both arms instead of just one. It is as if we were looking at a mirror with two wings. The slight difference created by the "unfolding" of the mirror wings shifts the two side figures down, establishing the entire movement as another linked-figure composition, although one in which the strong rhythm of independently expressive lines is almost overwhelming.

A number of the studies and paintings of this time expand the linear scarification of the faces of the *Demoiselles* to a consistent linear hatching of both figures and other forms. Daix calls this episode (1907 through early 1908) a "paroxysm of primitivism."[55] Throughout, Picasso continued a complex investigation of line as an element that hovers between description and independence as it presses to become a structural "figure." (The problem would remain the basis of much twentieth-century art, especially where the conception of style depended on the figure as its originating ground.) In these transitional years the performance of line was complicated still further by the special relationship of line and sculpture. The assertion of line as the edge of forms that can be either planar or volumetric seems to have been intensified by Picasso's studies of African sculpture, which clearly "draws" the contours of its bodies and uses shadow lines to emphasize the edges of planar forms. But he was also looking at two-dimensional sources: in his archives in the Musée Picasso, Paris, Anne Baldessari has found postcards of African tribespeople that she suggests he may well have used as aids in visualizing the paintings of 1908–9.[56]

The paintings of Picasso's African period reveal his investigation of tectonic form at its most intensive. As a result, as the studies for *Three Women* progress, they record his indecision: will these figures conform to the decorum of painting, as is suggested in the watercolor version of the prime figure from 1908, or will they be "sculptures"? In the finished *Demoiselles*, Picasso was imitating the

effects of natural light by means of a more or less homogenous paint surface and color contrast. Beginning with the still lifes of 1907 such as *Still Life with Lemon* (cat. 13), the Impressionist *taches*, and the *petites réalités* of Cézanne, Manet, and Seurat, went underground for a while (although they were always in mind), subsumed in value painting. The transparency of the watercolor versions is progressively replaced by studies in more opaque mediums. In the spring-summer version of *Three Women*, the battle is fought to a sort of momentary standstill as solutions suggest themselves both in opposition to one another and as syntheses: each touch is simultaneously light and shadow, an act of drawing and of painting, the figures are simultaneously volumetric and flat, and the lines are virtually on their own.

As we can see in Picasso's landscape *La Rue-des-Bois* (1908, cat. 11), Rousseau had been instrumental in demonstrating how light and shadow could conform to the logic of pictorial structure rather than imitate the effects of nature. The final *Three Women*, finished in the winter of 1908–9, resolves the issue in favor of tectonic form: it has the substance of an extraordinary bas-relief in which light and shadow are rendered as virtually autonomous of nature. "The light and shadows are independent of a specific light source."[57] Its figures could not create more of a sense of the plasticity of relief had they been carved on the face of the mountains that appear behind them. In a way, in fact, they *are* part of the mountain: their color is the red-brown of sandstone, as if the mountainside had been exposed in carving them.

Through 1908–9 Picasso continued to investigate the same complex of issues, further complicated by the question of finish. As mentioned earlier, Cézanne, clearly influenced by his own watercolors, had left areas of bare canvas in his later paintings, rendering form as transparent and transferring the light of drawing into painting. Picasso's 1908 watercolor is almost a finished work in Cézanne's sense, and at one stage of the oil studies for *Three Women*, again following Cézanne, he is interested in distinct touches of the brush as a method for unifying the surface. Color and brushwork remain a form of chiaroscuro rendering, and will continue to do so until 1912, and the invention of collage and papier collé. Picasso settled on no one idea of finish or of brushwork during this period; his color, however, got earthier and darker, at last almost muddy. Despite their implied volumes, the works of these years are essentially line drawings with a brush, infilled with paint, on a neutral unifying ground of sienna or of a deeper brownish color.

Partners

Braque and Picasso met in 1907, when Apollinaire brought Braque to Picasso's studio to see the *Demoiselles*. Both artists spent the summer of 1908 away from Paris, but in different locations, independently studying landscape with the work of Cézanne as a model. Back in the city in the winter of 1908–9, both worked on still lifes. Now close friends, they began an intimate collaboration as partners in the development of what would become Cubism. The stakes were very high, and so was the ambition—what were the chances of two painters of genius and of distinctly opposite temperaments and experience coming together and agreeing to meld their individual strengths to change the world? Braque, with no training in fine art theory and practice, had to teach

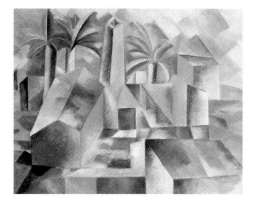

Pablo Picasso,
*Factory at Horta de
Ebro*, 1909.
State Hermitage
Museum,
St. Petersburg.

himself—in effect, to invent art for himself; Picasso, with too much training, had to reinvent art in order to succeed.

It was Braque's interests that prompted Picasso to reconsider other aspects of Cézanne—the still lifes, seated figures, and earlier landscapes of the 1870s. In the summer of 1909, again in the countryside—this time in Horta de Ebro, in northern Spain—he took the forms of the local landscape and the tumbling cubic blocks of the hillside villages as his motifs. Picasso's work that summer inaugurated his investigation of Cubism. The study was threefold: first, an analysis of the surfaces of self-contained complex forms and their constructive attachments, as expressed by their contours and internal subdivisions; second, a uniting of analogous forms in one complex form, an attachment of form to form; and third, the analysis—the restructuring—of the picture itself as a self-contained complex form, articulated by its internal divisions. Most important would be the analogy and transcription of the various classes of form into self-similar constructive elements differentiated by remnants or echoes of their former identities—often more than one former identity.

As Picasso grew closer to Braque in 1908–9, the experience showed him how forms could be analogized according to the place in which they live: the square format of the framing edge and the flat picture plane. Both could act as an external control, replacing traditional perspective. Form could be treated as architectonic, regardless of the subject. The investigation addresses pictorial structure; pictorial unity will depend on the creation of analogies (likenesses) among forms and on transcription between genres and disciplines.

The influence of Cézanne can also be seen in Picasso's various, very different renderings of Fernande Olivier from 1909—the coloristic surface distortions, the likening of her facial forms to apples or hillocks and of her tense forehead to cubic houses. These are the work of a serious "disciple." In part because the head is the most self-contained sculptural form of all, the bronze *Head of Fernande* (cat. 19) from 1909 (whose origin is in antique sculpture) marks an important moment in the formation of Cubist painting: it is a multiple transcription, or transmutation, of the same form from two dimensions to three and then back to two, and from figure to landscape. The sculpture's faceted forms are in fact a three-dimensional rendering of Cubist faceting—the head is painterly in the way it uses refracted light to break up volume. More significant still, *Head of Fernande* has taken on the form of landscape. The forehead particularly looks very like the forms of a mountain village. The alternating use of round and angular forms—which depends on the build-up of tectonic forms in an unstable equilibrium, only to be stabilized as a mass quantitative balance—will appear repeatedly in Picasso's two-dimensional renderings of figures and groups of figures. The head itself appears in several paintings, poised in exactly the same manner. Compare the brow of Fernande with the breastplate form of the 1908 watercolor study for *Three Women* for another analogy.

The various versions of the head, in painting and drawing and in this sculpture itself, must have been Picasso's attempt to come to terms with Braque's Cézannism. At this point freestanding sculpture was a means for Picasso, not an end; his interest lay in the dialogue between two and three dimensions inherent in painting. It was as a result of his coming to terms with Braque that, as the

investigation of these years continued, his color, unlike not only Cézanne's but his own color in the *Demoiselles*, came to depend on value rather than color contrast. Braque had already found his way to expressing flatness by reducing his painting to value rendering and, as described above, with the shadow system as an autonomous element.[58]

Cubism became an integration and a continuous tradeoff between the interests of Braque and Picasso. Braque initially had little interest in the nude; Picasso for his part had little interest in landscape or still life, the bases of Braque's Cézannism. In 1907–8, Braque had used landscape to concentrate on "what he called 'the visual space,' the 'space that separates objects from each other' . . . making space as concrete and pictorially perceivable as the objects themselves, which was in effect the explicit articulation and radicalization of a Cézannian idea."[59] As the two painters began their close relationship, it was these practices of Braque's that sparked Picasso's final reconceptualization of *Three Women*.

Braque had been independently concerned with Cézanne for some time before meeting Picasso or seeing the *Demoiselles*. The painting was a shock to him—its uses of Cézanne were entirely unlike his own. He did not like the work, but realized that he had to come to terms with its formal implications. In 1907–8 he painted his *Large Nude*, a vertical adaptation of Matisse's horizontal *Blue Nude* of 1907 and of Picasso's standing contrapposto figure from the *Demoiselles*. In it he struggles to integrate the self-sufficient figure so important to Picasso with his own conception of Cézannian form: the picture as complex tectonic "field." At the same time, he focused Picasso's attention on the high horizon of Cézanne, on the forms tumbling down, and above all on the tectonic modeling of these forms and the equal weight given to the spaces between them—the solid rendering of space.

In their joint adventure, Picasso continued to focus on the vocabulary and aesthetic system of drawing to locate the structural principle of the new work. Braque had started as a house painter, a paper-hanger and a master of trompe l'oeil effects. His feeling for the sensuous property of materials and the "tactility" of space was a major factor in the revolution. Aiming to remake representation totally, the two artists returned to the beginning—taking off from the ground floor, so to speak. Braque's beginning was Cézanne; Picasso had at his command the root of art itself, the drawing conceit that controlled Western representation, including Cézanne, Seurat, Gauguin, and van Gogh, to say nothing of the academic system. All these were his springboard to a new pictorial conception.

A primary issue in the new art was the statement in formal terms of man's relationship to his world. For the artists the relationship was one of figure to ground. It is the "I" question: How do I relate to the world? Or, even more acutely: How can I define myself as a human subject in the face of the world's overwhelming mechanistic drive to replicate me as just one more anonymous unit? Picasso and Braque convened to re-form space so that the figure could examine itself as if in constant conversation with its ground. Three previous generations had gradually loosened the shackles of scientific perspective, developing in its stead an array of individual perspective systems. Manet was vital to this process, as James H. Rubin writes, "Signs of artistic action on matter, while on one level . . . identifying matter as part of the same realm as consciousness, on another imply the possibility of their separateness, as dis-

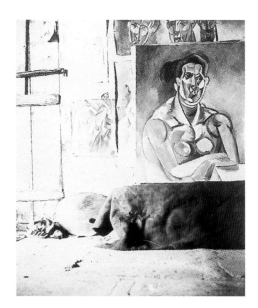

Pablo Picasso, *Bust of a Woman* in the studio at Horta de Ebro, 1909. Private Collection.

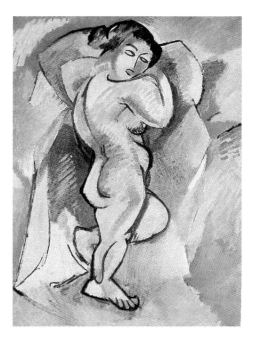

Georges Braque,
Large Nude,
1907–8.
Alex Maguy
Collection, Paris.

played by the former's susceptibility to manipulation by the latter. The explicitness of this dialogue as it is engaged in Manet's painting subverts the confidence of classical man in the objective status of reality, but leaves open the possibility of human fulfillment by featuring existence as an encounter between individuals and their material realm."[60]

The conversation between Picasso and Braque, and the conversation they inaugurate as part of the painting process, inscribed the individual in the material structure of representation. Their partnership was an attempt to ameliorate the anxiety of the human subject through a collective consciousness. Representation took place within, and as the product of, the constant awareness of a shaping hand within the pictorial space. The collective was the hoped-for site of a new anonymous ground of unity: the reformulation of the many back into one, but a polystructural one, a new system whose various elements could perform in concert to support a radical new kind of art.

Key to their new structure was the pictorial realignment of the old elements of figure drawing and perspective. The earlier dual system had found its unity by seeing everything from the external view. The new elaboration consisted in overlaying outline drawing with the grid of perspective and making figure and grid into formal analogies of one another, integrating the representation of figure and place—and then disintegrating it in a diabolically shifting formation of disunity/unity/disunity. In the work of Picasso and Braque from 1910, multiple dualities inhere in the contour and perspective grid as overlaid and intertwined in the drawing of the single figure, and in the shadow system as taken up by the patterns of marks that serve as the ground and by the play of the subtly modulated monochromatic colors.

Now the ground and the source of light became an issue, and finish became an integral subject. Here Picasso and Braque took up the atelier system, in which light and color had been unified under one conception. In the academic ateliers, a neutral brown was traditionally painted over the surface of the canvas as the base for the painting, a middle ground from which color, conceived of as tonal, could be modulated downward toward darker tones and upward toward lighter, brighter ones. In using such an ocher, Picasso and Braque no doubt had in mind not only academic precedent but their own landscapes of 1909, and especially the earth color of *Three Women*—and we have already seen an ocher painted in as a ground for the *Female Nude* of 1907, the study for the *Demoiselles*. The gray brushstrokes, with white as the highest light conforming to the system, also reflect the gray light of Paris.

The new unity/duality formation fostered a continual multiplication of division and mirroring tactics. It subjected perception to a cycle of replication, reopening, integration, and re-replication from within that established the new figure-ground relationship as an allegory of its own creation—worlds inside of worlds. By 1911 the tricks of illusionism had reached the point of a virtually hilarious multiplication of complexities, and of refusals to settle on a single solution. The cycle of re-creation seems to have slipped gears, almost to be running on out of control.

Representations at this stage of Cubism move both toward and away from "reality." The most important moves between "realities" are between two and three dimensions. An extraordinary marriage takes place in which the painting

is conceived of as an object while the representation within—based on the illusion of constant division, it has a built-in anxiety of identity—intermittently signals that it is to be read simultaneously as both flat and in relief. It is sculpture in a painterly mode. The basis of painting is as a schema, but here it pushes system past the point of making sense. Each unity takes its place, bows, and defers to the infinite opening within itself of possibilities in opposition to one another. The field of the painting can no longer be referred to as a space; even the shallow stage of the *Demoiselles* is displaced. Words like "site" or "realm," as used with reference to Manet, are even more appropriate to describe the place of a subject whose presence within the structure is now critical to representation.[61] The painting is conceived of as the equivalent of a "living" organism—a polymechanomorph. Each possibility works in opposition to the other. The inscription of these oppositions in classic Cubism emerge as "local acts of illusionism"[62]—disappearance and reappearances, images dissolving into one another as legible and illegible and the reverse, a constant play on identity. These acts are the building blocks of Cubism.

One of the issues between Braque and Picasso was that of talent and skill. Picasso had both in abundance, but even before meeting Braque he had put much of his skill aside, in what I believe was another bow to Cézanne. For Braque, certainly, Cézanne's awkwardness was a measure of his genius. (Braque always believed that Picasso's skill had allowed him to coast.) Cubism in any case reflected a will to create an anonymous art. It was a system that its inventors hoped could be shared by all, and in the same spirit in which they invented it—a styleless utopia of art. The hand was the key: Braque innately distrusted facility and Picasso renounced it. With no personal hand involved in painting, no individual "touch," one had difficulty (at first) in distinguishing a Braque from a Picasso, especially during the years of "high" Analytic Cubism (up to 1912). The idea may have been that a system that could be shared obviated the competition for a signature style. The removal of personal style in favor of collaboration, not only with each other but with a limitless historical and ahistorical cast, was intended as a subversion of the hierarchical system then still in place. As we have seen, an anonymous collective system is crucial in the history of Western representation. To take that system at its word, to turn it on its head and create something entirely new with it while also continuing to make it work, would be a great achievement. The reformulation would be especially effective if it did not involve two hands working as one but depended upon a universal analogy, so that the participants could work alone but be in harmony.

Picasso had the working model at hand in his knowledge of the anonymity conceptually embedded in the academic drawing system. The difficulty was that the freedom to be oneself and at the same time to be wholly in harmony with others had been historically impossible, because the objectivity needed to accomplish this could not be separated from subjectivity. The mechanistic repetition of this dilemma was built into the stage of the system at which individuality—the grace note—became the most important part of the practice of representation. But what if you threw out the gloss of individuality and returned to the ground of unity, the stage at which the system was so anonymous that using it automatically canceled out subjectivity? Picasso seems to have thought that he could transform the academic drawing system into a form of "existential praxis rather

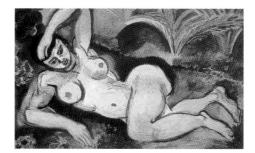

Henri Matisse, *Blue Nude, Souvenir de Biskra*, 1907. The Baltimore Museum of Art, Cone Collection, formed by Dr. Claribel Cone and Miss Etta Cone, Baltimore.

than a fusty set of theorems, a liberatory action in which the self comes to experience at the level of full self-awareness what was implicit in its inmost structure all along."[63] In doing so he could find the power to go behind the individual to the collective.

The two adventurers had exposed the fact that art was a language of conventions and always had been. Even when it was representational, its language had always taken precedence over "nature." There may have been some apprehension here on Picasso's part that individual style, with its endless need to repeat itself, was a dead end. Certainly that was a concern of Braque's; for both, invention—a new world view—took precedence. As Clark notes, it doesn't matter now that despite the shared language their individual temperaments are still readable. He writes, "Given the complexity of the Cubist idiom in 1911, and its strangeness, what matters first is that it has the look of a language, and one that is shared."[64] Picasso: "Almost every evening, either I went to Braque's studio or Braque came to mine. Each of us had to see what the other had done that day. A canvas wasn't finished unless both of us felt it was."[65] And from Braque: "We were prepared to efface our personalities to find originality."[66]

The sense of a shared adventure went beyond the two protagonists, and as it did so it changed. In 1913 Fernand Léger wrote, "We are arriving, I am convinced, at a conception of art as vast as the great epochs of the past: there is . . . the same effort shared among a collectivity. If one can doubt the whole idea of creation taking place in isolation, then the clinching proof is when collective activity leads to very distinct means of personal expression."[67] Françoise Gilot would recall Picasso saying,

> It was because we felt the temptation, the hope, of an anonymous art, not in its expression but in its point of departure. We were trying to set up a new order and it had to express itself through different individuals. Nobody needed to know that it was so-and-so who had done this or that painting. But individualism was already too strong. As soon as we saw that the collective adventure was a lost cause, each one of us had to find an individual adventure. And the individual adventure always goes back to one that is the archetype of our times: that is van Gogh's—an essentially tragic and solitary adventure.[68]

HIGH OR ANALYTIC CUBISM

Figure + Still Life + Landscape

We have seen that Cubism had built into its structure a collective memory. Picasso's art erudition was enormous: the conversation is not just about a collective or anonymous style, and the effacement of personality is not just between Braque and Picasso. Proposed as a figure-ground formation, Cubism goes back through the whole history of art as a metaphysical ideal. More immediately, the nineteenth-century French poetic tradition (not to speak of the Paris Commune of 1871) had ensconced the idea of the collective inside itself.

Cubism now became an intensive examination—detail by detail, painting by painting, each painting different from another—of forms conceived in a variety of self-similar descriptions and their variations in interchanging genre identifications. Between 1910 and 1912, Picasso returned again and again to the

contrapposto figure, both in drawing and painting. While the drawings obsessively subject the image to single alternative readings, the paintings compound these readings by overlaying them one on another. Both record a contest between the grid and the contour as they construct and deconstruct the image, rendering the marks as variously more linear (connective) or more signlike.

Female Nude (Autumn 1910, cat. 24) deliberately cuts off any suggestion of spontaneous life in the figure. It is a pointed mechanistic jest. Beginning with the *Demoiselles*, Cubist representation was initially a parody of academic representation; later it became a parody of itself.[69] If laughter was the fuel that made the machine in the garden of modernism run, Cubist parody, with its grotesque distortions of reality—its own reality—is that multigeared machine itself, for it is the nonpareil mechanism for the systematic production of analogy, responsible even for its parody of itself. The series of women—in reality always the same woman, in a constant state of flux—is now just such a machine production.

"Cubism was an art of realism and insofar as it was concerned with reinterpreting the external world in a detached objective way, a classical art."[70] But by 1910, as Picasso turned away from the live model, we have to take seriously the proposition that the detached objective view was leaning to the antic side of classicism. His drawing was becoming a parody of academic drawing; there is a sense of the absurd and ironic driving the enterprise, as the analogies multiply in more and more playful and, to those in the know, covertly sexual and slyly "obvious" ways. Jokes—visual puns—now become part of the coded system.

The three-quarter-length figure in *Female Nude* can be described as a nude counterpart to Cezanne's portraits of Mme Cézanne, seated. That Picasso now feels free to parody Cézanne (even to joke sexually by rendering Mme Cézanne unclothed) is apparent in the almost madcap hilarity of the work's mechanistic pileup of forms, a pyramidal structure that apes the format of traditional portraiture. And just look at the grotesque insolence of the purely mechanical face, with its hideous grimace, which identifies this woman as one of Picasso's female monsters. (Picasso's penchant for turning his women into monsters will recur throughout his work.)

A question arises: how do you pretend to classicism if your antics deliberately disrupt the "ideal" form of your model? We are removed not once but twice from the living figure; the human body is treated as an artifact left over from another world. This removal from reality makes visible the whole system of pictorial construction as a system of "ideal" analogies tying and untying description to and from objects. The picture itself is a construct, and the images on it are merely planar echoes of the canvas itself. The painting is an artifact several times removed from any reality other than its own and that of its prototypes. Among the more important of the latter is Seurat's marionette trombone player in *Parade de cirque*. This mechanistic figure's potential for movement is built right into the character in *Female Nude*—and into all the other Cubist figures. Thus the jokes in Cubism are in jokes, puns addressed to the visual adept and to an immediate circle. Like everything else in classic Cubism, answers multiply without producing stable solutions.

In *Female Nude*, Picasso uses a Cubist repertoire of painterly chiaroscuro devices, *passage* (the opening of contours to one another), and repeated small brushstrokes containing light, all assuring that each element of the figure remains

open and responsive to all of the others. The mechanistic figure's shadowy soul coalesces out of the ground of brushstrokes and is brought into conformity by the linear grid. Mechanistic plate forms build the picture from the ground up, clustering its shallow planes to the center and out toward the surface; but they have to be responsive not just to the ground but to each other, and they indulge in what might be called "slippage," tending to slip any rational placement the grid might impose and to pile up over one another. The unequal equilibrium that results is stabilized as quantitative mass, which takes the form of a pyramidal stack. The irony here is that as the slipped planes both oppose and constitute a unity, the painting—the figure—constantly transcribes itself between two dimensions and three, between painting and sculpture.

The soul of the picture—the pattern of little material brushstrokes—is grounded in a coupling of the painting method of the academic atelier and the grisaille technique of the medieval altarpiece, at their point of crossing: chiaroscuro. The first is a color system, the other a system using only black and white. One can imagine Picasso and Braque inciting each other to come up with references to every kind of conventional technique or historical praxis, only to use it in aid of radical subversion. In the atelier color system, as we have seen, an ocher-to-brown painted over the entire surface of the canvas was used as a middle ground from which to modulate color down or up. The grisaille system does exactly the same thing, but only on the white-to-black scale. There is a an overlap in conception again in the use of black: the black marks are not just shadow but embody "color" in honor of Manet, and of the Spanish tradition that Manet took up in using black as a color. And here pigment and light cross: black pigment is an amalgam of all of the colors, and white pigment is used as the point of highest light. Light, like black pigment, is composed of the whole color spectrum, but, unlike pigment, remains transparent.

Scenes of the theater had been a constantly repeated motif in nineteenth-century art. They are an important theme in the work of both Seurat and Degas; Seurat's *Parade de cirque*, as we know, takes place in a shallow stage space, articulated by lighting from footlights at the front and light at the back—the characteristic lighting effect that produces Cubism's limited hollow space as an effect of luminous expanse, almost without limit. Stage lighting creates its own chiaroscuro, not confined to black and white. "The literally tilted plane of many old theater stages, the use of gauze or scrim in a stretched plane for transparent theater effects, and the long scenographic tradition . . . of spatial illusion by 'reflection' of one plane in another, all contributed to the freedom with which perspective could be defeated."[71]

The insolence manifest in the formation of the figure becomes a double joke of identity. After examining *Female Nude* for a while, we become aware that the figure sits in a halo of light surrounded by an arch of black marks indicating a back plane. A change in the marking of paint in the left side of this arch signals both shadow and "reflection": the ground seems to be producing what may be a shadow of the figure, or its mirror image. The ambiguity cannot be resolved, it can only reproduce itself as a perceptual array of inherent possibilities.

The woman in *Study of a Figure* (1912) assumes an exaggerated version of the contrapposto pose in the *Demoiselles*—an especially interesting complication of it. The lower body turns on its axis particularly uncomfortably. The right

leg, which continues this twisted main axis, is seen frontally. The left leg is artificially elongated in order to bring it around from the buttocks at the left, where it passes behind the right leg, only to spiral back over itself as a flat ribbon. Picasso presents the woman not just as she is known from ordinary sight but as the artist knows her, from a composite of these disparate views and from the complex of sensations and perceptions they record. These are studio views, now compressed into one figure whose existence depends on a combination of particular forms and conceptual analogies. Into this amazing construction Picasso has inserted rounded forms signifying buttocks (there are two pairs, the second at the right side of the figure) and shoulders, and triangular forms for breasts—the survivors of a notional reality.

It is especially interesting that this woman is holding a baby, which rests diagonally across her body from right to left. Its head is almost integrated with the forms of her shoulder, while its buttocks and one leg are visible just below her hip, to the left in the drawing. Her particular forms—and her child—tend to disappear and reappear. To add to the analogous pileup, the baby's axial spine, which runs straight down from right to left, recalls the fingerboard of an instrument, and its buttocks are placed so as to suggest the curves of a guitar. Guitar-cum-baby adds yet another layer of complexity to the game of perceptual sorting. Now it is a game not only between details that need to be simultaneously integrated and differentiated but between genres, between still life and figure. So successfully has this game been proposed that the baby is seldom remarked in this drawing, nor in an earlier drawing of 1910, in which it can be seen a little more clearly.

The various "realities" make a point of the conceptual nature of the rest, while they add to our sense that we are not dealing with an ordinary visual experience. They are to a large extent the condition of the drawing's survival as an image of reality in the midst of all of these illusionistic devices. In the 1908 watercolor study for *Three Women*, the brushstroke had remained the unit of construction, uniting line, shadow, and color in one stroke. Now, in drawings, we can see how the analysis of form has become a conversation among pictorial elements, expressing the body as a system of structural axes and signs, each enforcing a particular view. The arbitrarily juxtaposed lights and darks expressed as planes (a device that had been in place as early as 1908) create a sensation of the figure as a form of relief sculpture, forcing the eye to jump from plane to plane across the contours. "Objects move; we move around the world; and we scan each object in the world in turn . . . the perceptual system uses the constantly changing viewer-centered descriptions of the world available at the retina to build internal representations: coherent object-centered descriptions of the world which are independent of incidental movements of the viewer or the object viewed."[72] But where there is no fixed view, and where every unity is open to any number of interpretations, and every interpretation to a new unity—doubt enters the equation. It is this doubt that Cubism now records, programming it as constant rereading.

As the figure and its shadows in the 1912 *Study of a Figure* construct one another, the line, though bound to a precise reality, becomes the structure of the picture while the shadow becomes its soul. Thus dense drawing at the top (always the sign in Picasso's work that we are in the presence of a classical sculpture),

and the general decorum of the figure as a planar object constructed by its own shadows, declare that we are dealing with a relief. So strong is the reference to sculpture that the drawing conforms to what is usually considered as "sculptor's drawing": the representation does not conform to its environment, the figure standing alone against the otherwise blank sheet. It bears no relation to a particular space or to the framing edge of its paper support. It is homeless, vagrant, so homeless that its top is cropped and a piece is added to the bottom in order to complete it. Even then it has been allotted only the merest indication of a floor on which to stand. Light comes through the construction from the paper ground, concentrating in the form of the baby to indicate her spontaneous creation as she twists around her mother, whom we may now see as a Madonna and Child. Taking center front position, she is the touchstone for art's attachment, through sculpture, to nature. Indeed drawing is a touchstone of sculpture; during the Renaissance, it had legitimized sculpture as an art, raising it from the stonemason's craft.

As an adept of classical language, Picasso had the knowledge necessary to reconcile all of the visual modes that in classical argument were separated and ranked in a hierarchy. In this drawing, as the various readings open to one another, they rehearse how the figure-cum-painting-as-object can be viewed, not just as painting or drawing or sculpture but as a larger whole, the site of a unity. But unity had come to mean a unity of parts within a whole—an exchange among aesthetics and techniques.

By 1912, Picasso was evidently thinking of his drawings as aesthetically independent of the works for which they were studies. They could stand on their own, whatever their level of finish. This drawing of a mother and child is a finished work in its own right. Moreover, Picasso's Analytic Cubist drawing did not stop with the study; rather, drawing was continued into painting, where its complexities and ambitions multiplied. The shadow system was taken up by the chiaroscuro of extraordinarily subtle marks and the modulated tints of "monochromatic" colors—not just browns, blacks, and whites but greens, blues, and less often other colors as well.

The piece of paper attached to *Study of a Figure* may record a change of mind or may have been planned deliberately. *Man with Mandolin* (1911, Musée Picasso), a three-quarter-length painting of a figure, has a piece of canvas sewn to the bottom in the same position as this piece of paper in order to elongate it to accommodate a full-length figure. As Clark points out, the attachment in the painting was an afterthought, evidently necessitated by the painting's being part of a commission for a group of five decorative panels. The commission was not completed, although Picasso worked on it for over two years; nevertheless it records a change of voice. On the top section, several layers of painting record constant changes of mind. It is virtually choked with *pentimenti* that register as local perceptual impossibilities—ironies of illusionism—vision "blindsided." The later, bottom section is less densely painted (even resulting in a slightly larger internal scale), leaving more air and breadth and space.[73] The lighter voice reverts—as an irony—to the classical possibility of "spontaneous" life in the figure.

The relief conception is the core of classical Cubism. As we shall see in the paintings discussed below, it represents the opening in painting to a conciliation between three-dimensional form and the two-dimensionality of representation.

Still Life
As Picasso began to work with Braque, the still life table became a prime subject.
It would renew itself repeatedly in new stylistic variations and in other genres.
Eventually it would serve as the basis for a whole new aesthetic.

Still Life with Compote (1909, cat. 21)
Printmaking was technically—that is, manually—useful for facilitating
transcription. As noted before, prints were the first objects studied in the
academy to learn the conventional signs for representation. Picasso often led
with a print when initiating a new idea. In making prints, various states can be
pulled as records, while the marks on the plate itself can be scraped down and re-
formed and the prints given entire new identities. Prints are mirror images by
virtue of the technique of printing.

 The etching *Still Life with Compote* began with two (possibly three) fig-
ures, which can still be faintly seen, since they were dug deeply into the plate
and were not entirely ground out or overcome by subsequent drawing over
them to create a still life after Cézanne. The composition originates in Manet's
painting *Dead Christ with Angels* (1864); the figures in the print are Christ and
the angels, and their positions in the painting are reversed in the print. Our
first impression is of a process of change. The figures were probably sitting
behind a table; over these faint marks are new ones retracing the outlines of
the initial composition. The shoulders of the figures are now the top edge of a
table tilted up to the plane, and their clothing has become a tablecloth, like
those of Cézanne, which cascades in folds down and over the old tabletop. A
neck and head can still be seen emerging from the cloth at the top center. On
the right, a forearm has become the dark oval of the top of the vase. The fruit
in the center of composition is formed from what were the breasts, now broken
and multiplied into smaller forms that are self-similar, as were the forms of the
hair in the heads of Fernande.[74]

 The original conception of the print can be made out by looking at the
Manet. (Manet himself made several prints of the painting, even reversing the
print.) The shoulders are Christ's, the forearm on the right (again because of the
reversal of the print) is Christ's right arm (seen at the left in the painting), its
opening is his foreshortened hand. The vase on the right in the print is his right
leg; the vase on the left, his left leg. The cascading cloth is the sheets on which
he sits, and the shape behind the pears is his loincloth. The pears themselves
seem to be developed from the shape of his calf muscle. The Cézannist rendering
obscures the Manet as a source.

 The transition reflects a metaphysical idea, for the process of tran-
scription and mirroring refers to the Neoplatonic notion that everything in
this world is made in the image of God. It then moves through the Christian
belief in the sacrifice of God's son for the redemption of man, represented by
the most mundane objects—a reminder of the sacrament—so that man now
takes center stage. (The mirroring of the image also inscribes Narcissus and the
pagan origins of art inside the still life, a genre that will now operate in on
many levels.) It is important that Picasso's opening to still life comes about
through the mediation of Cézanne, for it can be interpreted as the initiation of
the theme of the artist's studio in Picasso's work. The still life is a mirror of the

Pablo Picasso,
*Portrait of Marie
Laurencin (Three-
Quarter View)*
in the Boulevard
de Clichy studio,
Paris, Autumn 1911.
Musée Picasso,
Archives Picasso,
Paris.

57

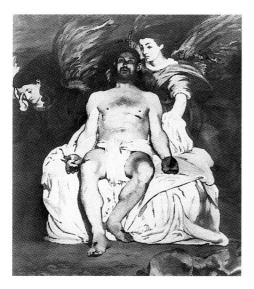

Édouard Manet,
*Dead Christ with
Angels*, 1864.
The Metropolitan
Museum of Art,
New York, H.O.
Havemeyer
Collection,
Bequest of Mrs.
H.O. Havemeyer,
1929.

artist. In the mirror, his own life is portrayed as art, and through it his life becomes one with art. The transition from figure to still life becomes a way to integrate the single figure into a more complex perceptual field; it will integrate the Cubist milieu of café interiors, the light refracting off windows, glasses, and bottles—the breakup in an interior microcosm of the larger, splintered view of the city. The still life table will support an everchanging parade of Picasso's immediate surroundings and objects: interiors, faces, figures, loves, friendships, mementos of daily routines, pleasures, vices. Occasionally a scrap of writing will bring an outside event to the surface. The glass—the smallest object in which the refraction of Cubist light is vested—or some other glass object is almost always included. Often the easel appears somewhere in the representation, merging café with studio. Very often the table is a *guéridon*, a round table with a central columnar support.

Bottle and Books (1910–11, cat. 25)

In *Bottle and Books* Picasso uses the pretext of piles of books to clarify his transformation of specific forms into a play of self-similar architectonic forms that behave like ciphers. Like the head of Fernande, the still life table is basically a self-contained form articulated by internal divisions. The composition here is based on enclosure drawing; it is a construction of blocklike forms reiterated in a checkerboard of lights and darks.

The elision of plane into plane—"*passage*" in Cubism—within a radically shallow illusory space leads the eye in measured steps, backward, sideways and around. The broken line, itself a remnant of the linear armature, functions as a connection between the remnants of notional objects and disparate perspectives (given by shadow), marshaling them into their precarious placement. The *passage* guarantees that the spaces between are palpable areas—in fact there *are* no spaces between, only the shadow pattern of repeated horizontal brushstrokes that modulate the surface of the canvas and create an originary ground from which the forms coalesce into less, rather than more, obedient little geometric enclosures.

The painting ultimately owes its architectonic structure to the small villages, with their stepped, tilting, and overlapping, cubic houses climbing the hills, that Picasso had depicted at Horta de Ebro in 1909 (see fig. p. 48). The reiteration of motifs and the virtually autonomous linear scaffolding break up the contained form and move it to occupy almost the whole of the surface. But classic Cubism does not focus solely on single motifs; as we saw in the almost tentative transcription of *Still Life with Compote*, the drawing system that drives Cubism insists that each genre be in constant conversation with the others. *Bottle and Books* shares the tectonic forms of the *Female Nude* of 1910, but the configuration is mutable.

Landscape

As a genre Landscape is rare in Picasso's work after 1909; it is not depicted at all in high Cubism. *Landscape, Céret* (Summer 1911) is a rare scene in which landscape as such plays an important role—and even this is not purely a landscape, it is a "villagescape" with landscape elements. But although almost nonexistent as an independent genre after 1909, landscape is the primary ground from which the

forms of classic Cubist pictures coalesce. The ambition to reform the structure of art would be incomplete with doing so "from the ground up," and the ground from which everything originates is the landscape.

Landscape was the setting in which the academicians had represented "civilization." In the paintings of Poussin, for example, landscape was a reference to Arcadia. As we have seen, Picasso had banished paradise/Arcadia, vacating the landscape to concentrate on the figure. But "landscape," for which we must also read "floor," was the home of the figure. The problem of integrating the sculptural figure into the scheme of Cubism was critical for both Picasso and Braque. Picasso solved the problem by building the structure of the landscape into the structure of the pictures, reexamining the landscape as villagescape.

In its internal plan, *Landscape, Céret* could be the container for a figure or a still life—the title is an important clue to reading the details. The overall gray-tan tones, with touches of green, may conform to the coloration of the local landscape, but are also the same as those in paintings of other genres, as are the dappled light and the small strokes of the brush. What identifies the painting as a landscape is details—of buildings, their roofs, stairways, at the top center a chimney, and just below that a window with curtains. Little strokes of paint also mass together to evoke clouds, or give the impression of nature coalescing out of bits of matter. Each type of element finds its own place in the alternating grid.

The transcription here is from *The Sea at L'Estaque* (1879), a Cézanne landscape (or one very like it) that would be in Picasso's collection when he died. Cézanne's painting depicts a village on the coast, with bits of greenery showing between the cubic buildings. The picture is divided into four horizontal zones. In the foreground is an earth-colored wall. Just behind it, reaching up the sides of the painting, are large trees whose branches stretch across the top edge to frame the view. The village is depicted as if it had been set down on a table. Behind the village is the sea, a plane high up against the horizon, which is just glimpsed through the framing treetops. The ground changes color at the horizon line to depict the sky. The sea very subtly suggests that it is tilted, but if you look too quickly, the sea and the sky seem to be a flat background rather than a series of tilted planes. The whole refers most immediately to the marriage of cityscape with landscape: transcription turns the city into a form of pastoral. *Landscape, Céret* inscribes the landscape-cum-cityscape-cum-pastoral—the fragmented close-up and personal views of Paris—into the heart of the structure of classic Cubism.

We have seen a formal conception similar to Cézanne's and Picasso's before: in Seurat's *Parade de cirque*, where the forms are made of little strokes coalescing out of matter, grouping themselves around light and dark masses in a grid of planes. This is that sophisticated compositional type taken to an extreme, a revolutionary version in which the grid of that virtually unseen perspective is tilted up to the plane to marry with planar recession, reassembling once again as enclosure drawing—this time more open and atmospheric. Now we see that enclosures will shelter anything. It is a structure in which a detail can change the whole world. Insert a nose, an eye, a woman's breasts. The grid that had originated in the play of attachment and detachment in the descrip-

Pablo Picasso, *Photographic Composition: Still Life on a Small Table at the Studio on Boulevard de Clichy*, Paris, 1911. Musée Picasso, Archives Picasso, Paris.

59

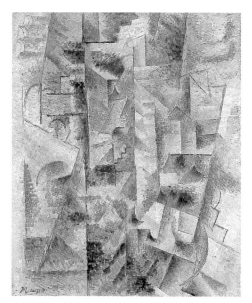

Pablo Picasso,
Landscape, Céret,
1911. The Solomon
R. Guggenheim
Museum, New York,
Gift of Solomon R.
Guggenheim, 1937.

tion of the contrapposto figure is now wholly in control of figuration—or is it only playing? Another way to see this is: re-creating the landscape as an architectonic object, a conceptual structure analogous to that of the tectonic forms of the figure, Picasso gave his frightful women a home in the structure of the new world—of which they were, in effect, in control, even as they laughed at the very idea of control.

ANALOGY AND ITS OTHER: FILM

Analogy is nothing more than a deep love that unites distant, diverse, and seemingly hostile things.

Filippo Tommaso Marinetti, 1913

Analogy and its other, transcription, are the machines in the garden of modernism, hurdy-gurdies grinding out metaphors in endless variations on one another, often in minute variations, manifesting the unity in difference that is the quintessence of modern life. As a coded system, analogy has the power to create visual metaphors between different classes of objects: a face is like a village, a body is like a guitar, which is like a violin, which suggests how a cheek may be curved, and the curve of an ear repeats the curves of both cheek and violin, and the violin is both played upon by a lover and is the loved one. Analogies pile on analogies and extend to senses other than the visual and tactile. In Spain the guitar is strummed to woo the lover; in popular imagery the guitar is often equated with a woman's body, which a musician can play.[75] Picasso's variations on the theme are: the loved one (the woman), the lover with the loved one (the man with guitar—and occasionally the woman with guitar, the woman being given the chance for sexual play), and the loved one *as* guitar.

Like the working of memory, Cubism works through endless analogies. In traditional art, drawing is the ultimate agent of analogy and analogy is the ultimate agent of freedom, crossing boundaries of space and time, boundaries between classes of objects, between saints and sinners, between sexes and genders, to create new classes of description. Drawing evades the strictures of time, blending memories with present events and reconciling contradictory and distinct categories of human endeavor. Finally, analogy, as part of the functioning of the brain, makes the leap that unites our varied technologies for aesthetic reproduction. According to Clark, "Cubism is the last best hope for those who believe that modern art found its subject matter in itself—in its own means and procedures. And . . . in doing so it found an idiom adequate to modern experience. And therefore founded a tradition . . . A fair test of these hopes, it follows, is what those who entertain them can find to say about Picasso's and Braque's paintings at the key moment of 1911–12. I think the answer is precious little, or anyway not enough."[76]

The constant dialogue between the two painters after 1909—their daring sense of having been engaged on an adventure together—becomes a platform from which the paintings of 1911–12 take off into an entirely other conversation about forming. Here is Baudelaire's "passion for the difficult." This is the point at

which the painting becomes a world in itself, one that constantly replicates itself in new worlds until it exhausts itself, only to begin again in the flicker of an eye.

The creation of a system was not enough—the ambition was to make painting a constant act of creation, to return it to its origins in matter, to replicate the process by which the self comes into being. The puns and jokes will allow no simple resolution: at one moment the eye seems to be paramount, at another the hand that shapes. Nor do the painters desire a resolution. The ambition of Cubism is the whole engagement of the senses that Cézanne had wanted for painting, the light, the form, the color and, as Clark says, all of this operating as a cooperative, an anonymous collective. The combination of visual and structural is no longer what Schapiro called a "sympathetic version of the mechanical in the constructed environment,"[77] it is an obsessive dark vision. The ceaseless repetition and variation on the same core themes of shadow, plane, and line, the degree of complexity, the "nuance and precision" that Clark sees "in the whole fabric of the touches,"[78] all the artifices of illusionism including volume, are part of an aspiration to show everything remade through art, to recycle art to its beginnings in form arising out of matter, to reattach to nature through a system of signs that pretends that everything that is the same is different and everything that is different is the same.

Everything above, and more, is true of Cubism as construed according to a history of painting, yet none of it is a satisfactory explanation for the sudden radical difference of the 1910 paintings and even more for those of 1911–12, which are more different still. What are the leaps of genius that so change the equation? The slipping planes, the flickering light, the fracturing of forms, and the open change to dark and ribald comedy—manifesting not in terror, as in the *Demoiselles*, but in a form of licentious slapstick—are all radically new. They may be intimated in the models mentioned but they are not played out in the same overt way. The disjunctions and the insults to propriety on the formal and social level had appeared in poetry, which in the nineteenth century had become intensely visual. Yes, caricature is a visual tradition—but it is still just a piece of the puzzle, the one that recalls the cackle of sexual laughter, thus inscribing darkness in the parody. What brings all the pieces together, what is the secret spark, for the radically new and irreproducible visual conception? Is there a *deus ex machina*, or a real machine, or perhaps both? History was one part of the equation, but the present—and the future—were the crux of the matter. Cubism never set out to be merely a rearrangement of the past; it was to subvert the past and to embrace the present in all of its mad contradictions.

In 1909, at Horta de Ebro, Picasso had made comparisons among his paintings by laying photographic negatives of them over one another to clarify the perceptual changes wrought by shifts layered into the depiction. The paintings that he examined in this way were the tectonically conceived paintings of the heads of Fernande, at rest on his studio floor. The problem (an odd opposite of Cézanne's need to restore the sense of the individual object to the picture) was how to break up these massive tectonic objects, restoring and reintegrating the Impressionist tradition of painterly illusionism, the breakup of light ("Cézanne's doubt"), into the equation without losing the figure. It seems possible and indeed probable, however, that when Picasso laid one negative over another he was

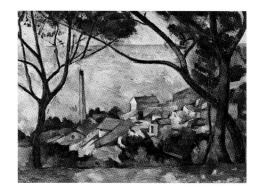

Paul Cézanne,
The Sea at L'Estaque
1879.
Musée Picasso,
Paris.

thinking not just of photography (and in this case probably also of stereoscopic images) but of film.[79] He was replaying the basis of film, a series of stills run together to make a moving view. In 1910 Picasso performed what at first appears to be the reverse (although the end was the same), in a photographic portrait he made of the Douanier Rousseau (see figs. on p. 63). In the first print Rousseau sits next to one of this paintings; we can see just the left edge, with jungle foliage and a monkey. In the second print, a negative of the painting has been placed sideways over the first negative to form a ghostly double image, in effect a film dissolve as a still photograph. This would seem to be another investigation of how one would dissolve a solid form into a transparent one.

Baudelaire wrote that the goal of the modern artist was to be "the painter of the passing moment and of all the suggestions of eternity that it contains."[80] The experience of urban life is part of the experience of these paintings—the momentary visual exchanges in the rush of the streets, the crowds, the ever accelerating transport, the artificial light. Paris is everywhere in these high Cubist pictures, and the artist's need is "to blend the ephemeral and the eternal,"[81] to catch "the momentary visual exchange which in an instant has transcended time and place and opened up the windows into another world."[82]

To the initial moderns, photography was a threat (even if it was also an aid). Film, on the other hand, was a challenge, an excitement. If the introduction into art of the coarse language of the everyday began with the poets who had first broached the idea of "newness," Picasso—the great visual thief—was certainly also stealing and transcribing from the movies, which he had been watching now for many years. Film had continued to keep available the low, music hall, circus, and parade traditions, the rough comedy of magic tricks and street jokes that Picasso was ready to transcribe into "high" visual art. Staller writes, "The relation between the cinema of Méliès and the Cubism of Picasso and Braque is not one of visual resemblance. Cubist works do not look like stills from Méliès films. . . . Yet many of Cubism's most radical features—such as the comic fragmentation of body parts, the use of conflicting multiple perspectives, and the insertion of letters, numbers, advertising copy and real prosaic objects—had already appeared, not in high art, but in the pervasive popular culture of film, especially the three-minute films from street fairs and billiard parlors that the artists and their cohorts had been watching at low film haunts in the rue Douai."[83]

But I believe we must understand Cubism's adventure with film as ongoing and evolutionary. From 1909 through 1911, Cubist paintings *do* try to look like film, but especially film as it was projected at the time, including the *trucs* of cutting—it is only gradually that the specific comical motifs come to the fore. In early film images the light flickered—the movement from one frame to another was not totally smooth, because of the erratic speeds at which some early cameras ran. As a result, reception by the eye was discontinuous, even though film could already be run at the rate of sixteen frames or more every second—the psychological threshold of illusion. And it may be that Picasso haunted the lower-class movie houses and penny arcades because they showed the comic and trick films in which the discontinuity of the actual makeup of a film's structure could still be seen. At any rate, the perceptual interruption fostered by the cutting of various viewpoints into film, and by montage and dissolve, is recorded in the flickering lights of Analytic Cubism, and in the structuring of Cubism as a series of impres-

sions that build and then fade and rebuild as disparate views and conflicting multiple perspectives.

Films were initially sepia before becoming black and white; long before the introduction of color film, some of them were hand tinted. Early film was visually soft, painterly in its light—it was shot partly outdoors, under available light, and partly indoors, under the same sort of lighting used for the stage. It seems impossible that Picasso would not have taken this medium, with its constant cross-cutting to create multiple views, into consideration in the structure of Cubism and into its range of color.[84] Finally, film was the ultimate key to the defeat of perspective: the film screen was a superior stage scrim—perhaps a form of canvas onto which images are projected in parallel to the projection of painting. Film's ambition was not to present merely "a small temporal segment of action but rather the totality of an action unfolding in a homogenous space"—an enframed space.[85] Moreover, as we see in, for example, *Bottle and Books*, Cubism resists filling in the corners of the paintings, which fade away at the edges. This quality, characteristic of classic Cubism in general—and of early film—points again to the understanding of the canvas, supported by the transparency of film, as a parallel and intersecting ground of origination. What happens on it takes place in a world apart. Above all film was transparent. Even more than photography and painting, it was a creature of light— a light that had to be captured for painting. Film was the ultimate machine for reproduction.

Comparisons between Cubism and film might mention not only the flickering light and monochrome of early movies but the resemblance of Cubism's scaffold structure to the frames of a film—now playing in concert rather than consecutively. The stacking up of the cubic forms in unequal overlapping configurations can be seen as analogous to the temporal overlaps caused by cross- and parallel cutting; the disparate views inscribed in Cubism by enclosure drawing can be related to filmic views. Cinematic construction, inscribed as the scanning of discontinuous perceptions, probably underlies Picasso's conception of the *Female Nude* of 1910, in which a polymechanomorphic figure constructs itself as a series of cubic frames, out of a concave space given by its own flickering reflective lights and irrational shadows. This conception is inscribed over the stage construction of the Seurat mannequin, which depended upon the play of paint masquerading as light.

Film, like street theater and the circus, surely appealed to Picasso, an artist of metamorphosis and analogy, as an art in which actors constantly and fluidly switched identities while also remaining recognizably themselves. Richard Abel writes that stop motion reverse motion, and multiple exposure, coupled with "a matte device masking off a specific area of the cameral lens . . . in *Le Portraite mystérieux* (1899), produced the delightful image of Méliès talking to a life-size portrait duplicate of himself. In film after film, [according to Linda Williams], Méliès obsessively repeated himself 'like a fetishist . . . making the game of presence and absence the very source of . . . the spectator's pleasure, while privileging . . . his own perverse pleasure in the tricks' of that game."[86] And the conception of each section of the enclosures in a painting such as *Landscape, Céret* as another kind of image could also be related to the primitive montage by which early film cuts from scene to scene, recording different classes of images

Pablo Picasso, *Two Portraits of the Douanier Rousseau,* Paris 1910. Musée Picasso, Archives Picasso, Paris.

63

and localities, from close-up to distance, from landscape to figure, each lingering for a moment in the mind's eye. Look again at the painting: it is composed as a series of film strips, cut into one another and "pasted" down overlapping one another—*collage avant collage, papier collé avant papier collé*. We must look again at Cubist painting from 1911 on for both the light of projection and the sense of a collage of film strips, now analogized to the grid. These properties play an increasingly important part, being repeated obsessively in painting after painting. We must also consider Abel's account of early film:

> The "cinema of attractions," to use Tom Gunning and André Gaudreault's formulation, is perhaps the best term for the mode of representation governing early film production and exhibition, and it has at least four principal components. First, early cinema was presentational, equating camera and spectator in what Jean-Louis Baudry and Christian Metz have called simply 'the gaze that sees.' That is, rather than narrate or, more precisely, focus on narrative and characterization, it tended to show or display—as an "attraction"—either the technical possibilities of the new medium or the spectacle of human figures, natural landscapes and constructed decors. Such a cinema, [Miriam] Hansen argues, was predicated "on distracting the viewer with a variety of competing spectacles . . . rather than absorbing him or her into a coherent narrative" or a "classical" diegesis of spatial-temporal continuity. As a corollary, it often addressed the spectator directly, not only through frontal staging but also through the recurring looks actors gave to the camera, perhaps in order to create a degree of audience collaboration with that display. Second, the tableau in early cinema generally was considered to be autonomous, for it assumed, in [Noël] Burch's words, the "unicity of the frame"— "any given tableau remain[ed] unchanged in its framing throughout its passage on the screen and from one appearance to the next." The objective, to quote Gaudreault, was "to present not a small temporal segment of action but rather the totality of an action unfolding in a homogenous space." Consequently, to use Gunning's precise phrasing, early films might be seen as "enframed rather than emplotted." Third, such a single unified viewpoint assumed a camera distance that usually described that enframed space in long shot, one of whose consequences was to make human figures primarily performers of physical action rather than "characters" with psychological motivations. And fourth, early films were sold as "semifinished products," in Thomas Elsaesser's apt phrase, which could be finished in exhibition in very different ways. All kinds of practices—variable projection speed (due to hand-cranking), music and sound effects accompanying the film images, *bonisseurs* or commentators providing explanations, exhibitors asserting the right to reedit and color the film prints they purchased—actively promoted a wide range of textural variance rather than anything like a definitive film text.[87]

Let us replay two previously mentioned Cubist paintings as they might be described with film as part of their structural mechanism and as a motif.

Man with Mandolin (Summer–Autumn 1911)
and *Female Nude* (Autumn 1910, cat. 24)

Film takes the transcription process one critical step further than the potential for movement in the metaphysics of the classical figure. With film as part of the mix we are obliged to deal with the figure as simultaneously transcribing itself between light and matter—transparency and opacity—and between two and three dimensions and doing this over and over, just as mod-

ernism obliges us to re-create ourselves and others anew all the time in conflicting surface and depth formations. In film, the subject constantly re-creates its own image, in imitation of living movement, by means of a series of minute incremental moves recorded in single photographic frames. The eye and the machine are conceived as analogues. The figure is turned into a machine, constructing itself and miming life. A paradox emerges as the projection machine is slowed down: as slow motion merges into stop motion, it exposes the mechanism of its movement, allowing the eye to reconstruct the individual frames represented as illusionistic devices. The slowdown leads us into a rehearsal of how we constantly construct and reconstruct our own reality and that of others as a series of illusions.

In the 1910 *Female Nude*, the figure seems content with the action of fabricating herself as a series of cubic forms that can be analyzed not only as enclosures but as film frames, moving at an almost leisurely rate as they pile up and over one another. We are still invited to recognize her, so that we might perhaps recognize her origins, and the parody lodged within them: in fact it is tempting to read her cubic, bunkerlike head (its form broken in accordance with Cubist faceting) as a combination of a movie camera and a projector, simultaneously recording and throwing light. What I have described as her features can then be reread as the handle of a cranking mechanism. The ground, which is rendered as dancing lights and shadows, accordingly becomes a film scrim on which this self-engendered mechanomorph is screening inchoate images brought to the threshold of existence as a product of her conceptual and perceptual faculties. Movement is transfigured into a trace of reality—as facts, however doubtful or threatened, that are to be realized by the mind. The flickers of light from the projector, recorded in the painting as little *taches*, encourage active reading, and here the eye is quicker than the machine. One of the work's jokes is that a traditional Christian aura—the reflective aura from the gold of Byzantine and early medieval religious art, here inscribed into the glitter of paint—is at this point rendered as the result of a mechanical process. The mechanomorph's aura also puns on an old idea of Western portraiture as a kind of beatification.

Both of these paintings allow us to relive movement by both following little *taches* and rereading multiple contours. A pun on the process of multiple exposure allows movement to be relived through the eye. The *Demoiselles* had not addressed a vital element of perception: the movement of the eye, which, with Impressionism, had become a central factor of painting. A serious painting practice had to take that factor into account, especially if it was to compete with science. The parallel of the flickers of light in film with little *taches* is what allows Impressionist rendering—the new tradition of illusion—back into these paintings, reattaching Cubism to the ongoing "tradition" of radical painting and allowing it to continue the attack from within.

According to Clark, *Man with Mandolin* makes it totally apparent that Cubism "stages the failure of representation, which he sees as the special problem of high Cubism." The recognition of an inability to create complete resemblance ultimately leads to a canvas that no one can read. He compares this to the case of Balzac's story *Le Chef d'oeuvre inconnu*, in which, after years of painting the same female figure, the painter Frenhoffer comes up with an image that is totally inchoate. Clark notes an excess of illusion in *Man with Mandolin*, at least in the

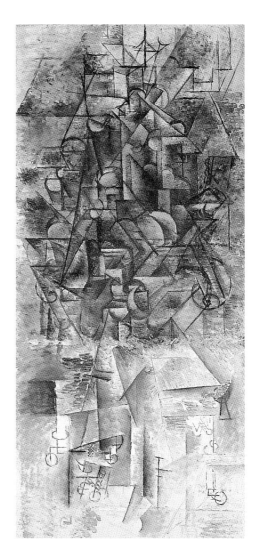

65

Pablo Picasso,
Man with Mandolin,
Summer–Autumn
1911. Musée
Picasso, Paris.

top part of the canvas. But we must ask why. Why is the work "too tactile"? Why, as Clark writes, do "the acts of illusionism work too efficiently" (if they do)? Why do they "not happen on the surface"? They "lost the metaphor of their own insufficiency." Why?[88]

In 1911 and 1912 the machine for reproduction in painting runs at higher and higher speeds until it virtually outruns its own illusions. A crisis is reached in painting's capacity to hold onto representation: as the painting machine tries to keep pace with the speed of the actual machine, the illusionary apparatus becomes denser and denser, and it becomes more and more difficult for it to maintain the transparency that enables it to integrate the frames into a coherent representation. In *Man with Mandolin,* the strumming of the mandolin becomes a metaphor for the action of painting. The work's focus is all on the action; if there is a psychological charge, it is supplied by the viewer's uncertainties. We are not sure whether we are seeing a figure at all, and when we decide we can trust that we are, we do not know if it is male or female.

In the top part of the painting, as the representation moves closer and closer to the speed at which we integrate individual frames into a smooth movement, the paint trying to record the motif's overlapping frames becomes more and more dense, tactile, as though trying to hold onto paint itself. Matter, piling up and overlapping, is closing out light, and we are forced at every turn into movement for its own sake, often simply to be frustrated in false maneuvers. A surfeit of contour profiles traps us into following the tactility of paint as it starts, stops, and turns in individual localities irrationally constructed by the framing mechanism. (This is particularly marked by the disparity between the upper part of the painting and the piece at the bottom, which, as remarked earlier, was sewn on later, and is far less congested. Plastically indecisive, it may or may not be complete; it does seem to describe a constructed decor, a table, but it may be reinstating the metaphysical idea of spontaneous movement into this dense image.) Like all Cubist pictures, the work is a closed tableau, despite its moving parts—a mark of film's intimate initial reliance on painting modes. The grid too runs out of sync: it is shifted to run diagonally so that it creates the illusion of shifting between the surface and the ground. (Its pattern is rather like a harlequin's diamond-patterned suit.) The metaphors of grid/film frame and movement/musical play are lost as Picasso tries to integrate them with one another, and with the body, as totally coincident. In the effort to make painting win out over all the other modes, painting loses its balance—the tension between the generative powers of the disparate elements critical to the illusion. (Clark believes the grid becomes too generative.) With technology envy—science envy—fueling the engine, too many things are happening simultaneously and too quickly.

In the rush, the idea of beauty is transformed. I've used nineteenth-century French poetry as a measure of Picasso's aspirations before; his duality takes the form of the sort of repetitive surface-depth formation present in Mallarmé's unrealized ideal, *Le Livre* (The book), a multivolume poetic construction in three dimensions. The book was "not meant to present itself merely as a limited or intrinsically constructed reality but rather as the reproduction or reconstruction of the process of reflection by which reality becomes reality and reality can be recognized as truth."[89] Beauty, once formulated as truth, can now be seen to oper-

ate under this somewhat grim banner: no superfluous makeup, no "color" as such, just a stringent adherence to the most basic, academic means of the illusionist's craft, which can conjure its own realities as magical sensory experiences. Picasso and Braque, like Manet, had different standards of beauty from the academic, yet they claimed their new, aggressively stripped-down truth as a higher form of beauty. Consequently, what may be the most important duality of all can be understood as built into high Analytic Cubism: despite its low demeanor, its parody of the themes of high art (café life, strolling players, sly sexual innuendoes), its aspiration at its heart was to be judged as high art—and not just as high art, but as a reshaping of art entirely.

Deciphering the various specific motifs in these paintings has become the game of a number of scholars. We have been in training, so to speak, since 1910. But we are not meant to decipher them in any usual sense: total coincidence is nor more in the cards than any fixed identity for "I." "I" as a projector, not just a camera, is an added part of the equation. From this point on we need to think of the appropriation of cinematographic devices as another layer of complexity in the two artists' ambition to totally remake painting—to modernize it—and restore it to its privileged place as the queen of invention.

THE SUBJECT

Cubism's ambition is too large, and Cubism itself too difficult, too dense, too ambitious, too dependent on local and constantly changing factors, to be easily comprehended. We are meant to measure that ambition by the art's fullness, its complexity, and by Picasso's and Braque's stubborn insistence, in stroke over congested stroke, on their immersion (as artists-cum-subjects) within the shaping process. Each stroke had to be seen and incorporated in the body as a tactile lived experience—a pleasure given to the body by sight. The philosophical ground for the new aesthetic is stated in terms of the analysis of perception: each distinct perception is brought into conformity in order to ensure that "abstract decision" is shifted from the "power of the head to the rule of the heart . . . to bodily disposition. The 'whole' human subject . . . must convert its necessity into freedom, transfigure its ethical duty into instinctual habit, and so operate like an aesthetic artifact."[90]

"For Manet," we are told, "the act of picturing was a pleasurable process . . . his art transcends the paradigm of external reading, moving rather toward a lived visuality." "In referring to the artistic self, then, rather than (or at least as much as) to the world, those markings, pictorial notations or signs move toward independence of their duty to the referent in the world and acquire the potential to be manipulated and enjoyed for themselves."[91] In classic Cubism, as in the work of Manet, part of the pleasure is watching the interaction between the paint as such and the object to which it refers.

Picasso and Braque too were careful not to lose contact with the identity of the object, but they did want to push their detachment from the object as far as it could go. How far, and how wittily, can the punning between individual components of the system advance while the painting still "represents"? The pleasure principle became for them a mad game, the multiplication of signs

67

threatening to break down visual structure completely. Representation was transformed into a system of hieroglyphics, destroying compositional hierarchy and object identity, playing off surface against visual depth. Cubism was a revolution not just in seeing but in seeing as being. Abstraction would have cast the human subject from the picture, undermining the "mirroring" effect between the picture as aesthetic artifact and the human condition. Essential to the picture was a rehearsal of the shifting ground that constituted the constantly multiplying identities of "I." *Cogito ergo sum*, but Rimbaud had reformulated the "I" question: "It is wrong to say 'I think.' One ought to say, 'I am thought' . . . 'I' is somebody else." His source in this insight "was the comparatively simple phenomenon of introspection—the mind observing itself at work. 'I am present at the hatching of my thought.'"[92] Mallarmé, the pivotal poet of his generation, said "I do not think, therefore I am not."[93] Rimbaud had thought of himself as a musician, the leader of an orchestra, in formulating his idea of "I" as a performance completed by others; for Picasso and Braque it is film that is built into their formulation of "I" as a process.

The two inventors had developed an apparatus that constantly reprised traces of "I," but only in momentary glimpses that immediately dissolve into indistinguishable traces of material struggling to nonconform. The notion that some system formalizing the conception of constantly multiplying ambiguities of space and time, and of "I" as a process, could be exercised from the standpoint of an anonymous collective was seemingly bound to fail, for as I quoted Picasso earlier, it turned out that the new order could only express itself through different individuals. No matter what the starting point, each subject could only become "a little work of art in itself, its form and content miraculously unified." To be infinite and absolute, to be free, was the subject of these pictures. But the odds were against such freedom, for "the subject is microcosmic of that more imposing aesthetic totality which is the universe."[94] Ensconced within the anonymous collective was its opposition—the thing it was struggling to overcome, the irreducible "I" to which those systems pointed.

Refashioning the preexisting forms of art, and reattaching art to nature by forcing the subject to reconstitute itself, paradoxically rendered both subject and alleged solution more mechanistic. Again and again, the subject was created as in the same condition as the world; the paradox of the "I"—the hand—versus its abnegation had been built in from the beginning. The sacrifice of identity was a hard task. By ironizing the failure to differentiate the subject, or so Picasso may have hoped, painting could arrive at a "form of objectifying knowledge coterminous with, even constitutive of the self—a cognitive power by which we could generate objectivity from the very depths of the subject without for a moment endangering its self-identity, a knowledge which would mime the very structure of the subject itself, rehearsing the drama by which it brings itself into being."[95]

With paradox built into its heart, the new system served very much the same purpose as the old. Anonymity by technique—what an irony. Seen as the heart of a totalizing system of representation, the new drawing system put in place in Cubism offered a universalizing and objective methodology. It could be stretched to contain any praxis, even a parody of itself. As both the problem and its solution, the flexibility of drawing seems to have been kind of prison

from which Picasso could not escape. Drawing is a form of mapping, a structure for locating built into our most primitive brain. A line—even one line—will always establish a location relative to any anchor to which we relate it; it is unfailing, mechanistic in its way. Drawing provides both a system of anchors and a way to constantly juggle and transform particulars into their opposites—figural versus structural, solid versus transparent, etc.—or to confound them so that nothing is clear. Attach that system of location and dislocation to the illusions, the uncertainties, that light creates—and paint is about those illusions—and it becomes impossible to escape its contradictions. The subject is woven into the ground, it cannot differentiate itself. It can only go over and over the grounds for failure that are built into the game of the finite versus the infinite—its own compliant structure.

From Picasso's standpoint his ambition for an anonymous collective in which it made no difference whose hand was involved may have been a failure (one must note in this context that Picasso's little touches in these paintings are among them the most beautiful brushstrokes in modern painting) but, on the other hand, his freely circulating signs for reality recorded a freedom never before achieved in painting. Anonymous at its heart, the new system was a collective of linear placements and generalized geometries that formed an apparatus for individual action capable of crossing all sorts of boundaries, spaces, dimensions, genres, and media, including film. Events transformed into objects, objects into events, disappearing and reappearing in response to the painters' command. What difference what objects, whose commands, who was on top? There was some sort of victory there.

But it did count who was on top—whose hand won. And Picasso had the winning hand. To repeat with Clark,

> What else would you expect: classic Cubism, to repeat, is not a grammar of objects or perceptions: it is a set of painterly procedures, habits, styles, performances, which do not add up to a language-game. These are exactly the circumstances in which there will most likely be one performer who invents the main way of doing things (or sees the point of the other's inventions) while the other just repeats or reproduces them, not very well. Not very well, because at the deepest level these are not ways of doing things that can be learned. They are not thrown up by any particular descriptive task. They do not reach out beyond themselves to a world where facility is no longer the issue, and pure endless inventiveness (the kind Picasso had up to here) is subject to the tests of practice. They are not shareable. Anyone can acquire the habits—the history of twentieth-century painting is largely made up of people acquiring them—nobody will ever discover what the habits are for.[96]

COLLAGE/PAPIER COLLÉ

The Mirror
The story now becomes even more complex, the moves faster, crashing headlong into one another. Classic Cubism may not have produced a new, universal, cooperative, anonymous system, but the idea of some set of procedures that could be implemented in defiance of the usual rules seems to have remained. The two fly-

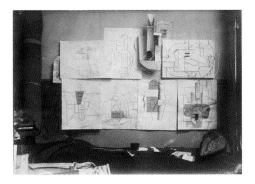

Pablo Picasso,
Papier collé on the
wall of the
Boulevard Raspail
studio, Paris, 1912.
Private Collection.

ers had several more ideas they wanted to try, and regrouped to reexamine some of the same questions in an entirely different way.

At one point during the mad multiplication of illusionist devices, in the spring of 1912, in *Still Life with Chair Caning* Picasso pasted a piece of oilcloth onto an oval canvas, painting a still life over the top half of what appeared to be the tilted-up surface of a table, and framed it with a rope, like some decoration a drunken sailor might find pleasing. Picasso had made the first collage. The oil-cloth bore a fake pattern of chair caning, which Picasso called attention to in the title as though it were real.

This weird jest was presented in the coarsest and most formally disruptive language. Made of despised material and fakery, it intervened in the dissolution of forms into signs only to present another order of the ironies of representation, parodying questions at the center of the issue: how do we know what we see? How do we test the way a picture reaches out to our experience of our own reality? How do we construct that relationship? When is a picture—a mental object—as real as reality, especially if reality is only a fake reality? Sheer fakery entered the equation. If brushstrokes and paint had engendered a crisis in identity, how much stronger would the experience be if one painted with elements snatched from the material world? Paint and painting were pitted squarely against ready-made illusionism and pseudo-sculpture, using materials that had never belonged to art-making. Here it was, high versus low, and presented in the most matter-of-fact way—a slap in the face of artistic propriety. As Picasso knew, in visual art as in poetry "there is no difference between a hoax and a revelation."[97]

Still Life with Chair Caning is a revelation—a revolutionary leap. An advanced version of the conundrums of previous work, it re-presents the figure-ground problem: a tilted-up plane, a shallow space for illusionist devices, opposes the ground as a vertical plane, identical with the surface. The planes that had pressed up to the surface in classic Cubist work have now expelled all of their carefully constructed shadow space—and themselves—so that ground and surface are one. The "space" is now truly mirror space. Any representation in the picture is owed to a reversal; it is truly an illusion, for it comes from outside—nothing is represented in the picture. The picture perpetuates the crisis in looking that originated in Velázquez's *Las Meninas* and was taken up by Manet in *The Bar at the Opéra*.

The "work" of art—its task—is to function as a hall of mirrors. Picasso is a mirror person: he is only able to see himself as reflected through something or someone else. That is why transcription is his greatest ally: he can always make something else his, or disguise himself as something else or someone else, even someone or something many times removed from himself. In *Still Life with Chair Caning* the mirror reading comes to mind only gradually. First we may wonder, is the oval a round table, a *guéridon*—a perspective projection? The opaque cane pattern renders the table as transparent: it is the chair under the table. The glass table top is streaked to suggest it as a reflective surface. Alternately the oval is to be read as a mirror. The still life representation resting or, rather, reflected—perhaps even projected—on its surface is peculiarly cut off at the top. Is this table-top tilted more radically up to the plane so that the representation of the table within the oval seems rounder (i.e., more up-tilted) and therefore alternately flatter and less flat than its support, which hangs flat to the wall? And does the alternation of flat or open versus volumetric depiction of the still-life elements pressed

up to the plane, in the context of what we know to be a flat ground, create the unease that argues for the peculiar unreality of the mirror image?

The physical "reality" of the object is emphasized by the rope that surrounds it and holds it as a physical fact to the horizontal plane, putting still more pressure on the levels of the planes as they press up against the surface. The paradoxical reading rests on pushing the physical limitations of the dialogue between the surface and the format to a newly radical limit. In the midst of a deep engagement with the ironies of perception, Picasso pretends to offer this strange object as a touchstone to ordinary material form. Perhaps he wants to reaffirm that these canvases he and Braque are working on are facts themselves, but that material facts are also the most difficult ground upon which representation must touch to create its illusion. The work of art, as a mental fact, proves itself more powerful than the mirror—or the projector—in offering to the subject the contradictions of experiencing itself as an object in the world. As a result, the ironies of illusionism multiply as fast as the complexities of experience itself. Picasso calls our attention to the play with the letters "*jou*" on the surface: both "play" and a fragment of "*journal.*"

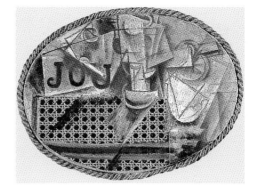

Pablo Picasso, *Still Life with Chair Caning*, Paris, 1912. Musée Picasso, Paris.

This is perhaps the most subtle and difficult of the paradoxical plays between the experiences of surface and depth that Picasso had yet presented. The double formation *mirror/painting* involves, on the one hand, the sense that the forms have an objective existence independent of us—they "appear available for our possession and control."[98] On the other, the illusion of depth suggests that the objects exist as the result of our own seeing.[99] (This is especially true of moving pictures.) The unassailable reality of the rope adds still other paradoxes: it mocks illusion, for it is available to our touch, and it turns the painting into a relief. The conception of the canvas as a form of relief precipitated a new idea of the work of art; the conception and task of the work of art were to change dramatically.

The conception of the canvas as a form of ironic mirror seems to have precipitated yet another new idea of painting, one that would concentrate on the materialization of the paradox. Braque had already commented on this by affixing a painting to the wall with a trompe-l'oeil nail. From 1910 through 1912, he and Picasso concluded an extraordinary and brilliant summation and overturning of the previous five centuries of visual art. They had taken the old anonymous academic system, with all of its pretensions, and turned it on its head, enabling it to manifest multiplicity and uncertainty, even outright ambivalence and contradiction.

Were it not for collage and papier collé, Picasso's and Braque's paintings might have been thought of as simultaneously the grand climax of Western painting and the failure of their dreams to remake art entirely. Instead, an extraordinary and brilliant wrap-up transformed into a brilliant future. In 1912, the introduction of a new set of material operations supported a dazzling leap into a reconceptualization of painting, sculpture, and drawing to combine them all in an entirely new mode, which produced a whole new world of representational strategies. Both inventions had within them the seeds of a future abstraction, on the one hand, and of art through the elevation of pastiche (and kitsch), on the other—although not every option would be exercised by Picasso or Braque, who both continued to resist pure abstraction. So strong was the two artists' sense of embarking in partnership on a wholly new conception of

71

painting that by 1912 Picasso was calling Braque *"mon vieux Wilbourg,"* after one of the Wright brothers.[100]

Still Life with Chair Caning propelled the two adventurers into another ardent search. Now that the representation no longer took place inside even the remnants of the shallowest kind of stage space, the surface was a last resort—even an attractive field for yet another new kind of representation. The worlds of advertising, hucksterism, popular songs, and low poetry had already become a part of the picture in 1911, when hand-painted lettering was introduced into the matrix as a play of brand-name labels and the titles of songs and newspapers. More than any other, this new class of signs borrowed from newspapers and films—and using new materials and techniques coincident with Braque's artisanal background—referred reading to the surface. Rubin has pointed out that,

> Along with Braque's and Picasso's depersonalization of their language went their sense of the studio as a place of "manual labor," where cardboard, sand, sawdust, metal filings, ripolin enamel, paper, wood, sheet metal, stencils, razors, housepainter's combs and other artisanal material and tools were increasingly employed in realizing a "popular" iconography of commonplace objects. Braque, wrote André Salmon, "brilliantly developed his thoughts on how the resources of the housepainter might enrich high art." Indeed, among Braque's many innovations in Cubist practice—such as using stenciled letters, charging pigment with sand and simulating wood and marble—had genuinely artisanal origins, while others, such as papier collé, though primarily formal in nature, displayed a craft character."[101]

Surface reading yielded a new array of strategies, which quickly multiplied to produce new mutations. Many of these depended upon still life; they pointed again to solid objects—to relief; all of them lived on the plane; all of them depended on a radical revolution in the material from which visual art was made and in the levels of illusion on which it operated. Poetry and film should be parts of any list of the newly most important "materials." The discontinuities of form each sired were based in formally disruptive verse and new dimensions of visual space.

The "synthetic" phase of Cubism was beginning. The threatened forms of high Cubism were to be reassembled and rehoused in more secure enclosures, though no less formally disruptive ones.

SYNTHETIC CUBISM

Papier Collé as a Poem of Broken Parts and Broken Bodies

Vowels

A black, E white, I red, U green, O blue—vowels,
One day I will recount your latent births:
A—furry black corset of spectacular flies
That thrum around the savage smells;

Gulfs of shade. E—whitenesses of steam and tents,
Proud glaciers' lances, white kings, quivering umbels.
I—purples, expectorated blood, the laugh of lovely lips
In anger or in the ecstasies of penitence.

U—eons, divine vibrations of viridian seas,
The peace of animal-strewn pastures and of furrows,
That alchemy imprints on broad studious brows.

O—the final trump of strange and strident sounds,
Silences traversed by Worlds and Angels:
O—Omega, the violet ray of His Eyes!

Arthur Rimbaud, 1873

According to Rimbaud's biographer Graham Robb, this poem, although unfinished and unpublished for years, immediately "spread through the Latin Quarter and caused a kind of intellectual gold rush." In these "early days of science envy . . . Rimbaud's beautiful sonnet appeared to offer up the simple secret of its creation and still had the power to create a hankering after unattainable precision . . . This is the ambiguity that lies at the heart of Rimbaud's work: the ardent search for powerful systems of thought that could be used like magic spells, conducted by an acutely ironic intelligence."[102] Very much the same thing happened to Braque and Picasso between 1910 and 1914 as Cubism caused a pictorial gold rush in the circles of poetry and advanced visual art.

As we have seen, the guitar (and its other, the violin) signifies the loved one—a play upon the figure. In papier collé the guitar is always the sign for the figure. Wherever there is an instrument the figure is always present. Sometimes it is female, sometimes it is male; sometimes we see its "other," a figure playing it; they engage in an exchange of forms, for they usually have a strong likeness to one another, inscribed by the prankishly obvious likening of contours. Events transform into objects, disappearing and reappearing in response to the painters' command. The subject changes form at will. One day a woman, one day a man, a still life, a violin, a guitar, all at the same time. Another sense of play comes into "relief": the guitar as a form of three-dimensional poetry.

Braque has been credited with clearing the ground: in the summer of 1912, in response to Picasso's pasting of oilcloth onto canvas, he is said to have made the first papiers collés, pasting false-wood-grained wallpaper onto another sheet of paper.[103] He then drew charcoal outlines around his pasted papers, imitating Picasso's outline drawing in order to incorporate the discrete pieces to the composition.[104]

The question of who did what first has nevertheless been a vexed one and there is very little information. We can be sure that Picasso was making paper constructions in 1912. At this point it is still frustrating to try to follow the discussions about precedence, but some scholars suggest that Braque had been making cardboard constructions as early as 1911, although none of them survive. In any case, the figural elements of the vocabulary had been established; indeed so had the whole conceit. What is impossible to distinguish in this daily dialogue is not so much each artist's hand as any way of sorting out whose idea came first:

73

the ideas existed as a pool, a unity from which either man could grab an inspiration, say "what if," and make an example for the other, so that both could then run with it. The partnership was a little like a tap dance for two in which one partner improvises a step, the other elaborates, and the first takes it farther still. If Picasso was the partner who made drawings for the constructions, it seems possible he made them because he was the draftsman, and he and Braque were again discussing the "interests" of the figure in the long dialogue between two and three dimensions. But they could equally have been discussing Braque's constructions of 1911.

The connection here between high Cubist painting, construction and papier collé can be seen more clearly by examining *Man with Guitar* (Autumn 1911–Spring 1912; Musée Picasso, cat. 27). The painting belongs to the same suite of decors (the suite not finished) as *Man with Mandolin*. It assembles the broken congested forms we saw in *Man with Mandolin* into more coherent frames; to literally rebuild representation and reestablish its priority in Cubism. It is not difficult to see that the representation is of a mustached man playing a guitar. He is, as in the drawings of 1914, a mask for Picasso as Manet, and at the same time a street tough, perhaps an *Apache* (those tough French dancers we see in films, throwing women around in cafés and knifing rivals). Another way of describing this painting is to remark that, in *Man with Guitar*, the machine for reproduction attached to the cycling of film frames once again slows down, the enclosure structure reasserts itself and the congested pileup of multiple forms is clarified and brought to order to produce—in some passages at least—a more readable if exceedingly strange representation.

The drawing system as regulator—or more accurately as the engine of transcription—integrates film's various devices to Picasso's obsession with painting-cum-sculpture and links that, too, to papier collé. In the paintings the subject is painting's power to construct illusions: there is no reality, there is only the construction and reconstruction of illusion; no identity is fixed. The drawing enclosures serve as the support in which body parts are abstracted—in the sense that they are reduced to schematic enclosures—so as to foster insecurity. In *Man with Mandolin*, as in the paintings examined earlier, these basic formal units facilitate the interchange of identities. The transition from dark at the top to pale, from detail to broad forms and from heavy to lighter paint surface as the image descends to the lower part of the painting, deliberately creates the illusion that the figure is carved from marble. The top, in its densely overpainted combination of monochromatic gray-scale and earth/ground tones, comes to "life" as a filmic representation painted over the statue. As the representation spills down from the top becoming less congested, slowing down and lighting up, the forms also become increasingly schematic until, at the bottom third, the composition is made up primarily of block-like enclosures, almost as though the figure were hewn from marble blocks—and these blocks resist particular identities. The painting seems to ask us to read it in two directions, one as a painting, the other as a sculpture. As we work upward (away from sculpture) drawing—and color— gradually differentiates the blocks into particular forms. At the top—the head— there is again a very detailed pileup of forms. All of this, of course, is the most skillful manipulation of painterly illusion, and we realize that we are again involved with the metaphysics of the classical figure.

All through the late spring and summer of 1912, Picasso had been drawing small outline studies, reasserting the line that, in 1911, had threatened to break down completely into a system of signs. Many of these drawings were studies for figures as planar part-to-part constructions; Picasso was taking the planar elements of the mother-and-child drawing *Standing Woman* from the summer of 1912, and turning them to fit into one another so that they could stand as figures, a bit like making a chair or table. *Standing Woman*, with its shadows, forms one of the links between the "cutting and pasting" of film strips in such paintings as *Landscape, Céret* and papier collé as such. This drawing—which conceives of the figure as a form of relief sculpture—and others like it in pure line drawing, were transcribed as reliefs in three dimensions and then into the most tenuous but literal idea of relief: drastically flat planes made out of cutout paper forms pasted onto the surface. Papier collé materializes illusion. Cutting secures the forms in the enclosures; it requires that they accept more stable sign-like identities. For instance, we may still read the curves of a violin or guitar as female—or indeed a curved cut as a sign for woman—or the reverse, although there may be no ambiguity about the object identification.

In the autumn of 1912, Picasso constructed a guitar in cardboard. He was also making drawings of guitars as open and closed planar forms and immediately saw a connection between this linear armature and, not only the drawings of constructions, but Braque's papier collé. The connection between the three-dimensional and the two-dimensional was a function of construction rather than simply of notation. By concentrating on the linear structure and dropping for the moment the shadow system, it became possible to get rid of the space of illusionism. In ensuing drawings, the guitar-cum-body is dissected and laid out against the surface as if it were a pattern to be traced. Each contour of the charcoal *Guitar* (1912) is capable of being developed as a distinct and complete pictorial element. These enclosures were the basic units of Cubism—and held Picasso's future: they became the basis of a new aesthetic. The three-dimensional guitar itself was the foundation for a whole new conception and technique of sculpture; like the mechanical figures in Analytic Cubism, sculpture was now to be constructed as the guitar had been deconstructed. (Picasso continued to construct guitars from a variety of materials through the next several years, sometimes using them as parts of larger ensembles, which have since been broken apart.)

The insertion of pieces of "reality" into the Cubist scaffolding changed the basis of pictorial illusionism. The pictorial view had not been intact for some time but, at this point in the paintings, the multiple viewpoints became more selective, and planar disjunction became a new structural means in which disjunctive elements of representation (like the cigarette in the mouth of the *Man with Guitar*) reinserted to the grid played themselves off against the illusion of a seamless wholethe shifting surface, providing sudden stops in what had seemed that perceptually consistent fabric of marks in the papiers collés as the cut and pasted elements slid under and over one another, they were connected to the surface of the picture and emplaced by line drawings. Elements of representation were made to coexist with constructed elements. The detailed deconstruction of objects gave way to planar representations of broad sections of forms. No longer a function of notional reality, scale was now a function of the construction itself; it was part-to-part scale, each part referring to another in an overall nonhierar-

chical arrangement. All sorts of nonart materials could now be introduced, incorporating colors and textures—from wallpapers, from newspapers—that served as a new, mechanical shadow system.

It is time to mention allegory. It is the double—the opposite of analogy—and it enters the picture with film. Allegory "is a figurative mode which relates through difference, preserving the relative autonomy of a set of signifying units while suggesting an affinity with some other range of signifiers."[105] Ranges of signifiers have been in active use for some time and will proliferate in ever new guises from this point on.

Film was mimetic, striving for the illusion of reality. Art, on the other hand, though mimetic, strove for iconic essence. How did one translate into the other? What was the overlap? Part of the answer lay in the body and part in the trickery of filmmakers such as Méliès. At this point the comic fragmentation and reassembly of body parts took on new significance. The multiple conflicting perspectives in the work developed not just from sight but from different modes of artistic discipline. The synesthesia involved the whole body of the arts. The cut-and-paste of papier collé is a direct theft from the cutting and splicing of film editing—especially that of Méliès and other creators of the "Cinema of Attractions" and its comic films—and from the cut-and-paste techniques of commercial advertising.

But film did not wholly displace poetry as the first among equals in this coalition of different media. Ardengo Soffici, founding coeditor of the Futurist journal *Lacerba*, as well as a painter and critic, worked in Paris for extended periods from 1903 to 1907 and again in 1910–12 and 1914; he had access to the studios of both Picasso and Braque. Rubin tells us he was "alone among Picasso's painter friends" in admiring *Les Demoiselles*. It was Soffici, Rubin writes, who linked Picasso to Mallarmé in an article in *La Voce* in 1911: "As Cubism evolves, Picasso presses his analysis beyond the study of volumes to the point at which it becomes 'a melodious fabric of lines and tints, a music of delicate tones—lighter or darker, warmer or cooler—whose mystery increases the pleasure of the viewer.' Here drawing becomes a 'ductile instrument, capable of a thousand shadings of the most subtle and fugitive implication' while taking on the value of a 'hieroglyph' with which Picasso 'inscribes a lyrically intuited truth' in a manner that recalls 'the elliptical syntax and grammatical transpositions of Stéphane Mallarmé.'"[106]

Mallarmé had been a great champion of Manet. Did Picasso now designate the poet as an absentee co-collaborator in connection to his own roots in that artist's work? Mallarmé, a seminal figure, is a logical link to Baudelaire, who is accordingly reinforced as a source for the constant variation in unity already built into Picasso's art. Mallarmé's aim was not only to disrupt poetic form, and thus its reading, but to incorporate time and space into it as well. The internal evidence for Picasso's ambition to emulate Mallarmé is very strong. Hans Rudolf Zeller writes of what has come to be called Mallarmé's dictum,

> Poems are made not out of ideas but of words . . . What happens to these words, which are "the same words the ordinary man reads every morning in the newspaper, but which he no longer understands," if he comes across them in a poem by Mallarmé? They are "transcribed by a poet." That is, their everyday function,

which is to describe something, communicate something, is systematically nullified, and Mallarmé calls this process of changing the everyday function of words "transposition." The fact that it is achieved is not a result of the words themselves but the position assigned to them in a selected system of arrangement.[107]

But transposition needed a structure, it did not work on a theoretical level. In order for words to change their function they had to be given a position in a design. Once placed, the word acquired not just one new meaning but "a whole new meaning boundary, according to how many dimensions of poetic space it could occupy. As something that is (for the moment) static, it is a 'structure' (which the reader will have to 'continue')." In poetry the rules of design are of course the rules of the line or sentence. In visual art they are the relationships negotiated by shapes. In Cubist papier collé the design was one in which high danced with low. Picasso may or may not have been not a great reader himself, but he was close to Apollinaire, who was well aware of Mallarmé. The earlier poet's work *Un Coup de dés jamais n'abolira le hasard* (A throw of the dice will never abolish chance) was first published in 1897, in the review *Cosmopolis*. It was not widely known at the time, but it was republished in 1914—the same year in which Apollinaire published his own collection of shaped poems, *Calligrammes*. In order for Apollinaire to have written *Calligrammes* he had to have had access to *Un Coup de dés*. It seems probable, then, that Picasso saw the poem too. At the very least, he would have known that Apollinaire and the poets in the artist's milieu were discussing Mallarmé's ideas intently, along with those of Rimbaud. [108]

The most important of these ideas was the break with tradition—the breaking of the boundaries of the old order, by whatever means. A parody of poetic transcription (run through film) could have been inspirational for Picasso. "Through the line"—in Mallarmé's case the alexandrine, in Picasso's the contour—each artist built his own "syntactical system" and at the same time made a positive break with tradition.[109] Picasso's ideas of Mallarmé—assuming that indeed they are part of the equation here, if only as interpreted by his fellow poets—were "surface," superficial impressions that connected to other ideas to spark a concept. Cutting and pasting inspired by film images provided a material base for the poetic life lived both on the plane and in several dimensions. In these Picasso's first generation of papiers collés, mirroring and newsprint were transcribed into a poetics of form in homage to the formally disruptive poetry of the generation of revolutionary poets who had first broached the idea of "newness."

These first papiers collés were relief constructions, in colored paper, of the guitar with sheets of music. In fact papiers collés were paper reliefs, simultaneously drawing, painting, and sculpture. Cutting into patterned or colored papers withdrew line so that contour was plastically coextensive with color. The figure was "liberated" from one ground only to attach to a new one, in an extraordinary interpretation of negative/positive re-marking. In this direct "carving out" of form, all the power of contour drawing accrued to the cut edge (as in woodcut), and attention was transferred to shape relationships. The guitar was a perfect subject for re-marking: unlike the figure for which it stood, it was a perfectly self-symmetrical mirror image of itself and could be constructed and deconstructed at will.

In the papiers collés made of newspaper, this new construction, along with the clustering of small marks formerly associated with shadow within the forms, created a new kind of optical disjunction in the plane, giving additional power to the edge. The cut created a new spatial freedom: ground and figures could engage in purely physical on-site spatial relocations. Constructing reliefs by cutting into paper and pasting was the most extreme parody of the idea of child's play yet. Building with blocks had been fruitful; now cutting and pasting added to the stream of complex paradoxical relations between forms and space.

These now virtually abstract still life forms cut from the newspaper are signs for figures. Picasso's cutouts perform on a stage of white; their positions are marked and re-marked by outline drawing. Each re-marking constitutes a different reading. But this shadow system was no longer aimed at producing an illusionist space: its little points of type, printed on the surface and confined by the cut edge of the "figure," were totally coincident with the extremely flat planes of the newspaper forms. They were on top and within.

Mallarmé had advanced the theory that reading was performative. The text of *Un Coup de dés* was printed in several sizes, some parts darker, some lighter. The page layout was a pattern of disjointed paragraphs and words, an arrangement that destroyed normal syntactical order and led the eye in leaps around and over the surface from block to block. (Mallarmé even called his poems "*dessins*"—drawings.) *Un Coup de dés* is usually regarded as the only achieved part of Mallarmé's greater endeavor, *Le Livre*, which was conceived as a three-dimensional structure in several parts. The idea was that different readers would read the text aloud, each reader "performing" it differently. Reading would consist of following each micro- or macro-structure for the duration of its performance time. Just as Mallarmé's various type sizes were meant to be read as dimensional shifts in space, the re-marking of the pasted pieces in papier collé is a structural metaphor for moving words or forms into new positions throughout the radically flat three-dimensional relief structure without reference to perspective. Mallarmé's *coup*, too, as in the French "*couper*," is both "throw" and "cut," and as such anticipates papier collé, and echoes the cut-up and puppetlike body parts in Méliès's films. Nor would Mallarmé, whose knowledge of English informed his linguistic devices, have been unaware of the meaning of "coup" in English: a brilliant stroke or strategy, a clever device.

Cutting inserts the aspect of performance written into both film and Mallarmé's poetry (and subtley into high Cubism); performance is now superimposed on the behavior of the forms in papier collé, dramatically exploding the forms into a variety of spaces. Performance also extended to the idea of the similarities between musical and poetic form, especially that between Impressionist music and Symbolist poetry. Debussy's *Afternoon of a Faun* is one of a number of musical compositions inspired by Mallarmé's poetry. Mallarmé himself, in one of his "first critical essays, 'Hérésies artistiques: L'art pour tous,' . . . suggests that the poetic text, in order to preserve its own sanctity, should follow music's example by enveloping itself in mystery and becoming impenetrable to the uninitiated." He also "compares the Symbolist's break with the alexandrine to modern music's deviations from classically structured melodies and rhythms."[110] In fact *Un Coup de dés* has often been interpreted as a musical score. Picasso's response to this current, as we see in *Violin and Sheet of Music* (Autumn 1912, cat. 34), and *Guitar* (Autumn

1912, cat. 35), was to incorporate into his first generation of papiers collés popular songs of the sort that might well be sung in music halls or played to accompany films.

Writing on the connection between Picasso and Mallarmé, Rosalind Krauss takes the phrase *"un coup de thé"*—a truncation of *"un coup de théâtre"*—in one of the papiers collés as a phonetic pun on *Un Coup de dés*, and, accordingly, not only as evidence of Picasso's awareness of Mallarmé but as a signal of that awareness to his inner circle.[111] For Krauss the cut elements in Picasso's papiers collés mirror one another in the same way that Mallarmé puns with words: *cigne* or *signe, naître* or *n'être, verre* or *vers, blanc* (white) or *blanc* (blank).[112] But they owe even more—or just as much—to Méliès's cinematic *trucs*.

According to Staller, Méliès's images depended upon "the extensive manipulation of celluloid after it had been exposed. Among his most daring was 'stop-action,' where he cut and spliced different frames of film together, and could thus magically appear to elide time or effect sudden metamorphoses."[113] We have seen in our discussion of Analytic Cubism that Picasso probably knew the technique. At this point the cinema's disruption of the formal order of the body became a parallel to the linguistic disruption registered by the poets: "Among Méliès's favorite effects," Staller writes, "was the fragmentation and reassembling of human bodies."[114] A favorite trick was to cut off parts of the body and send them floating off into space, only to reassemble them as needed and then let them float away again. Picasso, of course, has his own versions of the disassembly of the body, arising out of his sense of mirror form and reflected in the dissemination of like pairs of papiers collés cut from one matrix. Such forms have identical negative and positive contours—they live as if in a fold in space, the result of "the sacred cleft of the book's binding, where one page closes over the other in sensuous duplicity."[115] As Krauss explains, they are a variant of mirroring in which "no reality outside it is reflected . . . mimicry which mimes nothing being what Mallarmé calls 'a perpetual illusion without breaking the mirror.'"[116] Turned in space while still maintaining a precise likeness to one another, they have become an oppositional pair, both visually and verbally. Their visual similarities and dissimilarities open a conversation about form, disseminating new variations in new dimensions of space. Following in the tradition of the Cubist forms whose disparate views were turned to the plane, these papiers collés have become so radically flat that they have only two dimensions to show us. And so they have reassembled themselves to resemble what they presumably represent, turning front to back, upside down and sideways, shyly giving us one view at a time out of a series of possible views. And in fact the silhouettes engage in self-similar and mirror relationships: the reason the mirror doesn't break is that the whole operation is manual and takes place on the surface as a magician's illusion. Picasso flops one cut form over and moves it, "re-marking" it like Degas or like Méliès, but now in still other dimensions.

Krauss sees Picasso's visual punning as a variation on the poetic device of Mallarmé's in which *"verre"* and *"vers,"* "glass" and "toward," are both optically and orally self-similar, and *"signe"*—"sign" or "lettering"—is both the black newsprint of the newspaper cutouts and *"cygne,"* "swan." The swan of course is white, like the paper support of the papier collé.[117] And what of this white, which literally "supports" these moves? The *blanc*/blank ground would seem to have no

memory. Does it know whether it is space or surface? Happily it is both, for it is so white, such an "empty" body, that the limits of the edge only serve as a pressure that evinces it as a limitless volume, an emptying of memory into an eloquent silence—yet a silence that erupts with sound. The figure takes on a new relationship with its ground, forms slipping sideways over the surface of the picture, interchanging with one another, open and closed, closed, open. Just as the flat figure seems to come to rest on the surface of the sheet, in accord with the gesture that placed it, its own surface—the newsprint—raises a voice that works in opposition to its own flatness, its own calm. Suddenly it becomes active, engaging in conversations with itself, with other cut elements in the same relief, and with the outline drawings of other figures, its oppositional others. The reading of the pictorial surface becomes coincident with the dancing of cut body parts and with low prose poetry—"written" by Picasso.

Their type and newsprint imprinted with memories of Cubist tans, grays, and blacks, the pasted paper elements announce a new idea by their use of ready-made color and tone: truth to material. Yet many critics now believe that Picasso and Braque chose cuttings not only for their formal qualities but for their content, their texts. Like the forms in which they live, the pasted newspaper stories are radically fragmented. In Picasso's first-generation papiers collés, they and the fragments of ads and product names inserted into the compositions operate as poetry—the formal poetics of an alienated "reality" of the everyday. Was that poetics removed from reality or reaching out to it? A pure arrangement does not have an answer, it is "thought" and handed on.

Krauss describes the reading of these works: "Each newsprint fragment forms the sign for visual meaning; then as it butts against another, the sign reforms and meaning shifts . . . but then from the very site of these signs comes the sound of voices. . . . from the Balkans war comes the dispatch: 'Before long I saw the first corpse still grimacing with suffering; its face was nearly black.'" Quoting Félix Fénéon, Krauss compares these fragments to anecdotes from the nineteenth-century *faits-divers* section of *Le Journal*, or the "news in three lines. Thus: Love. In Mirecourt, a weaver, Colas, planted a bullet in the head of Mlle Fleckenger, then treated himself with equal severity.'"[118] (In fact the *faits-divers* formula had been incorporated into early French one-reel movies as disjointed episodic chase scenes.) This sort of shorthand story, Krauss notes, was later characterized as a fake narrative. She points to a papier collé in which one might focus on the phrase "*d'or*" as a reference to the circulation of money, as though a socioeconomic critique were fixed in these images—money offering a false standard for art, a fakery. (The false "coin" of Picasso's later work, she charges, is his making of a pastiche of his own inventions.)

Each papier collé also engages in conversations with others. Many more of the figures tell stories about the war then being fought in the Balkans, especially the armistice negotiations. Were newsreels of the war shown in Paris? Some newspaper fragments were published on the same day, others on consecutive days, giving blow-by-blow accounts of, say, the assassination of Najim Pasha, the chief negotiator for the Turks.[119] They seem to reach toward an ambition prompted by Mallarmé: like Mallarmé's *livre*, they seem meant to be read as three-dimensional structures in time and space. Cutting, "folding," and re-marking not only within each sheet but from sheet to sheet arranges a disarrangement of metaphoric

space to reach out into new dimensions of space. The unity of action and effect is similar to what Derrida called Mallarmé's "dissemination,"[120] yet another instance of appropriation on Picasso's part—and perhaps of science envy as well. The polyphonic voice, the redoubling and the mirroring, can be traced within a larger structure too: the charcoal-and-newspaper papiers collés as a group, a series within the greater body of work.

In Krauss's terms now (rather than Baudelaire's), "The opening up of an oppositional pair on the site of every unity" inserts the doubt in performance that we have seen at every stage of the Cubist endeavor.[121] These oppositional pairs are not just pairs, they are an unfolding of the whole, and they double and redouble on every level to fill their own hunger—their ambition to re-create existence. As Jean-Paul Sartre wrote of Mallarmé,

> The original relation to the world cannot simply be *given* nor can it exist as *potentiality*. It must be experienced and thereby *brought into existence*. This means that every human reality must re-create itself and continually re-create itself in its unique relation to the Whole. Being-in-the-world is the overcoming of pure contingency striving toward a synthetic unity of all random occurrences; it is the project of grasping every particular experience against the background of the entire universe and as a *particular and concrete limitation of the Whole*.[122]

The answer to the question of what level of illusion we are dealing with is, as always, several. The disarrangements in the new arrangement are arrived at structurally, by cuts into the systems of both literary narrative and visual form. Both spheres see an attempt to make form and content indistinguishable. One more remark about cutting: the voices from the cut papers are anonymous, the scissor cuts subtracting detail from the contour. But despite the increased "impersonality" of direct cutting, and of treating the form as a positive area rather than a negative one, cutting still synthesizes additional power on the edge. The author—the poet—and his coauthor have had another chance at "anonymity." Or have they? Are they just testing us with a "fraud" based in abstraction and non-sense? The date of the cutting from *Le Journal* in *Bottle, Glass, Newspaper* is December 14, 1912. The first article is about monetary negotiations in London. The second article is "Une dra[me] Parisien," a sensational story: "M. Walter de Mumm, described as a well-known sportsman, tall and elegant, has been shot at twice by his lover, an American woman, Mme de Barnes, 'tall and blond, of a remarkable beauty.' . . . The headlines actually were printed in the newspaper side by side."[123]

In 1913 these fractured poetic constructions became the elements of "backdrops"—stage or more likely film sets for the life of the artist as poet. Picasso called these decors his most important collages. Photographs of his studio from that year show papiers collés mounted on the wall, in a group portrait. The constructed paper guitar is part of this temporary ensemble, which is arranged to show the development of the idea: the guitar, as the originator, surmounts the grouping; the extraordinary outline drawing of the violin in the exhibition is pinned on the right; on the left are two more outline drawings. The lower row is composed of four newspaper papiers collés.

Photographic images also record the construction of another "decor" composed of a large canvas backdrop with a life-sized line drawing (with touch-

es of watercolor) of a Cubist figure. The reaching hands are made of newspaper. The scale is what is called "touch scale": one-to-one with the artist, measured by the artist's own reach. A real violin hangs from the upper left corner. A studio table—a *guéridon*—has been pulled up in front to the left. On the table is a newspaper, which leans against the canvas; the table also supports a bottle and a cup. Other studio elements are in view to the left—canvases, posters on the wall, and a small Cubist work with an advertisement for the Bon Marché department store as its primary focus. The environment no longer exists (except for the violin), but Picasso photographed it, then played with the photograph, masking parts out with blank areas. In one version he shifted the left side all the way to the right to re-create the image as if it were on a canvas with a blank ground on the left. Other photographs record other ephemeral constructions. In collage and especially in these "stage-sets" we can see that Picasso and Braque had given reality a structural function in the creation of illusion.

Papier collé also became the means for reintroducing color, which, as color—that is to say as pure local hue—had had no place in the shadow system of early Cubism. It had a structural function in papier collé, however, in that it was physically coextensive with the patch of paper. Contour delineation was withdrawn to the cut edge, making drawing a function of color construction as well as of line. Color—the final element of realism in the academic system—therefore became a function of collage's and papier collé's assertion of physical reality. The pieces of paper now existed as real in themselves, independent of the illusion into which they were incorporated; modified by drawing, shading, and the other means of illusion, they could move both toward and away from reality. Contour was plastically coextensive with color, but was liberated from the enveloping ground. The unexpected visual element in the structure was real: "The difference between collage materials [and the surface] creates the same discontinuity as that which exists between the different planes in real space."[124] The dislocation of ordinary vision had become a function of construction.

Collage and papier collé were Picasso's and Braque's legacy to twentieth-century art. With the two techniques, reality was dismantled and reconstructed at will; the variable viewpoint allowed a kind of selective roving around the picture, as if inviting the use of the picture plane as the airstrip for the world of things as found. The means became the motif, and the motif and the means projected their linear scaffold as the structure of twentieth-century art. The only intact viewpoint was that of the picture itself as an object. Although light from within had been a hallmark of Cubism from the start, once the shadow system was replaced by color patches of collage or papier collé the Cubist picture/object no longer depended upon any sort of illusionist rendering of light. What started as a continuity would complicate itself into a rupture.

Papier collé was an inspired reinterpretation of the conventional drawing system, which had been an aesthetic system in itself. Each visual element— color, contour, shading, texture—could operate as an independent agent while simultaneously functioning with and mirroring the others as a part of an autonomous system. Thus isolated, line could move toward analyzing the armature and breaking it apart, or it could be used synthetically to find figures in conjunction with the basic planar structure it had engendered in the first place, or it could be asserted as abstraction, in conjunction with the planes. Alternatively

the basic structure could accept representational elements while also opening to metaphoric allusion and symbolic reference. Line could also find abstract organic forms and accommodate impersonal handling as the most expressive gesture. The color plane could be left to stand alone. The result has been a continuous discourse in twentieth-century art among abstract and representational, organic and geometric forms, and between two- and three-dimensional modes. As Apollinaire wrote at the time, "You can paint with whatever you like, with pipes, stamps, postcards or playing cards, candlesticks, waxed cloth, collars, painted paper, newspapers."[125]

A system in which a detail could become the whole world allowed no hierarchies, whether of composition, medium, structure, or finish. If Cubism had broken down the hierarchies between genres by its analogic system, collage finally broke down the rest. Violating established boundaries, it destroyed the hierarchies of modes as well. A hybrid mediating between painting and drawing, it was both, but neither; as a child of construction, a connection between the flat and the constructed, it became the conceptual and actual link between painting, drawing, and sculpture. Lastly, it broke down the boundary between different levels of illusion: between the world conceived as an artifact and the new model the artists were constructing from its fragments. The revolutionary structural organization of collage had finally composed a new world view.

WORLD WAR I

In August 1914, war suddenly erupted after another assassination in the Balkans. Archduke Ferdinand of Austria, heir to the throne of the Austro-Hungarian Empire, was killed by a Serbian revolutionary. Nations rushed to take sides: France and England and their allies, Italy among them, versus Germany and the Austro-Hungarian Empire. All of the participants expected the struggle to end very quickly; it did not end until November 1918—four long years later.

War now overtook art. The summer of 1914 was the last moment of the grand adventure—and suddenly Braque, Picasso's intimate collaborator, and many other friends of his were gone, mobilized and sent to the front. Severely wounded with a head injury, Braque returned to Paris in 1916, much changed. In fact Picasso is said to have remarked that he never returned at all. Picasso did not go to visit his friend in the hospital—nor did Braque seem to want him to. They saw very little of one another subsequently; although Picasso wanted to resume their collaboration, Braque did not. Apollinaire too was wounded in the head, and finally died in the great influenza epidemic of 1918. Blaise Cendrars, another poet friend, lost an arm. Spain was a neutral nation and Picasso, as a Spanish citizen, was not required to fight. He did not experience the war directly. While his friends risked death, the horror of the trenches remained beyond his experience.

In examining his life and work during these years, we may at first think he was immune to that horror, but a new conservatism in his work—a withdrawal from invention into pastiche (however inspired)—may incorporate an unease, even a terror, of dislocation that was manifested as a return to the safety of old supports. In 1914, left behind in Paris and, as a young man not in uniform,

regarded with suspicion, Picasso continued to work in a mixed idiom that increasingly propelled him backward into classicism. As Cubism continued, his art became increasingly autonomous, especially with the invention of collage. We now see him delve into the past at will, working simultaneously in different styles—often in the same work—and exploring seemingly antithetical modes: painterly and linear, flat and sculptural or plastic, romantic and classical, Western and non-Western, combining observation and memory with formal construction. One line runs through these variations, however: analogy, the roots of which are ultimately in drawing. Through analogy, and for Picasso, these stylistic variations were not antithetical but rather reflections upon and fuel for one another in the investigation of what an open-ended and polyphonic system could engender.

In playing upon his variations, Picasso tended to work in series; he regarded his own previous images and styles, as well of those of others, as a private reservoir on which he could repeatedly draw. Left alone in Paris, he began to reintegrate his historical doubles Ingres, Manet, and Cézanne, while waiting for a new encounter—for a new, living collaborator. Just as each of his changes of lovers involves an encounter that one can track in his painting, each change of collaborators involves an encounter with an artistic other with whom he can work out a new aesthetic—usually through a combination of a new medium and a return to a basic historical model, the classical figure (and the changes he can wreak on it). That model acts as his anchor, reattaching him to the most important collaborator of all: the whole artistic context, and its source, the metaphysical idea that originates in the mind of God.

But we are no longer in the Garden of Eden, and Picasso is an outcast— a trickster, in the primitive sense, and a serious mischief-maker. Several figure drawings from 1913–15 allow us to follow his alternation and reincorporation of styles as a reconsideration of the kind of information the picture may contain, and how much self-resemblance its motifs can bear, while still resembling itself as a Cubist picture. In *Guitar Man* (1912–13, cat. 31), the face is a geometrized mask with a little mustache. The dome of the head (cut off at the top) and the features resemble a guitar, while the ears are the f-shaped sound hole cut into the guitar's body. We see a detail of Cézannian contour drawing in the strangely knotty upper arm, with its repeated contours. The schematic lower arm supports a hand with a silly pipe poised in it. These representations depend on the principle of collage: the insertion of observed pieces of reality—as opposed to signs for it, as in earlier work—now conforms to the new aesthetic. The details begin to assert the identity of an "individual." This is the beginning of a series of drawings of a mustached man whom Picasso initially observed in a café; he may have used a photograph of a Middle Eastern peasant for a reference.[126] The man appears with and without a dog (Picasso's), at a table, with and without a hat, etc. The hat is called variously a melon hat—by Braque, who sent several to Picasso—and a bowler. The figure was meant as a homage to Cézanne but also became one to Charlot—Charles Chaplin. Picasso described himself putting on a false mustache and trying the hats on.

The face—although drawn from memory, and factual in its details and arrangement—is presented as a mask, as though observed reality were a mere cover for resemblance and resemblance were a function of memory. The man always wears the same mask, but the very sameness of the mask is a red herring

in what turns into a detective film. The representations of this figure are stylized on several levels—as observed, as constructed, as remembered, and as a sly joke in which the representation is most probably of Picasso as the film villain Fantômas. This character first appeared in novels that began publication in 1911; five films were produced in 1913–14.[127] Fantômas is a masked thief, a serial murderer, an all-around old-fashioned mustachioed film villain who changes identity by means of masks. Despite—or because of—his criminality he is dangerously compelling. As the films continue, he acquires more and more identities, until no one knows who he truly is. Picasso was certainly aware of this nefarious character; in 1912 he and his cronies Apollinaire and Jacob had founded a Fantômas society, and they described the films as works of genius.

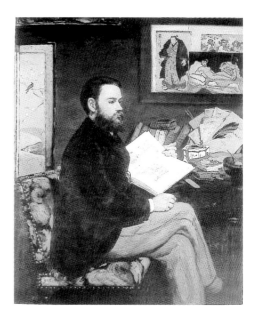

Édouard Manet, *Portrait of Emile Zola*, 1868. Musée d'Orsay, Paris.

Picasso *is* Fantômas. He was evidently proud of being an art thief: in one of those truisms that circulate, he is reputed to have said, "Talent copies but genius steals." It is not that Picasso's figures look like the Fantômas of the films, it is rather that they share ideas of masking and disguise, and of bringing to life a variety of nefarious characters. As Fantômas, Picasso disguises himself as a masked figure, "concealing" memories of earlier artists. The unidentified man in the café became a way to begin the transcription of these artists into the work. First among them was Manet, for the particular model to which the man attaches is Manet's *Portrait of Emile Zola*.[128] The attachment is also to Manet himself. The mask allows Picasso to fit Manet's Zola onto the figure stylized by Cézanne. The figure sits at a table with a glass, strumming a guitar—an object we know to read as "art." An observed hand is inserted into the constructed Cubist framework; this hand is emblematic of Manet, whose "hand" was taken—by Zola, among others—as expressive of the nature of his eye. Both men were initially considered members of the Realist movement. Both were considered profoundly original "yet unmannered," and Manet was considered objective in the way that nature is objective.[129] Picasso is signaling in this image that his objectivity is natural—that he is a realist in the same sense. And yet, at the same time, he is not: he is a fantast of the first order, antibourgeois and antisocial in his furtive theft of other's artistic identities.

As we watch Picasso synthesizing this string of identities as emblematic details of the ur-figure, we become aware of a new Cubist stylization, in drawing and in painting as well. This is Cubism from the outside—a Cubism based on "pasting" generalized planes, transcribing and layering them back and forth. In drawing, these depend on transcribing the cut edges of collage into contour drawing that takes over the outlines of larger forms and provides a scaffold of enclosures for the more representational observed details. Only then are the forms subjected to an exterior geometricization of specific parts, laid on from the top rather than building up from the ground. In other words, the forms are conceived as pasted onto reality: they are surface representations, masks for the artist—or perhaps for art.

Guitarist (1916)

The aim of Cubism from 1909 on had been a new form of painting. As early as 1913, Picasso had begun to code high Cubist painting into the new structure of collage; the guitarist now performs as the locus for the transcription of these ideas back into painting. The figure in *Guitarist*, presented as basic three-quarter

length, is a classic Cubist figure, but every part of his body is conceived as a cut and pasted element in which local color conforms to the cut shape. This has come to be known as the collage principle. The head and neck of the figure are conceived as the elongated neck and top scroll of a violin; his eye is a dot, the center of the scroll. The figure—the artist/lover playing the loved one/art—appears on an umber ground, signaling the atelier.

The violin man is created as a subtly modulated arrangement of stacked planes in which the color relationships work in two directions, depending on contrasts of light and dark and modulations of tone up toward the light and down into darkness, as in high Cubism. The figure is primarily tonal, but the head is contrasted against a white planar form, calling on memory to identify it as a classical head. The violin plays a guitar, his white hand looking as if it were pasted on. This hand is conceived in an entirely different mode from the rest of the picture, and is the brightest spot in it. Like the baby in the 1912 drawing *Study of a Figure*, the hand and the fingerboard on which it rests are the focus of light, and suggest the possibility of spontaneous creation. This passage is on the foremost plane in the painting, which is conceived as a relief of dynamically destabilized, though static, enclosures building to the center. The fingerboard is another tone of white, closer to the white at the top. A patch of green ground (a return to the rare deep green of *La-Rue-des-Bois* (1908, cat. 11) invokes landscape and seems inspired by Rousseau. Planes of Impressionist dots alternate as white on black (the man's neck and left arm), black on white, and black on gray (grisaille). There are two planes of blue on the right. The man is integrated into a *guéridon* table, geometrized as a checkerboard in two shades of brown.

I have gone into such detail to demonstrate that this single figure summarizes all of the concepts previously discussed. He is a synthesis of landscape and still life, of painting and sculpture and construction, of Méliès's film puppets and the heroes of Seurat and also of Picasso: Ingres is the violin;[130] Manet appears in the left hand playing the impossibly strung guitar, which is also his loved one, art;[131] Cézanne appears as blue; the green refers to Rousseau's exotic deep-green jungle scenes; Seurat and Signac are probably signed for in the dots. The checkerboard at the heart of the figure is both an emblem of the enclosure system and a memory of perspective. We have seen a chess game before; the board may be thought of as basic to the 1910 Cubist *Female Nude* in Philadelphia. The chief control is the mechanistic queen—art—who now belongs to Picasso, the clear winner here. He owns the pawns, the castle, the whole playing board, and he can move pieces around on it at will. He may even disrupt the old game to enforce new rules to repeat: in Cubism no single manifestation of identity is forever, no move is permanent, no form is secure in its space.

CUBIST SCULPTURE

By 1914, Picasso and Braque had been fully in command of a new structure for representation, one they, and others, could manipulate at will—and even use to dispense with representation. That year—the year of the start of World War I—Picasso had suddenly made a return to the subject of absinthe and to traditional free-standing sculpture as a support for painting. *The Glass of Absinthe* may be a

salute to his heroes, those poets and painters—like van Gogh—who had been destroyed by the liquor, that first avant-garde which had initiated the idea of the new. Perhaps he was reminded of absinthe because its dangerous addictive qualities were the subject of public discussion at the time; it was outlawed shortly after he made this sculpture. Perhaps he returned for a moment to freestanding sculpture as a memorial or, possibly, a monument. The glass had been a favorite motif of Cubism since 1909. In Cubism it is the repository for inwardness—a sort of holy grail of inwardness, and the emblem of a world.

The form of *The Glass of Absinthe* reifies it as a hallucination—a projection of its contents (Picasso himself had experimented with drugs). The creature of Picasso's mediation between two and three dimensions, *The Glass of Absinthe* is both a painting realized in three dimensions and a three-dimensional still life, a still life that is itself deconstructed according to the procedures of Cubist painting. The glass is in a state of flux, its outside turned inside; its twisted horizontal protrusions represent the level of liquid inside it. Several critics have analyzed the form as a face, with these elements as parts of its eyes.

The glass itself is modeled by the artist, but there is an added element: a real spoon (the tool of the addict), along with a real lump of sugar. The construction was later cast in six versions and each was painted differently. Each painted cast evokes a different formal aspect of the piece; each depends on a denial of its material base and the use of painterly devices to create a tension between painting and sculpture—a tension between form and "decoration." As a combination of real and unreal elements, the work is in the vein of collage, but not of the later collage aesthetic that would develop very shortly—in 1916—in the works of the Dada poets and artists, and then in Surrealism as disjunctive leaps in logic facilitated by the concept of cutting and repasting. In *The Glass of Absinthe*, the combination of elements still tells a coherent story; there is no unexpected and contradictory cut in iconographic sense between its hallucinatory elements. It is fascinating that this, the first object in the round of its kind, should be allegorical: and that its allegory, not only of plastic associations but of poetical ones, differs from one version of the glass to another, not unlike the changes of pose and paint surface which vary the otherwise self-same figures in the *Demoiselles*.

The version in this exhibition is painted in white and red. The choice of colors once more evokes Baudelaire. Absinthe is a cumulative poison; the white lead used in paint is also a cumulative poison, and the red paint may be a metaphor for blood, more specifically worker's blood, indicating a "solidarity" with the working class, a sympathy with misery for art's sake. As Baudelaire wrote,

> We had been waiting for so many years for some solid, real poetry! Whatever the party to which one belongs, whatever the prejudices one has inherited, it is impossible not to be moved by the sight of that sickly throng breathing the dust of the workshops, swallowing lint, becoming saturated with white lead, mercury, and all the poisons necessary to the creation of masterpieces, sleeping among vermin in the heart of districts where the humblest and greatest virtues live side by side with the most hardened vices and with the dregs from prisons. That sighing and languishing throng to which the earth owes its marvels, which feels flowing in its veins an ardent red blood, which looks long and sadly at the sunshine and shade of great parks and, for its only comfort and consolation, bawls at the top of its voice its song of salvation: Let us love one another.[132]

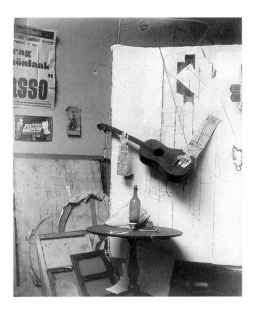

Pablo Picasso,
*Photographic
Composition with
"Construction with
Guitar Player,"*
Paris, 1913.
Private Collection.

The poetry of blood, of the sweet and the bitter, the grotesquerie of poverty and misery for art's sake—Picasso for some reason needs to reevoke all this as his early collaborators, his intellectual friends, leave Paris for the war. *The Glass of Absinthe* is a three-dimensional rendering of a synthetic Cubist still life, but its conception is pre-Cubist. Despite the added elements of the sugar and spoon, this sculpture retreats to the 1908–9 dialogue between painting and sculpture, only to advance more surely. The assemblage reliefs that surround and follow it belong to what would become known as the collage aesthetic, which itself, in the late 1920s, would be transformed into an entirely new aesthetic of sculpture.

In the spring of 1914 Picasso made several new relief constructions. This time he focused on the motif of the glass—but as an opaque container, not a transparent object. He had already made a number of small paintings of individual glasses, but ultimately the construction technique returned to those 1912 drawings. That technique had been a driving force in Picasso's work. From 1914 to 1917, using broken bits of material, wood, paper, and cut metal, he made a series of reliefs such as *Glass with Dice* (1914), in which the single die is a reference to Mallarmé.

Picasso would have many collaborators, living and dead, at every new rebirth. One would become the "father," giving him the tools he would need as he moved away from his mother to take his place as "the chosen one." The other, his mistress (or wife), would be the good mother, the muse—but also, eventually, the monster from whom he had to break away. Just as the *Demoiselles* represented a rebirth from which a whole new Picasso emerged, so did each new collaboration result in a new Picasso (or what he felt to be a new Picasso). But he would never have the same sort of collaboration he had had with Braque, the only artist whose work fully engaged him—the only one he treated as an equal. His new collaborators would usually be engaged with him as skilled craftsmen. Or, as in his next significant collaboration, they would come from another artistic discipline. Actual performance would not be an unlikely medium to investigate with yet another poet as guide.

In 1916 the poet Jean Cocteau contrived to be introduced to Picasso. Cocteau's milieu was the world of the theater, music, and ballet, the fashionable world of Paris society. He introduced Picasso to this world and to a new group of artistic collaborators, among them Sergey Diaghilev, the impresario of the Ballets Russes; the musician Eric Satie; and the dancer-choreographer Léonide Massine, with all of whom the artist worked on a new ballet conception: *Parade*. The war did not interfere with its conception; in fact the public was eager for diversion. Also, Picasso's art internalized struggle rather than displaying it. And he was in need of artistic companions.

INTERREGNUM: MEMORY AND METAMORPHOSES

Rome as Memory
The work on *Parade* took Picasso to the site of classicism: Rome. Classicism exists in that city as a thick temporal layer among others. Classical Rome was built up from the River Tiber as white marble over the red brick of an earlier, pagan

Rome. Roman classicism was itself a copy of an earlier body of art and architecture, that of Greece, which it translated into a larger, more aggressive, imperial version. Christian Rome was constructed over and around the ruins of Classical Rome, whose historical styles it reduplicated and recast.

The repeated encounters that Rome offers with multiple and visible layers of time create an impression of timeless stasis. In a single square or street, buildings quote and requote the same series of styles, suggesting an unchanging way of life still in progress and visible in the city's active life. To a visitor from France, Rome must have seemed a ghostly prediction of Paris, with its temporal layers from later periods than the classical heart of Rome—the medieval churches, the vast Baroque remodeling of the Louvre palace, the nineteenth-century neoclassical buildings and grand plazas. In Paris, though, everything was bigger, grander, and more fragmented. Rome was more human in scale. For Picasso it may have been too intimate and personal—the ghost of Ingres, who had directed the French academy and had lived in Rome for years, too close and present. Picasso is said to have been unhappy with Futurism, the Italian art inspired by his and Braque's Cubism.[133] Despite his close friendship with Soffici, and Soffici's extraordinary appreciation of his work, he was not at first flattered to find he had inspired others; in fact he was grumpy. In Rome to work on *Parade*, he pretended to have remained indoors, spending a lot of time in a bar opposite the railroad station, unless he was watching the ballet.

In fact, though, Picasso was much affected by Italy. He held it close, as though to examine its enchantment would spoil it. Between 1917 and 1924, he regularly traveled in Italy, and the evidence of his work shows that Italian art—and a sense of the Mediterranean as the seat of Western civilization—influenced him deeply.

The Life Class

The classical ballet is based on five positions, which depend on placements of the feet that are based on the contrapposto of classical statuary. The positions begin with a version of an archaic stance—a perfect stasis of all parts of the body, heels together, toes turned out, hands down and joined at the front, a perfect center balance. For the other positions the foot moves around in a circle pattern, first to a placement in which it is turned out and very slightly forward but still tight to the other foot, and then through a variety of stances in which it moves both farther from the body and to different angles, altering the balance slightly with each move, the arms and hands quietly echoing and balancing the moves of the feet. Meanwhile the upper torso remains still and the head turns slightly, in more echoes of classical statuary. In fact the ideal ballet stance and body are best described by the term "statuesque." The movements of ballet follow a course codified during the period from Alberti to Leonardo for the drawing of figures in motion.[134]

Parade utterly disrupted the decorum of the classical ballet, and even of Diaghilev's ballet, which had already incorporated popular dance motifs. At the ballet and in the rehearsal room, Picasso constantly drew the dancers, noticing and recording how, as they danced, their movements in unison with or in repetition of each other were variations of the poses and relationships of the linked figures in classical friezes. At rest they formed tableaux, again based

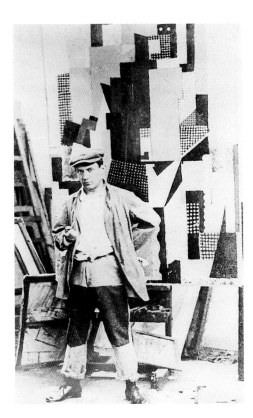

Pablo Picasso, Self-portrait with *"Man Leaning on a Table"* in Progress in the Rue Schoelcher studio, 1915–16. Musée Picasso, Archives Picasso, Paris.

89

on the lines of the friezes. Indeed they were realizations of the potential for life ensconced in the classical model (female as well as male). They were the embodiment of the simultaneously ephemeral and eternal so central to classical art. Perhaps Picasso remembered Degas's depictions of the awkward agonies that those poses inflicted, but the evidence of his drawings suggests that the movements of dance first and foremost seemed to him a funny parody of the Greek ideal of composure: a form of mime.

It may have seemed all the more ironic to Picasso—even fated, given that he was superstitious—that here he was, at the age of thirty-seven, having just achieved the ambition of creating an entire new structure for art, alone and back at the beginning again in the life drawing class. The succession of moves in the ballet precisely matched the progression of movements studied in the class. In fact the ideal presentation of the body in academic drawing demanded exact anatomical knowledge of the figure if all of its parts were to fit correctly and elegantly: "position" was more important than "excellence of figure, for the latter might be achieved by imitation, the former only by artistic understanding."[135]

As Picasso realized that the ballet was based on classical poses, he seems to have begun to see *Parade* as an opportunity to re-create the triumph of Cubism—and in its proper setting, the stage. As we have seen, stage lighting had played an important part in the conception of Cubism's hollow space, and Seurat's *Parade de cirque* had provided a precedent for the idea of staging a parade. Now Picasso had the chance to replay to another audience the revolution of Cubism, and to lay it to rest—to get on with his life in art in another way. His curtain for *Parade* staged Cubism's classical past as a blasted allegory, a story moving through different layers of time and apparently unrelated events and characters, transcribed to a stylistically seamless image. As Naomi Spector has written, its classicism is in total contrast to the scene that will appear when the curtain rises, a scene dominated by Cubist constructions, in the figure of the Manager, and expressionist sets.

Parade is an allegory of the radical change from classicism to collage form. The curtain is the prologue; it tells the story through a pastiche of allegorical motifs referring to themes from Picasso's pre-Cubist past. These are presented as if the mode of observation, using radically simplified contour drawing with local color. The group of harlequins around the table, one of them a guitar player, are a reference to Manet's *Déjeuner sur l'herbe*. There is even a reference to La Celestina, the blind-eyed, manipulative matchmaker and trickster whose presence is woven into the *Demoiselles*: the ladder shown on the curtain is the ladder from which the hero of de Rojas's book—here transformed into a monkey (perhaps a sign for the painter Rousseau, one of Picasso's others)—falls to his death while climbing to his love. (We will return to La Celestina at the end of Picasso's story.) The composition—a circle of figures, the forward harlequin looking at the angel-acrobat balanced on Pegasus's back—is the linked-figure concept inside the half circle of the stage. The stage floor is defined by parallel lines converging toward the back, recalling the structure of Renaissance perspective. The curtains are from the *Demoiselles*, as is the Cézannesque blue window.

At the same time that *Parade* restaged the triumph of Cubism, it announced that Cubism in its pure revolutionary form had had its run. Invention would now give way to thematic play on several levels, material and technical, as

well as iconographic. Picasso as conjurer had revealed the sources of invention, and his work—at least in two dimensions—would continue as variations in overlapping series expanding upon what had been achieved.

Picasso had been working on a group of several large paintings resembling the 1916 *Guitar Player* when Cocteau approached him to collaborate on *Parade*. The construction of the New York Manager and the Paris Manager depends on these paintings. Disjunctions of styles, motifs, techniques, mediums, and modes, facilitated by cutting and pasting, would continue to be an aspect of Picasso's work for the next several years. Oddly enough, his "pastiches" of papier collé, collage, film—indeed the whole principle of transgressing the lines between modes—was already developing as a coded aesthetic system in the work of Max Ernst, and would have long-term creative effects. The free transcription from one mode to another, with pastiche as an aesthetic, is at this writing the chief strategy of contemporary art—and has been since Pop. Nevertheless, for the next several years the order in Picasso's work would depend on his accidental return to the life class, with the wonderful differences that he replaced the single figure of the life class with several, and that from moment to moment the poses changed, forming new patterns with the others as living inscriptions of the ephemeral in the eternal.

Picasso's classicism has generally been connected with the "return to order" of the postwar years, but his revisiting of the roots of his art in academic classicism actually seems more connected to the beginnings of his distancing from Braque. The return to an art of observation through photography references initially to Cézanne and then to Ingres, seen in Picasso's drawing in several now-famous portrait drawings beginning with the *Portrait of Max Jacob* in 1915, signals a reconsideration of the sources of his art as Cubism became secure and widely disseminated.

And now the life class was in Rome, the original site of the original academy. The third step in academic training was drawing from antique reliefs and casts, and as we have seen, the concept of the work of art as a form of relief, dependent on contour drawing, with shadow and color as separate systems, was fundamental to the development of classic Cubism. Now drawing would again dominate Picasso's art, both as an independent method and in the realization of his painting style. As we have seen, Picasso had deliberately referred to the antique canon when he made the single figure the basis for the complexities of Cubist structure.

I think it important to note here that Picasso did not become either a naturalist or a classicist, or for that matter anything in between. It was still too important to him to shake things up and take control. A strange new adjustment of historical models interchanges with Cubism, with an occasional lapse into sentimentality—for the styles as much as for the subjects. The game of the reversion to previous models seems to be to revive them according to Picasso's rules.

The greatest painters in art history were those who were the most skillful at combining as many episodes as possible on the same surface, each episode comprising a complex interweaving of figures. Although a virtuoso variety was the ambition of these artists through the centuries, their compositions emulated and competed with those in antique friezes. The tool for the most complex of them was the linked-figure structure, in which, even (or especially) in antiquity,

the figures were self-similar in conception. Picasso would now produce single- and multifigure compositions in poses borrowed from this model as treated by some of its greatest practitioners.

William S. Rubin has recently begun to argue for the influence of Leonardo on Picasso's neoclassical works.[136] Leonardo is a natural point of origin for the renewal of classical order—or at least for a moment of rest, celebration, and renewal. The Neoplatonic ideal found its ultimate exponent in this Renaissance artist. As always, Picasso inscribed more than one style within another; his route back to observation as the basis for invention—from Cézanne to Leonardo—led through Poussin, Corot, and Ingres, through antique reliefs and Greek vase painting and fresco. Leonardo believed in the dictum—and I've referred to this before, without mentioning Leonardo by name—that the artist was to observe nature, but that his connection to "Idea" gave him the possibility of inventing as nature invents. His duty lay in this invention: "The divinity which invests the painter with Knowledge makes his spirit soar to likeness with God's spirit, for he freely uses his power to bring forth images." Leonardo also recommended that the student measure the course of his "progress in drawing by comparing his study of the model to one already made from his model by a more skillful predecessor."[137] But far from being merely a clever and skillful copyist, Picasso must be thought of as fiendishly ambitious, a genius of theft and disguise. He revived the primitive mechanisms and impulses by which the dead are brought alive. By recycling his heroes he took control of them. The progressive transcription of his mentors into all of his work, and his turn to them in Cubism after World War I (and in still later restarts), tell us that he alone was in control of his artistic creation.

Classicism again becomes an imaginary Eden, an Arcadia, that produces the impression of a false unity from which the hoped-for new innovations will erupt. The site of Eden is the Mediterranean, and here Picasso's figures dance and play. The figures of the "classical period" are paradoxes of representation: both flat and volumetric, they are studied from life yet are partially frozen as they pass through rendering from memory into classical sculptures. Memory works on two levels here: Picasso's drawings are not rendered directly from life, but are realized through a continuous parody of historical sources and, still more, of his own mastery of drawing and of his and Braque's recent inventions. The "style" belongs to no one. Embalming drawing in memory effects a curious depersonalization, an almost automatic vulgarity of rendering that is psychologically "primitive." The construction is curiously depersonalized yet operates in the mode of nostalgia; Picasso's new manner lacks emotional depth, as a mirror lacks real depth.

The touchstone for the realization of sculptural form in painting and drawing is contour drawing. Continuous contour drawing is a primitive form of line, for it lacks any expression of depth; it presents the figure as pure surface— no bone structure. Alberti had recommended breaking down rounded bodies into planes, but continuous contour, as a purely two-dimensional form of representation, is fundamentally the line of the sculptor seeking to describe his idea as it will emerge in plastic and material form. Picasso would now make a virtue of this line in painting and drawing. All of the figures have sharply defined contours. The figure is conceived as if it were a cutout. Color is based on cut-and-paste: the limit of the color serves as its own contour line. Sharp convex outlines seem to

press the bodies of color to swell into volumes, but their cutout contours return them to the surface as paste-ons. The surface of each cutout is resolved by a different treatment. Linear accents are often added to emphasize the plasticity of the forms. In a number of works, color is scrubbed away, as one might erase an area of chiaroscuro in a drawing to form a highlight—or as in a worn area of an aged fresco. In others, dry, sometimes scumbly brushstrokes build up from the cutout plane to create a sensation of plasticity.

Portrait of Mme Picasso (1922, cat. 56) and *Woman and Child* (1921, cat. 59)
In 1918 Picasso married for the first time. His bride, Olga Khokhlova,—one of Diaghilev's dancers—now became his principal model, being portrayed in a variety of costumes. In 1921 Picasso became a father. Several paintings in the exhibition portray Olga with their son, Paulo. *Portrait of Mme Picasso* (1922, cat. 56) idealizes her quite romantically as a saintly mother. The quality of the representation—a form of painting that is almost a drawing in its spareness and its dependence on outline drawing with the brush—rests in the work's origin in an extraordinarily painterly chiaroscuro drawing by Leonardo, the cartoon of *Saint Anne with the Virgin and Child and with the Infant St. John*. (Olga's pose is that of the Virgin.) In the several versions of this painting, Picasso substitutes touches of color, sometimes more, sometimes less, for Leonardo's chiaroscuro. Leonardo's drawing informs the manner, but as we see in *Mme Picasso* and several drawings on canvas, such as the *Man with Pipe* (cat. 57), it is Leonardo as negotiated through coarser rendering, especially of shadows, derived from "imitating" the sort of shadows rendered by photography, rather than observation. Olga, like her prototype, is soft and generous of body, almost boneless, and Picasso exaggerates the plumpness of the Christ child, particularly in the hands. Such hands would reappear on the figures in many of his later paintings.

In *Woman and Child* all of the methods of drawing are reconceived for painting in color, with papier collé as its basis. Form is handled as simultaneously flat and full: various kinds of chiaroscuro invite us to read bodies as volumetric, but no matter how three-dimensional the internal description—and the volume is vastly exaggerated as though a classical sculpture has been inflated and pressed between the surface and the back plane—the sharp edges of the contours discipline the volumes to conform to the surface as reliefs. The (relative) repression of subtlety in many of the outlines, and the mediation of the contour between two and three dimensions, remind us that Picasso often has at least one eye on Matisse. With their sharply defined outlines, dry surfaces and molded drapery, many of the '20s figures are conceived on the model of Renaissance frescos, especially those of Piero della Francesca, one of the earliest masters of linear perspective. The active poses of the figures acknowledge Poussin; the same lineage is at work in the construction of their geometric but textural grounds. Moreover, a distinctive and peculiar perspectival rendering has been inserted in the painting of figures. For Clark, Picasso's paintings of 1909, with their clashing perspectives and multiple viewpoints in which space and solid "turn in upon themselves," exaggerating activity in one painting and stilling it in another, had constituted a "Piero moment" because they "remind us of the reflexive quality of that previous tradition, its admission of paradox at the height of its powers."[138] Now Picasso examines that paradox in a full-force cartoon version of it.

93

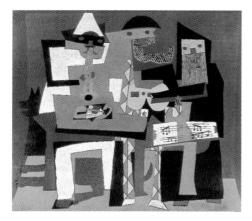

Pablo Picasso,
Three Musicians,
1921. The Museum
of Modern Art,
New York,
Mrs. Simon
Guggenheim Fund.

Even in its most ancient origins, continuous contour drawing is usually accompanied by modifications of detail. (The Paleolithic cave paintings at Lascaux, for instance, use the irregularities of the cave wall to suggest internal detail and subdivision.) In *Woman and Child*, color contrasts and distinct curved lines drawn horizontally (in this case with a pointed brush) around, for instance, the edge of an arm, indicate the roundness of the forms of the body. This linear drawing, whatever the tool, is a convention of marking shadow called "bracelet shading." In these curiously dry paintings, which emulate fresco technique, it serves as a device to heighten volume. White lines are used for highlights, black lines for shadow, and the white highlight, although rendered in a variety of techniques—and media, such as pastel—is the reminder that these are plaster statues (some more colored and thus more alive than others). The major color contrast is of direct opposites, red against blue, blue inside red. The figures in this tiny painting swell through their placement so close to the edges—the mother's head is even cut off at the top. This increases the sensation of volume: as the figure swells, the limits of the canvas press in to force an even more volumetric reading. The figures read as volumetric reliefs and as both continuous and, through color, in contrast. They are set against a pattern very like that in *The Sea at L'Estaque*, the Cézanne landscape that Picasso owned, and also a backdrop very like those of Piero's frescoes, with their classical cubic buildings. The colored ground is woven as a pattern of self-same brushstrokes, similar to those in high Cubism, but it is now a flat woven color field—a theatrical scrim—more like that of Seurat or Signac than like the palpitating Cubist ground of origination.

In this and other paintings of the time, the plastic modeling of the paint internalizes perspective within what might otherwise be flat forms, if judged by their continuous outline drawing and lack of bone structure. These curiously volumetric figures are often painted against the empty ground of the sea and land, but are framed from the sides by cubic walls and houses. The walls and houses too are subject to this peculiar treatment of line, which presses to create a sense of volume. Each color is confined to its own figure, with the baby's skirt in white. Repeating the relief configurations we know from Cubism, the colors build the composition by stacking the figures as reliefs from the plane forward, with the (flat-top) pyramid culminating front and center.

Variations
In the summer of 1921, Picasso painted two extraordinary three-figure Cubist compositions as a pair, both of them titled *Three Musicians*. These works are based on papier collé, in its function as a system of negative and positive enclosures and cut-out body parts. The figures appear against a brown ground, like the single figure in the 1916 *Guitar Player*, and in fact the composition of the later pair relates strongly to that work, being essentially a more complex division of internal space into compartments to accommodate three figures instead of one. The trio of masked musicians change places and attributes from one painting to the other: in one painting, in the Philadelphia Museum of Art, they are on a red stage, tilted flat to the plane; in the other, in the Museum of Modern Art, New York they are on a brown stage within a shallow perspectival space. In the latter work a dog (again Picasso's) sits as a shadow figure beneath the chair of the white figure playing the clarinet, and there is a table in front of the two musicians to the left. This

clarinet player has a mustache, and in the Philadelphia version all of the musicians have mustaches; the mustached man has been around since 1909 in various guises. Players of wind instruments have been around for a long while also, as have figures behind tables and harlequins. It is noteworthy that one of Piero's most famous images is the trumpeter in the *Battle between Heraclius and Chosroes*, in the Church of San Francesco in Arezzo. The trumpeter is a handsome Mediterranean type, a matinee idol not unlike Picasso himself (or the young man in *Man with a Pipe* of 1923), and he shows up in Picasso's classicizing paintings of the 1920s, minus his "instrument."

The musicians may well be a salute to Méliès, who, in 1900, had made a film called *L'Homme-orchestre* which, Abel writes,

> offers an especially striking instance of this game of doubled spectacle [the one cited previously in which Méliès had taken pleasure in his own tricks] with a "hidden trick" effect and a cleverly orchestrated mix of theatrical and cinematic devices. On a bare stage framed by painted-flat curtains are seven simple chairs lined up in a horizontal row against a black background. Méliès, who had started out as a magician, appears in white shirt and trousers, sits on the far left chair, and, moving from chair to chair, replicates himself into six musicians (each with a different instrument) and a centered orchestra conductor (with baton). The six musicians chat among themselves, perform under the conductor's guidance, and "fold" back, in pairs, into the conductor (stage center). After a wave of the baton seems to make the chairs vanish and reappear and then condense into one, a huge decorative fan rises up in the background and a puzzled Méliès sits on the remaining chair, only to promptly disappear.[139]

And et cetera, with more tricks as the action continues, but we have the important part in the six musicians. Obviously Picasso would be an offstage conductor, if not also the musicians.

This series of actions depends, of course, on an unusual number of multiple exposures and superimpositions, in order to magically multiply the magician himself. Yet it also depends not on stop-motion filming (as might be assumed) but, as Jacques Malthet discovered, on cutting different strips of film or "takes" together. Cuts or splices, for instance, are what actually cause the chairs to vanish and reappear; the cuts seem invisible simply because the exact duplication of framing from take to take maintains a strict continuity of space and action—making this the very first form of "invisible" editing.[140]

Assuming, of course, that the doubling of *Three Musicians* has something to do with Méliès's tricks, does Picasso return to this idea at this moment because it strikes him that he may have come upon the possibility of a complete coincidence of meaning and gesture—a seamless match of representation and its means in these abstract, empty forms? Performance is the one mode in which, if only for an instant, the coincidence of figure, read form, and gesture is perfectly aligned. It also calls into question just what he thinks he may be doing with these classicizing paintings.

Man with a Pipe (May 1923, cat. 57)
Picasso repressed his facility in drawing virtually throughout the Cubist period, but as early as 1914 it began to return to his work, in small details inserted into

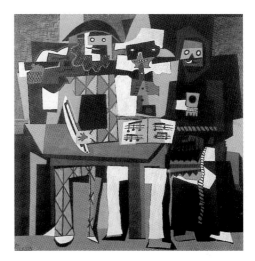

Pablo Picasso,
Three Musicians,
1921.
The Philadelphia
Museum of Art,
Philadelphia, A.E.
Gallatin Collection.

95

Piero della
Francesca, *The
Legend of the True
Cross: Battle between
Heraclius and
Chosroes*, detail.
Church of San
Francesco, Arezzo.

96

Cubist figures and in the outlines of parts of the Fantômas-related drawings. As he moved into the neoclassical period, artists whose drawing owed something to Leonardo—Ingres, of course, and Corot—came to his hand, but modified by his study of fresco. His beautifully phrased, almost flat-edged contour lines reformed outline drawing, and the shadows are so illusionistic as to render the head in both *Man with a Pipe* and others of the period as three-dimensional sculptural busts. Conceptually the figure of this seated dancer is a living sculpture, its seated pose, legs crossed, a sign that its potential for activity is greater than that of the standing figure.

All through the 1920s we see this game of musical chairs and identities, of sly sexual puns, and, especially, of temporal overlaps and stylistic theses and antitheses. At last, in 1928, Picasso dramatized his play in an artist's-studio composition, *Painter and Model* (Museum of Modern Art, New York). The composition is a sort of *faits-divers* of fractured planes, each telling one part of a fake narrative. A Cubist sculpture, portrayed as a painter with a primitive wooden arm, is painting a naturalistic contour, using a bust on a pedestal as a model. The bust is an abstract surrealist object with three eyes. The painter only has two. His top half is based on the constructed three-dimensional Cubist sculpture *Head*, of 1928, and he is elongated into a pipe-stem figure (which just may be a violin) holding a kidney-shaped palette. He is merely one variant of the thick black lines and black planes that structure the whole of the canvas into a series of compartments, whether "backdrops" or homes for figures or objects. I put "backdrops" in quotes because there is a time/space overlap at the center of the composition, where two lines cross at the top, in front of a blue window. Suddenly, in the center of a planar composition, a complex of clashing multiple perspectives produces an entirely other space enclosing the biomorphic painter's palette and the curving profile. The line that goes from upper right to lower left is the painter's brush (it touches the profile he is painting). The other—despite the thick shadow line just below the painter's hand, which initially reads as the edge of his canvas—extends the top of that canvas to the upper right, and includes part of the window in the painted representation. It then becomes hard to read which of these central elements are part of which painting, the represented one or the one Picasso is painting—although he is in fact painting both. He is representing, therefore he is a representation—or he is a representation, therefore he is?

One source of this strange spatial lapse into a multiplicity of possible spaces is the heritage of Cubism's moving body parts as passed through outline drawing, but it also recalls the films of Méliès, as well as the sudden jolt of surprise one gets from the magician's sleight of hand as it appears to cut the body. The sudden changes of views and fracturing of "reality" that film accommodated so well and brought to a new level, and the new space of Surrealism (especially its new arrangements of reality), also need to be taken into account. Film is either not a tactile medium at all or the most tactile medium of all. There is no doubt that despite the crossing at the center of *Painter and Model*, the many layers of space and style and mode, every one of these "figures" is on the same flat plane: the whole thing is a magical illusion—painting once more wins in the battle for the subject's attention. Most important, each element of the representation remains in place both despite and because of the fact that the line

is both a figure in its own right and a line of enclosure, disporting itself over the surface of the canvas to assume its various guises. *Painter and Model*, like *Still Life with Chair Caning* of 1912, is a statement of a fresh adaptation of the perceptual to the objective. It states the unity from which several variants will unwind.

Picasso has been charged with betraying the modernist project after the end of Cubism, but his project was remaking representation—making visual art, especially (at this stage) painting, into a means adequate to modern experience. Far from betraying the work he had done with Braque, although divorced from the other artist (at one point he called Braque his wife, at another he called himself Braque's wife), he continued alone to search for an anonymous collective art by collaborating with the whole of art history, projecting it as a collective and appropriating to its use any "style," any "story," that would further his cause. Drawing is the formal control for this enterprise. We have seen Analytic Cubism as a figurative scaffold, a form of structural board game, and the figure in the 1916 *Guitarist* as internalizing that board within itself—internalizing the mental fact. With collage and papier collé we have seen the figure use the board to move out into multidimensional space, a space both literal and figurative, poetic. Now each move on the board will be part of a multidimensional, multidirectional search in which one style after another will be subject to a parodic reappraisal, integration, and subsumption to Picasso's project.

The conversation between two and three dimensions, between planar and plastic or volumetric form, lies at the heart of Picasso's art. It intensified in 1928, being restated in the crossing between painting and sculpture. That year, Picasso, with the help of his fellow-Spaniard Julio González (a metalsmith whom he would inspire to make sculpture himself), began to make sculpture again. Effecting a shift in the idea of working in concert with observed form, he transcribed the guitars he had continued to fabricate as increasingly three-dimensional objects into figurative sculpture—and, in the process, reinvented the conception of sculpture as a construction. Picasso was to become one of the most important sculptors of the twentieth century. Constructed sculpture was an invention as important to sculpture as collage and papier collé were to painting—and the concept was based, not only on the guitar, but on applying the idea that one could paint with anything to the idea that one could make sculpture with anything. The metaphysics of the still life were inscribed into the figure in a new way, using objects as ready-made body parts. In sculpture as in everything else, Picasso never let go of anything. In his *Study for a Monument to Guillaume Apollinaire* (1928, cat. 69), his first thought was of a poured bronze morphological dream figure. But in a second version he turned to a linear structural mode, conceiving the monument from what would normally have been the armature of a sculpture modeled in clay. The sculpture became a three-dimensional scaffold, constructed from welded steel rods which he called—perhaps in jest, perhaps for those with literary minds, because it was a sort of literal conceit—"drawing in air."

Metamorphosis and the Technique of Body Parts
The Surrealist movement came to Picasso's attention even before the publication of the *First Surrealist Manifesto*, in 1923. Some of Picasso's closest friends—most notably Apollinaire, who had coined the word in conjunction with Picasso's

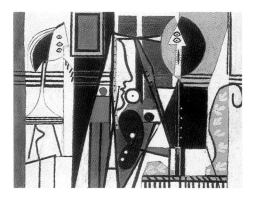

Pablo Picasso,
Painter and Model,
1928.
The Museum
of Modern Art,
New York, The
Sidney and Harriet
Janis Collection.

97

Parade—were Surrealists, and the Surrealist milieu may perhaps have reminded him of the poetic milieu of the *bande Picasso*, which had existed from the time of the *Demoiselles* until World War I. In plastic terms Surrealism was dependent on many of Picasso's inventions, and he adapted a number of its ideas to emphasize preexistent aspects of his work. But he never officially joined the movement, which, like the Dada movement, had initially rejected visual art. When Surrealism did accept visual art, it was through poetry seen as a collage of disassociated parts. In Dada, Max Ernst and Jean Arp had adapted the techniques of papier collé to facilitate the dream images and poetry that Surrealism would develop even further. Arp especially took advantage of the outline drawing and movable body parts that I earlier described as Picasso's heritage from Gauguin to describe ever more fantastic forms. Dada relied on the effects of chance juxtapositions, techniques that Surrealism then transformed into more systematic aesthetic principles.

The unexpected juxtapositions of unrelated images that characterized the art of Dada and Surrealism would later be called the "collage aesthetic." The collage process became, to use, the poet Lautréamont's phrase, "Beautiful, like the chance meeting of a sewing machine and an umbrella on a dissecting table." The Surrealists practiced "the cultivation of the effects of a systematic displacement."[141] Surrealism cast the artist as a medium. It was "based on the belief in the superiority of certain previously neglected associations, in the omnipotence of dreams, in the disinterested play of thought. It tends to ruin once and for all the psychic mechanisms and to substitute itself for them in solving the principal problems of life"[142] Surrealism introduced a new motif into modern painting: it made the unconscious a legitimate object of art. It also declared as its ambition the idea that "the marvelous should be made by all and not by one alone."[143] The marvelous could not be apprehended by reason (this was the basis for the ideas of the artist as a medium and of everyman as an artist); it was a function beyond the fantastic, a filmic shift in the seamless fabric of reality. The dreamlike irrationality of the Fantômas films was a principal influence on Surrealist film, which was the ideal medium for Surrealist collage.

When Surrealism embraced art it supported no single style. Many Surrealist painters, though, based their painting on a deep illusionistic space, a species of landscape meant to represent the space of the mind—the space of dreams. Surrealist iconography was a dream map of the unconscious. It was a kind of interior landscape structured on a Cubist model of moving body parts and the metamorphosis of objects into strange organic forms. These fantastic biomorphic images grew out of the drawing method, and specifically from what was called automatic drawing. This was a technique, not a style; believing that the key to the iconography of the unconscious was the dream, the Surrealists imagined that the way to reach the dream in waking life was to write and draw as though in a dream state, letting the hand, unmonitored by the will, find images composed of unlikely juxtapositions of fragments that together might provoke a narrative. Automatic drawing and automatic writing were thought to give access to primal images held in common by everyone's psyches. They were sources of the marvelous. The metaphysical notion of the artist's connection to God's capacity for spontaneous creation through drawing was transformed into the idea that one could reach the subconscious of each individual—and through that the collec-

tive unconscious of mankind—by means of these two techniques, which became the motivating force of Surrealism.

This idea of what might constitute an art made by all, or at least accessible to all, was a miraculous combination of (primarily male) fantasy, myth, Jung, Freud, and the Paris Commune (relived through the Communist Party). The Surrealists put simultaneity to work as virtual movement, an expression of the uncertainty of human experience, of the constant pressure for self-transformation. Movement also played a role the incorporation of chance and fate into the work. Sex became an explicit topic of art. Picasso's outline drawing now followed an overtly sexual path in its plastic manipulation of moving body parts.

Standing Woman (1927, cat. 74)

Standing Woman reverts to the mask of terror motivated by infantile sexuality first seen in the *Demoiselles*. Black line drawing describes a mask attached to a torso, whose lines also become the woman's legs, if we take the title at its word—although these "legs" ought to be her arms. Three curved lines indicate a hank of hair, two dots a nose. The fantastic dream image that the wire-like line constructs is painted over a Cubist planar element in translucent white (and at this point we must take for granted that these elements are always "cut" from papier collé, and they always are at heart "enclosures"). This white form, with a triangular extension at the top left and a curve at the right, is the woman's head and body. Attached to her body below the little circle of her navel is a pair of legs, which do not support her. These are the legs that should be arms, yet they appear below her navel. The ground is an indeterminate gray, densely material, and shows through the white form to bring them together on the same plane in an illusionistically rendered chiaroscuro painting of a sculptural construction. The top of the white form, with its triangular attachment, is the head, a planar representation of a violin in profile. (Compare this head with the violinlike head of the 1916 *Guitarist*.) The image shows a woman completely reconstructed as a violin; Picasso is playing Ingres.

In works such as *Femme* (1928), with its voluptuous play on Ingres's impersonal line, Picasso is "outing" Ingres's repression of sex. Both paintings reiterate the conversation in Picasso's work between two and three dimensions, and between conceptually geometric linear and planar formations and volumetric organic ones, such as those in the first study for a monument to Apollinaire (*La Métamorphose II*, 1928). The subject of the conversation is the mastery of creation, and the conversation, as always with Picasso, is fixed in the struggle to master the female body—nature's chosen vessel of reproduction.

Gray and Black Woman (1928–29, cat. 73)

A woman-cum-sea-monster is playing ball on the beach. Picasso had begun to transform women disporting themselves on the beach into long-limbed fantastic creatures as early as 1920, depicting them as if seen in a fun house mirror, their limbs extended into octopodan tentacles. In *Woman and Child*, Picasso had suggested the earthly Paradise, putting his skill to use in exaggerations of Renaissance painting and imitating classical sculpture with classical drawing. But the drawing there had been nostalgic, as if the method were seen from a great distance. As Picasso's depersonalized contour line reached out, it found

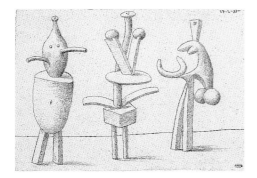

Pablo Picasso,
Anatomies:
Three Women,
1933. Musée
Picasso, Paris.

ever more fantastic shapes, realizing monstrous dreams beyond the distorting capacity of even the fun house mirror. The line became transformative, describing forms incredible and terrible, quasi-human and quasi-biological, as though of its own volition.

Picasso later told Françoise Gilot that as a child he had "often had a dream that used to frighten him greatly. 'I dreamed that my legs and arms grew to an enormous size and then shrank back just as much in the other direction. And all around me in my dream I saw other people going through the same transformations, getting huge or very tiny.'"[144] One of his later dreams, realized only in paintings and drawings, was to build a series of giant concrete sculptures along the Croisette in Cannes. *Gray and Black Woman* is one of many of his reflections related to that dream. The completed sculptures on the beach would have formed a sort dream landscape that at least to Picasso's mind would probably have been the ultimate representation of the psychological landscape. In his painting he would continue to elaborate on the relationship of line to dream, juxtaposing enclosed planes with grotesque linear forms. These works often used the tonal gray light of black and white movies as their color—an application of the dream world of Surrealism to film. But although several of Picasso's fellow artists, Fernand Léger and Salvador Dalí among them, either made short films or created passages for commercial films by others, Picasso did not become a filmmaker himself.

As the 1930s wore on, with their terrible economic depression, Picasso's figures became more and more agonized, his line often forming labyrinths, his colors—when he paints in color—garish, jarring. Perhaps these deformations and disruptions were purely personal, or perhaps his psyche was recording the general frustration and sense of hopelessness abroad in the world. He was not immediately affected, however, until the Spanish Civil War. His unwillingness to depict war directly, to describe political catastrophes in subject-specific motifs, was part of his debt to Manet, who had effected just such a sublimation to means rather than motif.

Classicism, Surrealism, and film may seem odd companions, but Picasso's classicism is related to Surrealism by the continuous unaccented contour line that can stretch to describe anything, from classical outlines to terrible swelling or angular forms, and that will circumscribe limbs wherever they may be. Surrealism and film imagery are natural companions, for fantastically disjunctive images are easily rendered in film by distortions of the lens or of the mirror, by dissolves, and so on. Surrealism's mythological account of experience had enforced Picasso's seer's eye. Again the old formula, reformulated: unity in apparent disunity opening to contradiction and returning again to a new unity. From 1927 to 1936, the years in which Picasso was closest to Surrealism, his drawing continued to take the lead, especially in his printmaking. The line that fosters images of Picasso's dreams is connected to the thread in the myth of Ariadne, who gave it to Theseus so that he could find his way out of the labyrinth of the Minotaur. The myth of the Minotaur led Picasso back to his Spanish roots and the corrida, with its primitive fundament of animal power conjoined to ritual sacrifice. In a series of extraordinary drawings, gouaches, and prints extending from 1933 through 1936, the Minotaur is the leading protagonist.

Technique as Motif
In the 1920s, mastery of disparate techniques, from different artists and time periods, had become more and more important to Picasso. Indeed technique was to become an obsession, a figure in the work, standing for what imprisoned the subject—Picasso—in the work. This is nowhere more apparent than in the prints and drawings of the 1930s.

The 1930s Prints: The Vollard Suite (1933, published 1939).
Blind Minotaur Guided by Marie-Thérèse with a Pigeon on a Starry Night (1934–35, cat. 93), *Minotauromachy* (1935, cat. 96), *Faun Uncovering a Woman (Jupiter and Antiope after Rembrandt)* (1936, cat. 94).
The dream monsters in Picasso's paintings of the previous few years were a projection of his pain over his increasingly unhappy relationship with Olga. At the start of most of his relationships with women, he seems to have seen them as dreaming idols; the focus of light, untouched except by his gaze, in his images of them they are virginal. But as he satisfied his sexual desires and his women became more real—even had babies—he saw them as monstrous. In either case they remained projections of a monstrous need that he could not and would not master, since it was the source of his power.

This, at least, is a part of the story told by the group of etchings on which Picasso began work in 1933, in the workshop of Roger Lacourière, the master printer whom he met that year. Lacourière taught him the techniques of intaglio printing, especially the sugar-lift method, which produces the most velvety and painterly effects.[145] Picasso's artistic mentor or archetype in the images that resulted was Rembrandt, whom he used to support him in the creation of a series of blasted narratives of his life situation. As ever, life was sublimated in mastery of technique; the subject can never escape its entrapment in the mechanistic turning of the pictorial machine, the mirroring and remirroring of his dilemma. At the same time that the prints show him intensifying his investigations of both myth and drawing, their primary subjects are touch and sight. The gaze related to the figuring hand both creates the gift of pleasure in seeing and subsumes within it the artist's mastery of the sexual object through his creative power. Picasso's art, despite all his "others," was now becoming an increasingly solitary adventure. Parts of his life were carried on in secrecy; his themes became allegorical, ever denser layers of identities in a masquerade that crossed time and space. The *Vollard Suite*, despite the twists and turns of iconography, is a sustained ode to the Mediterranean tradition, and to those myths and their monstrous manifestations responsible for its creation.

In 1927 Picasso had begun a secret affair with the young Marie-Thérèse Walter. Only seventeen when they met, she was not only his secret lover but his secret model: a small painting in the exhibition, *Beige and Black Composition (Marie-Thérèse)* (cat. 70), incorporates the disguised monogram MT, and she would later be the model for several monumental heads modeled in plaster in Picasso's retreat at Boisgeloup, a home he bought specifically to be with her and away from Olga. In 1935, Picasso was deeply depressed to discover not only that Marie-Thérèse was pregnant with his child but that she had decided they should part. Also in 1935, Olga finally turned him out. A work from that year, *Minotauromachy*, is the most famous of his prints and among the best known and sought

after of all his images. It and a related work, *Blind Minotaur Guided by Marie-Thérèse with a Pigeon on a Starry Night* tell us the story of the sexual rage that lies at the heart of Picasso's trapped relationships with both Olga and Marie-Thérèse.

The artwork transcends the antagonisms of everyday life without promising to abolish them. It is, for Theodor Adorno, perhaps "the only remaining medium of truth in an age of incomprehensible terror and suffering."[146] A "rational" end in itself, it brings to light the hidden irrationality of a rationalized society. In the mid-1930s Picasso was deep in Surrealism, and his art of this period works through a kind of logic in which persons and events are perceived as discrete phenomena without sequential or logical relationships between them. Now Picasso's images could be described as "akin to those dream images which blend cogency and contingency; and it might thus be said to represent an arational reason confronting an irrational rationality."[147] The external stimulus is wish-fulfilling fantasy, the mode is allegory.

Allegory, I've remarked earlier, is the opposite of analogy: "it is a figurative mode which relates through difference, preserving the relative autonomy of a set of signifying units while suggesting an affinity with some other range of signifiers."[148] The idea of affinity, or mimesis, becomes a ground of unity, only to be split. Mimesis embodies "the nonsensuous correspondences between disparate features of the artifact, or more generally the family relationships"—the resemblances and nonresemblances—"between subject and object, humanity and nature."[149]

Thus no identity, no emotion, is secure in the depiction. Marie-Thérèse's pregnancy arouses jealous rage and protective feelings all at once. She is pictured five times in *Minotauromachy*. In Picasso's *Crucifixion* of 1930, a man climbing a ladder is certainly Joseph of Arimathea, who climbs a ladder in the Passion story to unnail Christ. We may plausibly interpret the man climbing the ladder in *Minotauromachy* as Joseph of Arimathea also, although in this case he may be unnailing Picasso. He may also be interpreted as the hapless Calixto, who climbs a ladder in de Rojas's story *La Celestina*, and is killed by his own unslaked passion; but both stories are stories of passion, one pious, the other blasphemous. The man's lover and a young Celestina (or Olga)—depicted as Marie-Thérèse doubled—look down on the scene from the window. An innocent girl holds a candle to blind the Minotaur (Picasso's monstrous passion) so that the escaping pair cannot be followed; she wears a hat that once belonged to Marie-Thérèse. To the right, in the far distance, is a boat, perhaps suggesting freedom, or the escape vessel of Theseus in the myth. In the center is a wounded mare, a symbol, again, of Marie-Thérèse—the horse's injury suggesting her loss of the baby, whom the conflicted Picasso must protect. Lying on the mare is a beautiful *toreadora*, asleep or fainting. She and the mare are menaced by her own sword, which lies where the Minotaur can grasp it—will she be able to protect Marie-Thérèse and the baby, will she cut through the maze in which everyone in this image is entrapped? The story is told in the language of the corrida, with references to such tales as the rape of the Sabine women, forcibly made brides to the founders of Rome. The assembled cast is brought to an almost unbearable psychological and pictorial stasis by the means of depiction: the linear chiaroscuro, linear pattern on linear pattern, creates its own labyrinth. The

obsessively overworked digging and redigging of the print tells the story of entrapment by one's own passion.

But is this print the story of the Minotaur alone? Blasted allegories feature mixings of identity, as well as large gaps in story-telling logic. The horse features in the story of Odysseus, who overcame the Trojans to rescue Menelaus's errant bride, Helen, by building a wooden horse and emerging from its stomach. The Odyssey is the story of his eventful ten-year-long return from the Trojan wars, a poem sung by the blind Homer. Is Marie-Thérèse to be seen as Helen, rescued by the horse? If so, and if the thread—the line that entwines everyone in this story—connects Picasso to Theseus, the sword would seem to suggest Odysseus. Is Picasso also identifying with the ur-poet Homer, as if to signal that his quest is a form of blind search in which he will follow every avenue to work out his passion? *Minotauromachy* is a terrifying image. The culmination of the *Vollard Suite* but not part of it, it is customarily related to *Guernica*, Picasso's most celebrated painting.

Faun Uncovering a Woman (1936, cat. 94)
The enthralled faun would seem to enforce the reading of Picasso-as-Theseus in the earlier print. It is an extraordinary depiction of the theme of the artist's gaze as the source of his power—his unveiling of the girl reveals the light of creation. The scene is an annunciation, with news being brought to the Virgin Mary/the pregnant Marie-Thérèse, who was soon to suffer the same fate as her predecessors and become redundant in Picasso's life. But before her transformation from virgin to whore-cum-monster and her subsequent disappearance, she is portrayed repeatedly in several rather deliberately sickly-sweet colored paintings in the exhibition, as though through color Picasso, were telling us of his own skepticism about even this long-playing romance.

Sleeping Woman (January 23, 1932, cat. 84),
Woman with Bouquet (April 17, 1936 (cat. 86), and *Sleep* (1932, cat. 85)
Most of the *Vollard Suite* deals with the relationship of artist and model, and particularly with the power of the gaze, a theme we first saw in the 1904 *Meditation*. This concern carries over into the paintings, but where, in the prints, model and artist (now a sculptor) cross gazes in a battle for power in which the model is constantly caught in transition between life and art, in the paintings the gaze and hand of the artist take control. We can feel the hand of the shaper caressing and moving around the voluptuous body parts, using the pressure of that powerful outline to make them swell with pleasure. The woman is seen in vulnerable poses—sleeping and dreaming, absorbed in arranging flowers, as though an artist herself. In *Sleeping Woman* the dreaming Marie-Thérèse emerges on the canvas as both model and author, in a reciprocal act of creation: she both creates her own presence and is created by the drawing process, which produces her from a tangled labyrinth of lines produced by her own restless turns as she dreams, in what has been described as a postcoital sleep. At the last moment the painter's hand takes control and defines her features, emphasizing selected lines to create a volumetric relief image. In *Woman with Bouquet* and *Sleep* an Ingresque line again describes the voluptuous, ecstatically erotic pink bodies that in Picasso's art belong only to Marie-Thérèse.

WAR

Picasso's War and Guernica

> *. . . the street rises to the clouds tied by its feet to the sea of wax which rots*
> *its entrails and the veil which covers it sings and dances wild with pain . . .*
> *the light covers its eyes before the mirror which apes it and the nougat bar of*
> *the flames bites its lips at the wound—cries of children cries of women cries of*
> *birds cries of flowers cries of timbers and of stones cries of brick cries of furni-*
> *ture of beds of chairs of curtains of pots . . .*

Picasso, excerpt from *Dream and Lie of Franco*, 1937

As a Spaniard, Picasso indirectly entered World War II early, with what has been called fascism's rehearsal for the main event, the Spanish Civil War. The war between the democratically elected Spanish Republicans and Francisco Franco's fascist faction, allied to the Axis powers, began in 1936. Picasso remained in Paris. As a supporter-in-exile of the Republican cause, he was named the absentee director of Madrid's Prado museum. His famous two-part engraving *Dream and Lie of Franco* (1937, cats. 97, 98), from which the fragment of the poem above is excerpted, lampooned Franco savagely. It was made to raise money for the Republican cause, and was the prelude to his painting on the bombing of Guernica that same year. (The title is probably a variation on a title from Goya's etching series *Los Caprichos - Dream of Lies and Inconstancy*.) Each of the two plates was divided into comic strip frames; the last four frames of the second plate, finished on June 7, relate closely to *Guernica*, which Picasso had already begun. Franco is presented as a cartoon character, a loathsome turnip head, sex-crazed and impotent, who tried to rape Spain, presented variously as a beautiful woman, a horse, and a bull. He rides a horse and also a turtle.

In January of 1937, the Spanish Republican government had asked Picasso to make a mural for the world's fair that was to take place in Paris in June of that year. Picasso found his theme for the work on April 26, when the small Basque town of Guernica was bombed by German planes. Picasso had never visited Guernica; his only knowledge of it came from newspaper accounts and, surely, newsreels. His mural-scale painting on the devastation of the town was put together from photographs and articles published in *Le Soir* and *L'Humanité* after the notorious attack.

The painting was completed very fast. At the world's fair it took up the whole back wall of the Spanish Pavilion. This ambitious work is a compendium of Picasso's motifs, techniques, and emotions, and also relies on historical models from antiquity on, especially the story of the rape of the Sabines. The presence of a horse, as the apex of a pyramidal pileup of overlapping forms, informs us that *Guernica* relates to the heroic past—the great battle scenes of art history, which so often set horses in prominent positions. (The Spanish Civil War may have been the last war in which horses played a major role.) The horse also plays a part in the corrida.

Earlier battle paintings, however, were usually memorials, painted retrospectively to honor an army, its heroes and leaders. *Guernica*, on the other hand,

was a protest, painted not only to describe a recent disaster but to forestall potential future ones. The scene needed to be presented with immediacy and urgency. Picasso's model in his reconception of his art-historical precedents was cinema. We have seen that the primitive technology of film had found close common ground in Cubism, with its flickering perceptual play of paint into light and back, and its faintly mechanistic conception of the motif. The technology of film was now smoother, and film and painting were less compatible. Picasso had to find a more current method to transcribe his images of a horrific collective memory. His touchstones were the stories and photographs in the newspapers, which allowed him to inject the cross-cutting and light of film into a collage method integrated with a Cubist system of enclosure. *Guernica* is an ambitious linked-figure composition in which open and closed, light and dark passages overlap. The grisaille palette—black, white, and shades of gray—recalls the "color" and light of the film of the time. As a structure, the filmic concept constructs a drama of collective memory as blasted allegory: a narrative that reads back and forth on levels of art-historical time and metaphysical meaning, and that exists as both painterly and cinematic. In its role as film *Guernica* may allow the hope that we are seeing a momentary horror; as painting, however, the horror is eternalized.

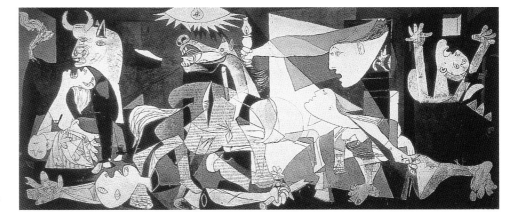

Pablo Picasso, *Guernica*, 1937. Museo Nacional Centro de Arte Reína Sofía, Madrid.

Guernica is also eminently theatrical. Not only do its internal visual mechanics suggest an action on a shallow stage, but in its original installation in the Spanish Pavilion it was placed to be understood as a theater piece—even a giant film screen. To encourage viewing this extraordinary tour de force from a distance, Alexander Calder's *Mercury Fountain* was placed in front of it so that if one wanted to get closer one had to go up to and around the fountain and walk across in front of it. Up close, the painting engulfs one in a darkened space. With its tonal grays and its light, we could be examining a collage of frozen film images. The image is constructed with side walls receding to scrimlike drops and theatrical flats in the back, and with a perspective grid in the floor, but the whole is nevertheless flat and planar. The transparency of the method—the combination of filmic light and overlapping cross-cuts, with linear drawing as the method of transcription—facilitates reflections back over all of art history's treatments of war and violence, even as the painting's title defines it as describing a particular place and time.

To the far right, Picasso has transcribed the figure with his hands up from Goya's extraordinary war painting of 1814, *The Third of May*. The warrior fallen from the horse is a *picador*. The whole is a plea for salvation. The image of horse and fallen figure relates to the Bible story of the conversion of Saint Paul, and the horse's wound suggests that at the center of the representation is the body of Christ. The various crying women have sources in historical paintings of the Crucifixion and Deposition; Picasso often made the women in his art the repositories of sorrow. The pattern of graphic strokes in the painting inscribes the ghost

of newsprint stories like those in the earlier papiers collés, but because they are simply strokes, not words or characters, they have a quality of horrified silence in the face of the savagery of the bombing. The bombing of Guernica was one of the first events to shake the world, not just as an event, but as an event turned into an object, a painting turned into a cry of protest. More than any other image of war, *Guernica* served as propaganda in the fight against fascism, and as a protest against war itself.

Because Picasso asked Alfred H. Barr, his great supporter and interpreter at the Museum of Modern Art, to shelter the painting until Spain again returned to democracy, the work went from the Spanish Pavilion to New York (after a European tour). Exhibited at the Museum of Modern Art, *Guernica* brought home the horror of war to an American audience, and served as a promise of freedom and a moral and artistic conscience for a world in conflict. It was Picasso's great hope that Spain would rid itself of Franco and fascism and that the painting would eventually join the great works in the Prado. In 1981, when Franco was dead and Spain had adopted its present form of government (a democracy headed by a monarch), the picture was returned to Spain, in an event timed for Picasso's hundredth birthday. Its presence in New York in the intervening years was critical to a different kind of freedom: its spirit and plastic ambition were the impetus for the gigantic leap into an entirely new art by the artists of the New York School. The art of Arshile Gorky, Jackson Pollock, and Willem de Kooning is unimaginable without its majestic presence.

Picasso continued to be obsessed with the images of *Guernica* through the summer of 1937. Having made many preliminary studies, he continued to make drawings, paintings, and prints as postscripts. It has been asked over and over why he did not make war pictures, but *Guernica* had said it all when it came to war. In the context of this story, in fact, *Guernica* opened World War II. War in Picasso's work would be described through all sorts of emotions of fear and loss experienced in other places and other times. Picasso's war was lived in the deconstruction of the body.

The Weeping Woman (1937, cat. 99)
The Weeping Woman etching is one of the postscripts to *Guernica* and one of Picasso's greatest prints, in any of its seven states. The figure is of course a *mater dolorosa*. Baer writes that she is in fact Picasso's own mother (though portrayed as Marie-Thérèse), weeping over the terrible events in Spain,[150] which Picasso integrated with his recollections of an earthquake, a terrifying childhood experience. Etching is the perfect medium for working out the emotional details of conflict. Working on the copper plate takes real physical effort; with each push of the burin, each reworking with the scraper, Picasso was reexperiencing a memory of terror and projecting up close the fear of an event taking place at a distance. "His mother," writes Baer, "had written him that her face was covered with soot and her eyes weeping and full of tears because of the convents and churches that were burning in Barcelona." She goes on to tell us that "in the sixth state [of the print], Picasso darkened, 'covered with soot,' his *Weeping Woman*'s face, then he 'cleaned it up' in the seventh state, working with his scraper on the dense drypoint lines as if in a mezzotint, and bringing out the modeling of the eyes, the cheekbone, and the tears."[151] Through the various states of the print we watch grief work itself

out through technique, turning this woman's head into a mask, making her the horror over which she cries, as if she were the masked murderer who was the cause of her own grief—and of her son's art.

Woman with Tambourine (January 1939, cat. 100)
The strange woman in is a reworking of two images, Degas's *After the Bath* (1883–84) and Poussin's *Bacchanal before a Herm* (1632–33).[152] She began as an unstable composite view of the Degas. Like the 1912 figure drawing of the woman with baby, she is seen from the front, with her buttocks swung around. She stands on one leg, bending the other in a dance position with its foot up to her calf. Her face is turned in two directions, her nose on one side, her mouth on the other. Picasso tracks her through a series of etchings in precariously unstable positions until state five, when her left leg (right in the printed image) swings out to balance the long ribbonlike arm that holds the tambourine. It is only a quasi-balance, for even if the figure comes into a tortured equilibrium as a composition against a velvety ground, it still fails equilibrium as a figure. What balance it has is achieved by resort to Poussin's Bacchanal, where a woman dances in the same position (reversed in the print).[153] Perhaps the instability Picasso inscribed in this woman can be traced to a series of outside events: Barcelona was under attack in January 1939, and would surely fall; his mother had died earlier in the month (Baer even speculates that, caught off balance, she fell); Marie-Thérèse was leaving his life, to be replaced by Dora Maar (which may be why the figure in *Woman with Tambourine* is facing in two directions); and Hitler's annexation of Austria in 1938, and the ensuing Munich conference, had made it increasingly evident that Europe was in a precarious state. Picasso was struggling for stability on every front.

Picasso had met Dora Maar in August of 1936. She became his companion the following year, and it was she who helped him to find the studio in which *Guernica* was painted, at 7 rue des Grands-Augustins—the street where the mad painter Frenhoffer lives in Balzac's story *Le Chef d'Oeuvre inconnu*, for which Picasso had earlier produced illustrations. Maar also documented the making of *Guernica* in a well-known series of photographs.

WORLD WAR II

In 1939 the second world war began in earnest with the invasion of Poland and soon engaged all of Europe. France was overrun by the Nazis and capitulated in June, 1940. Picasso chose to remain in France throughout the war and the Occupation. It was forbidden to show his work publicly and he lived and worked quietly, sometimes covertly. The faces and figures of his painted women during these years record sensuality and disfiguring anxiety at the same time, an extension of the disfigurements of the Surrealist years. This is a new kind of human body, one constructed out of disparate images culled from a variety of viewpoints as a pile of cuts and joins. Selected sections of face and body are seen from different viewpoints and joined together or piled up on one another in extremes of expressive anatomical disjunction. Their monstrosity is no longer comical, as it was in the Cubist figures; they are "real" though unrecognizable tortured people, each image

a sort of collective of the disasters of war. The continuous outline drawing allows Picasso to redistribute the parts of the figures, while filmic cross-cutting allows him to pile them up over one another. The mournful gray and white of many of the images tells us that they are at once solid, like modeled clay, and flat projections on the screen of Picasso's imagination. These are creatures of technology, but the materiality of the paint strokes shows that the artist's hand is in control.

In an extraordinary series of eleven lithographs, *The Bull*, (1945–46, cats. 119–129) Picasso slowly sections and strips the animal's body until all that is left is a linear skeleton. Still lifes focus on food and deprivation. Skulls warn of death as an everyday presence—the subject "on the table," so to speak. Picasso's aesthetic is always a politics of the body. Perhaps that is a part of what drew him to Communism, which made such a politics concrete. His initiation into the communion of art and political solidarity had been through Baudelaire's writings about the French communards. This while Baudelaire's communards had been an emotional initiation into the French political spirit as formed through art.

Visitors would come in the morning. Picasso would meet Maar for lunch. Many of his fellow artists had fled, others had joined the Resistance, and increasingly, as the Germans realized they were losing the war and went into a frenzy of reprisals, still others disappeared. In February of 1944, Robert Desnos, an old friend of Picasso's, was arrested and sent to a concentration camp in Germany; he was to die of the typhus contracted by many survivors of the camps just after they were liberated. Also in 1944, Jacob, despite his conversion to Catholicism years earlier, was sent to the camp at Drancy, where he died of pneumonia. Picasso was criticized for not going to Jacob's aide. But Picasso was resigned—fatalistic. He remained untouched by the Germans so long as he did not call attention to himself, perhaps, protected by his legal status as a noncombatant, a citizen of Spain. He had begun to write in a Surrealist style some years before, and he began to stage private readings of his work with those of his friends who remained. In 1944, a group gathered to act in and help him read his play *Le Désir attrapé par le queue*, directed by Albert Camus.

Paris was liberated on August 25, 1944. In October Picasso joined the Communist party. His first postwar exhibition, at the Salon d'Automne—his first inclusion in that salon—was greeted with violent protests. He was defended by his Communist (Surrealist) friends.[154]

Paloma Asleep (December 28, 1952, cat. 149)
In 1943 Françoise Gilot, a beautiful young photographer, visited Picasso in his studio. She soon appeared as an alternative model to Maar. In 1947 she moved into the studio. That year she bore a son, Claude, and then in 1949 a daughter, Paloma. The chubby child in *Paloma Asleep*, flattened and turned up to the plane so that we can appreciate her in all her wondrous boneless infant beauty, is Paloma. There are several wonderful images of Claude and Paloma in the exhibition, including *The Games* (December 25, 1950, cat. 142) and *Two Children with Tricycle* (1951, cat. 143). In late 1953 Françoise left Picasso. Although he lived alone for a while, he had already met a young divorcée, Jacqueline Rocque, at the pottery where he was working in Vallauris. By 1956 her image dominated his life. She became his new lover, his last companion, and, in 1961, his second wife.

THE LATE PICASSO

Epic and Carnival

> *There is no better starting point for thought than laughter; speaking more generally, spasms of the diaphragm generally offer better chances for thought than spasms of the soul. Epic theater is lavish only in the occasions it offers for laughter.*

Walter Benjamin, *The Arcades Project*

In the 1950s Picasso began to drop his mask. For the rest of his life he would be an anarchist celebrating the body, which was at his mercy just as he was subject to its demands, its pleasures, and the memories of both. First the others hidden behind his various disguises emerged as blatant copies; in 1955 he began what became a series of fifteen paintings, *The Women of Algiers after Delacroix.* Then, in the 1960s, Picasso himself emerged as dominant, an aged voyeur, a musketeer/buccaneer dominating a stream of erotic images based on his rivals, of whom he now had taken possession—or by whom he was now possessed. The list of Picasso's others from the 1950s onward includes both old favorites and new ones, but "it is all the same,"[155] as Picasso said in 1947, when he had the opportunity to hang his work in the Louvre alongside that of the Spanish masters he revered, to compare them; and again later to Gilot, looking at works of some of his favorite artists: the body and art, "are raw material to be organized."[156] If everything is the same there is no purpose to masks, to hiding, to pretending to differentiate oneself from others. Everything becomes one. In fact the phenomenon of everything becoming one began shortly after the split with Braque. In the '20s work, Piero is not just Piero, he is Ingres, and he is also Gauguin (the savior of pure outline drawing during late Impressionism) "striving to approximate the effects of Renaissance frescoes, both their decorative strengths and what he saw as their simple 'primitive qualities.'"[157] In the end Picasso would finally find an art without style, an art of pure bodily expression.

Shall we take Rimbaud as a prophet of this late explosion—of Picasso dropping the masks? Rimbaud knew the studios of his time. In the winter of 1871 he followed his friend Forain, a painter, around the Louvre; becoming disgusted with Forain's copying, and "having spared himself a trip to the toilet, he created paintings on the table with the powerful impasto of human excrement."[158] Forain took Rimbaud's insult as a manifesto of modern art: "'We shall tear painting away from its old copying habits and give it sovereignty. The material world will be nothing but a means for evoking aesthetic impressions. Painters will no longer replicate objects. Emotions will be created with lines, colors, and patterns taken from the physical world, simplified and tamed.'"[159] The energy and demonic laughter in Picasso's painted line come straight from his body—they lie in the memory of his whole being, bent to his will, tamed but by no means tame.

In image after image of Picasso's late work, the old, almost dangerously abstract impulses of Neoplatonism and metaphysics are run through the libidinal machine. There is the "cackle of obscene laughter" as Picasso, now resisting mortality, in a final extended burst of vigor replays for us "the vulgar shameless mate-

rialism of the body" and its joys as art.[160] His last years are recorded as quotation after quotation in an extended epic *parade*, staged as a serial drama of the flesh—and of the mastery of it through the obstinacy with which he invests in the act of creation. He now holds the key to his own parade. Carnival, circus, theater, and whatever form he wills, are part of a constant stream of choices, of masks, in which birth and death, high and low, destruction and renewal, instrument and instrumentality, all inscribe themselves in one another and turn back on themselves. It is a parade in which one identity is constantly inscribed in another, yet Picasso always returns to himself. On the one hand, "reason, unity, and identity are just so many superfluous bits and pieces."[161] But on the other, the fracturing of unity now compels a new unification, a reassembly of body parts and the artistic identities transcribed in them as a violent sexual commingling of fantastical forms distorted by desire.

There is a new material repleteness, of art and especially of paint and draftsmanship. But this is not the "old age" repleteness of a Titian, for example, or of Rembrandt, who is constantly mentioned by critics in this context because Picasso does call on him, as we shall see. The body's disarticulation, in earlier years fraught with an anxiety of abstraction in such images as *Man with Mandolin* (1911, Musée Picasso), now displays an obsession with material sensation. Picasso leaves clear traces of every correction, every stroke, with which his images are constructed. Beneath the cackle lies sexual anxiety vested in comic relief. Aura—the numinous shimmer of light—has disappeared into "irrational encounters doing service as tenor and topic."[162] Picasso is ambivalent: he portrays violent undifferentiated sensation, but does not engage in it. He had never had any depth, psychological or otherwise; everything has always been right there on the surface, even the identities behind the masks. He had lived through an era when the wrong identity could amount to an excuse for murder, through several confined wars and two major ones. On the one hand, his work is now a detective story, abounding with contradictory clues to alternate possibilities of identity. The story is one of serial engagement, serial murder, and magical revival. As with Fantômas, identity piles on identity. On the other, the strands of identity become so intertwined as to become unreadable. The story will never end—or so the artist hopes.

Picasso's late work conflates the oppositions and repeats within two motifs, the single figure and the couple, in obsessive and finally hilarious caricatural variations. In the prints, the brothel and the circus recur. In such paintings as *Crouching Nude (Reclining Woman)* (July 26, 1972, cat. 225) the body no longer has any context—it barely fits into the canvas. Its conventions are those of sculptural representation. It derives from the figure in the lower right of the *Demoiselles*, the woman with her back to us and her head skewed around to the front; but this head is a double image, based on two faces kissing—a close-up from a film. We can no longer tell whether we are seeing one figure alone or two embracing. At this point, years after first confronting the puzzling amalgamated front/back image on the lower right in the version of Cézanne's *Large Bathers* in the Philadelphia Museum of Art, and treating it as the stooping woman in the birthing position in the *Demoiselles*, Picasso has his own puzzling formulation of a double figure.

The double view of the head had been part of Picasso's work since the 1930s, and is most familiar to us from the famous *Girl with Mirror* of March 14,

1932, in the Museum of Modern Art, New York. Its transcription into a filmic kiss that brings Picasso together with his sexual other, or with two sides of himself, is repeated over and over. Sometimes two figures kiss; images such as *Child* (1971, cat. 217), with its sexually charged paint, give us male and female inscribed in one head. Each colored line transcribes the memory of its origin, in the pleasures of a sensual body, into an anxiety. Color is deliberately disharmonious, and line is scribbled or crudely broad. Body parts are pushed together, torturously angled and flattened to fit within the internal pattern of the sexually united figure. The ultimate collective, the ultimate unity, is the unity of man and woman; it is also the ultimate disharmony, the ultimate loss of identity, except that the suspension of identity results in a new unity in the ceaseless round of creation.

The line does not simply represent, it transcribes the painter's vitality into the body of work he will leave behind. And as time moves on, anxiety is left behind, and sheer physical joy emerges. There are no more "copies" in the paintings, there is only painting after painting—art by any name—almost to the day he dies. Technical change and mastery are vital aspects of his late parade. Just as some of Leonardo's most extraordinary work lies outside painting, Picasso's prints, which he called a form of writing, are among his most extraordinary late works— and among the most extraordinary in the history of both printmaking and drawing. While the paintings focus on male or female protagonists or both, the prints weave in and out to tell Picasso's story with an entire theatrical cast on stage. They continue to parade his others.

The 347 Suite and the 156 Suite

Picasso begins and ends with the theater and with the philosophical brothel, returning conceptually to what he began in the *Demoiselles*. The drama of La Celestina is finally told in a series of prints; shortly after, the ghost of Rembrandt returns in *Gran Teatro del Mundo*, after Calderón, and sometimes called *Ecce Homo*, because its setting is modeled on Rembrandt's etching of that subject. Both are graven images, each telling the story of one side of Picasso's double face. Celestina is the fates, indiscriminately mischievous, carnal, and worldly in the worst way. She never has to pay for her transgressions. With her one good eye she sees all, with her bad eye she casts a curse. Picasso juxtaposes and marries this story to the holy one, completing his epic drama of man—and, perhaps, creating a parallel in art to the story of his own life.

Picasso made the Celestina images as a group of small prints, the *347 Suite*, which were then reprinted as an illustrated book. Working with the master printer Aldo Crommelynck, Picasso used the same small plates to make the larger multi-image print in the exhibition.

The Tragicomedy of Calixto and Melibea is sometimes called a play, sometimes a novel in dialogue. La Celestina herself is an old hag who suffers from a disease of one eye. Her eye and Picasso's have through the years become symbolic of all eyes—the seer's eye, blind only to see more deeply. La Celestina is the source of the double eye that appears so often in Picasso's work. In the story she is the *duena*, both chaperone and procuress, who contrives to have Calixto meet Melibea, for whom he lusts. (In the prints, Picasso awards Jacqueline the part of Melibea.) She fans their adolescent passion and organizes an elopement while

two *mosqueteros* look on. These two voyeurs, Gert Schiff notes, are the traditional spectators of the early Spanish theater. They are also possibly soldiers of "their most Catholic Majesties? Or are they 'picarized noblemen,' by day leading the life of beggars and robbers and hiding under an ample cape clothes made of filthy rags?"[163] La Celestina's only thought—aside from voyeuristic pleasure, clearly as important a motive—is to make money for herself, her daughter, and her daughter's lover, in part by leading the *mosqueteros* to the local brothel by tempting them with naked women. All three characters are mischief-makers and deceivers of respectable townspeople and—not least, of their two naive protégés—who die without ever having made love. Now, in the prints, Picasso at last gives us this story to which he has so often referred. The ladder, for example, that we have seen through the years appears in one of the last scenes in the book, when Calixto, drawn on by passion, climbs a ladder to take Melibea away, only to fall to his death. Melibea in turn climbs a tower and throws herself to the ground, leaving a suicide note for her father. A number of other deceits and intrigues intervene in the action, keeping things lively. With its plots and subplots, the novel is in the picaresque tradition, and Picasso's prints record a carnal theatrical atmosphere. De Rojas's language—the novel is written in Catalan—is evidently quite colorful.

In the *347 Suite* and its pendant, the *156 Suite*, emotion is invested in technique, as it is in the paintings. A visual scan of these prints is a sensual experience. As Picasso takes control of the story and its mischievous fates, his methods are varied and inventive, ranging from aquatint and etching to "painting" with the sugar-lift technique and to drawing with steel wool. The scenes are invested with a madly haptic vitality of line, alternately suave and savage. Now velvety, now scratchy, the blacks are as colorful as blacks can get.

The *347 Suite* describe a "commingling of times and cultures: musketeers appear in the circus; harlequins in Homeric Greece; Amazons cavort like acrobats or in antique chariots doing acrobatics. As time shifts backward and forward, Picasso sees himself as a child prodigy, attended by the specters of Velázquez and Rembrandt, and by woman, that other source of his inspiration (a majestic mantilla-draped nude, led by La Celestina) . . . he appears as the king of life, with the virility of a Silenus by Rubens."[164] He will appear thus also in the world theater. He is also a "hoary, ivy-crowned satyr, led by the genius of youth amid a group of bacchanalian revelers and *majas*."[165]

La Celestina pops up again and again through the *347 Suite*, and all through the brothels of the *156 Suite*. Fate is never finished with anyone. Perhaps Picasso identifies with La Celestina's remark,

> For now I am a decayed creature, withered and full of wrinkles, and nobody will look at me. Yet my mind is still the same: I want ability rather than desire. Fall to your flag, my masters, kiss and clip. As for me, I have nothing else to do but look on and please mine eye. It is some comfort to me yet to be a spectator of your sports.[166]

In the *156 Suite* Picasso is two years older, and is no longer a participant—he can only look on or pose on the stage of the world theater, while his others and the characters he has created watch also, from the top, the bottom, and the sidelines. In this world there is no heaven and no hell. All pleasure has

its dangers, and human pleasure delights in the forbidden, which heightens it.

The protagonist for the Maison Tellier series is Degas. Picasso, as is now well-known, owned eleven Degas monotypes of scenes in a French bordello. Degas enters the picture as a double for Picasso, aged ninety, and Picasso takes control as he quotes a monotype of Degas that he owned, the earlier artist's *The Madame's Birthday*. Throughout the group, indirectly and, once, directly, Degas looks on from the side as the prostitutes cavort—we are back in a French brothel, as we were in the *Demoiselles*. In an aquatint of April 11, 1971, which follows a run of images in which Picasso makes a hell-house of the brothel, the scene changes. As Schiff writes, "Such is the power of wish-fulfilling vision that, in a transformation worthy of Rimbaud, the whorehouse appears to Degas as an ideal *Hellas* and one of the prostitutes presents herself to him as an Arcadian deity dallying with an infant faun. In the end, with all trappings of civilization removed, he sees the *maison close* as the haunt of primeval humanity."[167] But there may be someone else, or several someones, hiding in the house where Picasso's art began; Rubens comes to mind as one hidden protagonist of these new multifigure compositions, and Poussin and Titian add more layers. Picasso's "late style" is at least a nod to the baroque mastery of the complexities and subtleties of linked-figure composition. The commingling of images of other times and cultures invests these late works with the pagan cosmic forces that had been expressed as personifications in Western art. Pagan ideas once disguised within orthodox Western art, because they were impermissible, now cavort with their masters in this haut bourgeois Parisian fun house.

Style

Is it possible to talk of Picasso and style as such? I think not—even though one can recognize a Picasso as his. What is a style, then? It is a set of procedures, visual habits, and so on, that add up to a distinctive manner and partake of a unified world view; it is a question of identity posited as a singularity. In Picasso's case, although he has an identity, he has no distinctive manner. Instead we recognize mannerisms, habits, and motifs. He has a taste for appearing in disguise, even violating gender distinctions. He has a taste for trading women, and for transforming their identities in the twinkling of an eye. Picasso's eye—allied with his extraordinary hand—is the source of his power. His is an eye to be feared by all—his tool for stealing appearances and their double, the soul.

Picasso's academic training had been too strong to stop at style. It taught him from the beginning that style was a gloss, not the substance or soul of art. His tragedy—his paradox—was that in order to arrive at a collective that could be viewed as an aesthetic "machine" rather than a signatory style, he had to find it not as a collaboration but in the archetype exemplified by van Gogh's solitary journey through the history of art—electing for his artistic collective the dead, rather than the living, and subsuming them to one final subject, himself.

Picasso's art from Cubism onward is not about singular style. It is beyond the idea of style or any unified world view, however arranged, or whether useful to others or not. His ongoing trade—the task initiated by Baudelaire—is to provide an operational base for the miraculous conciliation of disparate if not absolutely contradictory modes. These cross in several conceptual and concrete dimensions: the three dimensions of reality, the two dimensions of painting (if

often mediated by sculpture). The stillness of representation crosses with the movement of life. A primary dimensional cross is that of concept, technique, and body: all three are assimilated to the work of art, not merely as a technical exercise but as the projection of a mystery of human desire.

No matter that an absolute coincidence of these phenomena was impossible, for they moved not only in many dimensions but absolutely outward, as though forming expanding constellations. "In the constellation," writes Terry Eagleton, "drawing, printmaking, sculpture (objects, including pottery) and painting, having been violated and reconformed, now form an array of distinct means deployed 'solely and exclusively in an arrangement of concrete elements in the concept.'"[168] If the "diverse extreme and contradictory elements"[169] of this outward-bound formation could provide no single ground of unity without simultaneously subdividing, then any "style" might prove useful. Any array of styles could be abstracted back to—that is to say analogized to—its primitive equivalences in order to begin the reformation of a new matrix: there is never any difficulty in recognizing Picasso's forms for they are self-similar. As a set of polydimensional matrices, the drawing system developed in Cubism could support gaps and fractures. It was so manipulable that it could assimilate the most significant and insignificant variances and assemble them into a new unity, only to open again to new ones in a constant round of creation and re-creation, a system that constantly dramatized the impossibility of the hoped-for miraculous unification of form and content.

The constellation that Cubism points Picasso toward is an update of Baudelaire's apparent site of unity, of the configuration of Mallarmé's *livre*. Benjamin and Adorno worked in collaboration to formulate the philosophical idea of the constellation. A fuller version of Benjamin's text runs, "Ideas are not represented in themselves, but solely and exclusively in an arrangement of concrete elements in the concept: as the configuration of these elements . . . Ideas are to objects as constellations are to stars . . . they are neither their concepts nor their laws . . . It is the function of concepts to group phenomena together, and the division which is brought about within them thanks to the distinguishing power of the intellect is all the more significant in that it brings about two things at a single stroke: the salvation of phenomena and the representation of ideas."[170] These "stubbornly specific concepts . . . in Cubist style refract the object in myriad directions or penetrate it from a range of diffuse angles."[171] Like Cubism, which may be its model (or at least one of them), Benjamin's and Adorno's constellations preserve the specificity of the detail but fracture identity, exploding the artifact into an array of disparate elements.

Picasso's aesthetic system constellates. As a configuration of elements, an array of sets of representational procedures, habits, and performances drawn from any moment in time, it moves in and out of unity. As an art form rather than a concept it must deal in material elements rather than pure ideas. If none of these material forms add up to a single signature style, they do add up to a collective aesthetic of deliberately disparate manners, all of which play their part in a bid for freedom. Revolutionizing the relationship between the part and the whole, they refuse to be dominated by a false unity—a false totality.

The drawing system designed initially to facilitate the salvation of the subject in the phenomena of perceptual fissures now has the more complex task

of reassembling the torn fragments of the body in the salvation of the human as subject. Picasso's constellating provides a model of the suspension of "identity without canceling it, broaches and breaches simultaneously, refusing at once to underwrite antagonism or supply false consolation."[172] The soul of Picasso's aesthetic is the figure—not that little work of art in itself, the metaphysical figure, which it analyzes to fragments and condemns by laughter early on, but "the mangled body of Baroque drama."[173] Picasso's is an aesthetic constellation of the particulars of the body, a politics of the body. "Since the living body—and the work of art—presents itself as an expressive unity, it is only in its brutal undoing, its diffusion into so many torn reified fragments, that the drama may scavenge for significance among its organs."[174] Picasso's body of art is created as an expressive unity by working through the hysterically comic and "estranging reconfigurations" of its parts, both male and female, as they struggle to reconform.

Dominating the savaged body, Picasso's aesthetic, though ultimately a collective of masks, is by no means anonymous. If the body of his art resists style as such, it nevertheless figures the divided body, the body of movable parts and mutable genders, as a unified system of material operations and formal devices that do not resist the singularity of his eye or the genius of his shaping hand. Picasso's Faustian bargain with the aesthetic is nevertheless a form of redemption: refusing to represent objects in themselves, he will only represent them as a constant rearrangements of events, divesting phenomena of their false unity "so that, thus divided, they might partake of the genuine unity of truth."[175] And so Picasso, despite—or because of—his updated aesthetic of body fragments, refuses to figure the impossibility of art. In fact, as we have seen, integral to his aesthetic of body parts is the salvaging of bits and pieces of the body of art as such. Though his aesthetic continued, in the tradition of the modern, to press the high tradition to which it owed its very existence toward a new extreme of self-destruction, he himself refused to finish that tradition off. In ruins, as tragicomic as he may have created it, however he breached and broached it, the tradition of representation remained his high ground.

Copyright © 2001 Bernice B. Rose

115

The title of this essay is quoted from Terry Eagleton, "The World as Artefact," in *The Ideology of the Aesthetic* (Oxford: Basil Blackwell Ltd, 1990), p. 120. "The World as Artefact" is the title of Eagleton's chapter on Fichte, Schelling, and Hegel.

[1] Ludwig Wittgenstein, *Tractatus Logico-Philosophicus*, 1921 (Eng. trans. London: Routledge & Kegan-Paul, 1972), pp. 7, 15–17.

[2] Charles Baudelaire, *The Flowers of Evil*, ed. Marthiel and Jackson Matthews (New York: New Directions, 1989), p. 30.

[3] Walter Benjamin, "Paris, Capital of the Nineteenth Century: Exposé of 1935," *The Arcades Project* (Cambridge: The Belknap Press of Harvard University Press, 1999), p. 9.

[4] Shelley Rice, *Parisian Views* (Cambridge: The MIT Press, 1997), p. 126.

[5] Baudelaire, "Three Drafts for a Preface," *The Flowers of Evil*, p. 27.

[6] Benjamin, "Paris, Capital of the Nineteenth Century," p. 9.

[7] T. J. Clark, *Farewell to an Idea: Episodes from a History of Modernism* (New Haven: Yale University Press, 1999), p. 175.

[8] Rice, *Parisian Views*, p. 126.

[9] Pierre Rosenberg, *Eighteenth-Century French Life-Drawing* (Princeton: Princeton University Press, 1977), p. 35.

[10] Ibid.

[11] Ibid., p. 35.

[12] James Henry Rubin, *Manet's Silence and the Poetics of Bouquets* (Cambridge: Harvard University Press, 1994), p. 30.

[13] Ibid., p. 30.

[14] There is some uncertainty as to when Picasso actually first saw African art. The date given here is from Pierre Daix, *Picasso: Life and Art*, Eng. trans. Olivia Emmet (New York: Harper Collins, 1993), p. 68.

[15] Rosenberg, *Eighteenth-Century French Life-Drawing*, pp. 35–36.

[16] Daix, *Picasso: Life and Art*, p. 30.

[17] Paul Cézanne, quoted by Émile Bernard in *Conversations avec Cézanne*, ed. P. M. Doran (Paris: Macula, 1978), p. 63.

[18] "The system developed in the watercolors not only dissolved the objects into ambient space but, by so doing, eliminated the material substance that remained the subject of the oil paintings." Lawrence Gowing, "The Logic of Organized Sensations," in William S. Rubin, *Cézanne: The Late Work* (New York: The Museum of Modern Art, 1977), p. 56. "The subject of Cézanne's pictures became the depiction of a profuse universe in the constant process of creating itself as a unified structure; nothing is given, the space and the objects constantly discover and reconstruct one another, there is no a priori system of perspective, the transparent color patch itself usurps the place of the object so that each brush stroke must 'contain the air, the light, the object, the construction, the drawing, the style.'" Maurice Merleau-Ponty, "Cézanne's Doubt," trans. Sonia Brownell, *Art and Literature* (Lausanne), Spring 1965, p. 111, quoted in Bernice Rose, *A Century of Modern Drawing from the Museum of Modern Art*, New York (London: British Museum Publications, 1981), p. 11.

[19] William S. Rubin, "Cézannisme and the Beginnings of Cubism," *Cézanne: The Late Work*, p. 191.

[20] Clark, *Farewell to an Idea*, p. 187. Clark cites a letter from Picasso to Braque of July 25, 1911: "Picasso describes one of his new paintings of the summer, most probably *Young Girl with an Accordion*, as 'very liquid in the beginning and done systematically Signac-style—with scumbling only at the end [très liquide pour commencer et facture méthodique genre Signac—des frottis qu'à la fin].'"

[21] John Golding, *Cubism: A History and Analysis 1907–1914* (London: Faber and Faber, 1959), p. 66.

[22] In Cézanne's *Large Bathers* in Philadelphia, a combination of back and front views can be seen in two figures on the lower right. See Clark, *Farewell to an Idea*, pp. 153–54.

[23] Jonathan Crary, *Suspensions of Perception: Attention, Spectacle and Modern Culture* (Cambridge: The MIT Press, 1999), pp. 228–29.

[24] Ibid., p. 229, citing Denys Hayes, *Greek Art and the Idea of Freedom* (London: Thames and Hudson, 1981), p. 33.

[25] Ibid.

[26] Meyer Schapiro, *Modern Art, Nineteenth and Twentieth Centuries: Selected Papers* (New York: Braziller, 1978), pp. 101–10.

[27] Crary, *Suspensions of Perception*, p. 229.

[28] Benjamin, "Paris, Capital of the Nineteenth Century," p. 8.

[29] Arthur Rimbaud, "Parade," *A Season in Hell and Illuminations*, Eng. trans. Bertrand Mathieu (Rochester: BOA Editions, Ltd., 1991), p. 89.

[30] According to Henri Dorra, Seurat's proportion for *Le Cirque* (1890–91, unfinished, Louvre, Paris) is based on the Golden Section, "that division of a line or proportion of a geometrical figure in which the smaller dimension is to the greater as the greater is to the whole." According to Neoplatonic philosophy, this was an ideal proportion. The connection suggests that Seurat's scientific structure was based in Neoplatonism insofar as the Neoplatonic physical world was seen as emanating from the divine being—to paraphrase Erwin Panofsky, quoting Ficino, Plotinus, and Abbot Suger in *Renaissance and Renascences in Western Art* (1972), pp. 183–88.

[31] Panofsky, citing Suger in *Renaissance and Renascences in Western Art*, pp. 183–88. According to Suger, the artist is charged with the task of providing "manual" guidance that "enables the human mind to ascend through all things to the cause of all things." Neoplatonic philosophy (here Pansofsky quotes Ernst Gombrich) "abolished all borderlines between the sacred and profane" and "succeeded in opening up to secular art emotional spheres that had hitherto been the preserve of religious worship." We can imagine Seurat's work as lit from within by this radiant light: science as metaphysics. We can also make the connection between the drawing and the idea, the conceptual principle of the work preceding its physical execution.

[32] Leo Steinberg, "The Algerian Women and Picasso at Large," *Other Criteria: Confrontations with Twentieth-Century Art* (New York: Oxford University Press, 1972), p. 162.

[33] Benjamin writes, "In Baudelaire's theory of art, the motif of shock comes into play not only as a prosodic principle. Rather this same motif is operative wherever Baudelaire appropriates Poe's theory concerning the importance of surprise in the work of art. From another perspective, the motif of shock emerges in the 'scornful laughter of hell,' which rouses the startled allegorist from his brooding." "Paris, Capital of the Nineteenth Century," p. 383.

[34] Clark, *Farewell to an Idea*, p. 175.

[35] Picasso's studies leading up to the *Demoiselles* include a number that focus on the face. Prostitutes were (and still are) known for the creative individuality of their makeup, which the studies incorporate with the painting of African masks. Baudelaire's essay *The Painter of Modern Life* includes a section titled "In Praise of Makeup." See Baudelaire, *The Painter of Modern Life and Other Essays* (London: Phaidon Press, 1995), p. 31.

[36] Ibid., p. 11.

[37] See Daix, *Picasso: Life and Art*, pp. 68, 82.

[38] Brigitte Baer, *Picasso the Engraver* (London: Thames and Hudson, 1997), p. 23. Even before the emergence of Freudian theories such as Baer depends upon, authors had looked for theoretical and poetic resolutions to perceived dualities. In nineteenth-century literature, for instance, "In the works of Hugo and Baudelaire, duality is often reconciled in the birth of some transcendent being." Mary Lewis Shaw cites Baudelaire's poem "L'Aube" as an example of such a solution, and another occurs in Stéphane Mallarmé's poem "Igitur." See Mary Lewis Shaw, *Performance in the Texts of Mallarmé, The Passage from Art to Ritual* (University Park: The Pennsylvania State University Press: 1993), p. 156.

[39] Baer, *Picasso the Engraver*, p. 23.

[40] In fact she probably has leucoma, a disease of the eye in which an opaque white film covers the eye.

[41] Clark, *Farewell to an Idea*, p. 167.

[42] Baudelaire, "Three Drafts for a Preface," p. xxvi.

[43] Baudelaire, "On the Essence of Laughter," p. 157.

[44] Michele Hannoosh, *Baudelaire and Caricature, From the Comic to an Art of Modernity* (University Park: The Pennsylvania State University Press, 1992), p. 37.

[45] Ibid., p. 38.

[46] Baudelaire, "On the Essence of Laughter," p. 157.

[47] Ibid., p. 54.

[48] Eagleton writes of "a nostalgia for the happy garden in which every object wore its own word in much the way that every flower flaunts its peculiar scent." However, "to mourn the non-particularism of language is as misplaced as regretting that one cannot tune into the World Cup on a washing machine." Eagleton, "Art after Auschwitz," *The Ideology of the Aesthetic*, p. 342.

[49] Eagleton, "The World as Artefact," p. 125.

[50] Ibid., p. 130.

[51] Joseph Meder writes, "The nineteenth century did not so much leave the Age of Reason behind as turn its inquiries from the 'sublime and beautiful' towards taxonomy, the physical sciences, and the sort of aesthetic that culminated in Adolf Hildebrand's *The Problem of Form in Painting and Sculpture* (first edition in German, 1893), still of importantce. The most weighty theories and aesthetics of the century probably have to bow down before Helmholtz, Chevreul, and Daguerre. Admittedly, the Impressionists would have found what they found with or without Chevreul, who gave scientific backing to Impressionism (which has little to do with drawing); but Helmholtz (*Physical Optics*, 1856–66) brought the study of binocular vision and color perception out of the empirical Dürer." Meder, *Mastery of Drawing*, trans. and rev. Winslow Ames, (New York: Abaris Books, Inc., 1978), p. 203.

[52] Arthur I. Miller, *Einstein, Picasso: Space, Time, and the Beauty that Causes Havoc* (New York: Basic Books, 2001), pp. 98–99, quoting Jean-Paul Crespelle, *La Vie quotidienne à Montmartre au temps de Picasso 1900–1910* (Paris: Hachette, 1979).

[53] Natasha Staller, "Méliès' 'Fantastic' Cinema and the Origins of Cubism," *Art History*, 12, no. 2 (June 1989), p. 202.

[54] Josep Palau i Fabre writes, "One of the most evident sources of Cubism is the cinema. From the moment montage is invented, when from one image you can jump to another or from one sequence to another, creating a solution of apparent continuity (in actual fact without a solution of continuity for the spectator), a language is created in which intelligence is understood through the eye. Cinema is based on an act of faith in the intelligence of the spectator superior to that which up to this point has been attributed to him. The cinema spectator understands by seeing, without a need for further explanations. This rupture and this confidence given to the spectator are those which Cubist cinema exploits for—and almost transposes to—painting and sculpture. Picasso had not attended the 1896 sessions of the Cinematógrafo Napoleón in Barcelona for nothing. And if in his Blue Period we see, as has been said before, the influence of silent films regarding the fixation of the world of interior sets, with Cubism it is the specific language of cinema, its syncopated structure, of which advantage is taken. But here the great difference between cinema and Cubist painting also appears. Although the cinema goes from one image to another or from one sequence to another, which apparently have little to do with each other, these images or sequences are shown successively, which the eye captures and transmits to the brain, that then puts them in order and understands them. On the other hand, in Picasso's Cubist paintings and sculptures, the images are offered simultaneously, and it seems that intelligence cannot capture this so rapidly and immediately. Jean Cassou was the first to point out that simultaneity was one of the characteristics of Cubism." Palau i Fabre, *Picasso: Cubism (1907–1917)* (New York: Rizzoli, 1990), p. 12. A great deal more work needs to be done on the relationship of film to Picasso's—and Braque's—development of Cubism. There seems to have been an ongoing transition from photographic examination, as a parallel with Impressionist practice, to a merging of photography into film practices, via Marey and Muybridge, as part of painting's possibilities. But Palau i Fabre does not take the idea any further. In her essay "Méliès's 'Fantastic' Cinema and the Origins of Cubism," written the year before, Staller had already made more specific connections between early Cubism and cinema.

[55] Daix, *Picasso: Life and Art*, p . 83.

[56] Anne Baldessari, *Picasso and Photography: The Dark Mirror*, Eng. trans. Deke Dusinberre (Paris: Flammarion, 1997), pp. 49–62. The catalogue for an exhibition at the Museum of Fine Arts, Houston.

[57] William S. Rubin, "Cézanne and Cézannisme," *Cézanne: The Late Work*, p. 176.

[58] See ibid., p. 178.

[59] Ibid., p. 169.

[60] James H. Rubin, *Manet's Silence*, p. 23.

[61] Ibid.

[62] Clark, *Farewell to an Idea*, p. 180.

[63] Eagleton, "The World as Artefact," p. 129.

[64] Clark, *Farewell to an Idea*, p. 221.

[65] Picasso, quoted in ibid., p. 222, from Françoise Gilot and Carlton Lake, *Life with Picasso* (New York: McGraw-Hill, 1964), p. 76.

[66] Braque, quoted in ibid., from Dora Vallier, "Braque, la peinture et nous: propos de l'artiste recueillis," *Cahiers d'Art*, 29, no. 1 (October 1954), p. 14.

[67] Fernand Léger, quoted in ibid., p. 221–22, from Léger, "Les Origines de la peinture et sa valeur représentive," *Montjoie!*, May 29, 1913, reprinted in Léger, *Fonctions de la Peinture* (Paris: Gonthier, 1965), p. 16.

[68] Picasso, quoted in ibid., p. 222, from Gilot and Lake, *Life with Picasso*, p. 75.

[69] See David Antin, "It Reaches a Desert in which Nothing Can Be Perceived but Feeling," *Artnews*, volume 70, no. 3

[70] Golding, *Cubism: A History* , p. 47.

[71] Meder, *The Mastery of Drawing*, 1, p. 471.

[72] Fred Dubery and John Willats, *Perspective and Other Drawing Systems* (New York: Van Nostrand Reinhold Company, 1972), p. 111.

[73] Photographs of Picasso's studio at the time show paintings sitting on easels with the legs and the lower cross structure clearly visible. The photographs suggest a metaphoric relationship between the easels and the lighter support in *Man with Mandolin* seem metaphorically related. Posed in this manner, the easel becomes a kind of abstract geometric structural element—a sort of incomplete or structural skeleton waiting to be fleshed out or clothed with canvas and paint. At the same time, the easels are metaphors for the scaffolding of Cubist painting.

[74] Picasso made the painting *Bread and Fruit Dish on a Table* (1908–9, Kunstmuseum, Basel) shortly after a much celebrated event, a 1908 feast for Henri Rousseau that was a central moment for the Paris avant-garde. This painting was subject to the same transcription from figure to still life seen in *Still Life with Compote*—the loaf of bread, for instance, was once an arm. Several small studies show the work's inception as a figural scene called *Carnival at the Bistro*, a composition not unlike the *Demoiselles* except for a table with an oval flap facing the plane and placed in front of the figures. The work has been compared with the "Last Supper" compositional type.

[75] See Robert Rosenblum, "Notes on Picasso's Sculpture," in *The Sculpture of Picasso* (New York: Pace Gallery, 1982), p. 7.

[76] Clark, *Farewell to an Idea*, p. 17.

[77] Schapiro, "Seurat," in *Modern Art: Nineteenth and Twentieth Centuries*, p. 108.

[78] Clark, *Farewell to an Idea*, p. 180.

[79] The use of the photographs of the 1908–9 paintings may have some connection to the use of picture postcards as the focal images for films about travel, which were very popular. In any case we know that film had already been on Picasso's mind for many years, and would have been so even through the period of his most "sculptural" painting.

[80] Baudelaire, "The Painter of Modern Life," p. 5.

[81] Rice, *Paris Views*, p. 116.

[82] Ibid., p. 151.

[83] Staller, "Méliès' 'Fantastic' Cinema," p. 202.

[84] Arne Glimcher, in conversation with the

117

author. Glimcher and I have been discussing film as an influence on Picasso's work for several years. He cited the multiple views—and especially the combination of disparate view s of the face and head—as evidence of filmic ideas in Picasso.

[85] André Gaudreault, quoted in Richard Abel, *The Cine Goes to Town: French Cinema, 1896 to 1914* (Berkeley, Los Angeles, and London: University of California Press, 1994), p. 62.

[86] Abel, *The Ciné Goes to Town*, p. 62. The author Abel quotes is Linda Williams.

[87] Ibid., pp. 60–61.

[88] In the fall of 1911 Picasso took a photograph of Marie Laurencin beside *Man with Mandolin*, with a table with several bibelots on of it. The bottom third is still clearly unfinished. According to Clark, "The photograph asks to be taken literally. And it's asking us to see Marie Laurencin as putting the gender of the painting in doubt." More than that, he believes the painting to be a restaging of the Frenhoffer problem because of this struggle for complete resemblance. For Clark, the photograph makes us aware that Cubist painting "stages the failure of representation" and does so in this painting in a particularly literal manner. "It may be that the reason the original *(Wo)man with a Mandolin* stood in need of a supplement was precisely because, inside itself, it failed to stage its own failure effectively enough. It lost hold of the fact that its illusionism, to reuse a phrase from Clement Greenberg, was essentially 'homeless.' It grew too much at ease with surface, and therefore with depth as well. It let the grid be generative, not cramping—extrapolation, not imposition. The grid in Cubism had to be both at the same time." Clark, *Farewell to an Idea*, pp. 189–91.

[89] Shaw, *Performance in the Texts of Mallarmé*, p. 239.

[90] Eagleton, "The World as Artefact," p. 114. In this sense Cubism is a visionary idealism.

[91] James H. Rubin, *Manet's Silence*, p. 27.

[92] Graham Robb, *Rimbaud: A Biography* (New York: W. W. Norton, 2000), p. 83.

[93] Mallarmé, quoted in Robert Greer Cohn, *Mallarmé Igitur* (Berkeley: University of California Press, 1981), p. 21. It is unclear whether Cohn is quoting Mallarmé or Rimbaud, or if this is a phrase of his own.

[94] Eagleton, "The World as Artefact," p. 131.

[95] Ibid., p. 129.

[96] Clark, *Farewell to an Idea*, p. 223

[97] Robb, *Rimbaud*, p. 137.

[98] James H. Rubin, *Manet's Silence*, p. 17. Rubin is paraphrasing Louis Marin, who remarked on the coexistence within the same visual work of two apparently contradictory interpretations: "on the one hand, a painting's flatness makes it seem a mirror reflection of our physical realm, which appears to have an objective existence, independent of our perception. It thus contains forms that appear available for our possession and control. On the other hand, as argued by Michel Foucault, a painting's three-dimensional illusionism creates the effect that what we see exists as a result of our own seeing—it is our own projection."

[99] Ibid., p. 17.

[100] William S. Rubin, *Picasso and Braque: Pioneering Cubism* (New York: The Museum of Modern Art, 1989), p. 33.

[101] Ibid., p. 19

[102] "If any single entity were to be given credit for Rimbaud's coloured vowels, it would be the duplicitous 'Green Fairy.' A doctor writing in a Communard newspaper in January 1872 prescribed small doses of absinthe for those who wished to 'illuminate the mind': 'The most curious thing about the transformation of the sensorial apparatus—the phenomenon, at least, that struck me most forcibly in the experiments I conducted on myself—is that all sensations are perceived by all the senses at once. My own impression is that I am breathing sounds and hearing colours, that scents produce a sensation of lightness or of weight, roughness or smoothness, as if I were touching them with my fingers.'" Robb, *Rimbaud*, p. 135.

[103] In 1930 the Surrealist poet and Communist Party member Louis Aragon, who was close to both Picasso and Braque, wrote one view of the situation, albeit from a considerable distance of time: "I do not know whether it was Braque or Picasso who first, in desperation, employed a wallpaper, a newspaper, or a ready-made stamp to complete or begin a painting which was to make art-lovers shudder, and if, in fact, desperation was the cause. It is probably useless to interrogate these two contemporaries on a priority that is less important than the spirit which initially appealed to glue and to the reality of borrowing. Do the two men themselves remember? I have heard Braque talk about what was then called a certainty—the glued element, around which the painting was to be constituted in a completely different perspective than it would have been had this element been imitated. Having gazed, in the miserable room at the Hotel Roma where Braque was painting, upon the drawings that filled the risks [sic] of the ramshackle partition, I know what emotion could have resided over that choice of paper which this painter suddenly preferred to painting. I am not sure that the justification he gave then really took that emotion into account. In any case, I will never believe (even if Picasso contradicts me) that the same preoccupations, the same rigor or the same arbitrariness, could have directed Picasso's and Braque's hands at that moment, when I can affirm that those two men are so perfectly different and so little reducible to a common denominator." Aragon, *Challenge to Painting* (Paris: Gallerie Goemans, Librairie Jose Corti, 1930), the catalogue for the exhibition "Exposition des Collages." Quoted in Lucy Lippard, ed., *Surrealists on Art* (Englewood Cliffs, N.J.: Prentice-Hall, 1970), pp. 38–39.

[104] Although Braque showed very few drawings, according to Aragon's description of his room above he evidently made many preparatory ones. Ibid., pp. 38–39.

[105] Eagleton, "Art after Auschwitz," p. 356.

[106] William S. Rubin, *Picasso and Braque*, p. 44, quoting Ardengo Soffici.

[107] Hans Rudolf Zeller, "Mallarmé and Serialist Thought," *Die Reihe*, no. 6 (1960), p. 7.

[108] Ibid. Robb writes, "Rimbaud's parodies are dazzling little cameos of street life in their own right, with gorgeous, mouth-filling constructions reminiscent of Baudelaire's early poems." Robb, *Rimbaud*, p. 137.

[109] Zeller, "Mallarmé and Serialist Thought," pp. 7–8.

[110] Shaw, *Performance in the Texts of Mallarmé*, pp. 30–31.

[111] Rosalind Krauss, *The Picasso Papers* (New York: Farrar, Straus and Giroux, 1998, paperback ed. Cambridge, MA: The MIT Press, 1999), p. 36.

[112] Ibid., p. 35.

[113] Staller, "Méliès' 'Fantastic' Cinema," p. 211.

[114] Ibid.

[115] Krauss, *The Picasso Papers*, p. 36.

[116] Ibid., p. 35.

[117] Ibid., p. 36.

[118] Ibid., p. 4. Krauss is quoting Félix Fenéon from Joan Ungersma Halperin, *Félix Fenéon: Asthete and Anarchist in Fin-de-Siècle Paris* (New Haven: Yale University Press, 1988), pp. 35–38.

[119] See Krauss's *Picasso Papers*, pp. 25–85, for more readings of these newspapers. Her complex and subtly structured text deserves reading in its entirety; my references here are to entice the reader into following her into another dimension of thinking about Picasso.

[120] See ibid., p. 78.

[121] Ibid., p. 46.

[122] Jean-Paul Sartre, *Mallarmé or the Poet of Nothingness*, trans. Ernest Sturm (University Park, PA: Pennsylvania State University Press, 1986), p. 89.

[123] Jean Sutherland Boggs, *Picasso & Things* (Cleveland: The Cleveland Museum of Art, 1992), p. 120.

[124] Daix, *Picasso, the Cubist Years, 1907–1916*, trans. Dorothy S. Blair (Boston: New York Graphic Society, 1979), p. 118.

[125] Guillaume Apollinaire, "Pablo Picasso," *Montjoie!*, March 8, 1913, reprinted in *Chroniques d'Art 1902–1918* (Paris: Gallimard, 1960), p. 367.

[126] See Baldessari, *Picasso and Photography*, figs. 144, p. 130 (APPH 3146 in the archives of the Musée Picasso, Paris), and 147, p. 131 (APPH

3147 in the archives of the Musée Picasso).

[127] The "penny novels" are by Pierre Souvestre and Marcel Allain; the films were produced by the Gaumont studios under the direction of Louis Feuillade. Ramon Navarro starred as Fantômas. The novels continued into the 1930s.

[128] The masked man also alludes to many other portrait paintings by Manet, whose portrait subjects have an eery similarity to one another.

[129] James Henry Rubin, *Manet's Silence*, p. 35.

[130] Ingres played the violin as a hobby. He thought he played well; his friends thought he was terrible. Since then, anyone who is gifted in one way but does something else badly is said to have a *"violon d'Ingres."*

[131] In Manet's *Guitar Player*, the guitar is strung in reverse and mirrored, but is not even comprehensible if it is deconstructed according to those rules— it is fabrication.

[132] Baudelaire quoted in Benjamin, *The Arcades Project*, p. 755.

[133] John Golding writes: "Marinetti, accompanied by Boccioni, Carrà, and Russolo, arrived in Paris in the autumn of 1911. Severini, who had not previously met Carrà and Russolo, now took all three Italian painters on a tour of the Paris studios and galleries. By the time that the Futurist exhibition opened at the Galerie Bernheim in February of the following year, Boccioni had reworked his *States of Mind*, a series of paintings which he felt held the key to a new range of subject matter in painting, and Carrà and Russolo had abandoned and destroyed some of their largest pre-Parisian canvases. Futurism's debt to Cubism was universally recognized. Apollinaire pointed out that Boccioni's best works were those in which he came nearest to recent works by Picasso which he had seen in Paris. Hourcade wrote of the Futurist exhibition in the *Revue de France*: 'L'on jurerait qu'un sage disciple des cubistes et un encore plus sage disciple de Signac les ont peintes en collaboration . . . Nos hôtes aux paroles rouges voudraient-ils brûler les musées pour détruire les preuves?' . . . the means by which the Futurists were expressing themselves at this point were largely borrowed from the Cubists, and occasionally, in some less well-informed criticism, the two terms became synonymous." Golding, *Cubism: A History*, p. 42.

[134] See Meder, *Mastery of Drawing*, 1, p. 311.

[135] Ibid.

[136] See William S. Rubin, *Picasso and Portraiture: Representation and Transformation* (New York: The Museum of Modern Art, 1996), pp. 90–109.

[137] Meder, *Mastery of Drawing*, 1, p. 225.

[138] Clark, *Farewell to an Idea*.

[139] Abel, *The Ciné goes to Town*, pp. 62–63.

[140] Ibid.

[141] Max Ernst, "What is the Mechanism of Collage?," 1920, reprinted in Lippard, ed., *Surrealists on Art*, p. 126.

[142] André Breton, "Manifesto of Surrealism," 1924, trans. Richard Seaver and Helen R. Lane, in *Manifestoes of Surrealism* (Ann Arbor: University of Michigan Press, 1969), pp. 9–10.

[143] Aragon, in Lippard, *Surrealists on Art*, p. 50.

[144] Christine Piot with Brigitte Léal and MarieLaure Bernadac, *The Ultimate Picasso* (New York: Harry N. Abrams, 2000), p. 240.

[145] Riva Castleman, *Prints of the Twentieth Century: A History* (New York: The Museum of Modern Art, 1976), pp. 110–11. Castleman writes, "With a brush and a liquid containing sugar, Picasso drew on a copper plate, which was then covered with an impervious thin varnish or asphalt ground that, during the etching period, would prevent acid from attacking portions of the plate not to be etched. . . . For the most part, resin was sprinkled over the open areas in order to obtain an aquatint texture rather than the harsher tone of simpler openbite etching."

[146] Theodor Adorno, quoted in Eagleton, "Art after Auschwitz," p. 351.

[147] Eagleton, "Art after Auschwitz," p. 351.

[148] Ibid., p. 356.

[149] Ibid.

[150] Baer, "Where Do They Come From—Those Superb Paintings and Horrid Women of 'Picasso's War'?," in Steven A. Nash, ed., *Picasso and the War Years: 1937–1945* (New York: Thames and Hudson, 1998), p. 88.

[151] Ibid., p. 88.

[152] See ibid., p. 61. Edgar Degas, *After the Bath*, c. 1883–84, pastel on monotype, private collection, and Nicolas Poussin, *Bacchanal before a Herm*, 1632–33, oil on canvas, The National Gallery, London.

[153] Ibid.

[154] See Judith Cousins, "Documentary Chronology," in William S. Rubin, *Picasso and Braque*, pp. 335–444. See this book for a complete biography of Picasso.

[155] Picasso, quoted in John Russell, "Comrade Picasso," *The New York Review of Books*, vol. XLVIII, no. 6 (April 12, 2001), p. 41.

[156] Eagleton, "Art after Auschwitz," p. 337.

[157] Robert Herbert, "Spirits on Canvas," *The New York Review of Books*, vol. XLVIII, no. 10 (June 21, 2001), p. 43. Herbert notes that Gauguin's "thin flat surfaces were used for what he called 'abstract simplifications of form.' Unlike van Gogh's these simplifications were not based on direct observation of nature. . . . He wanted a synthesis of imaginative forms whose colors and shapes would communicate his own conceptions free of the constraints imposed by naturalism." Herbert appends a note: Gauguin preferred the term "abstract" to "decorative" because art described by the latter term was seen as having a lower status. "Abstract" was a frequently used term in the nineteenth century in its meaning of drawing upon or out of nature. It did not signify an entire divorce from nature, as it came to in the twentieth century.

[158] Robb, *Rimbaud*, p. 146.

[159] Forain, quoted in ibid.

[160] Eagleton, "The Marxist Rabbi," *The Ideology of the Aesthetic*, p. 337.

[161] Ibid.

[162] Ibid., p. 338.

[163] Gert Schiff, *Picasso: The Last Years, 1963–1973* (New York: George Braziller, Inc., 1983), p. 42.

[164] Ibid., p. 47.

[165] Ibid.

[166] Fernando de Rojas, *La Celestina*, quoted in Jeffrey Hoffeld, *Picasso: The Late Drawings* (New York: The Hirschl and Adler Gallery and Harry N. Abrams, 1988), p. 14.

[167] Schiff, *Picasso: The Last Years*, p. 61.

[168] Benjamin, quoted in Eagleton, "The Marxist Rabbi," p. 328.

[169] Eagleton, "The Marxist Rabbi," p. 328.

[170] Benjamin, quoted in Eagleton, "The Marxist Rabbi," p. 328.

[171] Ibid.

[172] Eagleton, "Art after Auschwitz," p. 347.

[173] Eagleton, "The Marxist Rabbi," p. 335.

[174] Ibid.

[175] Benjamin, quoted in Eagleton, "The Marxist Rabbi," p. 328.

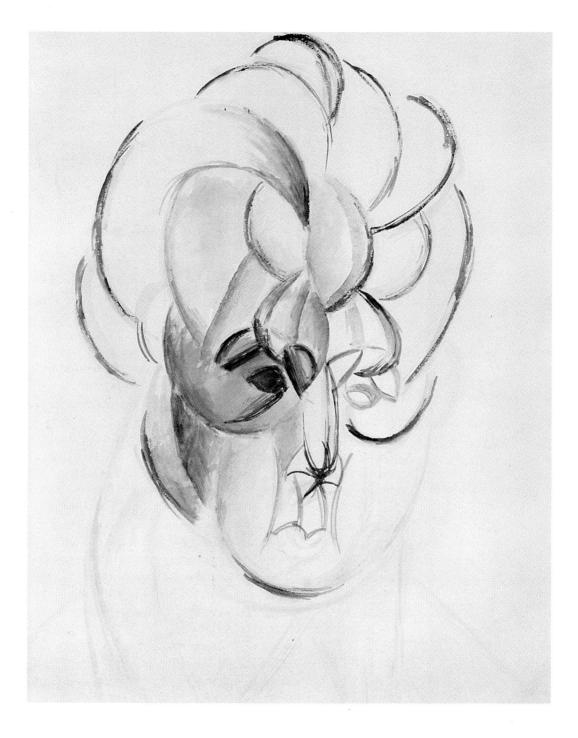

Pepe Karmel

Picasso's Sculpture: The Unstable Self

Pablo Picasso,
Head of a Woman,
1909. The Art
Institute of Chicago,
Alfred Steiglitz
Collection.

The importance of Picasso's sculpture was long obscured by the fact that he retained so many crucial works in his personal collection, with the result that they were rarely exhibited or reproduced. Pioneering accounts by Daniel-Henry Kahnweiler (1948) and Roland Penrose (1967) gave some idea of the breadth of his accomplishment in this medium. More recently, a brilliant series of exhibitions and catalogues, beginning with Werner Spies' 1983 *Picasso Plastiken*, has compelled the general recognition that he was one of the greatest sculptors of the twentieth century.[1]

Viewed from the point of view of his influence on other sculptors, Picasso's most important works fall into the first half of his career. His *Glass of Absinthe* of spring 1914 (cat. 54) stood for many years as the epitome of Cubist sculpture. Its fractured, cutaway sides offered a three-dimensional equivalent to the "transparency" of the broken forms in Cubist painting, while the introduction of an actual steel spoon between the sculpted forms of glass and sugar cube extended into the realm of sculpture the practice of collage, initiated in a canvas of 1912. (Absinthe was a bitter liqueur, which the drinker sweetened to his personal taste by pouring it through a sugar cube suspended on the flat spoon.) Picasso had six bronzes cast from his wax original, finishing each with a different "patina." In the present example, the goblet and interior are painted white, to match the sugar cube, while the base is a bloody red. Its pendant (in the Pompidou Center) has a light-colored base, while the upper part is coated with brown sand. Other examples are painted with the multi-colored dots often found in Picasso's contemporary still lifes. The cut-away form and painted surface of the *Glass of Absinthe* had an especially important influence on Russian artists such as Naum Gabo and Alexander Archipenko.

Another group of important Cubist works, the constructed guitars of 1912–13, languished for many years in relative obscurity; indeed, only in recent decades has their full importance been recognized. Since antiquity, sculptors had defined form either by by molding it from a soft substance or by carving it from a hard block. In both cases, the continuous contours of the finished sculpture echoed those of the human body, with its flexible masses wrapped in an all-embracing skin. Picasso now proposed a radically new way of making sculpture: by constructing it from independent strands and sheets of cardboard or sheet metal, arranged in parallel planes surrounding an open space. Volume replaced mass, and the continuous skin of traditional sculpture broke into a series of disconnected surfaces. This was a solution borrowed from Cubist painting, and the cardboard maquette for the *Guitar* was in fact incorporated into a kind of super-painting: a large relief construction representing a guitar and bottle on a table top, with a fictional wall and chair rail behind them—the group as a whole fastened to the real wall of Picasso's Boulevard Raspail studio.[2] The *Guitar* and the reliefs deriving from it led directly to the constructed sculptures and abstract reliefs of Vladimir Tatlin.

Picasso returned to the technique of constructed sculpture in his 1928 *Study for a Monument to Guillaume Apollinaire* (cat. 69) enlisting the aid of his friend Julio Gonzalez to assemble a figure from steel rods welded together to create a kind of "drawing in space." Apollinaire, a brilliant poet and critic, had died in the influenza epidemic of 1918. Looking for an appropriate grave

121

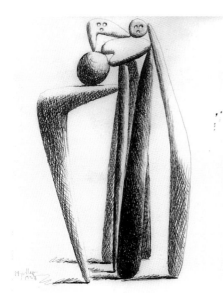

Pablo Picasso,
*Page from Sketchbook
1044 - Surrealist
Figures*, July 27,
Dinard–November
17, 1928, Paris.
Collection Marina
Picasso, courtesy
Galerie Jan Krugier,
Ditesheim & Cie,
Geneva.

122

monument, the committee of his literary admirers turned to Picasso, one of his closest friends. In the event, Picasso's proposals proved too radical for the committee, and his maquette of 1928 was only realized as a full-scale sculpture in 1962. In the interim, however, the maquettes, disseminated by photographs in magazines and books, and followed by larger welded sculptures such as the 1929 *Woman in a Garden*, had irrevocably changed the course of modern art, inspiring the welded works of sculptors such as Alexander Calder and David Smith.[3]

At the same time that he created the open volumes of the *Monument to Guillaume Apollinaire*, Picasso was also exploring the idea of their exact opposite: a series of enormously massive sculptures that would condense the complex forms of the human body into globular forms recalling primitive, amoeba-like organisms. Picasso had originally conceived these, in 1927, as studies for monumental sculptures to be erected along the promenade at Cannes. He then proposed using them as designs for the Apollinaire monument—an idea that the committee immediately rejected. To satisfy himself, Picasso realized two small versions of these sculptures. In both of them, a lumpish, mis-shapen body is supported by radically different appendages—in front, a small, club-like leg; in back, a large swollen foot recalling the oversized feet found in contemporary paintings by both Picasso and Joan Miró.[4] Here too, Picasso's new sculptural idea was disseminated, not by exhibitions but by photographs of the sculptures and of the numerous paintings and drawings associated with them (cat. 72 and *Page from Sketchbook 1044 - Surrealist Figures*). These inspired younger sculptors such as Henry Moore to explore a new style of massive, "biomorphic" forms.

With this handful of works, Picasso transformed the course of modern sculpture. However, they represent only a tiny fraction of his own production in this medium. In Werner Spies's massive catalogue of Picasso's sculpture, they are accompanied by another fifty works created in the years 1902–28, and succeeded by almost six hundred additional works created over the course of another four decades. (And even this total does not include his numerous sculptural ceramics.) The sheer bulk of Picasso's production threatens to bury the critic beneath a mountain of fascinating details, while making it difficult to see the larger profile of the artist's achievement.

The fact that the great majority of Picasso's sculptures date from the later decades of his career also influences the type of criticism they tend to attract. The criticism of Picasso's 1907–14 work—both sculpture and painting—focuses on the formal evolution and historical context of Cubism. From 1914 onward, Picasso criticism becomes increasingly biographical in character: his work is interpreted largely as a reflection of the vicissitudes of his personal life—which is to say, essentially, his love life. It has been argued that this is an inherently flawed way to approach Picasso's work. However, there is no obvious reason why symbols drawn from the artist's life should be considered less meaningful than symbols drawn from his historical or cultural context. If an artist such as Joseph Beuys can construct an oeuvre based on a fictitious personal narrative, why should Picasso be refused the right to treat the *actual* experiences of his own life as a generative myth? The biographical reading of Picasso's sculpture should not displace the formal reading, but it may certainly accompany it.[5]

From what might be termed a mythological point of view, Picasso's love life appears as a long exploration of his complex vision of femininity. "For me, there are only two kinds of women—goddesses and doormats," he told Françoise Gilot.[6] But this was a gross oversimplification. Examining Picasso's paintings and sculptures of his different companions, and the biographical narratives that accompany them, we find a kaleidoscopic range of qualities—tender intimacy, aloof grandeur, maternal tenderness, uncontrollable rage, drowsy eroticism, lacerating suffering—alternating from one representation to the next.

His 1906 *Head of a Woman, Fernande* (cat. 14) evokes the regal beauty that held Picasso in thrall despite their tempestuous relationship. The soft, melting treatment of Fernande's large features recalls the "Impressionist" sculptures of Medardo Rosso, whose elusive contours seem to capture not the forms of the face but the play of light across them. The soft modeling offers a sculptural equivalent for the salmon-colored haze that surrounds Fernande in Picasso's contemporary canvases.

Curiously, Picasso produced no sculpted portrait of Eva Gouel, the quiet, geisha-like companion who displaced Fernande in early 1912. It may be that the disjunctive vocabulary of Cubist sculpture did not lend itself to portraiture—or perhaps the constructed *Guitar*, with its curving sides, was intended as a disguised portrait.[7] Nor did Picasso sculpt his first wife, Olga Khokhlova, whose haughty, aristocratic features gaze from a series of realistic canvases. Other paintings and drawings of the early 1920s explore the tender image of a mother holding a child, although recent scholarship suggests that woman depicted here may be Picasso's friend Sara Murphy rather than his wife Olga.[8]

It was only in 1931, at the apex of his relationship with the young Marie-Thérèse Walter, that Picasso returned to the sculpted portrait. The large heads that Picasso executed at the chateau of Boisgeloup correspond closely to his paintings of the following year, where the nude Marie-Thérèse is shown asleep or in a post-coital trance, her generous body unfolded in a series of curved forms (cats. 84, 85). As John Berger has noted, the "rounded and powerful" nose of the sculpture, flanked by the orbs of the eyes, is a metaphor for the male sexual organ; the "soft, opened, and very deeply modeled" mouth, for the female sexual organ.[9] Discussing the paintings associated with the sculpture, Berger writes:

> "Here for everybody to recognize are William Blake's 'lineaments of gratified desire.' It is no longer possible to say whether these 'lineaments' are an expression of Picasso's pleasure in the woman's body, or a description of her pleasure…In these paintings Picasso is no more just himself: he is the two of them."[10]

In the largest painting of this series, *Girl with Mirror*, Picasso offered a kind of X-ray view of Marie-Thérèse's womb, suggesting that he was concerned not only with the pleasures of sex, but also with creation. "Every artist is a woman," Picasso once said,[11] suggesting that the merger of masculine and feminine elements in his sculpted head should also be read as a symbol for the

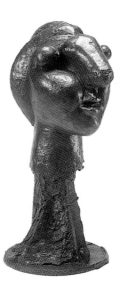

Pablo Picasso, *Woman, Marie Thérèse Walter*, 1931–32 (cast 1973). Patsy R. and Raymond D. Nasher Collection, Dallas. Photo David Heald, The Solomon R. Guggenheim Museum.

123

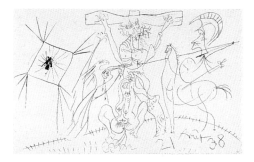

Pablo Picasso,
Crucifixion, 1938.
Museé Picasso,
Paris.

combination of male and female in the creative process. The paintings of the sleeping Marie-Thérèse may also touch on the theme of creativity: Picasso would certainly have remembered the Surrealist "epoque des sommeils," when dreaming was seen as the key to the unconscious, and the poet Robert Desnos, retiring for a nap, would hang a sign on his bedroom door announcing: "Poet at Work."

In the late 1920s, Picasso's paintings and drawings had frequently opposed the rounded, yielding forms associated with Marie-Thérèse Walter to the angular, threatening shapes associated with Olga, his estranged and resentful wife. Picasso and Olga separated definitively in 1935, but by now he seems to have become accustomed to the emotional rhythm of alternating between two women. In summer 1936 he began a relationship with Dora Maar, a brilliant but troubled photographer associated with the Surrealists. "Dora, for me, was always a weeping woman," he told André Malraux. Her image corresponded, for Picasso, to his deep-rooted belief that women were "suffering machines."[12] For the rest of the decade, the image of Marie-Thérèse would alternate with the image of Dora, distorted into a kind of Cubist monster. The motif of the weeping woman played a key role in the composition of *Guernica*, Picasso's anti-war canvas of 1937. It found comparatively little expression in the medium of sculpture.

However, the theme of profound suffering is anticipated, in disguised fashion, in the *Head of a Warrior* of 1933 (cat. 81). At first glance, this sculpture, depicting a Roman soldier with a large round nose and an even larger crest, seems like a purely comic figure, linked to Picasso's illustrations for a deluxe edition of Aristophanes' satire *Lysistrata*, in which the women of two embattled cities put an end to a the war by refusing to sleep with their soldier husbands until they make peace. In one related study, Picasso depicts himself as a warrior with a crested helmet, shaking hands with his foe (*Study for "Lysistrata*," December 31, 1933). However, as Werner Spies observes, the motif of the soldier with a crested helmet is also a recurrent feature of a long series of studies, executed in 1929–31, depicting the Crucifixion.[13]

A bizarre coda, drawn in August 1938, seems to expose the psychosexual underpinnings of Picasso's interest in the motif (see the *Crucifixion* of 1938 reproduced above). The crucified Christ howls at heaven, with His head tilted back and His tongue extended—a gesture borrowed from the grieving mother in *Guernica*. A Roman soldier with a crested helmet pierces His side, and a woman rushes forward to drink the spurting blood. In a profoundly blasphemous gesture, a nude Mary Magdalen crouches at Christ's feet, reaching out to stroke Him to orgasm, while she flings herself backward, farting explosively. The equation between extremes of pain and ecstacy, here expressed in caricatural form, seems to reflect Picasso's involvement with Georges Bataille and his group of dissident Surrealists.[14]

The agony of the 1930s came to a long-overdue conclusion with the end of World War II. By this time, Picasso had found a new companion, Françoise Gilot, who combined the intelligence, creative talent, and sensuality he had previously sought out in different women. In *Guernica*, Picasso had transformed Dora Maar's suffering into a symbol of Fascist aggression. He now reversed the process and drew on his own emotional rebirth to symbolize the

rebirth of European society, depicting Gilot as a blooming *Woman-Flower* (May 5, 1946, Private Collection). This was accompanied by a series of sculptures of flowers rising with extraordinary vitality from pots and watering-cans (cat. 150). Blossoms cast from cake tins spoke eloquently of the sweetness of life.

Picasso and Gilot had a son, Claude, in 1947, and a daughter, Paloma, in 1949. By 1950, however, their relationship had begun to sour, and Gilot declined to bear Picasso another child. His sculpture of a *Pregnant Woman*, cast in two slightly different versions (cats. 146, 147) seems to have represented a kind of "wish-fulfillment," as Gilot remarked in her memoirs. The couple were living in Vallauris, an important center for pottery, and the sculpture's full breasts and belly were modeled around clay pitchers.[15] The two continued to share their love for their children, and Picasso's paintings capture touching scenes of Gilot teaching Claude and Paloma to draw (cat. 155).

With the breakdown of his relationship with Gilot, Picasso's imagination seems to have turned back toward the image of aloof, reserved beauty that he had found in his first wife, Olga Khokhlova. In spring 1954 he encountered a young woman, Sylvette David, who provided the model for a series of figures drawn with black and white paint on sheets of folded sheet metal (cat. 156). But it was another woman, Jacqueline Roque, who was destined to play the part of Picasso's ultimate muse, depicted at first in a grave "Egyptian" profile that echoed the forms of the Sylvette sculptures (*Portrait de Jacqueline Roque aux mains croisées*, June 3 1954).[16]

This sequence of emotionally charged images provides an essential framework for any analysis of Picasso's sculpture as a whole. To fill in this frame, however, we need to look at the formal problems that preoccupied Picasso throughout his career.

Picasso liked to claim that he was an artist without a style.[17] This is not literally true: despite all his changes of style, a painting or sculpture by Picasso is instantly recognizable. What does seem to be true is that he was not *interested* in style. What preoccupied him, instead, were the absolutely basic problems of his medium. In painting, this was "the representation of the three-dimensional and its position in space on a two dimensional surface," as his friend and dealer, Daniel-Henry Kahnweiler, wrote.[18] Sculpture did not involve a translation from three dimensions into two, but it posed its own problems. One was traditional: how was the sculptor to arrange and articulate a series of masses in space? Another was new: how was the pictorial vocabulary of Cubism—lines and planes—to be translated back from two dimensions into three?

Many of Picasso's most powerful works confronted the old problem of massing. Although the figuration of works such as the 1928 *Female Figure (The Metamorphosis)* (cat. 68) and the 1931 *Heads* (cats. 84, 85) as revolutionary, their alternation between positive masses and negative volume remained deeply traditional. In between these appears a series of works that strain the traditional relation of mass and volume to its limit. These are the "stick figures" executed in 1931 (cats. 79, 80), just before Picasso embarked on the massive *Heads* of Marie-Thérèse. As Alfred Barr noted, these may have been inspired by archaic Etruscan bronzes.[19] The tall narrow format of these

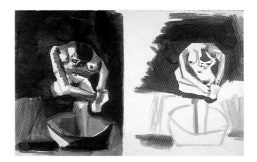

Pablo Picasso, *Two Women Washing*, July 1944. PaceWildenstein, New York.

125

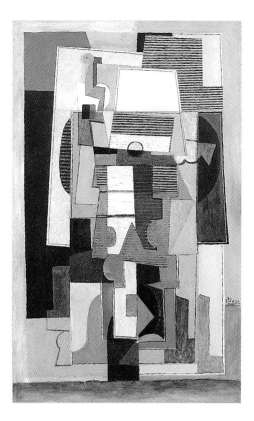

126

Pablo Picasso,
*Table, Guitar and
Bottle*, 1919.
Northampton
(MA), Smith
College Museum of
Art, purchased
Sarah J. Mather
Fund, 1932.

works evoked a kind of hieratic authority, but it also posed specific formal problems. How far could the literal mass of a sculpture be reduced without losing its ability to evoke the mass of the human figure? And how could the extremely shallow modeling imposed by Picasso's choice of materials—discarded sections of picture frames, later cast in bronze—be deployed to create a sense of dramatic contrast between different parts of the body? Some of these sculptures seem to anticipate the emaciated figures that Giacometti would begin making during World War II. Equally significant is the way that a formal discovery such as the consolidation of nose and brow into a single form, balancing the mass of the cheek (cat. 79), is immediately reprised by Picasso at a monumental scale (see fig. on p. 123).

Other sculptures reduce articulation to a minimum in order to explore the effects of pure massing. The face and nose of the 1933 *Head of a Warrior* are virtually shapeless; instead the effect of the sculpture depends on the contrast between their rounded forms and the flattened expanse of the crest. In *The Skull (Death's Head)* of 1943 (cat. 118), the bowling ball of the cranium is combined with the rounded planes of the face, as crude and simple as a welder's mask. Eyes, nose and mouth are indicated by simple indentations. Despite its modest size, the work has the terrifying density of a neutron star, sucking everything around it into its gravitational field.

In the optimistic post-war era, Picasso looked for ways simultaneously to affirm and deny the reality of sculptural mass. Beyond the contingent biographical reasons that led him to settle near Vallauris, he seems to have been drawn to the medium of ceramics because it allowed him to make works that were visibly hollow. Even cast in bronze, a work like the 1946 *Vase/Face* (cat. 131) is less massive than the stick-like sculptures of 1931 (cats. 79, 80). The familiar contours remind the viewer of the lightness and hollowness of a traditional vase. The seductiveness of the piece also reflects the economy of its symbolism. The bent-over spout becomes a nose that is also a phallus (like the nose of the 1931 *Head of a Woman*); at the same time the overall contour of the piece suggests a woman bending forward, as in Picasso's war-time drawings of a woman washing her feet (*Two Women Washing*, see fig. p. 125) or in his 1954 painting of Françoise Gilot and her children (cat. 155).

The *Little Girl Skipping Rope* of 1950 (cat. 148) denies mass in another fashion, suspending the large rounded form of the girl from a thin rope that seems obviously inadequate to support it. The uncanny negation of gravity anticipates more abstract works of the 1960s, such as Robert Grosvenor's *Tapanga*, where one leg of the sculpture is firmly planted in the earth while the other stops short of the ground, dangling outrageously in mid-air. The solution to the mystery, in both cases, is hidden engineering: photographs of the *Little Girl* in progress reveal a thick steel bar that would be concealed within the irregular twists of the "rope." However, the work offers a second, visual explanation: the girl's torso is formed from a pair of lightweight wicker baskets—light-weight, that is, until they were cast in bronze. Picasso's practice of sculptural *collage*, transforming inanimate objects into a living figure, seems to reverse the process, often visible in his paintings, drawings, and graphic work, by which a narrative composition with human figures is transformed into an iconic still life.[20]

However, much of Picasso's sculptural production is devoted to exploring the unstable border between sculpture and its sister medium, painting. This problem is most obviously addressed in Picasso's reliefs, such as his 1937 *Composition with Table and Apple* (cat. 107), whose deployment of three-dimensional elements in a two-dimensional setting looks back to the artist's constructions of 1913–14. The corrugated cardboard that appears at the center of the relief seems to have attracted Picasso because it provided a three-dimensional, ready-made version of a pictorial convention—the parallel lines used by nineteenth-century engravers to represent shadow. Corrugated cardboard thus made it possible to "represent" shadow on the surface of a three-dimensional sculpture or relief.

This material in fact conceals a reference to Picasso's long dialogue with Georges Braque, for it was Braque who first used corrugated cardboard in a papier collé of 1914. Returning from his military service in World War I, Braque made two additional papiers collés employing the material; in several drawings done for Pierre Reverdy's journal, *Nord-Sud*, he then translated the long parallel lines of the cardboard into a purely graphic pattern indicating shaded areas.[216] Picasso adopted this graphic device in a monumental still life, *Table, Guitar, and Bottle* (see fig. p. 126) painted in 1919. Thereafter, corrugated cardboard or its painted imitation became a regular feature of Picasso's work.[22]

This dialogue between three- and two-dimensional forms was also pursued in the figurative details of Picasso's sculptures. As early as 1909, in his proto-Cubist *Head of a Woman* (Chicago Art Institute), he seems to have worked the surface of the sculpture in two fundamentally different ways. For the most part, he shaped it into geometric equivalents for the forms seen in a preparatory drawing: the braids of the hair, the bulges of the brow, the beak of the nose, the tendons of the neck, and so on. In other areas, however, he treated the mass of the sculpture as a surface to be incised with graphic signs that described three-dimensional features without actually reproducing their forms. For instance, the eyelid on the right is defined as a projecting ridge above a hollowed-out eye, while the other eyelid is indicated by a deep-cut gouge above a solid mass where the eye should be. Many years later, Picasso told Françoise Gilot:

> "Everything is unique. Nature never produces the same thing twice. Hence my stress on seeking the *rapports de grand écart*: a small head on a large body; a large head on a small body. I want to draw the mind in a direction it's not used to and wake it up. I want to help the viewer discover something he wouldn't have discovered without me. That's why I stress the dissimilarity, for example, between the left eye and the right eye."[23]

The 1909 *Head* offers an early example of this principle, awakening the viewer's mind by using contrary forms to depict the exact same thing. The unrealism of one representation casts doubt on the realism of the other. If the gouge on one side of the face is an artificial "sign" for an eyelid, so too is the ridge on the other side.

It is thus at this moment, in 1909, that Picasso begins to explore the

Pablo Picasso,
Guitarist (Study for Construction?),
1912.
Musée Picasso,
Paris.

127

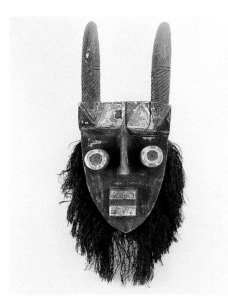

Pablo Picasso,
Grebo Mask. Musée
Picasso, Paris.

idea that sculptural forms can be signs or emblems rather than more or less faithful reproductions of real forms. Critics usually date this discovery to several years later, linking it to the Grebo mask (fig. at left) that inspired Picasso's constructed *Guitar* of fall 1912 . Kahnweiler describes this mask as a sign system that evokes the human face without resembling it. "The volume of the 'seen' face," he adds, "is inscribed nowhere in the 'true' mask, which provides only the outline of this face. The volume is seen somewhere before the real mask. The epidermis of the seen face only exists in the consciousness of the viewer who 'imagines' or creates the volume of the face *in front* of the plane surface of the mask."[24]

This imagined (or "virtual") facial plane is already an important element in the 1909 *Head*, where the lower part of the face has been deeply cut away at either side of the mouth and nose. The naturalistic contour of the face is indicated, in these areas, by the narrow ridges descending from eyes to jaw. The gouged-out areas between ridges, mouth, and nose provide shaded areas from which the mouth and nose emerge more saliently. (They may also be meant to reveal the internal volume of the head, as in *The Glass of Absinthe* of 1914).

If the "sign" begins to play an important role in the 1909 *Head*, it is not as a fixed or conventional unit of meaning. The gouge above the right eye may be a sign for "eyelid," but the gouged-out areas of the lower face are not signs for anything in particular. They are blank spaces, equivalent to the blank areas in Picasso's preparatory drawing (see fig. p. 120)—places where the machinery of representation ceases to function. Reconciling the sculpture's "positive" forms, its inscribed signs, and its blank spaces, to recreate a coherent image of a human head, requires the viewer's active participation—the "beholder's share," as E.H. Gombrich called it.[25] Throughout his career, Picasso requires the viewer to participate in this manner. In his *Female Figure (The Metamorphosis)* (cat. 68) of 1928, for instance, one breast is indicated by a projecting bulge, while the other is indicated by a curve and dot inscribed on the lower part of the figure. It is the viewer who must recognize that these are alternative ways of representing the same anatomical feature.

The formal developments of 1910–12 Cubism posed an even more radical challenge to traditional ideas of sculpture. Picasso's new compositions were constructed from lines and planes—one- and two-dimensional shapes—arranged in a three-dimensional space. This paradoxical combination was resolved in painting by limiting the depth of the depicted space, so that the floating lines and planes preserved a meaningful relationship, not only to the four framing edges, but also to the front and back planes of the composition. Picasso recreated this shallow, projective space in relief sculptures such as the 1912–13 *Guitar*. But it was not obvious how to justify an arrangement of flat shapes in a free-standing sculpture. One solution was to take as a model the arrangement of flat shapes in familiar objects such as furniture. As early as summer 1912, Picasso sketched a design for a Cubist woman constructed around the armature of an easel *Guitarist (Study for a Construction?)*(see fig. p. 127), Musée Picasso, Paris. This too remained a recurrent motif throughout his career. His standing *Man* of 1958 (see fig. on next page), for instance, evokes the same image of an easel.[26] The issue of

hollowness is here transformed by the disappearance of the sculpture's enclosing skin. The central core of the figure is explicitly revealed to be an empty volume.

The philosophical implication of this transformation is that there is no fixed core to human identity.[27] This idea is further addressed in Picasso's folded-metal sculptures of the 1950s and 1960s. Some of these, like the *Sylvette* of 1954, return to the pictorial syntax of 1908–9 Cubism, where recognizable forms are fractured and bent into distinct facets without quite breaking apart into independent planes. It is in these years that Picasso begins to represent bodies and objects simultaneously from multiple viewpoints. Within the perspectival conventions of Renaissance painting, with their insistence on a single, fixed viewpoint, this seems like a revolutionary innovation. However, the belated translation of 1908–9 Cubism into three-dimensional form provides a reminder that sculptors had long been preoccupied with the problem of multiple viewpoints: since Bernini, at least, they had attempted to create works that did not depend on a frontal viewpoint, but offered a *series* of satisfying compositions as the viewer circumambulated the sculpture. This corresponds, in effect, to the perception, in Baroque and modern literature, that human beings do not have a single, fixed personality, but reveal new aspects of their selves as they interact with different people and respond to new situations.

The problem of the knowability of the self is brought into sharpest focus in sculptures where Picasso offers the viewer two mutually incompatible viewpoints—a theme that emerges in the late 1950s and culminates in works such as the 1962 *Woman's Head* (cat. 172), which served as an initial study for the monumental *Head* erected in the Chicago Civic Center in 1967. As Werner Spies writes, one aspect of these sculptures cannot be predicted from another: they institute a "permanent destabilization" of the self.[28] In a larger sense, this destabilization—forcing us to reconsider our knowledge of the world and of our selves—seems to have been Picasso's goal throughout his long and extraordinarily productive career as a sculptor.

Pablo Picasso,
Man, 1958.
Private Collection.

129

1 See Daniel-Henry Kahnweiler, *Les Sculptures de Picasso* (Paris: Les Éditions du Chêne, 1948); Roland Penrose, *The Sculpture of Picasso* (New York: The Museum of Modern Art, 1967); Alan Bowness, "Picasso's Sculpture," in Roland Penrose and John Golding, eds., *Picasso in Retrospect* (New York: Praeger, 1973), pp. 122–55; Ron Johnson, *The Early Sculpture of Picasso, 1901–1914* (New York: Garland, 1976); Werner Spies, with Christine Piot, *Picasso – Das plastische Werk* (Berlin: Gerd Hatje, 1983), reissued in French and English as *Picasso: sculpteur* (Paris: Centre national d'art et de culture Georges Pompidou, 2000)—this superb catalogue raisonné is the *sine qua non* for all subsequent work on Picasso's scuplture; Carmen Giménez, ed., *Picasso and the Age of Iron* (New York: Guggenheim Museum, 1993); Elizabeth Cowling and John Golding, eds., *Picasso: Sculptor/Painter* (London: Tate Gallery, 1994); Marilyn McCully, ed., *Picasso: Painter and Sculptor in Clay* (New York: The Metropolitan Museum of Art, 1998).

2 See William Rubin, *Picasso in the Collection of The Museum of Modern Art* (New York: The Museum of Modern Art, 1972), pp. 74, 207–8; Edward Fry, "[review of] Pierre Daix and Joan Rosselet, 'Picasso: The Cubist Years,'" in *The Art Journal*, vol. 41, no. 1 (Spring 1981), pp. 92–93; Werner Spies, "La guitare anthropomor-phe," *Revue de l'art*, vol. 12 (1971), pp. 89–92; Pepe Karmel, "Beyond the 'Guitar': Painting, Drawing, and Construction, 1912–14," in Cowling and Golding, eds., *Picasso: Sculptor/Painter*, pp. 189–97.

3 See Roland Penrose, *Picasso: His Life and Work* (London: Victor Gollancz, 1958), pp. 49, 206–37; Penrose, *The Sculpture of Picasso*, pp. 21–22; Rubin, *Picasso in the Collection*, p. 128; Bowness, "Picasso's Sculpture," p. 139.

4 On the significance of the swollen-foot motif in Picasso's work, see Lydia Gassman, *Mystery, Magic and Love in Picasso, 1925–1938: Picasso and the Surrealist Poets* (New York: Columbia University PhD dissertation, 1981).

5 See Rosalind E. Krauss, "In the Name of Picasso," first published in *October*, no. 16 (Spring 1981); reprinted in Krauss, *The Originality of the Avant-Garde and Other Modernist Myths* (Cambridge: MIT Press, 1985), pp. 23–40; Krauss, "Life with Picasso: Sketchbook No. 92, 1926," in Arnold Glimcher and Marc Glimcher, eds., *Je suis le cahier: The Sketchbooks of Picasso* (New York: Pace Gallery, 1986), pp. 113–23; William Rubin, "Reflections on Picasso and Portraiture," in William Rubin, ed., *Picasso and Portraiture: Representation and Transformation* (New York: The Museum of Modern Art, 1996), pp. 12–109; Benjamin H.D. Buchloh, "Beuys: The Twilight of the Idol, Preliminary Notes for Cri-tique," originally published in *Artforum*, January 1980; reprinted in Buchloh, *Neo-Avantgarde and Culture Industry: Essays on European and American Art from 1955–1975* (Cambridge: MIT Press, 2000), pp. 41–64.

6 Françoise Gilot, Carlton Lake, *Life with Picasso* (New York: McGraw-Hill, 1964), p. 84.

7 Spies, "La guitare anthropomorphe."

8 William Rubin, "The Pipes of Pan: Picasso's Aborted Love Song to Sara Murphy," in *Art-News*, vol. 93, no. 5 (May 1994), pp. 138–47.

9 John Berger, *The Success & Failure of Picasso* (New York: Pantheon, 1965), p. 160

10 Berger, *The Success & Failure of Picasso*, p. 158

11 This remark, made by Picasso to Genevieve Laporte, is cited in Marie-Laure Bernadac and Androula Michael, eds., *Picasso: propos sur l'art* (Paris: Gallimard, 1998), p. 131.

12 André Malraux, *Picasso's Mask* (New York: Holt, Rinehart and Winston, 1976), p. 138

13 Werner Spies, *Picasso: sculpteur*, pp. 195 and 206.

14 Although the overt sexual activity emerges only in the 1938 drawing, Mary Magdalen's contorted and suggestive posture is already an important feature in Picasso's drawings of 1929–30. See the studies reproduced in Brigitte Léal, *Musée Picasso: Carnets: Catalogue des dessins*, vol. 2, no. 38 (Paris: Réunion des musées nationaux, 1996), pp. 41–43 and 46–50. These

are alluded to with some embarassment in in Alfred H. Barr, *Picasso: Fifty Years of his Art* (New York: The Museum of Modern Art, 1949), p. 167. One drawing from this series (Z. VII, 29) was reproduced in Bataille's journal, *Documents*, vol. 2, no. 3 (1930), p. 169; it is there dated to 1926, but this is probably a misprint for 1929. Bataille's brief essay, "Mouth," published in *Documents*, vol. 2, no. 5 (1930), p. 299, contains the observation that: "Terror and atrocious suffering turn the mouth into the organ of rending screams. On this subject it is easy to observe that the overwhelmed individual throws back his head while frenetically stretching his neck in such a way that the mouth becomes, as much as possible, an extension of the spinal column, *in other words, in the position it normally occupies in the constitution of animals*." (Translated in Georges Bataille, *Visions of Excess: Selected Writings, 1927–1939*, ed. Allan Stoekl [Minneapolis: University of Minnesota Press, 1985], p. 59) Bataille's description seems directly to anticipate the screaming heads of *Guernica* and of Christ in the 1938 drawing of the *Crucifixion*. On Bataille and the visual arts more generally, see Rosalind Krauss, "Corpus Delicti," in *October* 33 (Summer 1985), pp. 31–72; reprinted in Rosalind Krauss and Jane Livingston, *L'Amour Fou: photography & surrealism*, exh. cat. (Washington and New York: The

Corcoran Gallery and Abbeville Press, 1985), pp. 36–192.

[15] Françoise Gilot, Carlton Lake, *Life with Picasso*, p. 320.

[16] William Rubin, "The Jacqueline Portraits in the Pattern of Picasso's Art," in William Rubin, ed., *Picasso and Portraiture*, p. 458.

[17] See Picasso's remarks to André Verdet 1963, cited in Doré Ashton, *Picasso on Art: A Selection of Views* (New York: Viking Press, 1972), pp. 95–96.

[18] Daniel-Henry Kahnweiler, *The Rise of Cubism* (New York: Wittenborn, Schultz, 1949), p. 7.

[19] Alfred-H. Barr, *Picasso: Fifty Years of his Art*, p. 172. See also Spies, *Picasso: sculpteur*, pp. 156–57.

[20] See Bernice Rose's discussion, elsewhere in this volume, of Picasso's tendency to transform figure compositions into still lifes; and William Rubin's groundbreaking essay, "From Narrative to 'Iconic' in Picasso: The Buried Allegory in 'Bread and Fruitdish on a Table' and the Role of 'Les Demoiselles d'Avignon," in *Art Bulletin*, vol. 65, no. 4 (December 1983), pp. 615–49.

[21] In Braque's 1914 papier collé, *The Mandolin* (M.-F./C. 52), a strip of corrugated cardboard indicates the strings of the mandolin. In two works of 1918, *Bottle and Musical Instruments* (M.-F./C. 55) and *Guitar and Clarinet* (M.-F./C. 57), the material introduces a new texture

without having a specific figurative value.

[22] Studies for the Smith College still life appear in the carnet reproduced in Léal, *Carnets*, no. 22, pp. 28, 29, 30, 32. The narrow parallel lines of corrugated cardboard are also reproduced in 1925 paintings such as *The Dance* (Tate Gallery, London) and *The Embrace* (Musée Picasso, Paris), while the actual material is deployed in several sculptures of 1933, such as the *Leaning Woman* and the *Woman with Leaves*.

[23] Françoise Gilot, Carlton Lake, *Life with Picasso*, pp. 59–60.

[24] Daniel-Henry Kahnweiler, *Les Sculptures de Picasso*, n.p.

[25] E.H. Gombrich, *Art and Illusion: A Study in the Psychology of Pictorial Representation* (Princeton: Princeton University Press, 1960), "Part Three: The Beholder's Share."

[26] Werner Spies, Christine Piot, *Picasso: sculpteur*, note 690, points out a series of 1954 drawings that provide the immediate antecedent for this sculpture.

[27] On the philosophical implications of this formal issue, see Rosalind E. Krauss, *Passages in Modern Sculpture* (Cambridge: MIT Press, 1977), chapters 2 and 7.

[28] Werner Spies, Christine Piot, *Picasso: sculpteur*, p. 286.

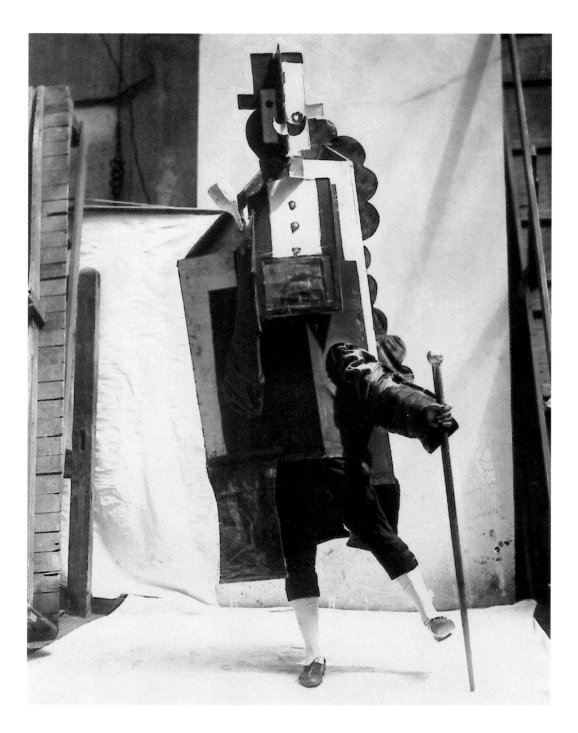

The *parade* is an old European tradition. A traveling theatrical troupe marches through the streets, performing to lure the public into their show. In full make-up, costume, and character—and accompanied by their brassy, hawking managers—they entertain so that people will enter. It is a moving advertisement, a tease.

Parade, the new ballet that the Parisian audience saw on May 18, 1917, inserted this brash, low form of popular entertainment into the realm of Diaghilev's supremely elegant and refined Ballets Russes. And it was a shock on several levels. From square one, it jarred this arty audience to see a Chinese Conjuror, a Little American Girl, and a pair of Acrobats—music-hall or vaudeville fare at best—at the Théâtre du Châtelet. To make matters worse, these three acts were being competitively touted by their coarse managers right on stage. Tasteless!

These three ungainly entrepreneurs were encased in outrageous get-ups ten or eleven feet high—startlingly, these were Cubism in three dimensions! The first, the haughty French Manager, was boxed from top hat to knees in a cardboard construction all angles and planes, like sandwich boards, with a dark row of curves scalloping down his back. The second, the American Manager, moved inside a stiff paperboard contraption of soaring skyscrapers and protruding cylinders, with spiky nautical flags bristling down his left side. These awkward constructions matched the rather primitive painted backdrop—an enormous Cubist painting! Its dynamic building facades and balustrades all tilted and pressed toward its center, the site of an off-kilter painted proscenium arch with its white curtain. This powerful backdrop's airless, angular outdoor cityscape clashed with the classical lyre and scroll atop the proscenium. Are we outside or inside? And this was the beautiful Paris, city of light skies and chestnut-lined boulevards?

The bizarre Third Manager embodied still further incongruity: the old gag of two men inside a canvas costume to imitate a Horse. A complete mis-match to his body, this creature's razor-sharp Cubist head is the anatomy and spirit of the animal reduced to a handful of geometric elements. The horse was supposed to carry a stuffed mannikin Manager in a tuxedo, but it kept falling down; so the horse itself became the Manager, both silly and fierce.

This was but one of many changes in the artistic evolution of this production, whose originator, the avant-garde poet Jean Cocteau, had conceived of as a circus ballet with a brash, contemporary tone. Naturally for him, elaborate spoken parts for the Managers were important features in his scenario. When Picasso came on board, this changed, along with much else. He wrenched the production into a more modernist—and more shocking—direction.

To the patrons, the visual assaults of Picasso's astounding Cubistic Managers' costumes and backdrop were especially disturbing following the evening's introductory, gentle show curtain—a warm, idyllic dream of performers at rest, lullingly like his Rose and Blue Period scenes of *saltimbanques*.

Eric Satie's music too, so pure and delicate in style, now popped with

Naomi Spector

Notes on Picasso's Designs for *Parade*

*Composition:
the Two Managers
and the Horse*, 1917,
detail.
Bibliothèque
Nationale de France,
Paris.

133

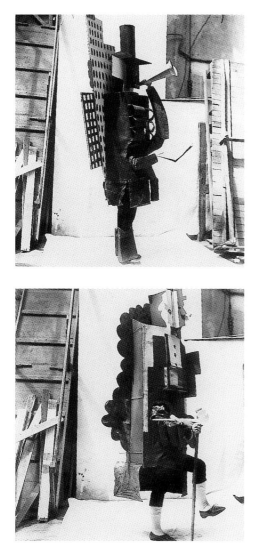

The American Manager (reconstruction 1994–95). Photograph of the original costume, ca. 1917. Bibliothèque Nationale de France, Paris.

The French Manager (reconstruction 1994–95). Photograph of the original costume, ca. 1917. Bibliothèque Nationale de France, Paris.

quotes from ragtime and with noises from "modern life"—sirens, tapping typewriters, gunshots. A charm bracelet carved of pearl, dangling gears and bullets.

Even Diaghilev's favored choreographer of the moment, the young, immensely talented Léonide Massine, responded imaginatively with movements that his traditionally schooled dancers needed to retrain themselves to realize. They had to mime a magician's tricks, modern modes of transportation, and acrobatic language; and they were required to act, not just dance, sometimes in outfits that constricted and dictated their actions.

The American and French Managers' topsy-turvy cardboard architectures not only boxed in the dancers inside them from the legs up, they almost doubled their height, limiting their body-awareness. Moreover, they had to find their way around the stage using only the costumes' small "windows." Fortunately, short-sightedness and lack of grace suited these characters admirably! But of course their bumptious staggerings about the stage were actually artful and distinctive choreography. The point is that the disjointed style of dancing followed the disjunctive style of the Cubist designs. As for the horse, the looseness of its cloth costume allowed an ordinarily stiff creature to move, and even to sit down, with a degree of elegance, further proving how wittily Massine had tuned into the modernist spirit.

But of greater historical importance than their aptness to the scenario, was the very presence here, for the first time, of stunning, fully realized three-dimensional Cubism.

Such extremely innovative and masterful sculpture would have been startling anywhere. On the stage, and on <u>this</u> stage in particular, the breakthrough was aesthetically and historically compounded. Cubism's famous multiple viewpoints were taken further by the possibility of actual three-dimensional viewing—not to mention the fact that these sculptures were meant to <u>move</u> in 360 degrees.

The front plane of the French Manager's top-hatted *tête* is white on the left and dark on the right, with his curly mustache in reverse tones. His body's intersecting planes and right angles accumulate into an irregular assemblage that reads both as construction and character. The right arm is hugely disproportionate, emerging apparently from the figure's hip. From its scrunchy-sleeved extension, the dancer's small hand wields an exaggeratedly long cane. His triple-length left arm emerges from the same level and reaches straight up to the chin, its tiny wood hand grasping an oversize white clay pipe. All the rectangles are offset by three round shirt buttons, brighter than the figure's one eye. Perhaps he is winking, or blind. But certainly, with its dark curving cape in addition to the entrepreneur's other attributes—top hat, cane, and mustache—this figure is the image of Diaghilev.

The bottom of the cardboard "box" of this sculpture-portrait is fabric, to allow the dancer's legs at least some right-angled stamping. This was a practical innovation but also one that might indicate Diaghilev's flexibility underneath all the stiff pomposity. Far beyond mere caricature, this

figure, though it is comical, pays tribute to that outrageously successful entrepreneur in its very radicalism, three-dimensional Cubism.

The American Manager's architecture is more pictorial and his head more abstracted. Dark-on-light and light-on-dark windowed skyscrapers clutch the figure's back, as if they had jumped on him from the painted backdrop. Rows of sideways cylinders make up his chest—rippling muscles? machine parts? His hands are positioned like the French Manager's, but he holds a placard in his right and a toot-toot megaphone in his left. There is a feeling of more advanced modernity in the American Manager, something more mechanistic. The difference in the legs is telling: the Diaghilev figure shows the dancer's legs and feet in white stockings and black shoes, so familiar in dance history. The American's legs are stiff cardboard shapes, extending the denial of the natural body even further physically and symbolically.

The horse is an exceptional case. Both frontally and in profile its Cubist head is a masterpiece of planar abstraction. It is a part which is also a whole, and it combines masterful formal organization and intense emotion. Its head/body incongruities intensified when it walked with its unforgettable waddling gait or when it reared on its hind legs.

In reality, a theatrical manager's job of communicating between artists, patrons, and audiences has great inherent difficulties. Belonging to no group, a manager must understand and attempt to satisfy everybody, and at times is resented by everybody. Working in the theatre for the first time may have jolted Picasso into an awareness of a manager's multi-directional position and disposition. His own fascination with the exercise of personal power may have been excited by a new understanding of the shifting complexities of a manager's roles and the ever-present possibility of real disaster. It was, after all, in the creation of *Parade's* Managers that these extraordinary Cubist masterpieces came about. We may never know what stimulated Picasso's imagination and will in 1917, but possibly the collaborative encounter with the powerful Diaghilev raised the creative temperature.

Satie had finished composing the music for *Parade* before Diaghilev took other collaborators to Rome to work early in the spring of 1917. Even earlier, however, in Paris, the composer saw that Cocteau's plans for the ballet's scenario were becoming overshadowed by Picasso's ideas. And his influence did not stop there.

Massine's spellbinding choreography for himself as the Chinese Conjuror perfectly caught Picasso's modernist spirit as well as the essence of a popular show magician. Introduced by the French Manager, this dance was full of right angles and straight lines and had a certain mechanical tone. In contradiction to the costume's silky fluidity and light puffiness, the dance's geometrical and lateral movements suggested a flat physique, with limbs that gestured independently. The geometric movements of this prestidigitator, and his exaggerated, mask-like facial expressions, emphasized his dehumanization. Throughout his act, he exerts total hypnotic suspense, from his astounding stiff entrance leaps until his final disappearance. He backs out into the white rectangle framed by the backdrop's painted proscenium,

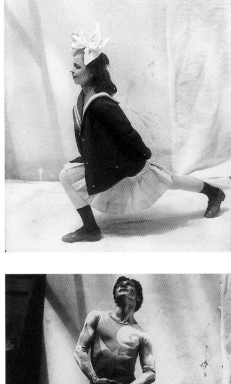

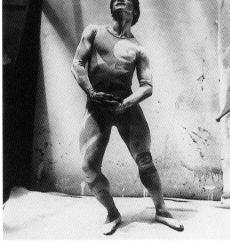

135

The Little American Girl (reconstruction 1994–95). Photograph of the original costume, ca. 1917. Bibliothèque Nationale de France, Paris.

The Acrobat (reconstruction 1994–95). Photograph of the original costume, ca. 1917. Bibliothèque Nationale de France, Paris.

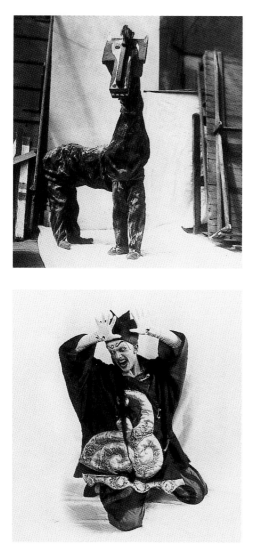

receding as if to a vanishing point. This finale climaxed the cinematic feel of a solo danced mainly in front of that rectangular white "movie screen" under the painted proscenium arch.

Introduced by the American Manager, the Little American Girl's eager temperament and whiz-bang energy most embodied the ballet's modern American jazz-age themes. She is advanced from a feminist viewpoint too, with her self-driven independence, her unalluring dress, and her fearless participation in every new prospect of modern life. Romance just doesn't come into it, not even flirting. Brave new whirl-wind.

The horse introduced the third act, the Acrobats. Except for the animal's superb Cubist mask, this act of the ballet seems to have been the most lyric in style. And yet this very incongruity contributed a further disjunction to the production.

So, in scenario, music, choreography and especially in its design elements, the entire ballet was filled with the hallmarks of Cubism—inter-cut, interrupting images, multiple viewpoints, and perhaps most upsetting the abrupt presence of elements from ordinary life. Cubist paintings and collages had been known to the *cognoscenti* for years, but never before in the theatre, and certainly not in three dimensions. Even Cubism's characteristic layered building-up of planes towards a painting's center was echoed in the backdrop's pictorial structure. Pressed by dynamic angles from both sides, its central painted proscenium arch was the focus of the visual and theatrical action.

In the ballet's interior narrative, the clumsy managers, after the brashest efforts, fail to bring in an audience; and they collapse. Faced with this, the performers themselves give it the old troupers' try; but they too fail. This "unhappy" ending was perhaps the final surprising reversal of the audience's expectations—though it must have been rather funny too.

In certain respects, such as this flop at the end of the performance, the story of the making of *Parade* seemed to mirror its internal structure. For despite the artists' enthusiasm, the *première* was not an immediate success with either the audience or the critics. In retrospect, probably it was not Cubism's visual innovations that disturbed people, but the incongruity of seeing low forms of art and elements from ordinary life as part of the ballet, a high art. Perhaps this misperception is one of art history's many "shocks of the new." In any case, importantly, it is precisely the transformation of these elements into the practices and effects of high art that marks *Parade* as a cultural landmark.

The tradition of making art of images and objects from daily or commercial life stretches at least from Impressionism through Pop; but *Parade* was the break-through in the theatre. The Ballets Russes' first project completely outside Russian artistic traditions marked a new historical position for the company. The producers signaled this redefinition by subtitling the production, "A Realist Ballet in One Act." In the program notes, Apollinaire even coined the term "*sur-réalisme*" for it!

A further delightful clue to the work's high artistic ambitions was announced by the American Manager. He struts on stage with flags flying, and in his right hand is a placard that reads,

The Horse (reconstruction 1994–95). Photograph of the original costume, ca. 1917. Bibliothèque Nationale de France, Paris.

Léonide Massine as the Cinese Conjuror, 1917. Bibliothèque Nationale de France, Paris.

PA

RA

DE

Parody! Far from a mere re-presentation of variety acts, the ballet is a thoroughly worked-out new conception on the subject of theatre. *Parade* is an artistic achievement of the highest order on the part of its presiding genius, Diaghilev, all its collaborators, and probably most of all, Picasso.

The process of shaping the production also mirrored the ballet's internal structure in that the artists' egos, intrigues, and rivalries reflected the characters' bombast and competitiveness. Cocteau hoped that his original idea of a circus ballet would launch his career with the Ballets Russes at last. Diaghilev had hesitated, famously putting off the Frenchman with, "Surprise me, Jean." In the event, through a tortured labyrinth of maneuvers among the group's "friends," and to his lifelong pride, Cocteau did enlist Picasso along with Satie; and in the end the collaboration succeeded.

Almost as soon as the planning began, Picasso's ideas were favored over Cocteau's, and not only for the costumes and decor. With Diaghilev's agreement, the poet's extensive speaking parts for the Managers, based mostly on advertising spiels, were eliminated. The Spaniard's powerful talent, and his equally gargantuan will to dominate things, inevitably made his the defining voice.

Bold and mocking, his presence was also marked by an intensity of commitment. Endless sketches and drawings attest to the complete seriousness and dedication he gave to the development of his ideas. These works on paper also indicate that from beginning to end a fascinating and crucial split persisted in his designs. The show curtain, the Chinese Conjuror, the Little American Girl, and the pair of Acrobats exemplify the artist's relatively traditional, representative tendencies. These were undoubtedly refreshed by the trip that the collaborators took to Naples during the weeks before the opening. There, leaving socializing with patrons to the others, Picasso spent time in bordellos and collecting prints and postcard images of Neapolitan folk figures and *Comedia dell'Arte* characters. These old Mediterranean traditions were among the sources for the costumes for the magician, the American Girl and the gymnasts—the sources the artist seems never to have put aside completely, even as he avidly mastered more radical directions.

The Conjuror's clothing is a glorious version of a typical Chinese magician's garb of its period. The costume is simplified and intensified and as red and yellow as the flag of Spain, but it is not a new idea. Also a stereotype, the navy blue middy top and white pleated skirt for the Little American Girl were finally just bought off the rack. Only her huge white hair ribbon remained from all Picasso's frillier sketches. In opposition to this specificity, the Acrobats' blue and white leotard designs, as tenderly rendered as the figures on the show curtain, are the ballet's most generalized—and prettiest. You can imagine their wearers tumbling around time-

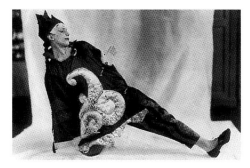

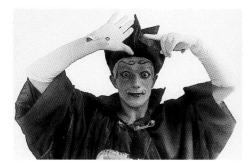

Léonide Massine as the Cinese Conjuror, 1917. Bibliothèque Nationale de France, Paris.

Léonide Massine as the Cinese Conjuror, 1917. Bibliothèque Nationale de France, Paris.

137

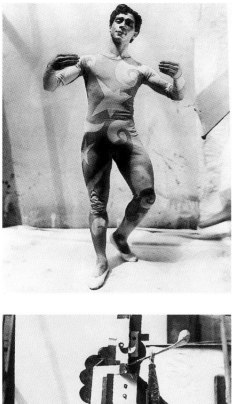

Nicolai Zverov as the Acrobat, 1917. Bibliothèque Nationale de France, Paris.

The French Manager, 1917. Bibliothèque Nationale de France, Paris.

lessly in their realm of clouds and blue space.

At the same time, Picasso's more masculine appetites produced the crunchy Cubistic masterpieces of the backdrop and the Manager's get-ups. They shout Picasso's mastery of advanced style and flaunt his perfect grasp of scale for the stage. All the more impressive is the zig-zag mix of the two visual styles through the ballet's three acts, demonstrating his grasp of the theatre's psychological, as well as formal, requirements.

After opening night, some critics complained that Picasso should have decided on one style or the other. True, pairing the two styles was a risk—perhaps the most radical decision of all—but with Olympian confidence he succeeded. He must have foreseen the rightness of using opposing styles in a story-ballet structured on artistic and commercial oppositions.

Beyond the success of Cubism on the ballet stage and of its effective face-off with more classical themes, one further aspect of the designs deserves notice. This is the wit, the irreverent humor, that we taste throughout the ballet, like delicious salt. It sparkles in innumerable details, such as the goofy crossed eyes of the horse's menacing head and brush-jabs of the backdrop's shrubbery—utterly dotty. Likewise, around the skyscrapers there is some doodling: foliage? clouds? or just some carefree loop-de-loops? Picasso pokes fun at anything: the bosses, pointillism, even masculinity. The *Managers'* prosthetically extended arms are suggestively exaggerated protrusions that function merely to hold up a clay pipe or a little megaphone, attributes neither hot nor effective.

Maybe there was a Spanish aspect to Picasso's need to dominate the Ballets Russes, including his conquest of the dancer Olga Khokhlova. (Cocteau's subsequent affair with another company dancer reflected his now imitative position.) Perhaps also the physical aspect of dance itself—body art—magnetized so direct and sexual an artist as Picasso. Temperamentally, he influenced the Ballets Russes to the point that their subsequent ballet, *Le Tricorne* (*The Three Cornered Hat*) was based enthusiastically on Spanish music and dancing, with of course new Spanish designs by Picasso. Further, his work with the company continued in the years ahead with *Pulcinella* and *Cuadro Flamenco*.

Perhaps his competitive need to be first was fueled also by his sense of himself as an artist and therefore an outsider. In any case, he did dominate *Parade*, in a grand telescoping succession. He must have been aware of his great achievements, because his vision in the ballet reaches beyond being the leader into a secure aesthetic arena in which tenderness was also possible. It is fascinating and touching to see that for once, on this "realistic" stage, all the macho toughness, the immense creative energy, the superb radical advances are in a kind of active equilibrium-of-conflict with the artist's older, humanistic artistic interests. Both *Parade's* narrative and its visual manifestations suggest in the end that the two forces' battle goes on forever. *Vive l'opposition!*

Today we can feel the spatial and kinetic tingle of standing bodily close to the grand painted backdrop and the three-dimensional Cubistic characters once brought to life by the exquisite dancers of the Ballets Russes. But the ultimate reward, the lasting power of such painting and sculp-

ture, lies in the dialogue between the themes envisaged by the artist and the tensions and reverberations they excite in us. These inner aesthetic dynamics concern truth, belief, the old, the new, the high consciousness and the playful spirit. Picasso's art for *Parade* challenges our senses, our minds, and our bodies to reach for new understandings of the endless ways we experience and imagine our existence—ways that are strong, surprising, and often terribly funny.

The American Manager, 1917. Bibliothèque Nationale de France, Paris.

Catalog

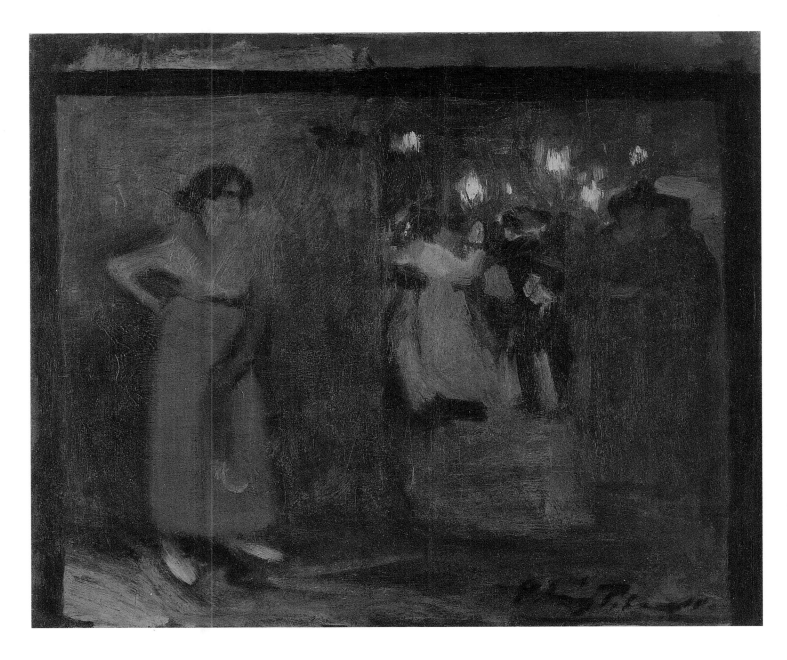

1 **Woman Observing the Party** (1898–99)
Estate of the Artist

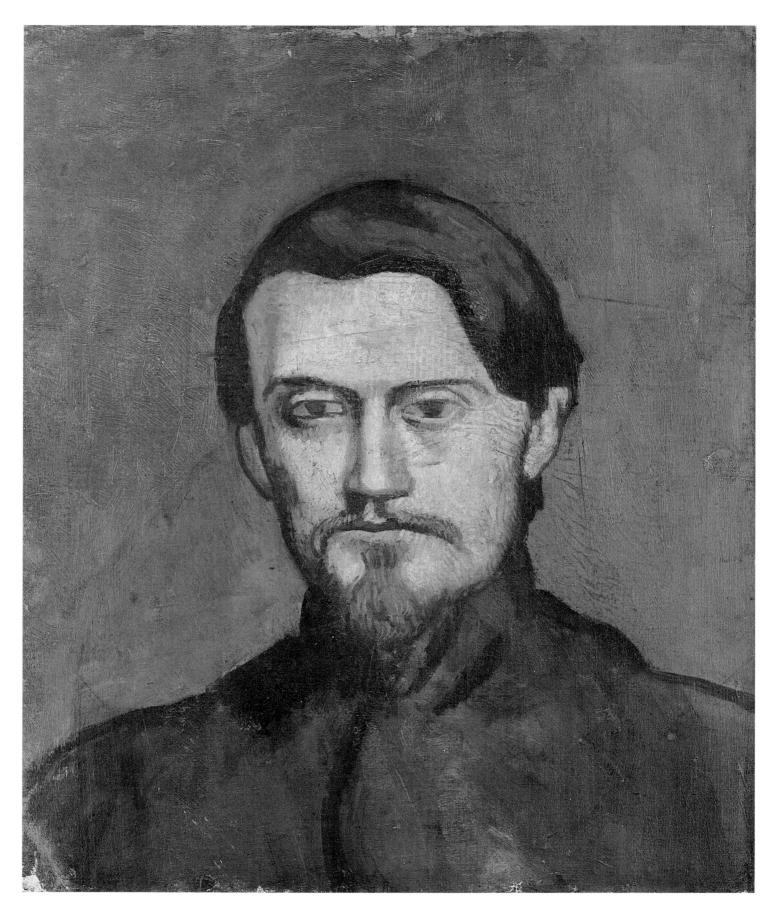

2 Mateu Fernández Soto (1901)
Estate of the Artist

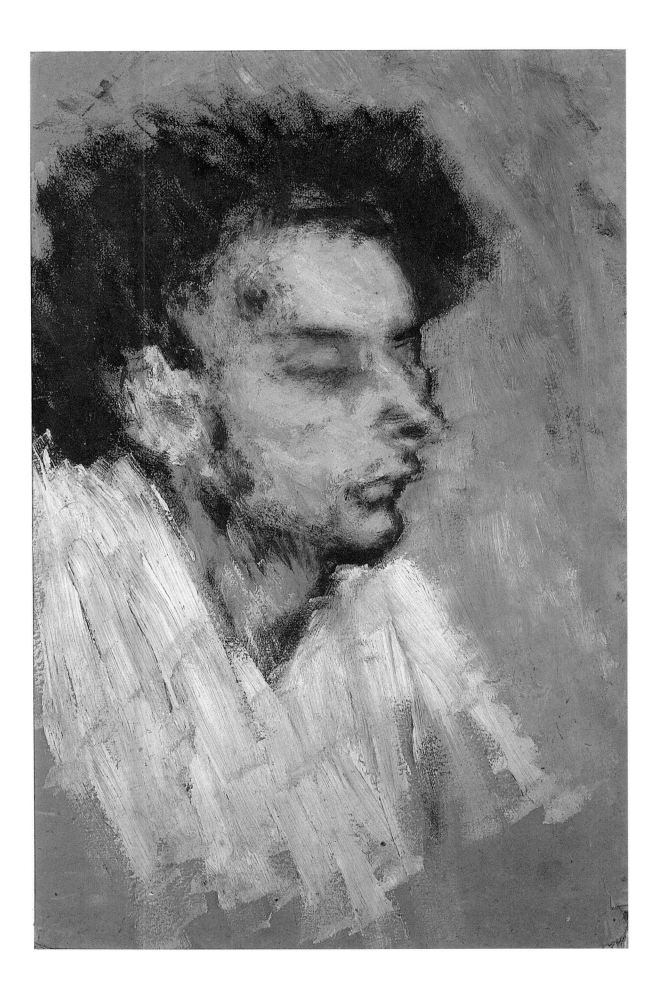

3 **Dead Casagemas** (1901)
Estate of the Artist

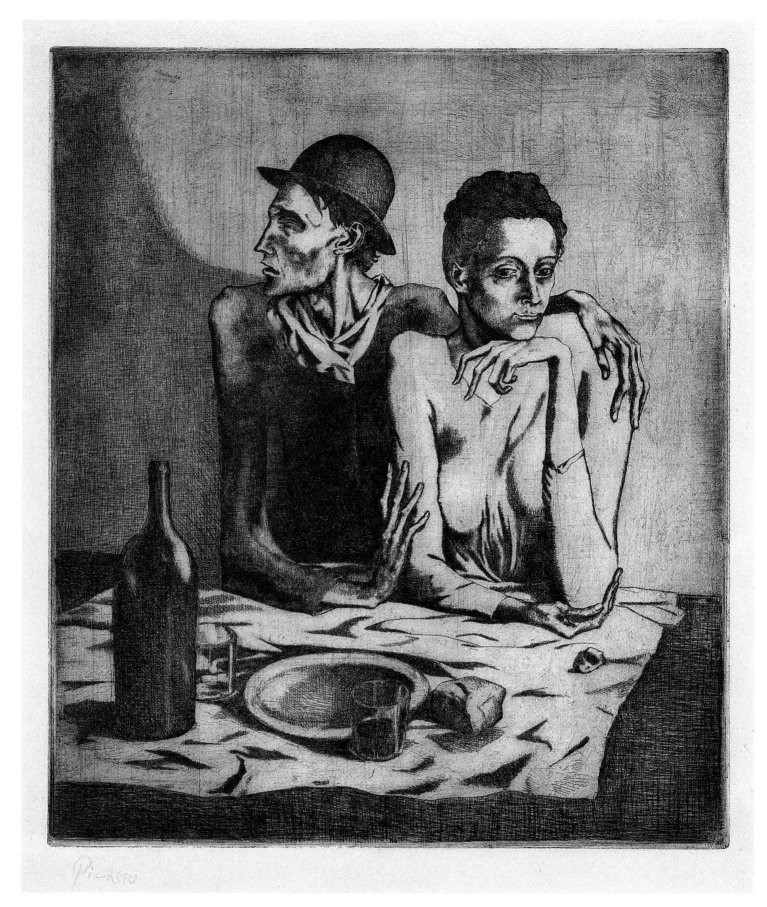

4 **The Frugal Repast**, second state, 1904
Francey A. and Dr. Martin Gecht, Gecht Family Collection, Chicago

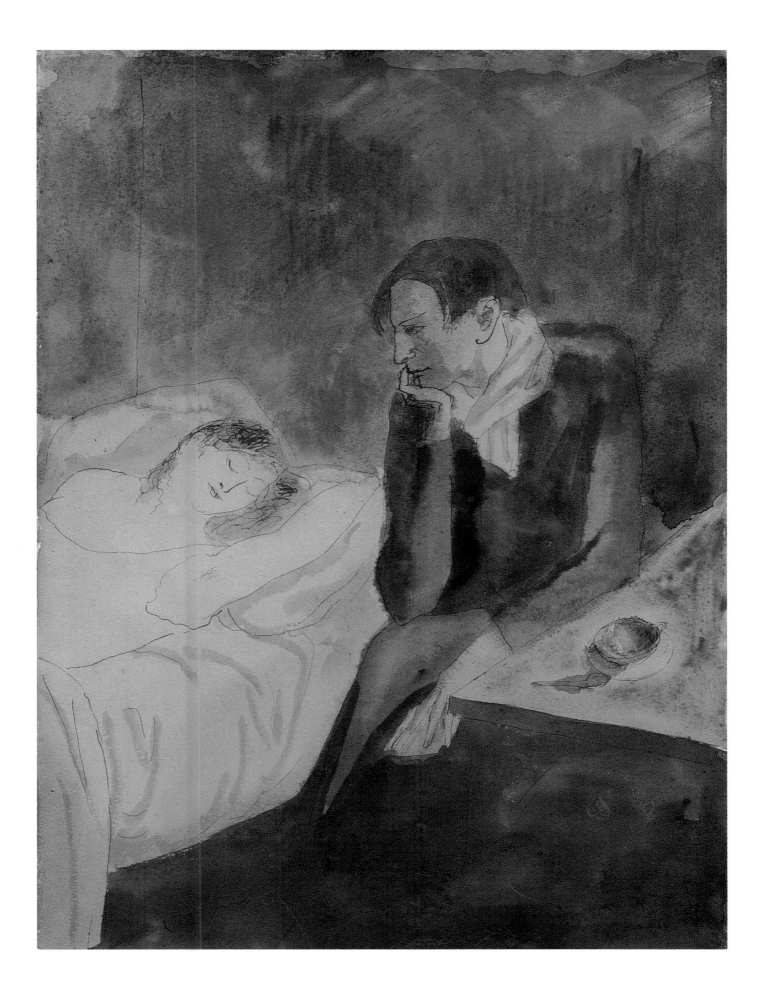

5 **Meditation**, 1904
The Museum of Modern Art, New York
Louise Reinhardt Smith Bequest

6 **Nude with Raised Arms**, 1907
Private Collection

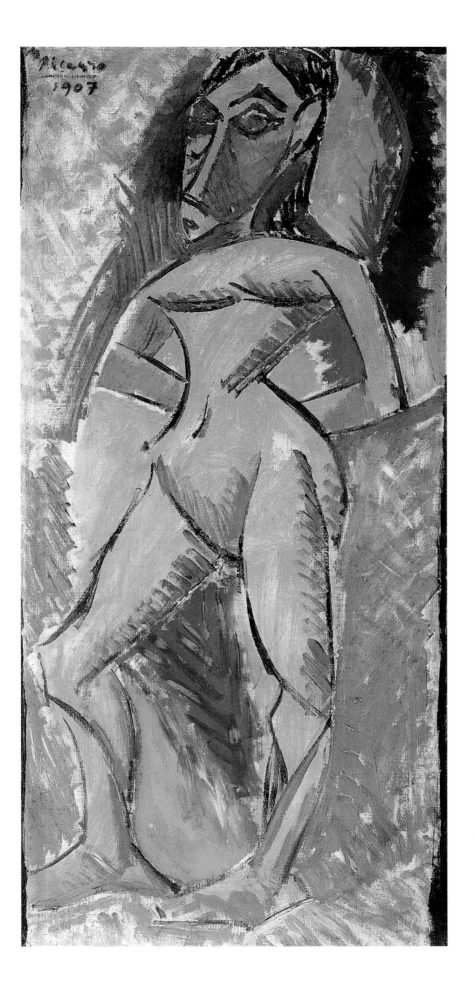

7 Female Nude, Spring 1907
Museo d'Arte Contemporanea, Jucker Collection, Milan

150

8 **Study for** *Les Demoiselles d'Avignon*, 1907
Estate of the Artist

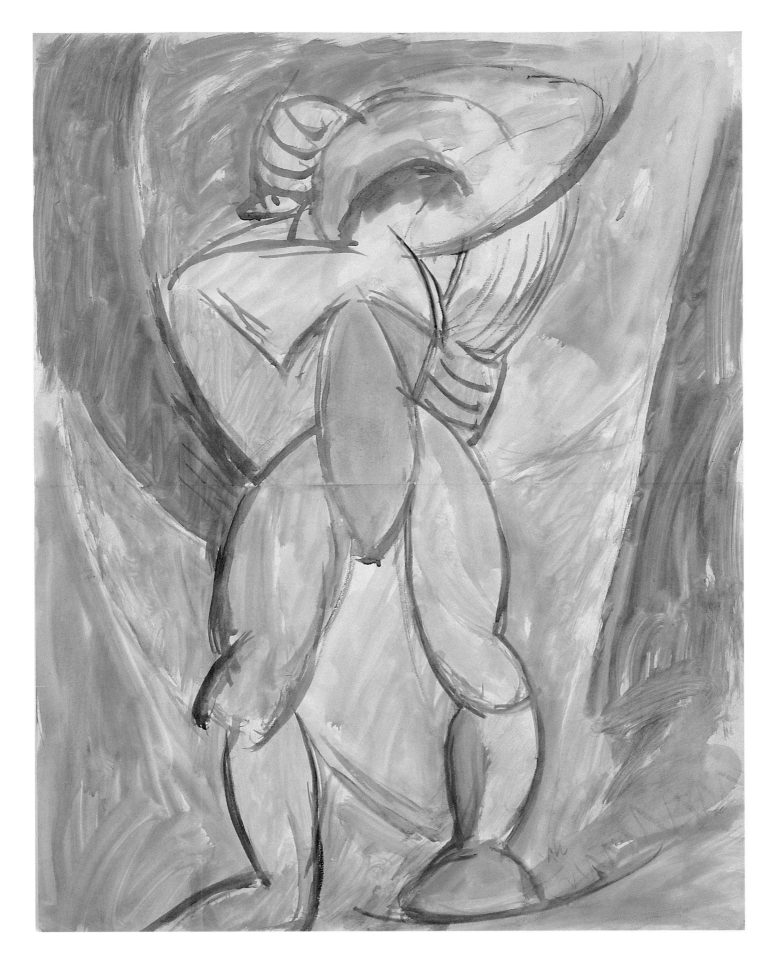

9 Sketch of Figure for *Three Women* (1908)
Estate of the Artist

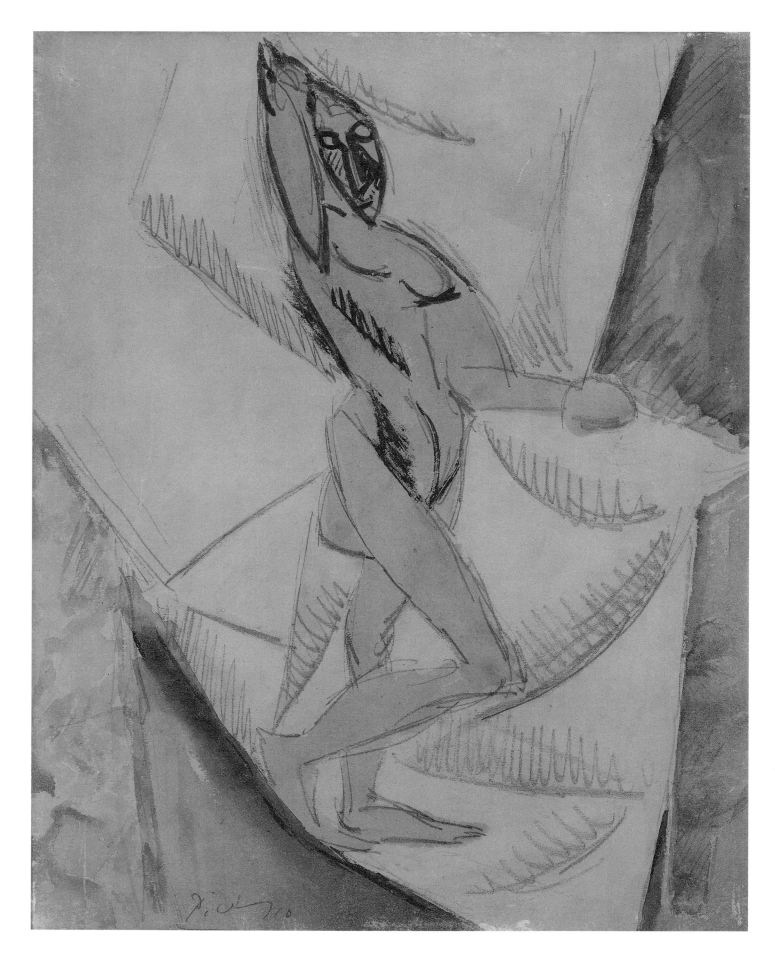

152

10 Study for *Nude with Drapery*, Summer 1907
Collection Linda and Morton Janklow, New York

11 **La Rue-des-Bois,** August 1908
Museo d'Arte Contemporanea, Jucker Collection, Milan

12 **Nude Woman, Three-Quarter View**, 1907
Estate of the Artist

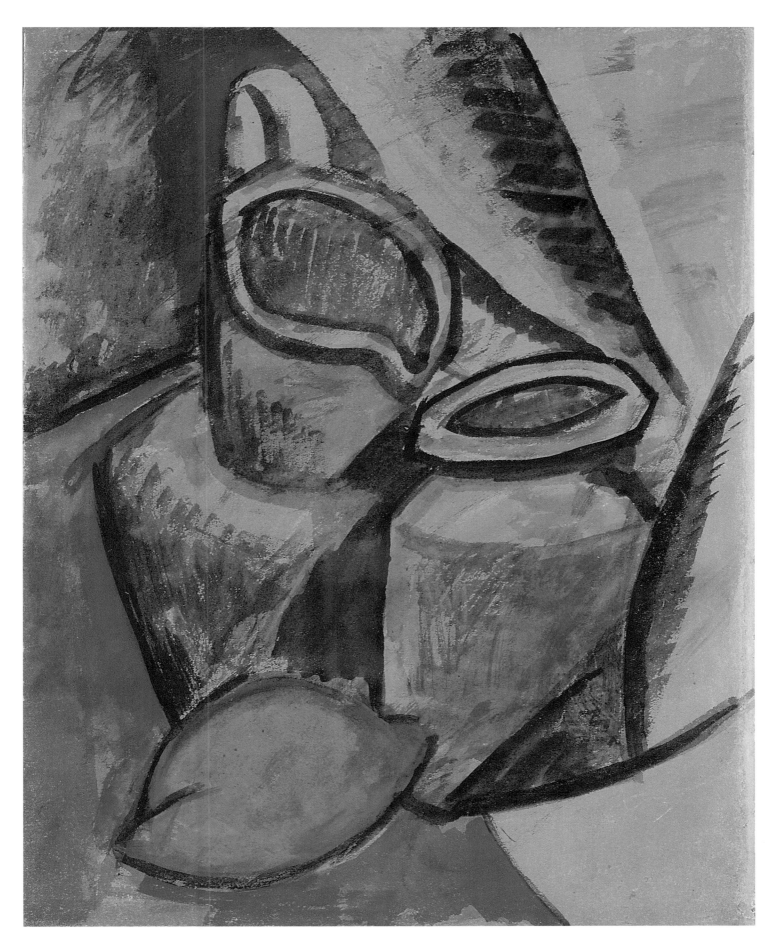

13 **Still Life with Lemon**, Summer 1907
Francey A. and Dr. Martin Gecht, Gecht Family Collection, Chicago

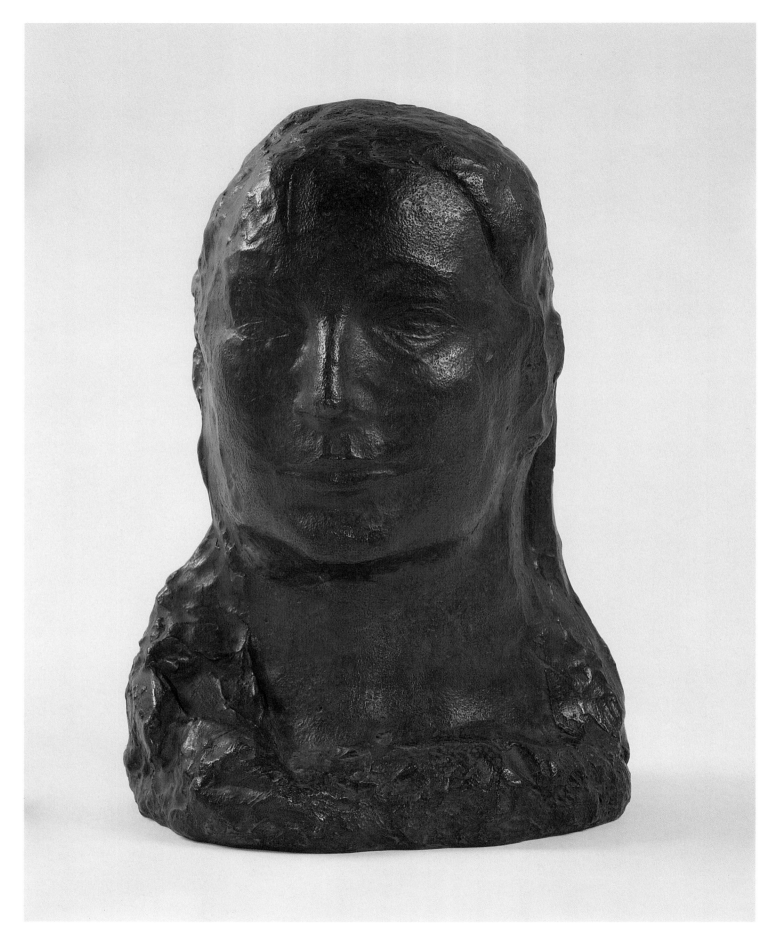

14 Head of a Woman, Fernande, 1906
Estate of the Artist

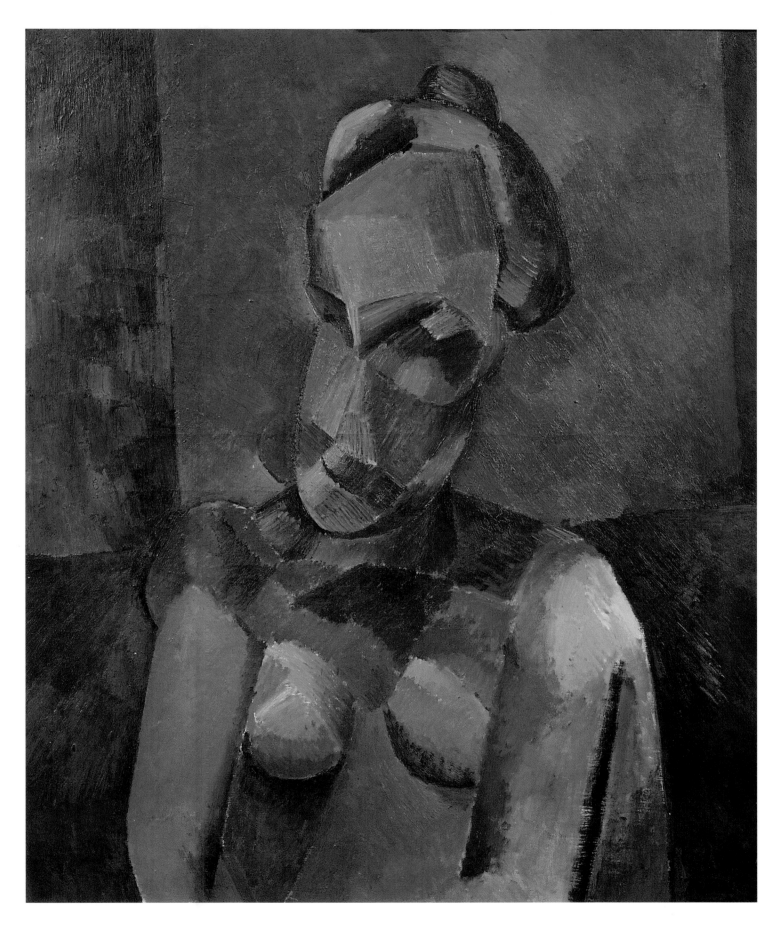

15 **Bust of a Woman**, 1909
Tate, London
Purchased 1949

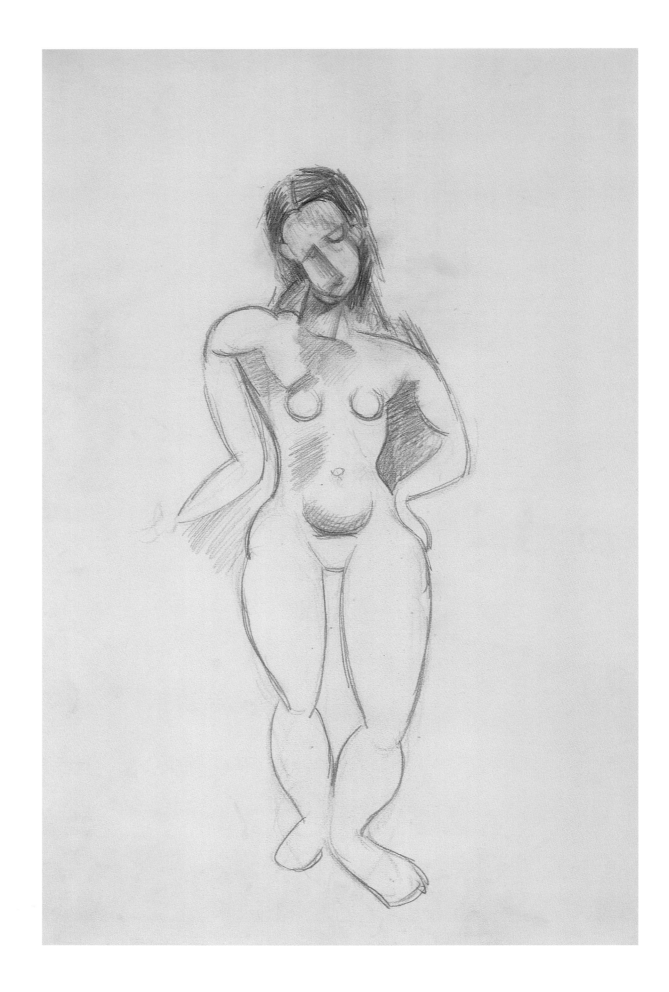

16 **Standing Nude**, 1909
Estate of the Artist

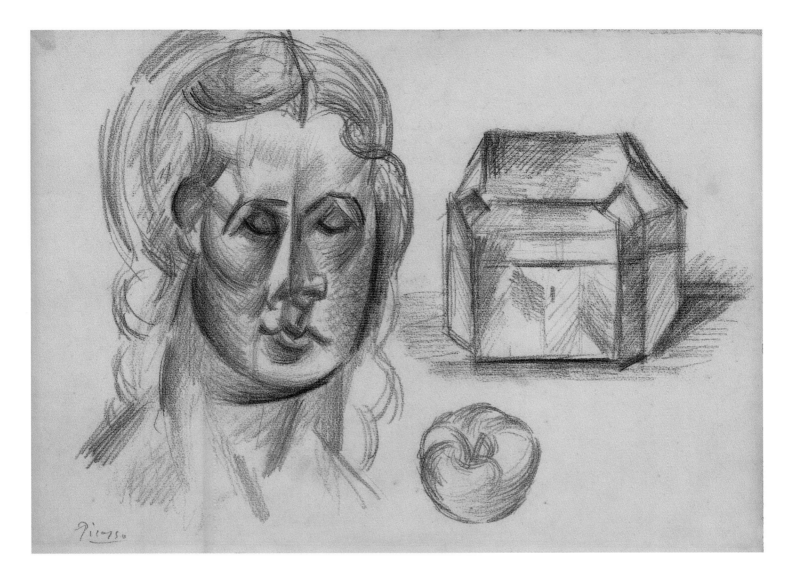

159

17 Head of a Woman, Coffer and Apple, 1909
Private Collection

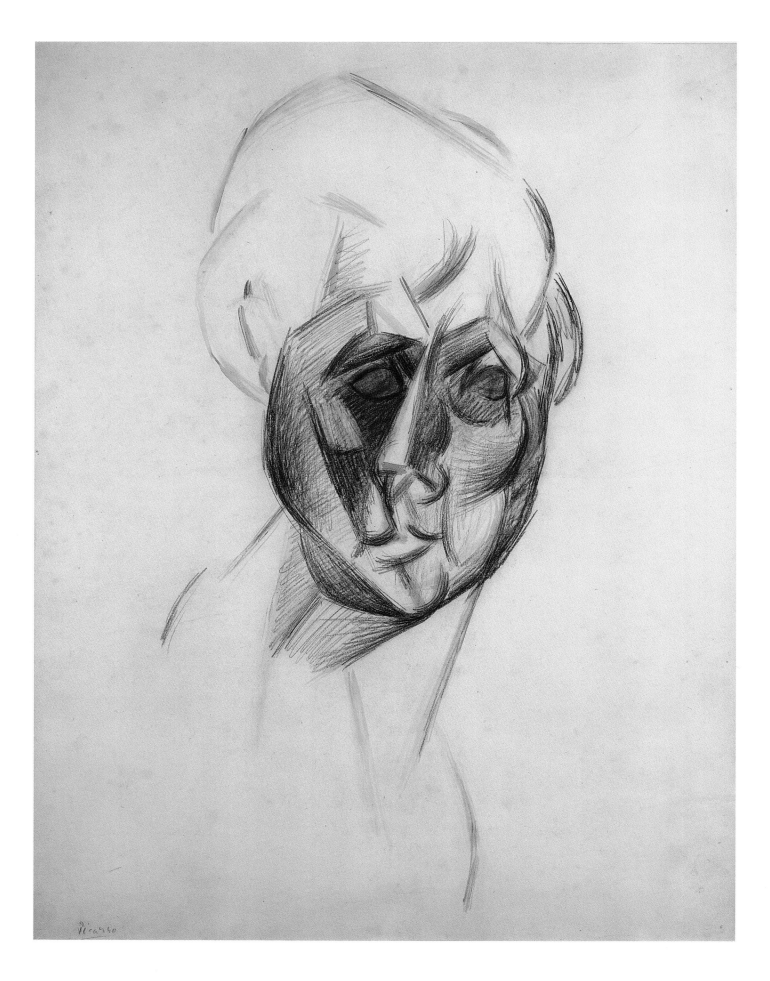

18 **Head of a Woman (Fernande)**, 1909
Collection Berta Borgenicht Kerr

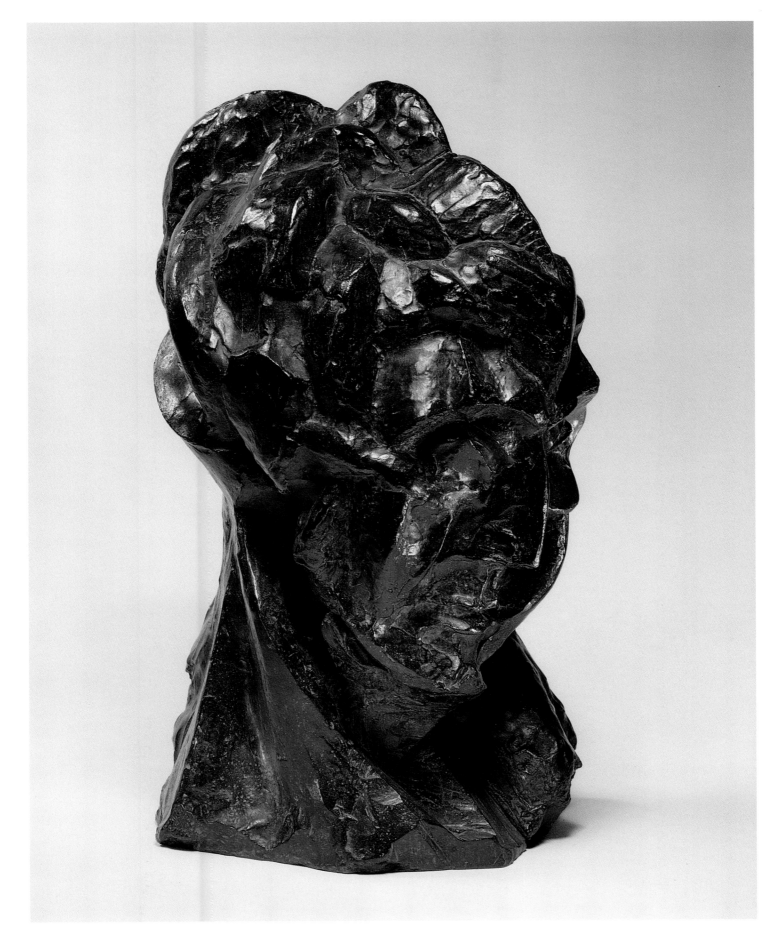

19 **Head of Fernande**, Autumn 1909
Private Collection

20 **Two Nude Figures,** 1909
Collection Hope and Abraham Melamed

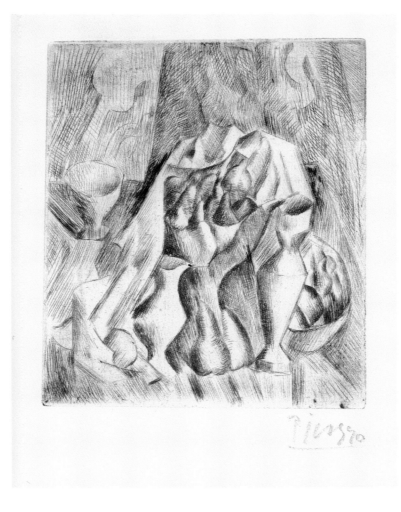

21 **Still Life with Compote**, 1909
Collection Hope and Abraham Melamed

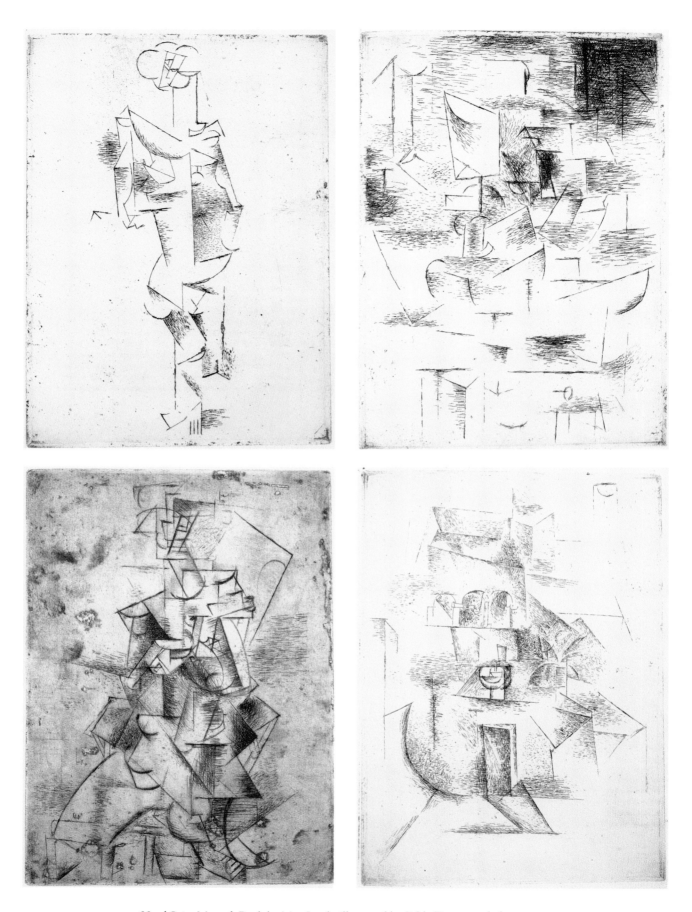

22a-d Saint-Matorel, Book by Max Jacob, illustrated by Pablo Picasso with four prints,
ed. Henry Kahnweiler, Paris 1911

22a **Mademoiselle Léonie**, August and Autumn 1910

22b **The Table**, August 1910

22c **Mademoiselle Léonie in a Chaise Longue**, August and Autumn 1910

22d **The Convent**, August 1910

Collection Hope and Abraham Melamed

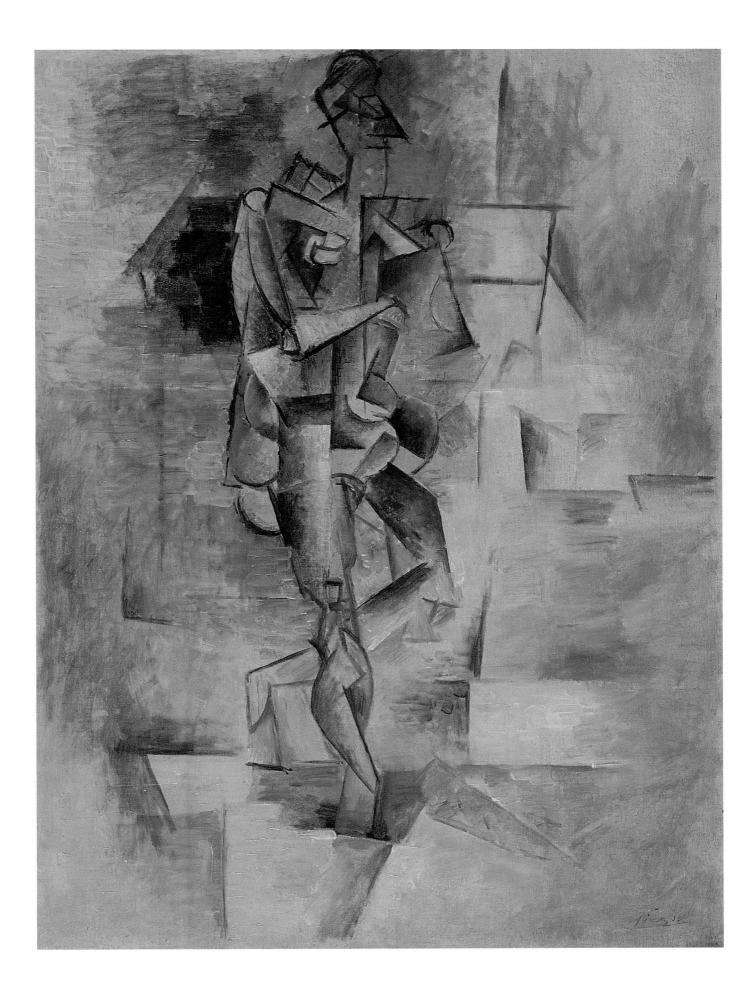

23 **Female Nude**, Spring 1909–10
The Menil Collection, Houston

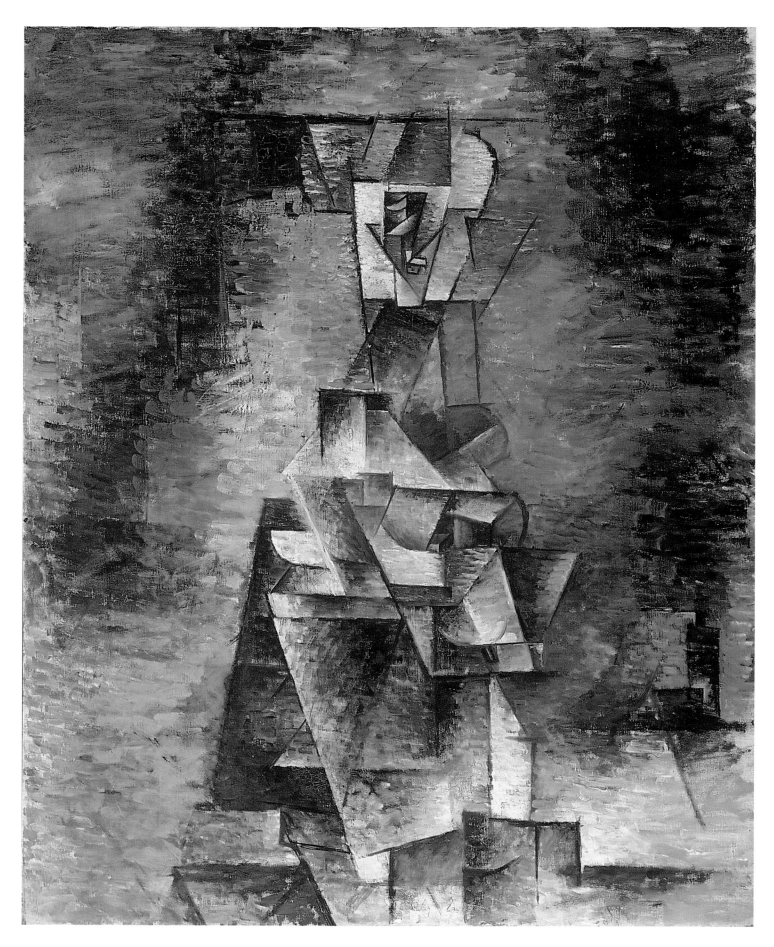

24 **Female Nude**, Autumn 1910
The Philadelphia Museum of Art, The Louise and Walter Arensberg Collection

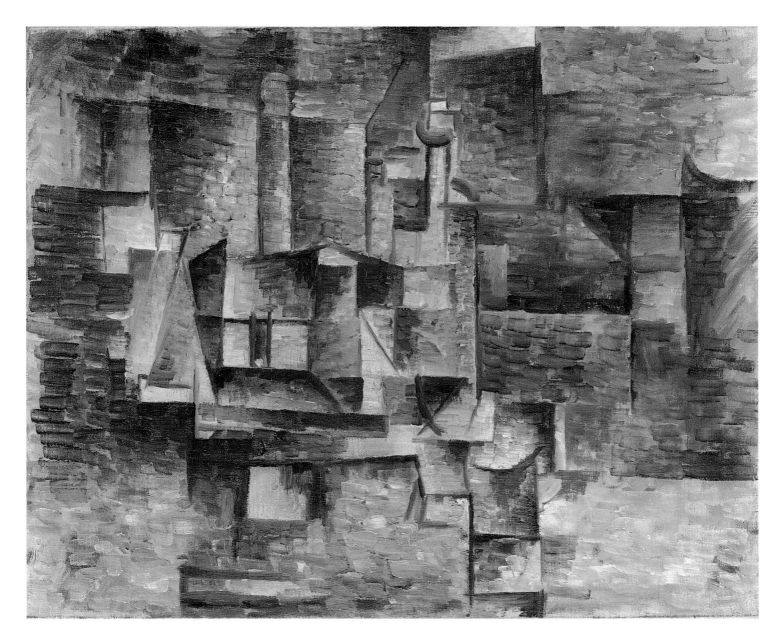

25 Bottle and Books, Winter 1910–11
Private Collection

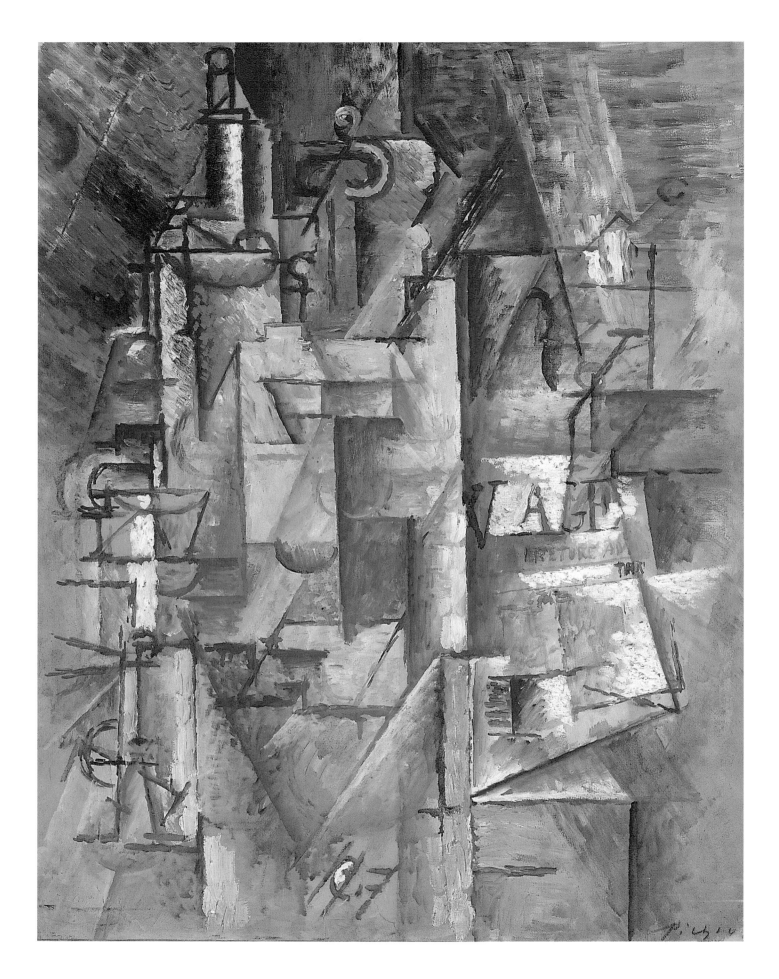

26 **Bottles and Glasses**, Winter 1911–12
The Solomon R. Guggenheim Museum, New York
Gift, Solomon R. Guggenheim, 1938

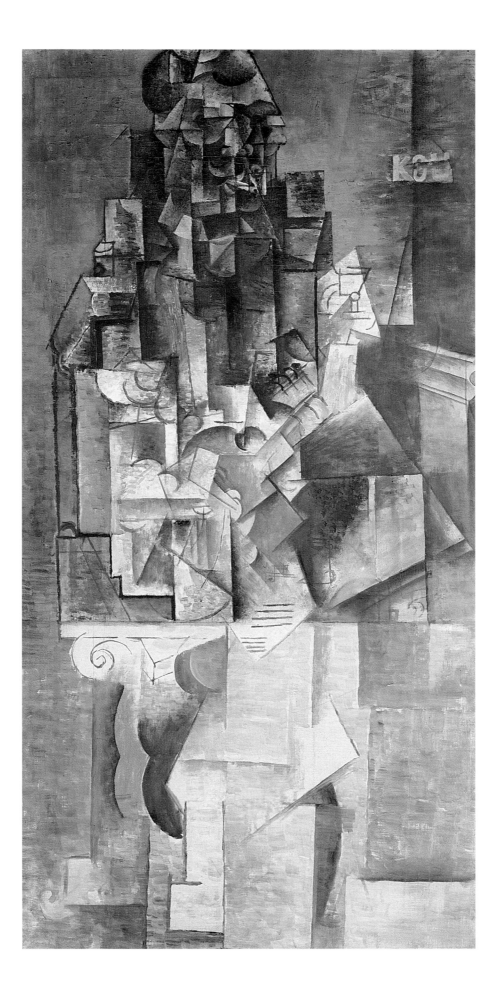

27 **Man with Guitar**, Autumn 1911–Spring 1912
Musée Picasso, Paris

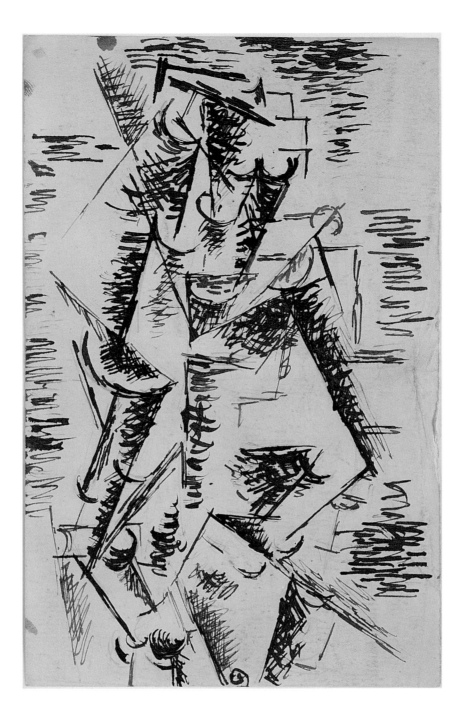

28 **Cubist Nude**, 1911
Estate of the Artist

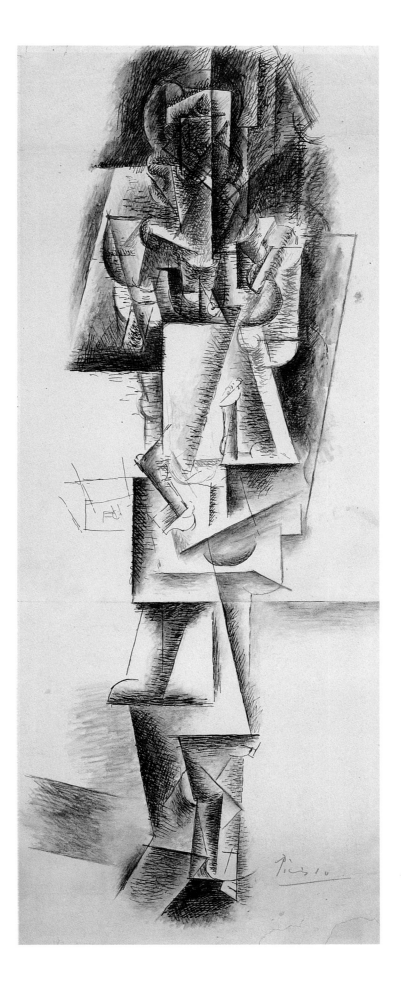

29 Standing Woman, 1911–12
Private Collection

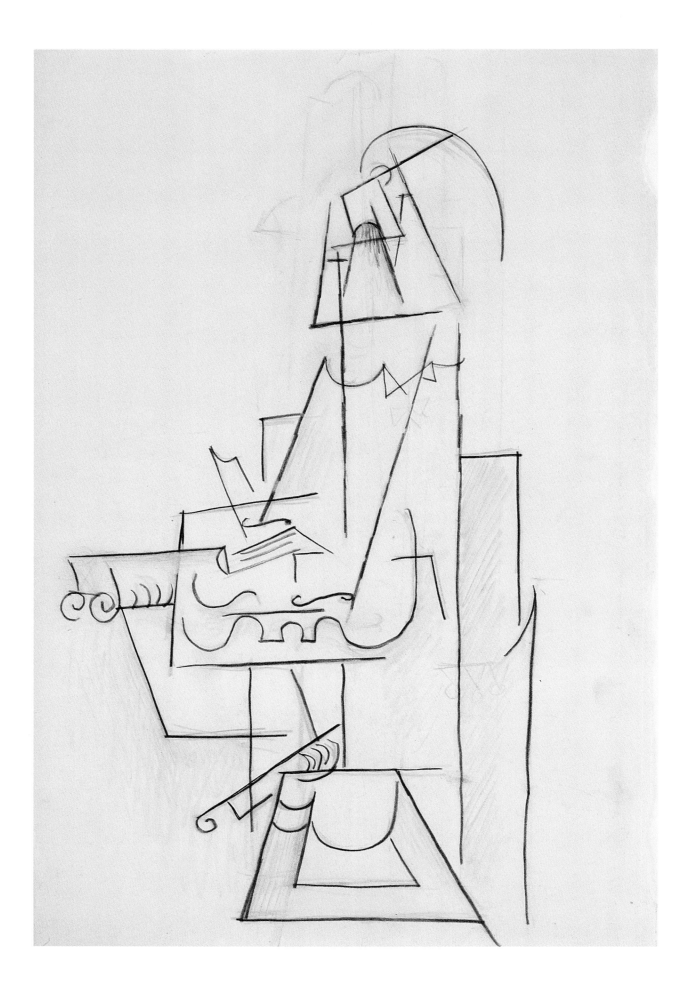

172

30 Man with Violin, 1912
Estate of the Artist

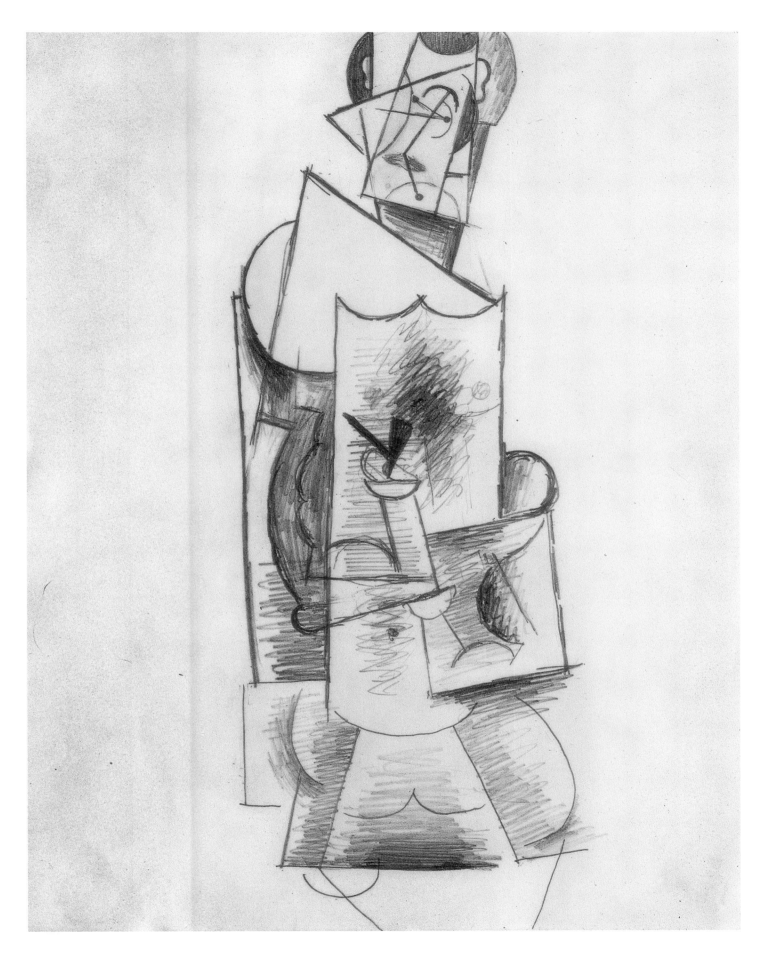

31 Guitar Man (Project for a Construction), 1912–13
Collection of Abigail G. Melamed

174

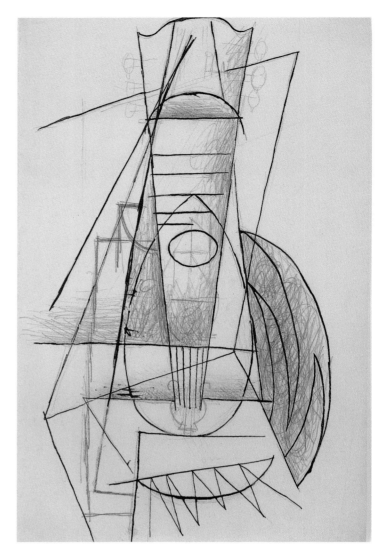

32 **Cubist Composition: Head**, 1912
Estate of the Artist

33 **Mandolin**, Summer 1912
Estate of the Artist

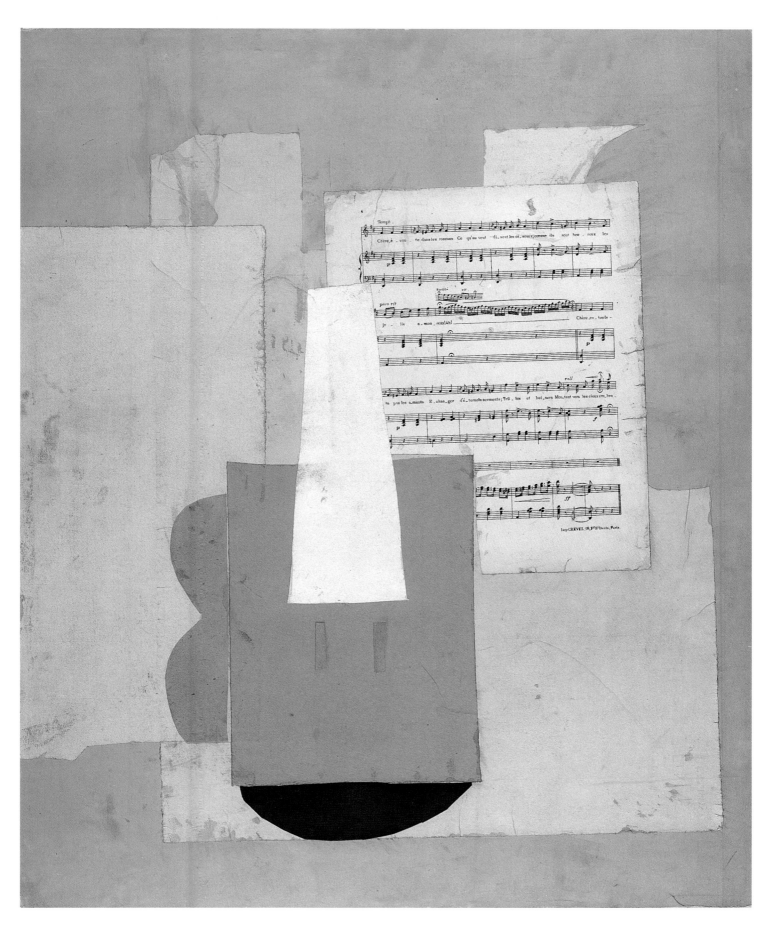

34 Violin and Sheet of Music, Autumn 1912
Musée Picasso, Paris

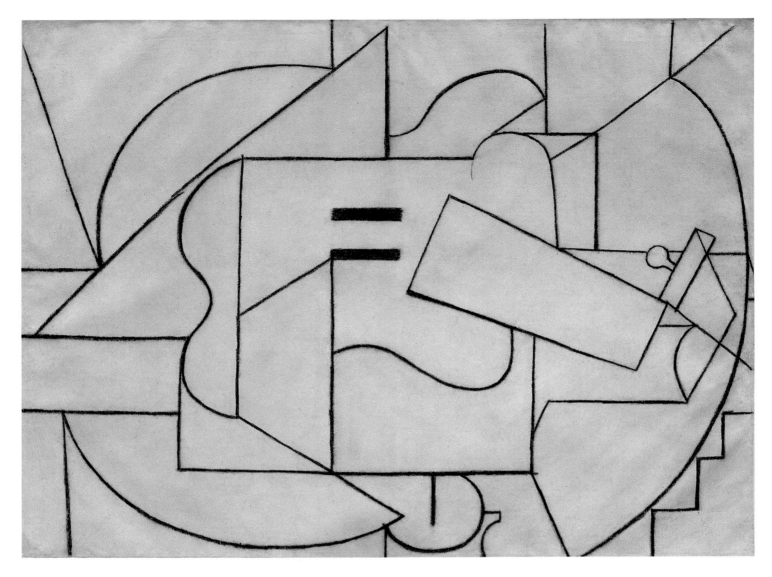

35 **Guitar**, Autumn 1912
Mr. and Mrs. Donald B. Marron, New York

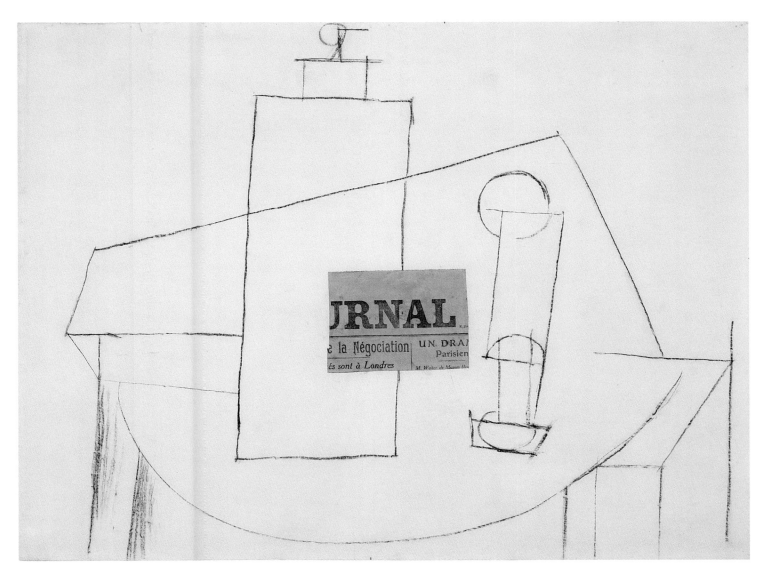

36 **Bottle and Glass**, Winter 1912
The Menil Collection, Houston

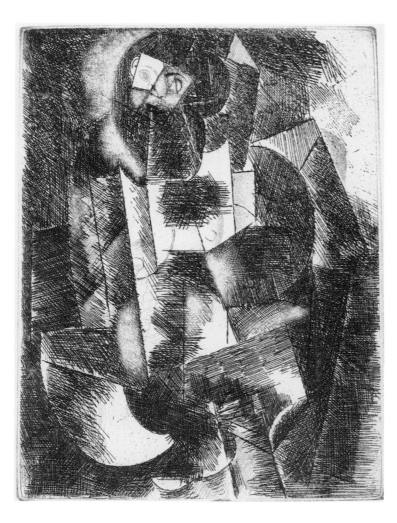

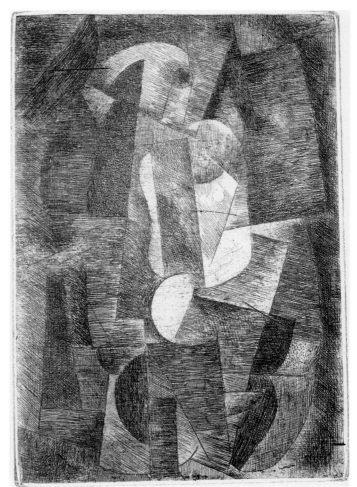

37a-c *La Siège de Jérusalem. La Grande Tentation Céleste de Saint-Matorel.*
Book by Max Jacob, illustrated by Pablo Picasso with three prints,
ed. Henry Kahnweiler, Paris 1914

37a **Nude Woman with Guitar**, Autumn–Winter 1913

37b **Woman**, Autumn–Winter 1913

Collection Hope and Abraham Melamed

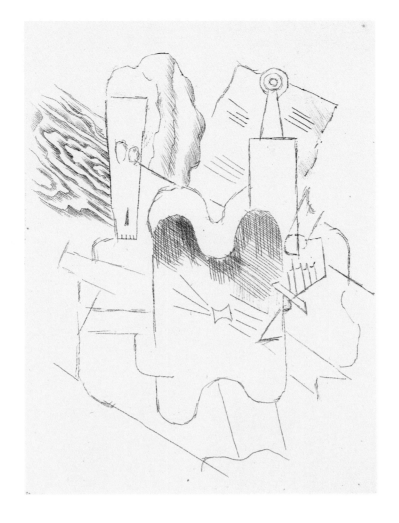

37c **Still Life with Skull,** Autumn–Winter 1913
Collection Hope and Abraham Melamed

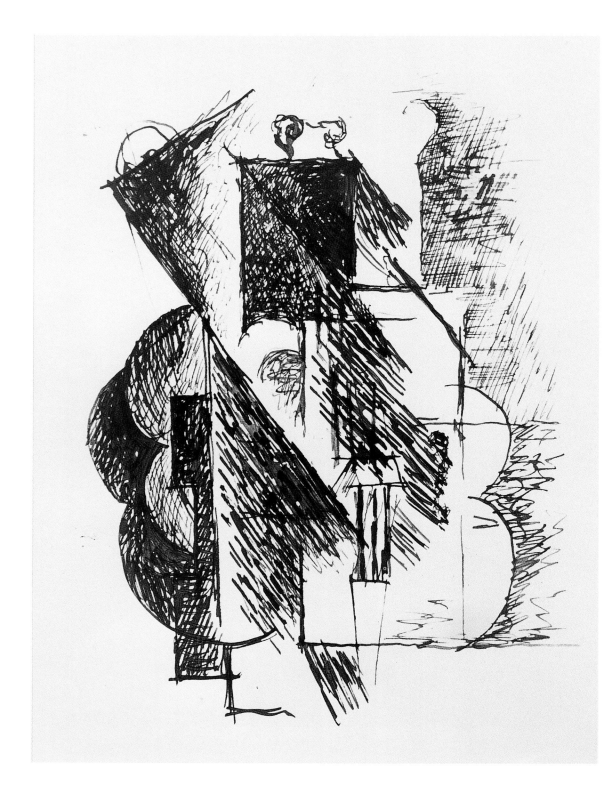

38 Violin, 1913
Collection of Abigail G. Melamed

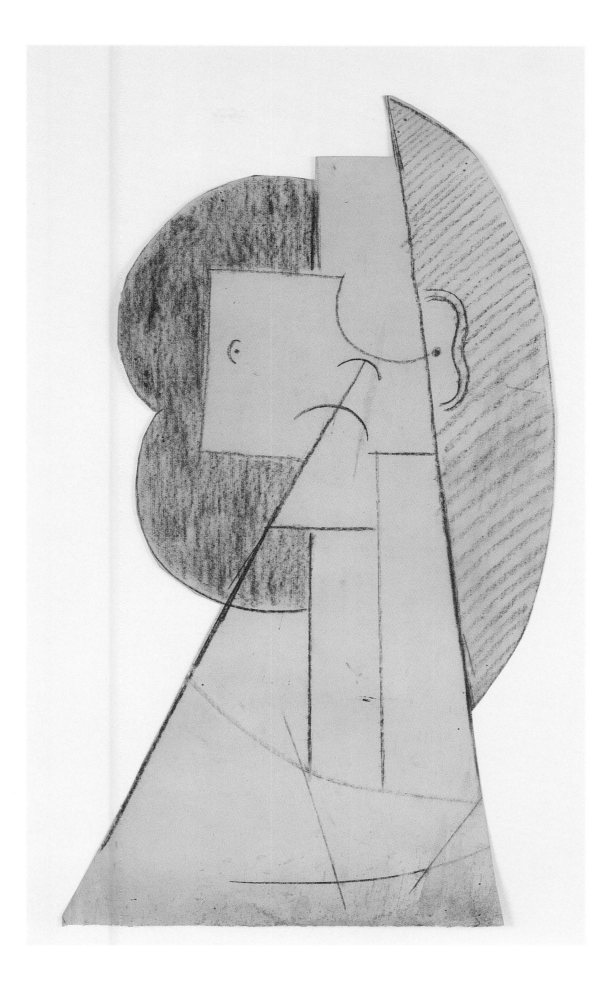

39 **Figure**, 1913
Estate of the Artist

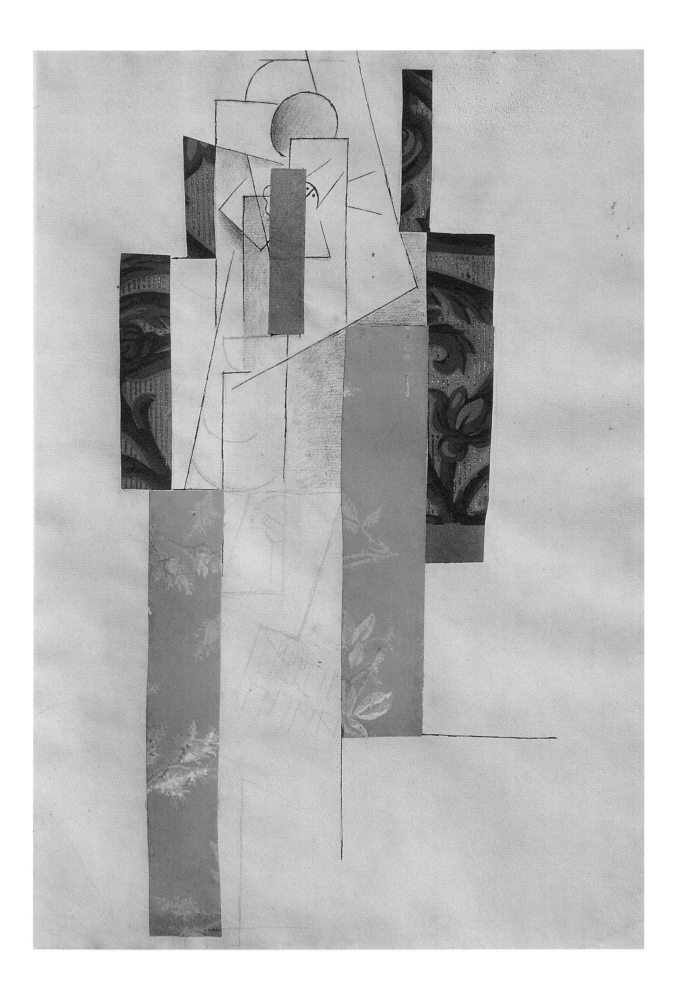

40 **Figure**, 1913
Collection Hope and Abraham Melamed

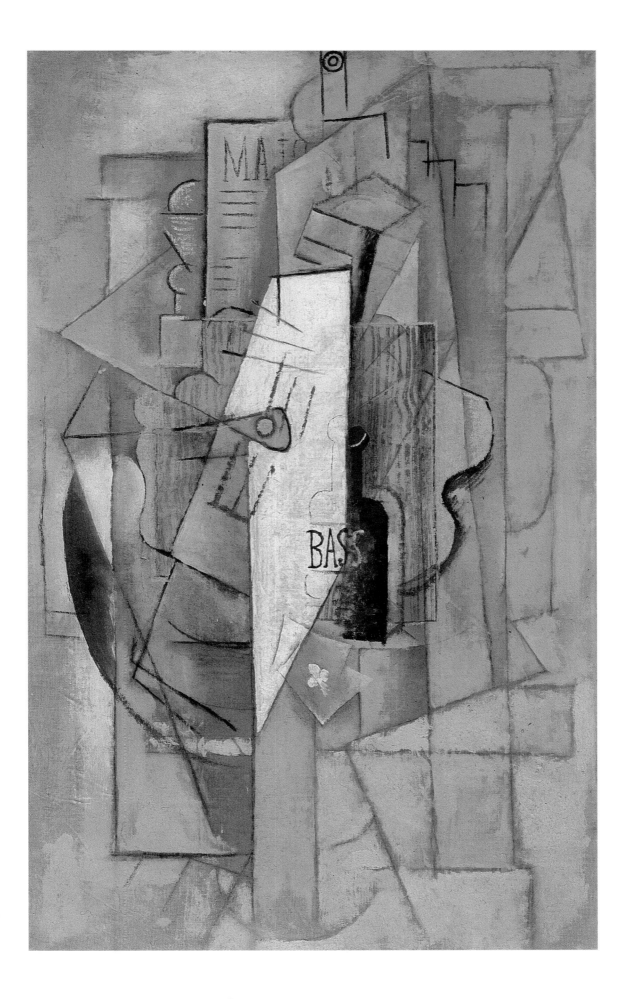

41 The Bottle of Bass, 1912
Museo d'Arte Contemporanea, Jucker Collection, Milan

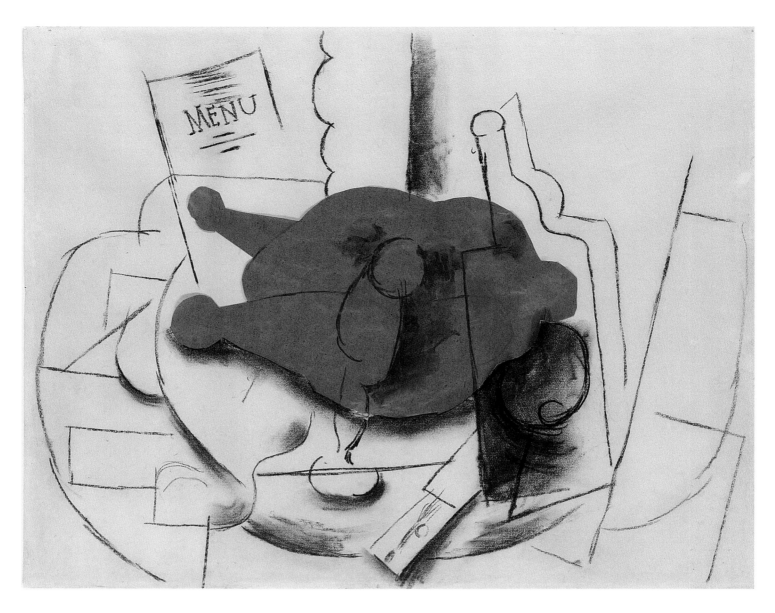

MENU

42 Chicken, Glass, Knife and Bottle, Spring 1914
Private Collection

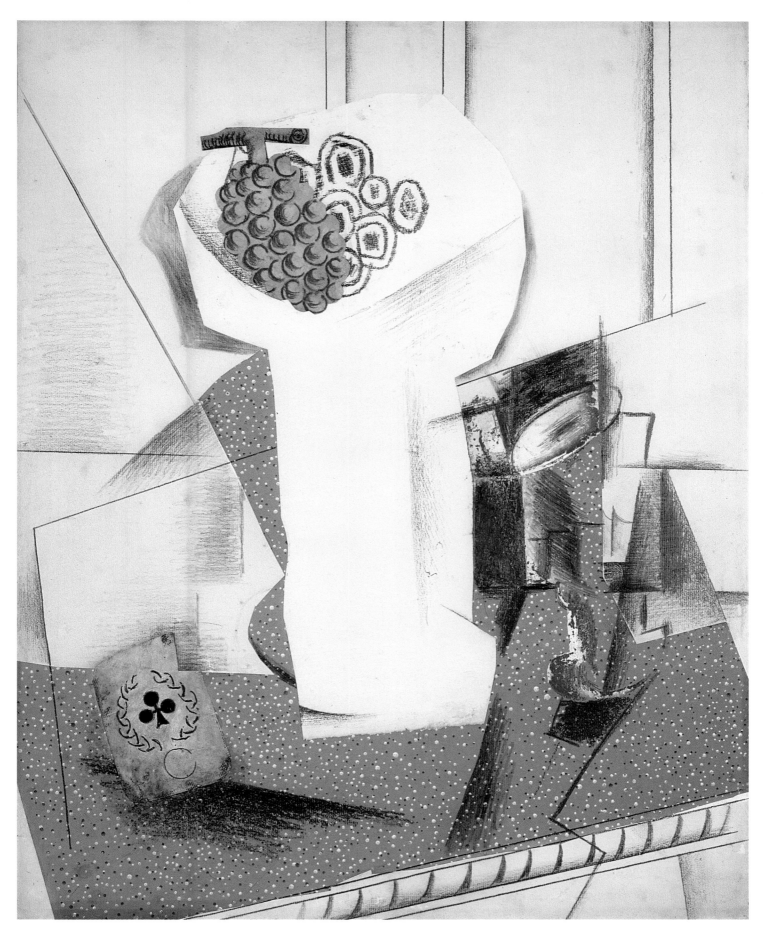

43 Fruit Dish with Grapes, Glass and Playing Card, Spring 1914
Private Collection

44 Figure with Crossed Arms, Summer 1914
Estate of the Artist

45 Seated Man with Moustache and Pipe, 1915
Estate of the Artist

46 **Seated Man with Moustache**, 1915
Estate of the Artist

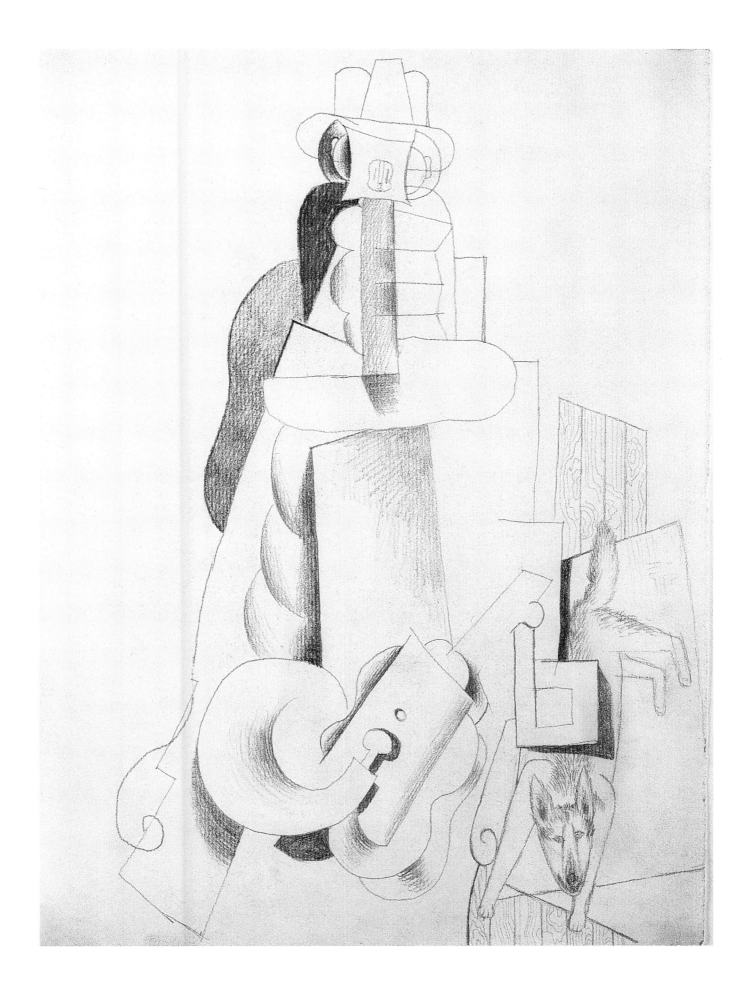

47 Man with Guitar and Seated Dog (Summer 1914)
Estate of the Artist

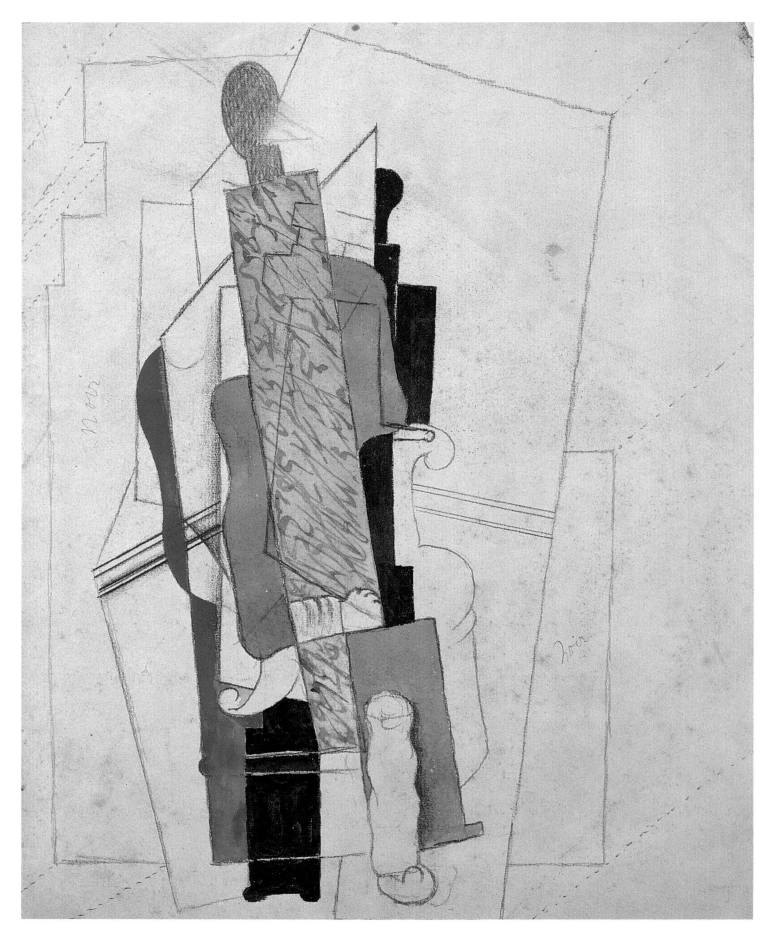

48 Man Seated in an Armchair (1916)
Estate of the Artist

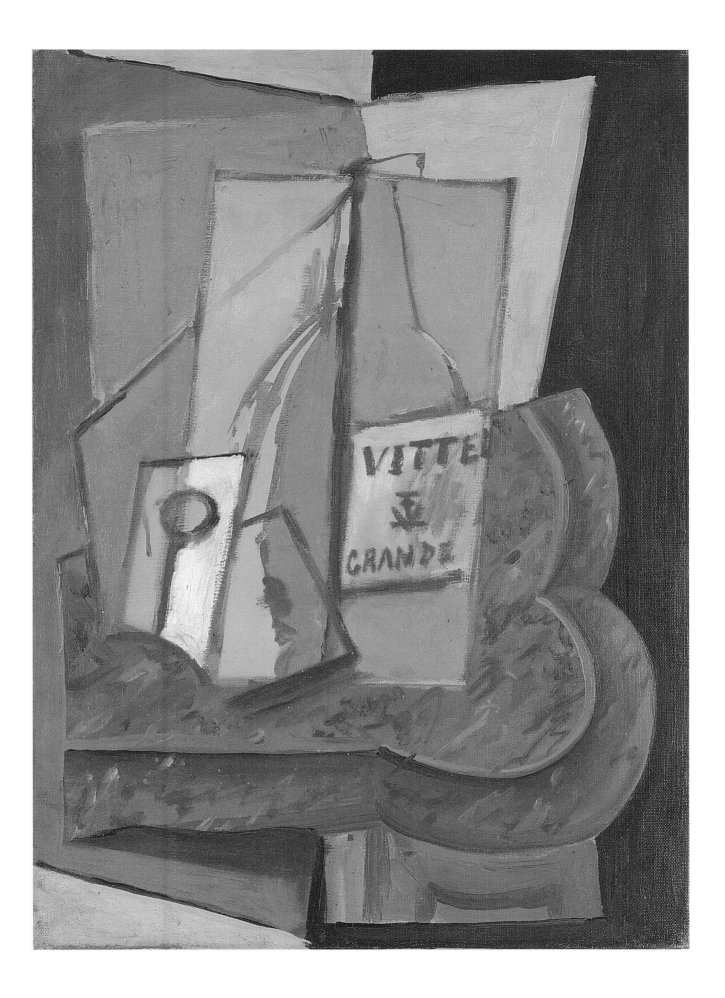

49 Still Life with Bottle of Vittel (1915)
Estate of the Artist

192

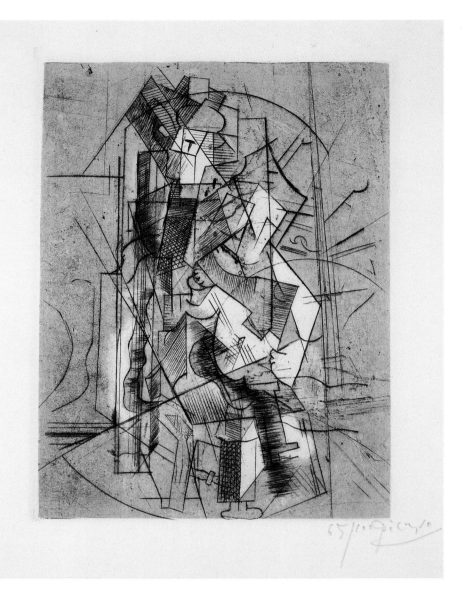

50 Man with Guitar, 1915
Collection Hope and Abraham Melamed

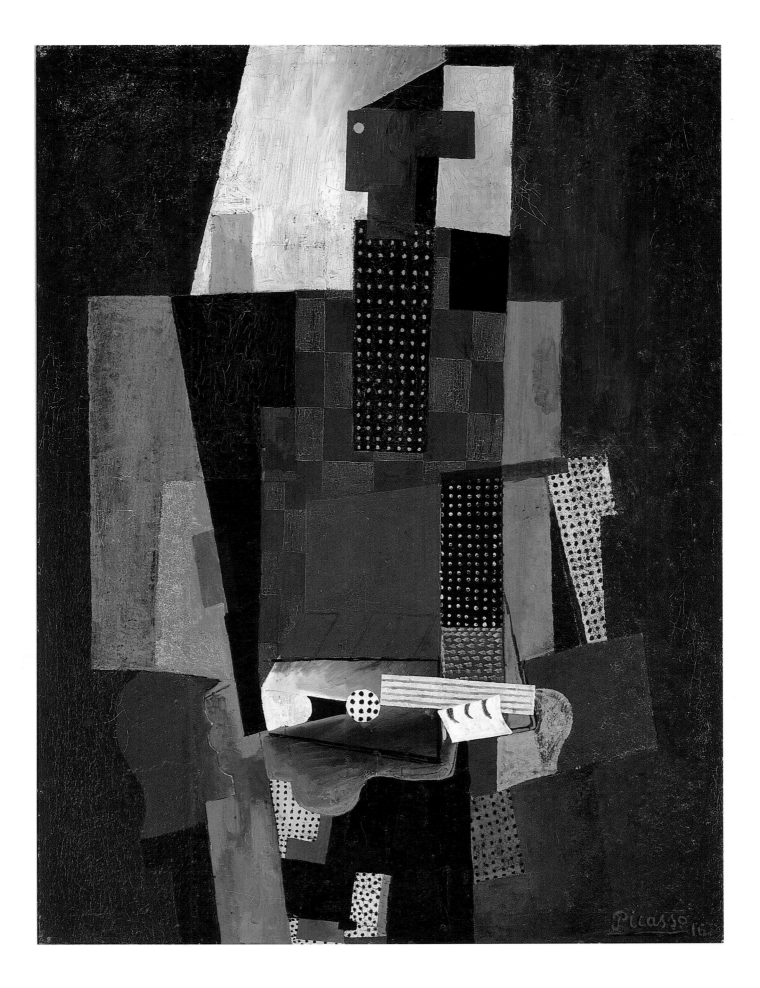

51 **Guitar Player**, 1916
Moderna Museet, Stockholm

194

52 Composition with Fruit against a Blue Background (1913–14)
Estate of the Artist

53 **White Composition against a Brown Background** (1913–14)
Estate of the Artist

196

54 The Glass of Absinthe, Spring 1914
Estate of the Artist

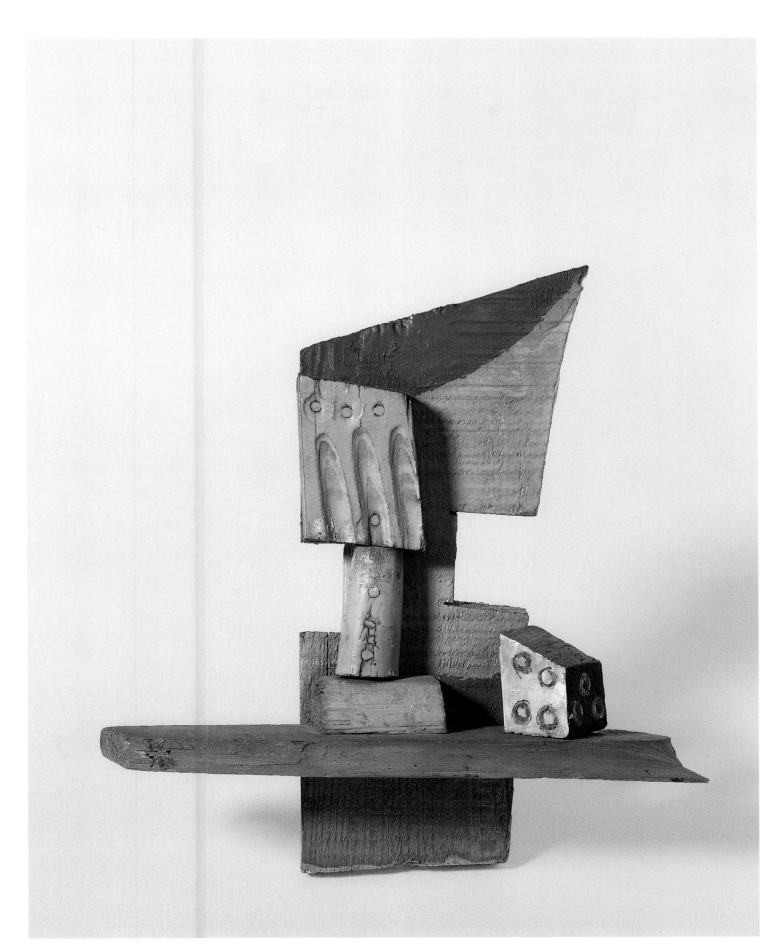

55 Construction: Glass and Dice, Spring 1914
Musée Picasso, Paris

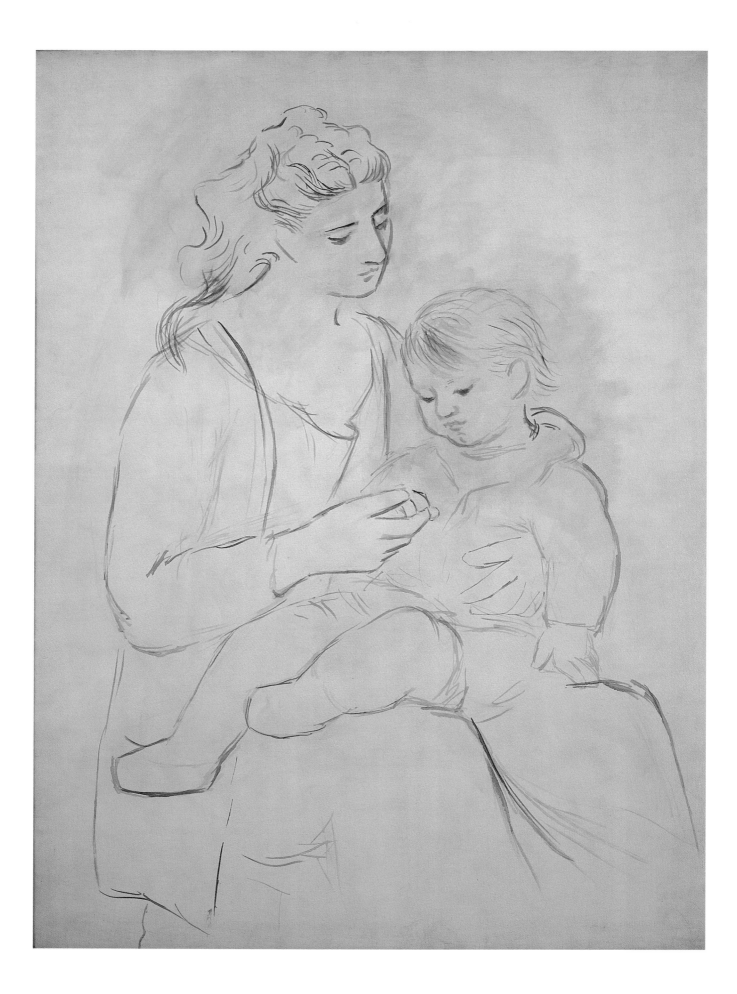

56 **Portrait of Mme Picasso**, 1922
Mr. and Mrs. Leonard Riggio

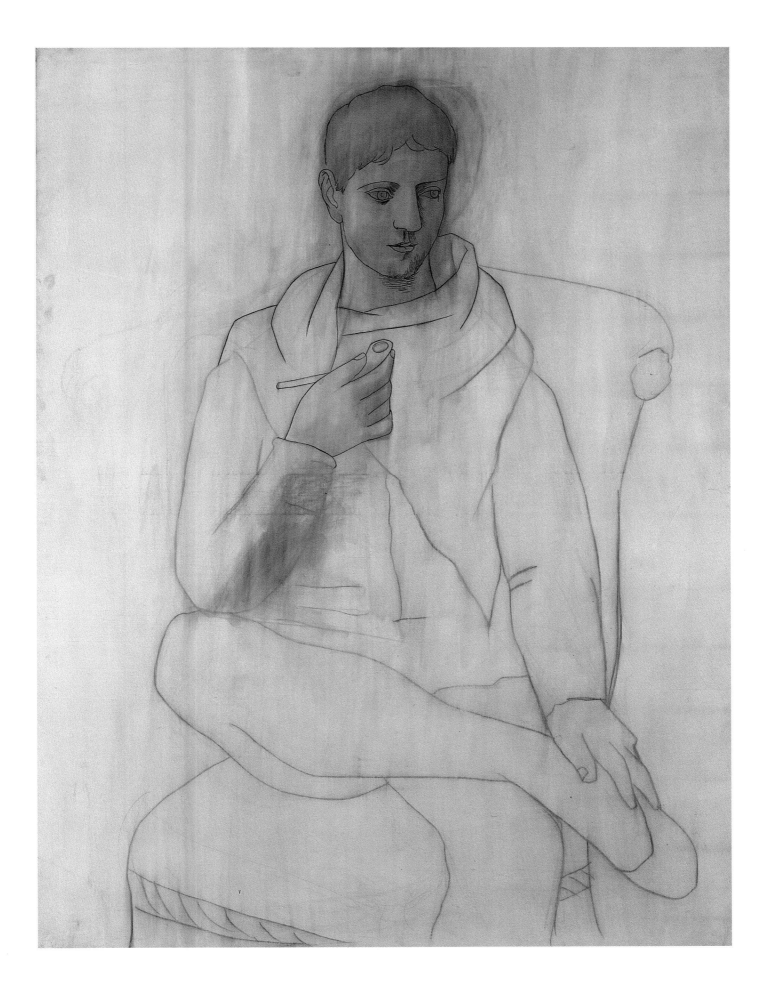

57 Man with a Pipe, May 1923
Estate of the Artist

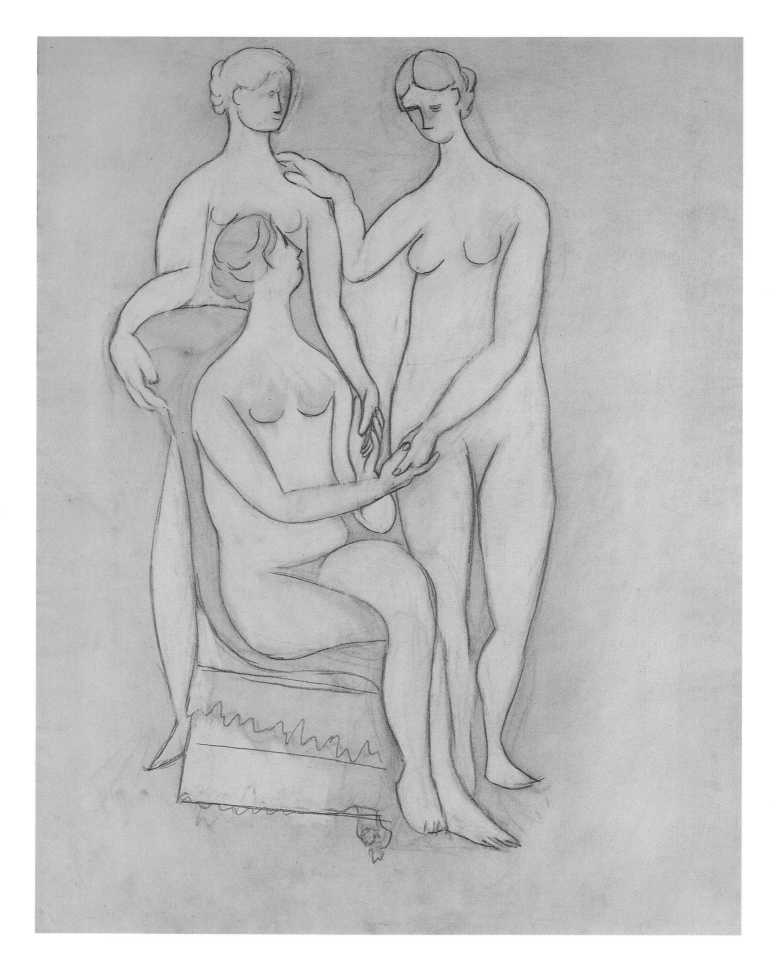

58 **Three Nudes**, 1920
Estate of the Artist

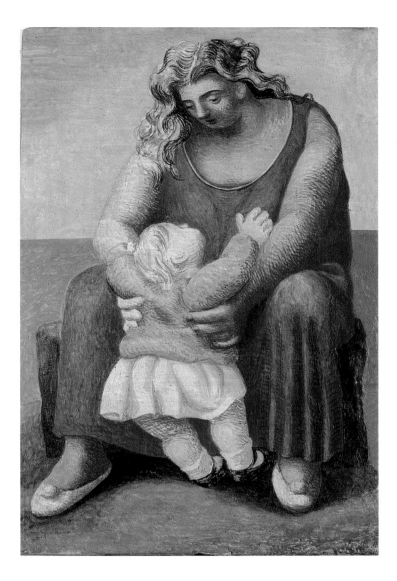

59 Woman and Child (Autumn 1921)
Estate of the Artist

60 **Woman with Missal** (Autumn 1921)
Estate of the Artist

61 **Still Life with "Journal,"** June 1923
Estate of the Artist

62 **Composition** (1920)
Estate of the Artist

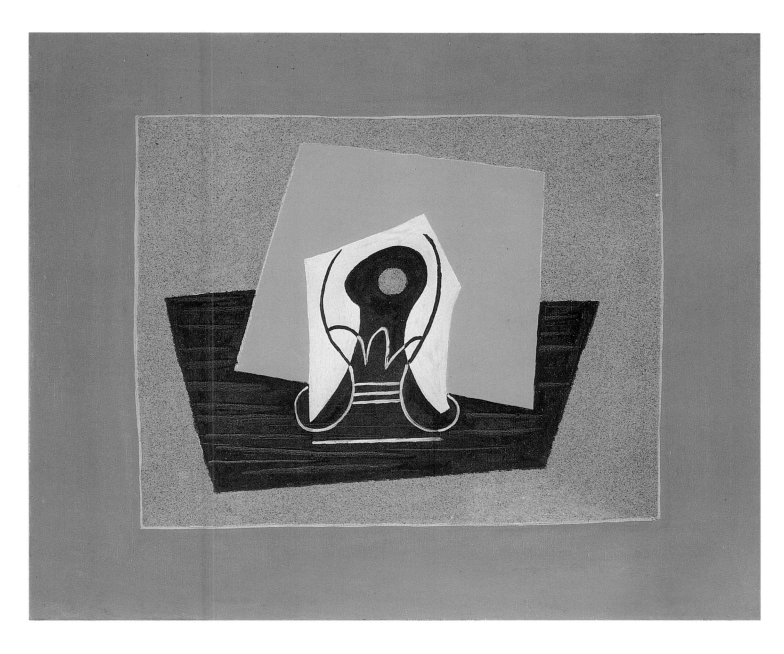

63 Still Life with Vase (Spring 1923)
Estate of the Artist

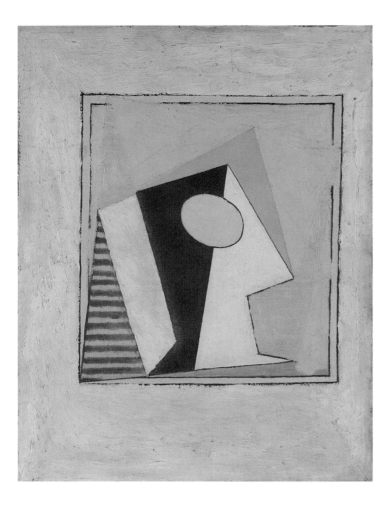

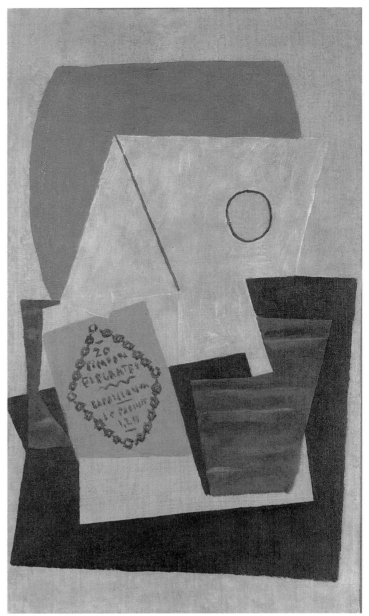

64 **Geometric Composition** (1918)
Estate of the Artist

65 **Composition with Blue Cigar Box** (Autumn 1921)
Estate of the Artist

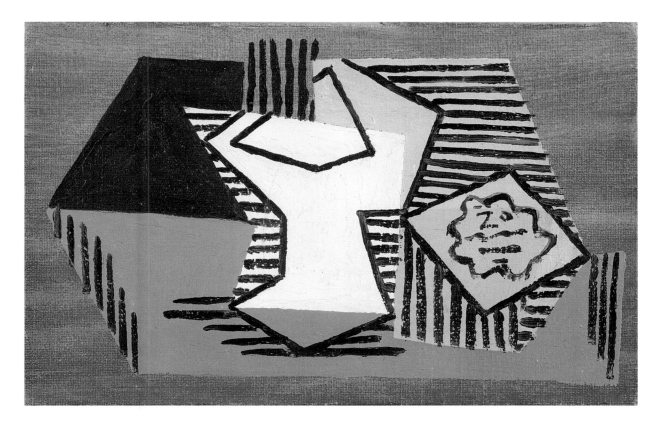

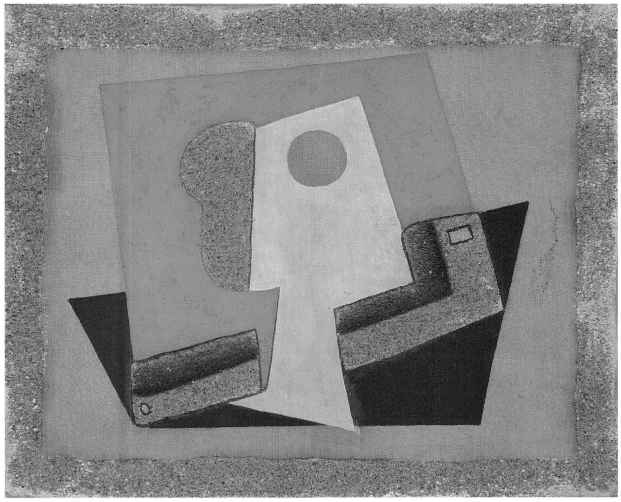

66 **Composition with Black Lines** (Summer 1922)
Estate of the Artist

67 **Composition with a Glass** (1917)
Estate of the Artist

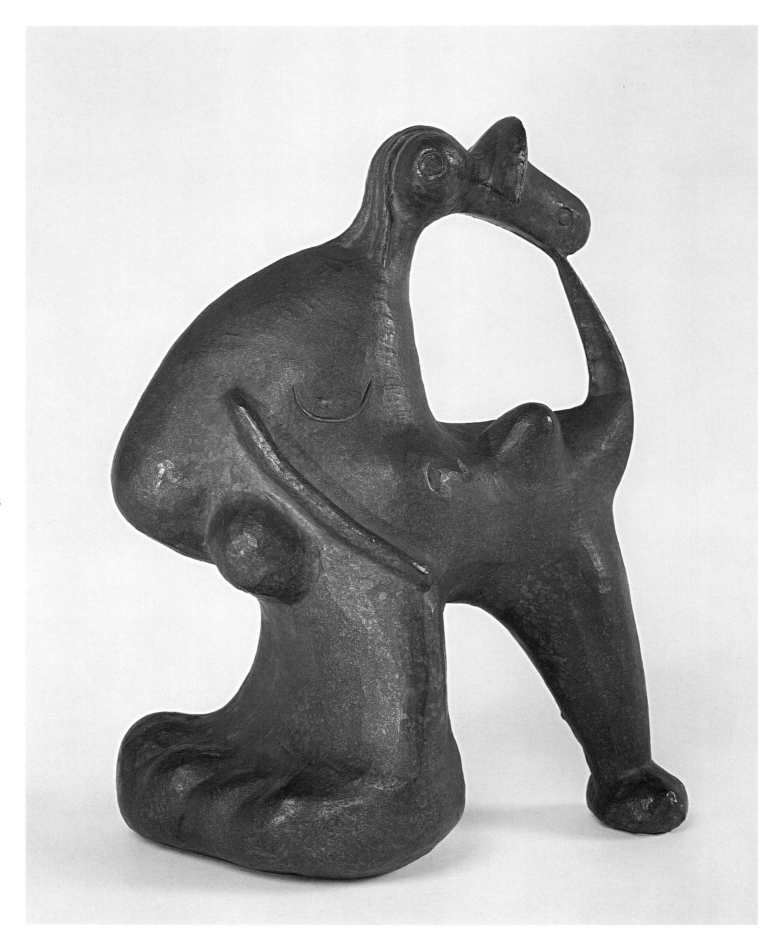

208

68 **Female Figure (The Metamorphosis)**, 1928
Estate of the Artist

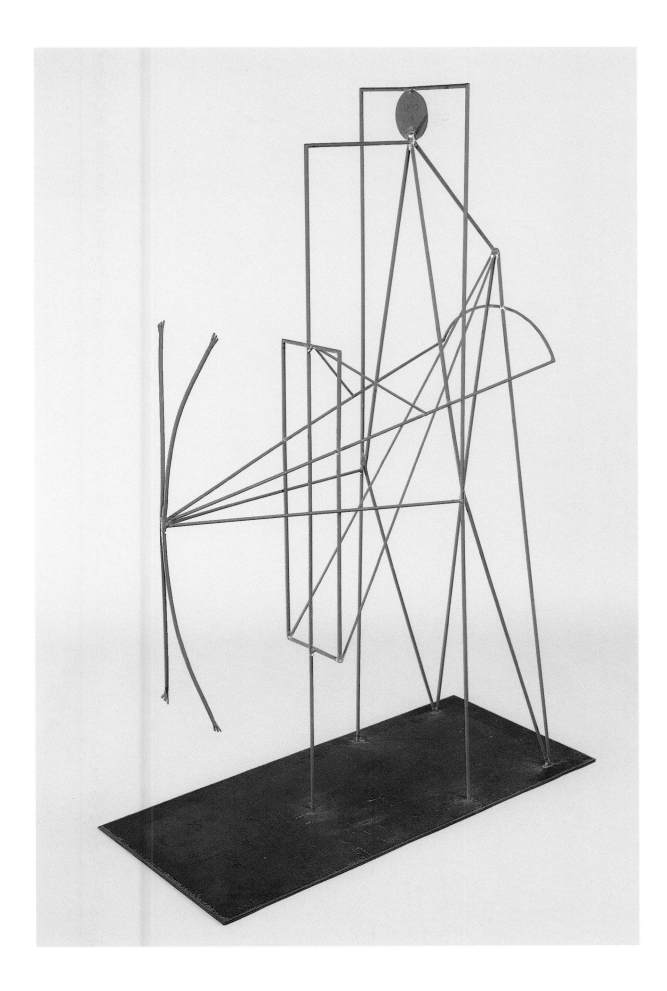

69 **Study for a Monument to Guillaume Apollinaire**, 1928/1962
Linda and Harry Macklowe

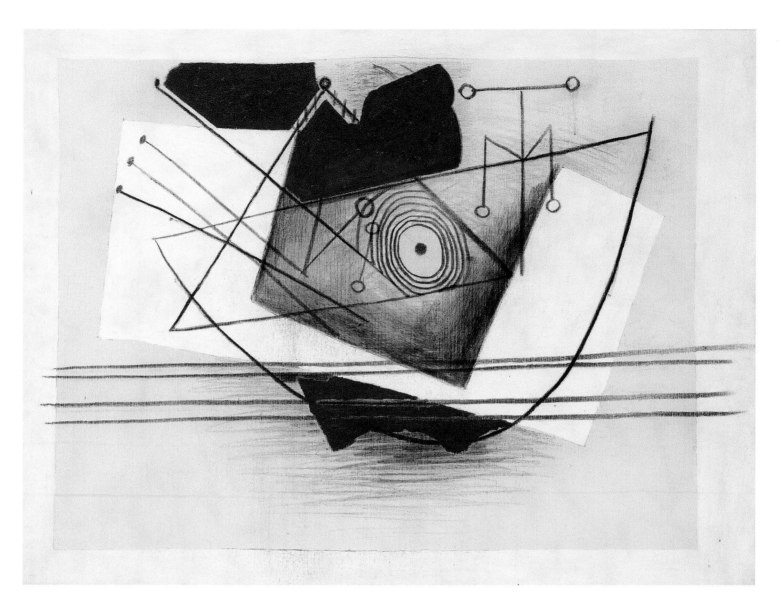

70 Beige and Black Composition (Marie-Thérèse), 1927
Private Collection

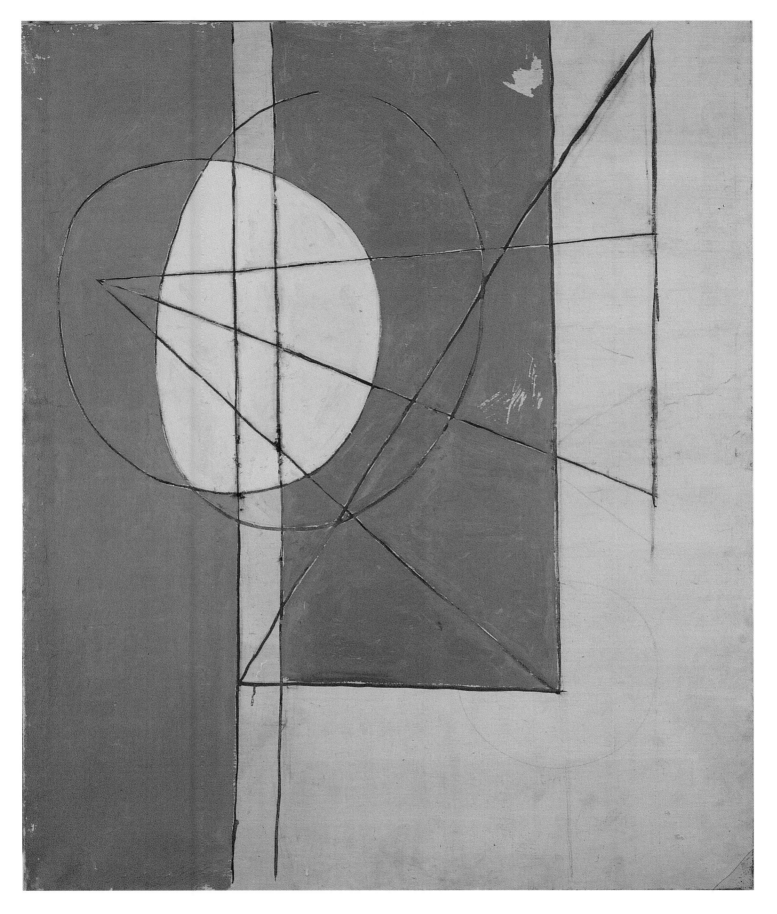

71 **Beige and Gray Geometric Figures** (1928)
Estate of the Artist

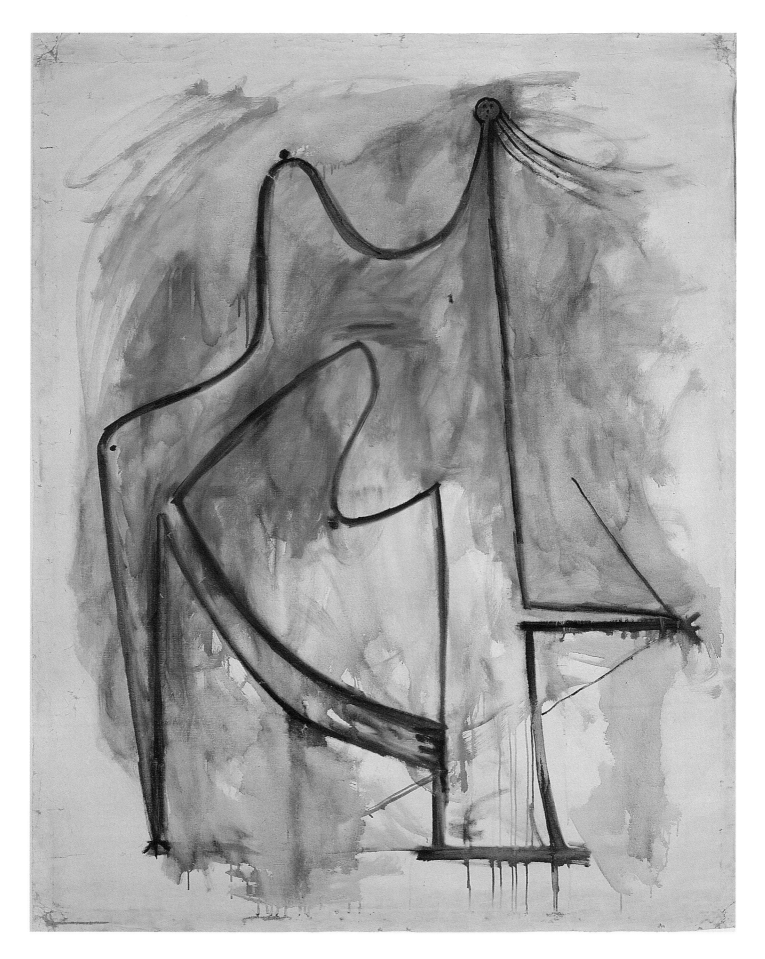

72 Woman (1928)
Estate of the Artist

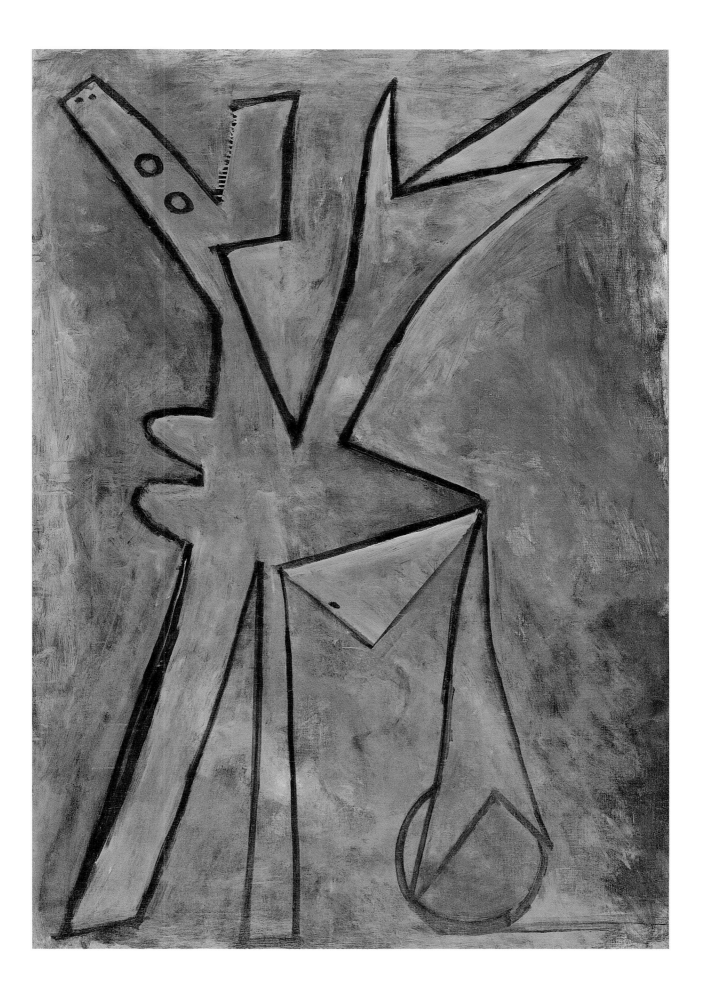

73 Gray and Black Woman (1928–29)
Estate of the Artist

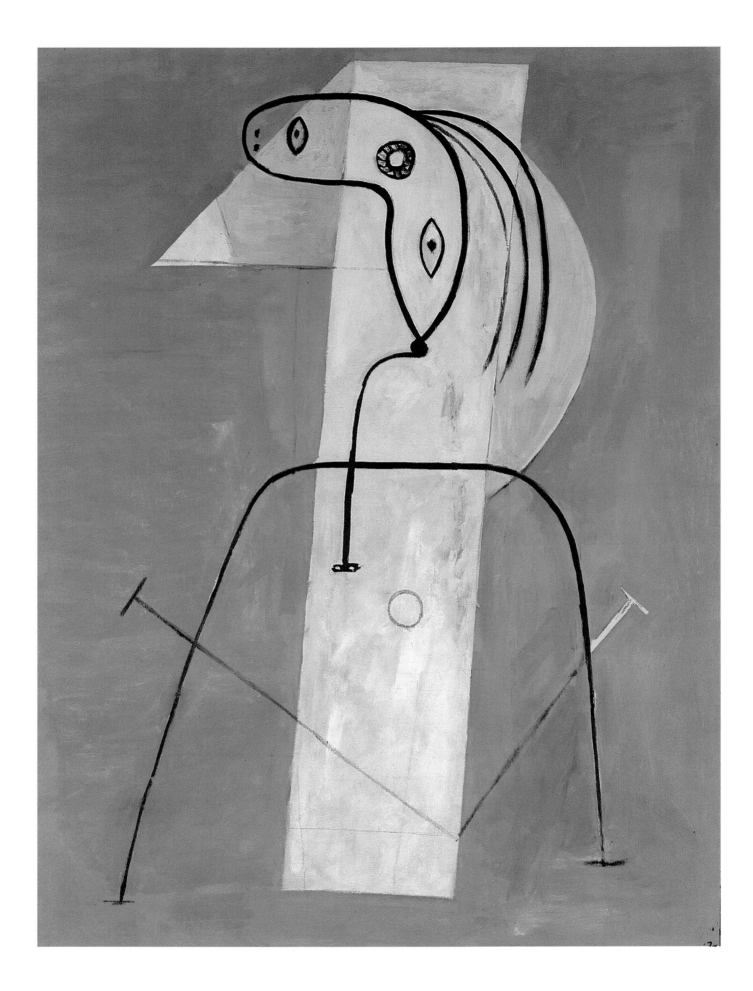

74 Standing Woman, 1927
Private Collection

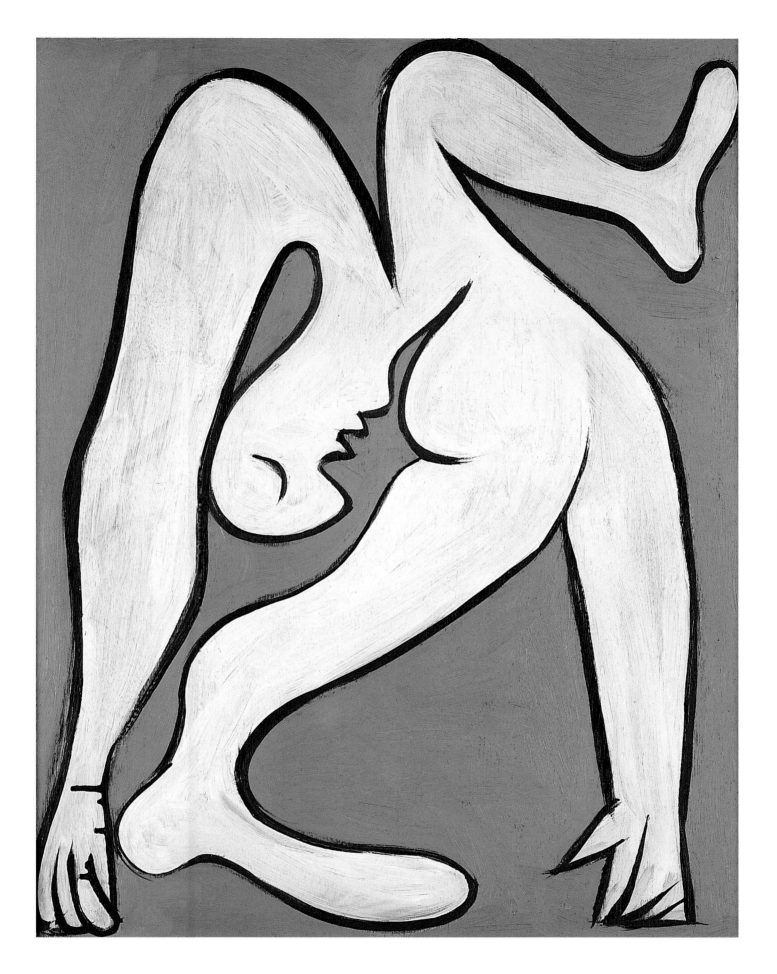

215

75 **Female Acrobat**, January 19, 1930
Estate of the Artist

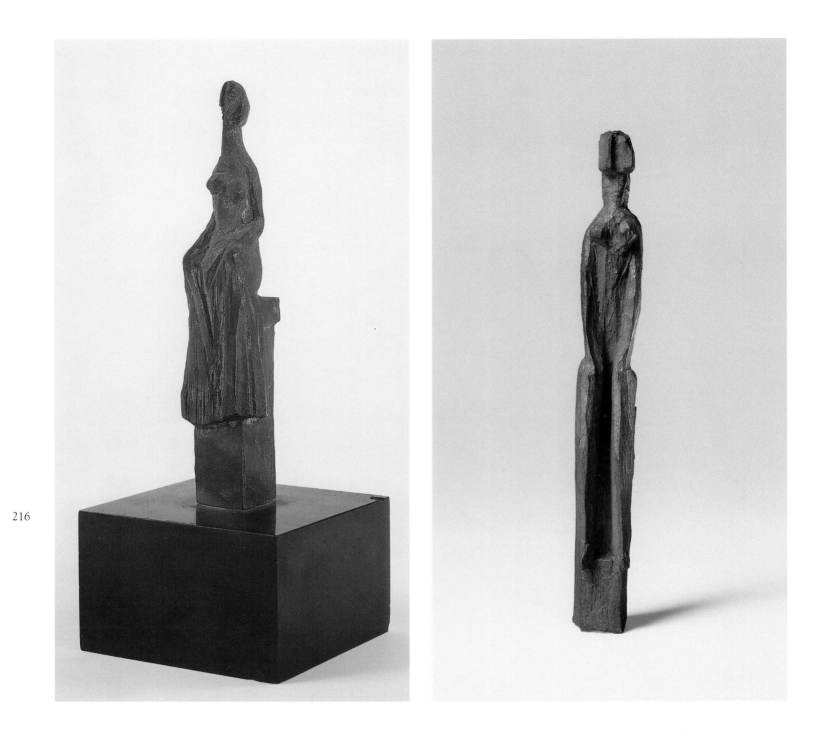

216

76 **Woman**, 1931
Estate of the Artist

77 **Woman**, 1931
Private Collection

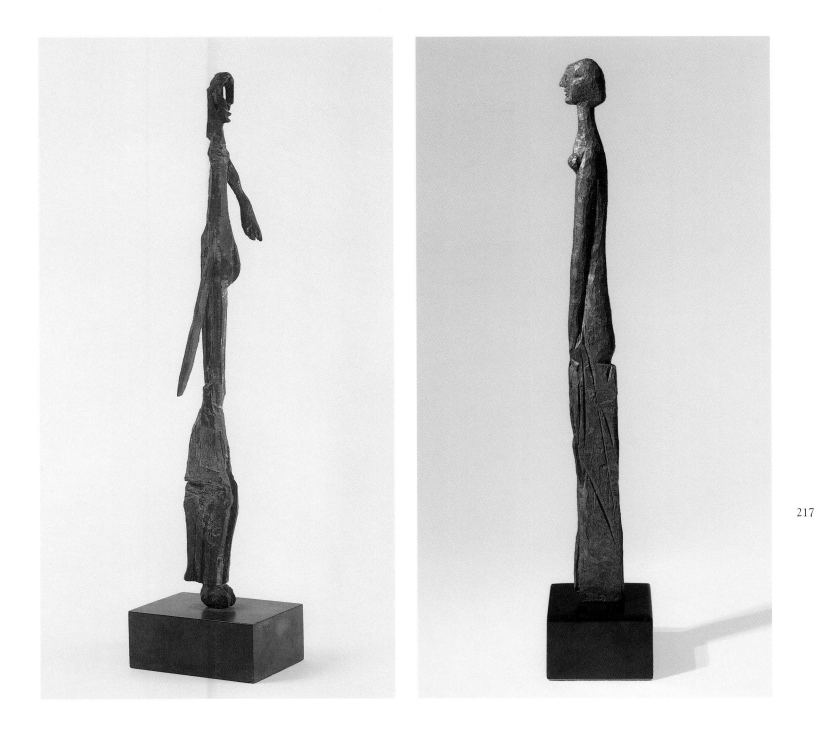

78 **Woman**, 1931
Estate of the Artist

79 **Woman, Boisgeloup**, 1931
Collection Dee Dee and Herb Glimcher

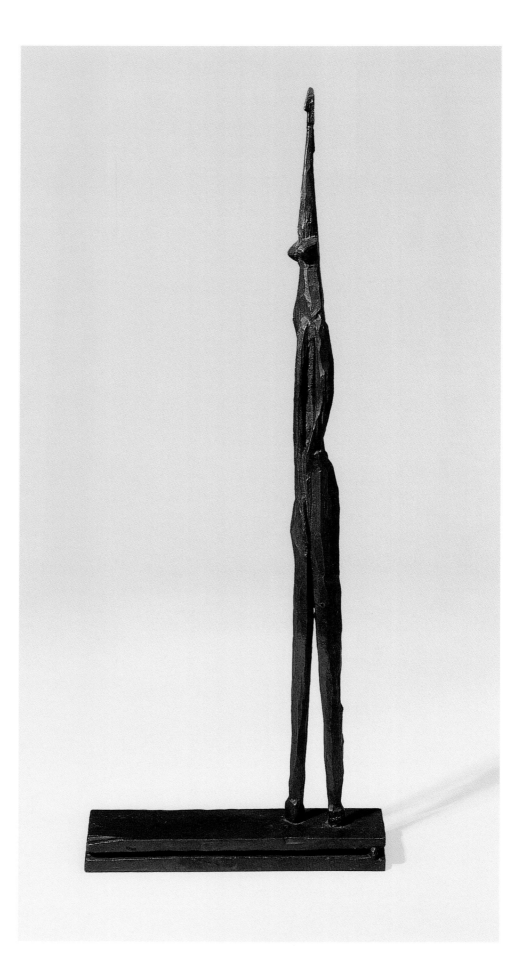

80 **Standing Woman**, 1931
Collection Julie and Edward J. Minskoff

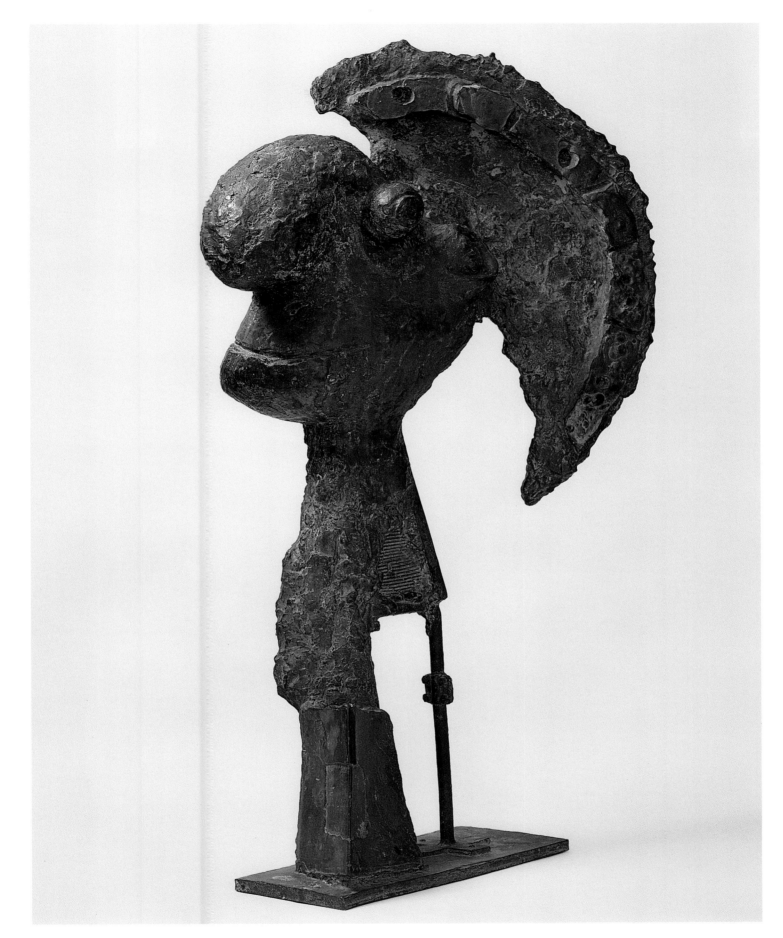

81 **Head of a Warrior**, 1933
Estate of the Artist

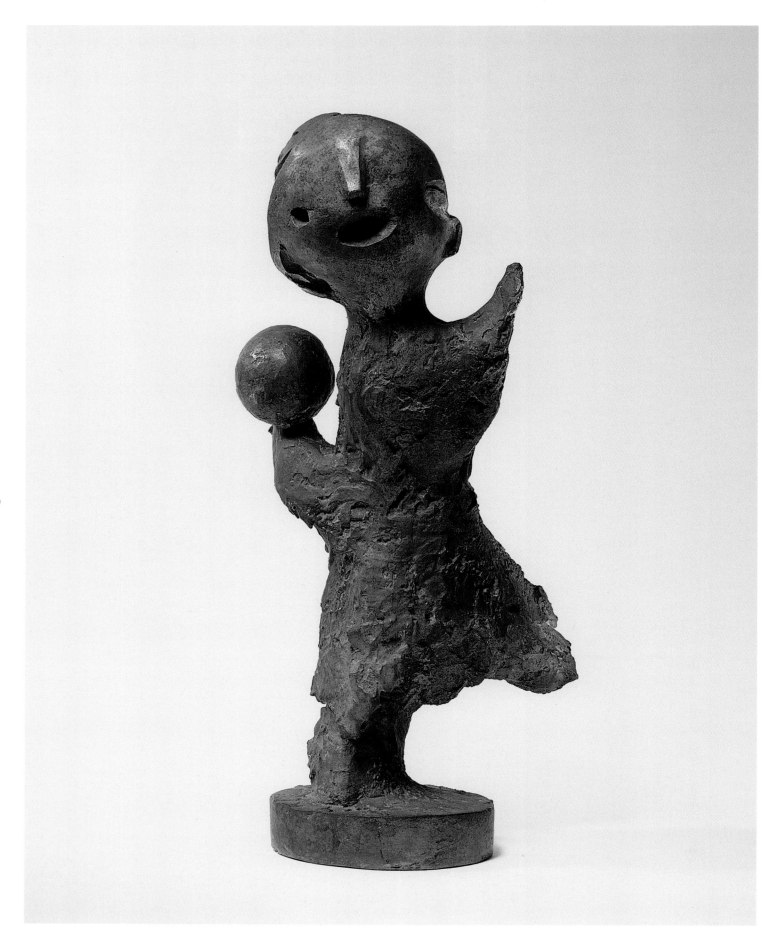

82 **Little Girl with Ball**, 1931
Private Collection

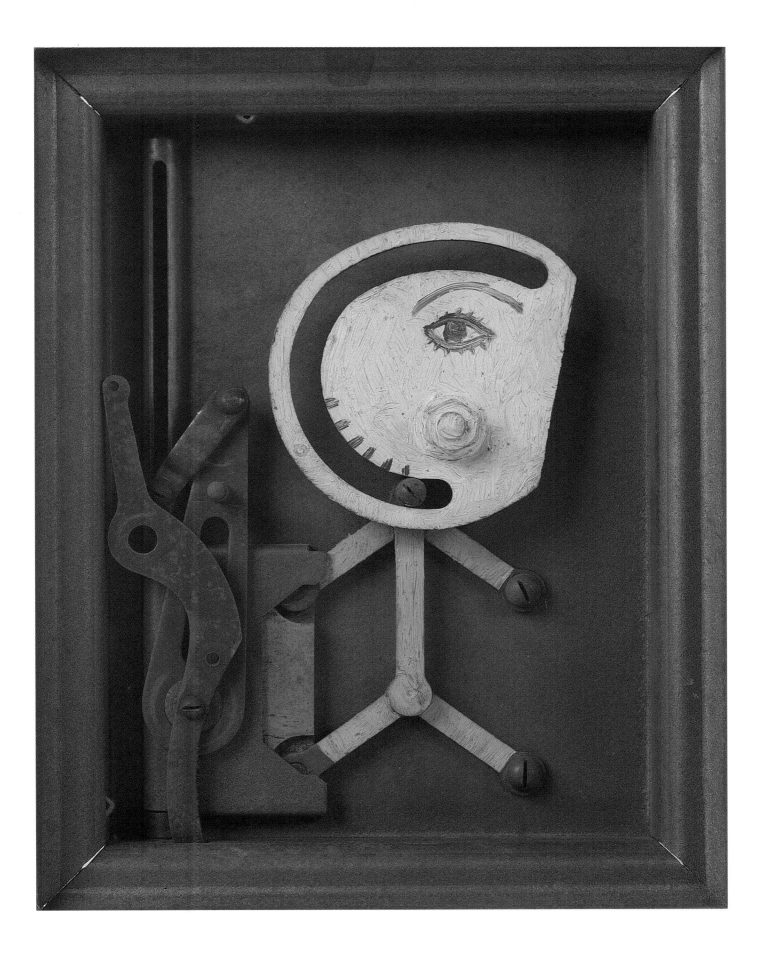

83 **Lock Figure**, 1935
Estate of the Artist

222

84 Sleeping Woman, 1932
From the Collection of Bill Blass

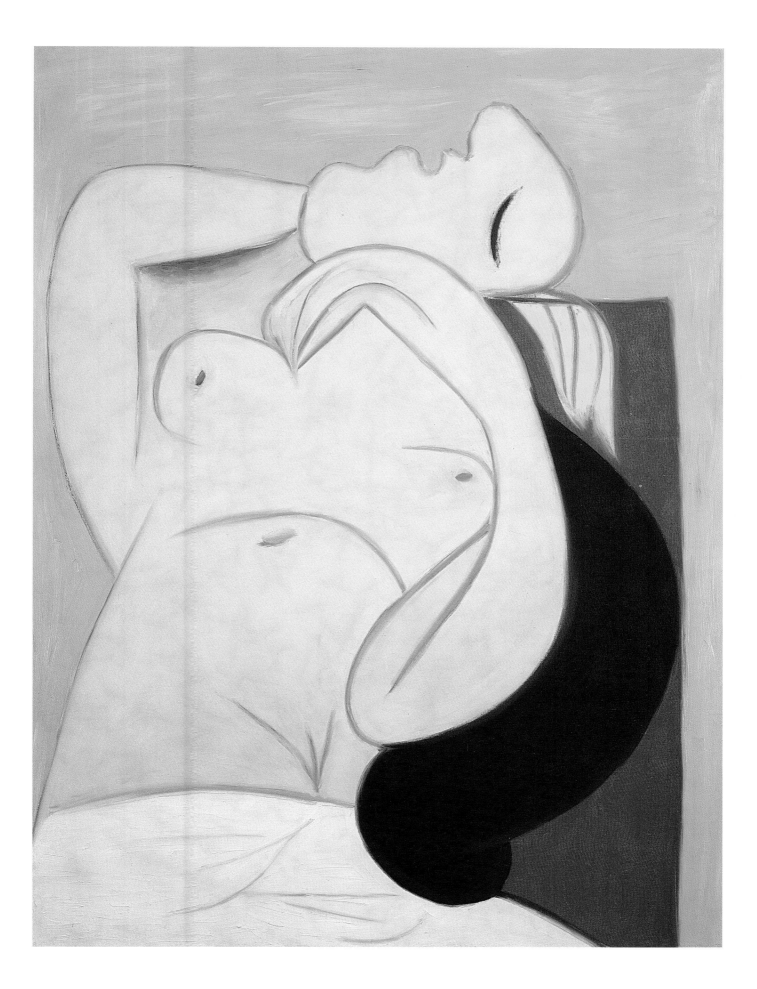

223

85 **Sleep**, 1932
Private Collection

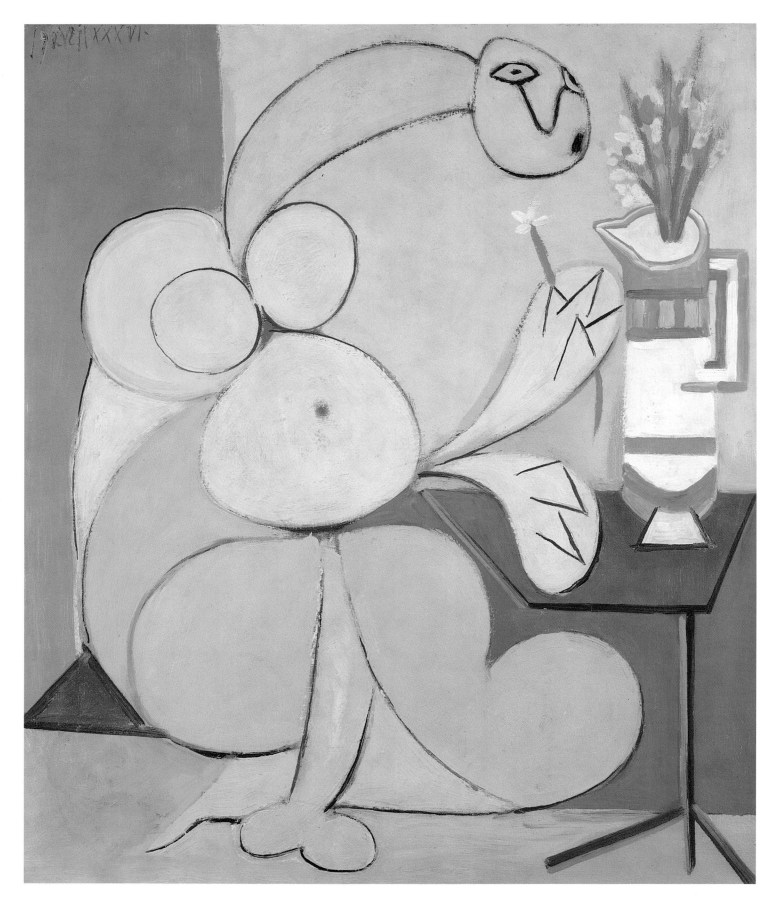

224

86 **Woman with Bouquet**, April 17, 1936
The Judy and Michael Steinhardt Collection, New York

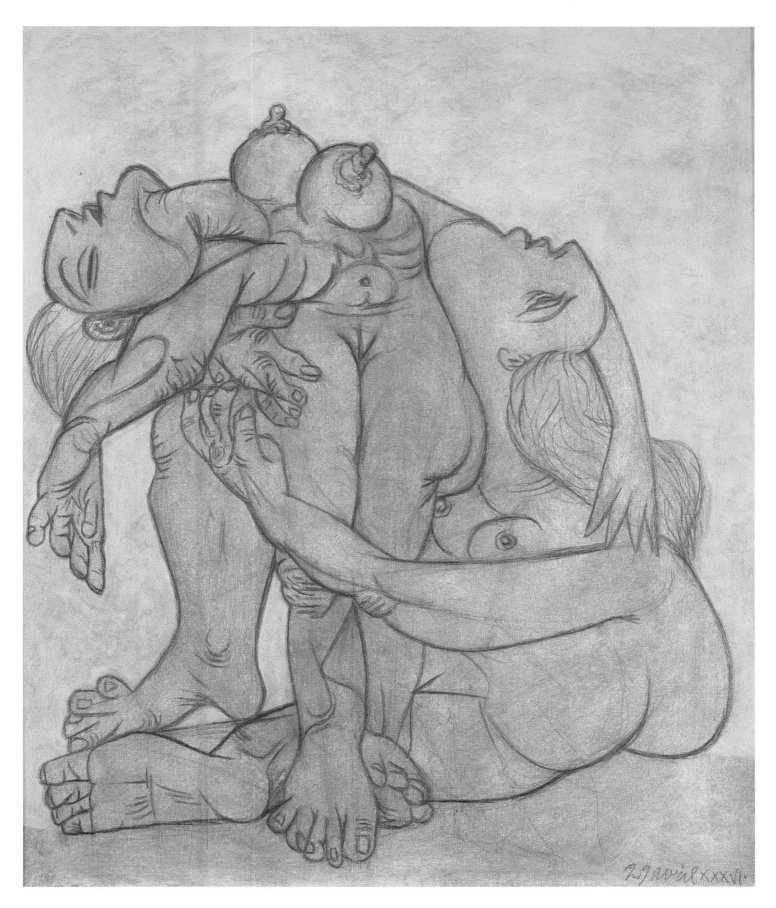

225

87 **Two Women**, April 29, 1936
Private Collection

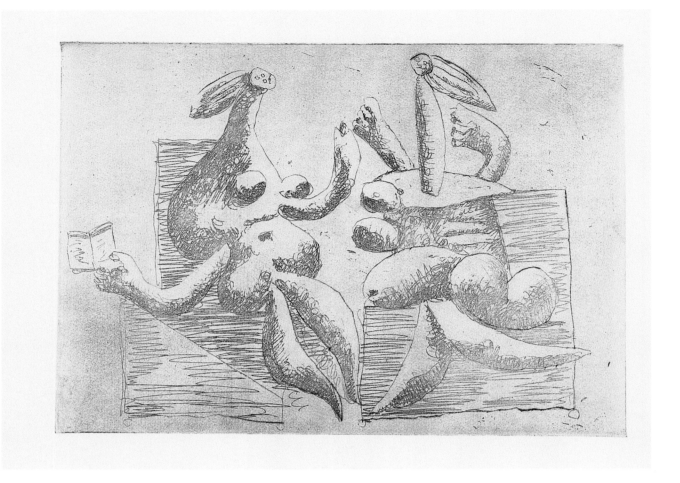

226

88 The Visit: Two Seated Women with a Book, February 18, 1933
Estate of the Artist

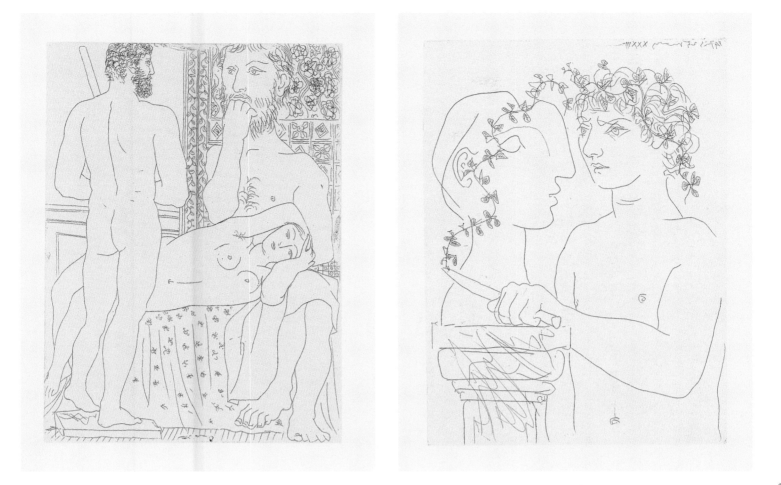

89 **Sculptor, Reclining Model and Self-portrait as Hercules**
Vollard Suite, March 17, 1933
Estate of the Artist

90 **Young Sculptor Finishing a Plaster,**
Vollard Suite, March 23, 1933
Estate of the Artist

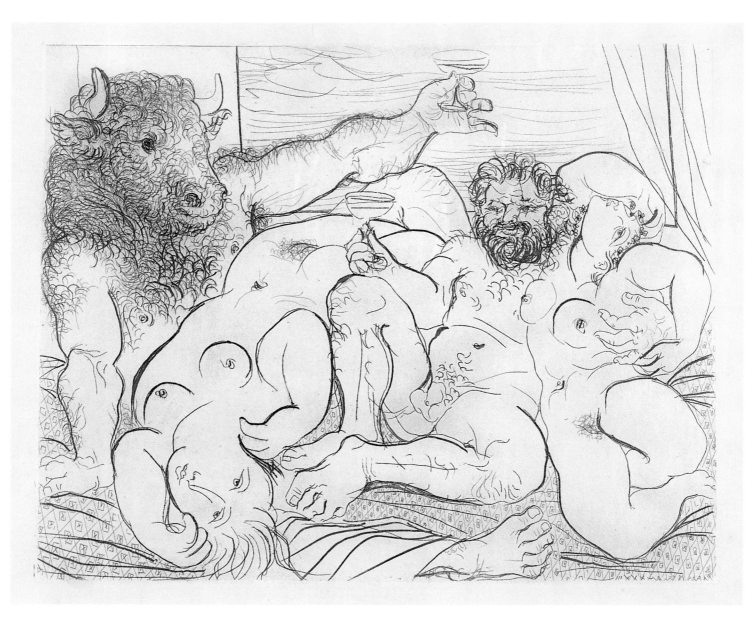

91 Bacchanal with Minotaur,
Vollard Suite, May 18, 1933
Estate of the Artist

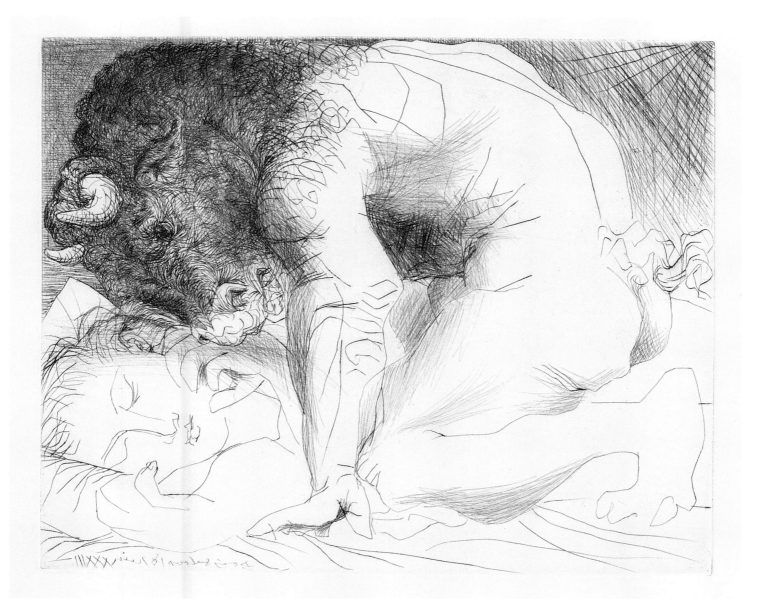

92 Minotaur Caressing the Hand of a Sleeping Woman with its Muzzle,
Vollard Suite, June 18, 1933
Estate of the Artist

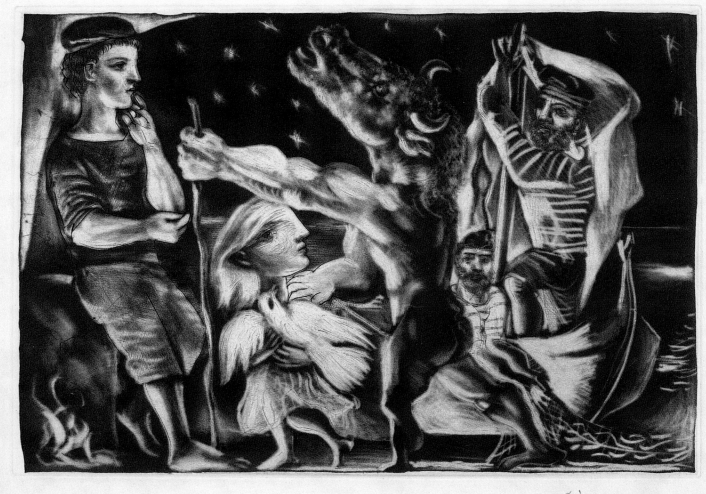

93 Blind Minotaur Guided by Marie-Thérèse with a Pigeon on a Starry Night,
Vollard Suite, December 31, 1934–January 1, 1935
Collection Linda and Morton Janklow, New York

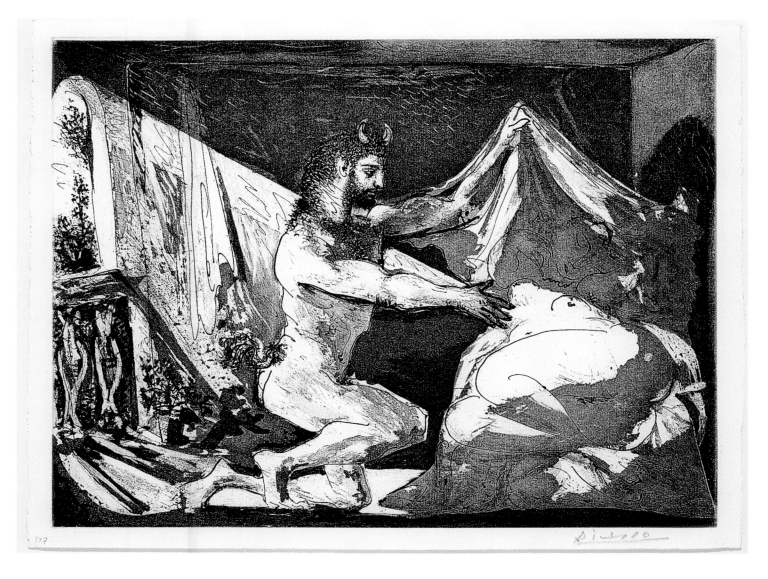

94 Faun Uncovering a Woman, *Vollard Suite,* 1936
Collection David Teiger

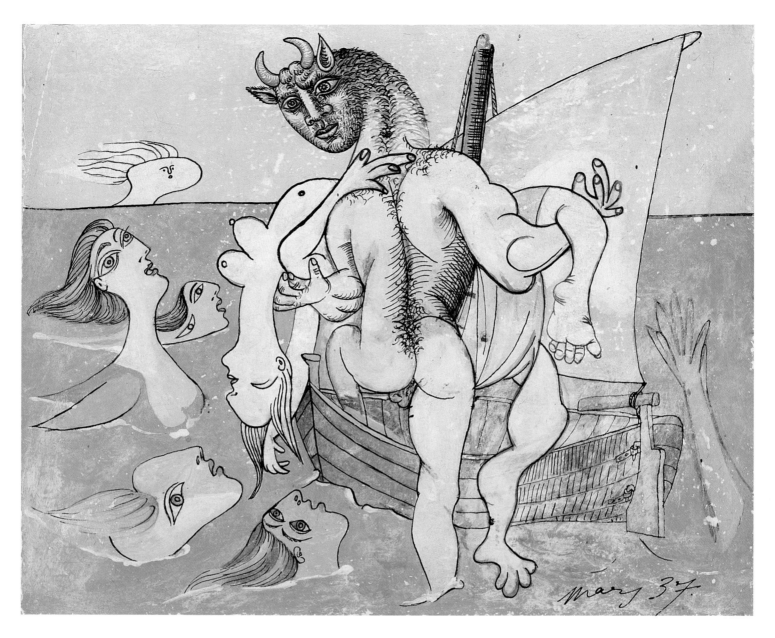

95 **Minotaur in a Boat Saving a Woman**, March 1937
Estate of the Artist

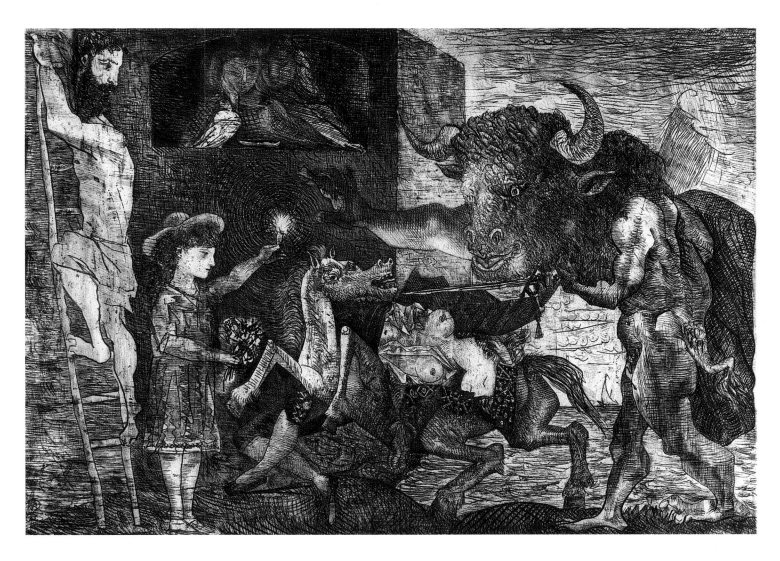

96 **Minotauromachy**, 1935
Musée Picasso, Paris

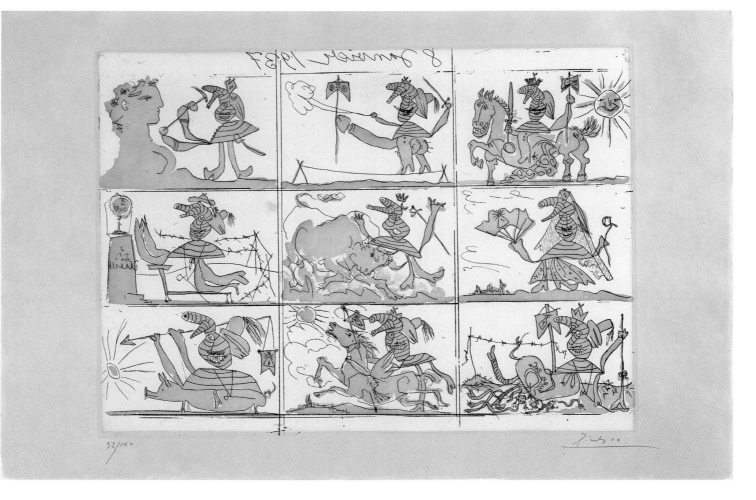

97 Dream and Lie of Franco (I), 1937
Private Collection

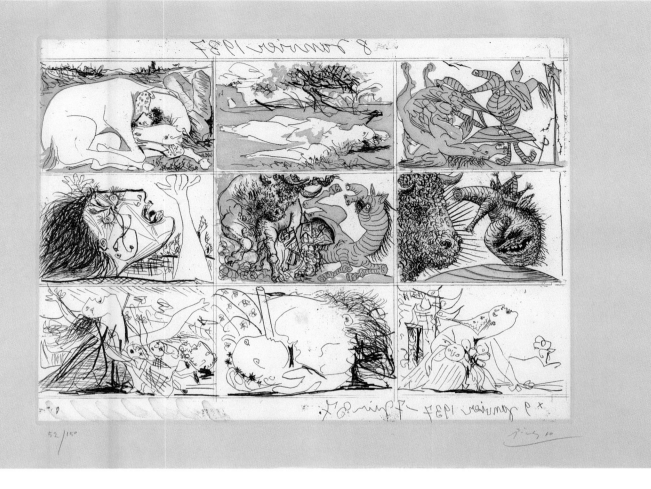

98 Dream and Lie of Franco (II), 1937
Private Collection

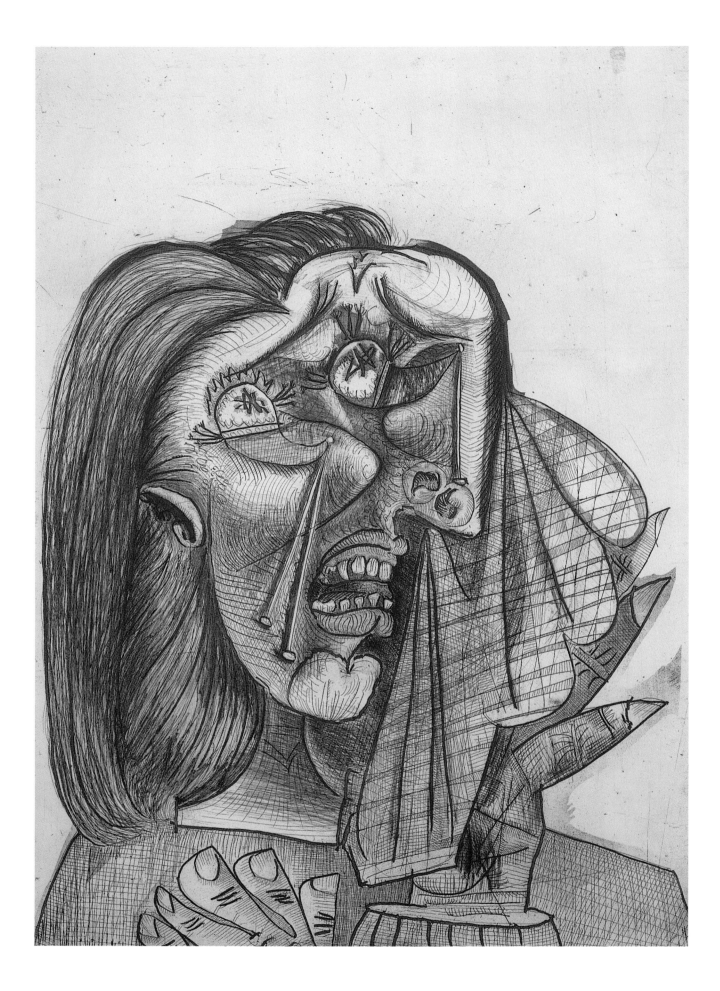

99 The Weeping Woman, 1937
Musée Picasso, Paris

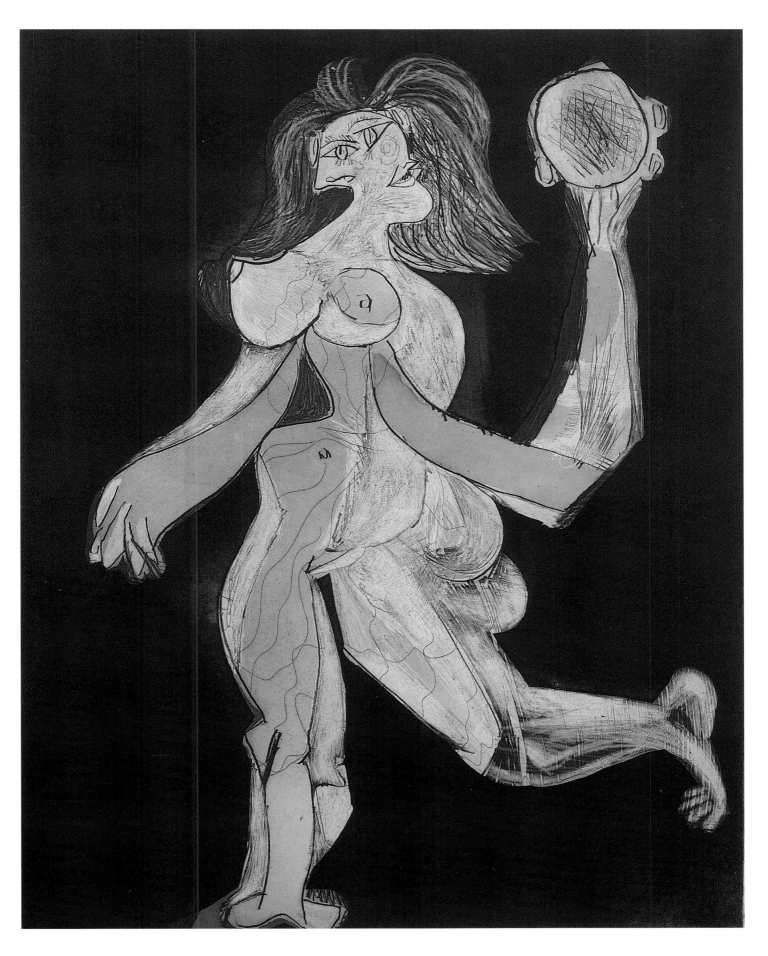

100 **Woman with Tambourine**, 1938
Musée Picasso, Paris

238

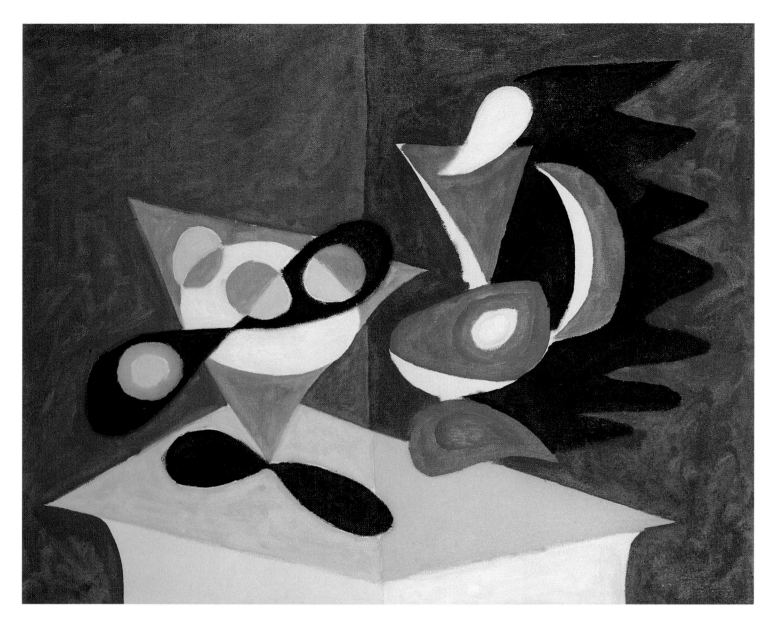

101 **Still Life with Pitcher and Compote**, January 22, 1937
Private Collection

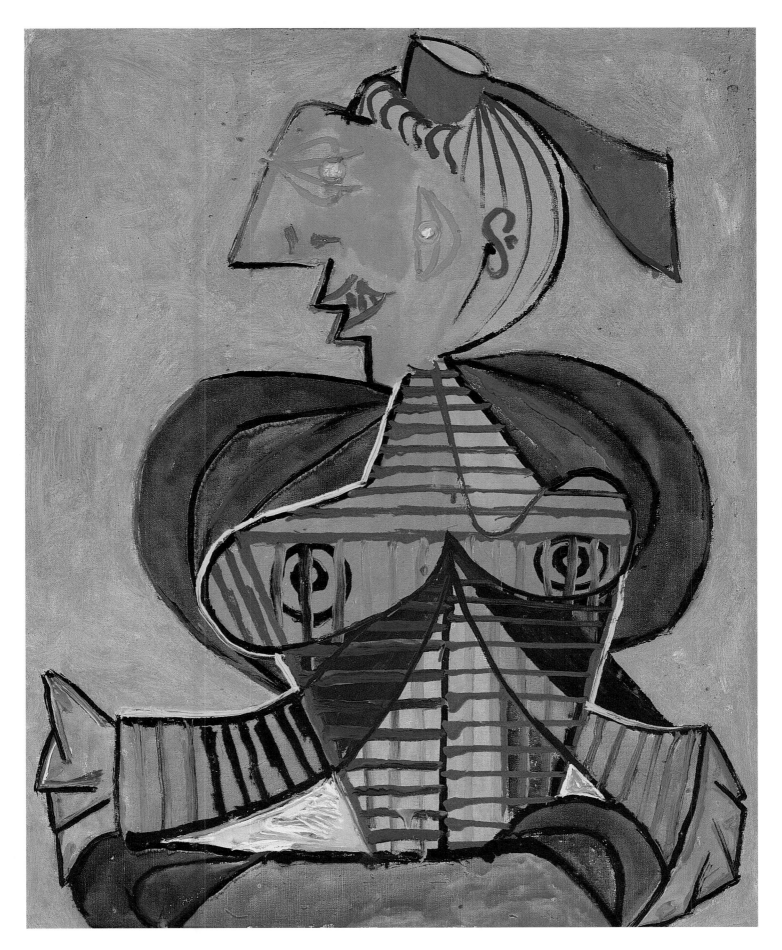

102 **Woman with Arlesienne Coiffe**, September 20, 1937
Estate of the Artist

240

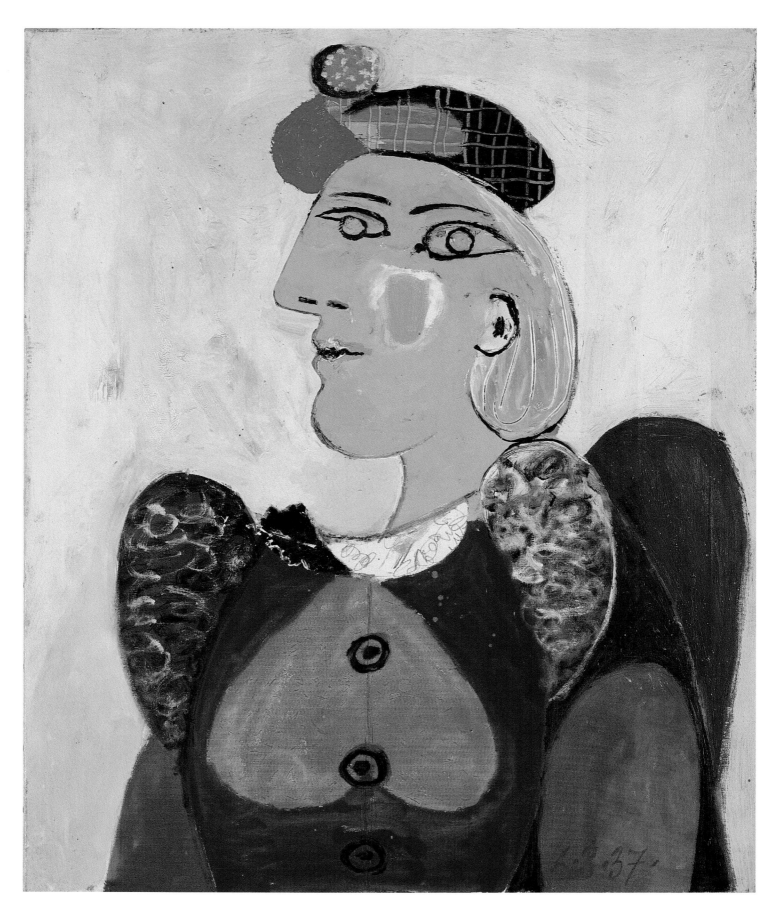

103 **Woman with Beret and Red Dress**, March 6, 1937
Estate of the Artist

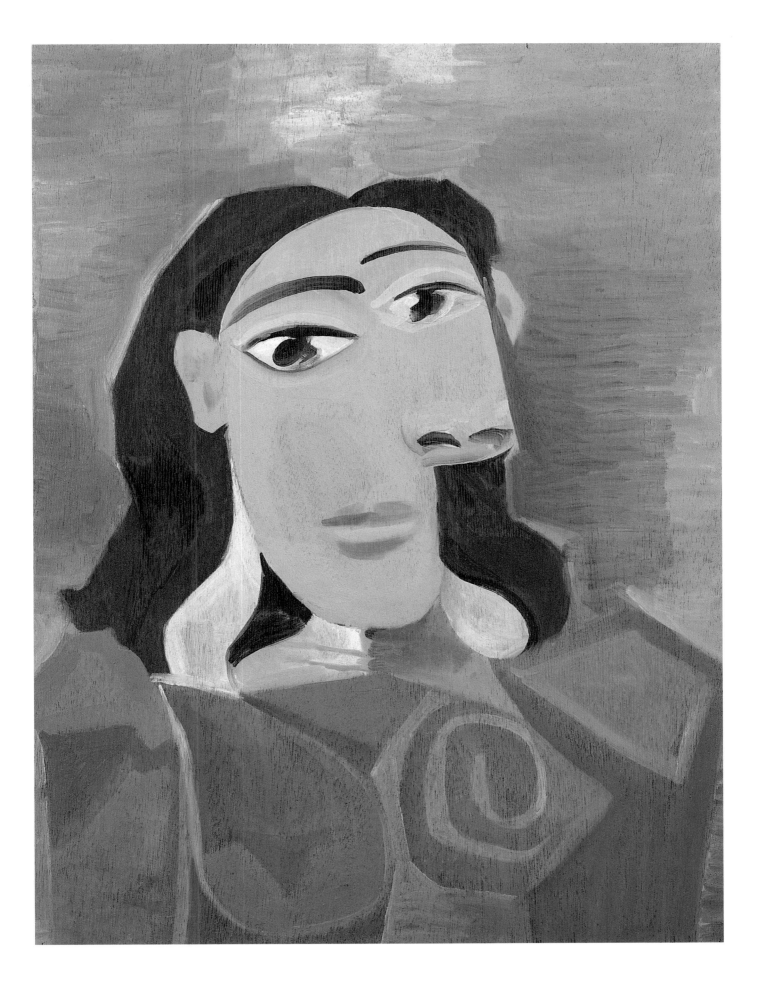

104 Woman with Red Hair and Blue Dress, March 1939
Madrigal Collection

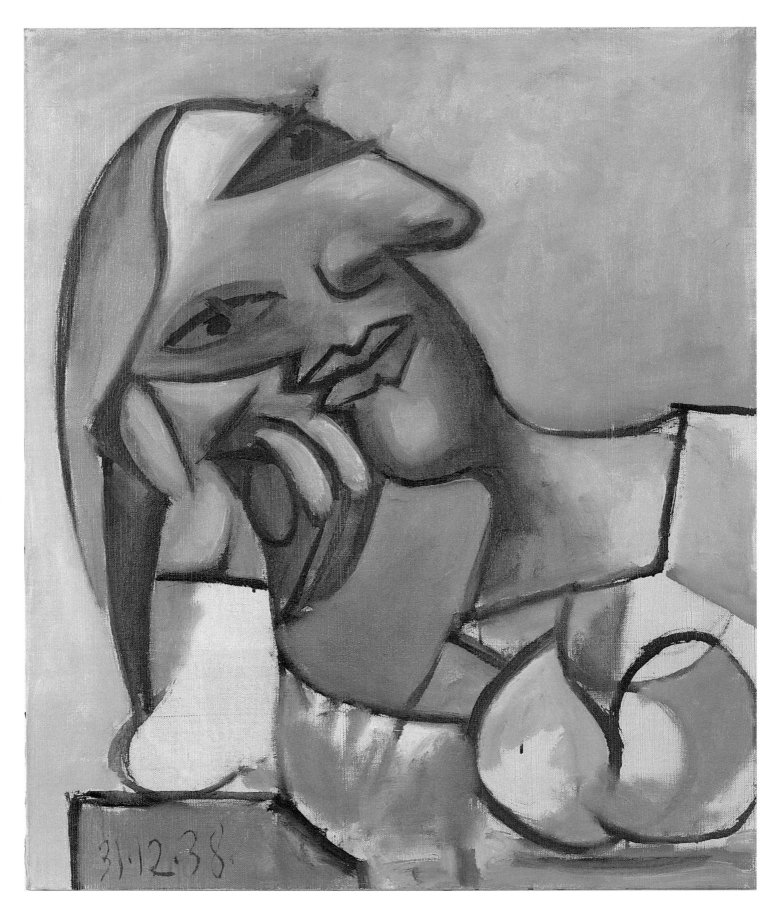

242

105 **Bust of Woman**, December 31, 1938
Estate of the Artist

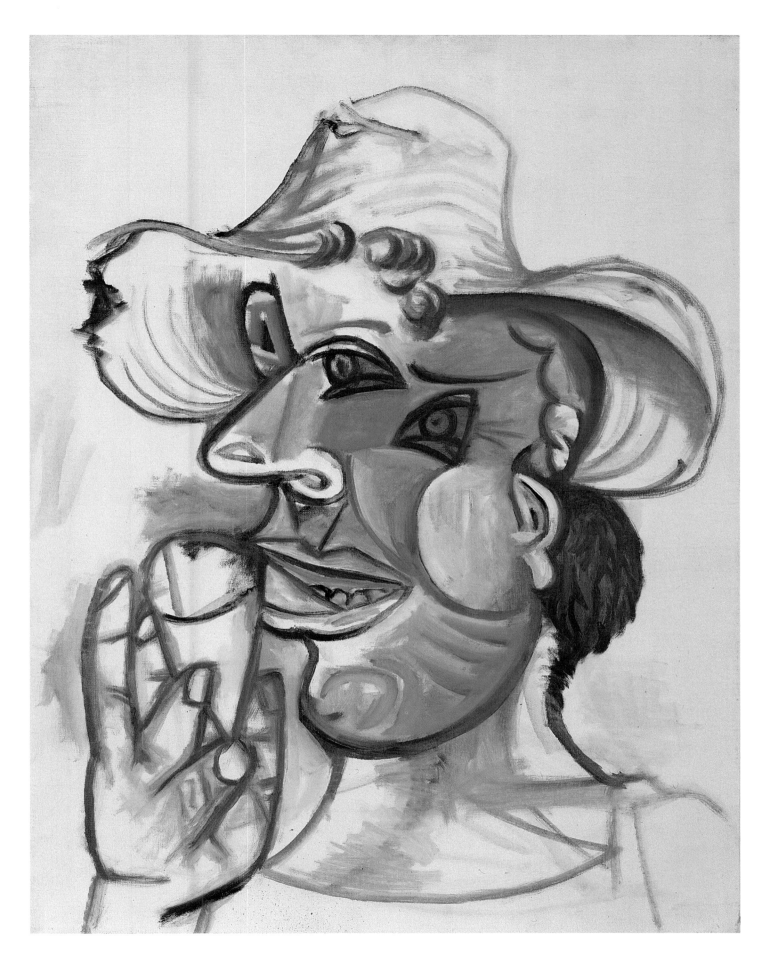

106 **Man with Ice Cream Cone**, July 26, 1938
Estate of the Artist

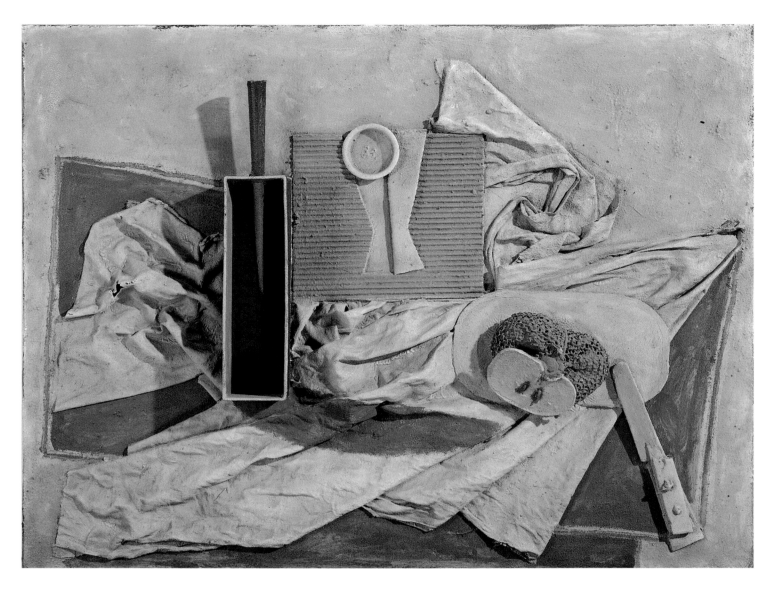

244

107 **Composition with Table and Apple**, September 2, 1937
Private Collection

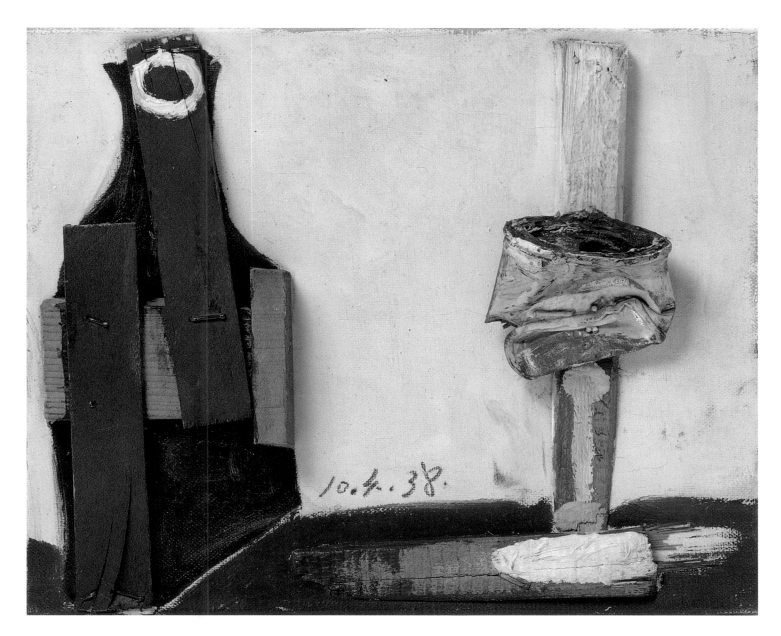

108 **Construction on Canvas,** April 10, 1938
Estate of the Artist

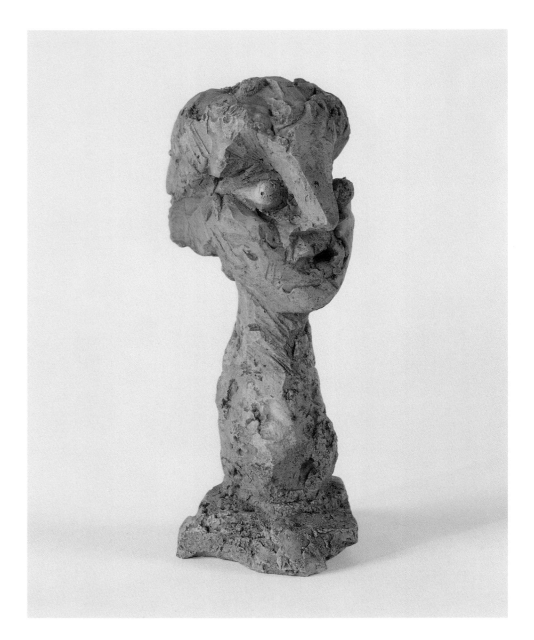

109 **Woman's Head**, 1943
Estate of the Artist

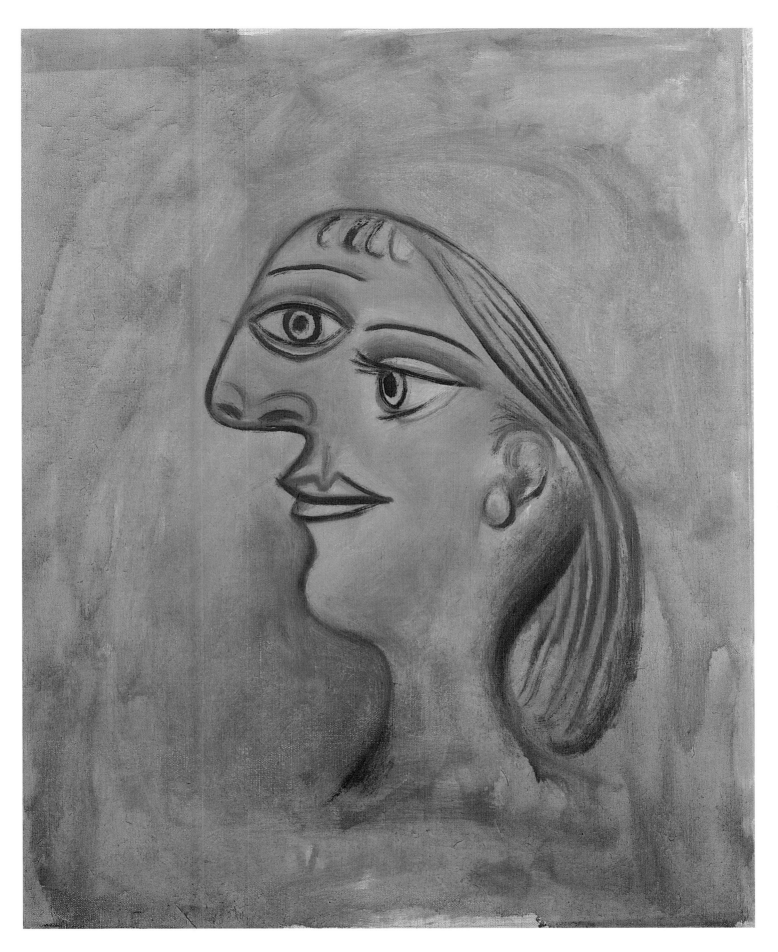

110 **Woman's Head, Left Profile**, March 16, 1938
Private Collection

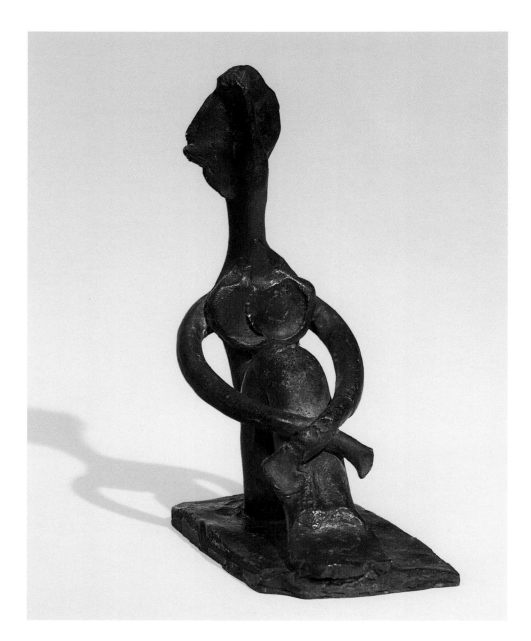

111 **Seated Woman**, 1945
Estate of the Artist

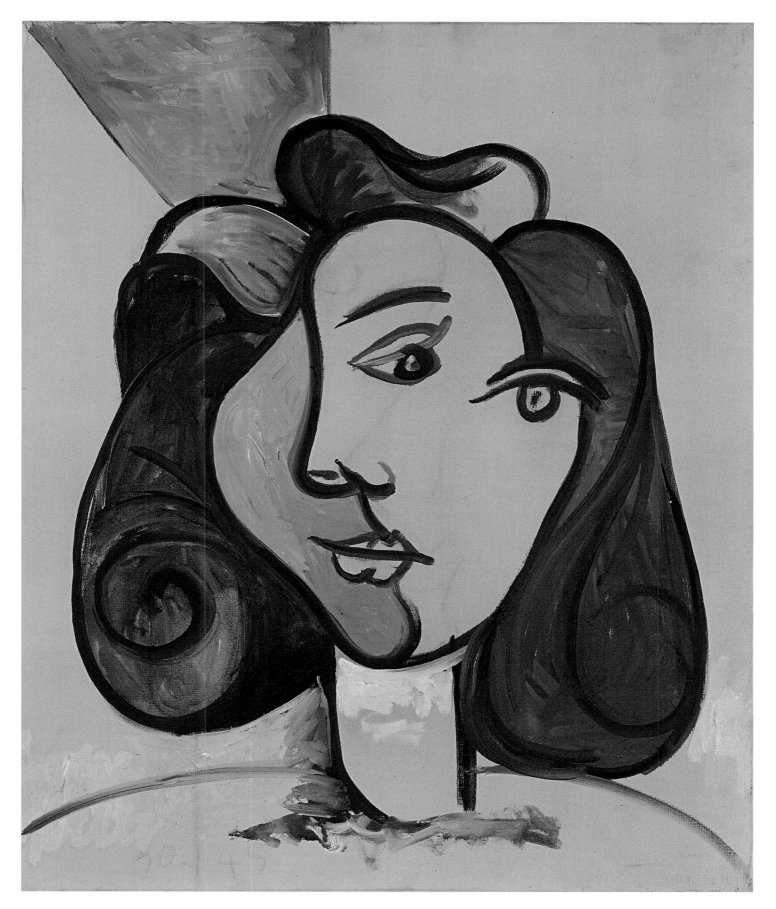

112 **Girl's Head**, January 30, 1945
Estate of the Artist

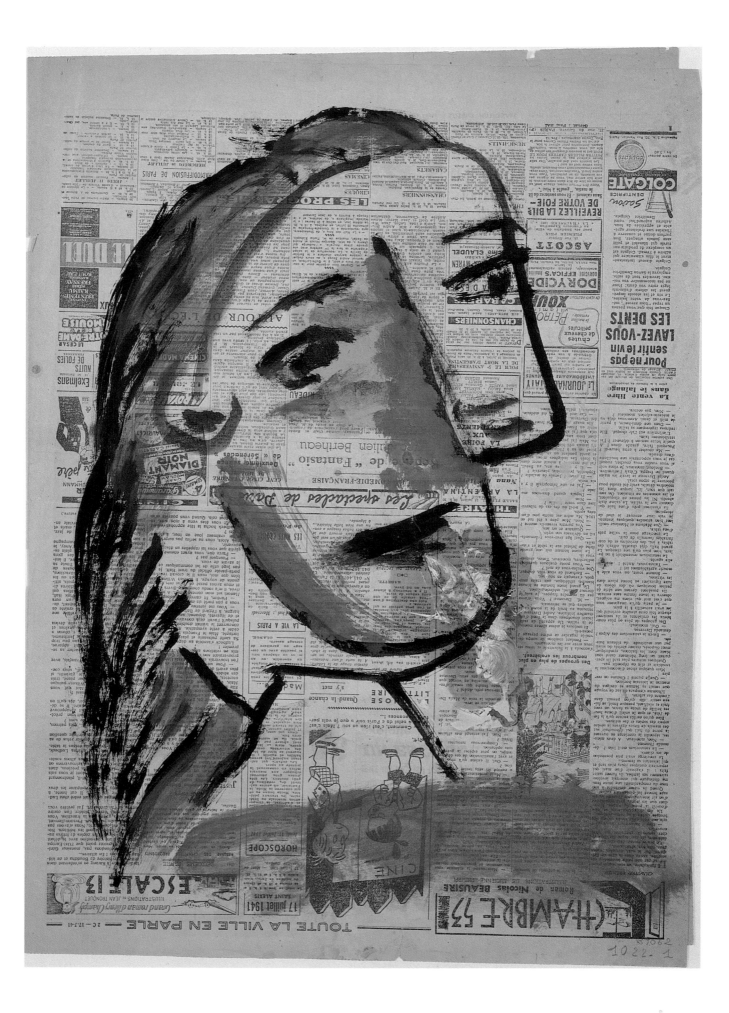

250

113 **Woman's Head** (1941)
Estate of the Artist

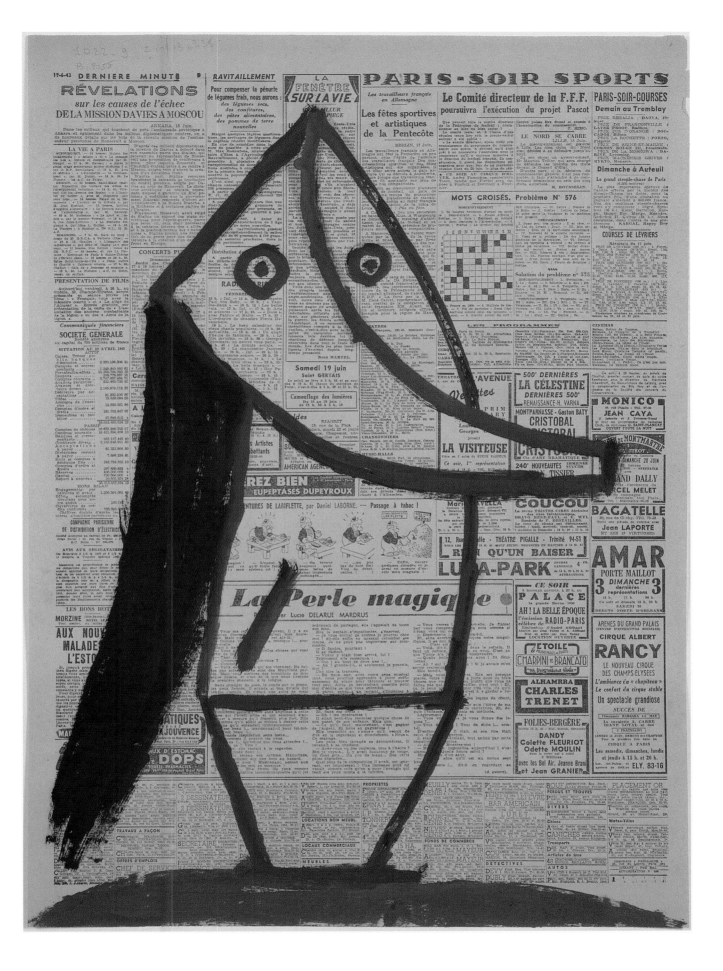

251

114 **Figure** (1943)
Estate of the Artist

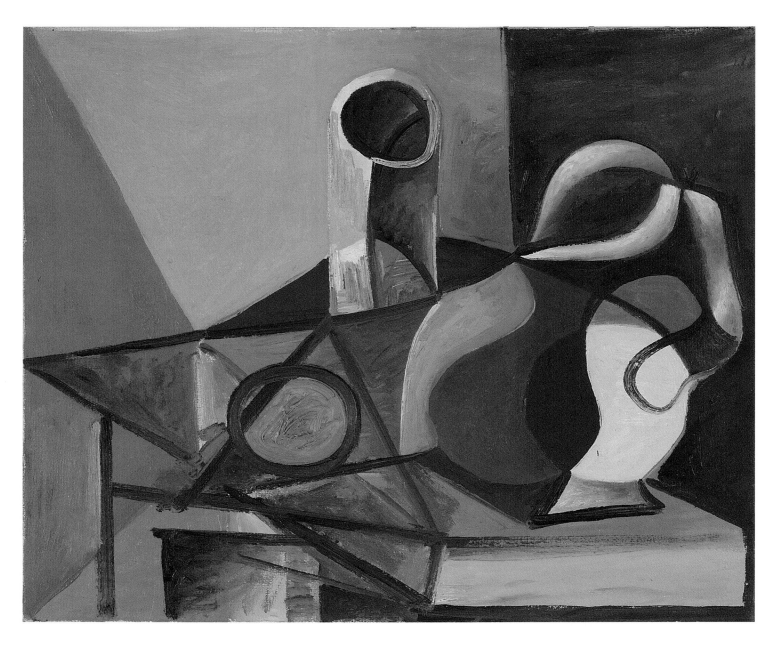

115 **Still Life with Pitcher and Glass,** July 19, 1944
Estate of the Artist

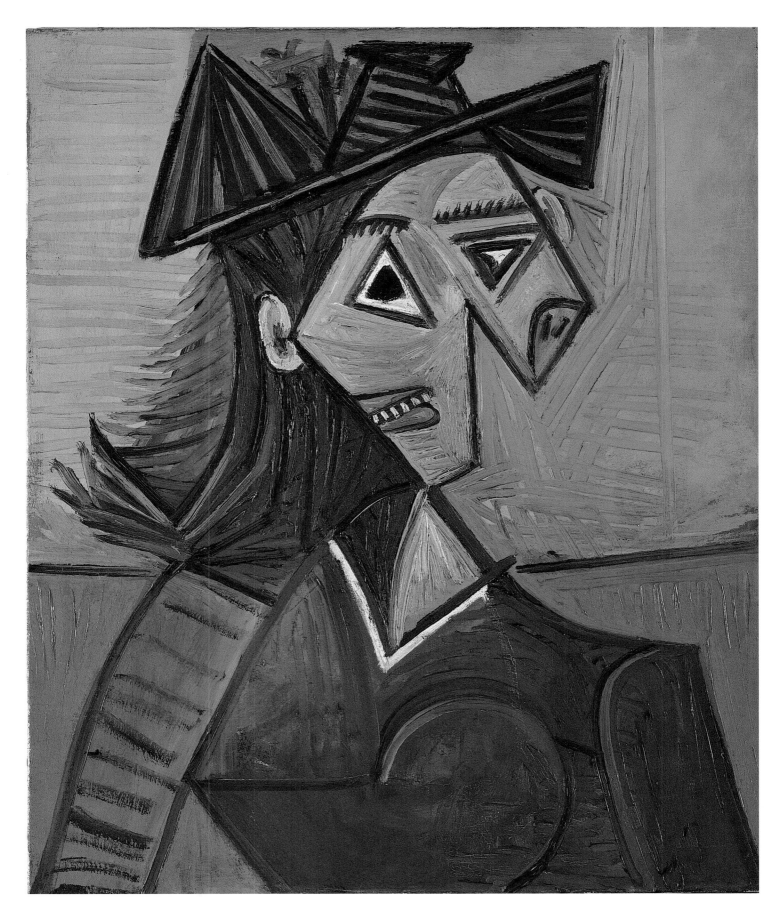

253

116 **Bust of Woman with Flowered Hat**, begun November 1939–completed July 29, 1942
Estate of the Artist

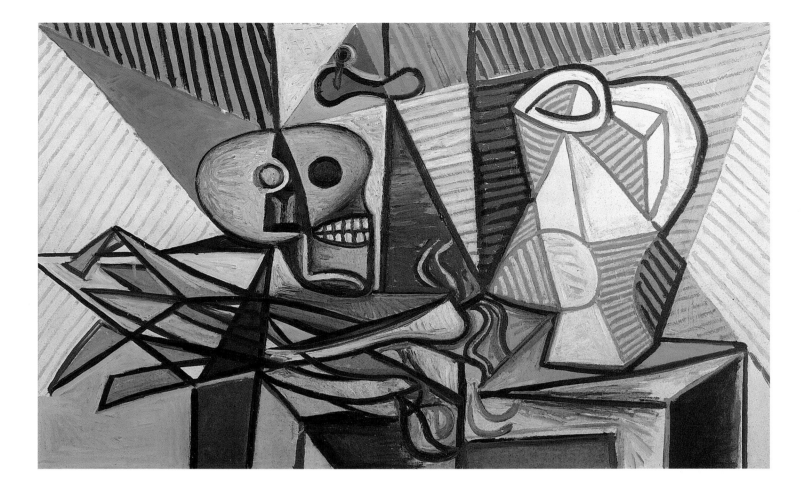

254

117 **Still Life with Skull**, March 15, 1945
Private Collection

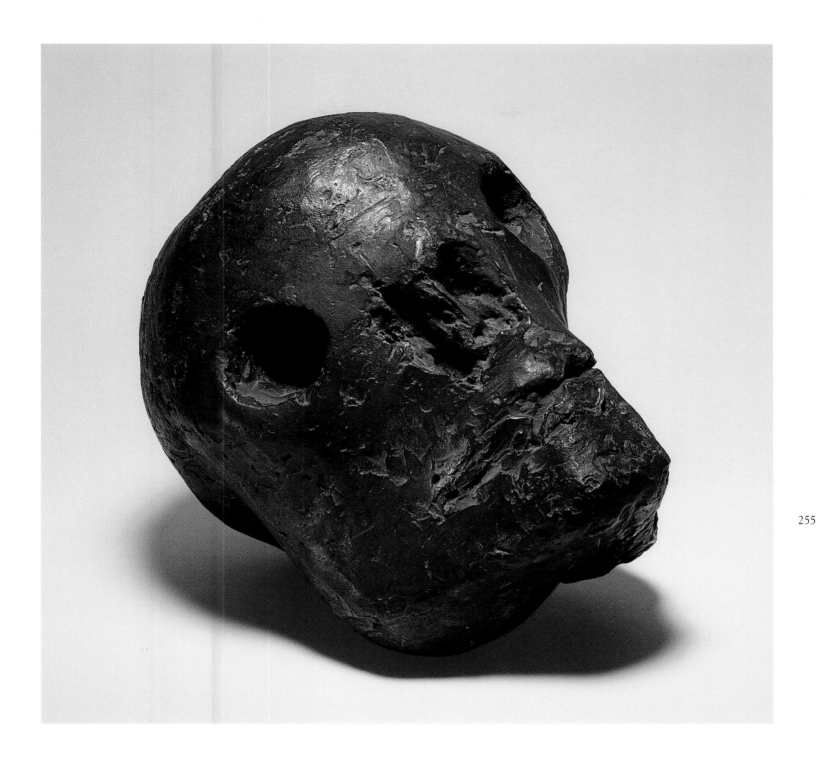

118 **The Skull (Death's Head)**, 1943
Private Collection

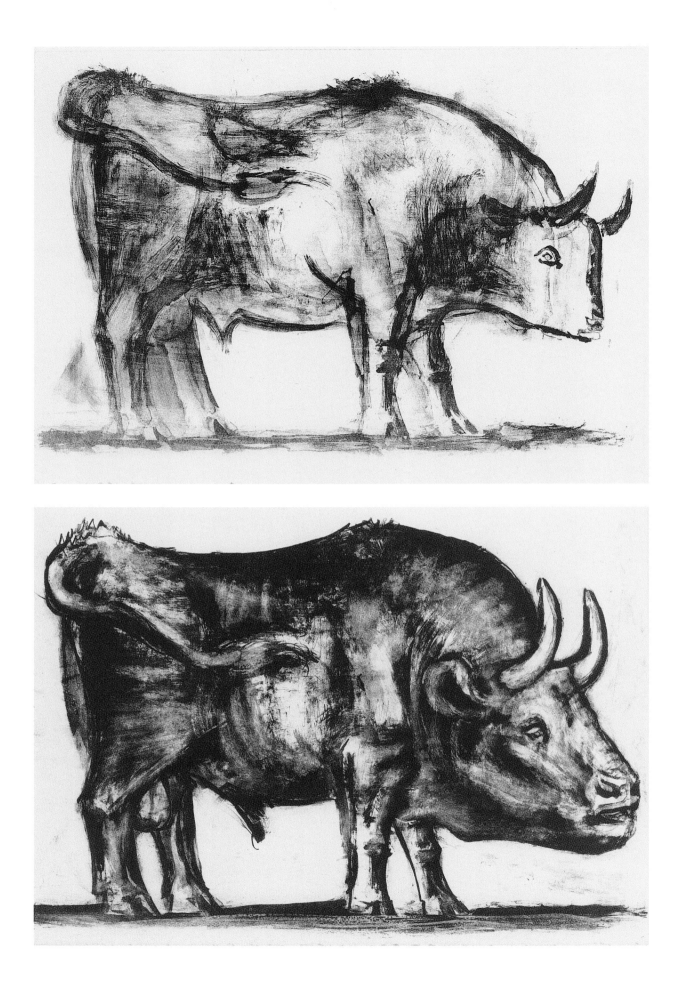

119 **The Bull**, first state, December 5, 1945
Estate of the Artist

120 **The Bull**, second state, December 12, 1945
Estate of the Artist

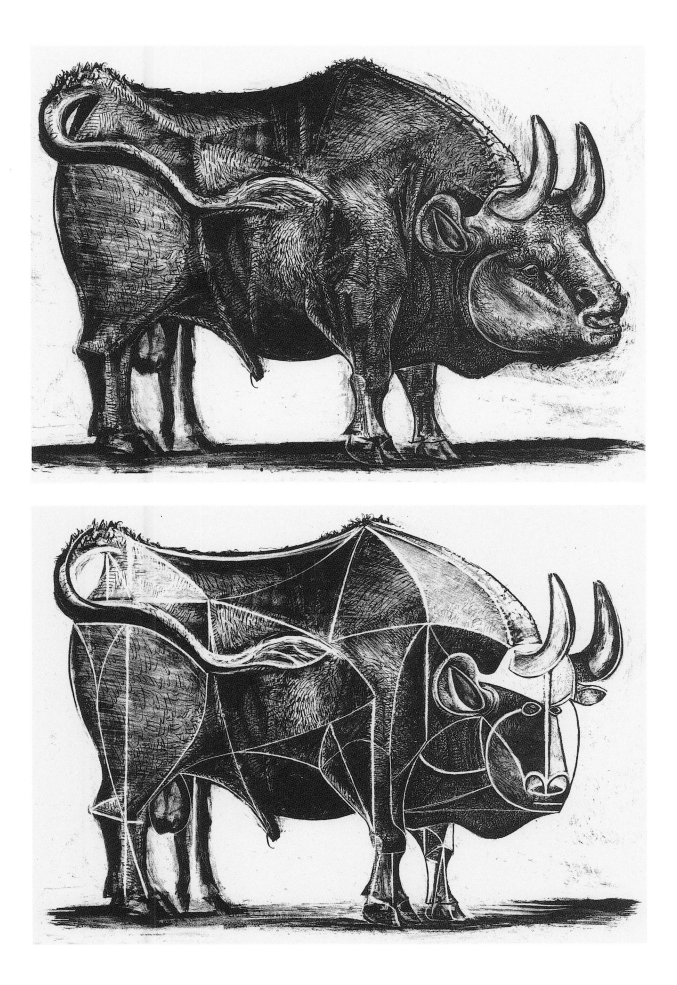

121 **The Bull**, third state, December 18, 1945
Estate of the Artist

122 **The Bull**, fourth state, December 22, 1945
Estate of the Artist

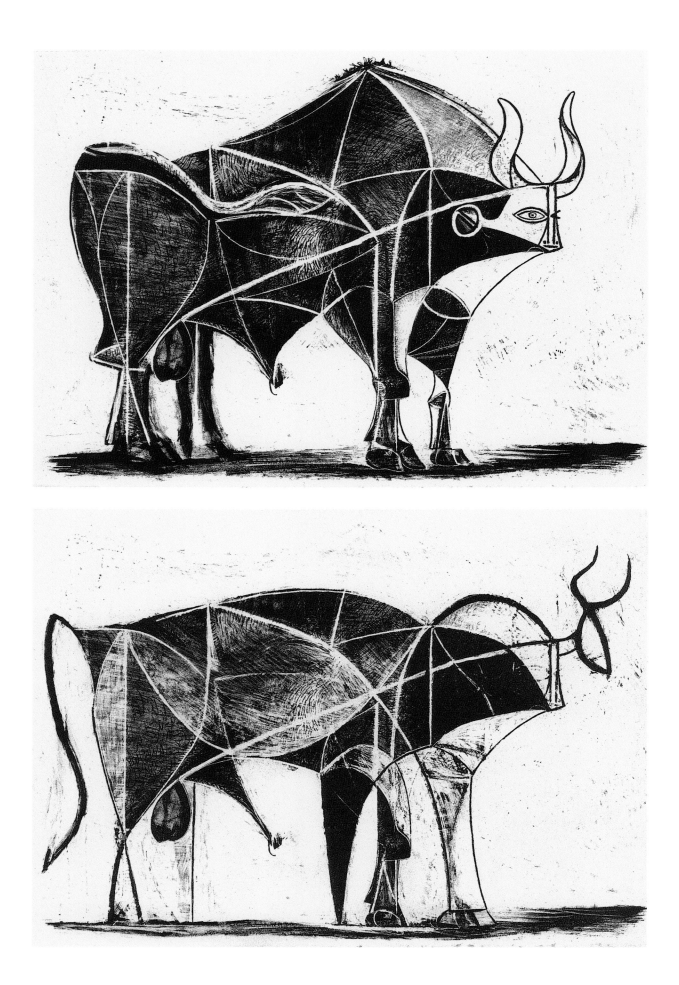

123 **The Bull**, fifth state, December 24, 1945
Estate of the Artist

124 **The Bull**, sixth state, December 26, 1945
Estate of the Artist

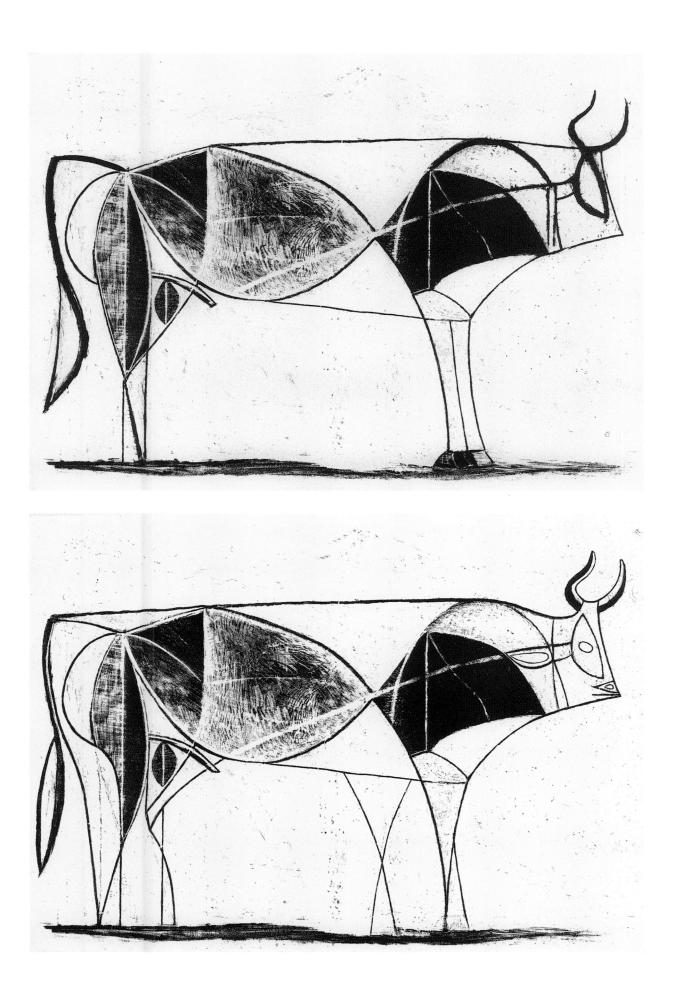

125 **The Bull**, seventh state, December 28, 1945
Estate of the Artist

126 **The Bull**, eighth state, January 2, 1946
Estate of the Artist

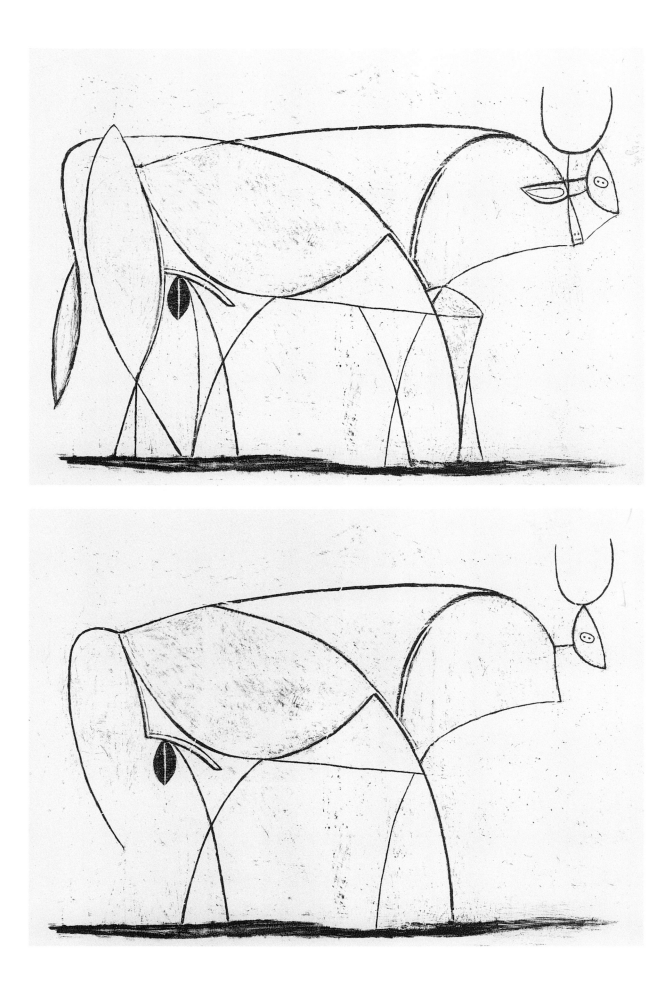

127 **The Bull**, ninth state, January 5, 1946
Estate of the Artist

128 **The Bull**, tenth state, January 10, 1946
Estate of the Artist

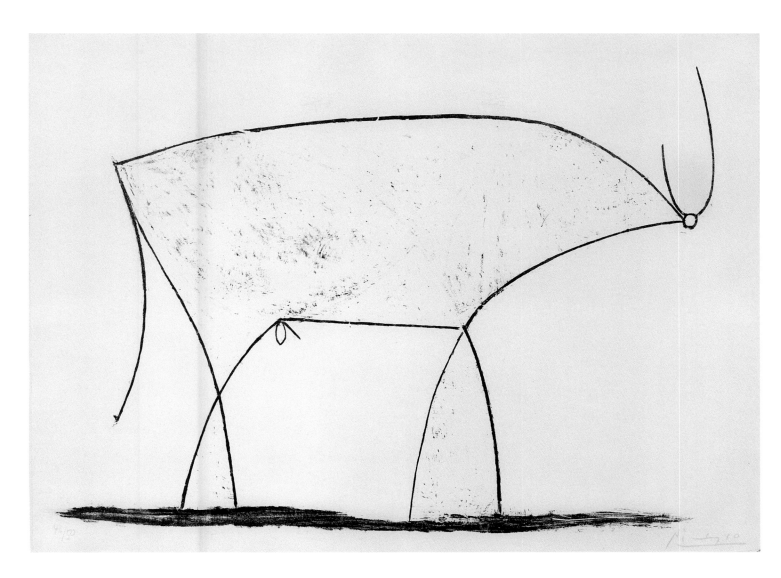

129 **The Bull**, eleventh state, January 17, 1946
Estate of the Artist

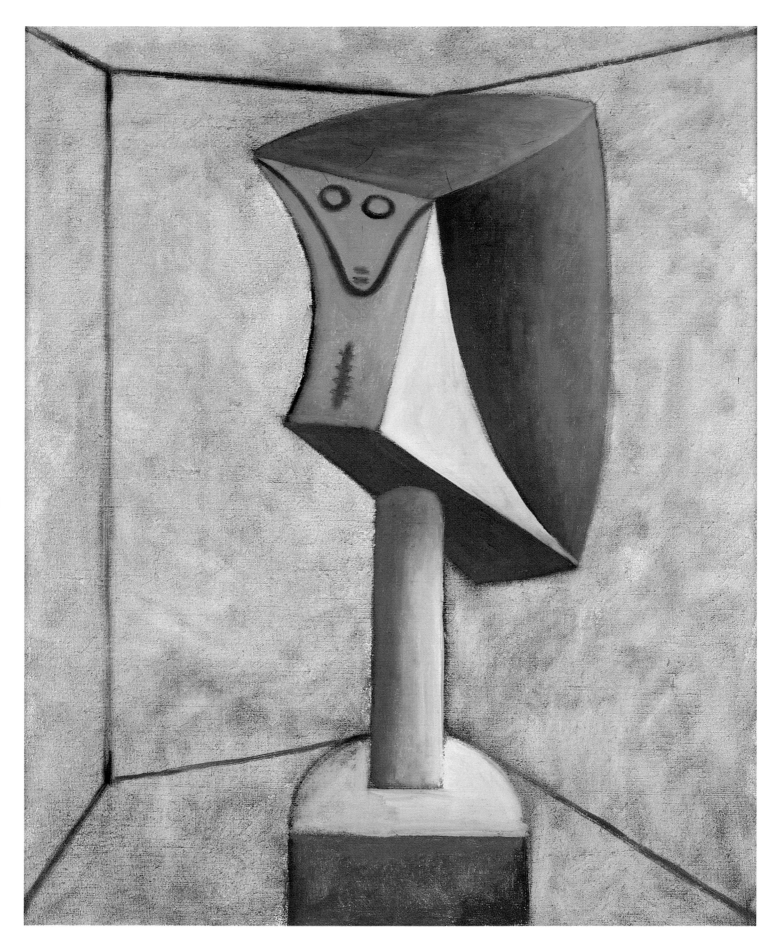

130 **Head Turned Three-Quarters to the Left**, February 15, 1945
Private Collection

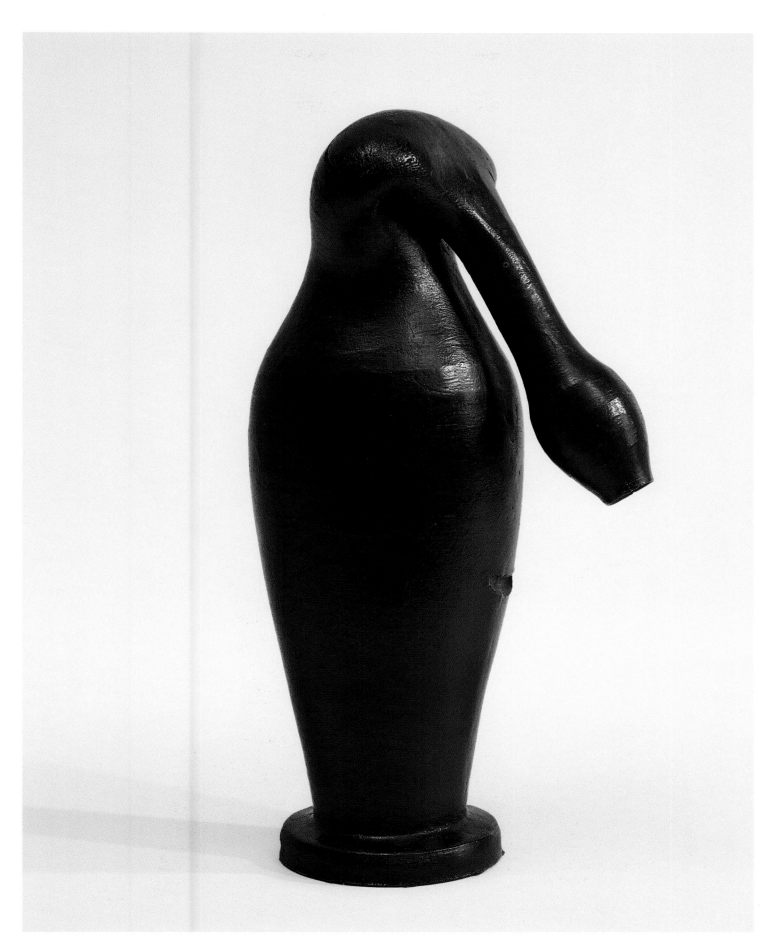

131 **Vase Face**, 1946
Private Collection

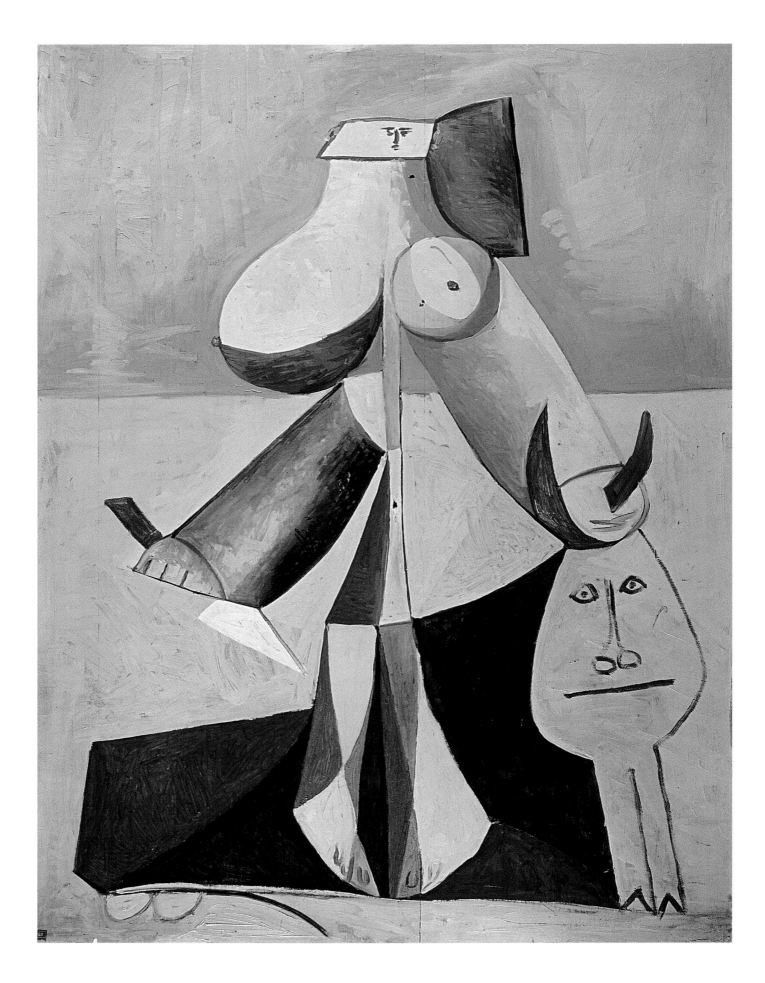

132 **Woman with Knife in Hand and Bull's Head** , June 6–19, 1946
Collection Linda and Harry Macklowe

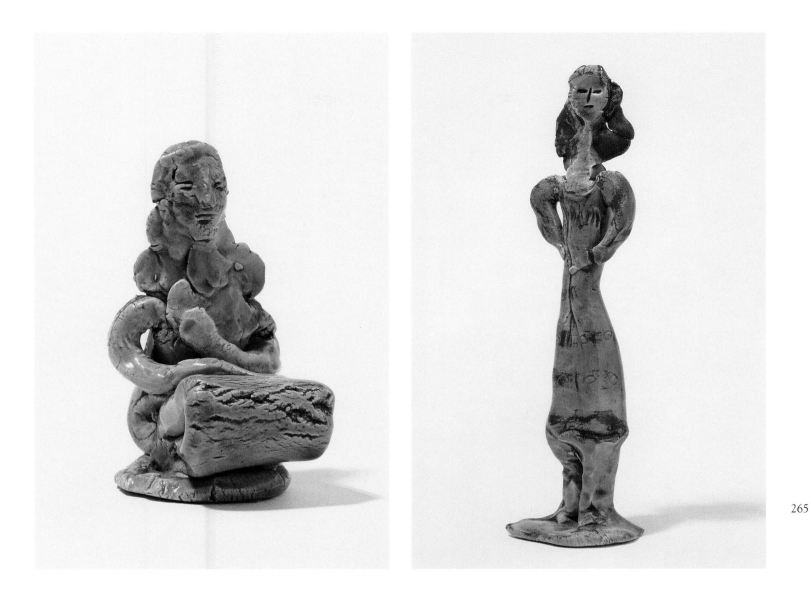

133 **Seated Woman** (1947)
Estate of the Artist

134 **Standing Woman** (1947)
Estate of the Artist

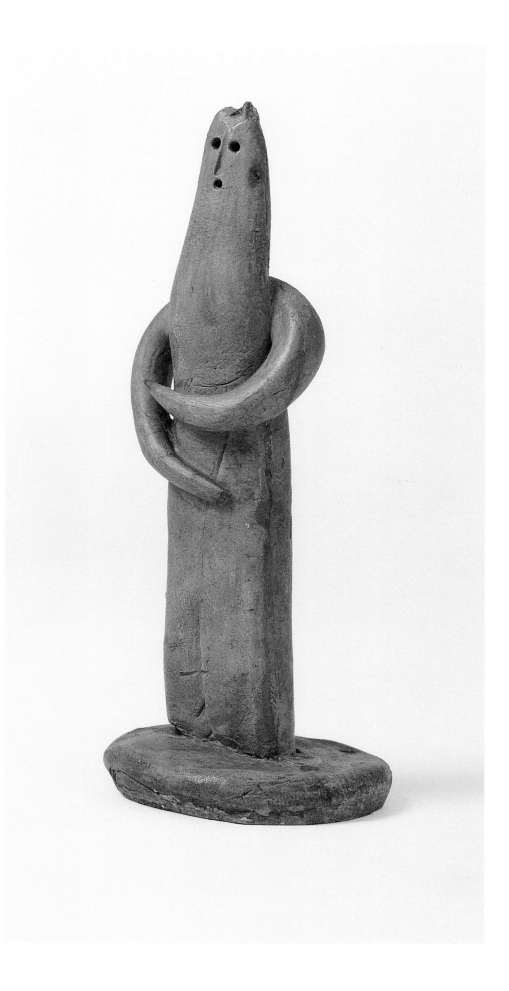

135 **Idol** (1947)
Estate of the Artist

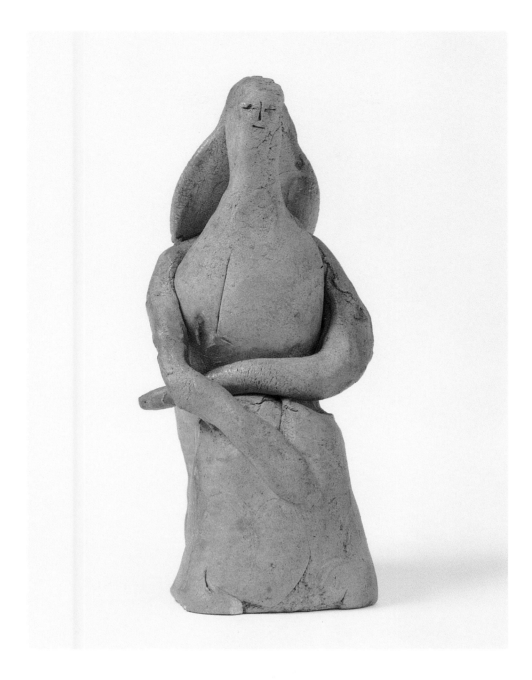

136 Seated Woman (1947)
Estate of the Artist

268

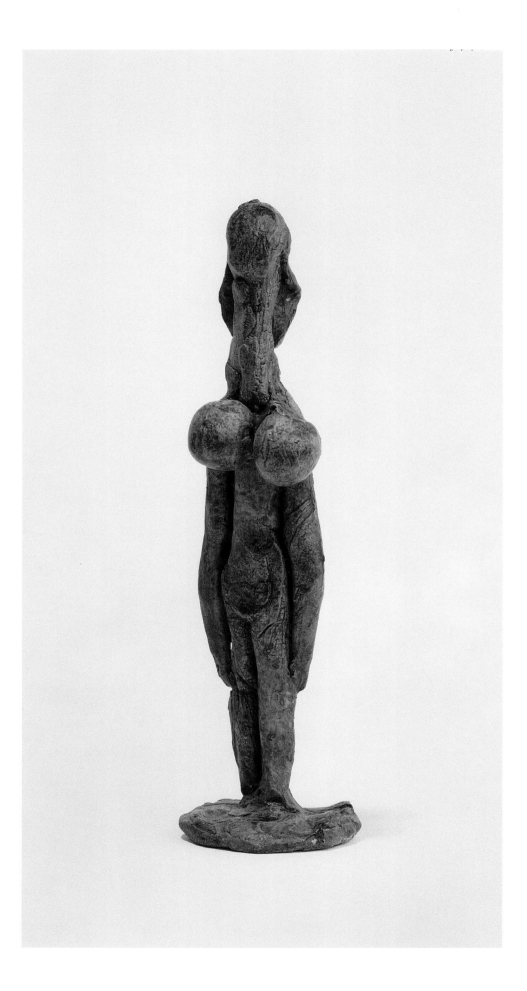

137 **Standing Woman** (1947)
Estate of the Artist

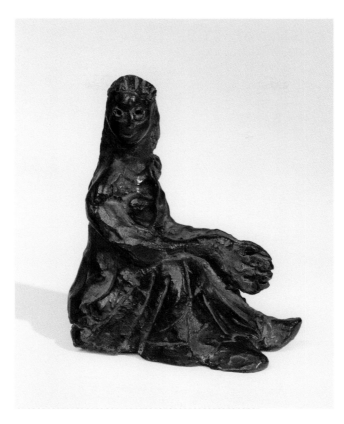

138 **Seated Woman**, 1950
Estate of the Artist

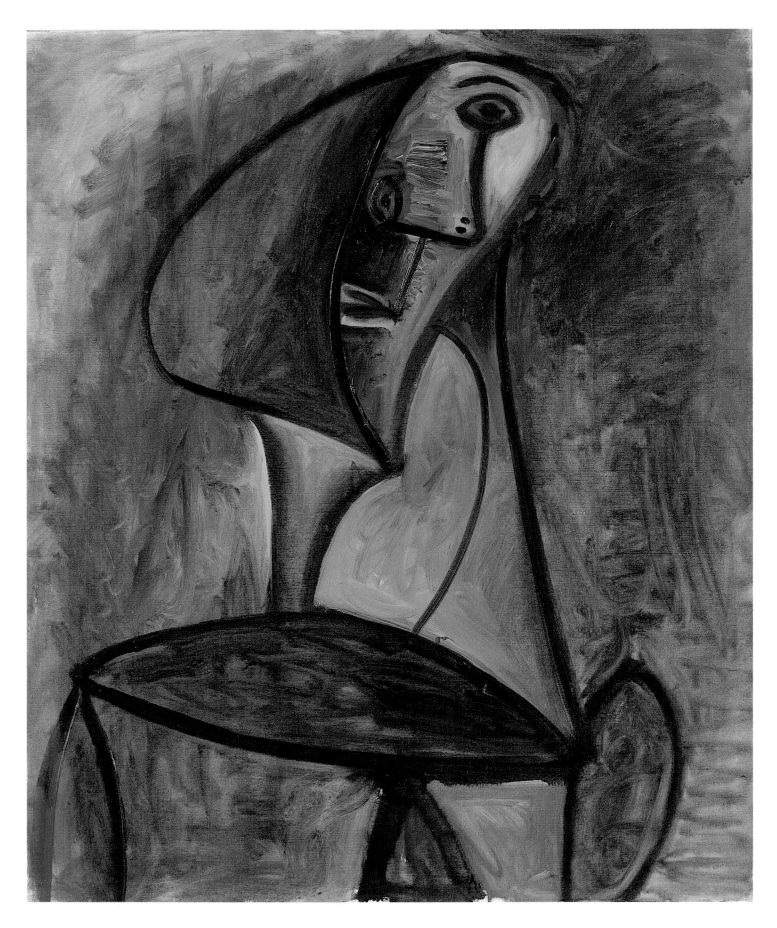

139 **Portrait of a Woman**, October 25, 1948
Estate of the Artist

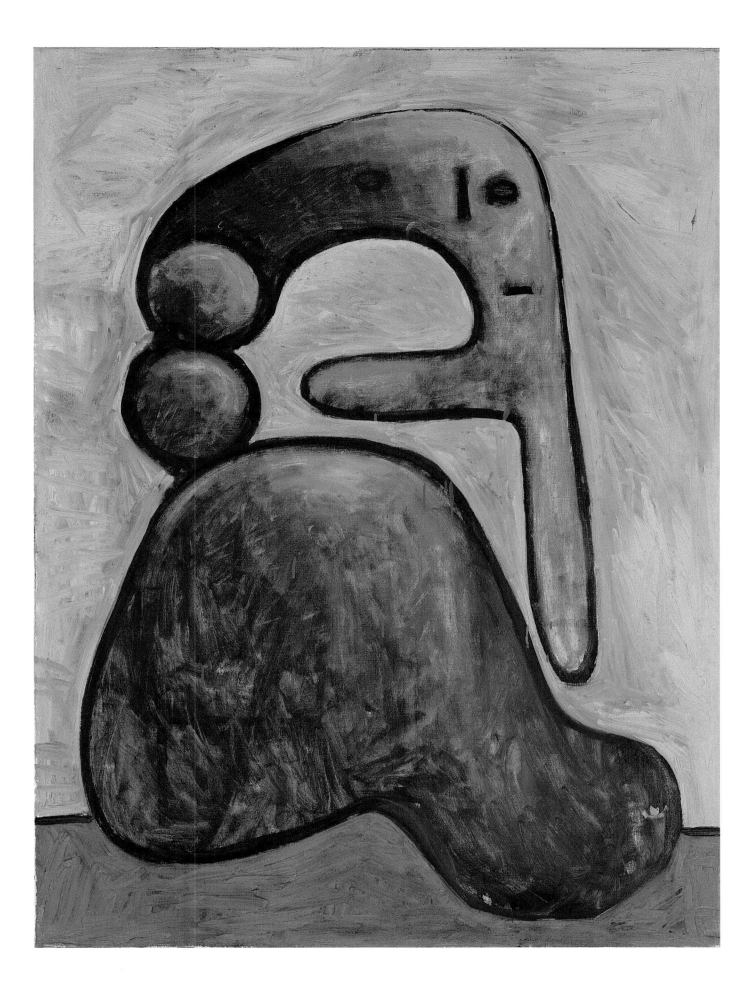

140 Nude Woman Against a Blue Background, February 19, 1949
Estate of the Artist

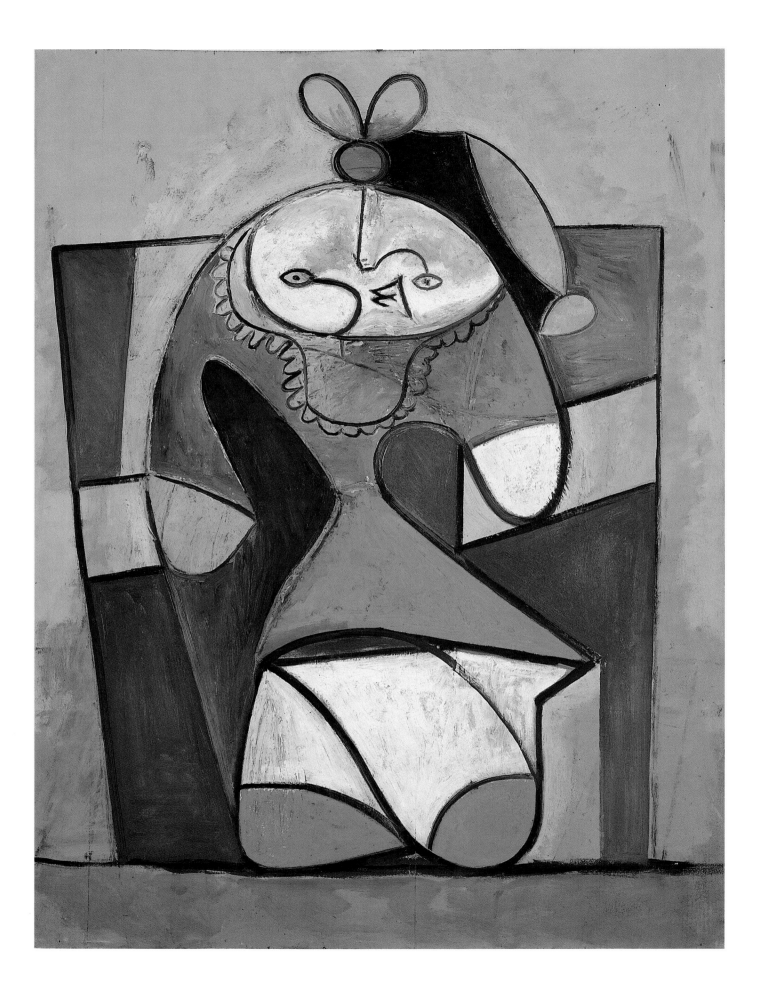

141 **Child in Blue (Claude)**, April 28, 1947
Private Collection

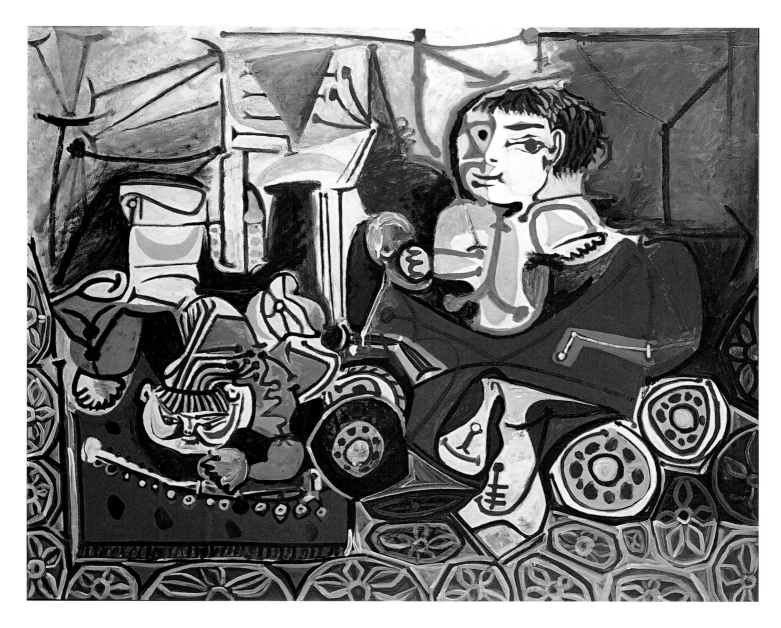

273

143 **Two Children with Tricycle,** 1951
Collection Dee Dee and Herb Glimcher

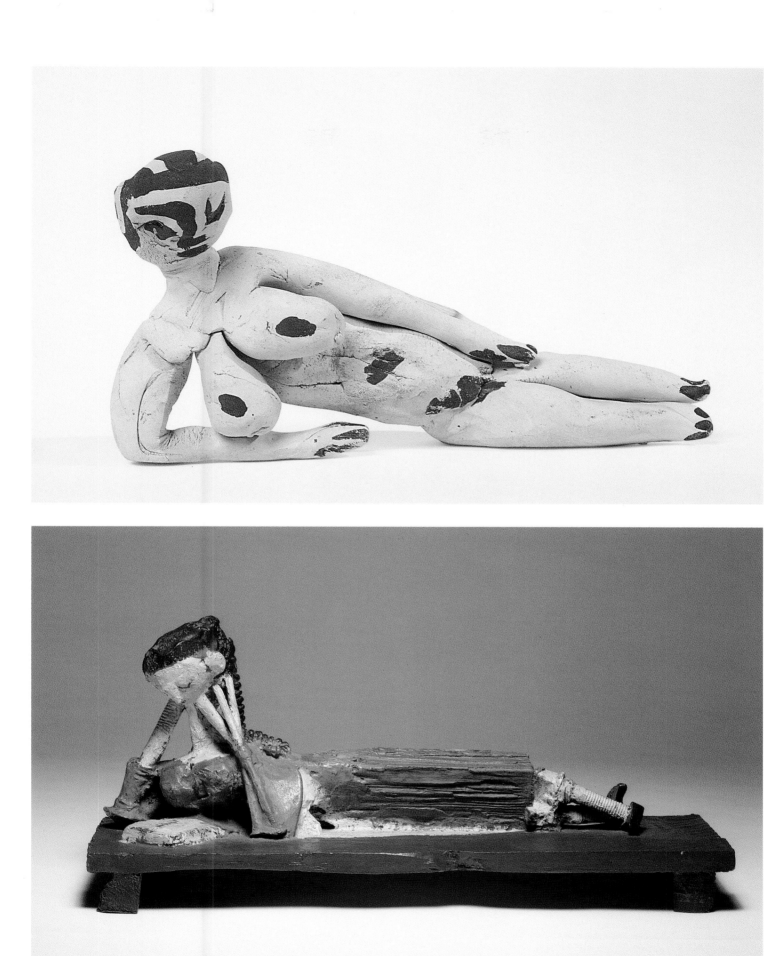

144 **Reclining Woman**, March 19, 1951
Estate of the Artist

145 **The Reader (Françoise)**, 1951–53
Private Collection

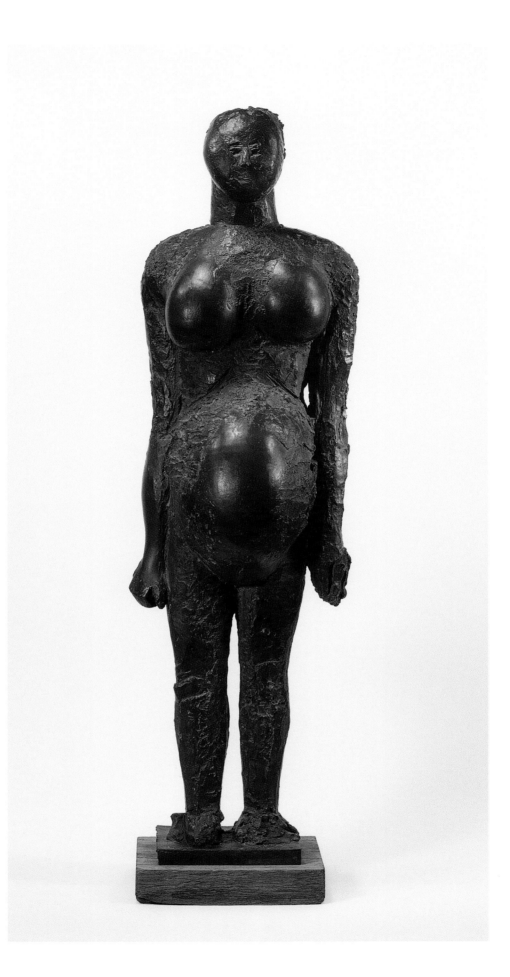

276

146 **The Pregnant Woman**, first state, 1950–59
Private Collection

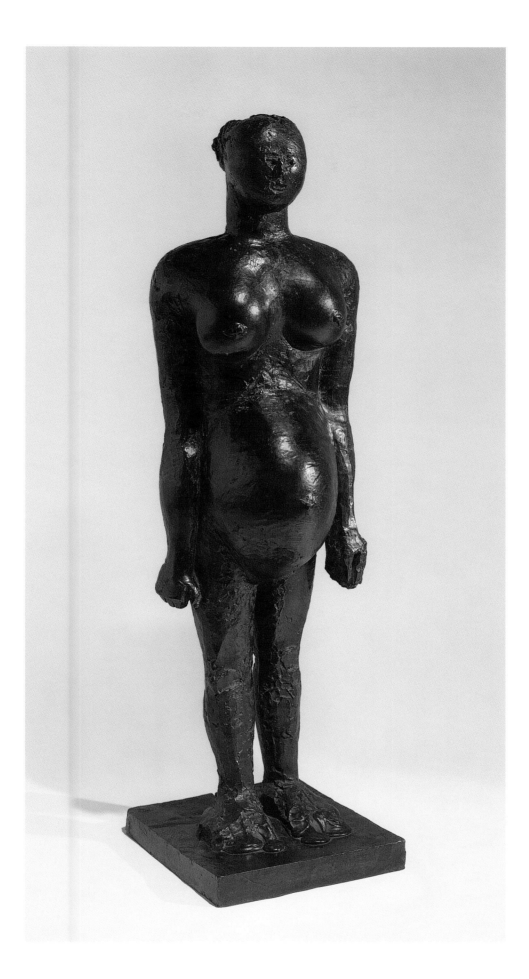

147 **The Pregnant Woman**, second state, 1950–59
The Patsy R. and Raymond D. Nasher Collection , Dallas

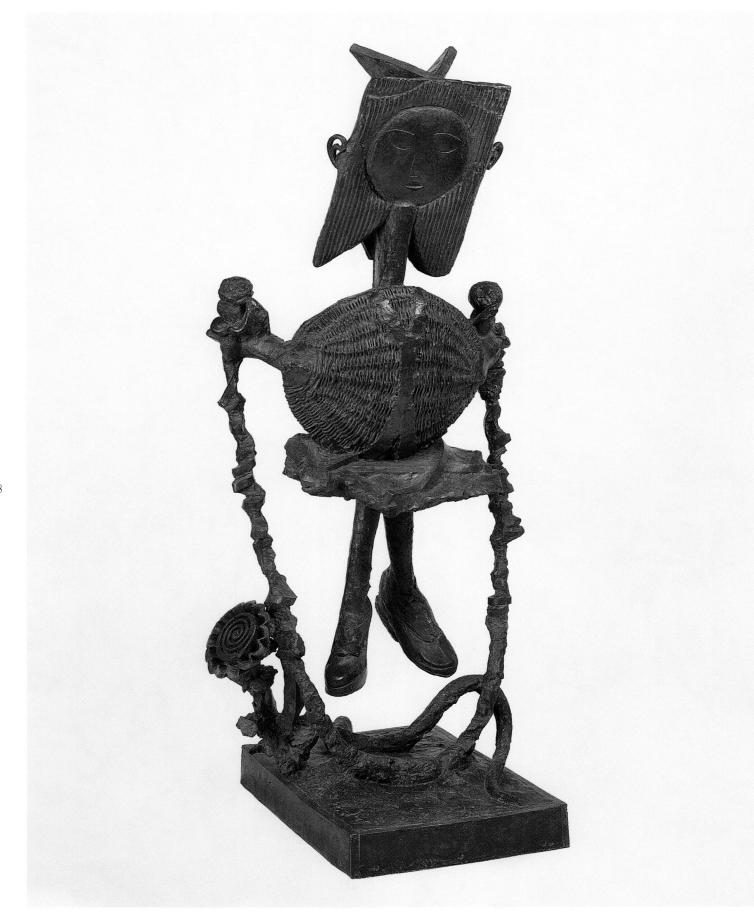

148 **Girl Skipping Rope**, 1950
Private Collection

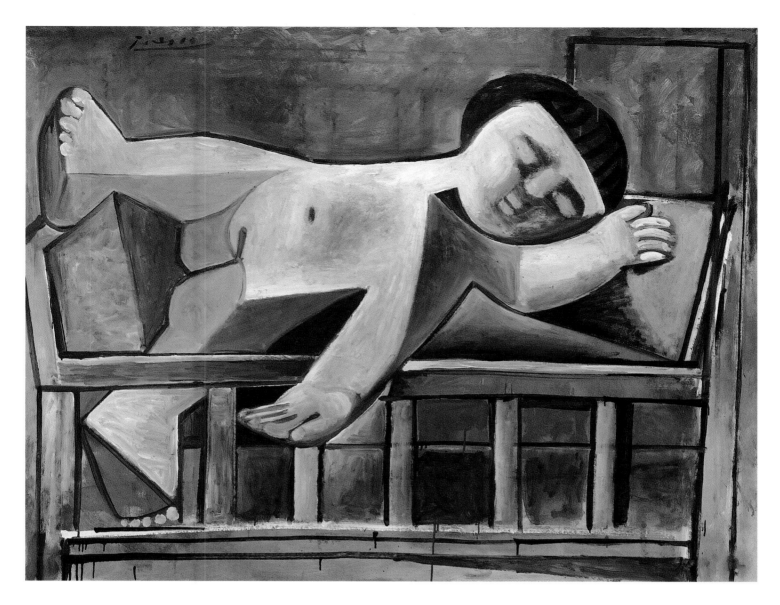

149 **Paloma Asleep**, December 28, 1952
Collection Mortimer B. Zuckerman

150 **Flowers in a Vase**, 1951
Private Collection

151 **Vase with Flower**, 1953
Estate of the Artist

152 **Watering Can with Flowers**, 1953
Private Collection

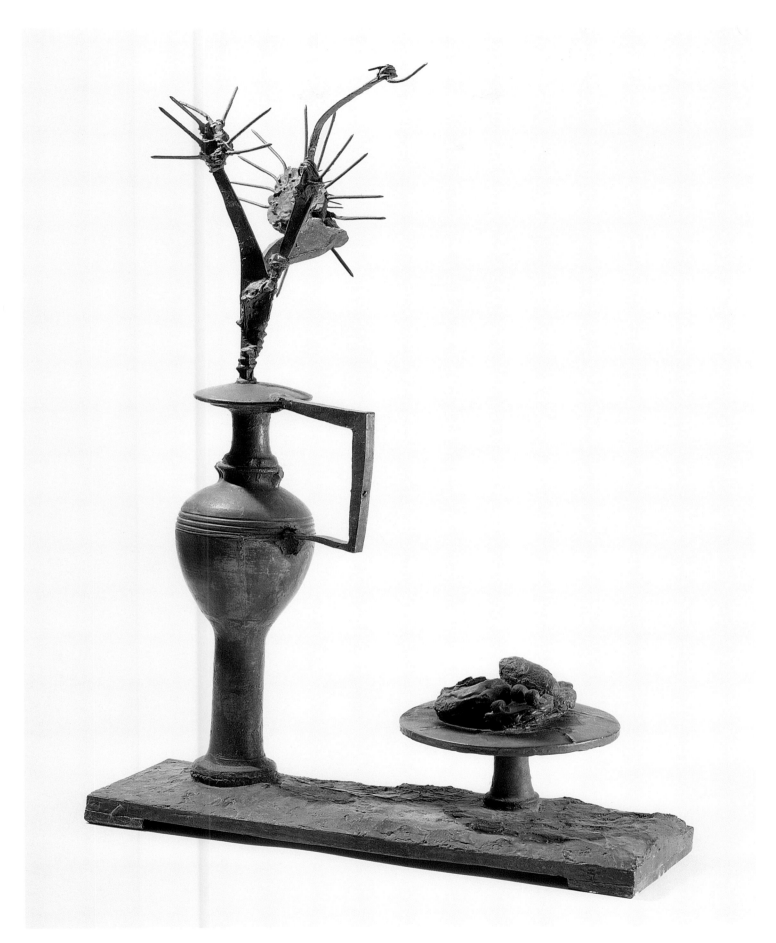

153 **Vase with Cardoons and Plate of Cakes**, 1953
Estate of the Artist

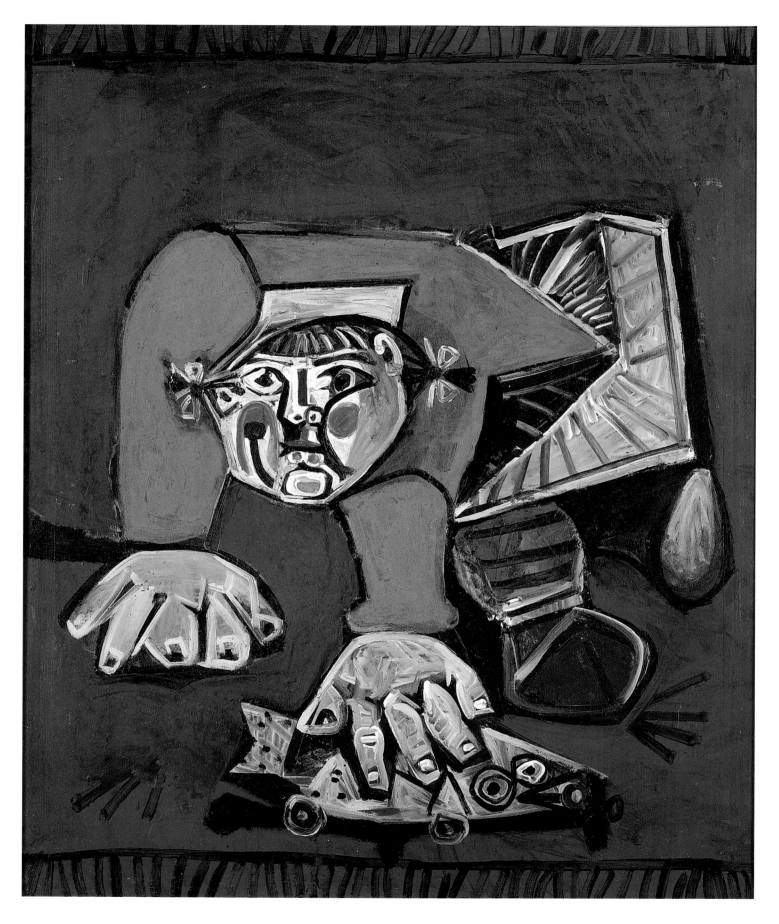

154 **Paloma against a Red Background / Girl Playing with a Car**, 1953
Private Collection

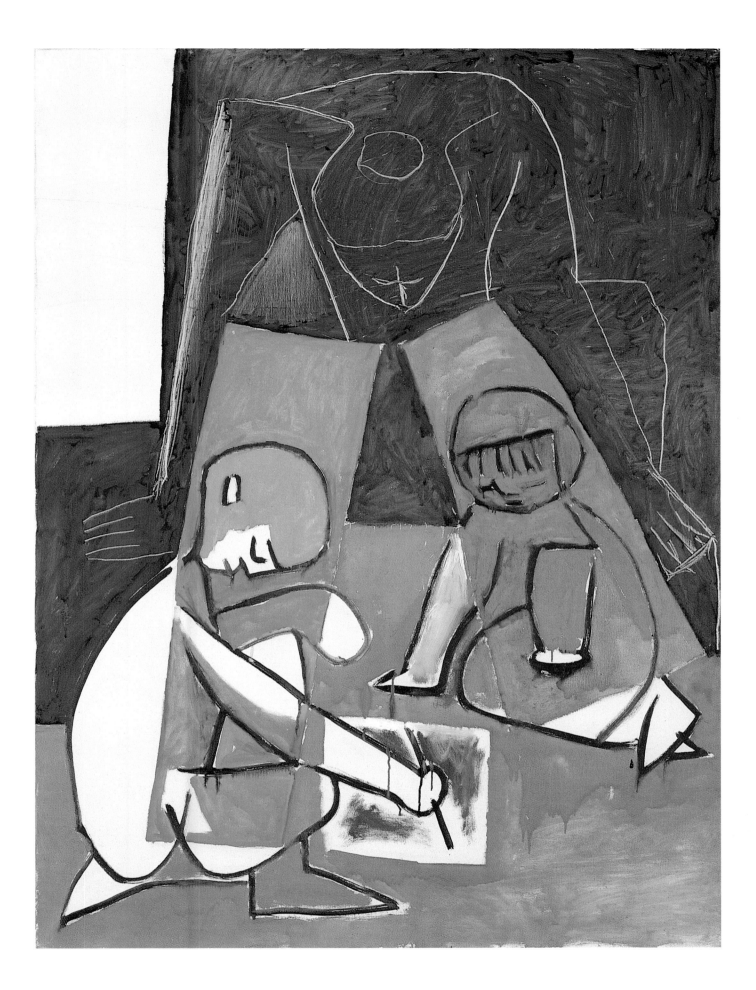

155 Woman and Children: the Drawing, May 15, 1954
Estate of the Artist

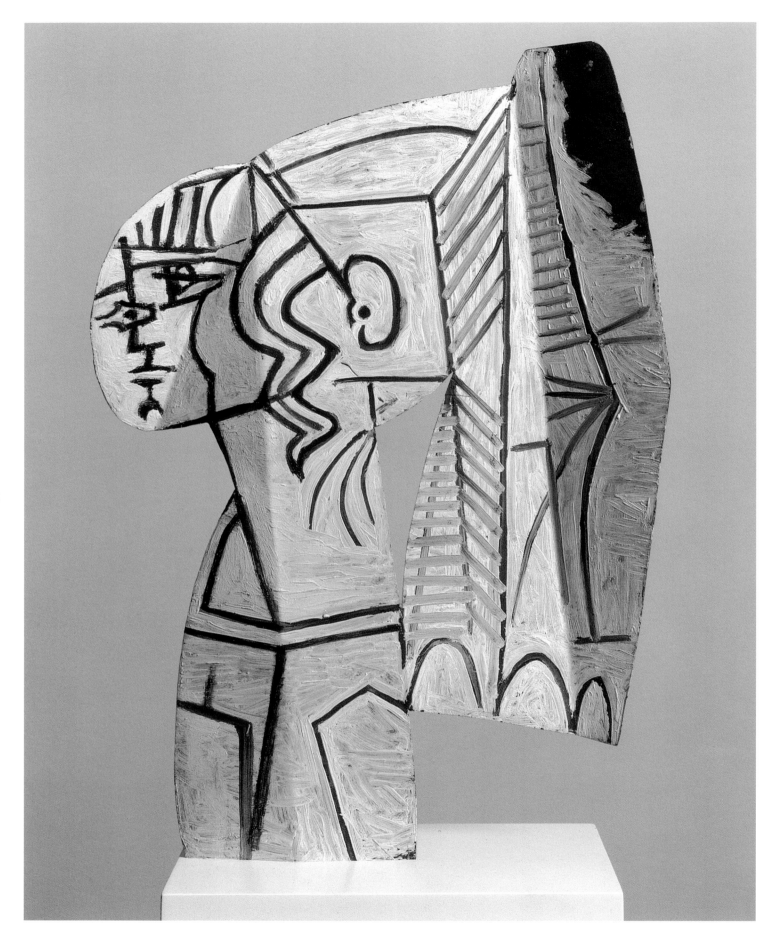

156 **Sylvette**, 1954, front
Private Collection, Courtesy Fondation H. Looser, Zurich

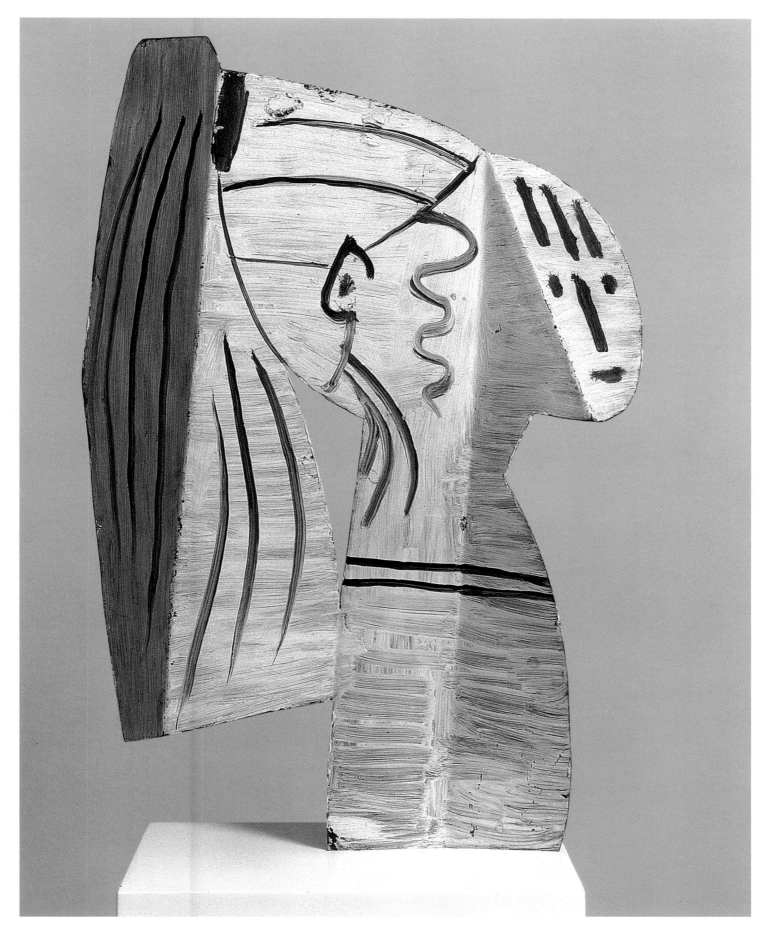

156 **Sylvette**, 1954, back
Private Collection, Courtesy Fondation H. Looser, Zurich

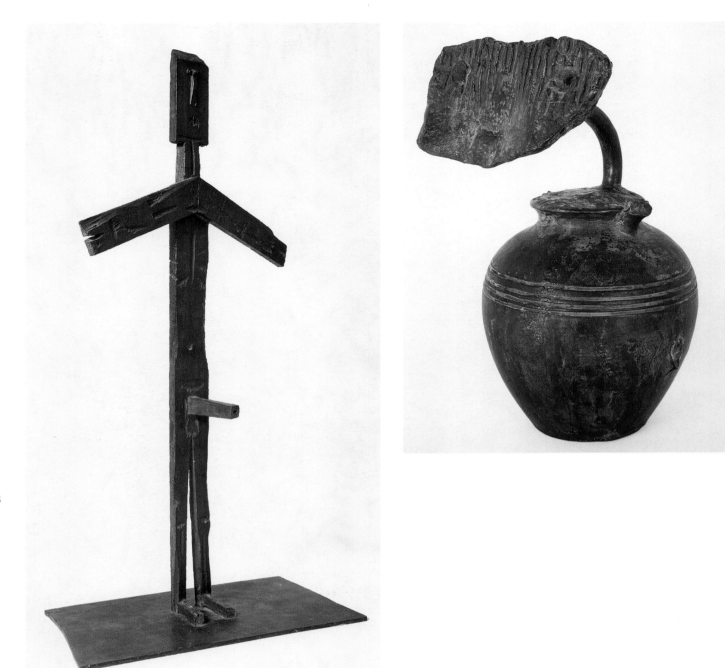

157 **Young Man**, 1956
Collection Linda and Harry Macklowe

158 **Face**, 1953
Collection Julie and Edward J. Minskoff

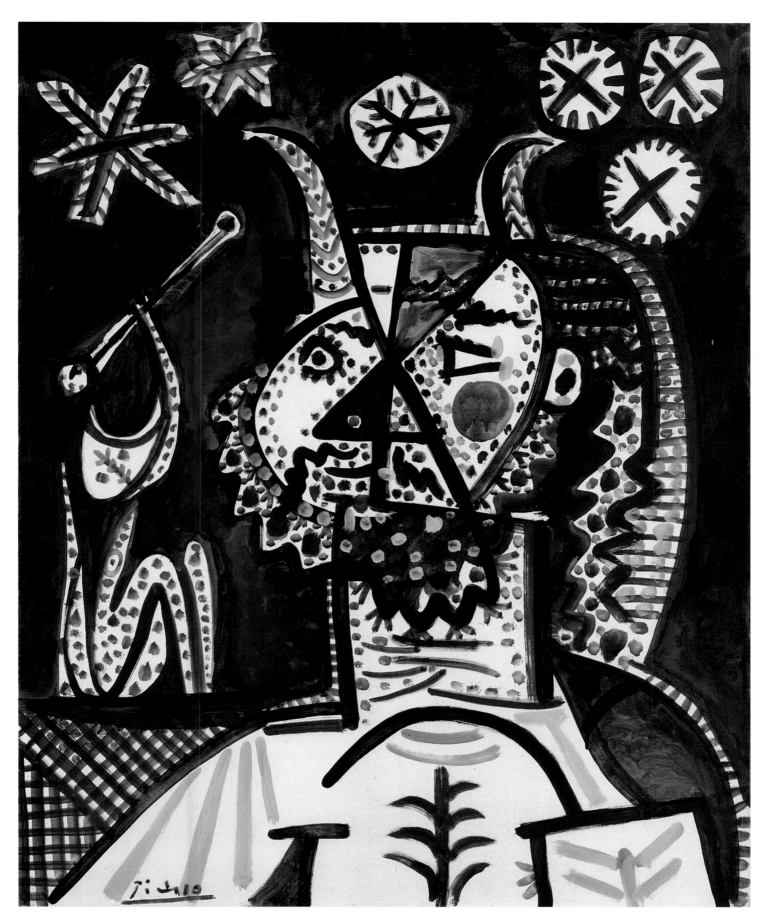

159 **Faun and Starry Night**, 1955
The Metropolitan Museum of Art, New York, Gift of Joseph H. Hazen, 1970

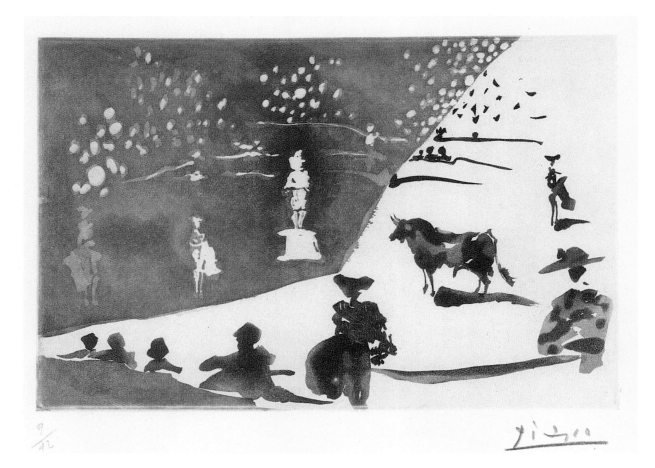

290

160a-h *La Tauromaquía, o arte de torear* (1796)
Selection of eight illustrations by Pablo Picasso from the portfolio by José Delgado, alias Pepe Illo, ed. Gustavo Gill, Barcelona 1959

160a **Bulls in the Field**, 1957

160b **The Pass called Don Tancredo's** 1957

Estate of the Artist

160c **The Bull Leaves the Pen**, 1957

160d **Bullocks Lead Away the Tame Bull**, 1957

Estate of the Artist

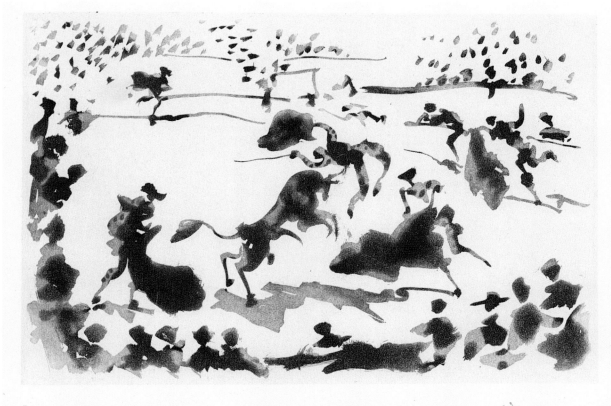

292

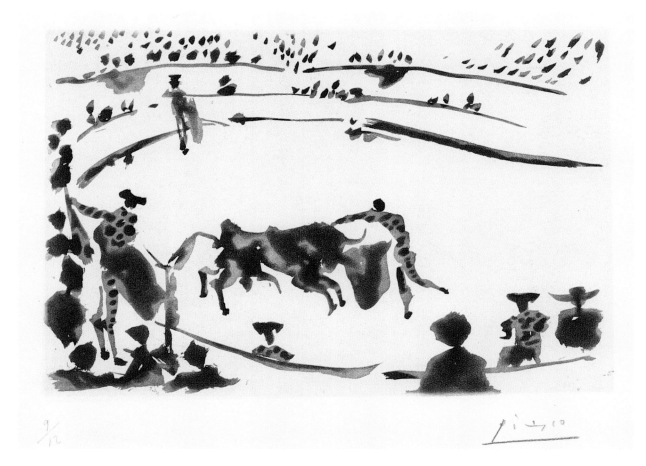

160e **Gored**, 1957
160f **The Kill**, 1957
Estate of the Artist

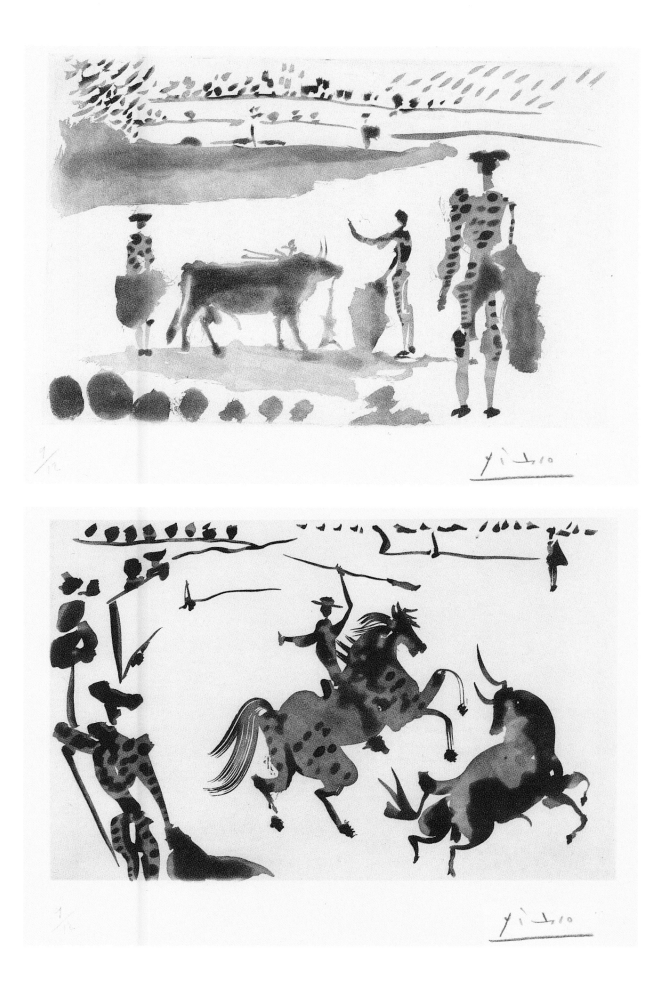

160g **After the Stabbing the Bullfighter Signals the Death of the Bull**, 1957

160h **Lancing the Bull**, 1957

Estate of the Artist

294

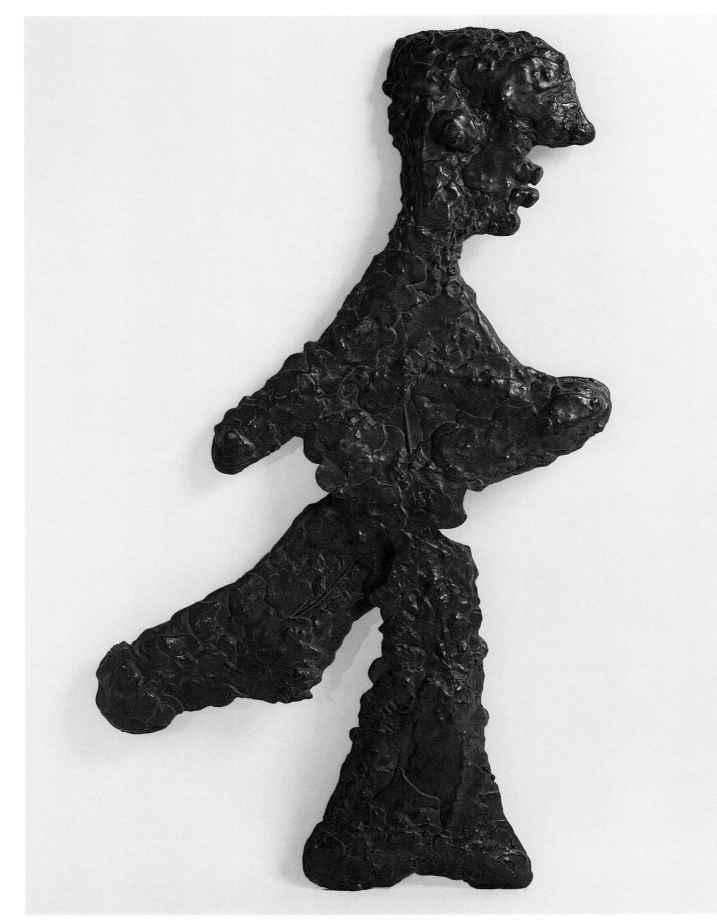

161 **Running Man**, 1960
Estate of the Artist

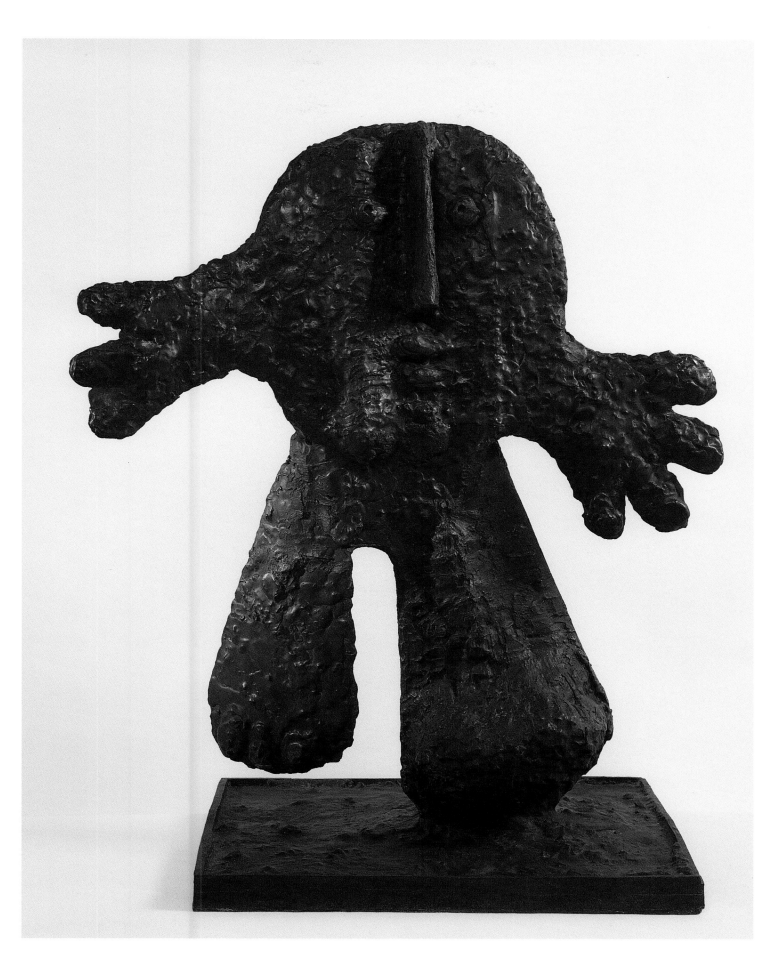

162 **Figure (Child)**, 1960
Estate of the Artist

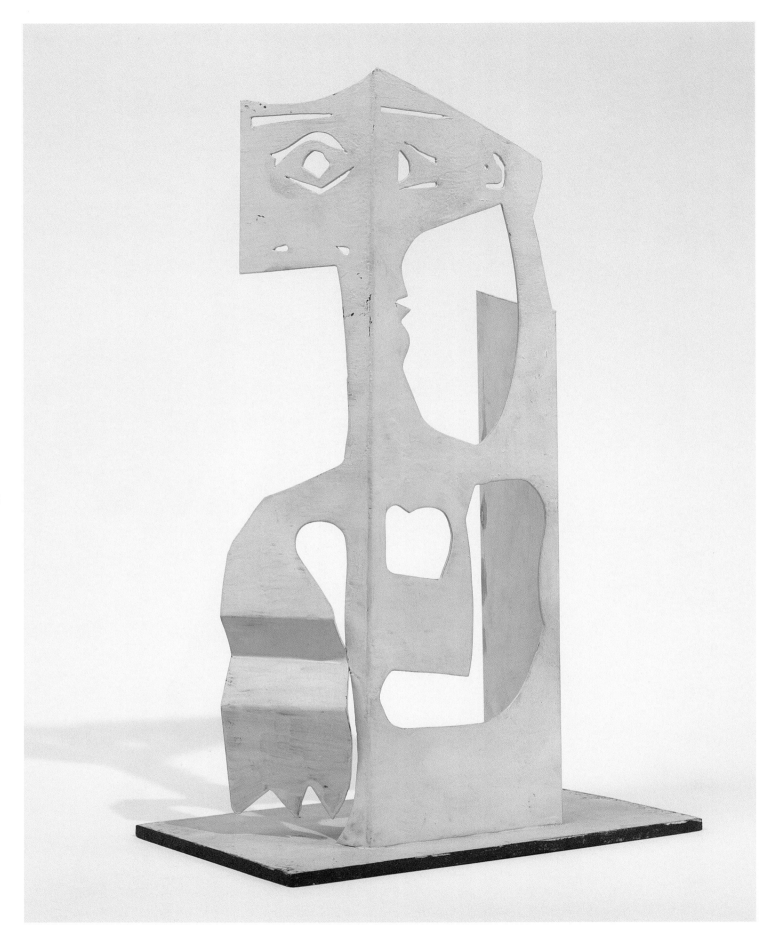

163 **Female Bust**, 1961
Estate of the Artist

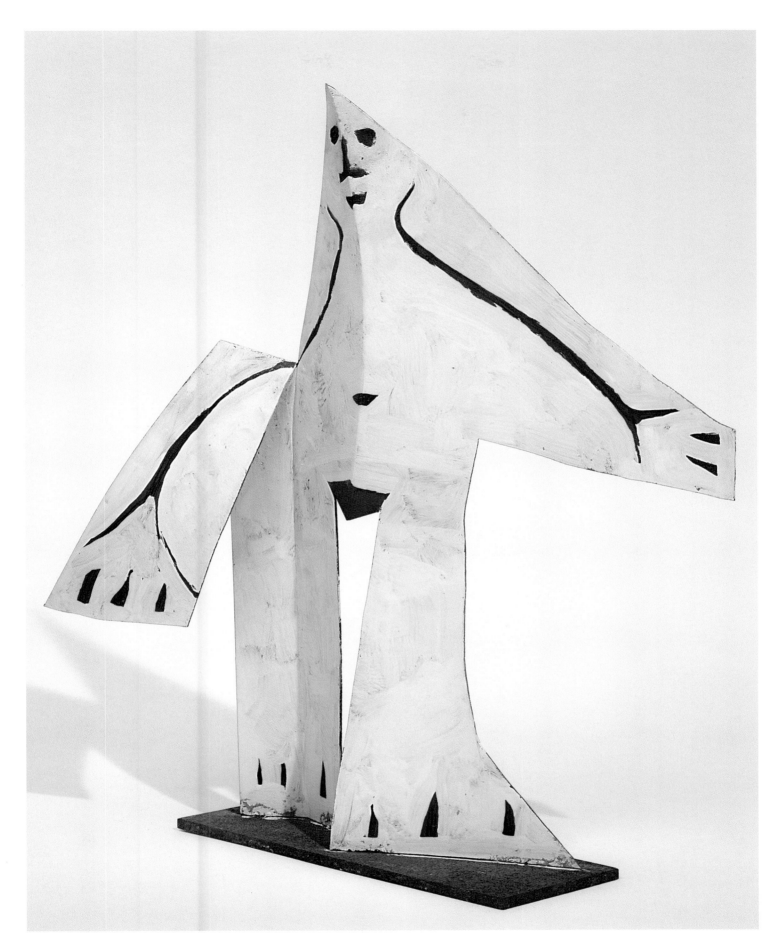

164 **Little Woman with Arms Outstretched**, 1961
Estate of the Artist

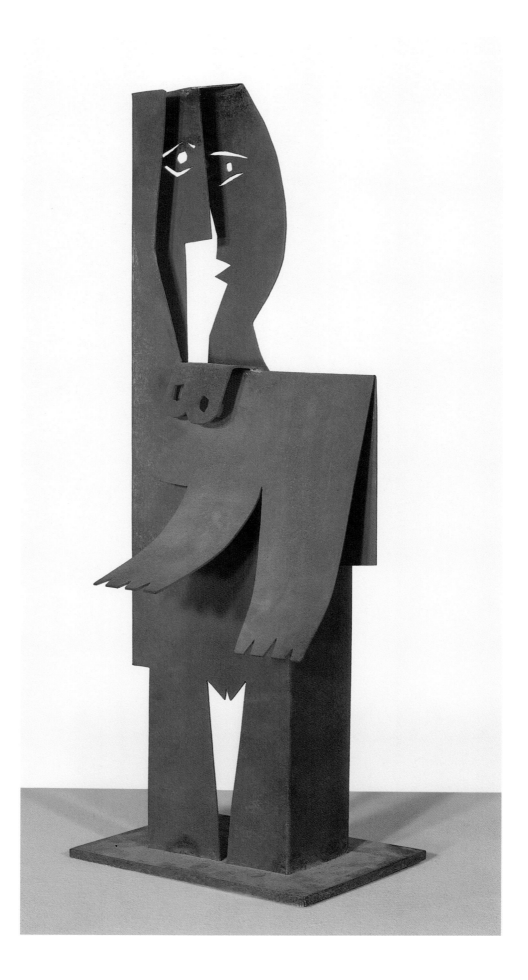

165 **Standing Woman**, 1961
Collection Terese and Alvin S. Lane

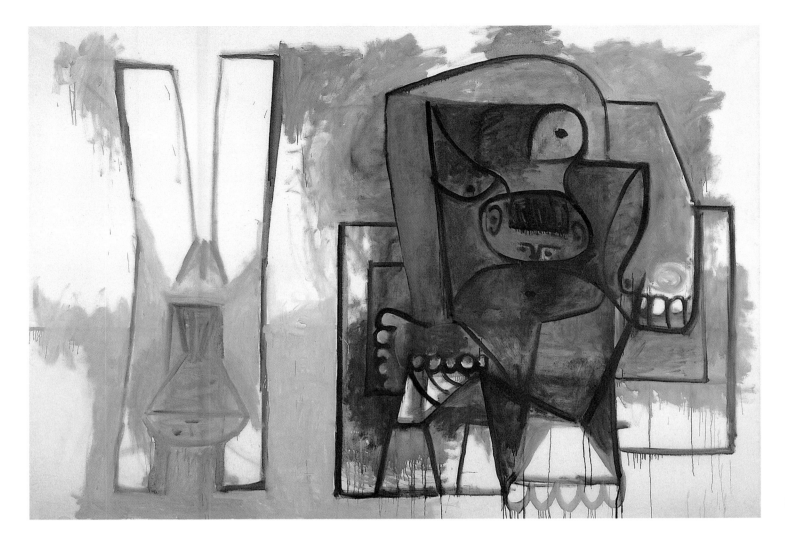

166 Seated Woman and Playing Child, February 3, 1960
Estate of the Artist

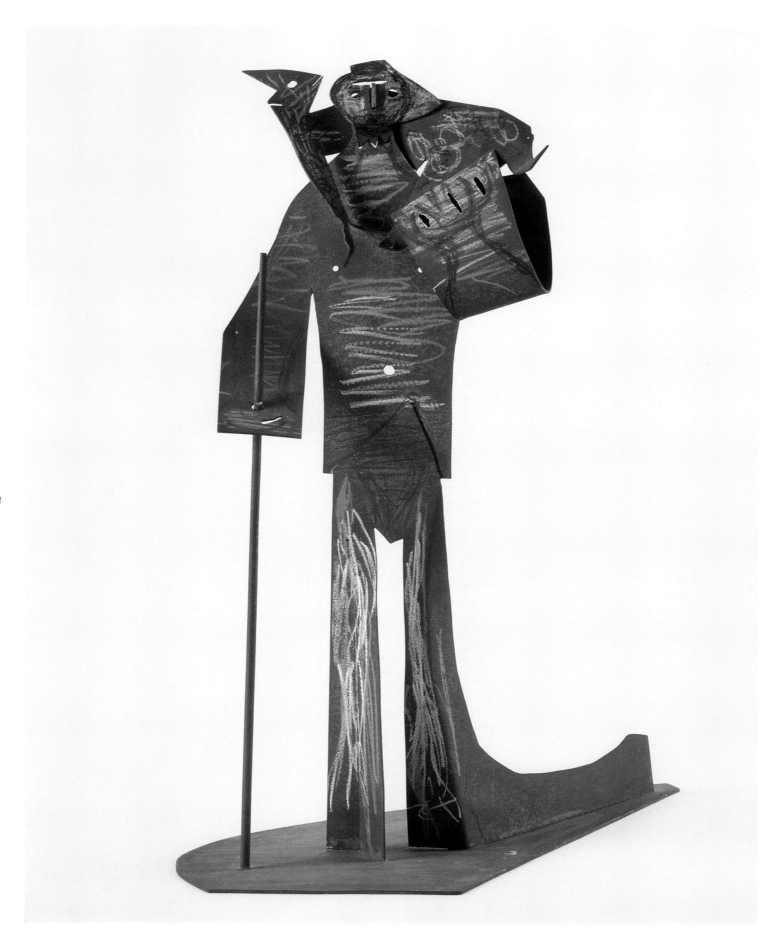

167 **Man with Sheep**, 1961
Estate of the Artist

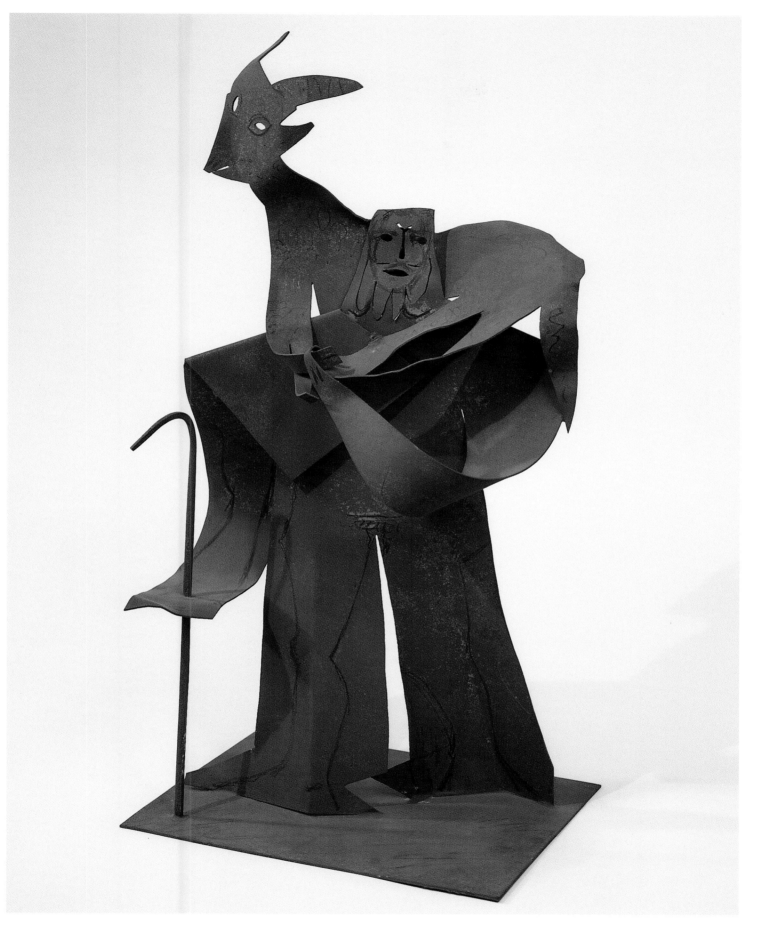

168 **Man with Sheep**, 1961
Collection Julie and Edward J. Minskoff

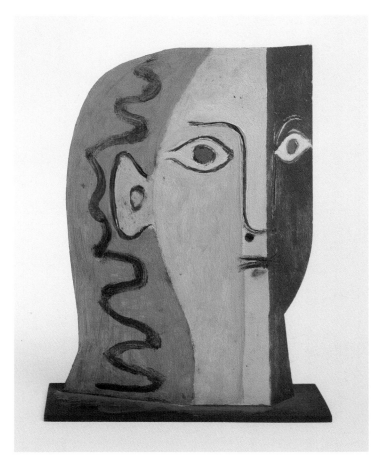

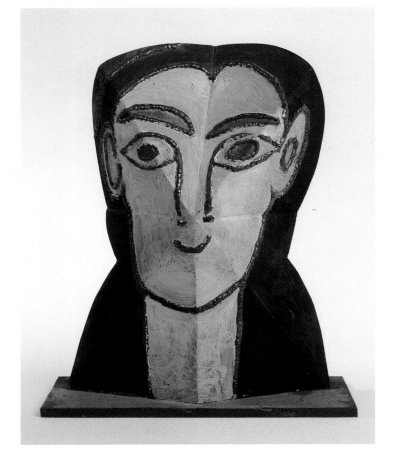

169 **Woman's Head**, 1961
Estate of the Artist

170 **Woman's Head**, 1961
Estate of the Artist

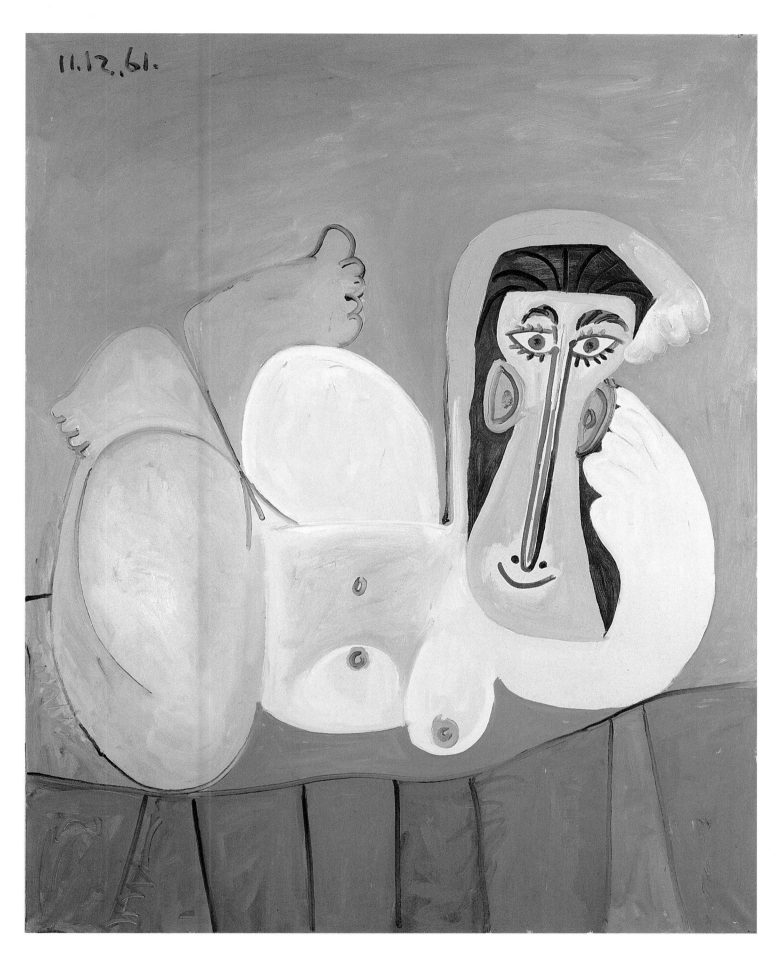

171 **Reclining Nude**, December 11, 1961
Private Collection

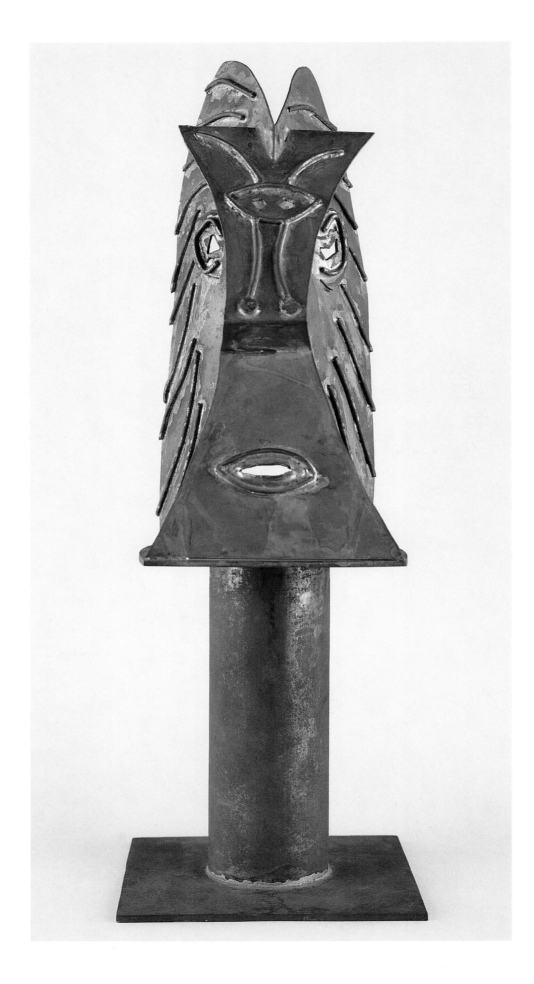

172 **Woman's Head**, 1962
Collection Linda and Morton Janklow, New York

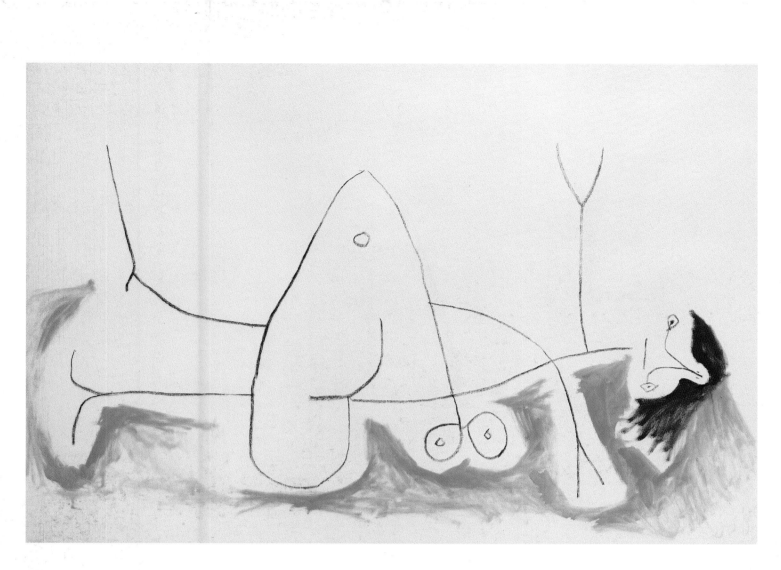

305

173 **Reclining Nude on Pink Cloth**, January 29, 1964
Private Collection

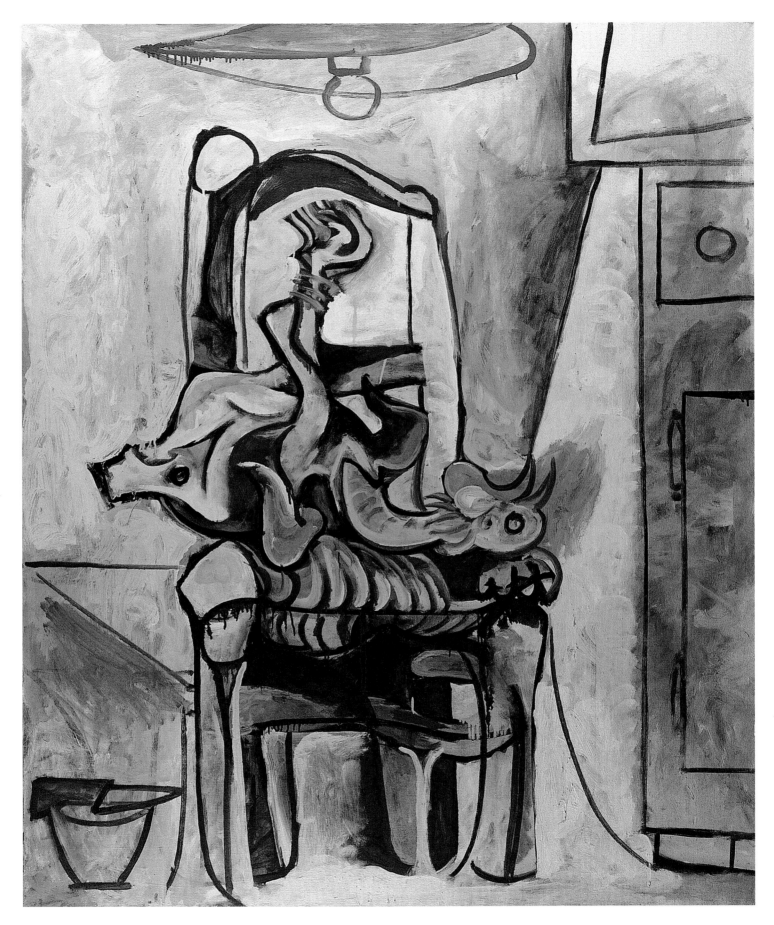

174 Rooster on Chair under a Lamp, April 24–27, 1962
Estate of the Artist

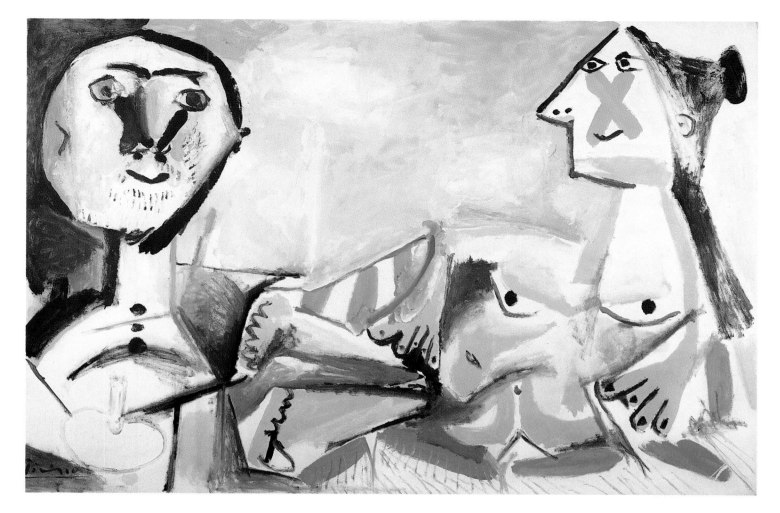

307

175 Painter and Model, November 8–9, 1964
Sammlung Frieder Burda

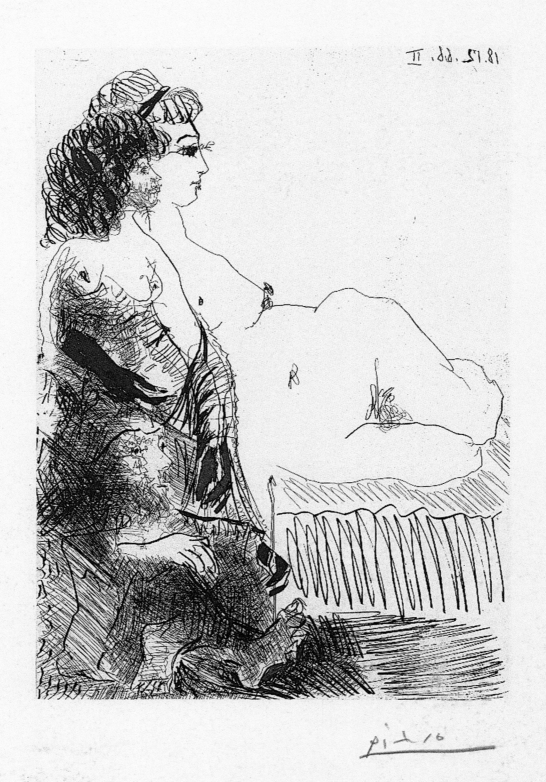

176 Untitled (Woman on sofa with seated girl and old man), December 18, 1966
Estate of the Artist

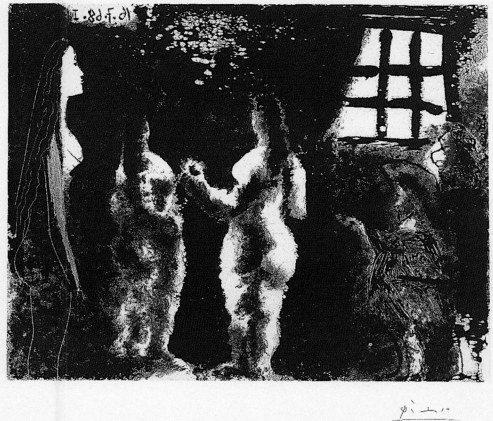

177 **Untitled (Around El Greco and Rembrandt: portraits)**, second state,
April 15, 17, 18 and 19, 1968
Estate of the Artist

178 **Untitled (Thinking of Goya: women in prison)**, July 16, 1968
Estate of the Artist

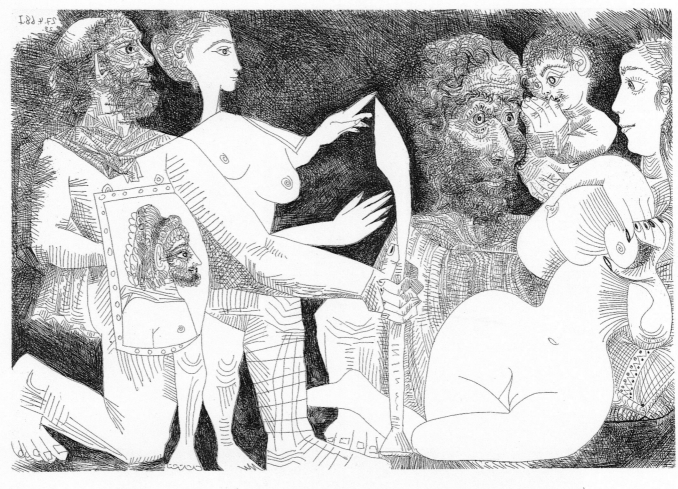

179 **Untitled (Mythological scene: perhaps Agamemnon's longing for Briséis),** April 27–28, 1968
Estate of the Artist

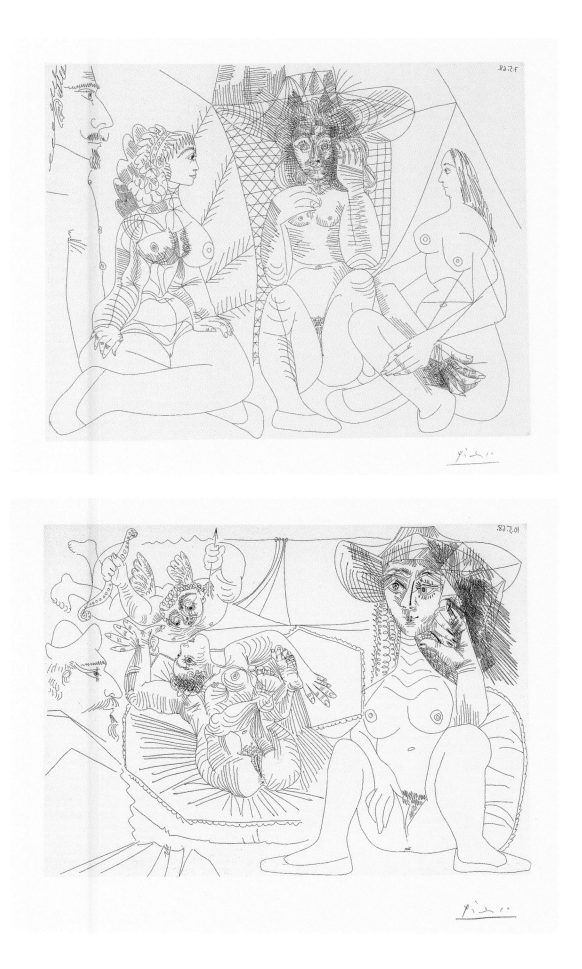

180 **Untitled (Three women passing time with a serious spectator)**, May 7, 1968
Estate of the Artist

181 **Untitled (Young woman with hat who sins in thought peeking at the prelate)**, May 10, 1968
Estate of the Artist

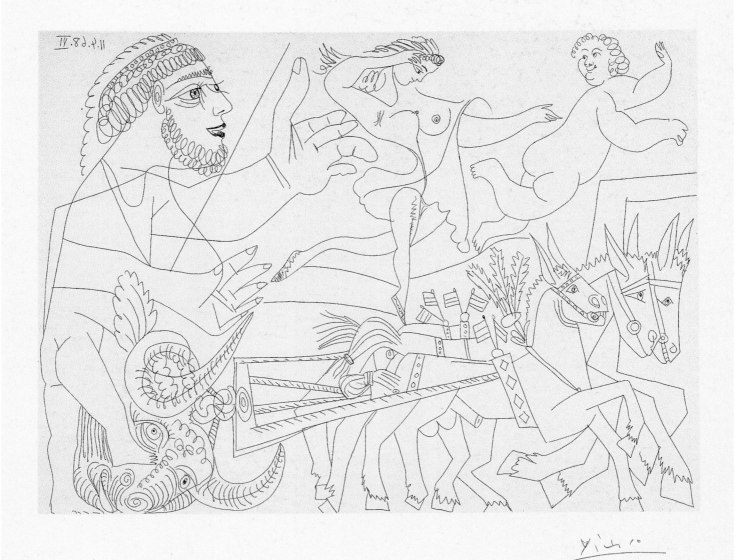

312

182 Untitled (El Arrastre, with equestrian and angel), April 11, 1968
Estate of the Artist

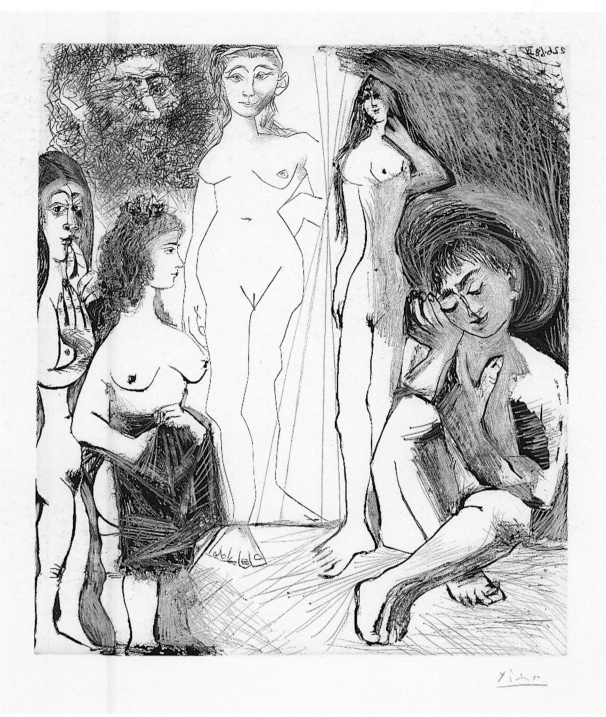

313

183 Untitled (Young man dreaming: women!), third state, June 22, 1968
Estate of the Artist

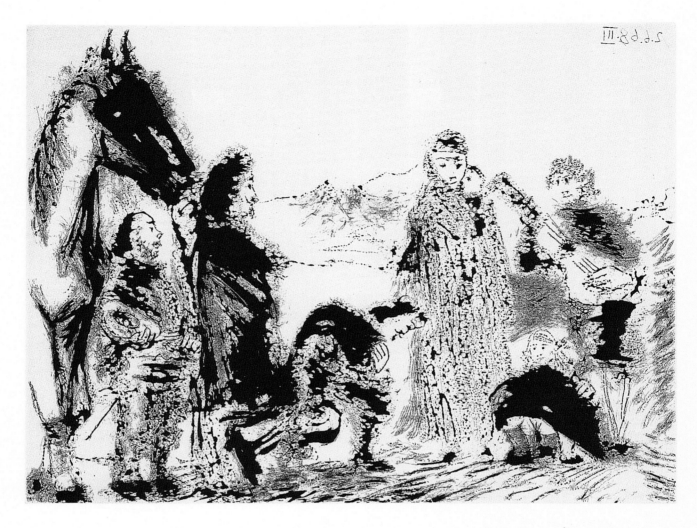

184 Untitled (Variation on the theme of Don Quixote and Dulcinea), June 2, 1968
Estate of the Artist

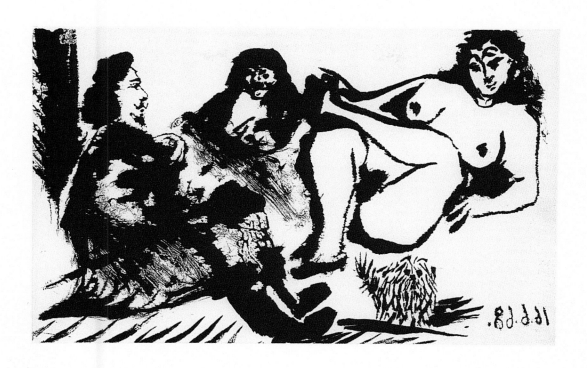

315

185 **Untitled (Thoughtful man at a woman's house, with La Celestina)**, fourth state, June 26, 1968
Estate of the Artist

186 **Untitled (Cavalier visiting a girl, with La Celestina and a dog)**, June 16, 1968
Estate of the Artist

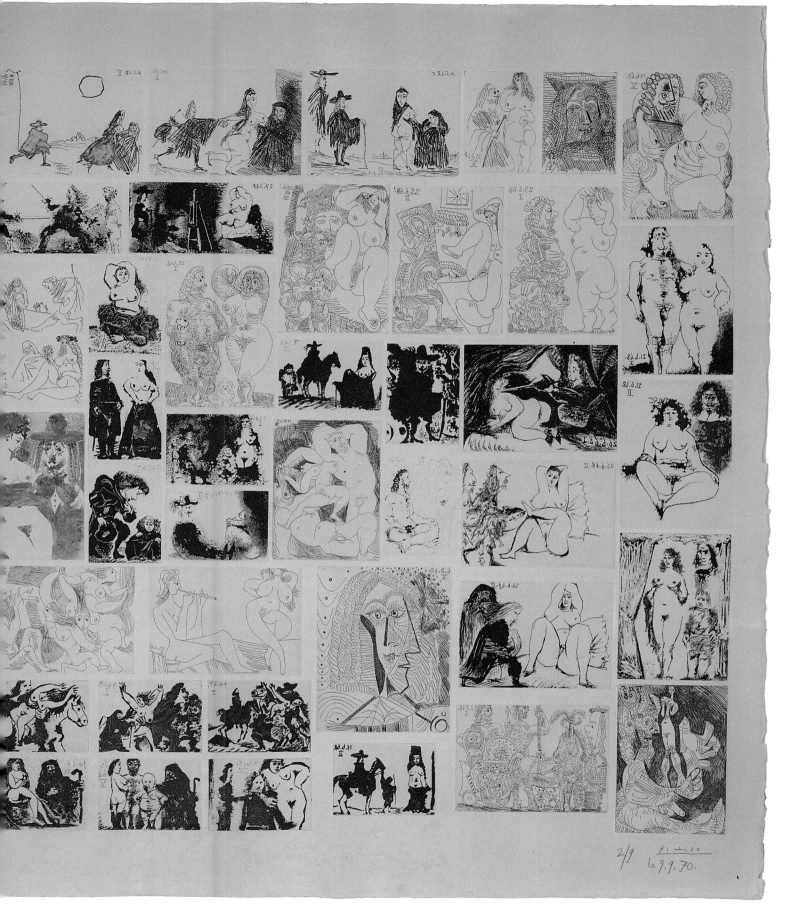

187 **Untitled (La Celestina)**, 1971
Estate of the Artist

318

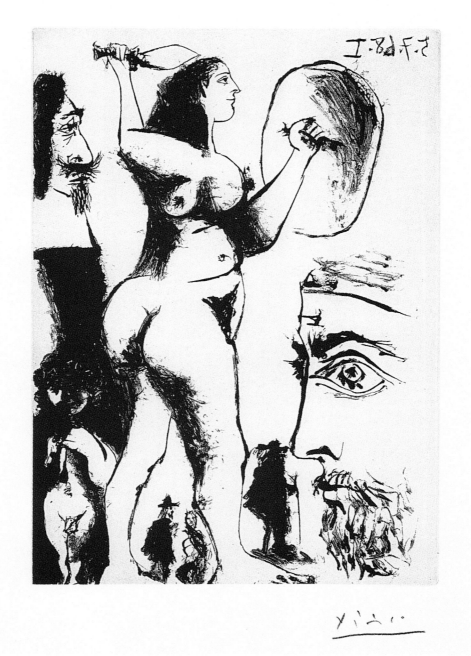

**188 Untitled (Painter or sculptor thinking of a female warrior,
with musketeer, cupid and small figures)**, July 5, 1968
Estate of the Artist

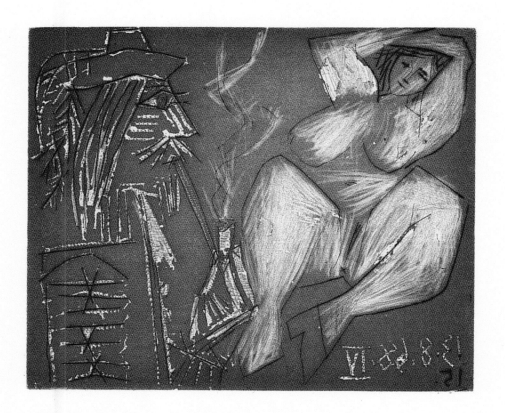

189 **Untitled (Young woman and smoker)**, second state, August 13 and 15, 1968
Estate of the Artist

190 **Untitled (Film shoot: two women)**, May 30, 1968
Estate of the Artist

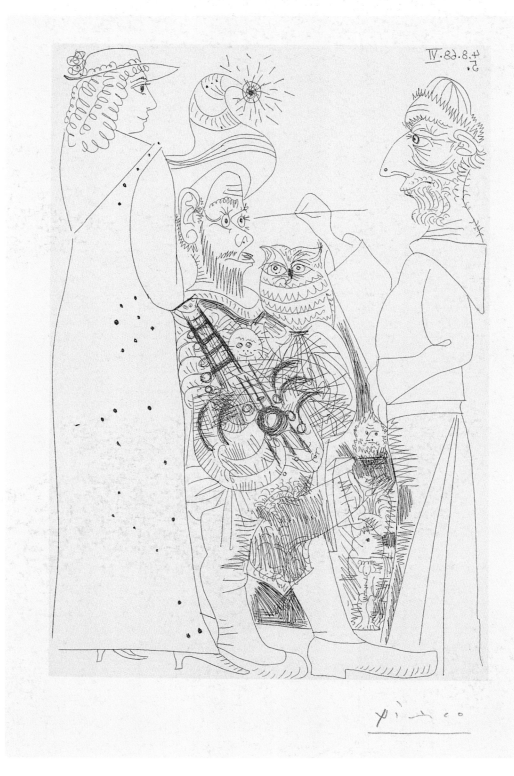

191 Untitled (Monk-painter and penitent, guitarist with owl and young spectator),
August 4–5, 1968
Estate of the Artist

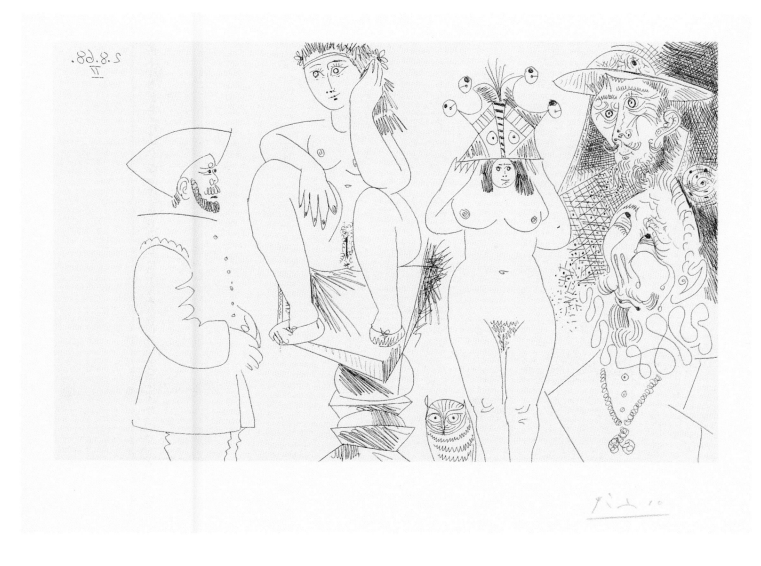

192 **Untitled (Two women, one on a trestle, an owl, Don Quixote, a gentleman
drawn from *The Burial of Count Orgaz* and a conquistador)**, August 2, 1968
Estate of the Artist

322

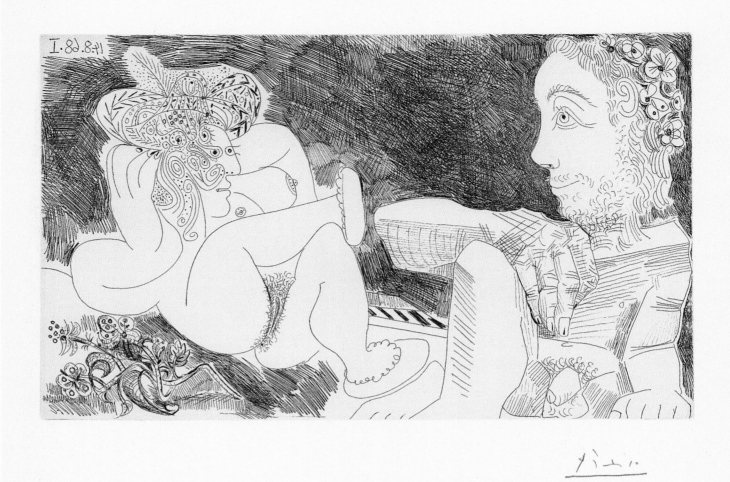

193 **Untitled (In the garden: odalisque in slippers with a flowered hat, and Ingres-like spectator),**
August 14, 1968
Estate of the Artist

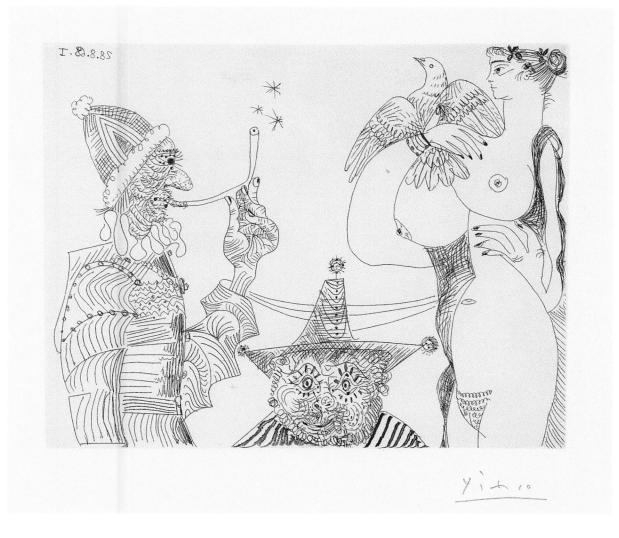

323

**194 Untitled (Opium reverie: smoker in a papal cap discovering the mystery of the trinity
in the breast and dove of a woman, with buffoon with triangular hat)**, August 28, 1968
Estate of the Artist

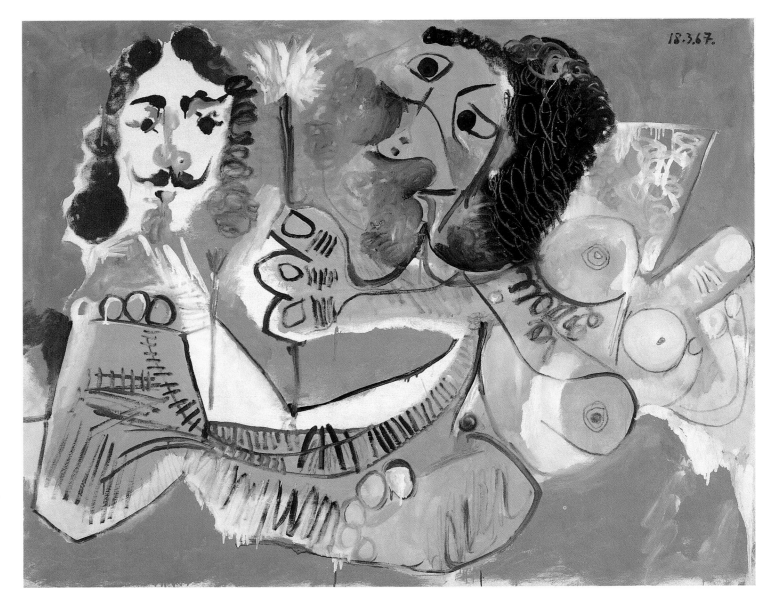

324

195 Musketeer and Woman with Flower, March 18, 1967
Fairfax Realty, Inc. Art Collection

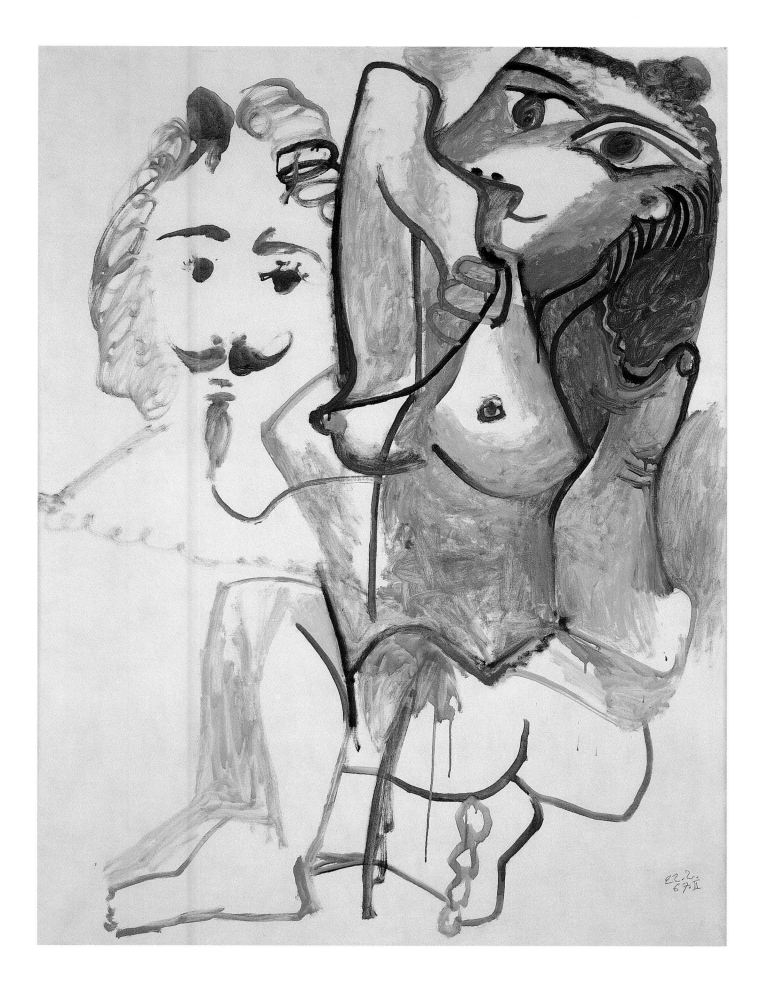

196 Nude Woman with Man's Head, February 22, 1967
Private Collection, Auckland

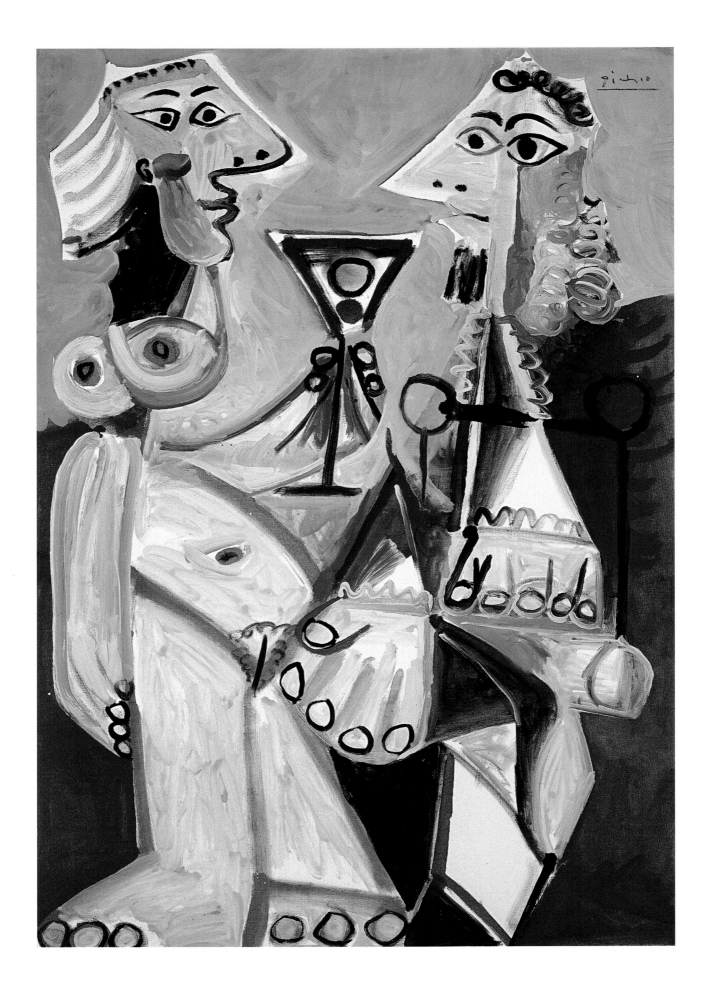

197 **Standing Nude with Goblet and Seated Man**, November 11, 1968
The Collection of Mr. and Mrs. Samuel H. Lindenbaum

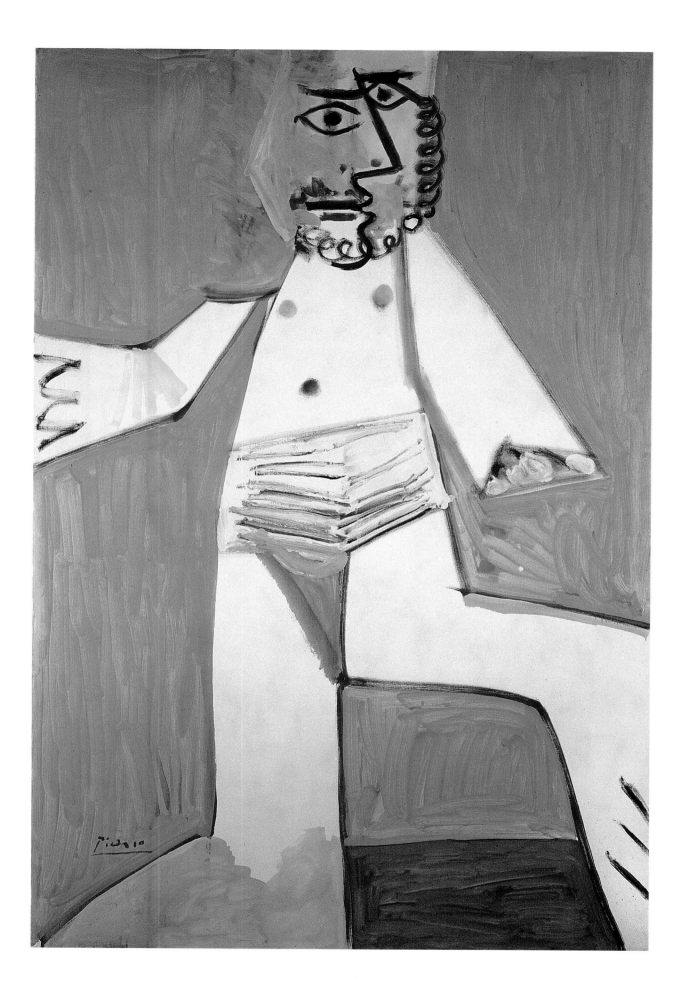

327

198 **Standing Man**, September 19, 1969
Sammlung Frieder Burda

328

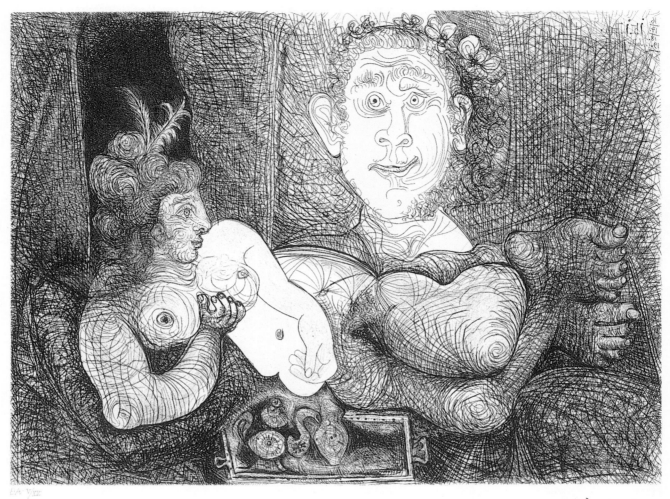

199 Untitled (The curtains of the picture, odalisque and painter), ninth state,
January 15–19 and February 6, 1970
Private Collection

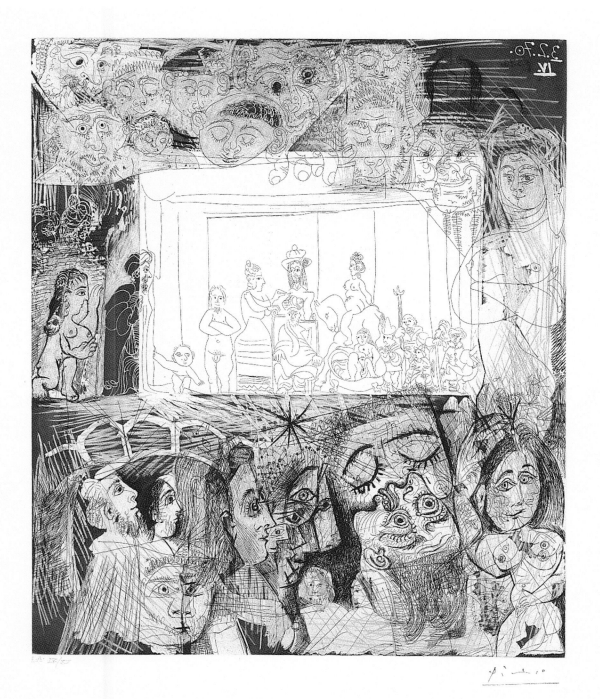

329

200 Untitled ("Ecce Homo," after Rembrandt), fifth state, February 4 and March 4–6, 1970
Estate of the Artist

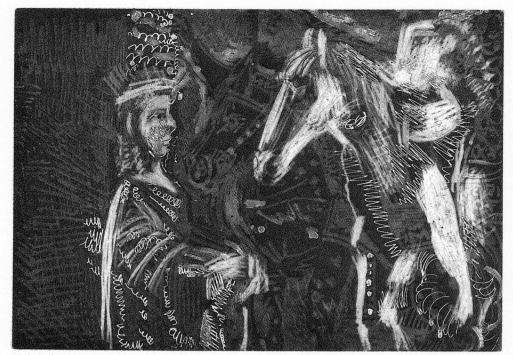

330

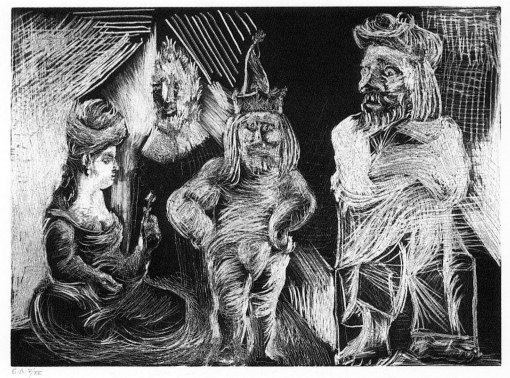

201 **Untitled (Old man and woman bent over the neck of her horse)**, second state, March 15, 1970
Private Collection

202 **Untitled (Woman with turban, old gentleman, executioner and wild-eyed man)**, fourth state, March 15, 16 and 18, 1970
Private Collection

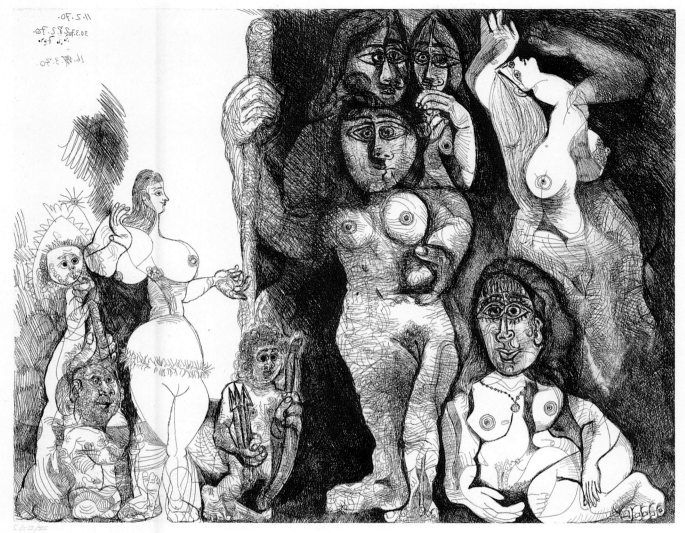

203 **Untitled (Spectacle: Amor ventures among the women),**
ninth state, February 11 and 28–March 3, 16, and 30, 1970
Estate of the Artist

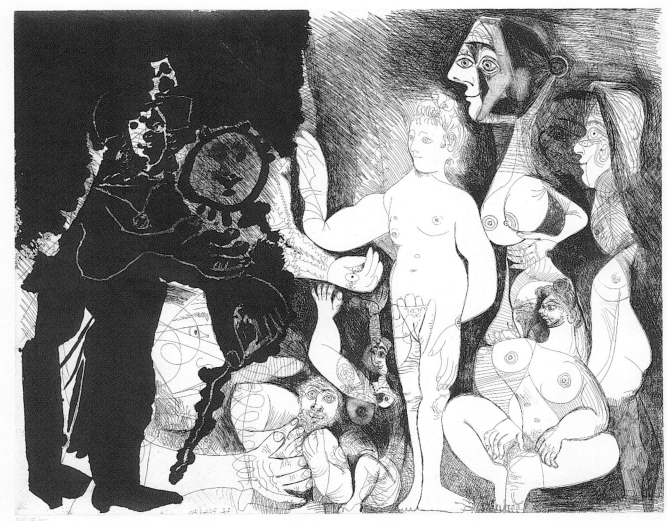

204 Untitled (Spectacle for a couple, Captain Frans Banningh Cocq and the women),
fourth state, February 16, March 2 and 4, 1970
Estate of the Artist

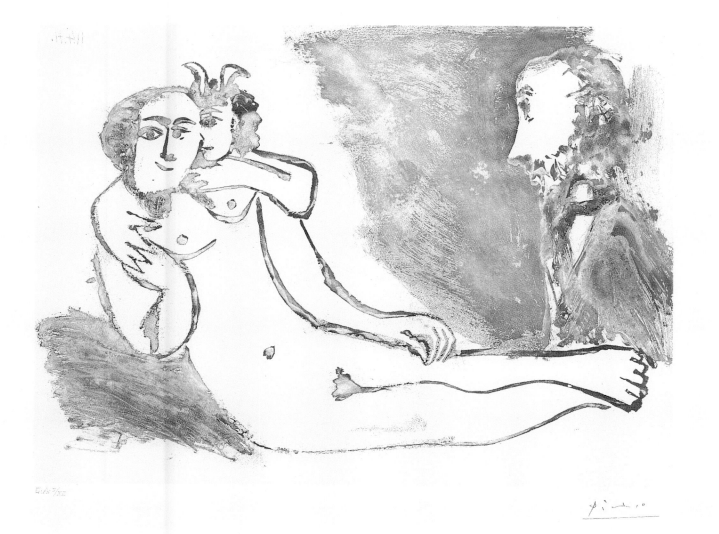

333

205 Untitled (Degas dreaming, faun whispering in a woman's ear), April 11, 1971
Private Collection

334

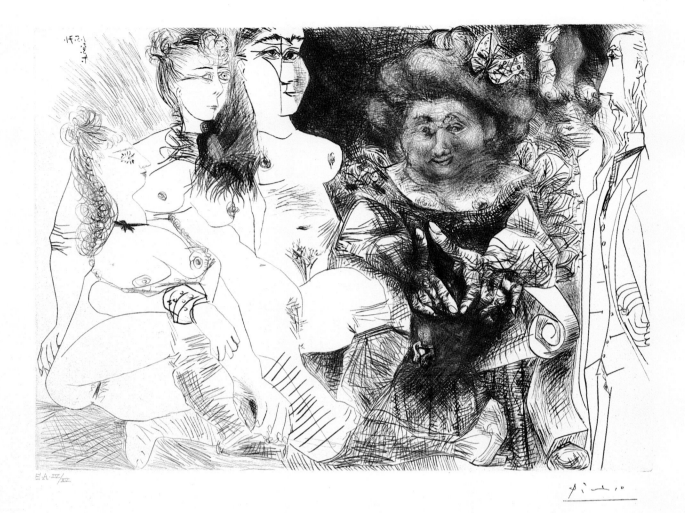

206 Untitled (The crafty madame with three girls, Degas with his hands behind his back),
second state, May 1–4, 1971
Estate of the Artist

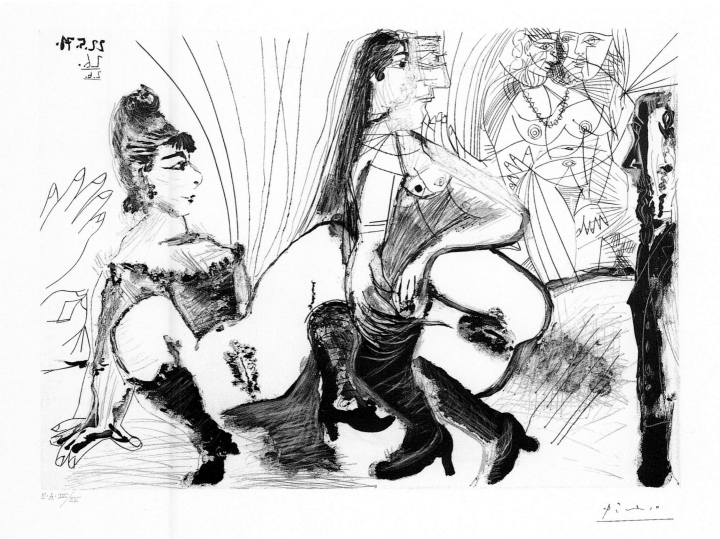

335

207 Untitled (Degas pays and leaves, the girls are not kind),
third state, May 22 and 26, June 2, 1971
Estate of the Artist

336

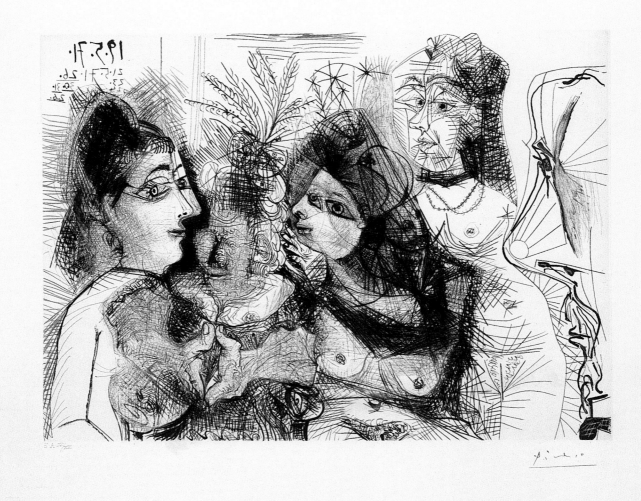

208 Untitled (Brothel, gossip, profile of Degas wrinkling his nose),
seventh state, May 19–31 and June 2, 1971
Estate of the Artist

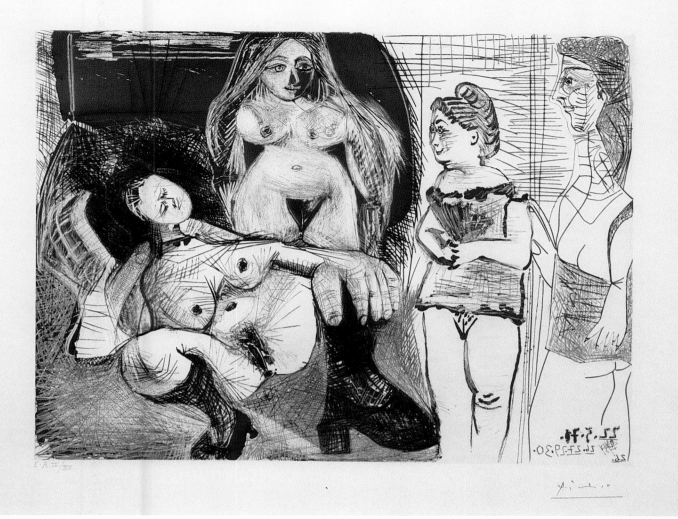

209 Untitled (Girls together, the owner),
fifth state, May 22, 26, 27, 29, 30 and June 2, 1971
Estate of the Artist

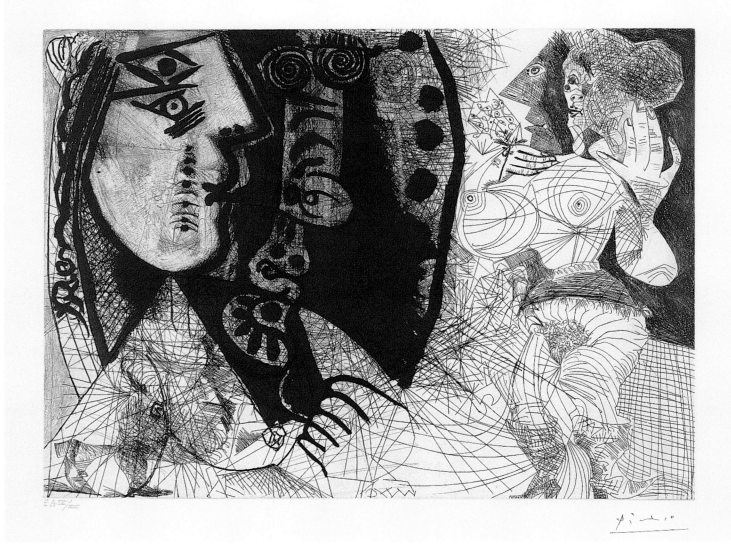

210 Untitled (Couple: woman and man-dog with flower woman),
seventh state, March 1 and 5, 1972
Estate of the Artist

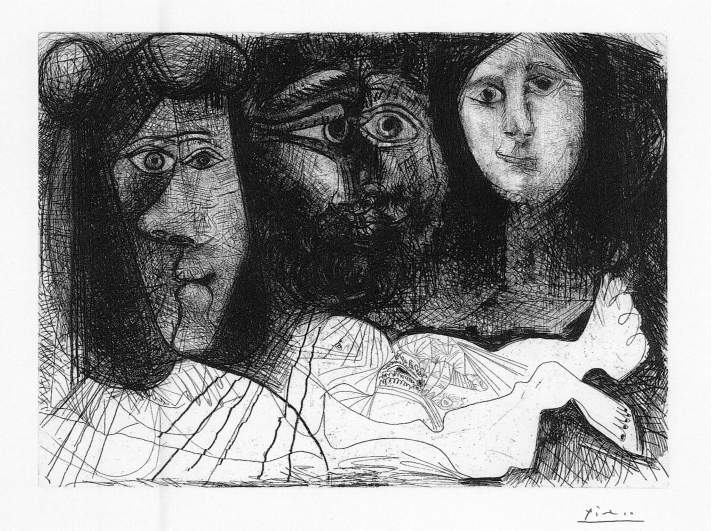

339

211 Untitled (Self-portrait, with two women, *The Fall of Icarus*),
eighth state, March 4 and 6, 1972
Estate of the Artist

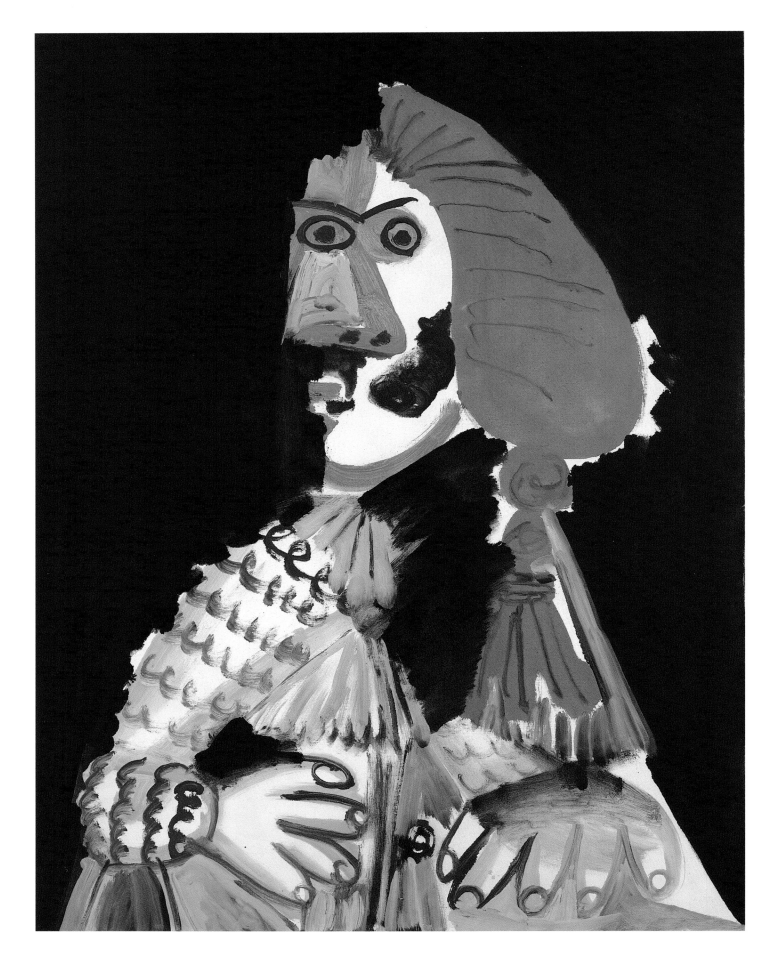

212 **The Matador**, October 4, 1970
Private Collection, New York

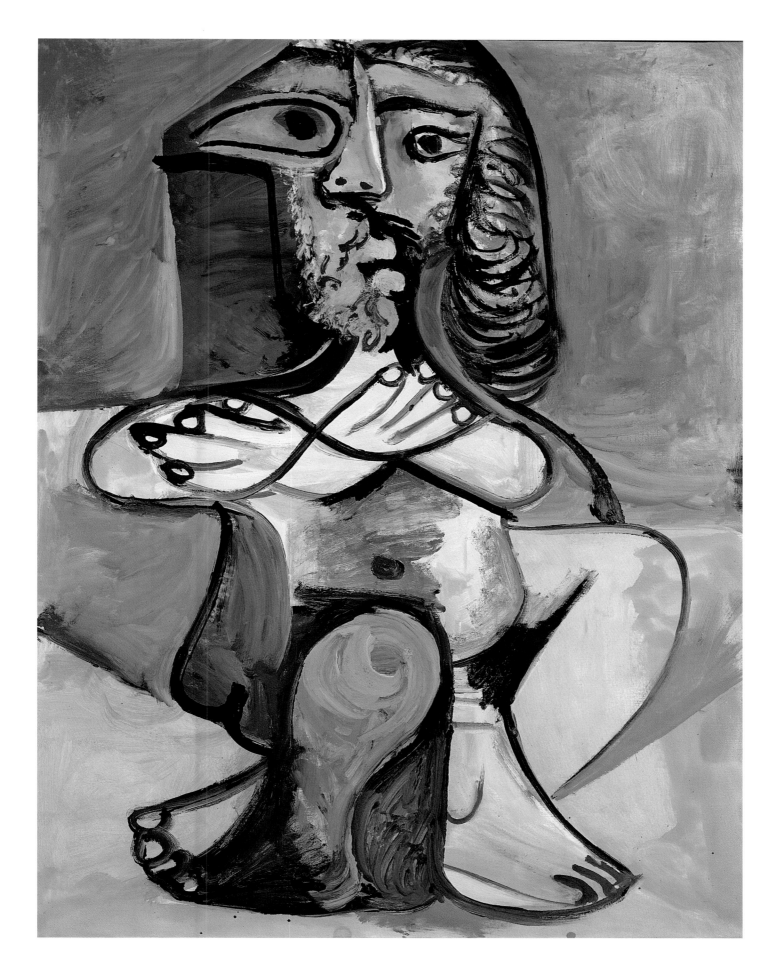

213 **Seated Nude Man**, July 30, 1971
Private Collection

342

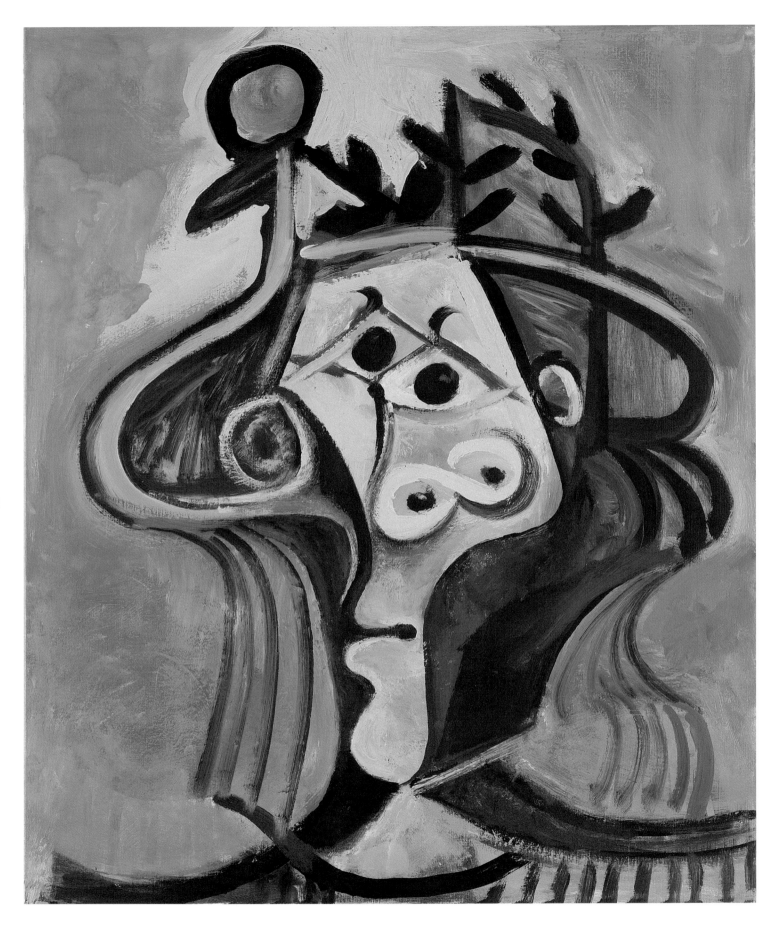

214 **Woman**, July 7, 1971
Estate of the Artist

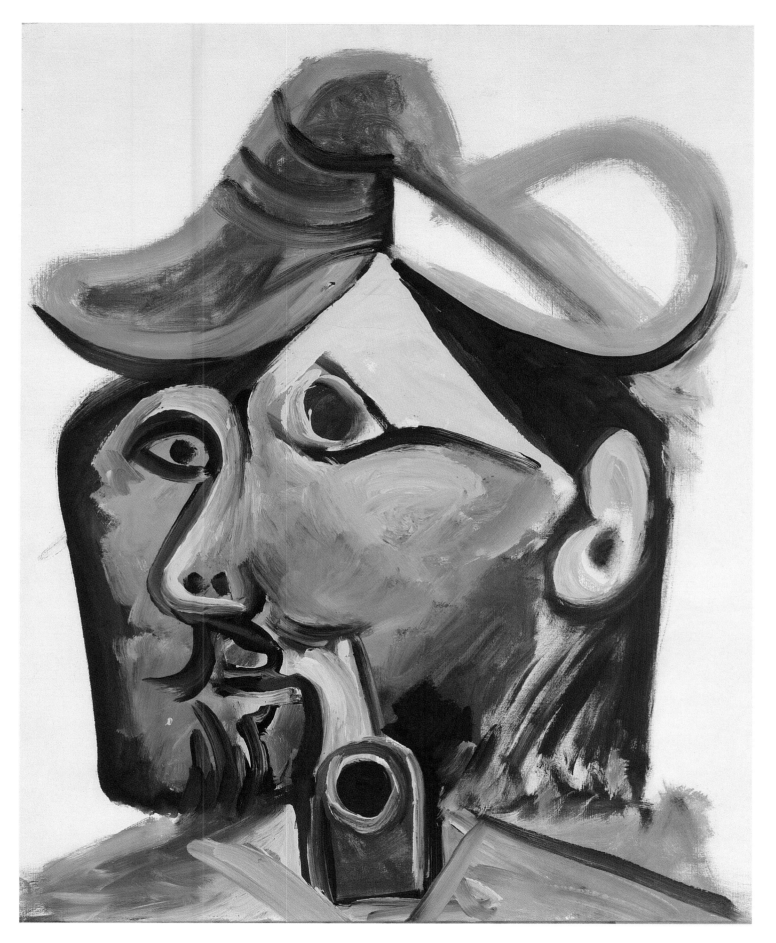

343

215 **Man**, July 9, 1971
Estate of the Artist

344

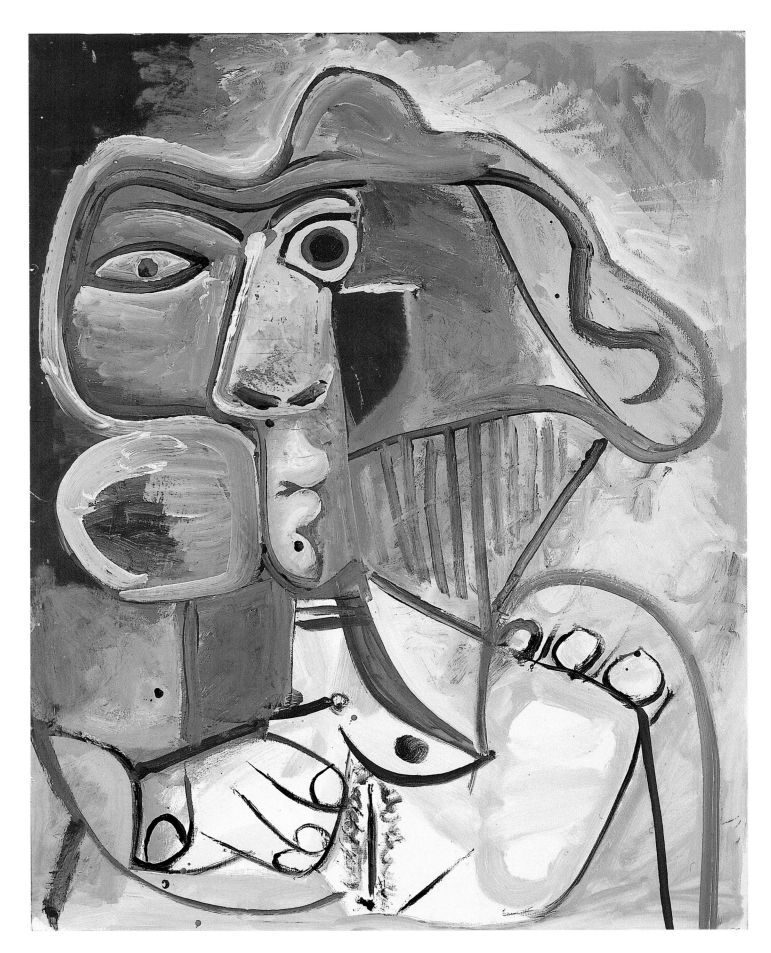

216 **Seated Woman**, September 16, 1971
Private Collection

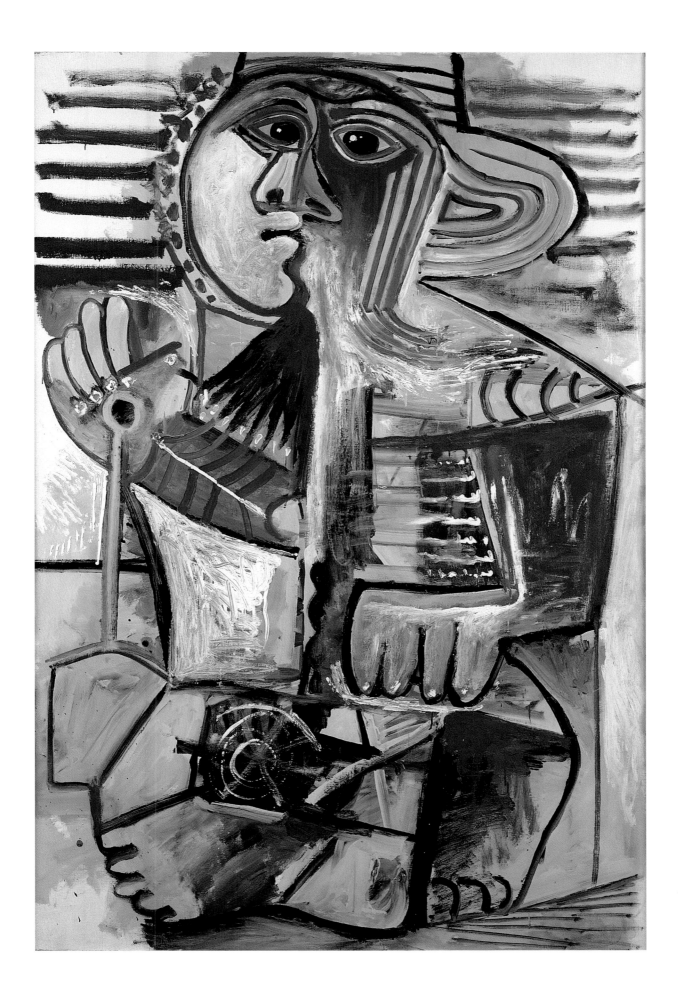

217 **Child**, July 15, 1971 (completed November 14, 1971)
Estate of the Artist

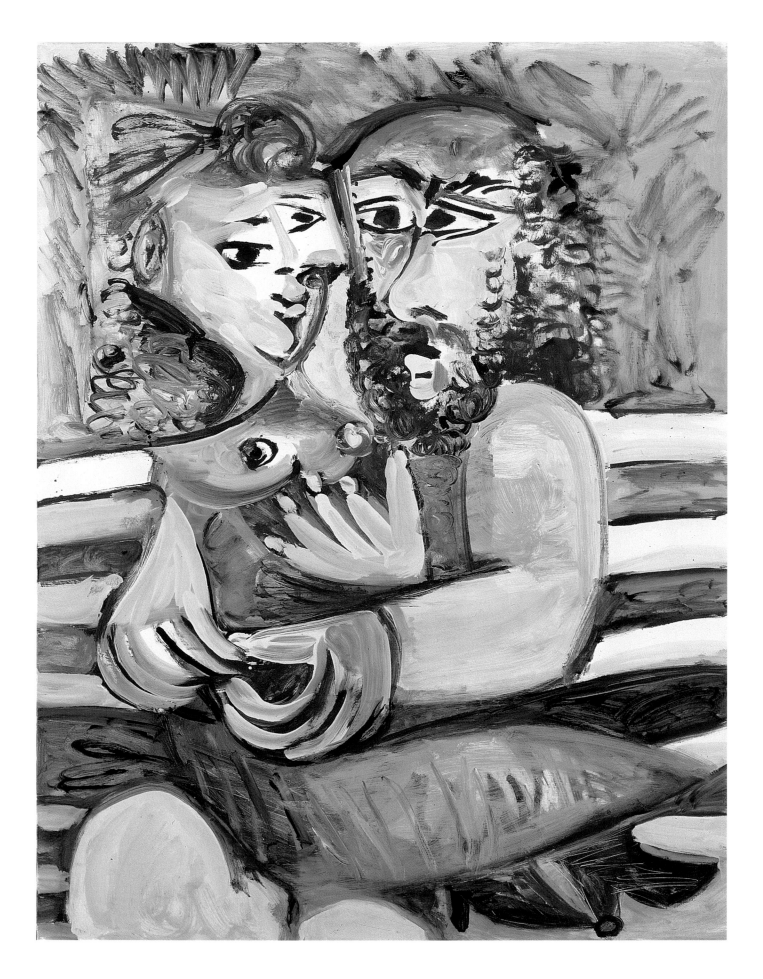

218 **Embrace**, July 28, 1971
Private Collection

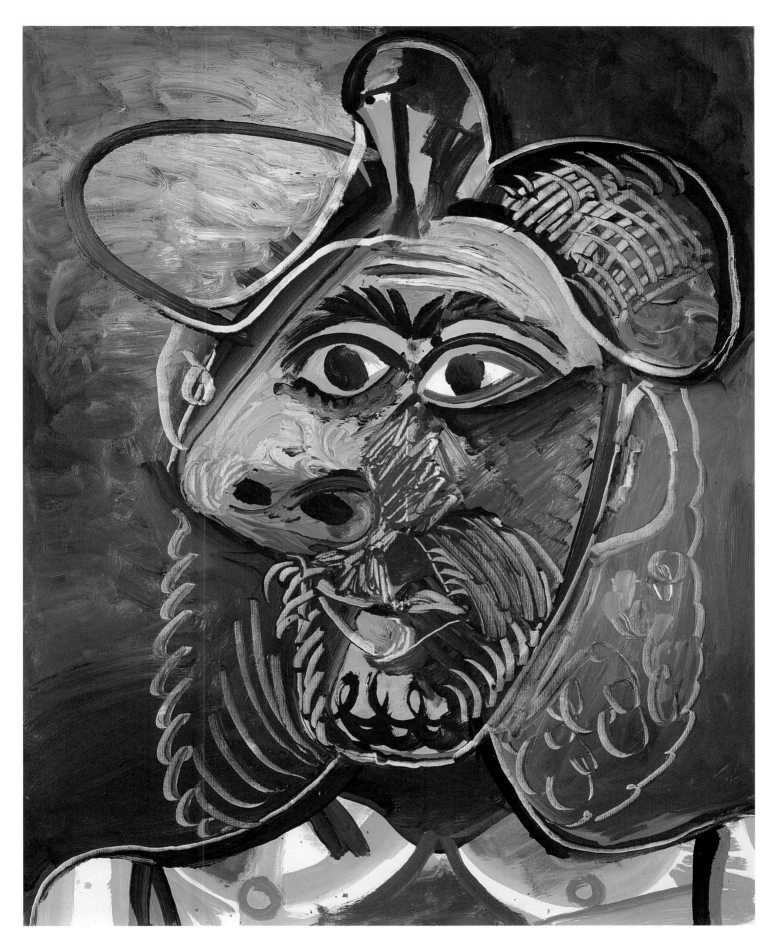

219 **Bust**, August 23, 1971
Estate of the Artist

348

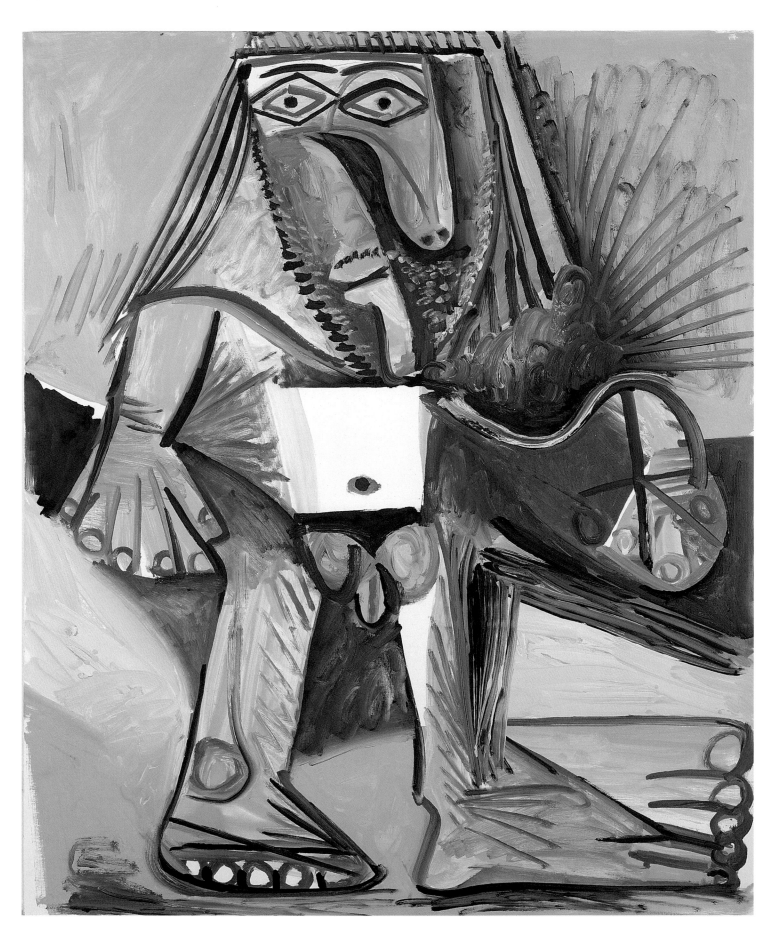

220 **Man**, August 16, 1971
Estate of the Artist

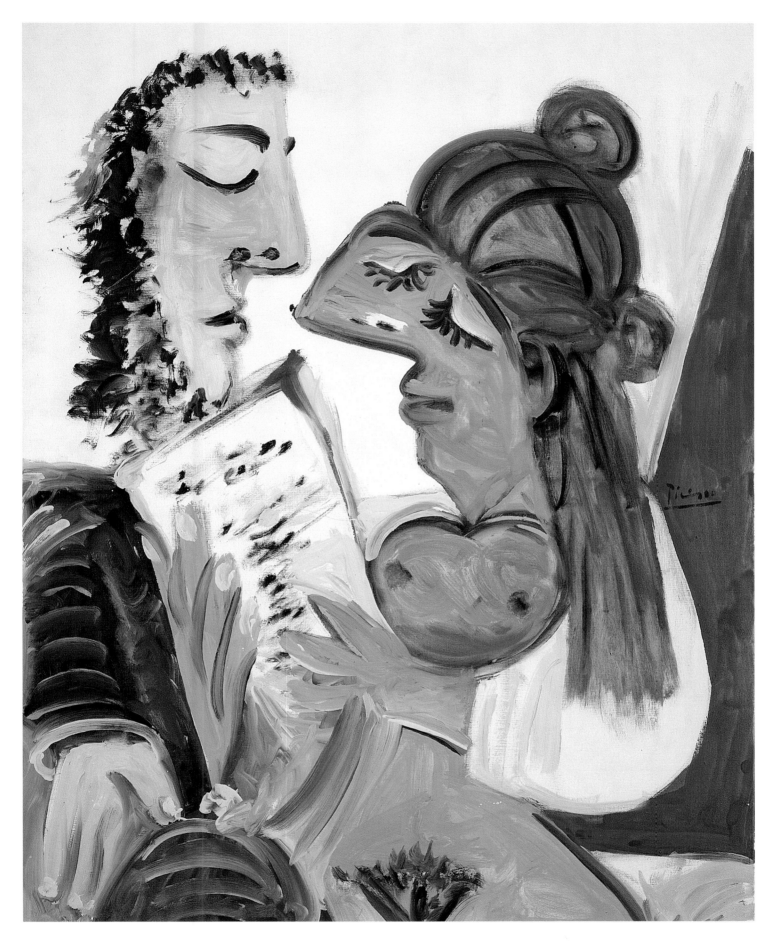

221 **Couple with Book**, January 12, 1970
Collection Dee Dee and Herb Glimcher

350

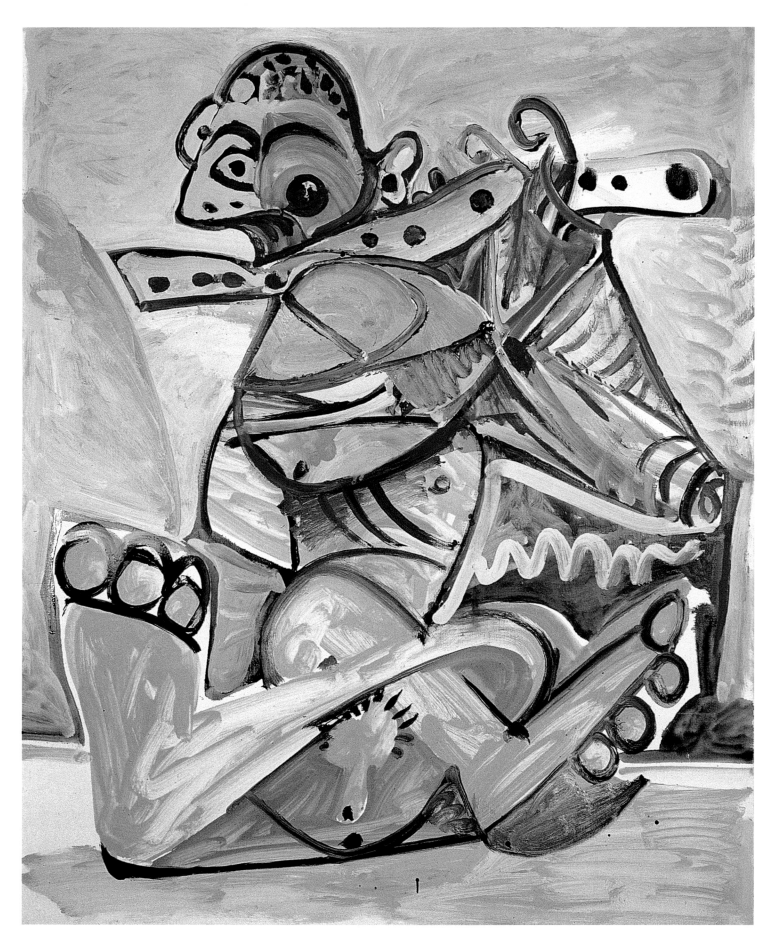

222 **Seated Man Playing the Flute**, July 30, 1971
Private Collection

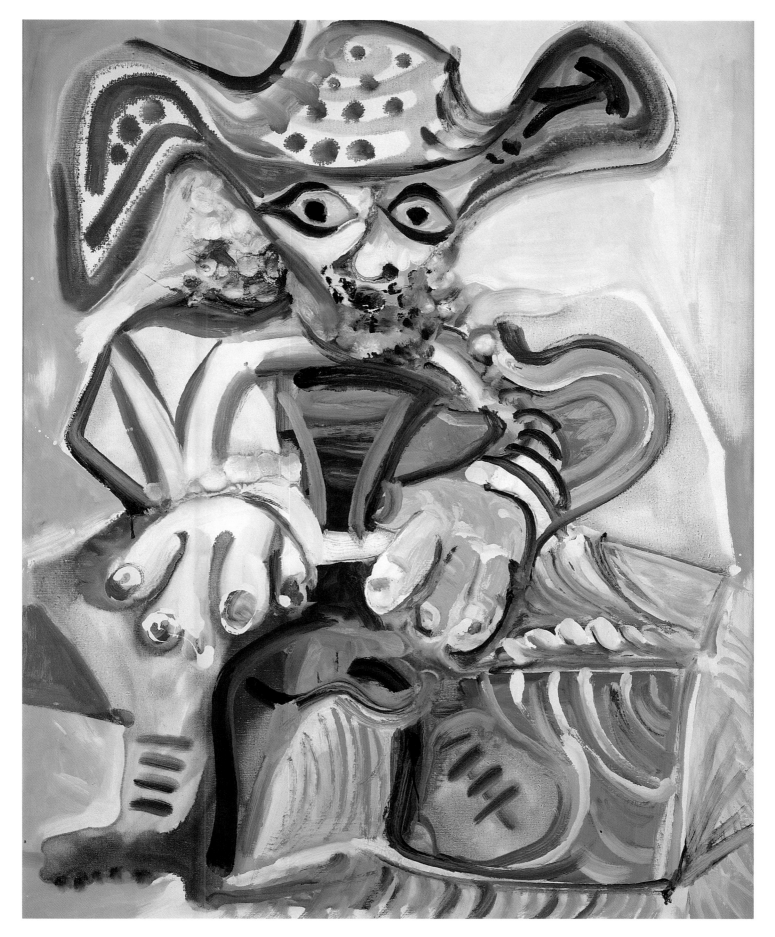

223 **Seated Man with Hat**, February 16, 1972
Sammlung Frieder Burda

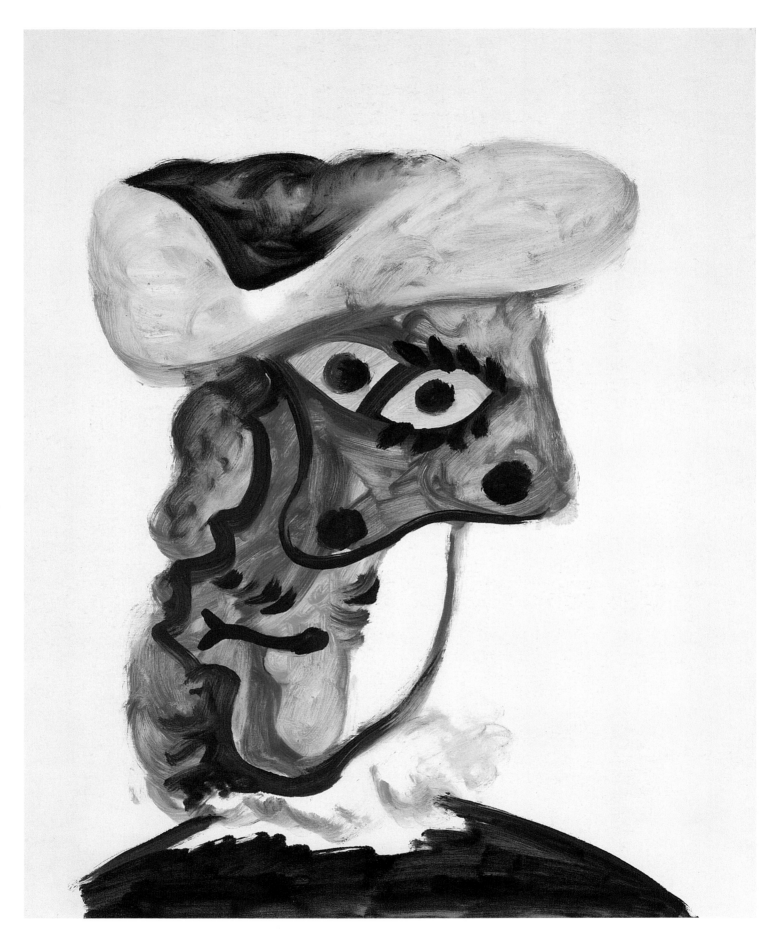

224 Head, April 9, 1972
Estate of the Artist

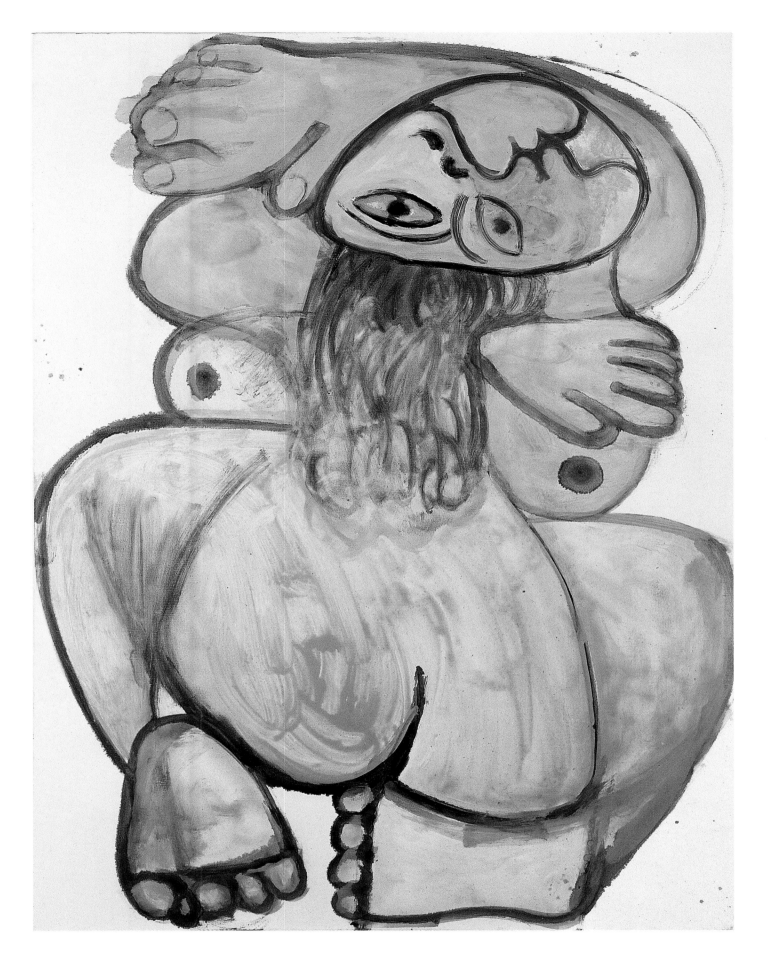

225 **Nude Crouching (Reclining Woman)**, July 26, 1972
Private Collection

List of Works

Note:
The dimensions given for drawings are the sheet size. For prints the dimensions given are of plate marks except in the case of lithographs, which are sheet size. Print titles in parenthesis are not the artist's own titles but are descriptive titles from the catalog raisonée of the prints. Works are in chronological order, they have not been separated according to media in order to reflect the artist's working order.

1
Woman Observing the Party
(1898–99)
Oil on canvas,
18⅛ × 21⅝ in. (46 × 55 cm)
Estate of the Artist
© Succession Picasso by SIAE 2001
© Images Modernes,
photo Eric Baudouin

2
Mateu Fernández Soto
(1901)
Oil on canvas,
18⅛ × 15 in. (46 × 38 cm)
Estate of the Artist
© Succession Picasso by SIAE 2001
© Images Modernes,
photo Eric Baudouin

3
Dead Casagemas
(1901)
Oil on paperboard,
20½ × 13⅜ in. (52 × 34 cm)
Estate of the Artist
© Succession Picasso by SIAE 2001
© Images Modernes,
photo Eric Baudouin

4
The Frugal Repast
Second state
1904
Etching,
18¼ × 14⅝ in. (46.3 × 37.7 cm)
Francey A. and Dr. Martin
Gecht, Gecht Family Collection,
Chicago
© Succession Picasso by SIAE 2001

5
Meditation
Paris, 1904
Watercolor, pen and ink on paper,
13⅝ × 10⅛ in. (34.6 × 25.7 cm)
The Museum of Modern Art,
New York
Louise Reinhardt Smith Bequest.
90.96
Photo © 2001 The Museum
of Modern Art, New York
© Succession Picasso by SIAE 2001

6
Nude with Raised Arms
Paris, Spring–Summer 1907
Pastel and black chalk
over pencil,
9½ × 7½ in. (24 × 19 cm)
Private Collection
© Succession Picasso by SIAE 2001

7
Female Nude
Paris, Spring 1907
Oil on canvas,
36⅝ × 17 in. (93 × 43 cm)
Museo d'Arte Contemporanea,
Jucker Collection, Milan
© Succession Picasso by SIAE 2001

8
Study for *Les Demoiselles d'Avignon*
1907
Watercolor on paper,
8⅝ × 6¾ in. (22 × 17.5 cm)
Estate of the Artist
© Succession Picasso by SIAE 2001
© Images Modernes,
photo Eric Baudouin

9
Sketch of Figure for *Three Women*
(1908)
Watercolor on paper,
25½ × 19¾ in. (65 × 50 cm)
Estate of the Artist
© Succession Picasso by SIAE 2001
© Images Modernes,
photo Eric Baudouin

10
Study for *Nude with Drapery*
Paris, Summer 1907
Watercolor and pencil on paper
mounted on canvas,
12 × 9¼ in. (30.5 × 23.5 cm)
Collection Linda
and Morton Janklow, New York
Photo Ellen Page Wilson,
courtesy PaceWildenstein
© Succession Picasso by SIAE 2001

11
La Rue-des-Bois
August 1908
Oil on canvas,
28½ × 23½ in. (72.5 × 59.5 cm)
Museo d'Arte Contemporanea,
Jucker Collection, Milan
© Succession Picasso by SIAE 2001

12
Nude Woman, Three-Quarter View
1907
Oil on canvas,
29½ × 21 in. (75 × 53 cm)
Estate of the Artist
© Succession Picasso by SIAE 2001
© Images Modernes,
photo Eric Baudouin

13
Still Life with Lemon
Summer 1907
Gouache on paper,
12½ × 13⅝ in. (32 × 34 cm)
Francey A. and Dr. Martin
Gecht, Gecht Family Collection,
Chicago
Photo James Balodimas
© Succession Picasso by SIAE 2001

14
Head of a Woman, Fernande
1906
Bronze, 14 × 10 × 9 in.
(36 × 25 × 23 cm)
Estate of the Artist
© Succession Picasso by SIAE 2001
© Images Modernes,
photo Marc Domage

15
Bust of a Woman
Paris, Spring 1909
Oil on canvas,
28¾ × 23⅝ in. (73 × 60 cm)
Tate, London,
Purchased 1949
Photo John Webb
© Tate, London 2001
© Succession Picasso by SIAE 2001

16
Standing Nude
1909
Pencil on paper,
19½ × 12½ in. (49.5 × 32 cm)
Estate of the Artist
© Succession Picasso by SIAE 2001
© Images Modernes,
photo Marc Domage

17
Head of a Woman, Coffer and Apple
1909
Pencil on paper,
9¼ × 12½ in. (23.5 × 31.8 cm)
Private Collection
Photo Sarah Harper Gifford,
courtesy PaceWildenstein
© Succession Picasso by SIAE 2001

18
Head of a Woman (Fernande)
1909
Black chalk and gray wash
on paper,
25¼ × 18½ in. (64.1 × 47 cm)
Collection Berta Borgenicht Kerr
Photo Schecter Lee
© Succession Picasso by SIAE 2001

19
Head of Fernande
Paris, Autumn 1909
Bronze, 16 × 9 × 10¼ in.
(40.5 × 23 × 26 cm)
Private Collection
Photo Studio Patrick Goetelen
© Succession Picasso by SIAE 2001

20
Two Nude Figures
1909
Drypoint,
5⅛ × 4⅜ in. (13 × 11 cm)
Collection Hope and Abraham
Melamed
Photo Larry Sanders
© Succession Picasso by SIAE 2001

21
Still Life with Compote
1909
Drypoint,
5⅛ × 4⅜ in. (13 × 11 cm)
Collection Hope and Abraham
Melamed
Photo Larry Sanders
© Succession Picasso by SIAE 2001

22a-d
Saint-Matorel, Book
by Max Jacob, illustrated
by Pablo Picasso with four prints,
ed. Henry Kahnweiler, Paris 1911.
Book 10⅜ × 8⅞ in.
(26.5 × 22.6 cm)
Collection Hope and Abraham
Melamed
© Succession Picasso by SIAE 2001

22a
Mademoiselle Léonie
August and Autumn 1910
Etching,
7¾ × 5½ in. (20 × 14.1 cm)
Collection Hope and Abraham
Melamed
Photo Larry Sanders
© Succession Picasso by SIAE 2001

22b
The Table
August 1910
Etching,
7¾ × 5⅝ in. (20 × 14.2 cm)
Collection Hope and Abraham
Melamed
Photo Larry Sanders
© Succession Picasso by SIAE 2001

22c
Mademoiselle Léonie in a Chaise Longue
August and Autumn 1910
Etching, and drypoint,
7¾ × 5½ in. (20 × 14.1 cm)
Collection Hope and Abraham
Melamed
Photo Larry Sanders
© Succession Picasso by SIAE 2001

22d
The Convent
August 1910
Etching,
7¾ × 5½ in. (20 × 14.1) cm
Collection Hope and Abraham
Melamed
Photo Larry Sanders
© Succession Picasso by SIAE 2001

23
Female Nude
Spring 1909–10
Oil on canvas,
28¾ × 21¼ in. (72.4 × 54.6 cm)
The Menil Collection, Houston
Photo Hickey-Robertson,
courtesy The Menil Collection
© Succession Picasso by SIAE 2001

24
Female Nude
Paris, Autumn 1910
Oil on canvas,
39¾ × 30½ in. (101.3 × 77.6 cm)
The Philadelphia Museum of Art,
The Louise and Walter Arensberg
Collection
Photo courtesy The Philadelphia
Museum of Art
© Succession Picasso by SIAE 2001

25
Bottle and Books
Paris, Winter 1910–11
Oil on canvas,
15 × 18⅛ in. (38 × 46 cm)
Private Collection
© Succession Picasso by SIAE 2001

26
Bottles and Glasses
Paris, Winter 1911–12
Oil on paper mounted
on canvas, 25⅜ × 19½ in.
(64.4 × 49.5 cm)
Solomon R. Guggenheim
Museum, New York
Gift Solomon R. Guggenheim,
1938
Photo David Heald,
© The Solomon R. Guggenheim
Foundation, New York
© Succession Picasso by SIAE 2001

27
Man with Guitar
Paris, Autumn 1911–Spring 1912
Oil on canvas,
61 × 30⅝ in. (155 × 77 cm)
Musée Picasso, Paris - Réunion
des Musées Nationaux
© Succession Picasso by SIAE 2001

28
Cubist Nude
1911
India ink on paper,
7 × 4⅝ in. (18 × 11 cm)
Estate of the Artist
© Succession Picasso by SIAE 2001
© Images Modernes,
photo Eric Baudouin

29
Standing Woman
1911–12
Ink and watercolor on paper,
21⅝ × 8¹¹⁄₁₆ in. (55.2 × 21.7 cm)
Private Collection
© Succession Picasso by SIAE 2001

30
Man with Violin
1912
Grease pencil on paper,
13⅝ × 8⅝ in. (34 × 22 cm)
Estate of the Artist
© Succession Picasso by SIAE 2001
© Images Modernes,
photo Eric Baudouin

31
**Guitar Man
(Project for a Construction)**
1912–13
Pencil on paper,
10¾ × 8½ in. (27.3 × 21.6 cm)
Collection of Abigail G. Melamed
© Succession Picasso by SIAE 2001

32
Cubist Composition: Head
1912
Pencil on paper,
11⅜ × 9 in. (29 × 23 cm)
Estate of the Artist
© Succession Picasso by SIAE 2001
© Images Modernes,
photo Eric Baudouin

33
Mandolin
Summer 1912
India ink and pencil on paper,
13⅝ × 8⅝ in. (34 × 22 cm)
Estate of the Artist
© Succession Picasso by SIAE 2001
© Images Modernes,
photo Marc Domage

34
Violin and Sheet of Music
Paris, Autumn 1912
Pasted papers on paperboard,
29½ × 25½ in. (75 × 65 cm)
Musée Picasso, Paris - Réunion
des Musées Nationaux
© Succession Picasso by SIAE 2001

35
Guitar
Autumn 1912
Charcoal on paper,
18½ × 24¾ in. (47 × 62.9 cm)
Mr. and Mrs. Donald B. Marron,
New York
Photo courtesy PaceWildenstein
© Succession Picasso by SIAE 2001

36
Bottle and Glass
Paris, Winter 1912
Charcoal, graphite
and newsprint on paper,
19 × 24⅞ in. (48.3 × 63.2 cm)
The Menil Collection, Houston
Photo Paul Hester,
courtesy The Menil Collection
© Succession Picasso by SIAE 2001

37a-c
*Le Siège de Jérusalem - La Grande
Tentation Céleste de Saint-Matorel.*
Book by Max Jacob, illustrated by
Pablo Picasso with three prints.
Ed. Henry Kahnweiler, Paris 1914.
Book: 8⅞ × 6⅛ in.
(22.5 × 15.8 cm)
Collection Hope and Abraham
Melamed
© Succession Picasso by SIAE 2001

37a
Nude Woman with Guitar
Paris, Autumn-Winter 1913
Etching and drypoint,
6¼ × 4½ in. (15.6 × 11.6 cm)
Collection Hope and Abraham
Melamed
Photo Larry Sanders
© Succession Picasso by SIAE 2001

37b
Woman
Paris, Autumn–Winter 1913
Etching and drypoint,
6 × 4¼ in. (16 × 10.9 cm)
Collection Hope and Abraham
Melamed
Photo Larry Sanders
© Succession Picasso by SIAE 2001

37c
Still Life with Skull
Paris, Autumn–Winter 1913
Drypoint on copper,
6¼ × 4½ in. (15.6 × 11.5 cm)
Collectione Hope
and Abraham Melamed
Photo Larry Sanders
© Succession Picasso by SIAE 2001

38
Violin
1913
India ink on paper,
7⅞ × 5⅞ in. (20 × 15 cm)
Collection of Abigail G. Melamed
© Succession Picasso by SIAE 2001

39
Figure
1913
Charcoal and cut and pasted
papers,
22⅝ × 11¾ in. (58 × 30 cm)
Estate of the Artist
© Succession Picasso by SIAE 2001
© Images Modernes,
photo Marc Domage

40
Figure
Spring, 1913
Ink, pencil and wallpaper on
paper,
16½ × 11 in. (41.9 × 27.9 cm)
Collection Hope and Abraham
Melamed
© Succession Picasso by SIAE 2001

41
The Bottle of Bass
Céret, Spring 1912–Paris 1914 (?)
Oil on canvas,
42⅜ × 25¾ in. (107.5 × 65.5 cm)
Museo d'Arte Contemporanea,
Jucker Collection, Milan
© Succession Picasso by SIAE 2001

42
**Chicken, Glass, Knife
and Bottle**
Spring 1914
Pasted papers and charcoal
on paper,
18¼ × 23¼ in. (46.4 × 59.1 cm)
Private Collection
© Succession Picasso by SIAE 2001

43
**Fruit Dish with Grapes,
Glass and Playing Card**
Paris, Spring 1914
Pasted papers, oil and charcoal
on paper,
26¾ × 20¾ in. (68 × 53 cm)
Private Collection
© Succession Picasso by SIAE 2001

44
Figure with Crossed Arms
Summer 1914
Pencil on paper,
11 × 9¾ in. (28 × 25 cm)
Estate of the Artist
© Succession Picasso by SIAE 2001
© Images Modernes,
photo Marc Domage

45
**Seated Man with Moustache
and Pipe**
1915
Pencil on paper,
12⅜ × 9½ in. (31.5 × 24 cm)
Estate of the Artist
© Succession Picasso by SIAE 2001
© Images Modernes,
photo Marc Domage

46
Seated Man with Moustache
1915
Pencil on paper,
11¾ × 7¾ in. (30 × 20 cm)
Estate of the Artist
© Succession Picasso by SIAE 2001
© Images Modernes,
photo Marc Domage

47
**Man with Guitar and Seated
Dog**
(Summer 1914)
Pencil on paper,
13 × 9⅝ in. (32.9 × 23.8 cm)
Estate of the Artist
© Succession Picasso by SIAE 2001
© Images Modernes,
photo Eric Baudouin

48
Man Seated in an Armchair
(1916)
Pencil and watercolor on paper,
12¼ × 9¾ in. (31 × 24.7 cm)
Estate of the Artist
© Succession Picasso by SIAE 2001
© Images Modernes,
photo Eric Baudouin

49
Still Life with Bottle of Vittel
(1915)
Oil on canvas,
17¾ × 12⅝ in. (45 × 32 cm)
Estate of the Artist
© Succession Picasso by SIAE 2001
© Images Modernes,
photo Marc Domage

50
Man with Guitar
1915
Engraving, 6 × 4½ in. (15.3 ×
11.5 cm)
Collection Hope and Abraham
Melamed
Photo Larry Sanders
© Succession Picasso by SIAE 2001

51
Guitar Player
Paris, 1916
Oil and sand on canvas,
51¼ × 38⅛ in. (130 × 97 cm)
Moderna Museet, Stockholm
Photo Anders Allsten, Moderna
Museet, Stockholm
© Succession Picasso by SIAE 2001

52
**Composition with Fruit
against a Blue Background**
(1913–14)
Oil and charcoal on paperboard,
6¼ × 5 in. (16 × 12.5 cm)
Estate of the Artist
© Succession Picasso by SIAE 2001
© Images Modernes,
photo Marc Domage

53
**White Composition
against a Brown Background**
(1913–14)
Oil on paperboard,
5 × 6½ in. (12.5 × 16.5 cm)
Estate of the Artist
© Succession Picasso by SIAE 2001
© Images Modernes,
photo Marc Domage

54
The Glass of Absinthe
Paris, Spring 1914
Bronze painted white and red,
8½ × 6½ in. (21.5 × 16.5 cm)
Estate of the Artist
© Succession Picasso by SIAE 2001
© Images Modernes,
photo Eric Baudouin

55
Construction: Glass and Dice
Paris, Spring 1914
Painted wood,
6¾ × 6¾ in. (17 × 17 cm)
Musée Picasso, Paris - Réunion
des Musées Nationaux
© Succession Picasso by SIAE 2001

56
Portrait of Mme Picasso
1922
Oil on canvas,
51¼ × 38½ in. (130.1 × 97.8 cm)
Mr. and Mrs. Leonard Riggio
Photo Ellen Page Wilson,
courtesy PaceWildenstein
© Succession Picasso by SIAE 2001

57
Man with a Pipe
May 1923
Oil, pencil and India ink on
prepared canvas,
51¼ × 38¼ in. (130 × 97 cm)
Estate of the Artist
© Succession Picasso by SIAE 2001
© Images Modernes,
photo Eric Baudouin

58
Three Nudes
1920
Pencil on paper,
25¾ × 19¾ in. (65.5 × 50 cm)
Estate of the Artist
© Succession Picasso by SIAE 2001
© Images Modernes,
photo Marc Domage

59
Woman and Child
(Autumn 1921)
Oil on wood panel,
5¾ × 3¾ in. (14.5 × 9.5 cm)
Estate of the Artist
© Succession Picasso by SIAE 2001
© Images Modernes,
photo Eric Baudouin

60
Woman with Missal
(Autumn 1921)
Charcoal and black chalk
on prepared paper,
41½ × 29½ in. (105 × 75 cm)
Estate of the Artist
© Succession Picasso by SIAE 2001
© Images Modernes,
photo Eric Baudouin

61
Still Life with "Journal"
June 1923
Oil on wood,
5¼ × 6⅝ in. (13 × 17.5 cm)
Estate of the Artist
© Succession Picasso by SIAE 2001
© Images Modernes,
photo Eric Baudouin

62
Composition
(1920)
Oil and collage on canvas,
28½ × 36 in. (72.5 × 91.5 cm)
Estate of the Artist
© Succession Picasso by SIAE 2001
© Images Modernes,
photo Marc Domage

63
Still Life with Vase
(Spring 1923)
Oil and sand on canvas,
15 × 18⅛ in. (38 × 46 cm)
Estate of the Artist
© Succession Picasso by SIAE 2001
© Images Modernes,
photo Marc Domage

64
Geometric Composition
(1918)
Oil and India ink on canvas,
13 × 9½ in. (33 × 24 cm)
Estate of the Artist
© Succession Picasso by SIAE 2001
© Images Modernes,
photo Marc Domage

65
**Composition with Blue Cigar
Box**
(Autumn 1921)
Oil on canvas,
11⅝ × 6¾ in. (30 × 17 cm)
Estate of the Artist
© Succession Picasso by SIAE 2001
© Images Modernes,
photo Marc Domage

66
Composition with Black Lines
(Summer 1922)
Oil on canvas,
5½ × 8¾ in. (14 × 22 cm)
Estate of the Artist
© Succession Picasso by SIAE 2001
© Images Modernes,
photo Eric Baudouin

67
Composition with a Glass
(1917)
Oil and sand on canvas mounted
on wood,
8¾ × 10¾ in. (22 × 27 cm)
Estate of the Artist
© Succession Picasso by SIAE 2001
© Images Modernes,
photo Marc Domage

68
**Female Figure
(The Metamorphosis)**
1928
Gilded bronze, 9 × 7¼ × 4½ in.
(22.8 × 18.3 × 11 cm)
Estate of the Artist
© Succession Picasso by SIAE 2001
© Images Modernes,
photo Marc Domage

69
**Study for a Monument
to Guillaume Apollinaire**
1928/1962
Welded steel,
47¼ × 31¾ × 14 ½ in.
(119.4 × 80.6 × 36.8 cm)
Linda and Harry Macklowe
Photo courtesy PaceWildenstein
© Succession Picasso by SIAE 2001

70
**Beige and Black Composition
(Marie-Thérèse)**
1927
Oil on canvas,
28¾ × 36¼ in. (73 × 92 cm)
Private Collection
© Succession Picasso by SIAE 2001

71
**Beige and Gray Geometric
Figures**
(1928)
Oil on canvas,
39½ × 31⅞ in. (100 × 81 cm)
Estate of the Artist
© Succession Picasso by SIAE 2001
© Images Modernes,
photo Eric Baudouin

72
Woman
(1928)
India ink on canvas,
53½ × 40½ in. (136 × 103 cm)
Estate of the Artist
© Succession Picasso by SIAE 2001
© Images Modernes,
photo Eric Baudouin

73
Gray and Black Woman
(1928–29)
Oil on canvas,
73¾ × 50½ in. (187 × 128 cm)
Estate of the Artist
© Succession Picasso by SIAE 2001
© Images Modernes,
photo Eric Baudouin

74
Standing Woman
1927
Oil on canvas,
50¾ × 37⅜ in. (128.9 × 95 cm)
Private Collection
Photo courtesy PaceWildenstein
© Succession Picasso by SIAE 2001

75
Female Acrobat
January 19, 1930
Oil on wood panel,
25⅝ × 19¼ in. (64 × 48.7 cm)
Estate of the Artist
© Succession Picasso by SIAE 2001
© Images Modernes,
photo Eric Baudouin

76
Woman
1931
Bronze, black paint,
height 6⅛ in. (16 cm)
Estate of the Artist
© Succession Picasso by SIAE 2001
© Images Modernes,
photo Marc Domage

77
Woman
1931
Bronze, 6⅞ × 9/16 × 1 in.
(17.5 × 1.4 × 2.5 cm)
Private Collection
Photo Studio Patrick Goetelen
© Succession Picasso by SIAE 2001

78
Woman
1931
Bronze, painted black,
height 18½ in. (46.5 cm)
Estate of the Artist
© Succession Picasso by SIAE 2001
© Images Modernes,
photo Marc Domage

79
Woman, Boisgeloup
1931
Bronze, 21½ × 2⅞ × ⅞ in.
(54.6 × 5.1 × 2.3 cm
Collection Dee Dee
and Herb Glimcher
Photo Ellen Page Wilson,
courtesy PaceWildenstein
© Succession Picasso by SIAE 2001

80
Standing Woman
1931
Bronze, 19 × 7 × 1¾ in.
(48.3 × 17.8 × 4.4 cm)
Collection Julie and Edward J.
Minskoff
Photo Ellen Page Wilson,
courtesy PaceWildenstein
© Succession Picasso by SIAE 2001

81
Head of a Warrior
1933
Bronze, 47½ × 27¼ × 11½ in.
(121 × 69 × 29 cm)
Estate of the Artist
© Succession Picasso by SIAE 2001
© Images Modernes,
photo Eric Baudouin

82
Little Girl with Ball
1931
Bronze, 19¼ × 10¾ × 7¾ in.
(49 × 27 × 20 cm)
Private Collection
Photo Studio Patrick Goetelen
© Succession Picasso by SIAE 2001

83
Lock Figure
1935
Found lock mechanism, painted,
9½ × 7½ in. (24 × 19 cm)
Estate of the Artist
© Succession Picasso by SIAE 2001
© Images Modernes,
photo Marc Domage

84
Sleeping Woman
1932
charcoal on canvas,
38¼ × 51¼ in. (97.2 × 130.2 cm)
From the Collection of Bill Blass
Photo Ellen Page Wilson,
courtesy PaceWildenstein
© Succession Picasso by SIAE 2001

85
Sleep
1932
Oil on canvas,
51¼ × 38¼ in. (130.2 × 97.2 cm)
Private Collection
Photo Ellen Page Wilson,
courtesy PaceWildenstein
© Succession Picasso by SIAE 2001

86
Woman with Bouquet
April 17, 1936
Oil on canvas,
28¾ × 23¾ in. (73 × 60.3 cm)
The Judy and Michael Steinhardt
Collection, New York
Photo Ellen Page Wilson,
courtesy PaceWildenstein
© Succession Picasso by SIAE 2001

87
Two Women
April 29, 1936
Oil on canvas,
25½ × 21¼ in. (65 × 54 cm)
Private Collection
Photo Studio Patrick Goetelen
© Succession Picasso by SIAE 2001

88
**The Visit. Two Seated Women
with a Book**
February 18, 1933
Drypoint and etching,
9 × 12½ in. (22.8 × 31.8 cm)
Estate of the Artist
© Succession Picasso by SIAE 2001
© Images Modernes,
photo Marc Domage

89
**Sculptor, Reclining Model
and Self-portrait as Hercules**
Vollard Suite, plate 37
March 17, 1933
Drypoint,
10½ × 7¾ in. (26.7 × 19.4 cm)
Estate of the Artist
© Succession Picasso by SIAE 2001
© Images Modernes,
photo Marc Domage

90
**Young Sculptor Finishing
a Plaster**
Vollard Suite, plate 46
March 23, 1933
Etching,
10½ × 7¾ in. (26.7 × 19.4 cm)
Estate of the Artist
© Succession Picasso by SIAE 2001
© Images Modernes,
photo Marc Domage

91
Bacchanal with Minotaur
Vollard Suite, plate 85
May 18, 1933
Drypoint,
11¾ × 14⅝ in. (29.9 × 36.5 cm)
Estate of the Artist
© Succession Picasso by SIAE 2001
© Images Modernes,
photo Eric Baudouin

92
**Minotaur Caressing
the Hand of a Sleeping Woman
with its Muzzle**
Vollard Suite, plate 93
June 18, 1933
Aquatint, drypoint and
engraving,
11¾ × 14⅝ in. (29.9 × 36.5 cm)
Estate of the Artist
© Succession Picasso by SIAE 2001
© Images Modernes,
photo Eric Baudouin

93
**Blind Minotaur Guided by
Marie-Thérèse with a Pigeon
on a Starry Night**
Vollard Suite, plate 97
December 31, 1934–
January 1, 1935
Aquatint, drypoint,
and engraving,
12½ × 16 in. (31.4 × 40.6 cm)
Collection Linda and Morton
Janklow, New York
Photo Ellen Page Wilson,
courtesy PaceWildenstein
© Succession Picasso by SIAE 2001

94
Faun Uncovering a Woman
Vollard Suite, plate 27
1936
Aquatint,
14½ × 17½ in. (36.8 × 44.5 cm)
Collection David Teiger
© Succession Picasso by SIAE 2001

95
**Minotaur in a Boat Saving
a Woman**
March 1937
India ink and gouache
on paperboard,
8¾ × 10¾ in. (22 × 27 cm)
Estate of the Artist
© Succession Picasso by SIAE 2001
© Images Modernes,
photo Eric Baudouin

96
Minotauromachy
1935
Etching,
19⅝ × 27¼ in. (49.8 × 69.3 cm)
Musée Picasso, Paris - Réunion
des Musées Nationaux
© Succession Picasso by SIAE 2001

97
Dream and Lie of Franco (I)
1937
Etching and aquatint,
15⅛ × 22½ in. (38.4 × 57.2 cm)
Private Collection
Photo Ellen Page Wilson,
courtesy PaceWildenstein
© Succession Picasso by SIAE 2001

98
Dream and Lie of Franco (II)
1937
Etching and aquatint,
15⅛ × 22½ in. (38.4 × 57.2 cm)
Private Collection
Photo Ellen Page Wilson,
courtesy PaceWildenstein
© Succession Picasso by SIAE 2001

99
The Weeping Woman
1937
Drypoint, aquatint and etching,
27¼ × 19½ in. (69.2 × 49.5 cm)
Musée Picasso, Paris - Réunion
des Musées Nationaux
© Succession Picasso by SIAE 2001

100
Woman with Tambourine
1938
Aquatint and scraper on copper,
26 × 20¼ in. (66 × 51.2 cm)
Musée Picasso, Paris - Réunion
des Musées Nationaux
© Succession Picasso by SIAE 2001

101
**Still Life with Pitcher
and Compote**
January 22, 1937
Oil on canvas,
19¾ × 24 in. (50 × 61 cm)
Private Collection
Photo Christian Poite
© Succession Picasso by SIAE 2001

102
Woman with Arlesienne Coiffe
September 20, 1937
Oil on canvas,
31¾ × 25½ in. (81 × 65 cm)
Estate of the Artist
© Succession Picasso by SIAE 2001
© Images Modernes,
photo Eric Baudouin

103
**Woman with Beret
and Red Dress**
March 6, 1937
Oil on canvas,
28¾ × 23⅝ in. (73 × 60 cm)
Estate of the Artist
© Succession Picasso by SIAE 2001
© Images Modernes,
photo Eric Baudouin

104
**Woman with Red Hair and Blue
Dress**
March 1939
Oil on canvas,
23⅝ × 17¾ in. (60 × 45.1 cm)
Madrigal Collection
Photo courtesy PaceWildenstein
© Succession Picasso by SIAE 2001

105
Bust of Woman
December 31, 1938
Oil on canvas,
24 × 19¾ in. (61 × 50 cm)
Estate of the Artist
© Succession Picasso by SIAE 2001
© Images Modernes,
photo Eric Baudouin

106
Man with Ice Cream Cone
July 26, 1938
Oil on canvas,
25½ × 19¾ in. (65 × 50 cm)
Estate of the Artist
© Succession Picasso by SIAE 2001
© Images Modernes,
photo Eric Baudouin

107
**Composition with Table
and Apple**
September 2, 1937
Oil on canvas and collage,
19¾ × 25½ in. (50 × 65 cm)
Private Collection
Photo Scott Bowron
© Succession Picasso by SIAE 2001

108
Construction on Canvas
April 10, 1938
Construction of wood, nails, iron
cup and oil on canvas,
8¾ × 10¾ in. (22 × 27.2 cm)
Estate of the Artist
© Succession Picasso by SIAE 2001
© Images Modernes,
photo Eric Baudouin

109
Woman's Head
1943
Varnished plaster,
6¾ × 3⅛ × 3½ in. (17 × 8 × 9 cm)
Estate of the Artist
© Succession Picasso by SIAE 2001
© Images Modernes,
photo Marc Domage

110
Woman's Head, Left Profile
March 16, 1938
Oil on canvas,
24½ × 19 in. (62 × 48.5 cm)
Private Collection
Photo Christian Poite
© Succession Picasso by SIAE 2001

111
Seated Woman
1945
Bronze, height 6½ in. (16.5 cm)
Estate of the Artist
© Succession Picasso by SIAE 2001
© Images Modernes,
photo Marc Domage

112
Girl's Head
January 30, 1945
Oil on canvas,
18⅛ × 15 in. (46 × 38 cm)
Estate of the Artist
© Succession Picasso by SIAE 2001
© Images Modernes,
photo Marc Domage

113
Woman's Head
(1941)
Oil on newspaper,
23⅝ × 17 (60 × 43 cm)
Estate of the Artist
© Succession Picasso by SIAE 2001
© Images Modernes,
photo Eric Baudouin

114
Figure
(1943)
Oil on newspaper,
23⅝ × 17 in. (60 × 43 cm)
Estate of the Artist
© Succession Picasso by SIAE 2001
© Images Modernes,
photo Eric Baudouin

115
Still Life with Pitcher and Glass
July 19, 1944
Oil on canvas,
21⅝ × 18⅛ in. (55 × 46 cm)
Estate of the Artist
© Succession Picasso by SIAE 2001
© Images Modernes,
photo Marc Domage

116
**Bust of Woman with Flowered
Hat**
Begun November
1939–completed July 29, 1942
Oil on canvas,
24 × 19¾ in. (61 × 50 cm)
Estate of the Artist
© Succession Picasso by SIAE 2001
© Images Modernes,
photo Eric Baudouin

117
Still Life with Skull
March 15, 1945
Oil on canvas,
28¾× 45⅝ in. (73 × 116 cm)
Private Collection
Photo Christian Poite
© Succession Picasso by SIAE 2001

118
The Skull (Death's Head)
1943
Bronze, 9⅞ × 8¼ × 12¼ in.
(25 × 21 × 31 cm)
Private Collection
Photo Studio Patrick Goetelen
© Succession Picasso by SIAE 2001

119
The Bull
First state
December 5, 1945
Lithograph,
11½ × 16¼ in. (29 × 42 cm)
Estate of the Artist
© Succession Picasso by SIAE 2001
© Images Modernes,
photo Eric Baudouin

120
The Bull
Second state
December 12, 1945
Lithograph,
11½ × 16¼ in. (29 × 42 cm)
Estate of the Artist
© Succession Picasso by SIAE 2001
© Images Modernes,
photo Eric Baudouin

121
The Bull
Third state
December 18, 1945
Lithograph,
11½ × 19 in. (29 × 42 cm)
Estate of the Artist
© Succession Picasso by SIAE 2001
© Images Modernes,
photo Eric Baudouin

122
The Bull
Fourth state
December 22, 1945
Lithograph,
11½ × 16¼ in. (29 × 42 cm)
Estate of the Artist
© Succession Picasso by SIAE 2001
© Images Modernes,
photo Eric Baudouin

123
The Bull
Fifth state
December 24, 1945
Lithograph,
11½ × 16¼ in. (29 × 42 cm)
Estate of the Artist
© Succession Picasso by SIAE 2001
© Images Modernes,
photo Eric Baudouin

124
The Bull
Sixth state
December 26, 1945
Lithograph,
11½ × 16¼ in. (29 × 42 cm)
Estate of the Artist
© Succession Picasso by SIAE 2001
© Images Modernes,
photo Eric Baudouin

125
The Bull
Seventh state
December 28, 1945
Lithograph,
11½ × 16¼ in. (29 × 42 cm)
Estate of the Artist
© Succession Picasso by SIAE 2001
© Images Modernes,
photo Eric Baudouin

126
The Bull
Eighth state
January 2, 1946
Lithograph,
11½ × 16¼ in. (29 × 42 cm)
Estate of the Artist
© Succession Picasso by SIAE 2001
© Images Modernes,
photo Eric Baudouin

127
The Bull
Ninth state
January 5, 1946
Lithograph,
11½ × 16¼ in. (29 × 42 cm)
Estate of the Artist
© Succession Picasso by SIAE 2001
© Images Modernes,
photo Eric Baudouin

128
The Bull
Tenth state
January 10, 1946
Lithograph,
11½ × 16¼ in. (29 × 42 cm)
Estate of the Artist
© Succession Picasso by SIAE 2001
© Images Modernes,
photo Eric Baudouin

129
The Bull
Eleventh state
January 17, 1946
Lithograph,
11½ × 16¼ in. (29 × 42 cm)
Estate of the Artist
© Succession Picasso by SIAE 2001
© Images Modernes,
photo Eric Baudouin

130
**Head Turned Three-Quarters
to the Left**
February 15, 1945
Oil on canvas,
32 × 25½ in. (81 × 65 cm)
Private Collection
Photo Christian Poite
© Succession Picasso by SIAE 2001

131
Vase Face
1946
Cast bronze, 11⅛ × 4 × 6¾ in.
(28.3 × 10.2 × 17.1 cm)
Private Collection
Photo courtesy PaceWildenstein
© Succession Picasso by SIAE 2001

132
**Woman with Knife in Hand
and Bull's Head**
June 6–19, 1946
Oil on wood panel,
51¼ × 38¼ in. (130.2 × 97.2 cm)
Collection Linda and Harry
Macklowe
Photo courtesy PaceWildenstein
© Succession Picasso by SIAE 2001

133
Seated Woman
(1947)
Glazed terracotta,
4¾ × 3⅛ × 2½ in.
(12 × 8 × 6.3 cm)
Estate of the Artist
© Succession Picasso by SIAE 2001
© Images Modernes,
photo Eric Baudouin

134
Standing Woman
(1947)
Glazed terracotta,
7 × 2 × 11½ in. (17.8 × 5 × 4 cm)
Estate of the Artist
© Succession Picasso by SIAE 2001
© Images Modernes,
photo Eric Baudouin

135
Idol
(1947)
Terracotta,
8 × 3⅜ × 3 in.
(20.5 × 8.5 × 7.5 cm)
Estate of the Artist
© Succession Picasso by SIAE 2001
© Images Modernes,
photo Eric Baudouin

136
Seated Woman
(1947)
Terracotta, 5 × 2½ × 2 in.
(12.5 × 6.5 × 5 cm)
Estate of the Artist
© Succession Picasso by SIAE 2001
© Images Modernes,
photo Eric Baudouin

137
Standing Woman
(1947)
Glazed terracotta,
height 7¼ in. (18.5 cm)
Estate of the Artist
© Succession Picasso by SIAE 2001
© Images Modernes,
photo Eric Baudouin

138
Seated Woman
1950
Bronze, 3¼ × 2¾ in. (8.2 × 7 cm)
Estate of the Artist
© Succession Picasso by SIAE 2001
© Images Modernes,
photo Marc Domage

139
Portrait of a Woman
October 25, 1948
Oil on canvas,
39⅜ × 31¾ in. (100 × 81 cm)
Estate of the Artist
© Succession Picasso by SIAE 2001
© Images Modernes,
photo Eric Baudouin

140
**Nude Woman against a Blue
Background**
February 19, 1949
Oil on canvas,
51¼ × 38¼ in. (130 × 97 cm)
Estate of the Artist
© Succession Picasso by SIAE 2001
© Images Modernes,
photo Eric Baudouin

141
Child in Blue (Claude)
April 28, 1947
Oil on board,
51⅜ × 38¼ in.
(130.5 × 97.2 cm)
Private Collection
Photo Ellen Page Wilson,
courtesy PaceWildenstein ©
Succession Picasso by SIAE 2001

142
The Games
December 25, 1950
Oil on wood panel,
46⅝ × 56¼ in. (119 × 144 cm)
Estate of the Artist
© Succession Picasso by SIAE 2001
© Images Modernes,
photo Eric Baudouin

143
Two Children with Tricycle
1951
Ink and gesso on wood panel,
19½ × 24 in. (49.8 × 60.7 cm)
Collection Dee Dee
and Herb Glimcher
Photo Ellen Page Wilson,
courtesy PaceWildenstein
© Succession Picasso by SIAE 2001

144
Reclining Woman
March 19, 1951
Painted terracotta,
4½ × 8¼ in. (11 × 21 cm)
Estate of the Artist
© Succession Picasso by SIAE 2001
© Images Modernes,
photo Marc Domage

145
The Reader (Françoise)
1951–53
Painted bronze,
6½ × 14 × 5½ in.
(16.5 × 35.6 × 14 cm)
Private Collection
Photo Studio Patrick Goetelen
© Succession Picasso by SIAE 2001

146
The Pregnant Woman
First state
1950–59
Bronze, 43 × 11⅞ × 9⅞ in.
(109 × 30 × 25 cm)
Private Collection
Photo Studio Patrick Goetelen
© Succession Picasso by SIAE 2001

147
The Pregnant Woman
Second state
1950–59
Bronze, 42¾ × 11⅜ × 13¼ in.
(108.6 × 28.9 × 33.7 cm)
The Patsy R. and Raymond D.
Nasher Collection, Dallas
Photo David Heald, The
Solomon R. Guggenheim
Museum
© Succession Picasso by SIAE 2001

148
Girl Skipping Rope
1950
Bronze, 59⅞ × 25⅝ × 26 in.
(152 × 65 × 66 cm)
Private Collection
© Succession Picasso by SIAE 2001

149
Paloma Asleep
December 28, 1952
Oil on wood panel,
44⅞ × 57 in. (114 × 144.8 cm)
Collection Mortimer B.
Zuckerman
Photo courtesy PaceWildenstein
© Succession Picasso by SIAE 2001

150
Flowers in a Vase
1951
Bronze (cast made from
assemblage of cake moulds and
ceramic), 28¾ × 19¼ × 16½ in.
(73 × 48.9 × 41.9 cm)
Private Collection
Photo Ellen Page Wilson,
courtesy PaceWildenstein
© Succession Picasso by SIAE 2001

151
Vase with Flower
1953
Bronze, 28½ × 17⅜ × 6¼ in.
(72.5 × 44 × 16 cm)
Estate of the Artist
© Succession Picasso by SIAE 2001
© Images Modernes,
photo Marc Domage

152
Watering Can with Flowers
1953
Bronze, height 33 in. (84 cm)
Private Collection
Photo Studio Patrick Goetelen
© Succession Picasso by SIAE 2001

153
**Vase with Cardoons
and Plate of Cakes**
1953
Bronze,
32¼ × 23¼ × 11⅞ in.
(82 × 59 × 30 cm)
Estate of the Artist
© Succession Picasso by SIAE 2001
© Images Modernes,
photo Eric Baudouin

154
**Paloma against a Red
Background / Girl Playing
with a Car**
1953
Oil on canvas,
49 × 40 in. (124.5 × 101.5 cm)
Private Collection
Photo Studio Patrick Goetelen
© Succession Picasso by SIAE 2001

361

155
**Woman and Children:
the Drawing**
May 15, 1954
Oil on canvas,
51¼ × 38¼ in. (130 × 97 cm)
Estate of the Artist
© Succession Picasso by SIAE 2001
© Images Modernes,
photo Eric Baudouin

156
Sylvette
1954
Sheet metal, cut and painted,
27½ × 18½ × 3 in.
(69.9 × 47 × 7.6 cm)
Private Collection,
courtesy Fondation H. Looser,
Zurich
© Succession Picasso by SIAE 2001

157
Young Man
1956
Bronze, 32¼ × 16¼ × 9 in.
82 × 41.3 × 22.9 cm
Collection Linda and Harry
Macklowe
Photo courtesy PaceWildenstein
© Succession Picasso by SIAE 2001

158
Face
1953
Bronze, 10½ × 6 × 7¼ in.
(26.7 × 15.2 × 18.4 cm)
Collectione Julie and Edward J.
Minskoff
Photo Phillips/Schwab,
courtesy PaceWildenstein
© Succession Picasso by SIAE 2001

159
Faun and Starry Night
1955
Oil on canvas,
36½ × 29 in. (92.7 × 73.6 cm)
The Metropolitan Museum of
Art, New York. Gift of Joseph H.
Hazen, 1970 (1970.305)
Photo © 1987 The Metropolitan
Museum of Art
© Succession Picasso by SIAE 2001

160a-h
La Tauromaquía, o arte de torear
(1796)
Selection of eight illustrations by
Pablo Picasso from the portfolio
by José Delgado, alias Pepe Illo,
ed. Gustavo Gill, Barcelona 1959
Lift-ground aquatint
Estate of the Artist
© Succession Picasso by SIAE 2001
© Images Modernes,
photo Eric Baudouin

160a
Bulls in the Field
1957
Lift-ground aquatint,
7¾ × 11½ in. (19.5 × 29.2 cm)
Estate of the Artist
© Succession Picasso by SIAE 2001
© Images Modernes,
photo Eric Baudouin

160b
The Pass called Don Tancredo's
1957
Lift-ground aquatint,
7½ × 11⅜ in. (19.5 × 29.2 cm)
Estate of the Artist
© Succession Picasso by SIAE 2001
© Images Modernes,
photo Eric Baudouin

160c
The Bull Leaves the Pen
1957
Lift-ground aquatint,
7⅝ × 11½ in. (19.5 × 29.2 cm)
Estate of the Artist
© Succession Picasso by SIAE 2001
© Images Modernes,
photo Eric Baudouin

160d
**Bullocks Lead Away the Tame
Bull**
1957
Lift-ground aquatint,
7⅝ × 11½ in. (19.5 × 29.2 cm)
Estate of the Artist
© Succession Picasso by SIAE 2001
© Images Modernes,
photo Eric Baudouin

160e
Gored
1957
Lift-ground aquatint,
7¾ × 11½ in. (19.5 × 29.2 cm)
Estate of the Artist
© Succession Picasso by SIAE 2001
© Images Modernes,
photo Eric Baudouin

160f
The Kill
1957
Lift-ground aquatint,
7¾ × 11½ in. (19.5 × 29.2 cm)
Estate of the Artist
© Succession Picasso by SIAE 2001
© Images Modernes,
photo Eric Baudouin

160g
**After the Stabbing the
Bullfighter Signals the Death
of the Bull**
1957
Lift-ground aquatint,
7¾ × 11½ in. (19.5 × 29.2 cm),
Estate of the Artist
© Succession Picasso by SIAE 2001
© Images Modernes,
photo Eric Baudouin

160h
Lancing the Bull
1957
Lift-ground aquatint,
7½ × 11⅜ in. (19.3 × 29 cm),
Estate of the Artist
© Succession Picasso by SIAE 2001
© Images Modernes,
photo Eric Baudouin

161
Running Man
1960
Bronze, 45½ × 24 × 2 in.
(115.6 × 61 × 5 cm)
Estate of the Artist
© Succession Picasso by SIAE 2001
© Images Modernes,
photo Marc Domage

162
Figure (Child)
1960
Bronze, 45½ × 37⅜ × 20⅝ in.
(118 × 95 × 53 cm)
Estate of the Artist
© Succession Picasso by SIAE 2001
© Images Modernes,
photo Marc Domage

163
Female Bust on Pedestal
1961
Sheet metal, cut and painted,
11¾ × 7⅝ × 4½ in.
(30 × 20 × 11.5 cm)
Estate of the Artist
© Succession Picasso by SIAE 2001
© Images Modernes,
photo Marc Domage

164
**Little Woman with Arms
Outstretched**
1961
Sheet metal, cut and painted,
14¼ × 13½ × 5⅛ in.
(36.2 × 34.5 × 13 cm)
Estate of the Artist
© Succession Picasso by SIAE 2001
© Images Modernes,
photo Marc Domage

165
Standing Woman
1961
Sheet metal, cut and painted,
17 × 6½ in. (43.2 × 16.5 cm)**
Collection Terese
and Alvin S. Lane
Photo courtesy PaceWildenstein
© Succession Picasso by SIAE 2001

166
**Seated Woman and Playing
Child**
February 3, 1960
Oil on canvas,
76½ × 110¼ in.(194.5 × 280 cm)
Estate of the Artist
© Succession Picasso by SIAE 2001
© Images Modernes,
photo Marc Domage

167
Man with Sheep
1961
Sheet metal, cut and assembled,
gesso, 17¾ × 11½ × 5⅛ in.
(45 × 29 × 13 cm)
Estate of the Artist
© Succession Picasso by SIAE 2001
© Images Modernes,
photo Eric Baudouin

168
Man with Sheep on Pedestal
1961
Sheet metal with graphite,
20¾ × 10½ × 8¼ in.
(52.7 × 26.7 × 21 cm)
Collection Julie and Edward J.
Minskoff
Photo Ellen Page Wilson,
courtesy PaceWildenstein
© Succession Picasso by SIAE 2001

169
Woman's Head
1961
Sheet metal, cut and painted,
11⅜ × 8½ × 2¾ in.
(29 × 21.5 × 7 cm)
Estate of the Artist
© Succession Picasso by SIAE 2001
© Images Modernes,
photo Marc Domage

170
Woman's Head
1961
Sheet metal, cut and painted,
8½ × 6⅝ × 3 in.
(21.5 × 17.5 × 7.5 cm)
Estate of the Artist
© Succession Picasso by SIAE 2001
© Images Modernes,
photo Marc Domage

171
Reclining Nude
December 11, 1961
Oil on canvas,
57½ × 44⅝ in. (146 × 114 cm)
Private Collection
Photo Christian Poite
© Succession Picasso by SIAE 2001

172
Woman's Head
1962
Sheet metal, bent and painted,
20½ × 6¾ × 6½ in.
(52.1 × 17.1 × 16.5 cm)
Collection Linda and Morton
Janklow, New York
Photo Phillips/Schwab,
courtesy PaceWildenstein ©
Succession Picasso by SIAE 2001

173
Reclining Nude on Pink Cloth
January 29, 1964
Oil on canvas,
35 × 51⅛ in. (89 × 130 cm)
Private Collection
© Succession Picasso by SIAE 2001

174
Rooster on Chair under a Lamp
April 24–27, 1962
Oil on canvas,
64 × 51⅛ in. (162.5 × 130 cm)
Estate of the Artist
© Succession Picasso by SIAE 2001
© Images Modernes,
photo Eric Baudouin

175
Painter and Model
November 8–9, 1964
Oil on canvas,
51⅛ × 76¾ in. (130 × 195 cm)
Sammlung Frieder Burda
© Succession Picasso by SIAE 2001

176
**Untitled (Woman on sofa
with seated girl and old man)**
December 18, 1966
Aquatint and etching,
12¾ × 8⅞ in. (32.5 × 22.5 cm)
Estate of the Artist
© Succession Picasso by SIAE 2001
© Images Modernes,
photo Marc Domage

177
**Untitled (Around El Greco
and Rembrandt: portraits)**
Second state
From the *347 Suite*
April 15, 17, 18
and 19, 1968
Drypoint,
8¾ × 12½ in. (22.4 × 32.1 cm)
Estate of the Artist
© Succession Picasso by SIAE 2001
© Images Modernes,
photo Marc Domage

178
**Untitled (Thinking of Goya:
women in prison)**
From the *347 Suite*
July 16, 1968
Sugar-lift aquatint,
12½ × 15½ in. (31.6 × 39.5 cm)
Estate of the Artist
© Succession Picasso by SIAE 2001
© Images Modernes,
photo Marc Domage

179
**Untitled (Mythological scene:
perhaps Agamemnon's longing
for Briséis)**
From the *347 Suite*
April 27–28, 1968
Etching,
11 × 15¼ in. (28.1 × 38.9 cm)
Estate of the Artist
© Succession Picasso by SIAE 2001
© Images Modernes,
photo Marc Domage

180
**Untitled (Three women passing
time with a serious spectator)**
From the *347 Suite*
May 7, 1968
Etching,
12¾ × 15¾ in. (32.4 × 40.1 cm)
Estate of the Artist
© Succession Picasso by SIAE 2001
© Images Modernes,
photo Marc Domage

181
**Untitled (Young woman with
hat who sins in thought peeking
at the prelate)**
From the *347 Suite*
May 10, 1968
Etching,
12⅝ × 16⅝ in. (31.4 × 41.6 cm)
Estate of the Artist
© Succession Picasso by SIAE 2001
© Images Modernes,
photo Marc Domage

182
**Untitled (El Arrastre, with
equestrian and angel)**
From the *347 Suite*
April 11, 1968
Drypoint,
12⅝ × 16⅝ in. (31.4 × 41.6 cm)
Estate of the Artist
© Succession Picasso by SIAE 2001
© Images Modernes,
photo Marc Domage

183
**Untitled (Young man dreaming:
women!)**
Third state
From the *347 Suite*
June 22, 1968
Sugar-lift aquatint and drypoint,
19½ × 16¼ in. (49.6 × 41.4 cm)
Estate of the Artist
© Succession Picasso by SIAE 2001
© Images Modernes,
photo Marc Domage

184
**Untitled (Variation on the
theme of Don Quixote and
Dulcinea)**
From the *347 Suite*
June 2, 1968
Sugar-lift aquatint and
drypoint,
8¾ × 11½ in. (22.3 × 29 cm)
Estate of the Artist
© Succession Picasso by SIAE 2001
© Images Modernes,
photo Marc Domage

185
**Untitled (Thoughtful man
at a woman's house,
with La Celestina)**
Fourth state
From the *347 Suite*
June 26, 1968
Sugar-lift aquatint and drypoint,
5⅝ × 8¼ in. (14.8 × 20.8 cm)
Estate of the Artist
© Succession Picasso by SIAE 2001
© Images Modernes,
photo Marc Domage

186
**Untitled (Cavalier visiting a girl,
with La Celestina and a dog)**
From the *347 Suite*
June 16, 1968
Sugar-lift aquatint,
3¾ × 6¼ in. (9.8 × 16 cm)
Estate of the Artist
© Succession Picasso by SIAE 2001
© Images Modernes,
photo Marc Domage

187
Untitled (La Celestina)
From the *347 Suite*
1971
Print (66 prints done with
different techniques and
reproduced on a single sheet),
dimensions vary, sheet size:
29¼ × 41¼ in. (74.5 × 104.8 cm)
Estate of the Artist
© Succession Picasso by SIAE 2001
© Images Modernes,
photo Marc Domage

188
**Untitled (Painter or sculptor
thinking of a female warrior,
with musketeer, cupid and small
figures)**
From the *347 Suite*
July 5, 1968
Sugar-lift acquatint,
18⅛ × 5¾ in. (20.8 × 14.8 cm)
Estate of the Artist
© Succession Picasso by SIAE 2001
© Images Modernes,
photo Marc Domage

189
**Untitled (Young woman
nd smoker)**
Second state
From the *347 Suite*
August 13 and 15, 1968
Sugar-lift aquatint,
scraper and drypoint on copper,
3¾ × 4¾ in. (9.9 × 11.8 cm)
Estate of the Artist
© Succession Picasso by SIAE 2001
© Images Modernes, photo Marc
Domage

190
**Untitled (Film shoot: two
women)**
From the *347 Suite*
May 30, 1968
Drypoint, aquatint and
scraper,
23½ × 4⅝ in. (59.5 × 11.9 cm)
Estate of the Artist
© Succession Picasso by SIAE 2001
© Images Modernes,
photo Marc Domage

191
**Untitled (Monk-painter and
penitent, guitarist with owl
and young spectator)**
From the *347 Suite*
August 4–5, 1968
Etching,
10¼ × 6⅝ in. (26 × 17.4 cm)
Estate of the Artist
© Succession Picasso by SIAE 2001
© Images Modernes,
photo Marc Domage

192
**Untitled (Two women, one
on a trestle, an owl, Don
Quixote, a gentleman drawn
from *The Burial of Count Orgaz*
and a conquistador)**
From the *347 Suite*
August 2, 1968
Etching,
7 × 10⅜ in. (17.7 × 26.3 cm)
Estate of the Artist
© Succession Picasso by SIAE 2001
© Images Modernes,
photo Marc Domage

193
**Untitled (In the garden:
odalisque in slippers with a
flowered hat, and Ingres-like
spectator)**
From the *347 Suite*
August 14, 1968
Etching,
7¾ × 12¾ in. (19.7 × 32.4 cm)
Estate of the Artist
© Succession Picasso by SIAE 2001
© Images Modernes,
photo Marc Domage

194
**Untitled (Opium reverie:
smoker in a papal cap
discovering the mystery of the
trinity in the breast and dove of
a woman, with buffoon with
triangular hat)**
From the *347 Suite*
August 28, 1968
Etching,
6½ × 18¼ in. (16.7 × 20.8 cm)
Estate of the Artist
© Succession Picasso by SIAE 2001
© Images Modernes,
photo Marc Domage

195
**Musketeer and Woman
with Flower**
March 18, 1967
Oil on canvas,
51⅛ × 63¾ in. (130 × 162 cm)
Fairfax Realty, Inc. Art
Collection
Photo Ellen Page Wilson,
courtesy PaceWildenstein ©
Succession Picasso by SIAE 2001

196
Nude Woman with Man's Head
February 22, 1967
Oil on canvas,
51⅛ × 37⅝ in. (129.9 × 96.2 cm)
Private Collection, Auckland
Photo Ellen Page Wilson,
courtesy PaceWildenstein
© Succession Picasso by SIAE 2001

197
**Standing Nude with Goblet and
Seated Man**
November 11, 1968
Oil on canvas,
51 × 35 in. (129.5 × 88.9 cm)
The Collection of Mr. and Mrs.
Samuel H. Lindenbaum
Photo courtesy PaceWildenstein
© Succession Picasso by SIAE 2001

198
Standing Man
September 19, 1969
Oil on canvas,
76¾ × 51⅛ in. (195 × 130 cm)
Sammlung Frieder Burda
© Succession Picasso by SIAE 2001

199
**Untitled (The curtains of the
picture, odalisque and painter)**
Ninth state
From the *156 Suite*
January 15–19 and February 6,
1970
Etching and drypoint,
12½ × 16½ in. (31.7 × 41.8 cm)
Private Collection
Photo Studio Patrick Goetelen
© Succession Picasso by SIAE 2001

200
**Untitled ("Ecce Homo,"
after Rembrandt)**
Fifth state
From the *156 Suite*
February 4, March 4–6, 1970
Aquatint, etchingr and drypoint,
19½ × 16⅜ in. (49.5 × 41.5 cm)
Estate of the Artist
© Succession Picasso by SIAE 2001
© Images Modernes,
photo Marc Domage

201
**Untitled (Old man and woman
bent over the neck of her horse)**
Second state
From the *156 Suite*
March 15, 1970
Acquatint and drypoint,
5⅞ × 8⅛ in. (14.9 × 20.8 cm)
Private Collection
Photo Studio Patrick Goetelen
© Succession Picasso by SIAE 2001

202
**Untitled (Woman with turban,
old gentleman, executioner
and wild-eyed man)**
Fourth state
From the *156 Suite*
March 15, 16, and 18, 1970
Aquatint,
12½ × 16½ in. (31.8 × 41.8 cm)
Private Collection
Photo Studio Patrick Goetelen
© Succession Picasso by SIAE 2001

203
**Untitled (Spectacle: Amor
ventures among the women)**
Ninth state
From the *156 Suite*
February 11 and 28,
March 3, 16, and 30, 1970
Etching and drypoint,
20 × 24 in. (50.8 × 63.3 cm)
Estate of the Artist
© Succession Picasso by SIAE 2001
© Images Modernes,
photo Marc Domage

204
**Untitled (Spectacle for a couple,
Captain Frans Banningh Cocq
and the women)**
Fourth state
From the *156 Suite*
February 16, March 2 and 4, 1970
Etching, drypoint, scraper and
aquatint,
19⅝ × 25 in. (50.5 × 63.3 cm)
Estate of the Artist
© Succession Picasso by SIAE 2001
© Images Modernes,
photo Marc Domage

205
**Untitled (Degas dreaming, faun
whispering in a woman's ear)**
From the *156 Suite*
April 11, 1971
Sugar-lift aquatint, 14⅜ × 19⅜ in.
(36.5 × 49.2 cm)
Private Collection
Photo Studio Patrick Goetelen
© Succession Picasso by SIAE 2001

206
**Untitled (The crafty madame
with three girls, Degas with his
hands behind his back)**
Second state
From the *156 Suite*
May 1–4, 1971
Drypoint,
14½ × 19½ in. (36.8 × 49.5 cm)
Estate of the Artist
© Succession Picasso by SIAE 2001
© Images Modernes,
photo Marc Domage

207
Untitled (Degas Pays and leaves, the girls are not kind)
Third state
From the *156 Suite*
May 22 and 26, June 2, 1971
Sugar-lift aquatint and drypoint,
14⅜ × 19½ in. (36.6 × 49.2 cm)
Estate of the Artist
© Succession Picasso by SIAE 2001
© Images Modernes,
photo Marc Domage

208
Untitled (Brothel, gossip, profile of Degas wrinkling his nose)
Seventh state
From the *156 Suite*
May 19–31, and June 2, 1971
Sugar-lift aquatint and drypoint,
14½ × 19½ in. (36.7 × 49.6 cm)
Estate of the Artist
© Succession Picasso by SIAE 2001
© Images Modernes,
photo Marc Domage

209
Untitled (Girls together, the owner)
Fifth state
From the *156 Suite*
May 22, 26, 27, 29, 30
and June 2, 1971
Sugar-lift aquatint and drypoint,
14⅜ xx 19 ⅜ in. (36.6 × 49.3 cm)
Estate of the Artist
© Succession Picasso by SIAE 2001
© Images Modernes,
photo Marc Domage

210
Untitled (Couple: woman and man-dog with flower woman)
Seventh state
From the *156 Suite*
March 1 and 5, 1972
Etching, drypoint and aquatint,
14⅜ × 19¼ in. (36.6 × 49.2 cm)
Estate of the Artist
© Succession Picasso by SIAE 2001
© Images Modernes,
photo Marc Domage

211
Untitled (Self-portrait, with two women. *The Fall of Icarus*)
Eighth state
From the *156 Suite*
March 4 and 6, 1972
Etching and drypoint
14½ × 19⅛ in. (36.5 × 48.6 cm)
Estate of the Artist
© Succession Picasso by SIAE 2001
© Images Modernes,
photo Marc Domage

212
The Matador
October 4, 1970
Oil on canvas,
45½ × 35 in. (115.6 × 88.9 cm)
Private Collection, New York
Photo Sarah Harper Gifford,
courtesy PaceWildenstein
Succession Picasso by SIAE 2001

213
Seated Nude Man
July 30, 1971
Oil on canvas,
45¼ × 38½ in. (114.9 × 87.6 cm)
Private Collection
Photo Ellen Page Wilson,
courtesy PaceWildenstein
© Succession Picasso by SIAE 2001

214
Woman
July 7, 1971
Oil on canvas,
31⅞ × 25⅝ in. (81 × 65 cm)
Estate of the Artist
© Succession Picasso by SIAE 2001
© Images Modernes,
photo Marc Domage

215
Man
July 9, 1971
Oil on canvas,
31⅞ × 25 ⅝ in. (81 × 65 cm)
Estate of the Artist
© Succession Picasso by SIAE 2001
© Images Modernes,
photo Marc Domage

216
Seated Woman
September 16, 1971
Oil on canvas,
45⅝ × 35 in. (115.9 × 88.9 cm)
Private Collection,
Photo courtesy PaceWildenstein
© Succession Picasso by SIAE 2001

217
Child
July 15, 1971 (completed
November 14, 1971)
Oil on canvas,
76¾ × 51⅛ in. (195 × 130 cm)
Estate of the Artist
© Succession Picasso by SIAE 2001
© Images Modernes,
photo Eric Baudouin

218
Embrace
July 28, 1971
Oil on canvas,
45⅝ × 38⅛ in. (116 × 97 cm)
Private Collection
© Succession Picasso by SIAE 2001

219
Bust
August 23, 1971
Oil on canvas,
36¼ × 28¾ in. (92 × 73 cm)
Estate of the Artist
© Succession Picasso by SIAE 2001
© Images Modernes,
photo Marc Domage

220
Man
August 16, 1971
Oil on canvas,
63¾ × 51⅛ in. (162 × 130 cm)
Estate of the Artist
© Succession Picasso by SIAE 2001
© Images Modernes,
photo Marc Domage

221
Couple with Book
January 12, 1970
Oil on canvas,
51⅛ × 38⅛ in. (130 × 96.8 cm)
Collection Dee Dee
and Herb Glimcher
Photo Ellen Page Wilson,
courtesy PaceWildenstein ©
Succession Picasso by SIAE 2001

222
Seated Man Playing the Flute
July 30, 1971
Oil on canvas,
57½ × 44¾ in. (146.1 × 113.7 cm)
Private Collection
Photo courtesy PaceWildenstein
© Succession Picasso by SIAE 2001

223
Seated Man with Hat
February 16, 1972
Oil on canvas,
57½ × 44¾ in. (146 × 113.7 cm)
Sammlung Frieder Burda
Photo Ellen Page Wilson,
courtesy PaceWildenstein
© Succession Picasso by SIAE 2001

224
Head
April 9, 1972
Oil on canvas,
31⅞ × 25⅝ in. (81 × 65 cm)
Estate of the Artist
© Succession Picasso by SIAE 2001
© Images Modernes,
photo Marc Domage

225
Nude Crouching
(Reclining Woman)
July 26, 1972
Oil on canvas,
45⅝ × 35 in. (116 × 89 cm)
Private Collection
© Succession Picasso by SIAE 2001

Appendix

1881

October 25: Málaga, Spain: Pablo Ruiz Picasso is born, first child of the painter José Ruiz Blasco and María Picasso López. Ruiz teaches drawing at the San Telmo School of Fine Arts and is curator at the Municipal Museum in Málaga.

1888–90

Pablo's earliest known drawings and paintings, of bullfights and animals, date from these years.

1891

September: the family moves to La Coruña (Galicia) on the Atlantic coast of northwestern Spain.

1892–95

Pablo is enrolled in the La Coruña School of Fine Arts where his father teaches. The boy studies drawing and painting, working from plaster casts and in life classes.

1895

Summer: en route from La Coruña to Málaga, the family stops at Madrid. Pablo visits the Prado Museum and sees the work of the great Spanish masters for the first time.

September: the family moves to Barcelona. Don José teaches at the School of Fine Arts, known locally as La Lonja, where Pablo studies classical art and still life.

Late 1895: Don José rents Pablo his first atelier near the family home.

1896

April: large academic canvas, *The First Communion*, is exhibited in Barcelona. Pablo attends a Barcelona film symposium, Cinematógrafo Napóleon.

1897

September: studies at Royal Academy of San Fernando in Madrid, where he spends time at the Prado copying the works of other artists.

November: in a letter to his friend Bas in Barcelona, he complains about the poor education Spanish painters receive and evaluates works he's seen in Prado: "If I had a son who wanted to be a painter, I would not let him live in Spain [or] . . . send him to Paris . . . but [I would] send him to Munich where one studies painting seriously without paying attention to fashions such as pointillism and others. I am not in favor of following any determined school because that

only brings about a similarity among adherents . . . Velázquez is first class. Some of Greco's heads are magnificent. Murillo is not always convincing. Titian's 'Dolorosa' is good; there are some beautiful Van Dyck portraits. Rubens has some snakes of fire as his prodigy. Teniers some very good small paintings, and everywhere 'Madrileñaitas' so beautiful that no Turkish woman could compare. . ."

Winter: decides to leave Academy, rupture in relationship with his father.

1898

Late spring: contracts scarlet fever and goes home to Barcelona.

Mid-June: goes to Horta de Ebro to recuperate at the home of his friend Manuel Pallarés and stays for eight months.

1899

February: returns to Barcelona, becomes one of the group of young artists who meet at the bar Els Quatre Gats, among them painters Carlos Casagemas, Isidro Nonell, Joaquín Sunyer, and Sebastián Junyer-Vidal; the poet Jaime Sabartés; and others. Among his older acquaintances are art historian Miguel Utrillo and the painter Ramón Casas, who introduces Picasso to the work of Toulouse Lautrec and Théophile Steinlen. Picasso makes drawings of his friends.

1900

Early in year: shares studio with Casagemas on calle Riera de San Juan.

February: Picasso has a show at Els Quatre Gats of his friends' portraits.

July 12: *Joventud,* a periodical, publishes his drawings, as does *Catalunya Artistica. The Last Moments,* a painting exhibited at Els Quatre Gats, is accepted by the Paris Universal Exposition, which opens May 1.

October: Picasso goes to Paris with Casagemas. They work in Isidro Nonell's studio, where Picasso paints his first Paris pictures. Berthe Weill, a Paris art dealer, buys three of these works. Picasso and friends from the Spanish colony of artists visit the Exposition and see works by Toulouse-Lautrec, Cézanne, Bonnard, Degas,

and other contemporary French artists.

December 20: Picasso returns to Barcelona without Casagemas, who has fallen in love with Germaine Pichot, a model. Picasso moves to Madrid.

1901

February 17: in despair because of his unrequited love for Germaine, Casagemas commits suicide in a café in front of Germaine Pichot and two Spanish friends.

March 31: with the writer Francisco de Asis Soler he publishes several issues of *Arte Joven,* showcasing the work of young writers and artists.

May: after returning to Barcelona, he leaves for Paris and rents Casagemas's studio, where during the next few months he paints an *Absinthe Drinker* and other scenes of Paris *demi-monde*. Pablo's earlier work is signed "P. Ruiz Picasso," and later "P.R. Picasso." He now begins to sign his works with the single word *Picasso,* his mother's surname.

June: the art dealer Ambroise Vollard shows some of Picasso's work. During the next nine years, Vollard will continue to buy works of Picasso's. Pablo meets the poet Max Jacob, who becomes an intimate friend.

Toward end of year: paints the circus, harlequins, and the earliest works in the Blue Period.

1902

January: Picasso returns to Barcelona and continues to work there. He meets the sculptor Julio González.

April 1–15: in Paris, Berthe Weill exhibits some of his paintings.

October: Picasso returns to Paris and shares a room at 87, boulevard Voltaire with Max Jacob.

November 15: Berthe Weill exhibits several of his Blue paintings in a group show.

1903

January: Picasso returns to Barcelona and during the next fourteen months, working in a studio he had once shared with Casagemas, produces about fifty works including *La Vie,* and in spring and summer, and *The Old Guitarist,* and *Blind Man's Meal* in the fall.

1904

January: completes *La Celestina*, a portrait of the madam with a "cast" eye (leucoma) from the famous Spanish Renaissance novel, *The Tragi-Comedy of Calixtus and Melibea*.

Spring: Picasso leaves for Paris where he rents a top-floor atelier in a Montmartre studio building at 13, rue Ravignan, dubbed by Jacob "Bateau-Lavoir," or "Laundry Barge." Other residents are André Salmon, Kees van Dongen, and eventually Juan Gris. Among the artists and writers who will meet there in the years Picasso is in residence are Alfred Jarry, Maurice Raynal, Max Jacob, André Salmon and, later, Matisse, Derain, Braque, Apollinaire, and Marie Laurencin, the dealer Daniel-Henry Kahnweiler, and the German collector Wilhelm Uhde. Picasso paints final "Blue Period" works in the summer.

Autumn: meets Fernande Olivier, his mistress until 1911. Makes second etching for *The Frugal Repast* (cat. 4) and later in the year paints *Meditation* (cat. 5). Final exhibition at Berthe Weill.

Picasso and Max Jacob attend the cinema together.

1905

February–March: Picasso shows first Rose Period paintings, eight large saltimbanques, and during the year makes other paintings and prints of circus life. Meets Gertrude Stein and her brother Leo, both of whom will collect his work.

Summer: Picasso's palette begins to change from rose to a terra cotta color.

October 18: Salon d'Automne opens with a sensational exhibition of work by the Fauves, including Matisse and Derain, an Ingres retrospective which includes *Le Bain turc*, ten paintings by Cézanne in another gallery, and three paintings by *le Douanier* Rousseau.

End of the year: he meets Derain, who owns a Cézanne *Bathers*. Begins *Portrait of Gertrude Stein*.

Late 1905–early 1906

Exhibition of primitive (pre-Roman) Iberian sculptures from Osuna. Matisse paints *Joie de vivre*

(*Joy of Life*), shown in Indépendants in summer, 1906.

1906

Early in year: studies Greek vases and Etruscan and Cycladic sculpture at Louvre. Picasso's palette makes full transition to terra cotta and gray.

March: meets Matisse at the Steins'. Work on Stein portrait continues until in frustration Picasso paints out the face.

With Fernande, Picasso summers in Gosol in the Spanish Pyrenees. Paints portraits of local men and women with stylized heads reflecting Iberian sculptural influence, which also appears in his many studies and paintings of nudes.

End of August: returns to Paris and completes Gertrude Stein portrait, painting in a masklike face. Sculpts *Head of a Woman, Fernande* (cat. 14), continues painting sculptural nudes, culminating in *Two Nudes*.

October: Cézanne dies in Aix; the Salon d'Automne shows ten of his paintings. Gauguin retrospective is mounted in Paris. Produces first wood sculptures and woodcuts in response to work of Gauguin

1907

Winter: Picasso makes sketches *Les Demoiselles d'Avignon*, conceived as multi-figural scene of sailors in a bordello.

Picasso, Fernande Olivier, Jacob, Apollinaire and other members of *La bande à Picasso* regularly attend the cinema on the rue Douai in Montmartre, where they enjoy the "low" atmosphere.

March: the Salon des Indépendants exhibits large *Bathers* by Derain and Matisse's *Blue Nude, Souvenir de Biskra*.

Late April and early May: work begins on the canvas for *Demoiselles*, partially motivated by Matisse's *Bonheur de Vivre* (*Joy of Life*).

May or June: Picasso goes to the ethnographic museum at Palais de Trocadéro to see the African sculptures. In June an exhibition of seventy-nine Cézanne watercolors opens in Paris. Picasso and Braque are already in contact through their mutual friend Apollinaire.

Early July: Picasso resumes work on

Demoiselles, repaints two figures at right in whose faces now show a stylization related to African masks. Finished painting is seen only by friends and colleagues in Picasso's studio for a few more months, then shown publicly for only two weeks in July, 1916. The first reaction to the painting is largely negative even among friends; Apollinaire responds with silence. The response at the first public showing is also negative.

Summer and Autumn: Picasso paints nudes showing a more pronounced "African" influence. He and Fernande live apart from September until late November.

October: the Salon d'Automne exhibits fifty-six Cézannes in a memorial show, some of them late "unfinished" works.

November: Braque visits Picasso's studio—he may have visited at the time of the Independents, but he certainly sees the *Demoiselles* on this visit and in response to that and to Matisse's *Blue Nude* will paint his own *Large Nude* in 1907–8.

1908

Through Spring: Picasso paints a number of vivid "African" works, nude women in landscapes. In spring–summer, makes a series of studies for first version of *Three Women*.

March: Braque exhibits four paintings at the Indépendants including *Nude* (ex-catalog). Picasso, who does not exhibit, nevertheless dominates by his influence on other artists.

Before August: he begins first version of monumental *Three Women* that he will finish the following January. Spends late summer through early fall with Fernande at La Rue-des-Bois, outside of Paris, where he paints figures and very early Cubist still lifes.

November: Braque's six Cézanne-influenced landscapes of L'Estaque, previously rejected by the Salon d'Automne are now shown at Kahnweiler's gallery. Critic Louis Vauxcelles in his November 14 review of the show in *Gil Blas* pokes fun at Braque's "*bizarreries cubiques*," saying that Braque "reduces everything, places and figures and houses, to geometric schemes, to cubes," thus giving

Cubism its name. This month, Picasso and Fernande hold a banquet for Rousseau which is attended by many poets and painters.

1908–9

Winter: Picasso and Braque begin close association. Each works in his own studio, but they meet on almost daily basis.

January: Picasso completes final version of *Three Women*.

1909

Early June–mid-September: Picasso and Fernande summer in Horta de Ebro (now Horta de San Juan), where he had spent eight months in 1898–99. A productive period in which he and Braque inaugurate Analytic Cubism with a series of faceted landscape paintings in greens and earth tones based on rock forms. Braque is at l'Estaque, Picasso at Horta de Ebro, more still lifes, and portraits of Fernande, a series begun in Paris.

September or October: returns to Paris, moves residence and studio to 11, boulevard de Clichy, although he continues to store his works at Bateau-Lavoir until 1912. Models *Head of Fernande* (cat. 19). Continues investigation of Analytic Cubism.

Head of Fernande, Picasso's only purely Cubist sculpture, influences the Futurists, especially Boccioni, and Gris, Laureins, Archipenko and Lipchitz.

1910

During the year, paintings are shown in Budapest, Dusseldorf, Munich, Paris, and London.

Early in year: portraits of Ambroise Vollard and Wilhelm Uhde completed.

Late June–early September: Picasso and Fernande spend summer on the Catalonian coast in Cadaqués, where they are joined by Derain and his wife. Earliest stages of "high" Analytic Cubism: paintings become more fragmented, planar, and abstract. Works on etchings for Saint-Matorel, by Max Jacob, published 1911 by Kahnweiler.

Early September: returns to Paris, paints Kahnweiler's portrait.

1911

Picasso's work appears in Berlin (twice), Amsterdam, and New York, where his work is exhibited for the first time in the United

States at Stieglitz's Photo-Secession Gallery. He and Braque refuse to enter either of the major exhibitions in Paris: the Salon des Indépendants in April and, in October, the Salon d'Automne, both of which show work of other Cubist painters.

Early in July: Picasso works alone in a studio in Céret, in the French Pyrenees. Writes to Braque in mid-July, asking him to join him there.

Early August: Braque, Fernande, and Max Jacob come to Céret. Picasso adds hand-painted lettering (previously used by Braque) to his surfaces.

Early September: returns to Paris. Relationship with Fernande begins to falter.

November: he forms a relationship with Marcelle Humbert (Eva Gouel), whom he has met at the Steins'.

1912

Lives with "Eva," and calls her "Ma Jolie" on paintings. Winter is culmination of high Analytic Cubism. Paints primarily still lifes, writing on some of them. Refuses to show at Salon des Indépendants exhibit in March, but it is noted by Apollinaire that "Picasso's influence is most profound" on the work of other artists.

Mid-January: new publication *Les Soirées de Paris* is founded by Apollinaire and André Salmon and others of Picasso's friends.

February: Picasso and Braque included in second *Blaue Reiter* (Blue Rider) exhibition in Munich.

Spring: Picasso writes on three still life paintings, "Notre avenir est dans l'air," "Our future is in the air." Using sheet metal and wire, makes *Guitar*, a three-dimensional form of planar Cubist painting, as well as cardboard constructions. In May, he creates the first collage, *Still Life with Chair Caning*.

Mid-May: goes to Céret with Eva, moving on to Sorgues, near Avignon, in late June. In July Braque and his wife join them. Picasso and Braque work closely again, Picasso nicknames Braque "Wilbourg" in honor of the aviation pioneer Wilbur Wright.

September: during Picasso's absence in Paris, Braque makes his first papier collé.

October–November: Picasso moves into a studio on boulevard Raspail. Begins to make his first papiers collés, writes to Braque: "I have been using your latest papery and powdery procedures." Collage and papier collé inaugurate synthetic phase of Cubism. Instead of fracturing real objects into fragments, the planes are broader and the material itself takes on the weight of representation; local color is introduced to work, as well as real materials from the outside world: pasted colored papers, newspaper, etc.

December: agrees to sell Kahnweiler all his paintings for the next three years, as does Braque. Cubism is denounced in the Chamber of Deputies on December 3.

1913

January: second generation of papiers collés.

February: first major retrospective in Germany of over 100 works from 1901–12 shown at Galerie Thannhauser, Munich.

February 17–May 18: eight works shown at pioneering "International Exhibition of Modern Art" at 69th Regiment Armory in New York City.

Mid-March: leaves for Céret with Eva and Max Jacob, later joined by Braque, and Juan Gris and his wife. Works with papier collé and begins a series of construction-montages, using paper, cardboard, sheet metal, string and wire which he continues into the '20s. Several are full-scale studio "environments," using real objects such as the violin; Picasso photographs these for the record.

Early May: Picasso's father dies. Pablo and Eva go to Barcelona for the funeral accompanied by Jacob who writes to Apollinaire, saying that Eva is not well.

June: Picasso and Eva return to Céret, where he paints and makes constructions using diverse materials in the by now highly developed style of Synthetic Cubism.

Autumn: Picasso and Eva return to Paris. Vollard buys fourteen circus prints from 1904–5, which he titles *Saltimbanques* and publishes in an edition of 270.

November: four of Picasso's "constructions" are published by Apollinaire in *Les Soirées de Paris* and provoke strong opposition among subscribers to the publication.

1914

Winter: third generation of papiers collés. Still life constructions of pieces of found wood and metal and paper.

Spring: *The Glass of Absinthe*, a three-dimensional sculpture, modeled in wax and topped by a real perforated metal absinthe spoon and lump of sugar, is cast in an edition of six bronzes, each painted differently, some with texture added, each with its own real spoon and sugar lump. Confrontation of found—real—with constructed is another important step in development of modern sculpture and a whole new aesthetic as one of the basis of Surrealism.

June: Picasso and Eva go to Avignon, near towns where the Derains and Braques are spending the summer. Makes over 100 drawings. Works on etchings for Jacob's *Siège de Jérusalem*.

August 2, 1914: war is declared. Derain and Braque are conscripted; Apollinaire volunteers. Picasso, as Spanish citizen, is exempt.

Mid-Autumn: Picasso and Eva return to Paris and Picasso continues to work. Paintings noted for their firm, discrete planes of color (modeled on papier collé), the term "Crystal Period Cubism" is used for these paintings.

1915

Spring: Eva's health deteriorates.

May: Braque is wounded at the front and returns to Paris. Picasso does not visit him in the hospital nor does Braque ask him to. Their intimate relationship is over.

December: Picasso paints a geometric *Harlequin*, which Jean Cocteau sees on a visit to Picasso's studio.

December 14: Eva dies of tuberculosis.

1916

February: opening of the Café Voltaire in Zurich marks the public debut of the Dada movement.

March 17: Apollinaire receives a serious head wound, returns to Paris, and is trepanned

Spring: Cocteau gives Picasso a harlequin costume; Picasso paints his portrait on May 1.

Late May: Picasso is asked to design costumes and scenery for Ballets Russes performance of *Parade* directed by Diaghilev, with scenario by Cocteau, music by Satie and choreography by Massine. *Parade* is first of several ballets on which Picasso will collaborate with the Ballets Russes over the next several years.

June: Picasso represented by five works in the first and only edition of *Cabaret Voltaire*, the first Dada publication. Moves to Montrouge, a working class suburb of Paris.

July 13–31: first public showing of *Les Demoiselles d'Avignon*, at Salon d'Antin in exhibition organized by André Salmon. Painting is ignored by press.

August: agrees to work on *Parade*.

December: Picasso organizes a banquet for Apollinaire to celebrate the publication of his *Le Poète assassiné*. The poet, "the bird of Benin," is Picasso.

1917

"Italian Years" begin.

Mid-February: Picasso and Cocteau leave for Rome to work on *Parade* with Diaghilev, Massine, and others. Meets Olga Khokhlova, a ballerina in the troupe. Goes to Pompeii and Naples with the troupe.

April or May: returns to Paris.

May 18: *Parade* premieres and is a *succès de scandale*, and some members of audience become raucous. Apollinaire's program notes use the word *"surréalisme"* for the first time, note the new unity of music, dance and sculptural form. Costumes of the "Managers" are Cubist constructions in three dimensions.

Early June: Picasso follows the Ballets Russes to Barcelona, where *Parade* is being performed. He and Olga stay in Spain when troupe leaves for South America.

Summer–November: paints Synthetic Cubist, Neoclassical, and naturalistic works, including portraits of Olga.

November: Picasso and Olga return to Paris. Through connections with Ballets Russes he begins to socialize with high society. Uses Pointillist stippling in his paintings.

1918

Winter: exhibition of some of Picasso's pre-Cubist paintings and work by Matisse at a Paris gallery. Paints Commedia dell'Arte scenes in realistic and Synthetic Cubist styles.

July 12: marries Olga at Russian Orthodox church, witnessed by Jacob, Apollinaire, and Cocteau. They honeymoon in Biarritz and return to Paris in late September. As an enemy alien Kahnweiler, who is German, is forced to close his gallery.

November 9: Apollinaire dies of the Spanish flu.

Mid-November: Picasso and Olga move to 23, rue La Boëtie.

1919

March: Braque exhibition in Paris is described by André Lhote as sounding the death knell of Cubism. First issue of *Littérature* (Paris), edited by Aragon, André Breton, and Philippe Soupault.

Spring: Meets Joan Miró and buys a painting from him.

Early May: goes to London to design sets and costumes for the Ballets Russes' production of *Le Tricorne*, by Manuel de Falla and stays three months.

July 22: first performance of *Le Tricorne*.

Late Summer: vacations with Olga in Saint-Raphael on the Riviera. Paints *Sleeping Peasants*, a precursor to "colossal" works that follow. Paints in both Classical and Cubist styles.

December: Diaghilev asks Picasso to design decor and costumes for *Pulcinella*, a ballet based on Commedia dell'Arte text, with music by Stravinsky. Diaghilev rejects first sketches as too modern.

1920

January 23: a Dada event, "Premier Vendredi de Littérature," is staged by *Littérature*, attended by members of the Paris art scene.

May 15: first performance of *Pulcinella*. Shortly afterward Picasso makes portraits of Satie, Stravinsky, and Manuel de Falla.

Summer: in Juan-les-Pins with Olga, works on series of gouaches of Commedia dell'Arte figures begun in Paris, as well as on paintings of large nudes.

September: returns to Paris.

1921

February 4: his son Paulo is born. Picasso draws a portrait of mother and child.

April: publication in Germany of first monograph on Picasso: *Pablo Picasso* by Maurice Raynal (published in France in 1922).

Late May: confiscated collection of art dealer Wilhelm Uhde, including some Cubist works, is auctioned.

Mid-June: first of four sales is held of works from Kahnweiler's collection, also sequestered during the war, among them thirty-six of Picasso's paintings and two of *Glass of Absinthe*.

Summer: in Fontainebleau, paints two versions of *Three Musicians* in a late Cubist style as well as monumental Neoclassical works of *Bathers* and *Three Women at the Spring*.

November: second Kahnweiler sale brings in much less for Picasso's Cubist works than for his recent works.

1922

Early in year: collector Jacques Doucet buys *Les Demoiselles d'Avignon* at urging of André Breton and Louis Aragon. It has been rolled up in Picasso's studio since 1916, unseen by the public.

Summer: in Dinard, Brittany, Picasso paints *Woman Running on the Beach*, one of the last colossal figure paintings, *Portrait of Mme Picasso*, and *Mother and Child*.

1923

Spring: works in severe Neoclassical style and naturalistic "Leonardo" style (in portraits of Olga) as well as still life with elements of Cubism. In summer all hard-edge elements give way to soft anthropomorphic forms.

Summer: at Cap d'Antibes, meets Gerald and Sarah Murphy, and paints her portrait (*Femme assise les bras croisés [Sarah Murphy]*). Meets André Breton. Paints *Pipes of Pan*.

July 7: Soirée "*du cour à barbe*" at Théâtre Michelet in Paris becomes a riot when someone shouts from audience that Picasso is dead on the field of battle (meaning Cubism is dead), and André Breton jumps onto stage to defend Picasso's honor and breaks the arm of one of the actors. The Dada soirée includes films by Hans Richter and Man Ray, sets and costumes by Sonia Delaunay and Theo van Doesburg, and music by Satie, Stravinsky and Darius Milhaud.

1924

In painting Neoclassic period of "Italian Years" draws to a close.

Paints large, boldly colored still lifes.

Mid-June: Picasso's collaboration in the ballet *Mercure* is reviled by some of the Dadaists during first performance in Paris. Breton and other surrealists disagree and publish a letter defending Picasso's designs.

Summer: vacations with Olga and Paulo at Villa la Vigie, Juan-les-Pins.

December: first issue of *La Révolution surréaliste* has reproduction of Picasso's *Guitar*, a large metal construction, made earlier this year.

1925

June: finishes *The Dance*. Marriage is deteriorating.

July 1: Erik Satie dies.

July: *Three Dancers*, completed in June, appears in fourth issue of *La Révolution surréaliste*, as does a reproduction of *Les Demoiselles d'Avignon*. Both paintings are reproduced for the first time. In the same issue, Breton claims Picasso as "one of ours."

Summer: Picasso family vacations in Juan-les-Pins, where Pablo paints *Studio with Plaster Head* and *The Embrace*.

November: shows Cubist pictures in "La Peinture Surréaliste," first group show of Surrealist artists, but also shows tendency toward expressionist deformation of body parts.

1926

January: first issue of *Cahiers d'art* published in Paris by Christian Zervos, who will go on to publish most of Picasso's work in a thirty-two-volume catalogue raisonné.

Spring: makes collages of guitars, using cloth, knitting needle, nails, a button, and thread.

June: retrospective show of work of past twenty years at Paul Rosenberg Gallery.

1927

January: meets Marie-Thérèse Walter. They become lovers later in the year, although he is still living with Olga and Paulo.

May 11: death of Juan Gris, from whom Picasso had been estranged.

Summer: with family in Cannes, where he makes series of drawings for Ovid's *Metamorphoses*. They show biomorphic bodies with exaggerated genitalia.

Winter: begins work on *The Studio*.

1928

Early in year: makes *Bather (Metamorphosis I)*, first sculpture since 1914 as the first proposal of a monument to Apollinaire. Completes *The Studio*, which prefigures the wires sculptures he makes in October and later in the year.

Late Spring: learns welding from Spanish metalsmith Juan González, now working in Paris. Inaugurates new technique and aesthetic of sculpture with welded wrought iron constructions and use of found elements. These later often served as the matrix for cast bronze sculpture.

October: in González's studio, completes wire constructions intended as maquettes for a monument to Apollinaire and *Head*.

Autumn: paints *Painter and Model*.

Winter: Picasso continues working in González's studio.

Throughout year marriage falters. Picasso continues painting biomorphic bathers and makes large metal sculpture *Woman in a Garden*.

1930

June: Picasso buys the château de Boisgeloup at Giscors, about 70 kilometers northwest of Paris.

Tendency toward expressive deformation and metamorphoses of body forms intensifies still further, culminates in such works as *Femme Acrobat*.

Summer: Juan-les-Pins, makes a series of material reliefs.

Autumn: he returns to Paris and rents an apartment for Marie-Thérèse on rue La Boëtie, near his and Olga's apartment.

1931

May: at Boisgeloup converts stable into a sculpture studio. Continues to work in González's studio welding metal, and returns to modeling clay and plaster.

This year sees publication of two major illustrated books. The first is Ovid's *Metamorphoses* with thirty etchings done in 1930–31, published by Skira. The second is Balzac's *Le Chef-d'oeuvre inconnu*, published by Vollard, with thirteen etchings and sixty-seven wood engravings.

Meets the photographer Brassaï, whose impression was of a simple,

direct man "without affection, without arrogance,without shame." His studio "was an apartment converted into a kind of warehouse. Certainly no characteristically middle-class dwelling was ever so uncharactistically furnished...empty of any customary furniture and littered with stacks of paintings, cartons...molds for his statues..." (Brassaï, *Picasso & Company* [New York: Doublday & Co., 1966], p. 5).

1932

Winter: series of paintings of Marie-Thérèse (*Sleeping Woman*) culminating in *Girl before a Mirror*.

Mid–June: major retrospective of 236 works by Picasso opens at Galeries Georges Petit, said to be the only exhibition he selected himself. Exhibit gets mixed reviews. Jacques-Emile Blanche writes: "It would seem that the latest avatars of the Protean creator of rue La Boëtie give the key to the enigma. Taste, taste, always taste, manual dexterity, Paganini-like virtuosity . . . He can do anything, he knows everything, succeeds at all he undertakes . . . Child prodigy he was; prodigy he is in maturity; and prodigy of old age to come, I have no doubt."

Summer: while Olga and Paulo vacation at Juan-les-Pins, Picasso apparently summers at Boisgeloup, continuing his series of sculpted heads of Marie Thérèse, and receiving visitors.

October: Zervos publishes the first volume of his Picasso catalogue raisonné.

1933

March 14–June 11: completes fifty-seven etchings, forty of them on theme of *The Sculptor's Studio*. Vollard will publish these, with others made between 1930 and 1937, as *The Vollard Suite* after World War II. Picasso establishes himself as one of the great printmakers in the history of art.

Autumn: Fernande Olivier publishes *Picasso et ses amis*, her memoir of life with Picasso earlier in the century. He attempts to stop publication to assuage Olga.

1934

Late August–mid September: with Olga and Paulo, travels in Spain following the bulls then visiting other cities.

September–mid-November: makes four prints of *Blind Minotaur led by Young Girl*, which are part of *Vollard Suite*.

1935

Spring: completes *Minotauromachy*.

May: Picasso stops painting for almost a year, making only prints and writing. Poems appear in *Cahiers d'Art*.

June: Marie-Thérèse's pregnancy becomes known. Olga and Paulo move out, but she and Picasso do not divorce because of community property laws. They will remain married until her death in early 1955.

October 5: Marie-Thérèse gives birth to María de la Concepción, known as Maya.

November: his old Barcelona friend Jaime Sabartés arrives from Spain to be Picasso's manager and companion.

1936

Forms close friendship with the surrealist poet Paul Eluard.

March 2: exhibition "Cubism and Abstract Art" organized by Alfred H. Barr opens at The Museum of Modern Art in New York with twenty-five works by Picasso.

March–April 25: Picasso and Marie-Thérèse secretly leave for Juan-les-Pins, where they live under the name Ruiz.

April: starts Minotaur series of gouaches, watercolors, and drawings.

July 18: Spanish Civil War begins. Picasso, still living in France, is named director of the Prado Museum by the Republicans.

Early August: stays at Mougins, a village above Cannes. Sees Dora Maar, a photographer whom he has met earlier in the year. The split-profile face, which is associated with Dora Maar, is recognized popularly as signature Picasso.

1937

January 8–9: makes two-part etching and poem, *Dream and Lie of Franco*.

Early in the year: Dora Maar finds him a new studio at 7, rue des Grands-Augustins. Invited by Spanish Republican government in exile to paint a mural for Spanish pavilion at Paris World's Fair, which is to open in June.

April 26: German planes bomb the Basque town of Guernica for three hours, providing Picasso with a subject. The bombing is widely covered in the press, with written accounts and graphic photos of the devastation.

May: Picasso begins to make sketches of *Guernica* using published news accounts and his own early works. Work begins on canvas May 11, with Dora Maar photographing the painting at seven stages during its completion.

June 4: *Guernica* is finished and installed in the Spanish Pavilion by mid-June.

Summer: in Mougins with Dora Maar, paints her portrait. Continues to use motifs from *Guernica* in his work over the summer and into the fall as postscripts to Guernica in drawings and in prints. One of the most famous of the prints is the *Weeping Woman*.

October–December: paints *Weeping Woman* and *Woman Crying*.

1938

March 11: the *Anschluss*. Germany annexes Austria. Picasso continues working in Paris through the spring.

Summer: stays in Mougins with Dora Maar.

Late September: returns to Paris.

1939

January 13: Picasso's mother dies in Barcelona. Two of his nephews fight on Republican side.

January 26: Barcelona surrenders to Franco.

March: German troops enter Prague; later in month Madrid succumbs to Franco.

April: at Le Tremblay-sur-Mauldre, Picasso paints *Cat and Bird* in two versions.

May 5–29: *Guernica* and studies for it exhibited in New York under auspices of American Artists' Congress for the benefit of the Spanish Refugee Relief Campaign. Works are later sent on to Los Angeles.

July 22: Ambroise Vollard, Picasso dealer for many years, dies.

August 23: Russia and Germany sign non-aggression pact.

September 1: Germany invades Poland. Great Britain and France declare war on Germany September 3.

1940

Early in year: Picasso takes studio overlooking the sea in Royan, on the Atlantic coast.

May 12: Germany invades Belgium. Later that month, Picasso makes death's head drawings.

June 14: German army enters Paris.

June 22: Pétain, premier of Vichy government, signs armistice with Germany.

June 23: German troops enter Royan.

August 25: Picasso returns to Paris with Dora Maar.

Autumn: leaves apartment at rue La Boëtie for duration, lives at studio at rue des Grands-Augustins. Is invited to live in Mexico and the United States, but prefers to stay in France.

Germans forbid public exhibition of his art.

1941–43

Picasso remains in Paris, converts bathroom of his studio into a sculpture studio. Creates large assemblage sculptures from found objects.

1943

May: meets Françoise Gilot at a neighborhood restaurant.

1944

Mid-August: moves in with Marie-Thérèse and Maya because of street fighting in Paris.

August 25: allied armies liberate Paris. Picasso returns to studio on rue des Grands-Augustins.

October 5: *L'Humanité,* the Communist newspaper, announces that Picasso has joined the Communist Party.

October 7: receives recognition for the first time from the Salon d'Automne with an exhibition of seventy-four works in a special gallery. Show is controversial, with some decrying his political stance, others his modernism. Later this month he says in an interview that his decision to become a Communist is "the logical conclusion of my whole life, my whole work."

1945

July: Picasso trades a still life for a house in Menerbes, a village in the Vaucluse, and turns the deed over to Dora Maar.

November: he begins to work on the first of over 100 lithographs he will do in the studio of Fernand Mourlot.

1946

Late April: Françoise begins to live with Picasso.

July 27: Gertrude Stein dies. She and Picasso have been estranged for many years.

1947

Françoise gives birth to Picasso's son Claude.

August: Picasso starts to make ceramics at Vallauris, making almost 2,000 pieces during the next year.

1948

Summer: Picasso, Françoise, and Claude move to a villa in Vallauris called La Galloise, which Picasso gives to Françoise.

August: he goes to Poland for Congress of Intellectuals for Peace. Visits Warsaw, Auschwitz, and Cracow.

1949

April 19: a daughter is born to Françoise and Pablo. She is named Paloma after Picasso's "Dove of Peace."

Autumn: he focuses more on sculpture.

1950

March: in Vallauris, uses found objects to create sculpture assemblages. *Pregnant Woman* is modeled using ceramic pots as forms, but will not be cast until 1959.

August: one of three casts of *Man with a Sheep* is placed in main square at Vallauris.

1951

June 25: Matisse chapel in Vence is dedicated. Picasso and Françoise do not attend, but visit the bedridden Matisse.

Summer: he is evicted from rue La Boëtie apartment, rents apartment on rue Gay-Lussac, returns to Vallauris.

July–August: spends time with Geneviève Laporte in Saint-Tropez.

1952

Late October: as his relationship with Françoise deteriorates, he leaves her in Vallauris with children and goes to Paris alone.

November 18: Paul Eluard dies.

1953

March: Françoise takes children from Vallauris to Paris; they return to Vallauris for the summer.

March 5: Stalin dies. French Communist party disapproves of Picasso's drawing of him, printed in *Les Lettres françaises*.

May–July 5: Major Picasso retrospective at Gallerie Nazionale d'Arte Moderna, Rome, with 135 paintings, thirty-two sculptures, thirty-nine ceramics, and forty lithographs and a catalog written by Lionello Venturi. Cocteau speaks at exhibition and talks about their early friendship.

Mid-August: in Perpignan meets Jacqueline Roque, a young divorcee.

Mid-September: returns to Vallauris.

September 20–November 20: Picasso retrospective travels from Rome to Palazzo Reale, Milan, with many works added, including *Massacre in Korea*, and *Guernica*. Picasso himself works on the installation.

Late September: Françoise takes children to Paris at end of month and moves into apartment on rue Gay-Lussac.

October: Picasso breaks off affair with Geneviève Laporte.

1954

June 2–3: Picasso makes three portraits of Jacqueline, whom he nicknames "Mme Z."

September 8: Derain dies, struck by an automobile.

September 19: Françoise and children go to Paris to live on rue Gay-Lussac. Picasso and Jacqueline move to rue des Grands-Augustins.

November 3: Matisse dies.

During this year Picasso constructs figures with wood and, in sheet metal, the so-called folded sculptures and 180 drawings of *Painter and Model* cycle.

1955

February 1: Olga dies at Cannes. Picasso is free to marry.

June: buys "La Californie," a large villa in Cannes with gardens and views overlooking the town and Antibes. Moves in with Jacqueline.

1956

October 25: celebrates seventy-fifth birthday with potters at Vallauris.

1957

Paints fifty-eight variations on *Las Meninas*, by Velázquez.

1958

September: buys sixteenth-century château de Vauvenarges, near Aix-en-Provence at the foot of Mont-Sainte-Victoire.

1959

August: moves into Vauvenargues. Publication this year of *La Tauromaquie*, with twenty-six aquatints and one etching by Picasso.

1961

March 2: Marries Jacqueline Roque at Vallauris.

June: he and Jacqueline move into Notre-Dame-de-Vie, a villa near Mougins in hills above Cannes.

October 25: celebrates eightieth birthday in Mougins.

Begins series of large cut sheet metal sculptures.

1963

October 11: Cocteau dies.

October: Crommelynck brothers, Aldo and Piero, set up studio for printing from copper plates. Picasso begins to work with them.

1964

Spring: Françoise Gilot and art critic Carlton Lake publish Gilot's *Life with Picasso*. Picasso attempts unsuccessfully to prevent publication in French, causing an estrangement from Claude and Paloma.

1965

Commission for a monument for new Civic Center in Chicago.

November: returns to Paris for ulcer operation at the American Hospital, his last stay in Paris.

1966

September 11: André Breton dies.

1967

Winter: refuses French Legion of Honor.

Spring: evicted from studio on rue des Grands-Augustins.

1968

February 13: Sabartés dies.

March 16–October 5: in Mougins makes 347 engravings (*347 Suite*) with themes from painter and model, lovers, circus and bullfight, as well as Spanish literature. Printed by Crommelynck brothers. *November 14*: paints *Still Life with Umbrella*.

1970

May–September: exhibition of of paintings and drawings at Palais des Papes in Avignon.

October 25: ninetieth birthday celebration.

May 12: Bateau-Lavoir, where Picasso lived and worked from 1904–13, burns down.

September 12: death of Christian Zervos.

1970–72

End 1970–March, 1972: makes 156 engravings (*156 Suite*).

1972

June–July: in Mougins makes series of self-portrait drawings with skull-like heads. Continues to paint.

1973

April 8: Pablo Picasso dies at Mougins.

April 10: he is buried on grounds of château de Vauvenargues. Jacqueline places bronze of *Woman with Vase*, made in summer 1933 at Boisgeloup. Paulo is only child permitted to attend.

Selected Bibliography

G. Adriani, E. Benesch, I. Brugge, *Picasso. Figur und Porträt. Haupt-werke aus der Sammlung Bernard Picasso* (Wolfratshausen: Edition Minerva, 2000).

R. Alberti, *Lo que canté y dije de Picasso*, Bruguera, Barcelona 1983.

R. Alberti, "Picasso et le peuple espagnol," in *Europe 48*, special edition for Picasso, nos. 492–93 (April–May 1970), pp. 42–47.

G. Apollinaire, "Picasso," in *Œuvres complètes*, vol. IV, M. Décaudin, ed. (Paris: Balland & Lecat, 1966).

G. Apollinaire, *Croniques d'Arte 1902–1918* (Paris: Gallimard 1960).

G. Apollinaire, *La corrispondenza con F.T. Marinetti, A. Soffici, U. Boccioni, G. Severini, U. Brunelle-schi, G. Papini, C. Carrà, L. Boana-to*, ed. (Rome: Bulzoni, 1992).

G. Apollinaire, *Œuvres en prose complètes*, 3 vols., P. Caizergues and M. Décaudin, eds. (Paris: Galli-mard, 1993).

G. Apollinaire, *The Cubist Painters, Aesthetic Meditations*, 1944. Trans-lated by Lionel Abel from the French, *Les Peintres Cubistes* (Paris: Eugéne Figuiere et Cie., 1913).

L. Aragon, *Picasso: sculptures, dessins* (Paris: Maison de la Pensée Française, 1950).

G.C. Argan, *Scultura di Picasso*, (Venice: Alfieri, 1953).

R. Arnheim, "Guernica: The Gen-esis of a Painting (1962)," in E.C. Oppler, *Picasso's Guernica* (New York: W.W. Norton & Company, 1987).

R. Arnheim, *Picasso's Guernica* (London: Faber & Faber, 1964).

D. Ashton, *Picasso on Art: A Selec-tion of Views, Documents of Twenti-eth Century Art* (New York: Viking, 1972).

B. Baer, *Picasso the Printmaker. Graphics from Marina Picasso Col-lection* (Dallas: The Dallas Muse-um of Art, 1983).

B. Baer, "Seven Years of Printmak-ing; The Theater and its Limits," in *Late Picasso* (London: The Tate Gallery, 1988).

B. Baer, *Picasso: Peintre-graveur. Catalogue raisonné de l'œuvre gravé et des monotypes 1935–1968*, 4 vols. (Bern: Kornfeld & Klipsten, 1986–89).

B. Baer, *Picasso im Zweiten Weltkrieg* (Cologne: Museum Ludwig, 1988).

B. Baer, B. Geiser, *Picasso peintre graveur: catalogue raisonnée de l'œu-vre gravé et lithographié et des mono-types*, 2 vols. (Bern: Kornfeld, 1990–92).

B. Baer, D. Dupuis-Labbé, P. De Montebello, *Picasso the Engraver: Selections from the Musée Picasso Paris with 126 Illustrations* (Lon-don: Thames & Hudson, 1997).

A. Baldassari, *Picasso photographe 1901–1916* (Paris: Réunion des Musées Nationaux, 1994).

A. Baldassari, "A plus grande vitesse que les images": *Picasso et la photogra-phie* (Paris: Réunion des Musées Nationaux, 1995).

A. Baldassari, *Le miroir noir: Picasso, sources photographiques* (Paris: Réu-nion des Musées Nationaux, 1997).

A. Baldassari, ed., *Picasso and Pho-tography: The Dark Mirror* (College Station, Texas: Texas A & M Uni-versity Press, 1998).

A. Baldassari, *Brassaï / Picasso. Conversations avec la lumière* (Paris: Réunion des Musées Nationaux, 2000).

R. Barilli, "Picasso, Braque e il cubismo," in *L'arte contemporanea da Cézanne alle ultime tendenze* (Milan: Feltrinelli, 1997).

A.H. Barr Jr., *Cubism and Abstract Art* (New York: The Museum of Modern Art, 1936; Cambridge, MA: Belknap Press of Harvard University Press, 1986).

A.H. Barr Jr, *Picasso: Forty Years of His Art* (New York: The Museum of Modern Art, 1939).

A.H. Barr Jr, *What Is Modern Painting?* (New York: The Museum of Modern Art [1943] 1974).

A.H. Barr Jr, *Picasso: Fifty Years of His Art* (New York: The Museum of Modern Art, 1946; New York: Arno Press, 1980).

A.H. Barr Jr., "Matisse, Picasso, and the Crisis of 1907," in *Maga-zine of Art*, vol. 44, no. 5 (New York, May 1953).

A.H. Barr Jr., *Picasso: 75° Anniver-sary Exhibition*, The Museum of Modern Art (New York 1957).

A.H. Barr Jr., *Matisse: His Art and His Public* (London: Frank Cass, 1967).

J. Berger, *The Success & Failure of Picasso* (Harmondsworth, Middle-sex, Baltimore: Penguin Books, 1965; New York: Pantheon Books, 1980).

M.-L. Bernadac, *Museo Picasso. Catalogo delle collezioni*, vol. I (Milan: Electa International, 1986).

M.-L. Bernadac, *Le Dernier Picasso 1953–1973* (Paris: Editions du Centre Pompidou, 1988).

M.-L. Bernadac, *Picasso 1953–1972: Painting as Model*, in *Late Picasso* (London: The Tate Gallery, 1988).

M.-L. Bernadac, C. Piot, *Picasso: Collected Writings* (New York: Abbeville Press, 1989).

M.-L. Bernadac, *Picasso e il Mediterraneo* (Rome: Edizioni del-l'Elefante, 1992).

M.-L. Bernadac, B. Léal, M.T. Ocaña, *Toros y toreros* (Paris: Réu-nion des Musées Nationaux/Spa-dem, 1993).

M.-L. Bernadac, G. Breteau-Skira, *Picasso à l'écran* (Paris: Editions du Centre Pompidou, 1995).

M.-L. Bernadac, A. Michael, eds., *Picasso. Propos sur l'art* (Paris: Gal-limard, 1998).

G. Bloch, *Picasso. Catalogue of the Printed Graphic Work*, 3 vols., (Bern: Kornfeld & Klipsten, 1968–69).

G. Bloch, *Pablo Picasso. Catalogue de l'œuvre gravé et lithographié 1904–1967*, 4 vols. (Bern: Korn-feld & Klipsten, 1968–79).

J.S. Boggs, *Picasso and Man* (Toron-to: Toronto Art Gallery, 1964).

J.S. Boggs, *Picasso the Last Thirty Years*, in *Picasso in Retrospect*, Sir R. Penrose and J. Golding, eds., (New York: Harper and Row, Icon Editions, 1980).

A. Blunt, *Picasso Classical Period (1917–1926)*, in *The Burlington Magazine*, 60, no. 781 (April 1968), pp. 187–96.

A. Blunt, *Picasso's "Guernica,"* (New York: Oxford University Press, 1969).

A. Blunt, P. Pool, *Picasso: the for-mative years. A study of his sources* (London: Studio Books, 1962).

A. Boatto, "L'autoritratto del-l'artista da giovane e l'autoritratto dell'artista da vecchio," in *Narciso infranto. L'autoritratto moderno da Goya a Warhol* (Rome-Bari: Lat-erza, 1998).

A. Boatto, "L'artista e la modella e il labirinto del Minotauro," in *Eros mediterraneo* (Rome-Bari: Laterza, 1999).

U. Boccioni, "Pittura, scultura futuriste [Dinamismo plastico]"

(Milan, 1914), in U. Boccioni, *Gli scritti, editi e inediti* (Milan: Feltrinelli, 1971).

W. Boeck, *Pablo Picasso: Lithogravures* (Paris, 1962).

B. Boeck, "Picasso and Communism," in *Arts Canada*, 37, no. 236–37 (September 1980), pp. 31–39.

B. Boeck, ed., *Picasso and Things* (Cleveland, Ohio: Cleveland Museum of Arts, 1992).

W. Boeck, J. Sabartés, *Picasso* (New York-Amsterdam: Abrams; Paris: Flammarion, 1955).

G. Boehm, U. Mosch, K. Schmidt, *Canto d'amore. Modernité et classicisme dans la musique et les Beaux-Arts entre 1914 et 1935* (Basel: Kunstmuseum; Paris: Flammarion, 1996).

Y.-A. Bois, *Matisse and Picasso* (Paris: Flammarion, 1998).

G.C. Bojani, *Picasso: la ceramica* (Milan: Electa, 1989).

H. Bolliger, *Picasso, Vollard Suite* (London, 1956).

G. Boudaille, "Picasso peintre politique? Non, Picasso et l'histoire," in G. Boudaille *et alii, Picasso* (Paris: Nouvelles Editions Françaises, 1985).

S. Bouvier-Ajam, "Picasso et la Maison de la Pensée," in *Europe* 48, special edition for Picasso, nos. 492–93 (April-May 1970), pp. 71–75.

A. Bowness, "Picasso's Sculptures," in *Picasso 1881–1973* (London: Paul Elek Ldt., 1973).

D. Bozo, *Picasso, œuvres reçues en payement des droits de succession* (Paris: Réunion des Musées Nationaux, 1978–80).

D. Bozo, "Introduzione," in *Musée Picasso. Catalogue des Collections* (Paris: Réunion des Musées Nationaux, 1985).

D. Bozo, M. Friedman, R. Rosenblum, R. Penrose, *Picasso from the Musée Picasso, Paris* (Minneapolis: Walker Art Center, 1980).

C. Brandi, "Picasso" (1943), in *Scritti sull'arte contemporanea*, 2 vols. (Turin: Einaudi, 1976).

Brassaï, *Picasso & Company* (New York: Doubleday & Co., 1966).

Brassaï, *Conversations avec Picasso*, (Paris: Gallimard, 1964).

Brassaï, D.-H. Kahnweiler, *Les sculptures de Picasso* (Paris: Editions du Chêne, 1948).

P. Cabanne, *L'épopée du cubisme* (Paris: Denoël, 1963).

P. Cabanne, *Le siècle de Picasso*, 4 vols. (Paris: Denoël, 1975).

F. Cachin, F. Minervino, *Tout l'œuvre peint de Picasso 1907–1916* (Paris: Flammarion, 1977).

P. Caizergues, H. Seckel, *Picasso, Apollinaire Correspondance* (Paris: Réunion des Musées Nationaux/Gallimard, 1992).

G. Carandente, *Picasso. Opere dal 1895 al 1971 dalla Collezione Marina Picasso* (Florence: Sansoni, 1981).

C. Carrà, "Picasso," from *Valori Plastici* (Rome, 1920), in C. Carrà, *Tutti gli scritti* (Milan: Feltrinelli, 1978).

M.A. Caws, *Dora Maar With and without Picasso: a Biography*, (London: Thames & Hudson, 2000).

J. Clair, O. Michel, *Picasso: 1917–1924. Il viaggio in Italia* (Milan: Bompiani, 1998).

J. Clair, *Picasso et l'abîme. Eros, Nomos et Thanatos* (Paris: L'Echoppe, 2000).

J. Clair, *Picasso érotique* (Munich-London-New York: Prestel, 2001).

J. Cocteau, *Le coq et l'arlequin* (Paris: Editions de la Sirène, 1928).

J. Cocteau, *Pablo Picasso 1916–1961*, with twenty-four lithographs by Picasso (Montecarlo: Edition du Rocher, 1962).

J. Cocteau, *Entre Picasso et Radiguet*, A. Fermigier, ed. (Paris: Hermann, 1967).

J. Cocteau, *Le passé defini*, 3 vols. (Paris: Gallimard, 1985).

J. Cocteau, *Le rappel à l'ordre*, (Paris: Stock, 1926).

J. Cocteau, L. Clergue, *Correspondance* (Arles: Acte Sud, 1989).

D. Cooper, *Picasso et le théâtre, Cercle d'Art* (Paris 1967; Barcelona: Gustavo Gili, 1968).

D. Cooper, *The Cubist Epoch*, Phaidon Press, London 1971.

D. Cooper, *The Essential Cubism: 1907–1920* (London: The Tate Gallery, 1983).

G. Cortenova, J. Leymarie *Picasso in Italia* (Milan: Mazzotta, 1990).

P. Dagen, "Impressions d'Afrique 1906–1908; L'archaïsme expressif; Transcriptions, stylisations e Divergences 1908–1914," in *Le peintre, le poète, le sauvage* (Paris: Flammarion, 1998).

P. Daix, G. Boudaille, *Picasso 1900–1906* (Neuchâtel: Ides et Calendes, 1966).

P. Daix, *La vie de peintre de Pablo Picasso* (Paris: Seuil, 1977).

P. Daix, J. Rosselet, *Le cubisme de Picasso. Catalogue raisonné de l'œuvre 1907–1916* (Neuchâtel: Ides et Calendes, 1979).

P. Daix, *Picasso créateur: La vie intime et l'œuvre* (Paris: Seuil, 1987).

P. Daix, *Picasso* (New York: Harper-Collins, 1993).

P. Daix, *Dictionnaire Picasso* (Paris: R. Laffont, 1995).

M. De Micheli, ed., *Picasso. Scritti*, SE (Milan, 1998).

R. Doschka, *Pablo Picasso. Metamorphoses of the Human Form. Graphic Works 1895–1972* (Munich-London-New York: Prestel, 2000).

D.D. Duncan, *Picasso's Picassos* (New York: Harper, 1961).

M. FitzGerald, *Making Modernism: Picasso and the Creation of the Market for Twentieth Century Art* (New York: Farrar, Straus and Giroux 1995).

M. FitzGerald, W. Robinson, *Picasso: The Artist's Studio* (New Haven-London: Yale University Press 2001).

F. Fosca, *Bilan du cubisme* (Paris: La Bibliothèque de l'Art, 1956).

P. Francastel, *Lo spazio figurativo dal Rinascimento al cubismo* (Turin: Einaudi, 1957).

J. Freeman, *Picasso and the Weeping Women* (New York: Rizzoli, 1994).

E.F. Fry, *Cubismo* (New York: McGraw-Hill, 1966).

B.G. Fryberger, *Picasso Graphic Magician. Prints from the Norton Simon Museum* (London: Philip Wilson Publishers, 1998).

S.G. Galassi, *Picasso's Variations on the Masters: Confronting the Past*, Abrams, New York 1996.

K. Gallwitz, *Picasso: The Heroic Years* (New York: Abbeville, 1985).

H. Gardner, *Creating Minds: An Anatomy of Creativity Seen Through the Lives of Freud, Einstein, Picasso, Stravinsky, Eliot, Graham and Gandhi* (New York: Basic Books, 1994).

A. Gehlen, "L'enigma del cubismo," in *Quadri d'epoca* (Naples: Guida, 1989).

B.G. Geiser, *Picasso: Peintre-graveur*, 2 vols. (Bern: Geiser, 1933).

F. Gilot, *Matisse and Picasso: A Friendship in Art* (London: Bloomsbury, 1990).

F. Gilot, C. Lake, *Life with Picasso*, (New York: McGraw-Hill, 1964).

D. Giraudy, *Picasso. La memoria dello sguardo* (Milan: Jaca Book, 1986).

D. Giraudy, *Picasso linograveur*, (Milan: Mazzotta, 1990).

A. Gleizes, *Du cubisme et des moyens de le comprendre* (Paris: La Cible, 1920).

A. Gleizes, J. Metzinger, *Du cubisme* (Paris: Figuière, 1912).

A. Glimcher, M. Glimcher, *Je suis le cahier: The Sketch-books of Picasso*, (New York: The Pace Gallery, 1986).

S. Goeppert, H. Goeppert-Franck, *Pablo Picasso, peintre, graveur, sculpteur, céramiste, poète* (Ingelheim am Rhein, 1981).

S. Goeppert, H. Goeppert-Franck, *La Minotauromachie de Pablo Picasso* (Geneva: Patrick Cramer, 1987).

S. Goeppert, H. Goeppert-Franck, P. Cramer, *Pablo Picasso. Catalogue raisonné des livres illustrés* (Geneva: Patrick Cramer, 1983).

J. Golding, *Cubism: A History and Analysis (1907–1914)* (London: Faber and Faber, 1959).

R. Gómez de la Serna, *Completa y veridica historia de Picasso y el Cubismo* (Turin: Einaudi, 1945).

E. Grazioli, ed., *Pablo Picasso* (Milan: Marcos y Marcos, 1996).

G. Habasque, *Le cubisme* (Geneva: Skira, 1959).

T. Hilton, *Picasso* (London: Thames and Hudson, 1975).

M. Jacob, "Souvenir sur Picasso conté par Max Jacob," in *Cahiers d'Art*, no. 6 (Paris, 1927).

M. Jacob, *Correspondences* (Paris: Edition de Paris, 1953).

D.-H. Kahnweiler, *Der Weg zum Kubismus* (Munich: Delphin, 1920).

D.-H. Kahnweiler, *Sculptures de Picasso* (Paris: Editions du Chene, 1948).

D.-H. Kahnweiler, *Mes galeries et mes peintres. Entretiens avec Francis Crémieux* (Paris: Gallimard, 1961.

D.-H. Kahnweiler, *Confessions esthétiques* (Paris: Gallimard, 1963).

D.-H. Kahnweiler, "Huit Entretiens avec Picasso," in *Le Point* (Paris, 1952).

D.M. Kosinski, *The Artist and the Camera: Degas to Picasso* (New Haven-London: Yale University Press, 1999).

R.E. Krauss, *Passages in Modern Sculpture* (Cambridge, MA: MIT Press, 1981).

R.E. Krauss, *The Picasso Papers, Farrar* (New York: Straus & Giroux, 1998).

B. Léal, *Carnets. Catalogue de dessins*, 2 vols. (Paris: Réunion des Musées Nationaux 1996).

B. Léal, M.-L. Bernadac, C. Piot, *Picasso, la Monographie, 1881–1973* (Paris: La Martinière, 2000).

P.E. Leal, *Las grandes series*, (Madrid: Aldeasa-Museo Nacional Centro de Arte Reina Sofia, 2001).

M. Leirs, *L'âge de l'homme* (Paris: Gallimard, 1946).

M. Leirs, *La course de taureaux* (Paris: Fourbis, 1991).

M. Leirs, *Journal 1922–1989* (Paris: Gallimard 1992).

M. Leirs, *Un Génie sans piédistal* (Paris, 1992).

J. Leymarie, *Picasso, métamorphoses et unité* (Geneva: Skira, 1971).

J. Leymarie, S. Ramié, G. Ramié, *Hommage à Pablo Picasso* (Paris: Petit Palais, 1966–67).

A. Malraux, *La tete d'obsidienne* (Paris: Gallimard 1954).

B. Mantura, *Picasso: 1937–1953. Gli anni dell'apogeo in Italia* (Turin: Umberto Allemandi, 1998).

S. Martin, *Picasso at the Lapin Agile and Other Plays* (New York: Grove/Atlantic, 1997).

K. von Maur, *Picasso und die Moderne: Meisterwerke der Staatsgalerie Stuttgart und der Sammlung Steegmann* (Stuttgart: Staatsgalerie Stuttgart, 1999).

M. McCully, *Picasso: the early years 1892-1906* (Washington: National Gallery of Art, 1997).

M. McCully, *Picasso Painter and Sculptor in Clay* (New York: Harry N. Abrams, 1998; London: Royal Academy of Arts, 1998).

M. McCully, *Picasso scolpire e dipingere. La ceramica* (Ferrara: Ferrara Arte, 2000).

F. Menna, "L'analitica cubista," in *La linea analitica dell'arte moderna* (Turin: Einaudi, 1983).

M.G. Messina, J. Nigro Covre, *Il cubismo dei cubisti: ortodossi-eretici a Parigi intorno al 1912* (Rome: Officina, 1986).

G. Mili, *Picasso et la troisième dimension* (Paris: Triton, 1970).

A.I. Miller, *Einstein, Picasso: Space, Time and the Beauty that Causes Havoc* (New York: Basic Books, 2001).

J. Moullin, "Picasso ou l'autoportrait metamorphosé," in *L'autoportrait au XXᵉ siècle* (Paris: Adam Biro, 1999).

F. Mourlot, *Picasso litographe*, 4 vols. (Montecarlo: André Sauret, 1949–64).

A. Moravia, P. Lecaldano, *L'opera completa di Picasso blu e rosa* (Milan: Rizzoli, 1979).

M.T. Ocaña, H.C. von Tavel, *Picasso 1905–1906* (Barcelona: Electa España, 1992).

F. Olivier, *Souvenirs intimes*, G. Krill, ed. (Paris: Calmann-Lévy, 1988).

F. Olivier, *Picasso e i suoi amici* (Rome: Donzelli, 1993).

E.C. Oppler, *Picasso's Guernica* (New York: W.W. Norton & Company, 1987).

R. Otero, *Ricordo di Picasso*, in E. Grazioli, ed., *Pablo Picasso* (Milan: Marcos y Marcos, 1996).

J. Palau i Fabre, *Picasso, The Early Years. 1881–1907* (Cologne: Konemann, 1980).

J. Palau i Fabre, *Picasso cubisme (1907–1917)* (Paris: Albin Michel, 1990).

J. Palau i Fabre, *Picasso (1917–1926)* (Cologne: Köneman, 1999).

H. Parmelin, *Picasso sur la place* (Paris: Juillard, 1959).

H. Parmelin, *Picasso Says* (London: Allen and Unwin, 1969).

O. Paz, "Picasso: Il corpo a corpo con la pittura," in E. Grazioli, ed., *Pablo Picasso* (Milan: Marcos y Marcos, 1996).

R. Penrose, *Picasso: Sculpture, Ceramics, Graphic Work* (London: The Tate Gallery, 1967).

R. Penrose, *Picasso, his life and his work* (London: Gollancz, 1958).

R. Penrose, *Picasso (1982)* (Paris: Flammarion, 1996).

Picasso. Las grandes series y los maestros del pasado (Madrid: Aldeasa, 2001).

P. Picasso, "Picasso speaks: A statement by the artist," in *The Arts*, (May 1923), pp. 315–26.

P. Picasso, "Pourquoi j'ai adhéré au Parti Communiste," interview with P. Gaillard, in *L'Humanité* (October 29, 1944), pp. 1–2.

Picasso. Das Spätwerk: Themen 1964–1972 (Basel: Kunstmuseum, 1981).

A. Pinotti, ed., *Pittura e idea. Ricerche fenomenologiche sul cubismo* (Florence: Alinea, 1998).

D. Porzio, M. Valsecchi, *Conoscere Picasso* (Milan: Mondadori, 1973).

M. Raynal, *Les maîtres du cubisme: Pablo Picasso* (Paris: G. Crès, 1921).

E. Raynal, *De Picasso au Surréalisme* (Geneva: Skira, 1950).

E. Raynal, *Picasso* (Geneva: Skira, 1953).

G. Ramié, *Picasso: ceramiques* (Paris: Hazan, 1962).

H. Read, "Picasso's Guernica," in *London Bulletin*, no. 6 (October 1938).

P. Read, *Picasso et Apollinaire. Les métamorphoses de la mémoire: 1905–1973* (Paris, 1995).

G. Regnier *et al.*, *Picasso: Une nouvelle datation* (Paris: Réunion des Musées Nationaux, 1990).

G. Regnier *et alii*, *Treasures of the Musée Picasso: Paris (A tiny Folio)* (New York: Abbeville Press, 1994).

T. Reff, "Themes of Love and Death in Picasso's Early Work," in *Picasso in Retrospect*, Sir R. Penrose and J. Golding, eds., (New York: Harper and Row, Icon Editions, 1980).

P. Restany, *Picasso. La collezione nascosta* (Turin: Umberto Allemandi, 1996).

F. Reuβe, *Pablo Picasso. Lithographs* (Stuttgart: Hatje/Cantz, 2000).

J. Reventós, *Picasso i els Reventós* (Barcelona: Gili, 1973).

P. Reverdy, "Pablo Picasso," in *Nouvelle Revue Française* (Paris, 1924).

J. Richardson, "L'epoque Jacqueline," in *Late Picasso* (London: The Tate Gallery, 1988).

J. Richardson, *A Life of Picasso 1881–1906*, vol. I (New York: Random House, 1991).

J. Richardson, *A Life of Picasso 1907–1917*, vol. II (London: Jonathan Cape, 1996).

M. Richet, *Museo Picasso. Catalogo delle collezioni*, vol. II (Milan: Electa International, 1988).

R.M. Rilke, "V Elegia Duinese," in *Elegie Duinesi* (Milan: Rizzoli, 1994.

B. Rose, *Picasso & Drawing* (New York: Pace/Wildenstein, 1995).

C. Rosen, H. Zerner, *Romanticism & Realism. The Mythology of 19ᵗʰ Century Art* (New York and London: Norton, 1984).

P. Rosenberg, *Donation Picasso. La collection personelle de Picasso* (Paris: Réunion des Musées Nationaux, 1978).

R. Rosenblum, *Cubism and Twentieth-Century Art* (London: 1960).

R. Rosenblum, *Picasso in Retrospect*, Sir R. Penrose and J. Golding, eds. (New York: Harper and Row, Icons Editions, 1980).

W. Rubin, *Picasso in the Collection of The Museum of Modern Art* (New York: The Museum of Modern Art, 1972).

W. Rubin, *Pablo Picasso: A Retrospective* (New York: The Museum of Modern Art, 1980).

W. Rubin, "Picasso," in *"Primitivism" in Twentieth-Century Art*, 2 vols. (New York: The Museum of Modern Art, 1984).

W. Rubin, "La genèse des Demoiselles d'Avignon," in H. Seckel, *Les Demoiselles d'Avignon*, vol. II (Paris: Réunion des Musées Nationaux, 1988).

W. Rubin, *Picasso and Braque. Pioneering Cubism* (New York: The Museum of Modern Art, 1989).

W. Rubin, ed., *Picasso & Braque: A Symposium* (New York: Harry N. Abrams, 1992).

W. Rubin, *Picasso and Portraiture: Representation and Transformation*, (New York: The Museum of Modern Art; Paris: Flammarion, 1996).

W. Rubin, *Picasso. Télérama hors/série* (Paris: France Inter., 1996).

S. Rusiñol, *Obres completes* (Barcelona: Editorial Selecta, 1956).

F. Russoli, *Pablo Picasso* (Milan: Edizioni d'arte Amilcare Pizzi, 1953).

F. Russoli, F. Minervino, *L'opera completa del Picasso blu e rosa* (Milan: Rizzoli, 1972).

F. Russoli, F. Minervino, *L'opera completa di Picasso cubista* (Milan: Rizzoli, 1972).

J. Sabartés, *Picasso: Portraits et souvenirs* (Paris: Louis Carré & Maximilien Vox, 1946).

J. Sabartés, *Picasso: Documents iconographiques* (Geneva: Pierre Cailler, 1954).

A. Salmon, *La jeune Peinture Française* (Paris: Societé de Trente/ Albert Messein, 1912).

A. Salmon, *La jeune Sculpture Française* (Paris: Societé de Trente/ Albert Messein, 1919).

A. Salmon, *Souvenirs sans fin*

(1903–1920), 3 vols. (Paris: Gallimard, 1955–61).

H. Seckel, *Les Demoiselles d'Avignon*, 2 vols. (Paris: Réunion des Musées Nationaux, 1988).

H. Seckel, *Max Jacob et Picasso* (Paris: Réunion des Musées Nationaux, 1994).

G. Severini, *Dal cubismo al classicismo. Estetica del compasso e del numero*, E. Pontiggia, ed., (Milan: SE, 1997).

G. Severini, *La vita di un pittore* (Milan: Feltrinelli, 1983).

M. Shapiro, *Modern Art* (New York: Braziller, 1978).

A. Soffici, "Picasso e Braque," in *La Voce*, no. 34 (August 24, 1911).

W. Spies, *Picasso: Das plastische Werk* (Stuttgart: Gerd Hatje, 1983).

W. Spies, *Picasso sculpteur. Catalogue raisonné des sculptures établi en collaboration avec Christine Piot* (Paris: Editions du Centre Pompidou, 2000).

J. Starobinski, *Portrait de l'artiste en saltimbanque* (Geneva: Skira, 1970).

G. Stein, *Autobiographie d'Alice Toklas*, French trans. by Bernard Faÿ (Paris: Éditions Gallimard, 1934).

G. Stein, *Picasso* (New York: Charles Scribner's Sons, 1939).

L. Steinberg, *Other Criteria: Confrontations with Twentieth-Century Art* (New York: Oxford University Press, 1972).

L. Steinberg, "A Working Equation or Picasso in the Homestretch," in *Print Collector's Newsletter* 3, no. 5 (November–December 1972), pp. 102–5.

L. Steinberg, "Le bordel philosophique," in H. Seckel, *Les Demoiselles d'Avignon*, vol. II (Paris: Musée Picasso, Réunion des Musées Nationaux, 1988).

L. Steinberg, "La fin de partie de Picasso," in *Le Cahiers du Musée national d'art moderne*, no. 27 (Spring 1989), pp. 11–38.

L. Steinberg, *Trois études sur Picasso* (Paris: Editions Carré, 1996).

E. Tadini, "Les Demoiselles d'Avignon," in *L'occhio della pittura* (Milan: Garzanti, 1995).

Tériade, "L'Avénement classique du cubisme," in *Cahiers d'Art* (1929), p. 452.

J. Thimme, *Picasso und die Antike* (Karlsruhe: Badisches Landesmuseum, 1974).

J. Thimme, "Pablo Picasso 'Minotauromachy,'" in *Jahrbuch der Staalichen Kunstsammlungen in Baden-Württemberg*, no. 18 (1981), pp. 105–22.

V. Trione, "Picasso: il genio senza piedistallo," in *Il poeta e le arti. Apollinaire e il tempo delle avanguardie* (Milan: Guerini e Associati, 1999).

W. Uhde, *Picasso et la tradition française* (Paris: Editions des Quatre Chemins, 1928).

A. Vallentin, *Picasso* (Paris, 1957).

L. Venturi, *Pablo Picasso* (Rome: De Luca Editore, 1953).

V. Zemanova, *Arte e creazione: Pablo Picasso e Jean Cocteau* ([Guidonia]: Shakespeare & Company, 1991).

C. Zervos, "Les Métamorphoses d'Ovide illustrées par Picasso," in *Cahiers d'Art*, 6, no. 7–8 (1931), p. 369.

C. Zervos, *Pablo Picasso: œuvres*, 33 vols., *Cahiers d'Art* (Paris: 1932–78).

Photograph Credits

Bernard Ruiz Picasso,
Pablo Picasso, Man and Artist

Photo André Villers

Bernice B. Rose,
Pablo Picasso:
The World as Artifact

Arezzo, Soprintendenza per i Beni Ambientali, Architettonici, Artistici e Storici

Baltimore, The Baltimore Museum of Art

Chicago, The Art Institute of Chicago
© 2001 Estate of Pablo Picasso / Artists Rights Society (ARS), New York

Madrid, Museo Nacional Centro de Arte Reína Sofia

Milan, Electa Archive

New York, PaceWildenstein

New York, The Metropolitan Museum of Art

New York, The Museum of Modern Art

New York, The Solomon R. Guggenheim Museum. Photo David Heald, The Solomon R. Guggenheim Museum

Paris, Alex Maguy Collection

Paris, Musée d'Orsay

Paris, Musée du Louvre

Paris, Musée Picasso
© Agence Photographique de la Réunion des Musées Nationaux. Photo R.G. Ojeda
© Succession Picasso

Philadelphia, The Philadelphia Museum of Art

St. Petersburg, State Hermitage Museum

Pepe Karmel, *Picasso's Sculpture: The Unstable Self*

Chicago, The Art Institute of Chicago, Collection Alfred Steiglitz
© 2001 Estate of Pablo Picasso / Artists Rights Society (ARS), New York

Collection Marina Picasso, courtesy Galerie Jan Krugier, Ditesheim & Cie, Geneva

Dallas, Collection Patsy R. and Raymond D. Nasher. Photo David Heald, The Solomon R. Guggenheim Museum

New York, PaceWildenstein

Northampton (MA), Smith College Museum of Art

Paris, Musée Picasso
© Paris, Agence Photographique de la Réunion des Musées Nationaux.
Photo Michèle Bellot, Beatrice Hatala, Hervé Lewandowski
© Succession Picasso

Naomi Spector,
Notes on Picasso's Designs for Parade

Paris, Cliché Bibliothèque Nationale de France

Catalog

Auckland (New Zealand), Private Collection. Photo Ellen Page Wilson, courtesy PaceWildenstein

Chicago, Francey A. and Dr. Martin Gecht, Gecht Family Collection. Photo James Balodimas

Collection Berta Borgenicht Kerr. Photo Schecter Lee

Fairfax Realty, Inc. Art Collection
Photo Ellen Page Wilson, courtesy PaceWildenstein

Collection Dee Dee and Herb Glimcher.
Photo Ellen Page Wilson, courtesy PaceWildenstein

Collection Terese and Alvin S. Lane.
Photo courtesy PaceWildenstein

Collection Mr. and Mrs. Samuel H. Lindenbaum.
Photo courtesy PaceWildenstein

Collection Linda and Harry Macklowe.
Photo courtesy PaceWildenstein

Collection Madrigal.
Photo courtesy PaceWildenstein

Collection Abigail G. Melamed

Collection Hope and Abraham Melamed.
Photo Larry Sanders

Collection Julie and Edward J. Minksoff. Photo Ellen Page Wilson / photo Phillips/Schwab, courtesy PaceWildenstein

Mr. and Mrs. Leonard Riggio. Photo Ellen Page Wilson, courtesy PaceWildenstein

Collection Mortimer B. Zuckerman.
Photo courtesy PaceWildenstein

Dallas, The Patsy R. and Raymond D. Nasher Collection.
Photo David Heald, The Solomon R. Guggenheim Museum

David Teiger Collection

Estate of the Artist
© Images Modernes, photo Eric Baudouin
© Images Modernes, photo Marc Domage

From the Collection of Bill Blass. Photo Ellen Page Wilson, courtesy PaceWildenstein

Houston, The Menil Collection. Photo Hickey-Robertson / photo Paul Hester, courtesy Collection Menil

London, Tate.
Photo John Webb
© Tate Gallery, London 2001

Milan, Museo d'Arte Contemporanea, Jucker Collection

New York, Collection Linda and Morton Janklow.
Photo Ellen Page Wilson / photo Phillips/Schwab, courtesy PaceWildenstein

New York, Collection Mr. and Mrs. Donald B. Marron.
Photo courtesy PaceWildenstein

New York, Private Collection. Photo Sarah Harper Gifford, courtesy PaceWildenstein

New York, The Judy and Michael Steinhardt Collection.

Photo Ellen Page Wilson, courtesy PaceWildenstein New York, The Metropolitan Museum of Art.
Photo © 1987 The Metropolitan Museum of Art

New York, The Museum of Modern Art.
Photo © 2001 The Museum of Modern Art
© 2001 Estate of Pablo Picasso / Artists Rights Society (ARS), New York

New York, The Solomon R. Guggenheim Museum.
Photo David Heald, The Solomon R. Guggenheim Foundation

Paris, Musée Picasso
© Agence Photographique de la Réunion des Musées Nationaux.
Photo Béatrice Hatala, Hervé Lewandowski, R.G. Ojeda
© Succession Picasso

Private Collection, courtesy Fondation H. Looser

Philadelphia, The Philadelphia Museum of Art, Collection Louise and Walter Arensberg

Private Collection.
Photo Christian Poite

Private Collection.
Photo Ellen Page Wilson, courtesy PaceWildenstein

Private Collection.
Photo Sarah Harper Gifford, courtesy PaceWildenstein

Private Collection.
Photo Scott Bowron

Private Collection.
Photo Studio Patrick Goetelen

Private Collection.
Photo courtesy PaceWildenstein

Sammlung Frieder Burda.
Photo Ellen Page Wilson, courtesy PaceWildenstein

Stockholm, Moderna Museet.
Photo Anders Allsten, Moderna Museet